Visions of
Yesterday

VISIONS OF YESTERDAY

Jeffrey Richards

Lecturer in History
University of Lancaster

Routledge & Kegan Paul London

First published 1973
by Routledge & Kegan Paul Ltd
Broadway House, 68–74 Carter Lane,
London EC4V 5EL
Filmset and printed in Great Britain by
BAS Printers Limited, Wallop, Hants
© Jeffrey Richards 1973
ISBN 0 7100 7576 6

For my parents

'Visions of yesterday or dreams of tomorrow,
who is to say which exerts the strongest
pull in the psyche of man'

Dr Louis Judd, *Anatomy of Atavism*

Contents

Illustrations

Acknowledgments

It is always a pleasure to thank one's friends and colleagues for help. I would like to thank the following for assistance and advice of various kinds: Allen Eyles, Robert Walker, Colin MacArthur, Andrew Wheatcroft, Nicky North, Anthony Slide, Dai Smith, Janice Brooke, Martin Blamire, Jean Ashcroft, Trevor and Andrea Page, Helen Thompson, Catherine Bailey, Mike Singleton, Phil Bonney, Charles Preece, Stuart Keen, Tony Tysoe and Mr King. Individual chapters were read by Michael Heale, Patrick Cosgrave, John MacKenzie, Richard Taylor and Stephen Lamley and I am indebted to them for many helpful suggestions. I owe a particular debt of gratitude to the last three named, who gave freely and unhesitatingly of their time and their knowledge and without whom I would have fallen into error too frequently. I would like to thank Professor Harold Perkin who first suggested that I should write this book. Thanks are also due to Robert Kingston Films, Ron Harris Cinema Services, the British Film Institute Education Depart-ment and the Imperial War Museum for kindly arranging screenings of films for me. I am indebted to the Cataloguing, Stills and Information Departments of the British Film Institute for their unfailing courtesy and helpfulness, and to the Deutsches Institut für Filmkunde for their help in the location of stills.

The stills reproduced in this book first appeared in films distributed by the following companies, to whom thanks are due: Warner Bros, Columbia, RKO Radio, Paramount, 20th Century-Fox, Republic, United Artists, Metro-Goldwyn-Mayer, Rank, Gaumont British, Associated British, British Lion, British National, British Instructional, Renown, Universal, Butchers, Ufa, Tobis and Terra.

Parts of this book appeared in different form in the periodicals *Cinema*, *Focus on Film* and *Silent Picture* and I am grateful to the editors for their permission to re-use the material.

Introduction

Georges Sorel wrote that all great movements are compelled by myths. In most cases the myths are more important than the reality. They give identity, purpose and meaning to a movement. They shape the attitudes and determine the outlook of its adherents. Taking the single example of the idea of racial superiority, one can see that when a race believes itself to be better than all the others, a whole set of assumptions is created which dictates relations with other people. Thus the myth gives birth to the attitudes and from the attitudes are fashioned an image of society.

These all-important myths are dramatized in art and literature, they are hallowed by tradition, they become part of the human experience. The popular arts have a great deal to tell us about people and their beliefs, their assumptions and their attitudes, their hopes and fears and dreams. The popular art form *par excellence* of the first half of the twentieth century has been the cinema. Both in America and in Europe from the 1920s to the 1950s cinema-going was a regular habit, film-making was a major industry and success at the box office was to be obtained by giving the people what they wanted; i.e. something to which they could relate and which therefore reflected themselves. The cinema combined all the other art forms (painting, music, the word) and added a new dimension – an illusion of life. Living, breathing people enacted dramas before the gaze of the audience and not, as in the theatre, bounded by the stage but with the world as their backdrop. The cinema has ceased to be a popular art form and its future direction is not yet apparent. But the product of its popular period remains a still largely untapped source of social history.

Only now is it being realized – and much more tardily in Britain than in the United States – that a study of the cinema can reveal much about, for instance, popular attitudes and ideals. One of the purposes of this book is frankly propagandist – to hasten the process of acceptance of Cinema Studies in this country. I look forward to the day when courses in Cinema Studies exist in every university and college in Britain, studying, criticizing, evaluating films from every point of view: aesthetic, technical, sociological, etc. The birth of this hoped-for day requires a change in attitude by university authorities. Moribund, Oxbridge-orientated university panjandrums are still to be heard up and down the country chuntering that if Cinema Studies is adopted then the next step will be Football Studies (and why not?).

This is one reason why I have chosen to examine the cinema from the point of view of mythology and ideology, to show how vital films have been in illustrating and dramatizing the basic elements of movements in recent history. This aim has dictated the form of the book. I am not embarked primarily on a critical or aesthetic evaluation of films. My role is much more that of a textual critic and I have therefore looked at both 'good' and 'bad' films in search of the themes that concern me. Routine circuit fodder may have little artistic merit but can prove richly rewarding as a reflection of certain ideas and preoccupations. I have excluded silent films from the discussion, partly because I am not competent to discuss them, but mostly because their simple lack of dialogue rendered the articulation of an ideology along the lines of Frank Capra, say, very difficult.

Because much ink and fury has already

been expended in discussions of the cinema of the Left, particularly those films which can be described as Marxist, I have chosen to look at the cinema of the Right, a relatively unexplored and unfashionable area. I have taken three case studies – American populism, British imperialism and German National Socialism – and after outlining the essential elements in their ideologies, I have sought to discover how they found expression in film. In the case of populism, I have chosen to look at the careers of three directors who by any standard must be regarded as great (even though the first two stand head and shoulders above the third): John Ford, Frank Capra and Leo McCarey. In the cinema of Imperialism and the cinema of Nazism there are no similar titans whose careers can be examined in the light of certain ideological themes, so I have decided to examine these cinemas by theme rather than by director. But I hope that the end-result will be the same.

With populism and Nazism, I am examining cinematic genres on which some research has already been done and can work to some extent within an established framework. But in looking at the Imperial cinema, I am entering virgin territory, tentatively feeling out the lines of the genre. I have therefore spread myself in all directions, looking in detail at the literature, to provide a starting point for an excursion into the films. I hope that from this preliminary investigation something has emerged which will help future students of the Imperial cinema.

I have confined myself to discussing how the ideas were expressed in films and not how successful they were in, for instance, converting people – if indeed it is determinable. Some other book some other time must tackle that problem. This book is far from being the final word on anything. It is intended to provoke questions and arguments and hopefully to stimulate further research in the areas I have been examining.

I have chosen, I hope rightly, to discuss certain films in detail rather than simply give a list of film titles. This is done partly to inform those who haven't seen the films what they are about and partly to show those who have seen the films how by virtue of their plot lines and thematic motifs they fit into the larger pattern of the genre.

There are a few technical points which should be pointed out. In brackets after each film title I have given the name of the director and the year of production. The publication dates of books in the notes and bibliography are the dates of the editions I have used and not necessarily of the first editions. I have differentiated between populism (the school of thought) and Populism (the political party) and similarly between federalism and Federalism, republicanism and Republicanism, etc. I have used the terms British and English interchangeably because the films do so and to make a distinction would render much of my discussion unintelligible.

The reasons for liking and disliking a film or indeed any work of art are so intensely personal as to defy analysis. They are dictated by the background, preoccupations and psychological make-up of the individual viewer. In other words what I love, you may hate. This naturally does not affect what the film is about and, as will become apparent, I have not left out a film simply because I do not like it, but I make no apology for the personal prejudice which sometimes creeps in, my undisguised affection for certain films, certain directors, certain actors and certain actresses. But that is because I write from a passion for and a commitment to the cinema and not from an aloof and bloodless objectivity. Here I stand ... now read on ...

Part 1

The Cinema of Empire

Towards a Definition of the Cinema of Empire

If it is possible to date the apogee of the British Empire, then that date is surely 1897. For in that year Victoria, the Queen-Empress, celebrated her Diamond Jubilee, sixty glorious years on the throne of the mightiest empire the world had ever known. Potentates from the four corners of the earth gathered to pay homage to her. An Imperial army, drawn from men of every colour and creed, paraded in glittering splendour through London. The most powerful fleet in the world lay for review at Spithead. Odes poured from the pens of poets, great and small. From Gibraltar to Rangoon, from Hudson's Bay to the Falkland Islands, people gathered to sing and dance and feast and revel. *The Times* called it the first Pan-Britannic festival. 'Imperialism in the air,' wrote Beatrice Webb in her diary; 'all classes drunk with sight-seeing and hysterical loyalty.' For that moment in history, Imperialism was in the air, a new kind of Imperialism, not Roman or Russian or French but British Imperialism. The celebration of the jubilee of its living embodiment, the almost legendary Great White Mother, can now be seen as the climax of that Empire and that Imperialism, an intoxicating burst of fervent enthusiasm for the destiny of the British race, an explosive expression of a divinely ordained British mission to rule the world.

Within the space of twenty years and two bloody wars, men were breathing a different kind of air, full of socialism, Bolshevism, nationalism, change and revolution. It was an air which proved fatal to the Empire. It took less than seventy years for the sun to set for ever on that seemingly imperishable realm. The great Imperial structure, with its complex balance of elements: good and bad, blood and sacrifice, profit and glory, nobility and snobbery, aspiration and dedication, had crumbled into nothingness. Even the last melancholy echoes of the durbar trumpets had melted into silence, the long, wearying silence of mediocrity.

Because the British Empire has ceased to exist and because the attitudes it most prized are currently unfashionable, a whole genre of films, constituting what I have called the Cinema of Empire, has remained undefined and unexplored. In this section, I propose to make a preliminary exploration and lay down some tentative guide-lines for future study.

By the Cinema of Empire, I mean not simply films which are set in the territories of the British Empire but films which detail the attitudes, ideals and myths of British Imperialism. Films which fall geographically within the boundaries of the Empire, such as Australian 'Westerns', fall spiritually outside the limits of the genre.

I shall begin by establishing, from an examination of politics and literature, what precisely British Imperialism was believed to stand for. What it actually stood for and how it was really created is unimportant for this study. What is important, as with all myths, is what it was believed to stand for and what it meant to its adherents.

In going on to analyse the myth, I shall discuss the Imperial archetype and the public school code, which sustained him, a discussion that necessarily involves examining films which have no connection with the actual, physical entity of the British Empire. I shall look at the attributes of Englishness, the idea of the white man's burden, the hierarchic structure of society and of the armed forces and the Imperial pantheon of

gods and heroes. I shall end with an examination of the racial base upon which the Empire was constructed and its responses to the different categories of native: the worthy opponent, the faithful servant, the rootless half-caste and the educated agitator.

One of the major contributions of the cinema to the dissemination of Imperial ideas was to give glamorous celluloid life to the great folk myths of Empire. The archetypal Empire builders, who had hitherto been faceless, were clothed in the flesh and features of the great stars. Errol Flynn and Gary Cooper, Douglas Fairbanks and Cary Grant lent their special magic to the Imperial cause, imbuing with their own charisma the key images: the square-jawed, pipe-smoking, solar-topeed English sahib, standing on a rampart at the mouth of the Khyber and shading his eyes as he scans the hazy horizon for evidence of Afridi restlessness; and the square-jawed, pipe-smoking, gold-braided naval officer, pacing the bridge of one of Her Majesty's ships and shading his eyes as he gazes through the salt spray for evidence of enemy surface raiders. These images are what the cinema of Empire is all about, crystallizing an ideal figure, the ideal striven after and imitated by the exponents of the myth of British Imperialism.

It is possible to discern two separate cycles of Imperial films, both in British and American cinema. The first cycle comes in the 1930s when the Empire is still flourishing and produces the classic expositions of the Imperial idea. In Britain Alexander Korda produces a memorable Imperial trilogy (*Sanders of the River*, *The Four Feathers*, *The Drum*) and in Hollywood almost every major studio contributes an Imperial epic to the cycle inaugurated by *Lives of a Bengal Lancer* in 1935.

A question often asked and not yet satisfactorily answered is: What was the fascination of such a subject as the British Empire for the United States, which had after all seceded from that concern in 1776? Several answers suggest themselves. Firstly, and perhaps most obviously, the far-flung African and Indian outposts of the Empire fulfilled the thirties' desire for exotic and romantic escapism, just as the South Seas, Shangri-la and Ruritania did. Secondly, there was the commercial factor. Film-making was primarily an industry. Its principal aim was to make money and so film companies cashed in on any success with imitations. It was the runaway success of Paramount's *Lives of a Bengal Lancer* (1935) that directly prompted the decision of Warner Bros to film *Charge of the Light Brigade* (1936), with most of the action taking place in India. Other major studios followed suit, notably 20th Century-Fox with *Wee Willie Winkie*, *Four Men and a Prayer* and *Clive of India*.

The Imperial ideological content is partly to be explained by straight imitation of the prototype *Bengal Lancer*. *Storm Over Bengal* (1938), for instance, followed the prototype so closely that it even utilized three members of the cast of the prototype (Richard Cromwell, Douglass Dumbrille and Colin Tapley). It is also partly to be explained by the choice of subject material and scriptwriters. The scripts tend to be the work of Englishmen, such as John L. Balderston, W. P. Lipscomb and Barré Lyndon, and the inspiration, either direct (as in *Wee Willie Winkie* and *Gunga Din*) or indirect, is Kipling, whose ideas inform the whole body of Imperial films.

Few American directors returned more than once to British Imperial themes and there was no director who worked in them with the consistency that Ford or Capra worked in populist themes. This suggests that the genre of films of Empire was a studio-created genre and the ideas were those of the writers and not of the directors. Ford, who, being Irish, profoundly disliked the British Empire, did in fact make three Imperial films (*Wee Willie Winkie*, *King of the Khyber Rifles* and *Four Men and a Prayer*) but his feelings towards them seem to be reflected in his comment on the latter: 'I just didn't like the story or anything else about it, so it was just a job of work.'[1]

The fact that the studios continued to make Imperial films throughout the thirties indicates that there was a market for them and Americans do seem to have responded

to Britain's folk myths in the same way that Britain responded to America's, the Westerns. There is in fact an area of cross-reference between the two genres. Physically, the Imperial archetype resembles the classic Westerner: tall, thin, phlegmatic. Gary Cooper, one of the greatest of all Western stars, made two significant contributions to the Imperial genre: *Lives of a Bengal Lancer* (1935) and *Beau Geste* (1939). While two notable films of Empire were actually remade as Westerns. *Gunga Din* (1939) became *Sergeants Three* (1961) with Frank Sinatra, Dean Martin and Peter Lawford as U.S. Cavalry sergeants and Sammy Davis Jr as a Negro Gunga Din; and *Four Men and a Prayer* (1938) became *Fury at Furnace Creek* (1948) with budgetary considerations reducing the four men to two – but keeping the same prayer.

Ideologically, American films of Empire were little different from British films of Empire. The one major difference seems to have been the unusual preponderance of Canadians who turn up in the British Imperial service, a device necessary to explain away the American accents of members of the cast. This went so far in *Bengal Lancer* as to give the British colonel an estranged American wife in order to explain the broad Yankee accent of his son, who claimed to be straight from Sandhurst, and to make the star Gary Cooper 'a Scotch Canadian'.

To what extent Hollywood was consciously propagandizing for the British Empire in the thirties is difficult to say. Britain undoubtedly was. Korda's Imperial films were an expression of his personal devotion to the British Empire, symbolized by the flying of the Union Jack at Denham Studios and his legendary comment when he received his naturalization as a British citizen: 'Now we'll show the bloody foreigners.' A similar patriotic feeling lay behind the Imperial films produced during Michael Balcon's régime at Gaumont British (*Rhodes of Africa*, *King Solomon's Mines*, *The Great Barrier*) and Herbert Wilcox's Queen Victoria films, a long cherished project of his. *Sixty Glorious Years* (1938), the second of them, was scripted

by Sir Robert Vansittart of the Foreign Office, who declared to Wilcox: 'You've made a film that is a warm tribute to the British Empire and at a time when the first step has been shamefully taken to bring about its disintegration.'[2] The Admiralty gave official backing to *Our Fighting Navy* (1937) and the War Office to *O.H.M.S.* (1936) in order to publicize the peace-time activities of the Armed Forces.

But although Hitler regarded *Bengal Lancer* as a valuable piece of propaganda for the British Empire and said so in a comment reported by the trade papers,[3] it is difficult to see Paramount regarding it as more than a bang-up action picture for their rising star, Gary Cooper. As the European situation worsened, however, a conscious propaganda content did creep in. Brian Connell recalls that in the late thirties Douglas Fairbanks, a noted Anglophile, consciously undertook a series of roles in pro-British Empire films (*Gunga Din*, *The Sun Never Sets*, *Safari*), in the latter two of which the villains are Fascists.[4] Some newspapers in the United States went so far as to protest at the pro-British slant of these films.

Ironically it was the war which killed the first cycle of Imperial films. The film of Empire bowed out in 1940 with *The Sun Never Sets* being followed by the prophetically titled *Sundown*. Both films showed the British Empire standing for values opposed to those of their Nazi villains. There was pro-British propaganda in abundance during the war. History was re-written to give it an anti-Nazi slant in films like *Lady Hamilton* (1941) and *Young Mr. Pitt* (1942). Hollywood produced a succession of tributes to the embattled and beleaguered British: *Mrs. Miniver* (1942), *The White Cliffs of Dover* (1944), and *Forever and a Day* (1943). The latter, directed by a syndicate of directors convened by Cedric Hardwicke and featuring a host of British stars, was deliberately designed as a tribute to the British spirit. Its profits went to the aid of the British Red Cross.

But films lauding the virtues of British Imperialism ceased, and this seems to have been deliberate policy. This is suggested by

the fate of the proposed film version of *Kim*. In 1942, M.G.M. planned to film Kipling's classic novel with Mickey Rooney, Conrad Veidt and Basil Rathbone. But the plan was shelved at the suggestion of the Office of War Information, who were afraid that a film about the glories of the Raj might offend India at a time when her co-operation was needed in turning back the tide of the Japanese advance.[5] Their fears were perhaps well-founded for there had been riots in Indian cities when Korda's *The Drum* was shown. Another indication of the change is to be seen in the fact that Zoltan Korda, who had directed brother Alexander's Imperial epics (*Sanders of the River*, *The Four Feathers* and *The Drum*) and Kipling adaptations (*Elephant Boy* and *Jungle Book*), directed in 1943 *Sahara*, described by Andrew Sarris as 'the first film to popularize the spirit of the United Nations'.[6] It tells of a handful of Allied soldiers, British, American and French, who, with the aid of a Sudanese, contrive to defeat a German battalion in the desert. It is one of a whole group of films clearly designed to promote international co-operation, which was necessary for defeating the Nazi menace; and under such circumstances films which demonstrated the intrinsic superiority of the British to everyone else would be a little untimely.

The war, however, changed much. After it, the Empire was never the same again. India was given her independence in 1947, uprisings of one sort or another convulsed Kenya and Malaya, the British withdrew from Palestine in 1948 and the wind of change swept away the British African Empire during the late fifties and early sixties. The cinema had already presaged the shape of things to come. For even before the war ended Thorold Dickinson had begun shooting in Tanganyika *Men of Two Worlds*, a film whose hero was an African and whose setting was an emergent continent.

Many films have sought to depict the passing of the British Empire: in Kenya (*Simba, Safari, Something of Value*), Malaya (*The Planter's Wife, The Seventh Dawn*), Palestine (*Judith, Exodus, Cast a Giant Shadow*), Cyprus (*The High Bright Sun*) and India (*Bhowani Junction, Nine Hours to Rama*). But as Leslie Halliwell has commented: 'The emergence of new states is a painful business as a rule and most of these films give the impression of being so much tasteless picking at sore points.'[7] I have excluded these films from discussion, either because they are simply action pictures or romantic dramas, which have introduced Mau-Mau or Malayan terrorists for the sake of topical colour, or because they fall into the school of films which is anti-Imperial and therefore lies outside the scope of this study.

Also outside the scope of our investigations are the Dominion Westerns. For the record, however, it should be noted that after the war, the increase in emigration to the White Dominions (Australia, New Zealand, Canada, South Africa) was reflected by the increase in the number of films dealing with these areas. But in general, they tend to fall into the classification of Westerns or pioneering dramas. For the White Dominions do not, as will become clear, form part of the area of fully-formed British Imperialism, which involves the ruling of native peoples rather than the settlement by large numbers of whites. The clutch of Antipodean films of the late forties and early fifties is, however, an interesting phenomenon: New Zealand being the setting of *Green Dolphin Street* and *The Seekers*, South Africa of *The Adventurers* and *Diamond City* and Australia of *Eureka Stockade, Under Capricorn, Bitter Springs, Kangaroo* and *Robbery under Arms*. Even the Huggetts, perennial comic cockney family of the late forties, emigrated in *The Huggetts Abroad* (1949) – perhaps predictably – to South Africa.

There has always been, of course, a profitable Hollywood line in Canadian 'mountie' pictures as an alternative to the home-grown cowboy films. A whole stream of them has been made, with such original titles as *Northwest Mounted Police* (1940), *Macdonald of the Mounties* (1952) and *O'Rourke of the Royal Mounted* (1953). Even Shirley Temple, having seen service in British India in *Wee Willie Winkie*, joined up for *Susannah of the Mounties* (1939). In general, these have been routine Westerns, though where there

is Imperial propaganda, I have noted it.

Paradoxically, it was the break-up of the British Empire that gave birth to the second cycle of films of Empire, dating from the fifties and the sixties. Though many of them pay lip-service to independence and changing times, their principal *raison d'être* is nostalgia, and in this vein some of the most notable films of Empire were created, for instance *Zulu* (1963), *55 Days at Peking* (1962), *Khartoum* (1966), and pre-eminently *Northwest Frontier* (1959), justly described by Raymond Durgnat as an 'elegiac farewell to Empire'.[8] These then are the cycles of the cinema of Empire and it is to an examination of them and the attitudes they enshrined that this section is devoted.

Notes

1 Peter Bogdanovitch, *John Ford* (1967), p. 69.
2 Herbert Wilcox, *25,000 Sunsets* (1967), p. 121.
3 *Today's Cinema* (7 February 1939), p. 1.
4 Brian Connell, *Knight Errant* (1955), p. 112.
5 Tony Thomas, Rudy Behlmer and Clifford McCarty, *The Films of Errol Flynn* (1969), p. 171.
6 Andrew Sarris, *The American Cinema: Directors and Directions* (1968), p. 182.
7 Leslie Halliwell, *The Filmgoer's Companion* (1967), p. 109.
8 Raymond Durgnat, *A Mirror for England* (1907), p. 82.

2 The Ideology of Empire

Our first task is to establish the ideology on which the cinema of Empire is based. What becomes immediately obvious when viewing these films is that, although they are made in the last decades of the Empire's existence, they do not reflect contemporary ideas about the Empire. The ideas they reflect are those of the late nineteenth century. There is virtually no advance made on the views so memorably expressed by such late Victorian prophets of Imperialism as Lord Curzon and Lord Cromer. The constitutional developments in the Empire in the inter-war years find no place in the cinema of Empire. In films, the Empire is unchanged and unchanging. Its doctrine is the doctrine that had emerged by the last decade of the nineteenth century.

The precise nature of British Imperialism was much debated in the late nineteenth century. For beneath the pomp and circumstance, the glitter and the bombast, lay an apparently irresolvable paradox in the nature of the Empire, in the aims of British Imperialism and in the mind of Victorian Man himself, confronted by the fact of a dominion embracing a quarter of the globe. The Empire had not exactly been acquired, as Sir John Seeley suggested, 'in a fit of absence of mind', but neither had it been acquired in pursuit of some Imperial grand plan.

There can be little doubt that the primary motive in the growth of the British Empire was economic. The desire for profit can clearly be seen to lie behind such diverse activities as the search for the North-West Passage, the foundation of the East India Company and the acquisition of Hong Kong. While the need to provide living space for surplus population largely explains the development of Australia and New Zealand.

As the Empire grew, strategic Imperialism became increasingly important. Strategic reasons can be discerned in the acquisition of the Cape and Canada and they explain why British dominion in India had by 1818 extended up to the Sutlej in spite of the affirmation of the India Act (1784) that this was 'repugnant to the wish, honour and policy of this nation'. Just as the genesis of the Empire was economic, so too initially was its strategy. For example, while it was strategically desirable for Britain to control Canada, it was also economically desirable for her to control the Canadian fur trade, and expansion in India was at first dictated by the need to protect the British trading interest in Bengal. However, once the Empire was a going concern, strategic motives took on an independent existence. The British began acquiring territories to prevent other powers doing so and international power politics became an important consideration in Imperial development.

Altruistic Imperialism played a very small part in the first phase of the Empire, but with the need to develop a doctrine it took on major importance. The missionary impulse, the desire to bring the heathen to the light of God, and the leadership principle, the idea that the British, being the greatest race in the world, had a duty to provide government and justice for inferior races, intertwined to create a continuing theme in Imperial writing: the idea that the British ran their empire not for their own benefit but for the benefit of those they ruled.

It was, however, the economic impulse which dictated the attitude to Empire that obtained in the early Victorian period. It used to be called anti-Imperialism, but a more realistic description would be 'informal

Imperialism' or 'Free Trade Imperialism'. For what it involved was opposition to 'formal' or 'territorial Imperialism'. From the 1830s to the 1860s there was a school of thought, represented by, for instance, the Manchester School of Cobden and Bright, which viewed the territorial Empire as a definite liability and called for it to be wound up. For them 'Imperialism' (by which they meant territorial Imperialism) was a dirty word which smacked of continental despotism. It was the antithesis of the English democratic tradition and, perhaps more important, of the Free Trade system, under which Britain, as the world's manufacturer, was reaping enormous profits.

Britain's industrial revolution had put her ahead of the rest of the world, ushering in a new age of coal and iron, of factories and machines, of mass production and increased capital investment, of the mechanization of industry and the mobilization of labour. The economic structure of Britain was transformed into a closely integrated organism. The British became the financiers and builders and manufacturers of the world. In South America they took over the mines, founded the banks, built the railways and ran the newspapers. It was this kind of Imperialism, with the minimum of responsibility and the maximum of profit, that the 'anti-Imperialists' of the Manchester School envisaged.

As William Huskisson, the apostle of British Free Trade, pointed out, British manufactures were so superior and being produced in such bulk that the world would have to buy them. On the other hand, Britain needed free access to raw materials to sustain her industrialization. The answer was to pull down the restrictive machinery of protection that was hampering expansion. Gradually this was done, culminating in the 1840s with the repeal of the Navigation Acts and the Corn Laws.

Under these circumstances, the existing colonies came to seem, in Disraeli's phrase, like millstones around the neck of our expanding commercial and maritime empire. The problems of colonial defence, colonial administration and colonial trade came

more and more to the forefront of public discussion. The idea that self-government for the white dominions was the answer took hold in the wake of the epoch-making Durham Report, which gave a measure of self-government to Canada.

Professor Vincent Harlow wrote that for a metropolitan power, whose economy was geared to an expanding empire of world trade, the gradual dissolution of a privileged and burdensome empire was a neat theoretical solution.[1] But 'theory' is the operative word. An empire of ocean trade routes, protected by naval bases and centred on a handful of key entrepôts may have been the ideal, but the dissolution of the existing colonial structure was ultimately impossible. For one thing, if Britain moved out, someone else would move in and this was strategically undesirable. For another, the colonies themselves, firmly rooted in the Old Colonial System, and dependent on Britain as a market for their staples and as a source of manufactures, resisted the attempt to shed them. Perhaps most significant is the fact that John Bright, one of the leading lights of the Manchester School, advocated the continued possession of India, abundantly demonstrating the peculiar ambivalence which already underlay Victorian ideas on Empire.

Bright believed that Britain had a responsibility towards India. Others went further. They believed that Britain had a responsibility towards all her colonies, and here we see the missionary impulse and the leadership principle being posited as the justification for territorial Imperialism and as the antithesis of the obsessional pursuit of profit that was the hallmark of the fashionable 'Free Trade Imperialism'.

The voice of the Evangelicals can be heard in the words of the Report of the Parliamentary Select Committee on Aborigines (1837):[2]

The British Empire has been signally blessed by Providence: and her eminence, strength, her wealth, her prosperity, her intellectual, her moral and religious advantages are so many reasons for peculiar obedience to the laws of Him

who guides the destiny of nations. These were given for some higher purpose than commercial prosperity and military renown. Can we suppose otherwise than that it is our office to carry civilization and humanity, peace and good government, and above all, the knowledge of the true God, to the uttermost ends of the earth?

In 1853 Earl Grey, the Colonial Secretary, gave a statesman's view:[3]

I conceive that, by the acquisition of its colonial dominions, the Nation has acquired a responsibility of the highest kind, which it is not at liberty to throw off. The authority of the British crown is at this moment the most powerful instrument, under Providence, of maintaining peace and order in many extensive regions of the earth, and thereby assists in diffusing amongst the millions of the human race, the blessings of Christianity and civilization. Supposing it were clear . . . that a reduction of our national expenditure . . . could be effected by withdrawing our authority and protection from our numerous colonies, should we be justified, for the sake of such a saving, in taking this step and thus abandoning the duty which seems to have been cast upon us?

Gradually, in the sixties and seventies, as Empire comes to mean something to be discussed and interpreted in intellectual circles, the mood changes. The view outlined by Grey gains wider acceptance. The concept of 'Greater Britain' emerges, popularized by Sir Charles Dilke. He preaches the union of the Anglo-Saxon races in Britain and the white dominions, linked by common institutions, language, culture and traditions. Dilke himself even adds the United States of America to this union, though some of his adherents were less favourable towards our rebellious ex-colony.

If 'Greater Britain' existed, then there must be a reason for it and that reason is to be found in the propagation of British ideas and the British way of life. Scholars like John Ruskin and J. A. Froude enthusiastically take up the idea. They advocate widespread settlement in the colonies, as a means of strengthening Britain in the world. Says Froude: 'With our roots thus struck so deeply in the earth, it is hard to see what dangers, internal or external, we should have cause to fear or what impediments could then check the indefinite and magnificent expansion of the English empire.'[4]

At first, this creed is confined to a small circle of intellectuals. It is Disraeli, the flamboyant 'impresario of Empire', who takes up the idea and brings it before the masses. While Disraeli's policies are not consistently and unfailingly Imperial in character, he does consciously adopt an Imperial position, using popular anti-Russian feeling as a springboard. Russia is portrayed as the threat to India. The Queen is proclaimed Empress of India in 1877 as an indication to the world that Britain will uphold her rule there. The Suez Canal is acquired to protect the British sea route to the East.

Strategically Britain goes onto the defensive. Russia, France, Germany are all growing rapidly in strength and power and to combat them Britain needs the strength of her Empire around her. We can link economic defensiveness with this new strategic defensiveness. Other countries are industrializing, developing their own capital supplies and their own manufacturing systems. They not only cease to need British goods but they enter into active competition with Britain for the world market. However, there are still large areas of the world in need of internal improvements, capital investments, railways, manufactures and public utilities. Prominent among these areas are India, Canada, Australia and New Zealand. In the second half of the nineteenth century, then, territorial Empire once again becomes a national asset. For strategic and economic reasons have combined to make it so.

Britain actively seeks to consolidate and centralize her control of her far-flung territories and at the end of the century there are innumerable schemes for Imperial Federa-

tion, Imperial Defence Systems and Imperial Customs Unions. But they can never work because of the paradox of the Empire. Disraeli summarized it when, in a speech in 1878, he described the British Empire thus:[5]

> No Caesar or Charlemagne ever presided over a dominion so peculiar. Its flag floats on many waters; it has provinces in every zone, they are inhabited by persons of different races, different religions, different laws, manners, customs. Some of them are bound to us by ties of liberty, fully conscious that without their connection with the metropolis they have no security for public freedom and self government; others are bound to us by flesh and blood and by material as well as moral considerations. There are millions who are bound to us by our military sway and they bow to that sway because they know that they are indebted to it for order and justice. All these communities agree in recognizing the commanding spirit of these islands that has formed and fashioned in such a manner so great a portion of the globe.

In fact, there was not one empire but three: the white dominions of 'Greater Britain', the Indian sub-continent, and the African territories, each having their own special roles and problems. While within each of these divisions there was a patchwork of colonies, protectorates, territories, dependencies, condominiums, not to mention Sarawak, with its white Rajah, and Egypt, which, though technically part of the Turkish Empire, was virtually run by the British Consul-General. There was nothing approaching the formal precision and order of the Roman Empire. And it never remained static. New concepts constantly appeared: dominion status, trusteeship, mandates, dyarchy and, finally, commonwealth. As James Morris has observed: 'What was true of one colony was seldom true of another and there were in 1897 43 separate governments within the British Empire, displaying every degree of independence and subjugation and all manner of idiosyncrasy.'[6] This ineradicable complexity negated any chance of achieving

formal order. The single binding force, then as now, was the Crown, and in the nineteenth century this meant the formidable figure of the Queen-Empress.

Disraeli's championship of Empire caused 'Imperialism' to become a political slogan. It was used, in its Napoleonic sense, to attack Disraeli, notably by Gladstone, who set his face against the expansion of the Empire and believed that the welfare of the white dominions required their independence. This political use of the term made it ripe for definition and the Earl of Carnarvon came up with a distinction which drew on that tradition already expressed by Earl Grey. He distinguished between two kinds of Imperialism.[7] False Imperialism was Caesarism, personal rule, militarism, a vast standing army, endless expense. But True Imperialism, was a concept of service, maintaining peace between tribes and settlements which would otherwise fight each other, developing areas productively, educating the people towards self-government. The result of this process of definition was the emergence into popular thinking of an honourable idea which was to become the cornerstone of Imperial ideology: an idea compounded of the ideals of service and duty.

The political defeat of Disraeli and the formation of the Liberal government meant the end of the use of the term 'Imperialism' as a party slogan. But the incompetence of the government in dealing with colonial matters led to Disraeli's name acquiring new glamour. He is seen as the creator of a vision of Empire. Imperial unity becomes the rallying cry of the opponents of Irish Home Rule and the march of events leaves Gladstone and company behind.

British Imperialism becomes an accepted and acceptable dogma and the world role of the British race a popular subject for debate. Sir John Seeley stresses the power of ideas to move men and urges the development of an Imperial ideology. He points the way towards the elaboration of the fully-formed Imperial religion, with its belief in British racial superiority and the Imperial duty to rule.

It was believed that the Anglo-Saxon race

was the race best fitted to govern. Joseph Chamberlain was expressing the view of many when he declared:[8] 'In the first place, I believe in the British Empire and in the second place, I believe in the British race. I believe that the British race is the greatest of governing races that the world has ever seen.' Similarly, Cecil Rhodes:[9] 'I contend that we are the first race in the world and the more of the world we inhabit, the better it is for the human race. Added to which the absorption of the greater portion of the world under our rule simply means the end of all wars.' Ultimately there would be an Anglo-Saxon world state. Whether or not the race included the Americans was a question still debated. One man had no doubt that they were to be included and that was the world's greatest consulting detective, Mr. Sherlock Holmes of Baker Street, who declared to Francis H. Moulton in 1887:[10]

> It is always a joy to me to meet an American, Mr. Moulton, for I am one of those who believe that the folly of a monarch and the blundering of a minister in far gone years will not prevent our children from being some day citizens of the same worldwide country under a flag, which shall be a quartering of the Union Jack with the Stars and Stripes.

With or without the Americans, the concept of the Anglo-Saxon world state, growing out of the British Empire, was one to which the masses could respond. And respond they did, encouraged by the newly-emergent popular press, like the *Daily Mail*, pledged by its own words to be 'the embodiment and mouthpiece of the Imperial idea'. It was pressure from mass opinion that forced Gladstone to send an expedition down the Nile to avenge Gordon. For Gordon was seen as a symbol of the British Empire, a Christian hero with an Imperial mission.

The duty of this superior race to rule found its expression in India and Africa. India, brightest jewel in the Imperial crown, had always held a special place in the Empire and Britain's attitude to her had undergone an interesting and radical change during the course of the century, the watershed being provided by the Indian Mutiny. The Empire had been acquired by merchant adventurers and gentleman warriors and in the first phase of its existence had been the object of vigorous reforms. These reforms were inspired by the Evangelicals and the Utilitarians, adherents of two movements with the same end in view: the improvement of India. 'The Utilitarians hoped to reform morals by improving society and the Evangelicals hoped to reform society by improving morals.'[11] Under their auspices, there was an era of enthusiastic westernization: in education, religion, customs and public amenities.

The Indian Mutiny (1857) was in part a reaction against this forcible westernization and came as a traumatic blow to the British. Savage revenge was followed by a crucial change of policy. Henceforth, the British remained aloof from religious and social questions and devoted themselves to the maintenance of law, the levying of taxes and the pursuit of what Percival Spear[12] called 'a policy of enablement', creating amenities and leaving the Indians free to use them or not as they chose.

There were several factors at work after the Mutiny to ensure that this change of attitude towards India became permanent. Missionary fervour declined and, with it, the original belief that Britain was educating the Indians towards self-government. As Empire became popular and even desirable, the idea was fostered that the British Raj in India should be permanent. It was argued on the one hand that India was not a nation but rather a geographical expression, and on the other hand that it provided a perfect arena for the exercise of the superior ruling ability of the British and their sense of obligation to less fortunate peoples. This conservatism was encouraged by the fact that it was the middle classes who provided the administrative class in India and, having gained the privileges and reforms they had sought in the early part of the century, now stood for the *status quo* and opposed all change. It was also encouraged by the English ladies, who, with the opening of the Suez Canal, arrived in force in India to join their menfolk and

sought to recreate English middle-class society in the sub-continent, reinforcing the consciousness of racial difference and bringing to an end the widespread practice of intermarriage and assimilation into Indian culture that had prevailed before the Mutiny.

Then in the 1890s, largely in response to the dictates of Mediterranean strategy and European power politics, Britain acquired an African empire and with it a whole new arena for the exercise of the British Imperial mission. In the 1880s and the 1890s, a group of serious-minded young Imperialists appear, who finally articulate the fully-formed Imperial religion. These are men like Curzon, Balfour and Milner, men who believe, with Lord Rosebery, that the British Empire is the 'greatest secular agency for good the world has ever seen'. Such men as these founded the Primrose League, its members pledged to maintain 'the imperial ascendancy of the British Empire'. With them, Imperialism transcends party lines and acquires the mystic appeal which is basic to the true Imperialism.

The nineteenth century, often seen as the age of faith, was in reality the age of crisis of faith, when Darwinism and Freudianism, for instance, undermined traditional beliefs. There were several reactions to this: atheism was one, a return to Roman Catholicism was another and a third was the creation of a new religious faith, compounded of duty and Empire and incorporating the Protestant work ethic and a Calvinistic belief in the British as an 'elect'.

It was Lord Curzon, greatest of Indian viceroys, believing that in Empire we had found 'not merely the key to glory and wealth but the call to duty and the means of service to mankind', who defined the essentially religious nature of Imperialism. He declared in 1907:[13]

Empire can only be achieved with satisfaction or maintained with advantage, provided it has a moral basis. To the people of the mother state, it must be a discipline, an inspiration, a faith. To the people of the circumference, it must be more than a flag or a name, it must

give them what they cannot otherwise or elsewhere enjoy: not merely justice or order or material prosperity, but the sense of partnership in a great idea, the consecrating influence of a lofty purpose. I think it must be because in the heart of British endeavour there has burned this spark of heavenly flame that Providence has hitherto so richly blessed our undertakings. If it is extinguished or allowed to die, our empire will have no more life than a corpse from which the spirit has lately fled and like a corpse will moulder.

The same fervent note sounds in the Imperial writings of the twentieth century. Curzon's words have become a meaningful attestation of the faith to new generations of Imperialists. Men like Leopold Amery, who declares in 1924:[14]

Like the kingdom of heaven, the empire is within us. It means more than the practical advantages of a common citizenship and a common defence or than opportunities for advanced trade. It is a living faith, a faith in something that can be done to raise the whole standard of man's life on this planet.

And Sir Edward Grigg, who writes of the Empire in 1937:[15] 'It is not the extent or wealth of that vast and varied Empire that stirs my blood: it is rather the immense responsibility for human welfare and the opportunity for human betterment which it represents.' Here we have the exposition of that altruistic Imperialism, whose growth we have traced alongside that of its antithesis, the purely material doctrine of economic Imperialism.

Lugard, Milner, Churchill, all preach the same gospel. It is a gospel of duty and hard work, often unsung, frequently resented but persevered in because of its righteousness of purpose. Thus Arthur Balfour in 1910:[16]

If I am right and it is our business to govern with or without gratitude, with or without the real and genuine memory of all the loss of which we have relieved the population and no vivid imagination of all the benefits which we have given

them: if that is our duty, how is it to be performed and how only can it be performed? We send our very best to these countries. They work and strive, not for very great remuneration, not under easy or luxurious circumstances, to carry out what they conceive to be their duty both to the country to which they belong and the population which they serve.

Uncannily echoing Kipling's poem 'The White Man's Burden', this statement puts into words what for the Imperialist in the field, invariably laconic and reticent by nature, was his guiding instinct. Comment on these statements is superfluous. They say it all. They also enshrine the complete set of assumptions which govern the actions of the heroes of the cinema of Empire, often unspoken but always there.

It was always to be the argument of the Imperialist to rest on his record, on the positive good which he had accomplished. Curzon's unforgettable words on laying down the office of Viceroy of India:[17]

A hundred times in India I have said to myself, Oh that to every Englishman in this country, as he ends his work, might be truthfully applied the phrase 'Thou hast loved righteousness and hated iniquity'. No man has, I believe, ever served India faithfully of whom that could not be said. All other triumphs are tinsel and sham. Perhaps there are a few of us who make anything but a poor approximation to that ideal. But let it be our ideal all the same. To fight for the right, to abhor the imperfect, the unjust, or the mean, to swerve neither to the right hand nor to the left, to care nothing for flattery or applause or odium or abuse, never to let your enthusiasm be soured or your courage grow dim, but to remember that the Almighty has placed your hand on the greatest of his ploughs, in whose furrow the nations of the future are germinating and taking shape, to drive the blade a little forward in your time, and to feel that somewhere among these millions, you have left a little justice or happiness or prosperity, a

sense of manliness or moral dignity, a spring of patriotism, a dawn of intellectual enlightenment, or a stirring of duty, where it did not before exist – that is enough, that is the Englishman's justification in India. It is good enough for his watchword while he is here, for his epitaph when he is gone. I have worked for no other aim. Let India be my judge.

Rather more prosaically, but no less memorably, Cromer outlined British achievements in Egypt:[18]

Slavery has virtually ceased to exist. The halcyon days of the adventurer and the usurer are past. Fiscal burthens have been greatly relieved. Everywhere law reigns supreme. Justice is no longer bought and sold. Nature, instead of being spurned, has been wooed to bestow her gifts on mankind. Means of locomotion have been improved and extended. The sick man can be nursed in a well-managed hospital. The lunatic is no longer treated like a wild beast. The punishment awarded to the worst criminal is no longer barbarous. Lastly, the schoolmaster is abroad, with results which are as yet uncertain but which cannot fail to be important.

This could be the text for the operation of British Imperialism everywhere. A very small number of men, inspired by the vision and the need, take up the 'white man's burden' and confer on less fortunate nations the benefits of civilization: roads, railways and telegraphs, schools, hospitals and universities, famine relief and irrigation, peace and justice, in a word, the Pax Britannica. It is this interpretation of Imperialism that can be applied equally to India, Africa and the White Dominions, a manifestation of the divine mission of the British, with their traditions of fair play and democracy and their ethic of service and self-effacement.

Within a few short years, it is all under attack. The Old Queen dies with her century. Comes the Boer War, a war felt by many to be unjust and unrighteous. Comes the First World War and the slaughter of the flower of Britain's manhood amid the mud of Flanders.

Comes the rise of nationalism and the demands of the educated élite of the Empire for self-government. Comes the economic interpretation of Empire, formulated by J. A. Hobson and taken up by the Marxists, the idea that Imperialism is incompatible with social reform and justice at home and is a monopoly capitalist conspiracy of Jews and financiers, aimed at exploiting underdeveloped countries. Comes the new world movement, Communism, and 'Imperialism' becomes its hate-word. Comes the rise of England's rivals, hating her and envying her for her strength and for her justice. So Germany, Italy, Russia, Japan, all attack British Imperialism. Comes the Depression and the glitter of Empire seems tawdry in the face of empty bellies and starving children.

But Britain maintains her Empire and her concept of Imperialism in the face of the onslaught and it achieves a final moment of glory. When Britain stands alone against the sinister might of Nazi Germany and the old Imperialist, Winston Churchill, takes the helm of the nation at war, the Second World War assumes the dimensions of a crusade against the forces of darkness, with the Pax Britannica, and all that is best in it, ranged with the forces of light. 'Surely', Professor Reginald Coupland had written in 1935,[19] 'this is a time when a world society such as ours, dedicated to freedom, yet knowing it can only be preserved or rightly used in unity, should stand firm for the defence of civilization as we understand it.' Our world society did stand firm, but 'civilization as we understand it' (i.e. the British Empire) was the price we paid for victory.

Churchill had no doubt but that the War had strengthened the bonds of the Empire, as he declared in 1946:[20]

It was proved that the bonds which unite us, though supple as elastic, are stronger than the tensest steel. Then it was proved that they were the bonds of the spirit and not of the flesh and thus could rise superior alike to the most tempting allurements of surrender and the harshest threats of doom. In that dark, terrific and also glorious hour, we received from all parts of His Majesty's Dominions, from the greatest and from the weakest, from the most modern to the most simple, the assurance that we would all go down or come through together. You will forgive me if on this occasion, to me so memorable, here in the heart of mighty London, I rejoice in the soundness of our institutions and proclaim my faith in our destiny.

But 'our destiny' had only a short time left to run. Within twenty years it was all gone: India granted independence, the tropical empire wound up, the Commonwealth established in its place. The British, assailed from every side, had lost confidence in themselves and their world mission. Impoverished by war, Britain found it more expedient to control her former colonies economically and indirectly. So Britain bent before the wind of change and shed those duties and responsibilities, which had so inspired the great men of the late nineteenth century. The wheel had come full circle as the expediency and profit motives which had dictated the 'informal Imperialism' of the early Victorian period once again reared up to extinguish the 'spark of heavenly flame' that had given birth to the Imperial religion.

Looking back at it now, we see only the paradox: in the nature and aims of the Empire, in its size and its complexity. What were the British working for? Great stress was laid by many on Christianity. The Queen herself had written: 'An Empire without religion is like a house built on sand.' Great Imperial heroes – Livingstone, Gordon, Raffles – were all animated by a fervent Christianity. But Christianity means Catholicism and Anglicanism and Evangelicalism and all three were represented in the Empire. Many, too, had serious doubts about Christianity. Many did not practise it at all. It is not in fact Christianity which was the religion of the Empire but Imperialism itself. For some, their Imperialism may have had a Christian flavour. But for others, it did not. For men like Younghus-

band and Kipling and Haggard, dissatisfied with existing creeds, it was something intensely personal, a vision, inspired and mystical.

The paradox in the aims of Imperialism was aptly summed up by Cromer:[21] 'The Englishman as Imperialist is always striving to attain two ideals which are mutually destructive: the ideal of good government, which connotes the continuance of her supremacy, and the ideal of self-government, which connotes the total or partial abdication of his supreme position.' Britain always claimed to be educating the natives towards eventual self-government, but her belief in the innate superiority of the Anglo-Saxon race must have inclined her to the conviction that they would never be fit for self-government, thus fostering what Francis Hutchins has called 'the illusion of permanence'.

There was paradox too in the mind of Victorian Man. At the same time he was optimistic when viewing material and scientific progress, and pessimistic when viewing the erosion of the faith. Striving for change and improvement and yet fearful of atheism and revolution, he was at once conservative and radical.

So what then is the meaning of Imperialism? What is the ideology of Empire? What is the dogma that underpins the Cinema of Empire? If one examines all the writings on the subject, I think one will find two themes recurring over and over: the themes of Destiny and Duty. From Marquis Wellesley, the conqueror of India, through Sir Thomas Fowell Buxton and the Evangelicals, through Earl Grey and Gladstone, Ruskin and Carlyle, Disraeli and Curzon, Milner and Churchill, runs the idea that Providence, Destiny, Fate, have shaped the British nation for a world mission.

At the same time, the idea prevails that the British, with their long tradition of parliamentary democracy, freedom of speech and the press, the equitable administration of justice, have a responsibility to provide the world, and especially the underprivileged races of what is known today as the Third World, with these benefits: Peace, Order and Justice. With her industrial development, Britain also has the means of improving the prosperity and situation of the peoples she rules, of achieving the greatest happiness for the greatest number, of spreading technological improvements across the world. Ultimately it does not matter that the Empire is complex and complicated, that the ideology is built on fundamental contradictions; what matters is the inspiration, the ethic of Empire: service, duty, responsibility. It is an ethic compounded from many existing impulses: the evangelical motive, the public school code, the Protestant work syndrome. It is an ethic which has brought out much that is good in the British and has accomplished a great deal that will be of lasting good in the world. The doctrine enunciated and hallowed in the speeches of Curzon and the writings of Kipling draws out the essence and heart and meaning of British Imperialism as its initiates saw it: Duty, Sacrifice, Responsibility – the Englishman's burden, in fact.

Notes

1 Vincent Harlow, *The Founding of the Second British Empire 1763–1793*, vol. ii (1964), pp. 795–6.
2 George Bennett (ed.), *The Concept of Empire* (1962), p. 105.
3 Ibid., p. 186.
4 C. A. Bodelsen, *Studies in Mid-Victorian Imperialism* (1924), p. 106.
5 G. E. Buckle, *The Life of Benjamin Disraeli*, vol. vi (1920), p. 284.
6 James Morris, *Pax Britannica* (1968), p. 200.
7 R. Koebner and H. D. Schmidt *Imperialism* (1964), p. 153.
8 Bennett, op. cit., p. 315.
9 J. G. Lockhart and Hon. C. M. Woodhouse, *Rhodes* (1963), p. 68.
10 A. Conan Doyle, *Sherlock Holmes: The Complete Short Stories* (1963), p. 68.
11 Francis Hutchins, *The Illusion of Permanence*

(1967), p. 10.

12 Percival Spear, *A History of India*, vol. ii (1965), p. 152.

13 Bennett, op. cit., p. 356.

14 Leopold S. Amery, *The Empire in the New Era* (1928), p. 20.

15 Sir Edward Grigg, *The Faith of an Englishman* (1937), p. 242.

16 A. P. Thornton, *The Imperial Idea and its Enemies* (1967), pp. 360–1.

17 Bennett, op. cit., p. 350.

18 Ibid., p. 361.

19 Reginald Coupland, *The Empire in These Days* (1935), p. 5.

20 Bennet, op. cit., pp. 417–18.

21 Morris, op. cit., p. 515.

Literature of Empire

The towering figure of Rudyard Kipling dominates the literature of Empire. In his stories and poems he translated into dramatic form the basic concept of Imperialism that had emerged in the writings and pronouncements of men like Curzon, Milner and Rosebery. Duty, discipline, obligation, self-sacrifice: these were the demanding, ascetic concepts which informed the body of his work. It was Kipling who amid the heady self-congratulation of the Jubilee sounded a sombre note of warning, a reminder that the Empire was not all pomp and glory but hard work and duty. In 'Recessional', he wrote:[1]

If drunk with sight of power, we loose
Wild tongues that have not thee in awe,
Such boastings as the gentiles use
Or lesser breeds without the law –
Lord God of Hosts, be with us yet,
Lest we forget – lest we forget.

It was an onerous duty, the duty of civilizing the world, and it had been granted to the English. It was the English dream.[2]

We were dreamers, dreaming gently, in
the man-stifled town.
We yearned beyond the skyline where the
strange roads go down,
Came the whisper, came the vision, came
the power with the need
Till the soul that is not Man's soul was
lent us to lead.
('Song of the English')

But he was under no illusion about it. It was a hard task, a thankless task:[3]

Take up the white man's burden, send
forth the best ye breed,
Go bind your sons to exile, to serve
your captives' need ...

And when your goal is nearest, the end
for others sought,
Watch sloth and heathen folly bring all
your hopes to nought.
('The White Man's Burden')

The burden was shouldered by a small and dedicated band of men about whom there was something of a masonic spirit. They spoke their own language, the technical jargon of the expert that Kipling loved. They were 'the sons of Martha', the unsung toilers of the world. Kipling's idea of Empire was of a 'community of men of identical race and identical aims, united in comradeship, comprehension and sympathy'.[4] To these men, the day's work was all. 'What mystery is there like the mystery of the other man's job or what world so cut off as that which he enters when he goes into it.'

But work meant something more to Kipling. It played a major role in his world-view. As he wrote in 'On the Gate':[5]

Heart may fail and strength outwear
and purpose turn to loathing,
But everyday affair of business, meals
and clothing,
Builds a bulkhead 'twixt despair and the
edge of nothing.

Dick Heldar, in the semi-autobiographical novel *The Light That Failed*, observes: 'It is better to remain alone and suffer only the misery of being alone, so long as it is possible to find distraction in the daily work.' For Kipling, individual identity and integrity were preserved, in a world where chaos lay around the corner, by the discipline of work. The Empire provided the framework wherein this work could be performed, building the 'bulkhead 'twixt despair and the edge of

nothing'. It is this which accounts for the almost Calvinistic fervour with which Kipling extols the virtues of hard work, which become because of their milieu the virtues of the true Imperialist.

Work is part of the Imperialist religion. So too is the law. The emphasis on the law, most pronounced in the *Jungle Books*, constantly recurs:[6]

> Now these are the laws of the jungle and
> men and mighty are they.
> But the head and the hoof of the law and
> the haunch and the hump is obey.

And again:[7]

> Keep ye the Law – be swift in all
> obedience
> Clear the land of evil, drive the road and
> bridge the ford,
> Make ye sure of each his own,
> That he reap where he hath sown,
> By the peace among our peoples let men
> know we serve the Lord.

This could almost be the form of instructions issued to the servant of Empire.

Kipling's greatest novel, *Kim*, tells the story of an Anglo-Indian orphan boy, torn between two divergent ways of life. When it comes to a choice between the Eastern way, the life of contemplation and withdrawal from reality, and the British way, the life of action and service and involvement in the world, Kim chooses the latter.

Kim celebrates 'the Great Game', the intricate and dangerous espionage network by which the British secured their rule in India. But more generally it was by obedience to the law and the performance of the day's work unselfishly and uncomplainingly that the British justified their presence in India. Their lot was described in 'On the City Wall':[8]

> Year by year, England sends out fresh
> drafts for the first fighting line, which is
> officially called the Indian Civil Service.
> These die or kill themselves by overwork
> or are worried to death or broken in
> health and hope in order that the land
> may be protected from death and sickness,
> famine and war and may eventually

become capable of standing alone. It will never stand alone but the idea is a pretty one and men are willing to die for it and yearly the work of pushing and coaxing and scolding and petting the country into good living goes forward. If an advance be made, all credit is given to the native, while the Englishmen stand back and wipe their foreheads. If a failure occurs the English step forward and take the blame.

Kipling praises the dedication and expertise of the bridgebuilders ('The Bridgebuilders'), the District Officers ('Head of the District') and the Anglo-Indian service family ('Tomb of his Ancestors'). But it is probably 'William the Conqueror',[9] which most fully and characteristically expresses the sacrifices and hardships involved in a life of service to the Empire. William is a girl, the sister of district police superintendant Martyn. At the age of nineteen, she comes to keep house for her brother, and during the next few years contracts typhoid fever, is nearly drowned twice and lives in spartan conditions. But she loves the life and delights in mixing with the men and listening to them talk of their work.

The greatest test comes when famine and disease break out in the South. Martyn is sent for and William insists on going along. The young engineer Scott, whom William loves, goes too. But while the crisis lasts, they neither meet nor speak and at one point Scott passes within a few miles of the place where William is camped but does not turn aside to visit her. 'It wouldn't be him if he did' is her only comment. Only when the famine is checked do they marry and go north. 'I knew he was pukka,' says Scott's chief admiringly, 'but I didn't know he was as pukka as this.'

As Richard Faber has observed: 'At bottom, his vision of empire did not depend on confidence in the genius or desire for glory of the British race. It depended on a belief in the sanctity of work and discipline.'[10] Kipling was the keeper of the conscience of the Empire. As he grew older, he grew more and more disillusioned at the way in which the

British were discharging their God-given mission. He hoped that the Boer War would prove an Imperial lesson 'which may make us an empire yet'. But he was soon again withering the English with the blast of his rage for neglecting their great task:[11]

> They unwound and flung from them
> with rage, as a rag that defiled them,
> The Imperial gains of the age which
> their forefathers piled them.
>
> They ran panting in haste to lay waste
> and embitter for ever
> the wellsprings of wisdom and strength
> which are faith and endeavour.
> They nosed out and digged up and
> dragged forth and exposed to derision
> All doctrine of purpose and worth and
> restraint and prevision.
>
> ('City of Brass')

But Kipling wasn't just the poet of the administrators; he also hymned the common soldier, whose blood paid for the Pax Britannica, and the public schools, the seedbed of Imperialism's future. English literature has always been steeped in the lore and traditions of the sea. We are, after all, an island race and the sea has been our defence and heritage for centuries. It is Britain's admirals, Drake, Blake, Nelson, who have been her greatest idols. The sailor has been represented as Britain's defence against tyranny and invasion. The soldier, on the other hand, has been seen as the symbol of this tyranny. As Charles Carrington comments:[12] 'Search English literature and you will find no treatment of the English soldier' on any adequate scale between Shakespeare and Kipling.'

Kipling painted a grimly realistic picture of the life of the ordinary British soldier in India, a life lived amidst oppressive heat, devastating epidemics and irremediable boredom, in which the only relief was drunkenness and lechery. It was against this background that he set the exploits of his 'Soldiers Three', Mulvaney, Ortheris and Learoyd, who incarnated the spirit of grumbling resourcefulness which has always characterized the common soldier.

Nor did he forget the subalterns, 'boys in age, men in character, blessed with the adventurous ardour and audacity of youth'. 'Only a Subaltern'[13] is the simple and moving tale of Bobby Wick, an ordinary, decent lad, fresh from England, who is initiated into the traditions of the regiment, learns how to handle the men and earns their respect, works tirelessly to help stem a cholera outbreak but succumbs to it himself and dies. His quiet courage, fresh enthusiasm and unquestioning devotion to the regiment and to his duty mark him as the archetype of the young public school-bred officer, whose ilk staffed the furthest outposts of the Empire.

Kipling wrote his *Barrack-room Ballads*, dedicated to Tommy Atkins 'with my best respects', to celebrate the common soldier. They have about them the almost tangible feel of life and death, drink and boredom, raw nerves and bursts of sudden violence. Kipling faithfully chronicles the public antipathy to the soldier except in wartime ('Tommy'), the joy of going home ('Troopin'), nostalgia for the East ('Mandalay'), the respect for a brave adversary ('Fuzzy-Wuzzy'), and memorably the hopelessness of the gentleman rankers, 'the legion of the lost ones, the cohort of the damned.'

Behind the servants of Empire, 'the Westward Ho and Cheltenham and Haileybury and Marlborough chaps who went out to Boerland and Zululand and India and Burma and Cyprus and Hong Kong . . . and lived and died as gentlemen and officers,' were the public schools. Kipling made his contribution to public school literature with *Stalky and Co.*, based on reminiscences of his own school days.

In many ways, Kipling's public school stories are untypical of the genre as represented by Frank Richards or Talbot Baines Reed. For one thing they dealt with the United Services College, which was poor, had no traditions and was an institution for the sons of service fathers who couldn't afford to send their sons to the older public schools. Stalky and Co. break bounds, smoke unashamedly, don't attend or support compulsory games and despise the type of public

school goody-goody depicted by Dean Farrar in *Eric, or Little by Little.*

But if one examines the stories closely, one finds that they are not quite the misfits they might seem. Whenever they discomfit masters or prefects, it is because these figures are guilty of humiliating or persecuting them, thus letting down the best traditions of the public schools. They disapprove of and take steps to stop the bullying of small boys. They are learning the obedience to the rules, self-reliance and initiative, as well as 'the lesson of their race, which is to put away all emotion and entrap the alien at the proper time', all of which will stand them in good stead when they go out to serve the Empire. Most revealing of all is 'The Flag of their Country', a story which discloses Kipling's vision of patriotism as an inner, incommunicable, mystic thing, which involves him inevitably in hatred of crude jingoism. An MP comes and lectures the boys on patriotism, going so far as to wave a flag at them, to their utter horror. They regard him as 'a heathen – an outcast – beyond the pale of toleration, self damned before all men'. Why? Because:[14]

> In a raucous voice, he cried aloud little matters, like the hope of Honour and Glory, that boys do not discuss even with their most intimate equals: cheerfully assuming that, till he spoke, they had never considered these possibilities. He pointed them to shining goals, with fingers which smudged out all radiance on all horizons. He profaned the most secret places of their souls with outcries and gesticulations.

This is why they oppose the formation of a school cadet corps and compulsory attendance at games. They already have the spirit and have no need to demonstrate it, although, significantly, in an emergency when the school team needs men, they rally round and play. They also hero-worship the distinguished old boys who return to the school on leave from the North-West Frontier. Fifteen years later when all the old friends except Stalky, all now army officers or politicals, get together to reminisce, still calling each other by their old school nicknames ('Tertius', 'Pussy', 'Turkey'), they recount the wondrous deeds of Stalky in India and recall with affectionate nostalgia the old days at Westward Ho! For Kipling, Stalky is the ideal public school boy, a natural, born leader, resourceful, courageous, patriotic, and 'India is full of Stalkies . . . Cheltenham and Haileybury and Marlborough chaps that we don't know anything about and the surprises will begin when there is really a big row on.'

John Buchan was a practising Imperialist, one of Milner's young men in South Africa and later Governor-General of Canada. Like Kipling, he responded to the mystical concepts of duty and destiny and to Britain's world mission. In his autobiography, he outlined his vision of Empire: 'I dreamed of a worldwide brotherhood with the background of a common race and creed, consecrated to the service of peace; Britain enriching the rest out of her culture and traditions and the spirit of the Dominions like a strong wind freshening the stuffiness of the old lands.'[15] Alan Sandison has admirably summed up this commitment to the Imperialist religion. He writes that for Buchan the Imperial idea:[16]

> was represented in the total of service and sacrifice, duty and trust, clear purpose and exemplary conduct, demanded of and willingly given by the true servant of Empire. For him, it was an idea which awakened all that was best in man and curbed all that was worst, reminding him of his own higher nature: an idea which united man to man in a great fellowship which was more than the sum of individual effort: an idea which would have behind it a great catholic tradition of thought and feeling, in art and conduct, of which no part, but the empire itself, would be the appointed guardian.

With this dour and demanding creed went a total rejection of that other, more public, face of Imperialism, jingoism. Just as Kipling had denounced it in 'Recessional', so Buchan denounced it in *A Lodge in the Wilderness*: 'Jingoism, then, is not a crude

Imperialism; it is Imperialism's stark opposite ... it has no kinship with the ideal of an empire moving with one impulse towards a richer destiny ... the glory of England is not the mileage of her territory but the state into which she is welding it.'[17] Duty is the guiding force in the life of the true Imperialist, as Mr Scrope says in *A Prince of the Captivity*.[18] Duty is 'a thing both terrible and sweet, transcending life and death, a bridge over the abyss to immortality. But it requires the service of all a man's being and no half gods must cumber its altar.'

Buchan's great contribution to the literature of Empire was to fashion the archetypal clubman, the officer and gentleman who hunted and fished and shot and in his spare time polished off the enemies of his country. At the heart of his books is the brotherhood, the tightly-knit all-male group, a literary equivalent of the genuine all-male groups who helped run the Empire, groups like Milner's 'Kindergarten' and Rhodes' 'Twelve Apostles'. They were composed of young men of similar backgrounds who belonged to the same clubs and probably went to the same schools. Their life was within the group and it was this idea that Buchan conveyed so well in his books. His heroes tended to marry late in life and, even then, to expect their wives to adapt to the existence of the group. Dick Hannay, for instance, freely confesses: 'Women had never come much my way and I knew about as much of their ways as I knew about the Chinese language. All my life I had lived with men only and a rather rough crowd at that.'[19]

It is Dick Hannay, later Major-General Sir Richard Hannay, KCB, DSO, who is the most famous of Buchan's heroes and most perfectly represents the archetype. He stood for all that was finest and noblest in the concept of 'officer and gentleman'. Brave, honourable, resourceful, patriotic, unemotional, he shared with his friends the feeling expressed by one of them: 'I was meant by Providence to be in the service and to do work under discipline – not for what it brought me, but because it had to be done.'[20]

Modelled on Lord Ironside, Hannay, the steady, reliable, sporting clubman, is perfectly complemented by his close friend Sandy Clanroyden, brilliant, restless, unpredictable, a blend of Lawrence of Arabia and Aubrey Herbert and typifying the romantic, visionary face of Imperialism. Sandy, educated at Eton and Oxford, son of a peer of the realm, is a master of disguise, the first white man to ride through the Yemen, a figure well known in the caravanserais of Bokhara and Samarkand at the time when he was 'keeping a watchful eye on Central Asia'. 'In the old days, he would have led a crusade or discovered a new road to the Indies.' But today he is engaged on 'the Great Game', the secret service work so necessary for the preservation of the Empire and for making possible the 'old English way of conducting foreign policy' in which Sandy is a great believer. This involves regarding 'all foreigners as slightly childish and rather idiotic and ourselves as the only grownups in a kindergarten world. That meant that we had a cool, detached view and did even-handed, unsympathetic justice.'[21]

Buchan's heroes are pre-eminently sportsmen. Dick Hannay shoots and his son, Peter John, boxes. Sir Edward Leithen is a fisherman and shot. Jaikie Galt is a Rugby Blue and he makes a man of the flabby press baron, Thomas Carlyle Craw, in *Castle Gay* by introducing him to fell-walking. Life too must be played according to the rules. War and espionage are grim games with 'our side' against 'their side'. 'Oh well done, our side,' exclaims Sandy as the Cossack cavalry thunders to the rescue at the climax of *Greenmantle*. It is Sandy, too, who flies to D'Ingraville's château on Mont Blanc to exchange salutes before battle commences in *The Island of Sheep*, and when 'their side' is beaten, 'our side' invites them to dinner to celebrate the end of hostilities. In *Mr. Standfast*, Hannay finds that he cannot shoot Moxon Ivery in the back even though he intends spreading anthrax germs throughout the British army. A swift uppercut to the jaw is the method Hannay prefers. Likewise in *Greenmantle*, when the German von Stumm torments him and then fights dirty, Hannay sees red and declares: 'You infernal cad, I'm going to knock the stuffing out of you.'

Hannay prevents the dispositions of the British fleet getting into German hands just before the outbreak of war (*The Thirty-Nine Steps*), with his group (Archie Roylance, Peter Pienaar, John S. Blenkiron and Sandy), foils a jihad in the Near East which would threaten our route to India (*Greenmantle*) and exposes a German masterspy operating in England in the guise of a pacifist and intellectual (*Mr. Standfast*). Hannay's motive in accepting his missions is that unspoken patriotism and adherence to duty which Kipling would have recognized as the fulfilling characteristic of the true Imperialist. As his chief, Sir Walter Bullivant, comments: 'I may be sending you to your death, Hannay – Good God, what a damned taskmistress duty is! – if so, I shall be haunted with regrets but you will never repent. Have no fear of that. You have chosen the roughest road but it goes straight to the hill-tops.'[22]

As in all games, so too in 'the Great Game', one respects one's adversaries, even the Germans. Of Captain Zorn, Hannay remarks: 'That fellow gave me the best feel of any German I had yet met. He was a white man and I could have worked with him. I liked his stiff chin and steely blue eyes.'[23] Of Gaudian the engineer, he says: 'Clearly a good fellow, a white man and a gentleman. I could have worked with him for he belonged to my own totem.'[24] It is all here, the grounds for respect: the fellowship, the gentlemanliness, the acceptance of a man one could work with. Hannay is even able to feel sympathy with the Kaiser, whom he sees tormented by his responsibility for the Great War – a feeling remarkable in a book written in 1916. The arch-enemies are always those worthiest of the greatest respect, men like Dominick Medina in *The Three Hostages*, 'the best shot in England after His Majesty', an ascetic, a hypnotist, a devil-worshipper, a seeker after absolute power, or Captain Jacques D'Ingraville, strong, ruthless, impoverished French aristocrat, whom Peter John sees as 'magnificent, wonderful, terrible, inhuman, like some devastating force of nature' and Hannay sees as 'a fallen angel'. These are the dark side of the mirror, men of Hannay's totem gone wrong, dangerous adversaries but worthy of respect.

Completely unworthy of respect, however are the intellectuals. An anti-intellectualism informs Buchan and his fellow Imperial writers, indicating the Imperial antithesis of thought and instinct. In *Mr. Standfast* Buchan mercilessly mocks the pacifist commune at Biggleswick Garden City, which Hannay has to infiltrate. Hannay's stomach is turned by the collection of weedy, pretentious intellectuals he comes across, men like Aronson the novelist who:[25]

> proved on acquaintance to be the worst kind of blighter. He considered himself a genius whom it was the duty of the country to support and he sponged on his wretched relatives and anyone who would lend him money. He told me he sought 'reality' and 'life' and 'truth' but it was hard to see how he could know much about them for he spent half his day in bed smoking cheap cigarettes and the rest sunning himself in the admiration of half-witted girls. My fingers used to ache to box the little wretch's ears.

Similarly Barralty, one of the villains of *The Island of Sheep*, is the centre of an intellectual circle, contemptuously described by Sandy:[26]

> it was the usual roundup of rootless intellectuals and the talk was the kind of thing you'd expect – terribly knowing and disillusioned and conscientiously indecent. I remember my grandfather had a phrase for the smattering of cocksure knowledge which was common in his day – 'the culture of the mechanics' institute'.

What Buchan seems to have held against them most of all is the fact that they were frauds, who didn't really believe what they were saying. The genuine, principled pacifist, like Launcelot Wake, on the other hand, was worthy of respect and even affection – wrong maybe, but a good chap none the less.

The descriptions given by Hannay and Sandy very much epitomize the attitude of the average Imperial writer to intellectuals. They were dirty and snide, vulgar and pre-

tentious, cowards and weaklings. They played no sport and they poured scorn on the idea of serving their country. They had not gone to public school and they knew nothing of duty, good fellowship or good sportsmanship.

This, then, was the clubland hero, a figure much in evidence in fiction between the wars – though probably no writer was so prolific a creator of them as Dornford Yates, in whose books heroes with names like Crispin Willoughby or Dominick Medmenham tackled villains called Sir Henry Bleeding or Douglas Bladder, while moving between their country place and the club on those well-defined social rails on which the life of a gentleman is run.

The true 'Novel of Empire' only began to appear in the last decades of the nineteenth century and to take shape under the influence of Kipling. Even so, there had been a handful of novels earlier in the century which can be seen to conform to the meaning of Empire as it emerged in the literature and political thinking of the late nineteenth century. One such is *Oakfield* by William Delafield Arnold, brother of the poet Matthew Arnold and son of Dr. Thomas Arnold of Rugby. It tells the story of Oakfield, a young man who goes out to India to serve, distinguishes himself in battle against the Sikhs, serves manfully as Assistant Commissioner at Lahore and a few years later, his health broken, returns home to die in his beloved Lake District. Oakfield sees India as a penance and service there as a burden and a duty to be endured rather than enjoyed. He is the direct precursor of Kipling's work-obsessed sahibs.

In the wake of Kipling, however, came a flood of writers whose work to a greater or lesser degree echoes and is inspired by Kipling. Probably the most notable is A. E. W. Mason. Sometime journalist, traveller, MP and secret service agent, creator of the great detective Hanaud and author of several fine historical romances, Mason made two notable contributions to the Imperial genre with *The Four Feathers* and *The Broken Road*.

The Four Feathers is one of the classics of Imperial literature. It echoes *The Light That Failed* in its Sudanese setting and in its blind hero, who gives up the girl he loves to spare her the hardship of being married to a blind man. At the start of the book, the hero is Harry Feversham, who from youth has been obsessed not by fear but by the fear of being afraid and of betraying the long family tradition of bravery in war. The crux comes when he hears rumours of war in the Sudan and resigns his commission, receiving three white feathers from his brother officers, which become four when his fiancée Ethne Eustace adds hers.

Harry sets out to return the four feathers, but thereafter he slips from the centre of the stage and his best friend, Captain John Durrance, takes over. Durrance is a simple soldier whose creed is that 'to die decently is worth a good many years of life'. Lost in the Sudanese desert, he goes blind and thereafter it is his story that occupies the author. Sensitively and poignantly, Mason conveys the tragedy of the man who, in proportion to the great loss of his sight, increases in stature and perception as he adjusts to his affliction. Ethne, taking pity on him, agrees to marry him. But he realizes that she still loves Harry, and when he learns that Harry is a prisoner in Omdurman, he arranges for his escape. Harry returns to England and is reunited to Ethne by Durrance, who is best man at the wedding. That done, he sails for Egypt, back to the desert and the lonely places that he loves. Extremely well-written and often very moving, it is a story of courage, determination, quiet heroism and self-effacement in the best tradition of Englishry.

Equally fine is *The Broken Road*, which tells the story of two schoolfriends Shere Ali and Dick Linforth, who are at Eton together. The former is the son of the Khan of Chiltistan and the latter the son of the Linforths, whose lives are dedicated to the building of the road along the Indian frontier. Both fall in love with the beautiful, but shallow and worthless, Violet Oliver; but she rejects the proposal of Shere Ali because marriage to an Indian would ruin her social position, and ultimately the proposal of Dick because she cannot measure up to his

dream. Shere Ali is called back to Chiltistan to rule. He doesn't want to go. England is his home, is all he has known. He has been brought up as a white man. But he goes, only to learn how different it is in India, where he is regarded as a stranger by his own people and an inferior by the British. Eventually he throws off his European clothes and European ways and leads his people in a hopeless revolt against British rule.

Written with the avowed intention of persuading official opinion against bringing Indian princes to England and ensuring that they can belong to neither world, the tragedy of Shere Ali is handled with skill and compassion. But equally skilful and compassionate is Mason's delineation of the discipline and hardship of Imperial service. This is enshrined in the memorable concept of 'the Road'. 'The Road' is the destiny of the Linforths; their fulfilment lies in its completion: 'The power of the Road is greater than any government. It will go on to the foot of the Hindu Kush and then only will British rule in India be safe,' an earlier Linforth had written. Dick Linforth's father had died pushing it forward, but Dick is determined to continue the work. When the summons comes he is at Chatham, and he responds to it with all the fervour of the true servant of Empire.[27]

'Gentlemen, the Queen. God bless her!' and all the company rose and drank the toast. The prayer, thus simply pronounced amongst the men who had pledged their lives in service to the Queen, had always been to Linforth a very moving thing. Some of those who drank had already run their risks and borne their sufferings in proof of the sincerity; the others burned to do likewise. It had always seemed to him, too, to link him up closely and inseparably with the soldiers of the regiment who had fallen years ago or had died quietly in their beds, their service ended. It gave continuity to the regiment of Sappers, so that what each man did increased or tarnished its fair fame. For years back that toast had been drunk, that prayer

uttered in just those simple words and Linforth was wont to gaze round the walls on the portraits of the famous generals, who had looked to these barracks and to this mess room as their home. They too had heard that prayer and, carrying it in their hearts, without parade or needless speech, had gone forth, each in his turn, and laboured unsparingly.

But never had Linforth been so moved as he was tonight. He choked in his throat as he drank. For his turn to go forth had at the last come to him. And in all humility, he sent up a prayer on his account that he might not fail – and again that he might not fail.

This was the spirit of faith and service in which the servants of Empire went forth and in which they gave their lives. The Empire was a hard mistress, however. It took the best years of their lives and then turned them adrift. There is Sir Charles Luffe, dying during a native uprising and warning against sending Shere Ali to England because of just what happens. But both he and his warning are forgotten. The devotion to duty, however, is memorably expressed: 'I have lived for the frontier. The frontier has been my wife, my children, my home, my one long and lasting passion. And I am well content that it has been so. I don't regret missed opportunities of happiness.'[28]

There is Charles Ralston, the Commissioner in Peshawar, unmarried, ageing and tired. Like Luffe, his work has been his life. He has to disappoint Linforth by telling him that he has been summoned not to continue the Road but to exert a beneficent influence on Shere Ali, which, if successful, will obviate the need for the Road. As Ralston tells him what he must do, Linforth sees for the first time the real Ralston.[29]

Here was no official, here was a man. The attitude of indifference had gone, the air of lassitude with it. Here was a man quietly exacting the hardest service which it was in his power to exact, claiming it as a right and yet making it clear by some subtle sympathy that he understood very well all that the service

Hannay

John Buchan created the archetypal gentleman Imperialist in Dick Hannay. But the cinema has yet to produce a definitive screen portrait.
1 (above) Robert Donat played Hannay in *The Thirty-Nine Steps* (1935) as a debonair Canadian adventurer
2 (below) Kenneth More played Hannay in *The Thirty-Nine Steps* (1959) as a tweedy, genial English amateur

would cost the man who served . . . With each sentence Ralston had become more and more the dominating figure. He was so certain, so assured. Linforth recognized him no longer as a man to argue with; but as the representative of Government which overrides predilection, sympathies, ambitions and bends its servants to their duty.

There was something implacable and relentless in the tone and the words. There was more, too. There was an intimation, subtly yet most clearly conveyed, that Ralston had in his day trampled his ambitions and desires beneath his feet in the service of the Government and asked no more of Linforth than he himself had in his turn performed.

'I too have lived in Arcady,' he said.

Ralston demonstrates his courage and dedication by going into the streets singlehanded to rid Peshawar of a self-styled goddess, who is causing trouble. It isn't bravado, it is policy. To assume that no one questioned his authority was the best way and the quickest to establish it. It was the Great Bluff, by which the English contrived to rule a sub-continent with only a handful of men.

The book ends on a sad, downbeat note. Three years after the suppression of Shere Ali's rebellion Linforth is on leave in London. He meets Violet Oliver, now happily married, and tells her the end of the story. Shere Ali had been tracked along the Road and captured – by Linforth. He has been deported to Burma, where he is drinking

himself to death. Linforth walks away past a club where an old gentleman is dozing among his newspapers. 'I suppose I shall come to that,' he says. The spirit has gone out of him, like Ralston. The service has broken him, but he continues to serve.

Underlying the work of writers like Kipling, Mason and Buchan, we can see a thoughtful, consistent and complete world-view, based on similar assumptions and exploring the meaning of concepts like 'duty' and 'patriotism' which are integral to the Imperial vision. Their work is a fictional elaboration and exploration of the ideas which we saw emerging from the speeches and writings of the political Imperialists; and both Kipling, in films of *Gunga Din*, *The Jungle Book*, *Wee Willie Winkie*, *The Light That Failed* and *Kim*, and Mason, in films of *The Drum*, *The Four Feathers* and *Fire Over England*, were to achieve memorable cinematization. Surprisingly only one of Buchan's novels was to be filmed and this was *The Thirty-Nine Steps*. The first version was Hitchcock's exciting and entertaining 1935 production with Robert Donat playing Hannay as a dashing, debonair Canadian adventurer. It bore little resemblance to the book. It was this version, rather than the book again, which was remade unmemorably by Ralph Thomas in 1959. The characterization of Hannay differed, however, and, as played by Kenneth More, he emerged as a tweedy, genial English amateur. Though the cinema has yet to produce a definitive Hannay, Buchan's archetypal creation of the gentleman Imperialist remains an undoubted major influence on many other writers and film-makers.

Notes

1 Rudyard Kipling, 'Recessional', in *Kipling's Verse* (Inclusive Edition) (1937), p. 326.
2 Kipling, 'Song of the English', ibid., p. 171.
3 Kipling, 'The White Man's Burden', ibid., pp. 320–1.
4 Bonamy Dobrée, *Rudyard Kipling: Realist and Fabulist* (1967), p. 94.
5 Kipling, 'On the Gate', *Debits and Credits* (1949), p. 358.
6 Kipling, 'The Law of the Jungle', in *Kipling's Verse*, p. 546.
7 Kipling, 'Song of the English', ibid., p. 169.
8 Kipling, 'On the City Wall', *Soldiers Three and Other Stories* (1940), p. 324.
9 Kipling, *The Day's Work* (1898), pp. 170–214.
10 Richard Faber, *The Vision and the Need* (1966), p. 104.
11 Kipling, 'City of Brass', in *Kipling's Verse*, p. 314.

12 Charles Carrington, *Rudyard Kipling: His Life and Work* (1970), p. 146.

13 Kipling, 'Only a Subaltern', in *Wee Willie Winkie and Other Stories* (1899), pp. 101–20.

14 Kipling, *Stalky and Co.* (1922), p. 212.

15 John Buchan, *Memory Hold the Door* (1940), p. 130.

16 Alan Sandison, *The Wheel of Empire* (1967), p. 179.

17 Buchan, *A Lodge in the Wilderness* (n.d.), pp. 227–8.

18 Buchan, *A Prince of the Captivity* (1933), p. 48.

19 Buchan, *Greenmantle* (Hannay Omnibus ed.) (1963), p. 325.

20 Buchan, *The Courts of the Morning* (1929), p. 20.

21 Buchan, *The Three Hostages* (Hannay Omnibus ed.), p. 920.

22 Buchan, *Greenmantle*, p. 143.

23 Ibid., p. 179.

24 Ibid., p. 203.

25 Buchan, *Mr. Standfast* (Hannay Omnibus ed.), pp. 475–6.

26 Buchan, *The Island of Sheep* (1968), pp. 106–7.

27 A. E. W. Mason, *The Broken Road* (1907), p. 169.

28 Ibid., p. 31.

29 Ibid., pp. 227–8.

Myths and Myth-Figures

While it is the 'serious novels' which explore the ideas of Imperialism, it is the 'popular novels' which create the myths and myth-figures. They take facets of the archetypes analysed by Kipling, Buchan and Mason, strip them of their psychological depth and human frailty and magnify them to infinity. The result is that for the mass of the reading public it is not Harry Feversham or Bobby Wick or even Sandy Clanroyden who represents the Imperial spirit. It is Sanders of the River, Bulldog Drummond and Tarzan. For these are the figures who have passed into popular mythology. They have become part of the folk heritage. Even people who have never read the books know the names and what they stand for. The reason is simple. They are superhuman, larger-than-life manifestations of a simplified set of assumptions about Britain and her world-role. They are the gods and heroes of the Imperial sagas, operating in a world in which everything is simply Right or Wrong and Good always triumphs over Evil.

The spirit of Kipling hovers visibly over Talbot Mundy and Edgar Wallace in their colourful, streamlined, fast-moving popularizations of the Imperial ethos. Mundy represents a cross-fertilization of Kipling and Rider Haggard, notably in *King of the Khyber Rifles*, whose hero Captain Athelstan King, moustached, square-jawed, eagle-eyed and resourceful, foils a jihad of the hill tribes in India, fomented by the Germans during the First World War. The object of the revolt is certainly not independence. 'What but to force the Khyber and burst into India and loot?' It is the Raj which is India's only defence and it is her secret agents, men like King, engaged on 'the Great Game', who have to prevent such evil happening. King is aided by the mysterious Yasmini, called 'She', widow of a hill rajah and three parts Russian. She offers King her love, but he cannot take it for 'He was a servant of the Raj; his life and love had been India's since the day he first buckled on his spurs and she would not have understood that.' Echoes of Kipling filter through the serial-style exploits: the wild rides, mysterious assignations and sudden, violent death. Mundy also produced an imitation *Kim* in his novel *Om*, the story of Cottswold Ommony, àn orphan boy with an attendant Lama, who travels India searching for his sister.

The prolific Edgar Wallace created in his 'Sanders of the River' stories, far and away his best work, the classic District Officer, clearly based on the Kipling prototype. Wallace drew for inspiration on his experiences and observations of the Congo, where he had been sent as a reporter for the *Daily Mail*. But he set the stories on an unnamed river in British West Africa. His hero, Mr. Commissioner Sanders, was 'a mixture of Harry Johnston and the other West African Commissioners of whom he had heard such romantic and bloodcurdling tales'.[1] The stories were an immediate success, and in all he wrote 102 of them. He eagerly read up on the African tribes, their customs and folklore, and 'when the facts were insufficiently picturesque, he glibly invented them, referring in knowledgeable footnotes to mysterious native rites, traditions and superstitions, which he had entirely invented.'[2]

Sanders is the ultimate British District administrator in Africa: stern but just, all-wise and all-knowing, keeping himself at a distance from the people he rules, but knowing their languages and their customs

and able to pass amongst them in disguise without detection. 'There is one type of man that can rule native provinces wisely and that type is best represented by Sanders,' wrote Wallace in *Sanders of the River*,[3] the first book in the series.

The full collection of stories reveals in detail a range of attitudes and attributes that perfectly reflects the qualities which Wallace and his vast readership most admired in the archetypal British colonial administrator. Sanders is governed by instinct and experience, common sense and an inflexible sense of justice. He is no high-flying intellectual or theorist: 'He had to treat with folk who, in the main, were illogical and who believed in spirits. When you deal in the abstract with the government of races so influenced, a knowledge of constitutional law and economics is fairly valueless.'[4]

He had no doubt about what his job was, as he tells the sceptical native Fomba in *Sandi the Kingmaker*:[5]

'Lord, why do you come to these lands?' he asked bluntly. 'To bring the law,' said Sanders.

Now in the Bomongo language, there is only one word for 'law' and 'power' and for 'unbiased justice' there is no other word than 'vengeance'. So for law, Sanders used the word 'lobala', which means 'right' as distinct from 'wrong'.

Fomba was frankly puzzled. 'Lord, what is right?' he said.

'This is right, Fomba,' he said 'to keep faith, to harm none and to give every man his due.'

The stories reveal Sanders's duties in more detail.

He stamped out the general practice of witchcraft and human sacrifice, he discouraged with rope and irons the formation of secret societies, he dealt hardly with raiders but walked warily when he had to deal with customs which were logically sound, however revolting they might be in the eyes of civilized Europe.[6]

In other words, he maintained Law and Order and Peace. He shouldered the white man's burden and made his justice swift and stern. 'He governed a people 300 miles beyond the fringe of civilization. Hesitation to act, delay in awarding punishment, either of these things would have been mistaken as weakness amongst people who had neither power to reason nor will to excuse nor any large charity.'[7]

Sanders might be reprimanded by interfering do-gooders, who came in from outside knowing nothing of the people or the problems – men like the armchair commissioner in London who sought to impose a uniform code, derisively called 'The Little Tich Code', on the Territory; or the newspaper investigator, who sought to expose Sanders's alleged mistreatment of the natives and found himself slapped with a libel suit; or the new Governor who sought to stop the arbitrary use of the death penalty, evoking a threat of resignation from Sanders if he did. But Wallace clearly disapproves of these outsiders as much as Sanders does. He goes so far as to suggest that whatever the well-meaning outsiders thought, the native peoples understood and approved of the way Sanders dealt with them. 'Behind Sanders in his more drastic treatment of native misbehaviour was the implied sanction of the people he punished.'[8]

It is small wonder, in view of his experiences with them, that Sanders:

was not popular with outsiders, because he hated interference of all kinds and turned a hard face to all strangers. Across the Territories might have been written in letters a mile high 'No admittance except on business.' He had turned down more exploration parties and more traders than any ten commissioners in Africa. He had had sermons preached against him in missionary circles and had been most offensively prayed for; he had been reported and paragraphed, and very unpleasant articles had been written about him. But his policy of non-interference was one that had the sneaking approval of his superiors,

though occasionally he had found himself in conflict with the powers.[9]

But conflict or no conflict, the powers knew whom to turn to when they needed someone to settle affairs in the Old King's country: 'We think that in six or seven months, a strong, resolute man with a knowledge of the native – a superhuman knowledge, I might add – could settle the five territories now under the Great King and establish law and justice in a country which is singularly free from those ethical commodities.'[10] That superhuman figure is Sanders and he does it, as he does everything, with his handful of Houssa troops, his river-boat 'The Zaire', his network of spies, his favourite native chieftain Bosambo and the two other white men who form his staff: the irascible Captain Hamilton and the gangling, monocled silly ass 'Bones' (Lt Augustus Tibbetts). Alone and surrounded by thousands of tribesmen, Sanders and his little band accomplish the pacification of the territory.

Why do they do it? This is answered by their attitude towards the natives, which is paternalistic. This is why someone has to come in from outside and tell the natives what is right and what is wrong, to stamp out evil and hang malefactors 'from the highest branch of the highest tree on the highest hill in the village'. It is because the natives are mere children.

> By Sanders' code, you trusted all natives up to the same point as you trust children with a few notable exceptions. The Zulu were men, the Basuto were men, yet childlike in their grave faith. The black men who wore the fez were subtle but trustworthy; but the browny men of the Gold Coast who talked English, wore European clothes and called each other 'Mr.' were Sanders' pet abomination.[11]

Here is the clear distinction between the educated native, who is one of the greatest dangers to the perpetuation of British rule, and the ordinary native, who lives in his village and does as he is told by the trusted henchmen of Sanders, like Bosambo. Sanders expels two negro missionaries from the territory for preaching a doctrine of equality ('A black man is as good as a white man any day of the week'). Sanders regards this as seditious subversion. He also expels the Rev. Kenneth MacDolan, another negro missionary, for trying to set up a famine relief system, thus encouraging the natives to avoid paying their taxes ('White missionaries, yes, but black missionaries I will not endure'). The effects of a Western education on a negro are generally deemed to be harmful, witness the classic case of Tobolaka.

Two stories in the volume *Bosambo of the River*, called 'The Rise of the Emperor' and 'The Fall of the Emperor', tell the tale of Tobolaka, who is sent out by the interfering Colonial Office to be overlord of the River. He is a B.A. and a Baptist and has been in the United States. He arrives wearing European clothes, which infuriates Sanders into declaring: 'Nothing tires me as much as a Europeanized-Americanized native. It is as indecent as a niggerized white man.'[12] Sanders makes Tobolaka speak the native dialect and call him 'lord' to emphasize his inferiority to the whites. He also sends back the white girl who arrives from America to marry Tobolaka.

It is not long, however, before power corrupts the new Emperor and he becomes a bloodthirsty tyrant and is deposed. Interestingly Wallace presents Bosambo as the representative of the right-thinking native as much opposed to Tobolaka as Sanders is and for the same reasons: 'I have seen nations where white and black are mingled and these people are without shame, with no pride, for the half of them that is proud is swallowed by the half of them that is shameful and there is nothing of them but whitemen's clothing and blackmen's thoughts.'[13] It is the classic defence of *apartheid*.

Just as he despises the educated native, for getting above his station, Sanders cherishes a certain affection for the faithful native, for knowing his station and keeping to it. 'There was a newspaperman who said I treated my people like dogs. I believe I do. That is to say I treat them as if they were real good dogs.'[14] This is not intended to be

as derogatory as it sounds for it stems from the well-known principle that the English think more of their dogs than of their children. But like dogs, Sanders has to make sure that his 'people' know who is the master. He has the native Kabalaka whipped for calling him 'white man' instead of 'lord'. '"To me you shall say 'lord', also your king shall say 'lord', for I am lord of these parts over you all and will rule you with wisdom and guide you to justice, so that no man shall be oppressed."'[15]

Not surprisingly he is unshakeably opposed to miscegenation. When a succession of young officers become enamoured of the beautiful M'Lino he sends them home, declaring: '"Monkey tricks of that sort are good enough for the Belgian Congo and for Togoland, but they aren't good enough for this little strip of wilderness."'[16] That no good can come of it is demonstrated by the cautionary tale of John Silwick Aliston, a drunken and degraded Oxford B.A., who marries a mission-educated negress B'firi and when the ceremony is over, drinks himself to sleep and weeps, 'absurdly conscious of his degradation – absurdly, because he degraded his caste with open eyes.'[17] He becomes a bandit and ends up murdering his wife and dying of drink half an hour before being hanged.

One of the great paradoxes of British Imperial history was the twin attitudes of confidence and fear, confidence in the rightness of British presence in far-off lands and at the same time fear that British rule would be violently overthrown. There was ample justification for such fear. Imperial rule in Africa had only been established in the face of a succession of revolts (the Matabele War, the Ashanti War, the Zulu Revolt, the Mad Mullah's Revolt in Somaliland). The British in India never quite got over the shock of the Indian Mutiny and they always secretly dreaded the possibility of another one. The Jamaican Revolt similarly proved another shattering blow. The British could never understand why, when they had given them their freedom, the ex-slaves of Jamaica should be so ungrateful as to rise in rebellion. This legacy of revolt and unrest contrived to

fill the Imperial letters and memoirs of the late nineteenth and early twentieth centuries with an exaggerated fear of conspiracy. In both novels and films of Empire, one of the most common themes is the successful suppression by the British authorities of a plot or rebellion. In the twentieth century, in particular, this obsession found an outlet in two national phobias, characterized as 'The Red Peril' and 'The Yellow Peril'.

For millions of fiction readers 'The Yellow Peril' meant, in literary terms, Fu-Manchu, the creation of Sax Rohmer. Sax Rohmer (real name:Arthur Sarsfield Ward), a former journalist turned writer, an expert on the occult and an initiate of the Golden Dawn, created a whole series of unjustly neglected thrillers about secret cults, sinister Oriental masterminds and unearthly creatures, perhaps the most notable being *The Green Eyes of Bast*, *Fire Tongue*, *Grey Face* and *Brood of the Witch Queen*. But his most unforgettable contribution to literature and to myth is the immortal Dr Fu-Manchu.[18]

Imagine a person tall, lean and feline, high shouldered, with a brow like Shakespeare and a face like Satan, close shaven skull and long magnetic eyes of the true cat-green. Invest him with all the cruel cunning of an entire Eastern race, accumulated in one giant intellect, with all the resources of science past and present, with all the resources of a wealthy government – which, however, has already denied all knowledge of his existence. Imagine that awful being and you have a mental picture of the yellow peril incarnate in one man.

'The Yellow Peril', a phenomenon at once cultural, sexual and defensive, was much in men's minds at the turn of the century as revolution ended the centuries-old domination of the Manchu dynasty and the world became aware of the frightening potential of 'Young China'.

Fu-Manchu, incalculably old and possessed of powers unknown to Western science, heads a secret worldwide organization, the Si-Fan, its aim – what else? – world domination. Fu-Manchu's arch-enemy is Burmese

Police Commissioner Nayland Smith, who certainly does not underrate the gravity of his task:[19] 'I have travelled from Burma not in the interests of the British Government merely, but in the interests of the entire white race, and I honestly believe, though I pray that I may be wrong, that its survival depends largely upon the success of my mission.' Smith, dedicated to his work, rarely smiles, never relaxes and has no personal life, unlike his friend and chronicler Dr Petrie. Petrie finds time to marry the beautiful Kâramanèh and he eventually drops out of the series to enjoy wedded bliss, leaving the battle for the white races to more dedicated hands.

The origins of the Fu-Manchu stories can be seen in Conan Doyle. Sherlock Holmes, Dr. Watson and Moriarty are the models for Nayland Smith, Dr Petrie and Fu-Manchu; while the fog and gaslight atmosphere of the Holmes stories is crossed with the sleazy poetry of Thomas Burke's Chinatown to provide the milieu for the clashes between Smith and the Doctor. Although it is possible to trace its origins, the Fu-Manchu saga soon leaves them far behind to create its own special universe, memorably limned by Rohmer, who is unequalled in the evocation of atmosphere. Chinese opium dens in Limehouse, half-naked Burmese dacoits in the back streets of Wapping, beautiful slave girls with fur coats thrown hastily over scanty harem dress, mysterious drugs, religious stranglers, fog: these are the elements of Rohmer's world and through them strides Nayland Smith, surely, as Raymond Durgnat has observed,[20] an echo, conscious or otherwise, of the Saxon folk hero, Wayland Smith.

The first and perhaps the best of the thirteen Fu-Manchu novels, *The Mystery of Dr. Fu-Manchu*, was originally written as a serial for *Collier's Magazine* and published in book form in 1913. It sees Smith and Petrie attempting to halt the murderous career of the Doctor, who is planning to silence all the important men aware of the awakening menace of China. The list of the Doctor's victims reads like a roll-call of the Empire's great men: Sir Crichton Davey of the India

Office, the only man to understand the importance of the Tibetan frontier; Rev. J. D. Eltham, better known as 'Parson Dan', the fighting missionary whose teachings had been partly responsible for the Boxer rebellion and who, aided only by a dozen cripples and a German doctor, had held the hospital at Nan-Yang against two hundred Boxers; Sir Lionel Barton the explorer, the first white man to enter Lhasa; Graham Guthrie, British Resident in North Bhutan; and Henry Stradwick, Lord Southery, the finest engineer of his day.

Rohmer suggests the contrast between the sinister power of the East and the straightforward strength of the West, as a wave of exotic perfume sweeps into a room: 'It was a breath of the East that stretched out a yellow hand to the West. It was symbolic of the subtle, intangible power manifested in Dr Fu-Manchu, as Nayland Smith – lean, agile, bronzed by the suns of Burma – was symbolic of the clean British efficiency which sought to combat the insidious enemy.'[21]

Over the years, the world situation changed. Nayland Smith received a knighthood and rose to be head of the British Secret Service and Rohmer took up residence in the United States. The Doctor duly transferred his operations there, seeking to take over the Presidency (*President Fu-Manchu*). *Re-enter Dr. Fu-Manchu* saw the Doctor teamed with the Communists, though contemptuous of them, and the wheel came full circle in the last novel written before Rohmer's death in 1959, *Emperor Fu-Manchu*. In this novel, the ageless Doctor, whose name certainly suggests kinship with the Chinese Imperial dynasty, was seeking to overthrow the régime of Chairman Mao and make himself Emperor.

Fu-Manchu was much imitated in literature, and the Western World was much menaced by such facsimiles of the Doctor as Edgar Wallace's Fing-Su in *The Yellow Snake*, Harman Long's Lo-Khang in *Master of Evil* and most recently, Ian Fleming's Doctor in *Doctor No*. But 'The Yellow Peril' will be indelibly associated with Fu-Manchu, who takes his place among the myth-figures who

have emerged from 'the pulps'.

'The Red Peril' too entered 'the pulps' and found adversaries in such characters as Bulldog Drummond and Tarzan. Captain Hugh 'Bulldog' Drummond was created by Colonel H. C. McNeile, who wrote under the pseudonym of 'Sapper', and is said to be based on the author's close friend Gerald Fairlie, who in due course became 'Sapper's' collaborator and eventually his successor in chronicling the exploits of their hero. Superficially 'Sapper's' books might seem to resemble Buchan's. They share a common anti-intellectualism and anti-Bolshevism, a reverence for sport and sportsmanship and the apostrophizing of the gentleman clubman and the all-male public school 'brotherhood'. But a closer examination reveals a range of Fascist thuggery that would have appalled Dick Hannay or Sandy Clanroyden. Drummond and co. were definitely not of their totem.

Drummond, officer and gentleman, boxer and golfer, is a man who lives by his instincts and finds thinking rather painful. He talks much of sport and sportsmanship and the boxing metaphor extends to the titles of some of the books (*Knock-out*, *The Third Round*, *The Final Count*). He gathers around him a group of similar inclinations (Algy Longworth, Toby Sinclair, Peter Darrell, Ted Jerningham), men who converse in a sub-Wodehouse patois and call each other 'dearie' and 'old flick'.

In the first book of the series, *Bulldog Drummond*, this group comes up against its arch-enemy, the ruthless but able Carl Peterson, who, backed by a syndicate of anti-British financiers, plans, by using Bolshevik agitators, to paralyse Britain by strikes and take power ('One of the vilest plots ever dreamed of by the mind of man'). Drummond sets himself to foil this plot ('Evolution is our only chance, not revolution'). But in doing so, he reveals himself to be a dangerous pathological maniac.

We are told early in the book that during the war the ordinary cut and thrust of battle was not enough for him and he would go off into no-man's land at night and break the necks of the Boche. During the course of the book, he pushes Henry Lakington, 'the most dangerous man in England', into a vat of acid and deliberately breaks the arm of the German Kauffner and then blows a poisoned dart in his face. Compare this with Hannay's reluctance to shoot an enemy agent in the back.

Drummond himself is not concerned with ideologies. He just knows that Bolshevism is wrong, instinctively ('Like most normal Englishmen, politics and labour disputes had left him cold in the past'). It is left to the American, the outsider, to deliver 'Sapper's' message. Behind all the troubles of the nation are opportunists out for their own ends, working-class dupes who are simply being used and intellectuals ('They're the worst of the lot'):[22]

> Not one in a hundred of the so-called revolutionary leaders in this country is disinterested. They're out for number one and when they've talked the boys into bloody murder and your existing social system is down and out, they'll be the leaders in the new one. That's what they're playing for – power and when they've got it, God help the men who gave it to 'em.

It is the classic right-wing view of revolution. Just as the portrait of the hollow-eyed visionary fanatic, Volsky, is the right-wing archetype of the Russian revolutionary: ' "I know not what this young man has done. I care less. In Russia, such trifles matter not. He has the appearance of a bourgeois, therefore he must die. Did we not kill thousands, aye tens of thousands of his kidney, before we obtained the great freedom." '[23]

It compares with Buchan's belief expressed in *The Three Hostages* that 'all the contemporary anarchisms ... were interconnected and out of the misery of decent folks and the agony of the wretched tools certain smug entrepreneurs were profiting.' Criminal conspiracy was becoming more widespread because of a 'hideous, untamable breed' engendered by the war:[24] 'You found it among the young Bolshevik Jews, among the young entry of the wilder Communistic sects and very notably among the sullen murderous

hobbledehoys in Ireland.'

The difference between reactions is that Hannay and co. fight this menace with their own weapons: fair play, respect and good sportsmanship, whereas Drummond and co. use methods as ugly as those of their enemies, whom by and large they despise. Being a gentleman, Drummond tends to judge his opponents by the way they are turned out. Of a prominent trades union leader, he comments: ' "I only saw him once and then his shirt was dirty." ' To Volsky, he says with cool insolence: ' "I don't know which distresses me most, your maggoty brain or your insanitary appearance." '[25]

But if *Bulldog Drummond* is alarming, its sequel *The Black Gang* is terrifying, one of the most frighteningly paranoid novels of recent times. In it, Drummond and co. form the Black Gang, a ruthless black-clad extra-legal Fascist organization, which holds secret court martials of Bolsheviks, whom it classes either as unscrupulous scoundrels or fanatical madmen. In fact, it bears an alarming resemblance to the S.S.

As Drummond tells Charles Latter, the cowardly, power-lusting M.P.:[26]

'The gang . . . came into existence to exterminate things like you. Ever since the war, you poisonous reptiles have been at work, stirring up internal trouble in this country. Not one in ten of you believe what you preach: your driving force is money and your own advancement. And as for your miserable dupes – those priceless fellows who follow you blindly because – God help them, they're hungry and their wives are hungry – what do you care for them, Mr. Latter? You just laugh in your sleeve and pocket the cash.'

The gang begins its career by chloroforming the police to get at a secret meeting of Bolshevik agitators. The meeting consists of three clerks ('A nasty faced trio with that smattering of education which is truly a dangerous thing') and two Jews. The clerks are let off with a warning but the Jews are flogged 'within an inch of their lives'. Later on, Latter is deliberately driven insane by Drummond. Count Zadowa, the hunchbacked financier, gets off lightly:[27] 'because the hunchback was a hunchback – though endowed withal by nature with singular strength – it jarred on Drummond to fight him as if he had been a normal man.' So instead, he flogs him with a rhinoceros hide whip until his arms ache and then flings him into a chair, gasping, cursing and scarcely human. Then, as if that is not enough, he throws him down the stairs. Finally, Drummond goes berserk in the shrubbery at Maybrick Hall, decimating the Bolsheviks in an orgy of electrocution, shooting and neck-breaking, culminating in the bayoneting of Yalowski to the wall of the house.

But after the Bolsheviks are rounded up, the whole episode is covered up by the authorities. After all, Drummond had been the fag of Sir Bryan Johnstone, the Police Commissioner, familiarly known as 'Tum-Tum'. The Black Gang, its work done, is dissolved with the blessing of the Home Secretary, who is last seen at the Albert Hall being taught the foxtrot by Drummond.

This unbelievable catalogue of thoroughly unsporting and unEnglish carryings-on seems to have got the anti-Bolshevism out of 'Sapper's' system, for thereafter Drummond settles down to the familiar round of kidnappings and murders, stolen jewels and secret passages, criminal hunchback masterminds and unbalanced scientists, dwarf assassins and deadly cobras and mysterious houses on the Essex/Romney Marshes, with a spot of neck-breaking thrown in for old times' sake.

Drummond has been incarnated countless times on the screen and the cinema has done him the distinct service of cleaning up his image. In films, as played by such well-bred actors as Ronald Colman, Jack Buchanan, Tom Conway, Walter Pidgeon, Ron Randell and Ray Milland, he has been portrayed as a debonair gentleman adventurer, the best kind of Englishman and a credit to the Breed. He has generally confined himself to fighting crime in the good, clean, wholesome English manner we expect of our heroes.

The Black Gang was in fact brought to the screen as *The Return of Bulldog Drummond*

(Walter Summers, 1934). Ralph Richardson as Drummond came nearest of all the screen incarnations to the physical appearance and psychological make-up of the character. But both in Richardson's performance and Walter Summers's adaptation, the barbarities of the original were commendably played down. Drummond emerges rather more as an endearing overgrown schoolboy than as a dangerous paranoiac. He still leads his 'Black Gang', renamed for the purposes of the film as 'The Black Clan', though that has equally unfortunate connotations. But the punishment they mete out to enemies of the Empire is mild by comparison with the book. Charles Latter, instead of being driven insane, is simply dunked in Barking Creek. Carl Peterson (suavely played by Francis L. Sullivan) is accidentally electrocuted. The film also expresses scepticism about Drummond's organization, through the medium of the Police Commissioner who declares: 'Black Clans, pink shirts, green jerseys, don't fit in this great country of ours.' After this screen venture, Drummond's black mask was laid peacefully to rest.

But a similar illegal organization was idealized in Edgar Wallace's *The Four Just Men*, filmed by Walter Forde in 1939. The Four Just Men (Hugh Sinclair, Griffith Jones, Frank Lawton and Francis L. Sullivan) believe that the end justifies the means and act accordingly. The end in the film *The Four Just Men* is to smash a plot which aims to destroy the Empire by bombing the Suez Canal and thus preventing the movement of troops to the East. The means they adopt is to electrocute in his bath a pacifist Member of Parliament and substitute for him one of their number (Hugh Sinclair) who is an actor. Posing as the M.P., he delivers a rousing patriotic speech in parliament, warning the nation of its peril, and the film ends with shots of defence preparations being made against the danger. Given the timing of the film, the message is entirely understandable, but the methods employed are a trifle infra dig. Secret organizations were really frightfully bad form and thankfully appeared rarely in the cinema of Empire.

In the writings of Sapper a far more attractive figure than Bulldog Drummond is Jim Maitland, hero of twelve short stories. He is an 'immaculately dressed figure – tall, lean and sinewy, with sunbronzed clean-cut face tanned with years of outdoor life – and clearest of all, the quite unnecessary eyeglass', a gentleman and a sportsman who wanders the world 'with a spare set of underclothes and a gun'.[28]

He rescues from humiliation at the hands of the dago a drunken and derelict ex-Balliol man, Raymond Blair, and reunites him with his wife, whom Jim secretly loves, on a South Sea island. In Egypt, he takes up 'the Great Game':[29]

> 'It's the Game, Dick, the Great Game. The only game in the world worth playing. Sometimes I've been tempted to chuck up roving and take to it permanently.'
> 'Secret service work', I cried. Jim lifted a deprecating hand.
> 'Let us call it research work among the native population', he murmured.
> 'You don't suppose, do you, old man, that the British government runs 500 million black men here and in India by distributing tracts to 'em.'

He foils Baron Stockmar, who, besides being the agent of an unnamed foreign power, refuses to drink a toast to the King in the mess of the Royal South Sussex Regiment and then throws wine in Jim's face, calling him 'a coward and an Englishman'. There is a duel, and although Stockmar wounds Jim with a dum-dum bullet, Jim shoots him through the brain. Jim is a far better representative of the 'Breed' than Drummond, and has more in common with the standards expressed by 'Sapper's' other memorable short story collection, *The Dinner Club*.

Someone whose methods occasionally resembled Drummond's was Tarzan, though he had as an excuse the fact that he had been raised by apes and not at one of England's leading public schools. Edgar Rice Burroughs created in Tarzan of the Apes one of the most famous and enduring of all fictional characters. Based fairly obviously on Kipling's

Drummond

The cinema did Bulldog Drummond the service of cleaning up his image. The pathological Fascist thug of the books became a debonair gentleman adventurer on film.

3 (left) Ronald Colman as Drummond and Charles Butterworth as Algy are menaced by Oriental Warner Oland and his minions in *Bulldog Drummond Strikes Back*

4 (below left) Ray Milland as Drummond and Reginald Denny as Algy find a dead dummy in *Bulldog Drummond Escapes*

5 (below) Illegal secret organizations were frightfully bad form and appeared rarely. One instance is *The Four Just Men*. Griffith Jones, Francis L. Sullivan, Frank Lawton and Hugh Sinclair plot to electrocute a pacifist M.P. in his bath

Mowgli,[30] just as that character had been inspired by Haggard's wolfboy Galazi in *Nada the Lily*, Tarzan was the son of John Clayton, Lord Greystoke, peer of the realm, who, born after the marooning of his parents, grew up with the apes and after being discovered and rescued when grown up, resumed his place in the House of Lords.

Tarzan first appeared in 1912 in *All Story* magazine and subsequently in book form, followed by no less than twenty-six sequels. It is worth pointing out the very real difference between the film and book Tarzans. Tarzan in the books is an English gentleman, living on a palatial plantation in East Africa, overlord of a tribe of faithful natives, the Waziri, married to Jane, daughter of American professor Archimedes Q. Porter and fluent in several languages. On film, Tarzan is a half-naked noble savage, living in a tree house, married to Jane, daughter of English trader James Parker, and speaking in monosyllables. The most famous of these is of course: 'Me Tarzan . . . you Jane.' Though like most famous movie lines (e.g. 'Come with me to the Casbah' and 'Play it again, Sam'), it is a misquote and was never actually spoken in the film.

The original novel, *Tarzan of the Apes*, opens in 1888 with John Clayton, Lord Greystoke, sailing for Africa where, having transferred from the army to the colonial service, he is to investigate reports of slave-trading by an unidentified foreign power in a British West African colony. But a mutiny puts him and his wife ashore, they both die, and their child, born in the jungle, is raised as an ape. Burroughs believed that heredity would overcome environment and that the generations of culture bred into the child would not yield to savagery. Under it all, he remains an English gentleman. Eventually rescued and returned to England, he finds civilization wanting and goes back to his beloved jungle, all set for a sequel, *The Return of Tarzan*. During the course of this book, he marries Jane, discovers a hoard of Atlantean gold in the lost city of Opar and becomes chief of the Waziri. Jane and Tarzan eventually produce a son, Jack, who in *Son of Tarzan* gets kidnapped and ends up fending

for himself in the jungle, where he earns the name of 'Korak the Killer'. Naturally, he too contrives to remain a gentleman and ends up marrying Meriem, an Arab girl, who turns out inevitably to be the long-lost daughter of a French general.

Tarzan becomes something of a hero of Empire when he is not off discovering lost civilizations where medieval crusaders, ancient Romans or early Greek Christians still survive. He helps the British in East Africa against the Germans (*Tarzan the Untamed*, 1919), foils Communist agents seeking the gold of Opar to finance world-wide revolution (*Tarzan the Invincible*, 1931 and *Tarzan Triumphant*, 1932) and in *Tarzan and the Foreign Legion* (1944) he is to be found in Sumatra fighting the Japanese, while serving as a colonel in the R.A.F.

On a still lower level, the simplified and stereotyped elements of the Imperial creed, more often than not finding expression in an aggressive jingoism, were propagated by melodramas and boys' papers in the nineteenth century. There was an insatiable appetite for melodrama among the working classes of Victorian England. It represented for them an escape from the drabness and harshness of their lives and they would sit in the gallery, with their pints of beer in their hands and their packets of fish and chips in their laps, cheering and hissing as the age-old battle of Good and Evil unfolded again before their eyes.

The most popular early form of melodrama, a direct product of the Romantic movement, was Gothic and Eastern melodrama. By the middle of the century, however, it was on the decline. At a time when the Empire as a concept was coming into vogue, military and nautical melodrama increased in popularity and this was fed into the later large-scale sensation melodramas. These plays packed in everything that the fevered imagination of the playwright could devise, from full-scale massacre to shipwreck, train crash and earthquake, but with a full Imperial overlay, which presented the Empire to the working classes in terms it could understand – basically that the British were better than everybody else.

Tarzan
6 Tarzan of the Apes was in reality John Clayton, Lord Greystoke, and the cinema saw him performing deeds of valour in the Imperial service. Here in *Tarzan the Ape Man*, Johnny Weissmuller rests from his labours – with Maureen O'Sullivan

At the start of the century it was Nelson and Wellington who starred in the melodramas, as dramatizations of the major battles of the Napoleonic wars were staged. In some of these, Napoleon was presented sympathetically as an adversary worthy of respect. But the cheers were always for Wellington ('Where danger is, there will I be found. Now then for victory and for England') and Nelson, who invariably dies to the stage direction 'curtain descends as the orchestra plays "Rule Britannia"'. The major battles of the Crimean War and the Indian Mutiny likewise found their way on to the stage.

Dion Boucicault's *Jessie Brown, or The Relief of Lucknow* (1858), in which the gallant Jessie defied the mutineers and rallied the defenders of Lucknow, contained the memorable final sequence in which the British are just about to shoot their women and children before dying in a last stand when Jessie hears the pipes of the relieving forces and they are saved. This scene so embedded itself in the literary consciousness of the age that it was to turn up again and again in the cinema of Empire. The skirl of the pipes heralding the imminent relief of a beleaguered fort on the verge of surrender figures in the climax of at least three Imperial films: *The Four Feathers* (1929), *Unconquered* (1947) and *55 Days at Peking* (1962).

It was the jolly Jack Tar, however, who was the favourite hero of popular melodrama. Called by such names as Union Jack, Ben Brace and Jack Stedfast, he was patriotic, fearless and magnanimous ('To insult even a foreman labouring under misfortune is unworthy the character of an Englishman', *Britain's Glory*, 1797). Indeed, there seems to have been a mystical belief in the protection that could be afforded by the flag. For two plays, *The White Slave or The Flag of Freedom* (1849) and *British Born* (1872), contained identical scenes in which the hero is wrapped in the Union Jack when about to be shot and the natives, overcome with shame, lower their rifles and he is saved. In a less believing age, the same stratagem was attempted with less happy results. In *The Best House in London* (Philip Saville, 1967), George Sanders,

annoyed at being interrupted at tea by Indian rebels, wraps himself in the flag and dares them to fire. They pause and look at each other in wonderment. But the next scene is of Sanders's coffin, draped in a bullet-riddled Union Jack, being lowered over the side of a ship. The natives obviously hadn't seen the play.

The Imperial melodrama came to full flower at the end of the nineteenth century in plays with such self-explanatory titles as *Pluck, One of the Best* and *With Flying Colours*. *Khartoum* (1885) contains all the classic elements: disgraced British officer making his way to Egypt to rejoin his regiment and die bravely; hero's wife seeking news of her husband, captured by the Mahdi; and a rousing climax in which the heroine's party is attacked by Arabs in the desert and the husband appears to rescue her, as the stage directions read: 'a gunboat works on at the back, flying Union Jack and manned by Blue Jackets with a Gatling gun – opens fire on Arabs . . . Arabs cower; English cheer; music – Rule Britannia.'

True Blue (1896) concerns a villainous dago plot to sink H.M.S. *Watteau* and sets the temptress Carlotta to seduce the captain, Captain Maitland:

> *Carlotta* You are a man. A man.
> *Maitland* I am more. I am the
> commander of a Queen's ship.

Naturally the plot fails. Most splendid and way-out of all is *The Price of Peace* (1900), summarized thus by Michael Booth:[31]

> In the presence of two cabinet ministers in his office, the Prime Minister, to save the Empire, shoots a Russian diplomat who possessed vital British state secrets. He announces his deed to a full House of Commons, justifies himself in a speech of impassioned patriotism and drops dead of a heart attack. The Leader of the Opposition is the villain and is strangled by a Chinaman in the saloon of a sinking yacht.

Critics like George Bernard Shaw might scoff but the public lapped it up throughout the nineteenth century, just as their children

lapped up the juvenile periodicals.

The late nineteenth century saw the great flowering of boys' periodicals and they were permeated by much of the same ethos as the melodramas. *Young England*, *Union Jack*, *Boy's Standard* and pre-eminently the *Boy's Own Paper* carried literally thousands of stories, all of them in the same mould, by a group of incredibly prolific writers, many of them retired army officers like Major Charles Gilson and Lt Col F. S. Brereton. Their aim was to build character. *Chums*, edited by novelist Max Pemberton, urged its readers to take cold baths, though not to splash the water 'so as to give the servant trouble', and advised the taking up of cricket, both these activities being great builders of character.

The young reader was encouraged by stories of Imperial heroes, who played 'the Great Game' in distant parts of the world or, like Sexton Blake and his faithful assistant 'Tinker', sought to scotch the enemies of Empire here at home. He was warned against the fickle foreigner by endless tales of invasion, generally by the French or the Russians, in which St Paul's Cathedral and Big Ben were invariably blown up, the King kidnapped and London bombarded by an aerial fleet.

The same spirit pervaded boys' weeklies throughout the first half of the twentieth century and probably down to the time when many of them ceased publication in the fifties and sixties. The visual media stole the young readership. They could now see Sexton Blake and Tarzan on television without having to read about them. There can be no contesting George Orwell's verdict, arrived at in 1940 in his still definitive essay on boys' weeklies, that these weeklies were in their politics Conservative – and what is more pre-1914 Conservative – and that they certainly inculcated the view that 'there is nothing wrong with laissez-faire capitalism, that foreigners are unimportant comics and that the British Empire is a sort of charity-concern that will last forever.'[32]

The public school stories of *Magnet* and *Gem* and the adventure stories of *Wizard* and *Hotspur* with their cricket-bat wielding secret agents on the North West Frontier

and sporting soldier heroes on the Western Front are underpinned by exactly the same assumptions and beliefs that sustained Wallace and 'Sapper', Mundy and Rohmer. There was no secret about the effects of these papers. In fact their publishers were proud of them. The Amalgamated Press, one of the leading publishers of boys' papers, declared:[33]

> These boys' journals aimed from the first at the encouragement of physical strength and patriotism, of interest in travel and exploration and of pride in our empire. It has been said that boys' papers of the Amalgamated Press have done more to provide recruits for our Navy and Army and to keep up the esteem of the sister services than anything else.

The field of boys' writing is inevitably dominated by G. A. Henty, a former newspaper correspondent who turned to writing stories for boys and churned out some ninety novels, as well as editing *Union Jack*. His stories were required reading for generations of children and one comes across many a battered copy of Henty in second-hand bookshops, bearing a label which attests it as a school or Sunday school prize.

Twenty-five of his novels are concerned with the Empire and they are all pretty well the same. Poor but honest orphan boys go out to the colonies, suffer various trials and tribulations, win name and fame through shot and shell by sheer pluck, marry the colonel's daughter, win the V.C. and help some great British hero, Clive, Kitchener or Roberts, to maintain British rule in far-off lands.

His heroes are typical public schoolboys, younger versions of 'Sapper's' breed. For instance, Charlie Marryat in *With Clive in India* (1887) is:[34]

> a tall lad of 16 . . . slight in build, but his . . . muscles as firm and hard as those of any boy in the school. In all sports requiring activity and endurance rather than weight and strength, he was always conspicuous . . . he was a capital swimmer and one of the best boxers in the school.

He had a reputation for being a leader in every mischievous prank; but he was honourable and manly, would scorn to shelter himself under the semblance of a lie, and was a prime favourite with his masters as well as his school fellows.

Like 'Sapper', Henty has no time for intellectuals. As a character in *With Clive in India* says:[35]

Give me a lad with pluck and spirit and I don't care a snap of my fingers whether he can construe Euripides or solve a problem of higher mathematics. What we want for India are men who can ride and shoot, who are ready to start on a hundred mile journey on horseback, who will scale a hill fort with a handful of men or with half a dozen sowars tackle a dacoit and his band. What do the natives care for our learning? It is pluck and fighting power that have made us their masters.

Charlie Marryat will undoubtedly grow up into Jim Maitland or perhaps Sanders of the River.

The object of Henty's heroes is the maintenance and extension of British rule, naturally. For its benefits are unquestioned and unquestionable. As a Kashmiri officer in *Through the Sikh War* declares of British rule:[36]

'What a blessing it would be to this country! In the first place, there would be neither taxation nor oppression. All would live and till their lands and work their loom, secure of enjoying their earnings in peace. Money would flow into the country for the sahibs would come in great numbers from the plains for health and for sport and would spend their money freely.'

This is the British mission in the world but it has to be pursued with no nonsense or shilly-shallying.

As Stanley's uncle says to him one day in *On the Irrawaddy*:[37]

'There is no doubt that we shall shortly have a big war with the Burmese. The fact that these constant acts of aggression are met only by remonstrances on our part increases their arrogance and they are convinced that we are in mortal terror of them. They say that in Assam their leaders are openly boasting that 'ere long they will drive us completely from India and one of their generals has confidently declared that after taking India, they intend to conquer England. With such ignorant people, there is but one argument understood, namely force; and sooner or later we shall have to give them such a hearty thrashing that they will be quiet for some time.'

In general, Henty's attitude to natives is absolutely typical of the dichotomy in the views of the Imperialist. He respected the fighting races, believing the Afghans to be fine soldiers 'when led and organized by British officers'. He approved of the faithful servant, one of whom invariably died in each book saving the life of the hero. But of the African native, he held exactly the same view as Wallace:[38]

They are just like children ... clever up to a certain point, densely stupid beyond it ... absolutely without originality, absolutely without inventive power. Living among white men, their imitative faculties enable them to attain a considerable amount of civilization. Left alone to their own devices they retrograde into a state a little above their native savagery.

It is, under the circumstances, in their interests to submit to British rule. Many of the same attitudes and archetypes are to be found in a whole succession of boys' writers, for instance Captain W. E. Johns's sagas of Biggles and co., which are still tremendously popular. The gentleman hero, his all-male coterie (Algy, Bertie and Ginger) and their sporting and cleanly-fought contests with dago and hun place these sagas in the tradition of 'Breed' literature, only slightly simplified for younger readers.

From boyhood to old age, then, the average Englishman was reinforced in his instinctive

assumptions by a flood of easily obtainable and readily understandable books. It was these myths and archetypes, popularized in such works that would be presented through an essentially 'popular' medium of entertainment – the cinema.

Notes

1 Margaret Lane, *Edgar Wallace* (1939), p. 225.
2 Ibid., pp. 226–7.
3 Edgar Wallace, *Sanders of the River* (1919), p. 62.
4 Ibid., pp. 61–2.
5 Wallace, *Sandi the Kingmaker* (1929), p. 64.
6 Wallace, *Again Sanders* (1952), p. 38.
7 Wallace, *Sanders of the River*, p. 7.
8 Wallace, *Again Sanders*, p. 37.
9 Wallace, *Sanders* (1964), p. 177. .
10 Wallace, *Sandi the Kingmaker*, p. 20.
11 Wallace, *Sanders of the River*, p. 6.
12 Wallace, *Bosambo of the River* (n.d.), p. 59.
13 Ibid., p. 72.
14 Wallace, *Sanders of the River*, pp. 195–6.
15 Wallace, *Sandi the Kingmaker*, p. 77.
16 Wallace, *Sanders of the River*, p. 170.
17 Wallace, *Sanders*, p. 52.
18 Sax Rohmer, *The Mystery of Dr. Fu-Manchu* (1932), p. 21.
19 Ibid., p. 7.
20 Raymond Durgnat, 'Spies and ideologies', *Cinema*, no. 2 (March 1969), p. 11.
21 Rohmer, *The Mystery of Dr. Fu-Manchu*, p. 95.
22 'Sapper', *Bulldog Drummond* (Drummond Omnibus ed.) (1967), p. 245.
23 Ibid., p. 137.
24 John Buchan, *The Three Hostages* (Hannay Omnibus ed.), p. 872.
25 'Sapper', *Bulldog Drummond*, p. 140.
26 'Sapper', *The Black Gang* (Drummond Omnibus ed.), p. 328.
27 Ibid., p. 406.
28 'Sapper', *Jim Maitland* (n.d.), p. 18.
29 Ibid., p. 216.
30 See the detailed discussion in Robert W. Fenton, *The Big Swingers* (1967), pp. 60–6.
31 Michael Booth, *English Melodrama* (1965), p. 175.
32 George Orwell, 'Boys' Weeklies', *Collected Essays, Journalism and Letters* (1970), vol. 1, p. 528.
33 E. S. Turner, *Boys Will be Boys* (1948), pp. 113–14.
34 G. A. Henty, *With Clive in India* (n.d.), p. 11.
35 Ibid., p. 193.
36 Henty, *Through the Sikh War* (quoted by Robert A. Huttenback, 'G. A. Henty and the vision of Empire', *Encounter*, vol. xxxv no. 1 [July 1970], p. 49).
37 Henty, *On the Irrawaddy* (n.d.), pp. 27–8.
38 Henty, *By Sheer Pluck* (n.d.), p. 118.

5 The Old School Tie

As was observed earlier, the ingredients of successful film propaganda are stereotyped characters, basic ideas and simplified assumptions. Film-makers use these to manipulate the emotions of the audience. The audience's mind must not be bothered with the evaluation of detailed arguments or the investigation of complex problems. The audience must be swept up into the drama, involved on the side of Right and pitted against Wrong. They must be encouraged to identify with the hero and by doing this they will automatically identify with the ideas he embodies. These ideas, which will be very simple and straightforward, will dictate the course of the action and will already be very largely known to the audience, who, seeing his 'type', will expect him to act in a certain way. What we must do is analyse these recognized attributes and see how they are given cinematic life.

The Imperial archetype, both in his specifically Imperial films and in his non-Imperial films too, is sustained by and regulates his life according to the code, the principal product of the English public school system. The system, as we know it, emerged in the second half of the nineteenth century, following a tradition established by Dr. Thomas Arnold of Rugby. His avowed aim was to create a 'school of Christian gentlemen' and to instil his pupils with 'first, religious and moral principle; second, gentlemanly conduct; third, intellectual ability.'[1] The order of priorities is significant. It harmonizes with and fosters the traditional English mistrust of the intellectual, which we have already seen expressed by the right-wing fiction writers.

The educational curriculum was aimed at producing the good all-rounder, the argument being that 'specialized knowledge may become obsolete; general qualities of mind cannot.'[2] This is what encouraged concentration on Classics, of no practical value in itself but invaluable for training the mind, and the institution of compulsory Games, to promote the 'team spirit' and to discipline the body.

Since their main aim was the building of character, the public schools set themselves, on the one hand, to develop physical hardiness: hence, cold showers, cross-country runs, spartan dormitories, outside lavatories and the glorification of games, typified by the invention of a particularly brutal form of football at Rugby School. On the other hand, they sought to give their pupils moral training, to develop ethical self-restraint, a proper sense of values, a preparation for the exercise of power. One of the keys to this was the prefect system, by which power was delegated to senior boys and they were put on their honour not to abuse it. It came to be realized that power was best achieved by inspiring respect and not fear, and so the concept of the gentleman leader was fostered. The playing of games reinforced this code of behaviour, with its basic attitudes of 'playing the game' and being a 'sporting loser'.

The creation of a team spirit was all-important, for it played down the role of the individual and exalted the group. This was excellent preparation for the time when the public schoolboy would go on to the Army, the Colonial Service or the House of Commons, all having their own rituals and disciplines, like the school. The system of living together in the monastic all-male environment of the House, the playing of games (notably rugby and cricket), the deliberate cultivation of traditions and

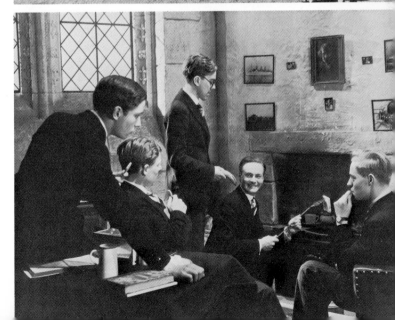

7 (above) The old school – focus of loyalty and tradition (*If . . .*)
8 (centre) Playing the game – Rugby of course – and learning the team spirit (*Tom Brown's Schooldays*)
9 (below) The all-male élite group – teatime in the study room (*The Housemaster*)

rituals (school songs, school uniforms, school slang), into which all new boys had to be religiously initiated, the strict disciplinary system, the rigidly defined hierarchy of ranks and privileges, in which you had your place and through which you rose: all these were characteristic elements of the public school and aids to the creation of a corporate spirit and a group loyalty. Ultimately they are summed up and symbolized by the old school tie, the bond which united the small élite group running the country and the Empire.

Almost unconsciously, the public school boy absorbed a complete code of behaviour which would enable him to do 'the right thing' in any situation. It involved obedience to superiors, the acceptance of a position in the hierarchy, team spirit and loyalty. It produced the gifted amateur, trained for nothing and ready for anything, who had a relaxed air of command, a sense of duty and a feeling of the obligation of the superior to his inferiors.

It also involved the traditional British phlegm, reserve, understatement, unflappability, the stiff upper lip. It was frightfully bad form to display any kind of emotion in public. This resulted from the inculcating of modesty in victory and defeat, the all-male society in which emotion was sissy, the encouragement of restraint in the exercise of power. The system bred lack of sympathy and understanding, lack of imagination and interest in new ideas, but it also bred a sense of duty, fairness and self-sacrifice for the good of others. It is this training which lies behind the code of Harry Daventry (Edward Ashley), the rather stuffy fiancé of Sarah Millick (Jeanette Macdonald), in the Hollywood version of Noël Coward's *Bitter Sweet* (W. S. Van Dyke, 1941). Embarrassed by her emotional behaviour, he declares: 'I have a simple philosophy. There is a limit to everything.' It is a philosophy of which any public school headmaster would have approved.

It was men like this who governed the country and the Empire in its heyday. In 1928 fifty-two out of fifty-six bishops were ex-public school boys. In 1934, eighty-nine

M.P.s were Old Etonians. It was public school boys, too, who became the District Commissioners of the Empire. It was a simple matter to channel the qualities of the public school ethos into that ideology of Imperialism whose development we have traced. As J. E. C. Welldon observed:[3]

An English headmaster, as he looks to the future of his pupils, will not forget that they are destined to be the citizens of the greatest empire under heaven: he will teach them patriotism, not by his words only but by his example. He will inspire them with faith in the divinely ordained mission of their country and their race: he will impress upon their young minds the conviction that the great principles upon which the happiness of England rests – the principles of truth, liberty, equality and religion – are the principles which they must carry into the world: he will emphasize the fact that no principles, however splendid, can greatly or permanently affect mankind unless they are illustrated by bright personal examples of morality.

Consciousness of class and its obligations became wedded to consciousness of race and its obligations and the public school boy obediently exchanged school cap for solar topee and sailed for warmer climes to take up the white man's burden. Lord Lugard is a perfect example of this. Dame Margery Perham describes his standards thus:[4]

(They) were those, he claimed, of an English gentleman, derived immediately from his family, public school and army training and ultimately, perhaps from the code of the medieval Christian knight. It was a double caste in that he felt himself to belong to a class within his nation and to a nation within Africa, both of which, he believed, had the code of *noblesse oblige*.

The public school system influenced not only the administrators but even the system of colonial administration. As Sir Kenneth Bradley wrote of the public school system:[5]

Small wonder that a handful of men

who had this schooling could keep the Pax Britannica right round the world over the teeming millions of the old empire with justice and mercy as well as they did. The theory of indirect rule in colonial administration, that is to say, the delegation of power and responsibility to traditional rulers and chiefs, instituted by Lord Lugard in Nigeria, was only the prefectorial system writ large, with, mutatis mutandis, the District Officers as masters, the chiefs as prefects and the tribesmen as boys. The pattern fitted African tribal society well enough and was easily understood by chiefs and people.

It also fitted the familiar Imperialist view, as expressed by Henty and Wallace, which equated the natives with children.

Following the establishment of the new public school system, an entirely new genre of literature appeared, the public school story. It was dedicated to the propagation of the public school creed, not only amongst boys who were at or who were going to public school but also amongst boys who would never go to public school. They would, however, absorb something of the ethos at second hand. It is this childhood reading of the average cinema audience which partly explains how they understood without being told what to expect of a certain 'type' of film hero.

The genre was virtually created by Thomas Hughes with one book, *Tom Brown's School-days*, published in 1857. Its hero, Tom Brown, is the son of a country squire. He is one of 'the great army of Browns' (the public-school-educated middle classes) 'who are scattered over the whole empire on which the sun never sets and whose general diffusion (Hughes) takes to be the chief cause of that empire's stability'.[6] He goes to Rugby School and is educated under the régime of Dr Arnold. Moulded by this system, Tom's ambition is: ' "to be A1 at cricket and football and all the other games ... I want to leave behind me the name of a fellow who never bullied a little boy or turned his back on a big one." '[7] These are the public school characteristics: fairness, courage, sportsmanship.

The same spirit suffused the pages of Hughes's successors in the genre: Talbot Baines Reed (*The Fifth Form at St. Dominic's*, *The Cock House at Fellgarth*) and R. Hope Moncrieff (*Stories of School Life*). The appearance of the *Boy's Own Paper*, that tremendously influential periodical that shaped the ideas and attitudes of several generations of young Britons, meant a flood of these stories. But undoubtedly the most prolific and influential of these writers was Frank Richards, who, though he had himself never been to public school, created the ultimate public school fables. Writing under a battery of pseudonyms (Martin Clifford, Owen Conquest, Ralph Redway, Clive Clifford) for a battery of periodicals (*Magnet*, *Gem*, *Pluck*, *Modern Boy*, *Union Jack*), he created St Jim's (with its trio of heroes: Tom Merry, Manners and Lowther), Rookwood (stories of Jimmy Silver and co.) and, most famous of all, Greyfriars (Harry Wharton and the Famous Five and, as comic relief, 'the fat and fatuous owl of the Remove', Billy Bunter). His aim, as stated in his autobiography, was 'to entertain young people and in an unobtrusive way to guide and counsel them.'[8]

Greyfriars first appeared in *Magnet* on 15 September 1908 and thereafter appeared regularly, in one form or another, up until the death of Frank Richards on Christmas Eve, 1961. One of the most famous series of stories, *The Rebellion of Harry Wharton*, deals with the disgrace of Harry Wharton, head boy and captain of footer in the Remove, who, stripped of all his offices and rejected by his friends, becomes the scapegrace of the school. Due to a misunderstanding and the persecution of the bullying prefect Gerald Loder of the Sixth, Harry is punished for something he didn't do. Burning with injustice, he defies authority and indulges in a series of pranks and breaches of discipline. This causes the normally mild Bob Cherry to deliver a reproof:[9]

'I'd have liked to give Loder one in the eye when he butted in at Courtfield

today. But I don't quite see how they'd run a school if a junior dotted a prefect in the eye every time he felt inclined. Come to that, fellows often feel like dotting a master in the eye. I think there's a limit, Wharton, and so long as we're in the Remove, it's up to us to toe the line.'

Here Bob is endorsing the philosophy of Harry Daventry and advocating the acceptance both of obedience to discipline and of position in the hierarchy. Loss of privileges is the penalty for breach of discipline.

In spite of all, Harry remains the ideal schoolboy. He will not lie, even to save himself from a flogging. He will not 'sneak' on Loder. He remains a sportsman. When his friends drop out of the Remove football team and he plays Bolsover instead and Bolsover commits 'a foul of the most palpable description', Harry's reaction is predictable:[10] '"Get off, you cur," muttered Harry Wharton, his face crimson with rage and shame, "Get off before I boot you off."' Harry is caned for smoking but isn't guilty:[11]

> If faults of temper and pride had been Wharton's undoing, at least there were no petty vices about him. Fellows like Skinner and Snoop smoked in their studies and fancied themselves frightfully doggish, the Bounder smoked sometimes, chiefly because it was forbidden. Wharton, whether he was the worst boy in the form or not, had a healthy contempt for such dingy folly.

Finally, he runs away and is pursued by Mr Quelch, the form-master, whom he rescues from drowning. Harry confesses his fault at last, is reinstated and will in future do his best to curb his pride. The moral of the story is that personal feelings (pride, revenge) must be subordinated, that obedience to discipline, loyalty and team spirit must prevail.

The Famous Five, like Stalky and Co., represent those all-male peer groups, which are to continue into adult life, becoming Hugh Drummond and co., Dick Hannay and co., and Jonah Mansel and co. Harry Wharton is the nephew of Colonel Wharton, Bob Cherry the son of Major Cherry. There can be little doubt that their future, like their elders', lies in the service of their country and that in them we see the embryo clubman hero of the next generation.

School songs succinctly enshrine the spirit that the schools were trying to inculcate. Take, for instance, the school song of the King Edward VI School of Birmingham:[12]

> We sing our living heroes who learned the game of life,
> In cricket's honest warfare and football's manly strife,
> In triumph ever modest, in danger ever cool,
> They win throughout the world, boys, fresh laurels for the school.
>
> We sing our great departed whom none may disallow,
> Strong souls whose tasks are ended, sweet voices silent now,
> Their memories lead us forward to still uphold the fight,
> To strike at wrong and falsehood and guard the truth and right.
>
> Old time is on our track, boys, and seas may soon divide
> The voices now united, the friends now side by side,
> But wheresoere we carry the pride of Edward's name,
> Let each forget himself, boys, and play to win the game.

This contains everything: games, the team spirit, loyalty, tradition, hero worship, modesty, fairness, justice, truth, self-sacrifice and service overseas.

Sir Henry Newbolt's poems, which have been called 'the most passionate expression in literature of the love of the public schools',[13] similarly hallow the spirit of the system, most memorably in 'Vitaï Lampada', which is based on an analogy between cricket and war. In 'Clifton Chapel', he sets out to list the schoolboy vows:[14]

> To set the cause above renown,
> To love the game beyond the prize,

The ritual elements of public school life
10 Dinner (*Goodbye, Mr. Chips*, 1939)
11 (below) Call-over (*Goodbye, Mr. Chips*, 1970)

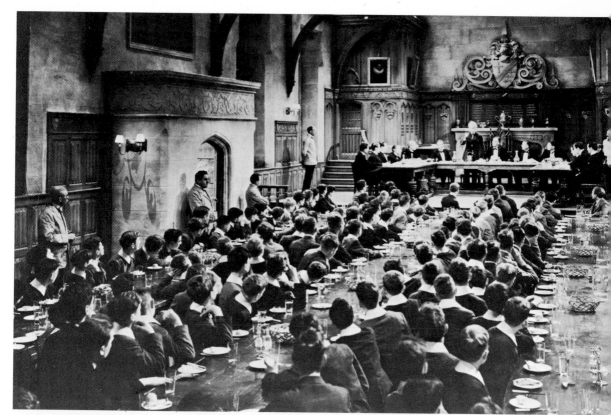

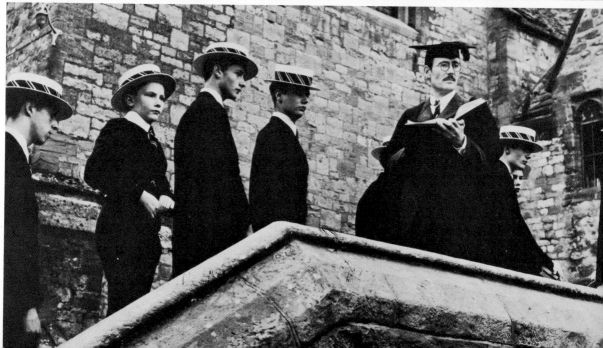

To honour, while you strike him down,
The foe that comes with fearless eyes,
To count the life of battle good
And dear the land that gave you birth
And dearer still the brotherhood
That binds the brave of all the earth.

Most famous of all in the vein, and too famous to need repeating here, is Kipling's 'If'. However, the ultimate equation of cricket with warfare comes in Canon H. D. Rawnsley's *Ballads of the War*, and in particular in the poem 'In Honour of Lt. Frederick Greville Egerton':[15]

Egerton – you of 'The Powerful' – when
 the doom came,
Doom crashing on thro' the miles of the
 murderous air,
Did you not feel as you played in war's
 terrible game
That the bowling was fair?

Did not your thoughts, when so mortally
 wounded you fell,
Back to the green level pitch and the
 playing field run,
There where your wicket was fortress,
 the cricket ball shell –
And war was begun?

'There goes my cricket' you cried, but
 your fast failing breath
Challenged no umpire, you held the ball
 truly was sent,
And back to the awful Pavilion we
 players call Death,
How bravely you went!

Egerton – you of 'The Powerful' –
 honoured by all,
Honoured and mourned for and missed
 as a man and a friend,
Well did the spirit you learned from the
 bat and the ball
Help to the end.

As interesting as the fact that this poem should be written is the other fact that it is based on a contemporary report of Egerton's death. His last words really were: 'There goes my cricket.'

Egerton perfectly demonstrated the code of the Old School in action. He had played the game and lost, and died a sporting loser. It is the code, which underlies the 'clubland' literature of the inter-war years, that we have already examined. Dornford Yates, for instance, dedicated his book *Valerie French*: 'To the English, to whom to live or die according to the best traditions comes natural.' Rider Haggard too testified to his adherence to the same code when he dedicated his novel *Allan Quatermain* to his son:

In the hope that in days to come, he and many other boys, whom I shall never know, may in the acts and thoughts of Allan Quatermain and his companions, find something to help him and them to reach what with Sir Henry Curtis I hold to be the highest rank whereto we can attain – the state and dignity of an English gentleman.

The public school archetype was never better described than by 'Sapper' in his early novel *Mufti*:[16]

Before the war, Derek Vane had been what is generally described as the typical Englishman. That is to say, he regarded his own country . . . whenever he thought about it at all . . . as being the supreme country in the world. He didn't force his opinion down anyone's throat. It simply was so. If the other fellow didn't agree, the funeral was his, not Vane's. He had to the full what the uninitiated regard as conceit; on matters connected with literature or art or music, his knowledge was microscopic. Moreover he regarded with suspicion anyone who talked intelligently on such subjects. On the other hand, he had been in the eleven at Eton, and was a scratch golfer. He had a fine seat on a horse and rode straight; he could play a passable game of polo and was a good shot. Possessing as he did sufficient money to prevent the necessity of working, he had not taken very seriously the something he was supposed to be doing in the city. He belonged in fact to the Breed: the Breed that has always existed in England and will always exist to the world's end. You may meet its

members in London and Fiji, in the lands that lie beyond the mountains and at Henley, in the swamps where the stagnant vegetation rots and stinks, in the great desert where the night air strikes cold. They are always the same, and they are branded with the stamp of the Breed. They shake your hand as a man shakes it; they meet your eyes as a man meets it. Just now a generation of them lie around Ypres and La Bassée; Neuve Chapelle and Bapaume. Dead yes, but not the Breed. The Breed never dies.

'Sapper's' short story collection, *The Dinner Club* is the perfect case study of 'the Breed' in action. In the story, 'Sentence of Death',[17] Jack Digby, 'a first class specimen of the sporting Englishman', is given a couple of years to live because of a heart condition. So he takes on himself the blame for robbing a safe, which had in fact been robbed by the weakling brother of the girl he loves. Then he vanishes to save her the misery of marrying and losing him. He joins the cavalry and, we learn, 'stopped one – somewhere up Ypres way'. In 'A Bit of Orange Peel',[18] Sgt Trevor, gentleman ranker, is revealed as a gentleman by his superlative cricketing skill, which could only have been learned 'at a first class public school'. But the woman he loved and who had married someone else when he disappeared into the army, under an assumed name, after his father lost all his money, turns up at the match. Later Trevor (real name: Jimmy Dallas) saves her young son's life when his dog cart runs away. At his hospital bedside, she confesses her love to Jimmy, overheard by her husband, Giles Yeverley. He makes no indication that he has heard her, playing his part for ten minutes 'stifflipped and without a falter'. Soon after that he is drowned, while on holiday, even though a first class swimmer. Jimmy and the widow marry, never knowing that Giles had overheard.

In 'Jimmy Lethbridge's Temptation',[19] Jimmy persuades Molly to marry him, even though she is still in love with his best friend, Peter Staunton, missing, believed killed in action. One day, he sees Peter in the street, playing a barrel organ, and discovers that he has completely lost his memory. He is tempted to pass on, but decides to play the game. He takes Peter to a brilliant surgeon, who cures him, and then he reunites him with Molly and departs. In 'The Man who Couldn't Get Drunk',[20] variations of which 'Sapper' penned several times, Jimmy Mainwaring (for some reason, almost all his heroes are called Jimmy, just as his heroines are called Molly) who had committed 'the unforgivable sin among gentlemen the world over – cardsharping', buries himself in a remote African port. Drinking himself to death, he contrives still to remain immaculate in white silk shirts, pith helmet and monocle. But he falls foul of the dagos ('I frankly admit that my love for the dago has never been very great') and they kidnap the woman he loves who had married another when he left and now providentially turns up. He goes after her and sacrifices his life to rescue her.

'The breed' also found itself immortalized on celluloid. A clutch of films, which is absolutely representative of its time and the code of its ruling élite and which could never be made nowadays, survives to show us how the Cinema presented the code in human terms to the mass audience.

Several of these films link the public schools with the Empire by showing us a parable of the 'Breed' in an Imperial setting. A classic of its kind is *Another Dawn* (William Dieterle, 1937), which shows how a triangle situation resolved itself in a British desert outpost, according to the rules. Colonel John Wister (Ian Hunter), while on leave in England, falls in love with Julia Ashton (Kay Francis), a beautiful socialite who is still grieving for her dead aviator fiancé. He proposes marriage and she accepts, though pointing out that she can never give him more than friendship. They return to the British fort at Dikut, which Wister commands, and there Julia meets dashing, handsome Captain Denny Roark (Errol Flynn, no less) and falls in love with him. But because Roark is an officer, a gentleman and a sportsman, the two do nothing

dishonourable and spend most of their time discussing what is the most decent thing to do. At this crucial point, the natives rise in revolt and to defeat them it is necessary to blow up a dam, which is far enough away so that a plane can get there but not back. It calls for a 'suicide mission'. John and Denny toss for it and Denny loses. But as he is saying goodbye to Julia, they hear the plane taking off. It is John, who, having discovered the state of affairs, is deliberately sacrificing his life to allow the lovers 'another dawn'. It is, after all, the only decent thing a chap could do, under the circumstances.

This basic situation cropped up again and again. In *The Last Outpost* (Louis Gasnier and Charles Barton, 1935), the setting is once again the desert. Captain Michael Andrews (Cary Grant), attached to a mechanical unit reconnoitring in Kurdistan, is captured by the Kurds. He is about to be shot when he is rescued, in the nick of time, by a Kurdish officer, who reveals that he is, in fact, Smith of British Intelligence (Claude Rains). Smith puts himself at the head of an alliance of pro-British tribes and defeats a Kurdish attack. Peace and order are restored to Mesopotamia.

While Andrews is recovering from his injuries in Cairo, he falls in love with his nurse, Rosemary Stevenson (Gertrude Michael). She returns his love but tells him that she is the victim of a hasty wartime marriage. Her husband turns out to be none other than Smith, whose real name is John Stevenson. At this crucial point, Andrews is ordered to the Sudan, where the natives are proving restless. Stevenson follows him there, intent on killing him. They meet at a lonely outpost but they decide to put the interests of their country before personal animosities when the fort is attacked. Together they help repel the natives and Stevenson surrenders Rosemary to Andrews, wishing him all the happiness he has been denied.

In *The Wheel of Life* (Victor Schertzinger, 1930) Captain Jim Youllet (Richard Dix) of the British Army, while on leave in London, saves the life a young girl (Jobyna Ralston) and falls in love with her. But on rejoining his regiment in India, he discovers that she

is the wife of his commanding officer (O. P. Heggie). To avoid a scandal, Youllet is transferred to Tibet. But they meet again when he is sent to rescue a group of British travellers, besieged in a Tibetan monastery by Himalayan hillmen, and discovers that the girl is one of the group. Believing themselves lost, they confess their love. However, the colonel arrives with a relief column, learns the truth of the situation and deliberately goes out and 'stops one' in order to allow the lovers 'another dawn'.

This kind of dilemma pursues the officer and gentleman everywhere, even into a prisoner-of-war camp. In Roy Del Ruth's exciting and well-made *Captured* (1933), based on a play by Sir Philip Gibbs, the setting is an Allied P.O.W. camp in Germany. The Senior British Officer is Captain Fred Allison (Leslie Howard) and he obtains better conditions for the prisoners by promising that the privileges will not be abused. It is his public school training coming out here. His word of honour is willingly accepted by the camp Commandant, Colonel Ehrlich (Paul Lukas), who is an ex-Balliol man and former Oxford University fencing champion, and therefore without question an officer and gentleman.

The situation is complicated by the arrival of Lt Jack Digby (Douglas Fairbanks Jr) (shades of 'Sapper') who is in love with Allison's wife, Monica (Margaret Lindsay). Unable to stand the strain of deceiving his old friend Allison about the situation, he breaks his word of honour and escapes. But at the time he does so, a murder is committed in the camp and Digby is suspected. Ehrlich demands his extradition and the British commanding general (Halliwell Hobbes) sends Digby back to the Germans, confident that the Germans would do the same if the situation were reversed. Digby is tried and found guilty but saved by the last-minute confession of the real murderer. Allison learns the truth about Monica and Digby and, realizing that he cannot win back his wife's love, sacrifices his life to allow the other prisoners to escape. When the mass escape has been accomplished, British planes fly over the camp to salute the dead Allison

and Ehrlich too stands and salutes a brave foe.

This plot was used, in reverse, in *Who Goes There?* (Maurice Elvey, 1938) with the similar setting of a First World War P.O.W. camp. Captain Beck (Jack Hawkins) has had an affair with the wife (Sophie Stewart) of Captain Hamilton (Barry K. Barnes). So during an escape attempt, he deliberately sacrifices his life to enable Hamilton to escape so that he can be reunited with her.

In all these films the protagonists are army officers, almost certainly the products of Sandhurst and public school. They are concerned to make as little fuss as possible and often are inspired to their actions as much by love for the other man, whom they were probably at school with anyway, as for their wives. They certainly act in the best traditions of 'the Breed', no scenes or re-criminations, just a quick handshake, a shy smile and the fade out, preferably fighting the enemy and, if possible, against over-whelming odds. But they are confident that they are doing the right thing and will very shortly be admitted to the great Old Boys' Club in the sky.

They have demonstrated the training that makes the Englishman, in love as in war, a good loser. It is perhaps significant that many of the best-remembered events in British military history are heroic defeats: Dunkirk, the Charge of the Light Brigade, the Death of Gordon at Khartoum. All three of these have been the subject of notable films.

Perhaps the archetypal gallant loser is *Scott of the Antarctic*, as played by John Mills in Charles Frend's film of that name (1948). Captain Robert Falcon Scott sets out to reach the South Pole for purely patriotic reasons ('I think an Englishman should get there first'). He raises an expedition of similar souls, mostly naval officers, and they pit themselves against the terrifying forces of nature. They soldier on even after learning that Amundsen has decided to go south, even though he had told everyone he was going north ('Damned unsporting'). They cover their disappointment at each stage with a smile, a joke and a stiff upper lip: when they find Amundsen's flag at the Pole

and when they discover their stores have run out. Captain Oates (Derek Bond), 'a brave man and a gallant gentleman', quietly and without fuss goes out into a snowstorm to die, so as not to burden the others.

It is a respectful, and finally very moving film tribute as we hear Scott's last diary entry read on the sound track and the camera focuses on the faces of the explorers, fever-bright and etched deep with suffering. They are dying as they have lived, as gentlemen and sportsmen. There are several poignant scenes in the film, whose poignancy derives from a very British feeling of understate-ment. One is when Oates meets Scott for the first time. It is pouring with rain. Oates says: 'I've come all the way from India to join your show.' They shake hands and Frend intercuts close-ups of the two faces and one can see the unspoken confidence and mutual respect in their eyes. Another is the scene of the ship's departure for the Antarctic. There is a series of beautifully observed stiff-upper-lip farewells, the band plays 'Will ye no come back again?' and Wilson walks silently along the deck of the ship as it pulls out in order to remain opposite to his wife on the quay. The silence of the two as they gaze at each other contrasts movingly with the wild cheering of everyone around them.

It has generally been public school atti-tudes rather than the public schools them-selves which have figured in films. But there has been a handful of notable public school films. The one which probably gives the most accurate picture of life in a public school is Lindsay Anderson's devastatingly brilliant *If . . .* (1968), filmed on location at Cheltenham College. The very title is an ironic comment on the spirit of Kipling.

Anderson has claimed[21] that the film is not simply an attack on the public school system but that the school is being used as a meta-phor for the Establishment. However, the very fact that the public schools contribute so much to the creation of that Establish-ment turns the attack back on them in the end. Amusing and biting by turns, it re-creates the enclosed, all-male world of public school. It is a rigidly ordered society,

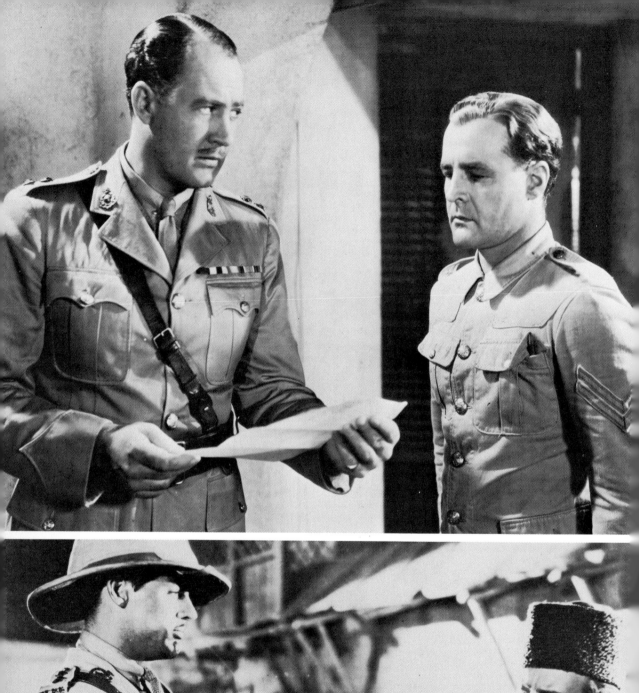
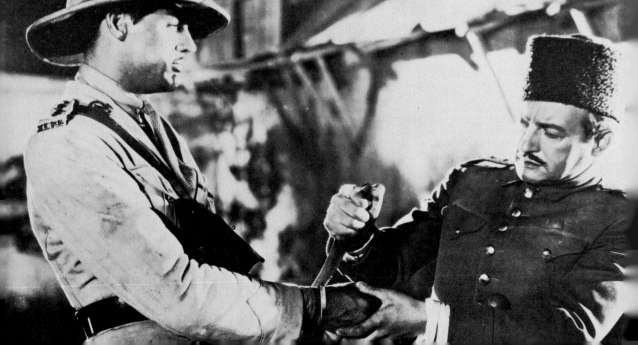

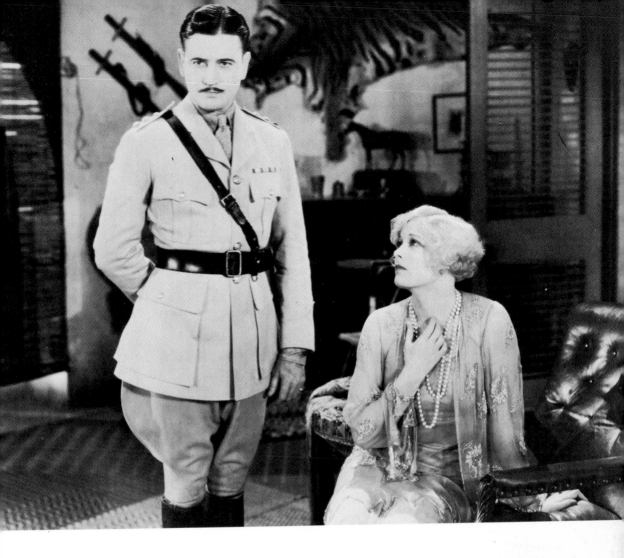

Doing the decent thing
12 (above left) Ian Hunter and Reginald Sheffield in *Another Dawn*
13 (left) Cary Grant and Claude Rains in *The Last Outpost*
14 (above) Richard Dix and Jobyna Ralston in *The Wheel of Life*

with an unshakeable hierarchy (from 'scum' (fags) to 'whips' (prefects)), with its own self-perpetuating slang (scene where the new boy is instructed in it) and its ritualistic compulsory games (with matron entering into the supporters' bloodlust and shrieking: 'Fight, college, fight, fight, fight'). The background of routine, ritual and discipline is meticulously observed: medical inspection, chapel, dinner, dormitory inspection, cadet corps exercises.

The school is, in effect, run by 'the whips', cold, self-possessed, dangerously powerful figures, who find outlets for their sexual urges in homosexuality and sadism. They deal with nonconformists summarily: cold showers and, when that fails, brutal flogging. Above them are the masters, headed by the bland, pseudo-liberal headmaster, most of them eccentrics or perverts or ineffectual nonentities. The history master (brilliantly played by Graham Crowden) rides his bicycle into the classroom, singing hymns at the top of his voice. The chaplain (Geoffrey Chater) twists the nipples of small boys in his maths class and pruriently asks for details of the 'dirty thoughts' that another boy confesses. Author (David Sherwin) and director (Lindsay Anderson), who were both at public school, appreciate well enough what the public schools are aiming at and they give to General Denson (Anthony Nicholls), the visiting V.I.P. at Founder's Day, a speech which perfectly captures the spirit:[22]

'You're lucky. Yes – a lot of men would give their eye-teeth to be sitting where you are sitting now. You are privileged. Now, for heaven's sake, don't get me wrong. There's nothing the matter with privilege as long as we're ready to pay for it. It's a very sad thing but today it is fashionable to belittle tradition. The old order that made our nation a living force are for the most part scorned by modern psychiatrists, priests, pundits of all sorts. But what have they got to put in their place? Oh, politicians talk a lot about freedom. Well, freedom is the heritage of every Englishman who speaks with the tongue that Shakespeare spoke.

But, you know, we won't stay free unless we are ready to fight. And you won't be any good as fighters unless you know something about discipline. The habit of obedience, how to give orders and how to take them. Never mind the sneers of the cynics. Let us be true to honour ... duty ... national pride. We still need loyalty ... we still need tradition. If we look around us at the world today, what do we see? We see bloodshed, confusion, decay. I know the world has changed a great deal in the past fifty years. But England, our England, doesn't change so easily. And back here in college today – I feel, and it makes me jolly proud, that there is still a tradition here, which has not changed and by God it isn't going to change.'

We are being invited in *If ...* to laugh at the general. But what he says so perfectly summarizes the public school ethos that the speech could easily have been given straight in a film like *Goodbye, Mr. Chips* and would not only have seemed perfectly in place, but would have been received with applause. In *If ...* the answer of the film's heroes is to turn a machine gun on the general and the other guests and finally on the audience, who, Anderson implies, are guilty by virtue of their complacency of perpetuating the system of hierarchy, repression and privilege, epitomized by the public schools.

At the other extreme from *If ...* we have the classic portrayal of the life of a public school master in James Hilton's gentle, affectionate, sentimental novella *Goodbye, Mr. Chips*, twice brought to the screen by M.G.M., first in 1939 with Robert Donat winning an Academy Award for his performance in the title role and again in 1969, with Peter O'Toole giving the performance of a lifetime and gaining an Academy Award nomination.

The 1939 version, directed by Sam Wood, and including scenes shot on location at Repton, stuck closely to the novel. It opens with the aged Chips racing along to assembly, to find himself locked out – for the first time in his career. A new boy is also locked out and

15 (right) The Arche-
typal Gallant Loser:
John Mills as Captain
Robert Falcon Scott in
Scott of the Antarctic
16 (below) The Classic
Heroic Defeat: *Charge
of the Light Brigade*

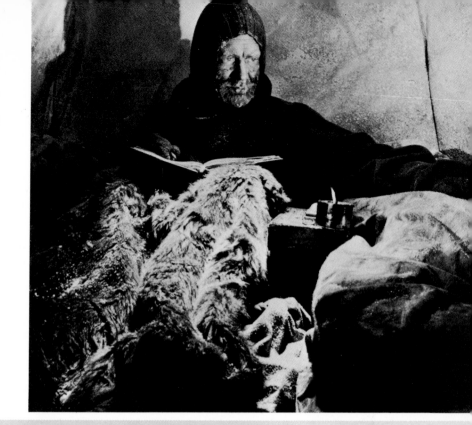

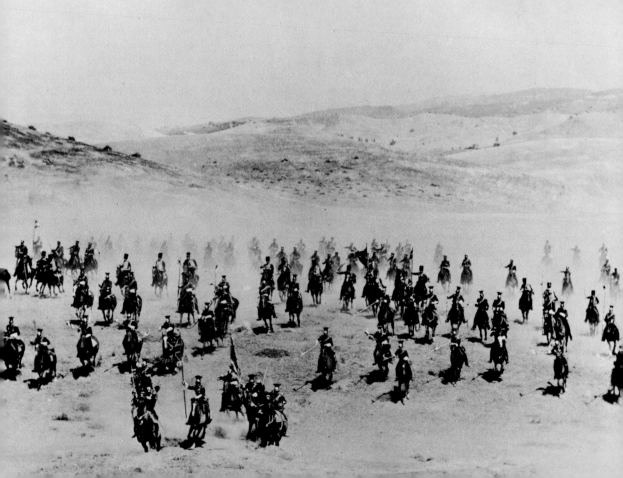

Chips talks to him, initiating him into the history and traditions of Brookfield School. Sir Francis Drake went there, it seems, as did many of the ancestors of this new boy, who is in fact the Duke of Dorset. When assembly is over, the boys flood out and Chips greets them all by name and exchanges jokes and stories with them. Then he goes home and, sitting by the fire, he drifts off into a reverie, in which he recalls his past life. A dedicated young teacher of twenty-four, he arrives at Brookfield in 1870 to teach Latin. Ragged by the boys on the first day, he is reprimanded by the headmaster and determines to become a strict disciplinarian.

Neither the boys nor the staff forgive him, however, when this adherence to discipline goes so far as to keep his class in one day when they are needed to play in a vital cricket match, which the school, in consequence, loses. As the years pass by, Chips becomes a lonely, boring, prematurely aged figure, passed over for promotion and known only for his ability to keep discipline. Then on a walking tour of Austria he falls in love with a young Englishwoman, Katherine Ellis (Greer Garson), and marries her. Rejuvenated, he wins the confidence and affection of the boys, under her guidance. She dies in childbirth but Chips carries on, remembering the lessons she taught, to become one of Brookfield's living traditions.

A new headmaster, knowing nothing of these traditions, seeks to retire him as too old-fashioned. Chips makes an impassioned defence of the old system:

'I know the world's changing. I've seen all
the old traditions dying one by one . . .
grace and dignity and a feeling for the
past . . . You're trying to run the school
like a factory for turning out money-mad,
machine-made snobs . . . Modern methods!
Poppycock! Give a boy a sense of humour
and a sense of proportion and he'll stand
up to anything.'

This speech outlines the philosophy which Chips embodies. He is defending the old public school tradition of concentrating on the building of character, in order to turn out the gentleman all-rounder. The true gentleman is neither money-mad nor a snob.

Later Chips, acting headmaster during the First World War, endorses the disciplinary system. He beats a boy who claims that the masters are all funks because they aren't in the army. But having done this ('You must know the meaning of discipline'), he then explains to him why they are not in the army and the boy goes away contrite. The film ends with Chips dying. He hears the doctor say that it was a pity he never had any children. But he answers: 'I have . . . thousands of them . . . all boys.' Superimposed on the screen, we see a procession of the boys he has taught over the years.

It was a good film, but the remake was even better, in fact one of the finest films the cinema has produced. Terence Rattigan's script is superb: witty, polished, sympathetic, and although departing from the plot-line of the novel, perfectly capturing the spirit. Where Sam Wood's direction was competent and workmanlike, Herbert Ross's direction of the remake was lyrical, sensitive, deeply moving and frequently inspired. Wood's film, in spite of its Repton exteriors, too often has a cramped, artificial, studio-bound look about it. Ross's film, shot on location at Sherborne School and amid the ruins of Pompeii (where Chips takes his holiday, instead of the Austria of the original version and the Lake District of the book) enables him to use his camera to create wonderful passages of visual poetry. Leslie Bricusse's insufficiently appreciated musical score (notably the wistful 'Where did my childhood go?') effectively underlines the mood of the film. While Donat's Chips is a fine performance by a conscientious artist, it is essentially a performance. But Peter O'Toole *is* Mr Chips, perfect down to the long, loping walk, the pedantically precise method of talking, even the way he smokes his cigarettes. It is the finest thing O'Toole has ever done. It will be difficult for him to surpass it. It is the combination of O'Toole's acting, Rattigan's script and Ross's direction that gives the film the tremendous emotional impact that Wood's film so rarely achieves.

In the superb opening sequence the film at once establishes the mood, a nostalgic sense

Two versions of *Goodbye, Mr. Chips* have celebrated the men who dedicated their lives to teaching and to passing on the public school traditions from generation to generation.

17 (right) Robert Donat as Chips in 1939

18 (below) Peter O'Toole as Chips in 1970

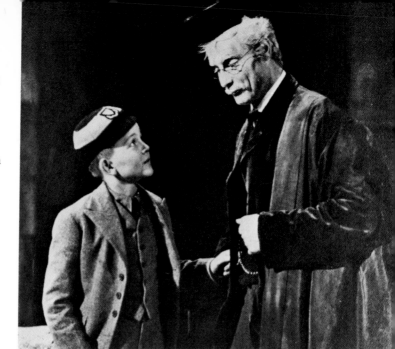

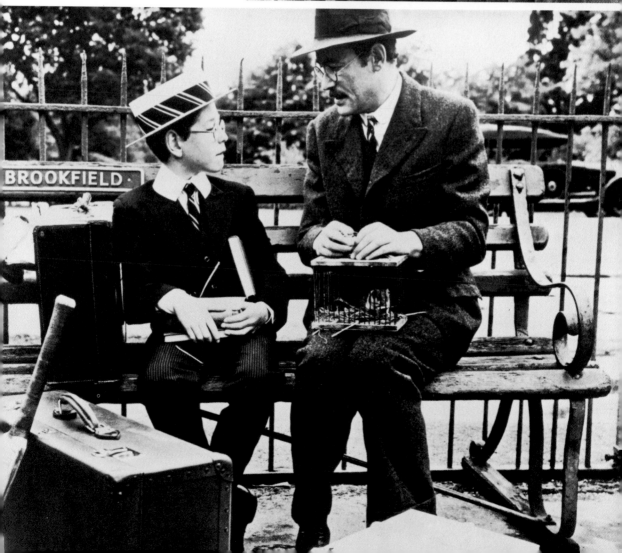

of childhood's end and a hankering for the golden, carefree days of youth. There is a long shot of the cricket pitch, seen hazily as if in memory, then the camera prowls through the empty corridors and classrooms and the school song echoes hollowly on the sound track. We meet Chips, middle-aged, unpopular, lonely, who says of his pupils: 'They think I'm a bore. They're probably right.' Unable to communicate to them his genuine affection, he sees his life and his vocation withering away. All this is transformed by his marriage and then his development into a much-loved school character, finally becoming headmaster during the war. Supremely moving are the scenes in which his class learns of the death of his wife during a lesson, in which he delivers his farewell speech as snow gently falls and the final scene, different from and subtler than the last scene in the book. Retired now and a very old man, but still living near the school, Chips walks slowly to the school and stands in the courtyard as the boys pass by, lifting their hats automatically. The camera pulls back until his figure is lost amid the crowd of boys and the cluster of old buildings. He is, as it were, being absorbed into the fabric of the place.

Both versions of the story are permeated by an affectionate nostalgia, a warm regard for the men who dedicate their lives to teaching and who perpetuate and symbolize the traditions which they are instilling in their boys: loyalty to the school, the maintenance of discipline, rule by respect rather than by fear. They also perfectly demonstrate the cinematic use of the archetype to embody a set of values and the employment of the audience's emotion to induce acceptance of those values. Chips does not need to make long orations. We know what he believes in and, because we like him so much, we believe it too. How long we continue to believe it after we have left the cinema depends on us individually. But, for a magical ninety minutes, we are Chips and we feel what he feels and we believe what he believes. That is the power of film.

There is more than a touch of Chips about Charles Donkin, the hero of Herbert Brenon's immensely enjoyable film *The Housemaster* (1938), based on Ian Hay's play.[23] Donkin, engagingly played by Otto Kruger, is donnish, sympathetic, good-humoured, equipped with pince-nez and pipe, and in the main plot of the film he stands for the defence of tradition against innovation.

The film opens with a montage of old buildings: cloisters, quad, gateway, to establish the setting, Marbledown School, and then cuts to the first scene, Charles Donkin the housemaster beating a boy for breaking the bounds imposed by the new headmaster. Donkin disapproves of the new headmaster's policy but backs him up out of a sense of loyalty. The film traces the increasing conflict between Donkin and Rev. Edmund Ovington (Kynaston Reeves), the headmaster.

Ovington stands for complete change and is in the process of totally reorganizing the school. He outrages the boys by putting the town out of bounds and forbidding the school to participate in the annual regatta. Donkin tells him that he has all the attributes of a successful headmaster except one – humanity – and that is the most important of all. Ovington accuses Donkin of fomenting rebellion against him and although Donkin angrily refutes this, when the whole of his house break bounds and return to stand outside the house and boo the headmaster, he feels that he has no alternative but to resign.

Sadly, Donkin wanders round the school for the last time and then delivers a farewell speech to the House, reminding them of the code: always be loyal even if it is against your convictions, always be considerate of other people's feelings for that is what being a gentleman means, always speak the truth. But even as he is packing, Sir Berkeley Nightingale (Cecil Parker), cabinet minister and school governor, comes to the rescue. He persuades the Prime Minister to appoint Ovington Bishop of Outer London and Donkin is asked to become Headmaster. So the old school is saved at the expense of the Church. There is a fine ending, which symbolizes the victory of tradition over innovation. The school gathers in the hall for the end of term sing-song and ends with 'Old

The defence of public school traditions

19 (right) Housemaster Otto Kruger (seated) fights headmaster Kynaston Reeves to preserve the traditional way of life of Marbledown School (*The Housemaster*)

20 (below) Flashman, having transgressed the Code of the school, is expelled from Rugby by Dr Arnold (Robert Newton). Tom Brown and Ned East look on (*Tom Brown's Schooldays*)

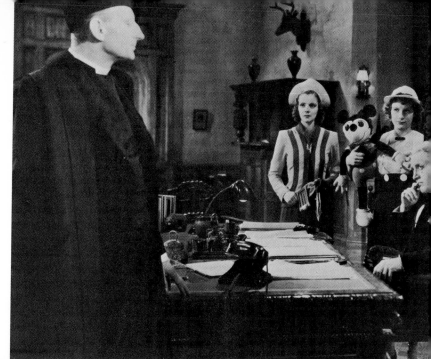

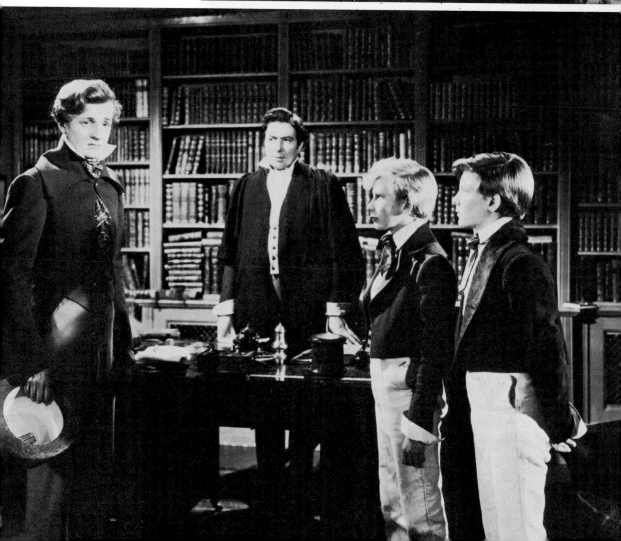

Aquaintance', whose strains reach Donkin in his rooms. With a smile, he lights his pipe and sits down by the fire to do the *Times* crossword. All is well.

Donkin, like Chips, is a fixed point in a changing world, a reassuring reminder of all that is good in tradition. The background detail of the film suggests the same sort of feeling: the comforting familiarity of the ritual of dinner, prayers ('Onward Christian Soldiers' appropriately being sung), rowing practice (Donkin, a former Blue, helps coach the eight), and parties in the dorm after lights out. Discipline is firmly maintained, flogging is administered as a matter of course and accepted by boys and masters as essential; while everyone (boys, masters, governors) venerates tradition, with the solitary exception of the headmaster, and he is duly disposed of. But it should be said that Kynaston Reeves, excellent as the thin-lipped, inhuman, clerical head, later achieved mythic immortality as the classical incarnation of Mr Quelch in television's fondly remembered series of Greyfriars adaptations.

While *Goodbye, Mr. Chips* and *The Housemaster* dealt essentially with the master, *Tom Brown's Schooldays* dealt with the boy and in fact detailed the introduction at Rugby of what was to become the Public school code. There have been two sound versions of the film: an American version (Robert Stevenson, 1939) with Cedric Hardwicke as Dr Arnold, James Lydon as Tom and Freddie Bartholomew as East and a British version (Gordon Parry, 1950) with Robert Newton as Dr Arnold, John Howard Davies as Tom and John Charlesworth, stealing the film, as East.

The 1939 version opens with Arnold being invited to become headmaster of Rugby and accepting because it will give him an opportunity to put his educational theories into practice. He tells his pupils that the future of England depends on her young men and that he is going to give them self-governing opportunities and responsibility with the institution of the prefectorial system. He warns them that lying will not be tolerated and that any pupil whose influence is destructive will be expelled, bringing disgrace on himself and his family. There are several expulsions and the doctor comes under fire, even from members of his own staff.

But he is encouraged by the support of Squire Brown, who demonstrates his faith in Rugby by sending his son Tom there. Tom becomes great friends with East who instructs him in the Code, notably that whatever happens no boy must sneak on another. Tom runs foul of Flashman when he organizes the juniors to resist him and his bullies. Tom is 'roasted', but he does not sneak, and later whips Flashman in a fight. But a master reports the roasting and Flashman is expelled. Everyone assumes that Tom sneaked and he is ostracized. Tom borrows a cart without permission and wrecks it. East is accused and threatened with expulsion. At first Tom, embittered by his treatment, refuses to speak, but eventually he does own up. He is beaten but not expelled, since he has proved an honourable chap and he and East are reconciled.

The remake, filmed partly at Rugby itself, remained much closer to the book. It opens similarly with the appointment and reforms of Arnold, the encounters with Flashman and the fight when Tom beats him. But then it diverges from the American version. Arnold places under Tom's protection the frail, fatherless Arthur, and Flashman deliberately picks on Arthur, to provoke Tom. Tom and co., however, save Flashman from drowning. Arthur falls in the water trying to help and becomes seriously ill. Flashman claims he rescued Arthur after Tom and East pushed him in. They deny it, but the ban on 'sneaking' forbids them from telling what really happened. Happily, a witness comes forward who gives the true story, Flashman is expelled, Arthur recovers and the term ends happily.

Though both films differ from each other and from the book, to the extent that they sometimes seem like two completely different films, both films accept and glorify the Code: loyalty, discipline, taking your punishment like a man, the fair use of power. Flashman is the all-time cad, epitomizing everything that the good public school boy should shun; while Tom is the cadet Im-

perialist, who learns the Code, becomes one of the 'Breed' and will go out to join 'the army of Browns' who are keeping the Pax Britannica 'neath palm and pine.

Notes

1 Vivian Ogilvie, *The English Public School* (1957), p. 145.
2 Rupert Wilkinson, *The Prefects* (1964), p. 71.
3 J. E. C. Welldon, 'Schoolmaster' in *Unwritten Laws and Ideals of Active Careers* (ed. E. H. Pitcairn) (1899), p. 284.
4 Margery Perham, *Lugard: The Years of Adventure 1858–1898* (1956), p. 197.
5 Sir Kenneth Bradley, *Once a District Officer* (1966), p. 15.
6 Thomas Hughes, *Tom Brown's Schooldays* (n.d.), p. 7.
7 Ibid., pp. 194–5.
8 Frank Richards, *The Autobiography of Frank Richards* (1952), p. 171.
9 *Magnet*, vol. xlii no. 1285 (1 October 1932), p. 10.
10 *Magnet*, vol. xlii no. 1291 (12 November 1932). p. 18.
11 *Magnet*, vol. xlii no. 1292 (19 November 1932), p. 2.
12 *K. E. G. S. Aston Souvenir Handbook*, ed. N. E. Wiggett (1962), p. 18.
13 E. C. Mack, *Public Schools and British Opinion since 1860* (1941), p. 252.
14 Sir Henry Newbolt, 'Clifton Chapel', *Collected Poems* (1907), pp. 128–9.
15 Canon H. D. Rawnsley, 'In Honour of Lt. Frederick Greville Egerton', *Ballads of the War* (1901), pp. 22–5.
16 Richard Usborne, *Clubland Heroes* (1953), p. 155.
17 'Sapper', 'Sentence of Death', *The Dinner Club* (n.d.), pp. 57–76.
18 'Sapper', 'A Bit of Orange Peel', *The Dinner Club*, pp. 98–121.
19 'Sapper', 'Jimmy Lethbridge's Temptation', *The Dinner Club*, pp. 192–216.
20 'Sapper', 'The Man who Couldn't Get Drunk', *The Dinner Club*, pp. 263–87.
21 Lindsay Anderson and David Sherwin, *If . . .* (1969), 9.
22 Ibid., pp. 158–60.
23 Basil Wright in *Spectator* (20 May 1938) described the film as 'a sympathetic and astonishingly accurate picture of public school life'.

The Imperial Archetype

The Imperial hero figure conforms to a definite physical and spiritual archetype. He is tall, thin, square-jawed, keen-eyed and almost always equipped with pipe and moustache. It is difficult to overestimate the importance of the pipe and the moustache. They are what the horse and gun are to the Western. They are the key icons of the Imperialist, lending him a dignity and dependability, which their removal likewise removes. One only has to look at the screen appearances of Ronald Colman, greatest of Imperial actors, to notice the difference the moustache makes. With it, there is self-confidence, a sense of belief in oneself and one's duty, a feeling of reliability. Without it, the face seems to become thinner and longer, the eyes to mirror a melancholy and world-weariness.

R. J. Minney has called Colman's moustache part of 'the architecture of that well-known face'[1] and he recalls a conversation he had with Colman about whether or not he should shave it off to play Clive of India. Minney, although he was co-author of the screenplay, argued that he should not because it would confuse and upset his audience, who were accustomed, conditioned even, to seeing him with it. But Colman was persuaded to sacrifice the moustache in the interests of historical authenticity by Hugh Walpole.

The removal of the moustache for a subsequent Colman film, this time *A Tale of Two Cities* (Jack Conway, 1935), made such an impression on Alistair Cooke that he opened his review of the film by discussing it.[2] The Colman moustache and the Colman voice were *de rigueur* for the aspiring Imperial actor. One can see an illustration of this in the performance of the young Laurence Olivier, playing English journalist Julian Rolfe, in *The Yellow Ticket* (Raoul Walsh, 1932). It is a bid by Fox Studios to create a facsimile Colman. The Colman moustache, voice, manner: all are perfectly reproduced.

This similarity in appearance of the Imperial actor is emphasized by the scene at the end of *The Four Feathers* (1929 version), when our four heroes, Feversham, Trench, Castleton and Durrance, are drawn up to receive their medals. The camera pans along the line and they all look exactly the same: tall, thin, square-jawed, keen-eyed, and, of course, moustached. It is this all-important appearance which surely explains the casting in major Imperial roles in *The Painted Veil* (Richard Boleslavski, 1934) and *The Rains Came* (Clarence Brown, 1940) of George Brent, visually fitting the archetype but never able to conceal his broad American accent.

Spiritually, the Imperial archetype recalls his literary counterpart. He is a man of Dick Hannay's totem. He is the gentleman all-rounder, the gifted amateur, the man with 'a sense of humour and a sense of proportion', born to command and never questioning that right to command, inspired by and living by the code of the old school: loyalty, dignity, honour, dedication to duty, self-sacrifice for the good of others, playing the game, doing the right thing, keeping a stiff upper lip.

There was in the cinema a whole range of actors who embodied these characteristics and this life style, a breed which has no counterpart in the modern cinema and whose achievements there is a tendency to overlook because of the critical neglect of their genre and their acting style. They are the men I would call the Imperial actors. They were the Hollywood British Colony, flying the flag, taking tea at four, playing cricket,

maintaining their British citizenship.³ Greatest of them all is Ronald Colman, perhaps the most characteristic is C. Aubrey Smith, and at their shoulders stand the great Imperial stars (Clive Brook, David Niven, Herbert Marshall), the second leads (Ian Hunter, John Sutton, Patric Knowles, John Loder, Reginald Gardiner, Reginald Denny, Reginald Sheffield, Richard Greene, Ralph Forbes), the character actors (Nigel Bruce, Alan Napier, Paul Cavanagh, Hugh French, Robert Coote, Lester Matthews, Miles Mander, Montagu Love, Halliwell Hobbes, Arthur Treacher etc.).

British-born character stars, like Cedric Hardwicke, Basil Rathbone, George Sanders and Robert Douglas, who played a wide variety of parts, could stiffen the upper lip and turn in as good an Imperial performance as anyone should the occasion demand it. Hardwicke, for instance, played three memorable Imperial figures: Allan Quatermain in *King Solomon's Mines* (Robert Stevenson, 1937), Dr Thomas Arnold of Rugby in *Tom Brown's Schooldays* (Robert Stevenson, 1939) and Dr David Livingstone of Africa in *Stanley and Livingstone* (Henry King, 1939). Basil Rathbone, probably the finest of all swashbuckling villains and the definitive screen Sherlock Holmes, contributed two studies to the Imperial iconography, as a District Officer in Africa in *The Sun Never Sets* (Rowland V. Lee, 1940) and as Commander of an airforce squadron in the First World War in *The Dawn Patrol* (Edmund Goulding, 1939).

Actors like Cary Grant and Ray Milland, and that consistently underrated and ill-appreciated actor, Michael Rennie, though British by birth, acquired mid-Atlantic accents and played all kinds of roles. But even they could sport topee, pipe and moustache with the best of them: Grant in *The Last Outpost* (1935), Milland in *Beau Geste* (1939) and Rennie in *King of the Khyber Rifles* (1954), for instance. Even more so, Errol Flynn, the king of the swashbucklers, who maintained in his youth a perfect English accent, starred in one of the greatest of all Imperial films, *Charge of the Light Brigade* (Michael Curtiz, 1936), as well as *Another*

Dawn (William Dieterle, 1937), *The Dawn Patrol* (Edmund Goulding, 1939) and *Kim* (Victor Saville, 1950).

Many of the Imperial actors were in fact educated at public school and it is small wonder that they conveyed the essence of the Code so effortlessly. Aubrey Smith was at Charterhouse and Cambridge, David Niven at Stowe and Sandhurst, John Loder at Eton and Sandhurst, John Sutton at Wellington and Sandhurst, Basil Rathbone at Repton, Ronald Colman at Hadley, Reginald Gardiner at Shrewsbury, Clive Brook at Dulwich College and George Sanders was expelled from a whole succession of schools, including Bedales and Brighton College.

It is Ronald Colman, who, more than any other actor, epitomizes the Imperial archetype, whether playing a pillar of the British Raj, a Flemish freedom-fighter or François Villon, the vagabond king. What made up the distinctive Colman personality? If we examine the parts he played, we can isolate several obvious ingredients. He was tall, dark and good-looking. Indeed in 1935 he was voted the handsomest man on the screen. This helped to secure for him stardom in silent films. But it is not the source of his star quality. If he had died in 1928, his silent career would have given us a very misleading picture of his personality. For, incredible as it may seem in the light of his subsequent career, Colman was hailed, after his success in *The White Sister* (Henry King, 1924), as the new Valentino. It was to exploit this image that producer Samuel Goldwyn teamed him with Valentino's erstwhile co-star, Vilma Banky, in a series of romantic costume dramas. But as Joe Franklin has perceptively observed: 'Even when he was playing a gypsy outlaw or a fiery lover, he always somehow contrived to remain suave, debonair – above all, polite and well-mannered.'⁴ The truth is that Colman was basically miscast in these passionate, extrovert Latin lover roles and this miscasting derived entirely from his physical appearance.

The factor which was to change the Colman screen persona by adding that extra dimension, was sound. His voice proved to be his greatest asset: gentle, cultured, exquisitely

The moustache

The moustache was one of the badges of the Imperialist. Note the difference its removal makes to Ronald Colman's face. With it, confidence and self-sufficiency. Without it, melancholy and world-weariness.

21 (below left) Ronald Colman in *The Prisoner of Zenda*
22 (below right) Ronald Colman in *Clive of India*

The archetype

The Imperial heroes conform so strictly to an archetype that when they get together they look exactly the same.

23 (above right) The heroes of *The Four Feathers* (1929 version): Clive Brook, Theodore von Eltz, Richard Arlen
24 (below right) British army officers in India (*Storm over Bengal*) – amongst them Gilbert Emery, Douglas Walton, Patric Knowles

modulated and very English. It proved to match that gracious, good-natured, well-mannered style which had been at odds with his Valentino appearance. But more than this, his voice had an indefinable fragility, reminiscent at times of Robert Donat and perhaps resulting from the lung complaint from which he had suffered since being wounded in the First World War. (Donat, one recalls, had suffered from asthma.) This fragility suggests at once the inner sensitivity and inner strength that were to make his finest performances so memorable.

Who but Colman could have made Rudolf Rassendyll's coronation oath in *The Prisoner of Zenda* (John Cromwell, 1937) so real and moving a covenant with his nation and his nation's past: 'I, Rudolf, with justice and mercy to deal sovereignty, to guard with vigilance and honour the welfare of my peoples, from all enemies to defend them and from the throne of my ancestors to bear faithful rule, all this do I swear.' Who else but Colman could have pronounced the little love poem from *If I Were King* (Frank Lloyd, 1938) with such wistfulness and such affection:

Ah, love, if I were king,
The stars should be your pearls upon a
 string,
The world a ruby for your finger ring,
And you should have the sun and moon
 to wear,
If I were king.

Who else but Colman could have pronounced Sydney Carton's scaffold speech so movingly as to make it the unbearably emotional climax of *A Tale of Two Cities* (Jack Conway, 1935):

Seamstress You are not afraid. It's almost
 as though you welcomed death.
Carton Perhaps I do. Perhaps in death,
 I receive something I never had before.
 I hold a sanctuary in the hearts of
 those I care for. It is a far, far better
 thing I do now than I have ever done, it
 is a far, far better rest I go to than I have
 ever known.

These lines might almost be the text for the Colman character as it emerged in the thirties, the summation of the Imperial character. The combination of Colman's physical appearance and his voice, as revealed by the talkies, created the definitive screen personality.

At the most superficial level he could play, quite effortlessly, debonair, light-hearted charmers in frothy, inconsequential comedies and it is these which are among his least successful films, for they indicate that his potential is not being fully used. Into this category fall such trifles as *The Man Who Broke the Bank at Monte Carlo* (Stephen Roberts, 1935), *Lucky Partners* (Lewis Milestone, 1940) and *My Life with Caroline* (Lewis Milestone, 1941).

On the second level he could, by accentuating the devil-may-care roguishness, play gentleman thieves, like A. J. Raffles in *Raffles* (George Fitzmaurice and Harry D'Arrast, 1931) or Barrington Hunt in *The Unholy Garden* (George Fitzmaurice, 1931), and vagabond kings, like François Villon in *If I Were King* (1938) and Hafiz the beggar in *Kismet* (William Dieterle, 1944).

On the third and most profound level he could suggest, beneath an apparently light-weight exterior, the reserves of dedication and resourcefulness which can produce greatness – and it was in this kind of role that he gave his most memorable performances: as Rudolf Rassendyll in *The Prisoner of Zenda*, as Robert Conway in *Lost Horizon*, as Martin Arrowsmith in *Arrowsmith* and as Robert Clive in *Clive of India*.

The Colman character lived by the code. To him, honour, duty, self-sacrifice were not just words. They were very real concepts, which governed his conduct and his actions. It is easy enough to sound pompous and self-righteous when dealing with concepts like these. But the Colman character never did. This was because of the sense of humour that seasoned everything he did. The light-hearted, bantering style of conversation, the wry jokes acted as a perfect balance to the solid virtues he incarnated – Chips's 'sense of humour and sense of proportion'.

The themes of honour, duty and self-sacrifice run like an invisible thread through

American actors who fit the archetype visually are
cast in key Imperial roles even though vocally they
betray their transatlantic origins.
25 (left) George Brent in *The Rains Came* (with
Brenda Joyce)
26 (right) Warner Baxter in *White Hunter*

his thirties films, binding them together into a completely coherent 'oeuvre'. In *Beau Geste* (Herbert Brenon, 1926) and *Under Two Flags* (Frank Lloyd, 1936), he joins the Foreign Legion under an assumed name to save the family from disgrace, in both cases taking the blame for something he has not done. In the films in which he plays dual roles, *The Magic Flame* (Henry King, 1927), *The Masquerader* (Richard Wallace, 1933) and *The Prisoner of Zenda* (1937) he is faced always with the same problem: a conflict of love and honour. Taking the place of his double to avert national catastrophe, he inevitably falls in love with the wife/fiancée of the man he is impersonating and is faced with an agonizing choice. But, in the end, he chooses the course of honour. It is *The Prisoner of Zenda* which contains the classic scene of love and honour in conflict and it is worth recalling in its entirety for the perfection of the treatment.

Princess Flavia (Madeleine Carroll), dressed in black, stands in a bower window, shafts of sunlight streaming in around her, highlighting her radiant blonde beauty. Rassendyll enters and bows hesitantly. Her attempt to be formal and distant breaks down when she sees he is wounded. Their love reasserts itself when he tells her that he is going home to England.

Rassendyll Come with me. I won't give you up. I won't let them stand in the way of our happiness. Come with me.
Flavia Oh, if only I could.
Rassendyll There's a world outside, our world, and a throne for you, a woman's throne, in my heart.
Flavia I want that. And you'll always love me, always as now.
Rassendyll Always, always. Think, my love, you'll be free of all these cares and duties, to live your life as freely and joyously as . . . Flavia, what's the matter?
Flavia I was born to these cares and duties, Rudolf. Help me to do what I was born to do, help me to do what I must.
Rassendyll My dear, how can I? I love

you.
Flavia But is love all? If love were all, I could follow you in rags to the end of the world. If love were all, you'd have left the king to die in his cell. Honour binds a woman too, Rudolf; my honour lies in keeping faith with my country and my house. I don't know why God has made me love you. I only know I must stay.
Rassendyll I was mad to ask you.
Flavia For one lovely moment, I too was mad.

So they part and Rassendyll rides off into the sunset, his job done, his honour satisfied, his heart broken. He has played the game.

Similarly there is the theme of duty. Robert Clive feels himself to be a man of destiny, whose task is to secure British rule in India. ('India is a sacred trust. I must keep faith.') To this end he sacrifices the life of his child, the love of his wife, his wealth and, ultimately, his reputation. Martin Arrowsmith, impelled by an equally irresistible sense of duty to mankind, throws up his comfortable country practice and goes off to the West Indies to find a cure for the plague. His wife goes with him and dies during an epidemic. But he carries on the search. François Villon, who although French is very much a projection of the Colman personality, teaches King Louis XI the duties of kingship, just as Rassendyll teaches King Rudolf V.

But perhaps the most consistent theme is that of self-sacrifice, one of the noblest attributes of man and one which requires the greatest courage when it is quiet, personal and unsung. Colman evoked all these qualities when playing renunciation scenes. In *The Dark Angel* (George Fitzmaurice, 1925), Ronald Colman played Hilary Trent, blinded in the First World War. Not wanting his sweetheart, Kitty, to marry him out of a sense of obligation, he rehearses perfectly a farewell scene, which will convince her that he can see. The scene goes as planned until the end when Kitty extends her hand and he ignores it. She leaves but, learning the truth, returns and is united with him. The same

Ronald Colman – greatest of all Imperial actors
27 (above) The renunciation scene from *The Prisoner of Zenda*: Ronald Colman with Madeleine Carroll
28 (right) Ronald Colman as A. J. Raffles, cricketer and cracksman

theme recurs at the end of *The Light That Failed* (William Wellman, 1940), based on Kipling's novel. Blind artist Dick Heldar (Colman) renounces his childhood sweetheart and goes off to the Sudan, where he 'stops one – up Khartoum way'.

In *Cynara* (King Vidor, 1932), as Jim Worlock, a respectable middle-aged lawyer, he becomes involved with a shopgirl while his wife is away on the continent. When she returns, he ends the affair and the girl kills herself. At the inquest, the coroner declares Jim responsible. Although he knows that the girl has had other affairs and is emotionally unstable, he won't blacken her character by revealing this. Disgraced, he leaves for South Africa to start a new life, but his wife, who has learned all, joins him on the ship.

He makes renunciations in *Under Two Flags*, *The Unholy Garden* and, most notably, *A Tale of Two Cities*. Sydney Carton, drunkard and ne'er-do-well, falls in love with Lucie Manette, but she loves Charles Darnay. When Darnay is arrested in Paris, Carton demonstrates his love by changing places with Darnay and going to the scaffold in his place.

The film which triumphantly draws together all these threads is John Cromwell's *The Prisoner of Zenda*, one of the purest and noblest fables of love and honour ever put on film. The direction is faultless, the writing brilliant, the production impeccable, the score unforgettable and the actors so perfect that one would be forgiven for thinking that the parts had been written for them. What more can one say? Glittering set-pieces are handled with elegance and panache, the intimate moments with sensitivity and sincerity and the film reaches its climax with perhaps the most exciting and certainly the most amusing sword duel in all cinema. It is Hollywood myth-making at its most potent and most evocative.

Throughout the film run the three themes I have outlined: honour, duty, self-sacrifice, and Colman incarnates the perfect Imperial hero, a man who does what he must quietly and without fuss. He tells Flavia: 'I love you more than truth or life or honour.' But of course, he does not; he cannot. Honour

triumphs.

Why is Colman so convincing in his performances? The answer is simple. He was himself an embodiment of the virtues he suggested. Off screen, as well as on, he was a quiet, pipe-smoking, cricket-playing Englishman, who collected Dickens first editions. Rassendyll says of himself in *Zenda*: 'I was born with a natural distaste for crowds.' Colman too was notorious for his love of privacy. Also in *Zenda*, Rupert of Hentzau sneers: 'You have worn the Queen's uniform and the old school tie.' Colman too had worn both. Clive of India says, on coming home: 'It's such a good country, one wonders why we ever left it.' Colman too never gave up his British citizenship, saying: 'I wouldn't dream of being anything else.' This is the essence of star personality, complete conviction and sincerity in the playing of parts, and it is the star personality rather than the actor which is the stuff of cinematic myth. The two need not be mutually exclusive. But the truly great stars need something more than simply acting skill and Colman had it.

Where Colman was the greatest of the Imperial actors, C. Aubrey Smith was the doyen of the British colony in Hollywood, a position that was recognized when he was knighted in 1944. Craggy, authoritative – with a hawk nose and square jaw which looked as if they had been carved out of granite and a voice to match – stern yet kindly, used to being obeyed and very British, he radiated absolute integrity. He was the living embodiment of the Imperial spirit. Not surprisingly, he had, in his youth, been a Cambridge cricketing Blue and had captained Sussex at cricket. He was a pioneer of cricket in the USA and the founder and captain of Hollywood Cricket XI, among whose members were Colman, Clive Brook and Boris Karloff.[5]

Smith's first screen appearance was in 1915 and thereafter he made several British silents. But his period of greatest fame began with his talkie début in *Bachelor Father* (1931), made when he was sixty-eight. From then until his death in 1948, at the age of eighty-five, he was never out of work and through a succession of Hollywood's finest

films he contrived to impersonate virtually the whole of the British ruling classes. He played two Prime Ministers: the Earl of Chatham in *Clive of India* (1935) and the Duke of Wellington in *The House of Rothschild* (Alfred Werker, 1934) and *Sixty Glorious Years* (Herbert Wilcox, 1938). He played generals: General Burroughs in *The Four Feathers* (1939 version) and General Mandrake in *Ten Little Niggers* (René Clair, 1945), the latter being a film of Agatha Christie's thriller and not a defence of British colonialism. He played admirals, like Admiral Trimble in *Forever and a Day*, directed by Herbert Wilcox, Frank Lloyd, Victor Saville and Robert Stevenson in 1943. He played peers of the realm: the Duke of Revelstoke in *Waterloo Bridge* (Mervyn Leroy, 1940) and Lord Kelvin in *Madame Curie* (Mervyn Leroy, 1943). He played a Chief Constable in *Rebecca* (Alfred Hitchcock, 1940), the Lord Chief Justice in *Unconquered* (Cecil B. DeMille, 1947) and the Chancellor of Oxford University in *The Adventures of Mark Twain* (Irving Rapper, 1944). Most characteristically, he was the ultimate Indian army officer in *Lives of a Bengal Lancer* (1935), *Wee Willie Winkie* (1937) and *Four Men and a Prayer* (1939). He even played a brace of Imperial bishops, in *Eternally Yours* (Tay Garnett, 1939) and *Dr. Jekyll and Mr. Hyde* (Victor Fleming, 1941), in the latter delivering a sermon to celebrate Queen Victoria's Diamond Jubilee.

Almost at the end of his life, he achieved stardom in a couple of Republic 'B' features: *Secrets of Scotland Yard* (George Blair, 1944) and *Scotland Yard Investigator* (George Blair, 1945), playing Sir James Collison, special investigator at Scotland Yard. During 1947, he paid a visit to England to see the cricket and to play Lord Caversham in *An Ideal Husband* (Alexander Korda, 1948). Shortly after completing this role he died, just as he was preparing to return to Hollywood to play Old Jolyon Forsyte in M.G.M.'s film version of *The Forsyte Saga*. Smith was at his most impressive, however, when he played Colonel Zapt in *The Prisoner of Zenda*, a British Army officer in all but name. ('I have a feeling about my king, about the crown . . .

I feel about it as any other man might feel about his children or . . . the woman he loved.') It is Zapt who persuades Rassendyll to impersonate the King ('You're bound in honour to play the King's part'), guides and counsels him throughout the imposture and finally escorts him to the border, paying him the highest tribute he can ('Englishman, you are the finest Elphberg of them all').

He did not always play Englishmen. He was, for instance, a French priest in *The Hurricane* and a Swedish soldier in *Queen Christina*. But they always came out the same. On one occasion, this had hilarious results, as Sir Cedric Hardwicke recalled in his autobiography.[6] During the war, 20th Century-Fox hired a group of British actors (Hardwicke, Rathbone, Nigel Bruce, Roland Young and Aubrey Smith among them), to play the Japanese War Cabinet in Lewis Milestone's *The Purple Heart*. Perfectly made up, they came on to the set and Aubrey Smith announced in impeccable English: 'We are gathered heah to considah the next crushin' blows to delivah to the enemy Americans.' Everyone collapsed in hysterical laughter and Fox brought in White Russian émigrés to play the parts.

Whatever his limitations, Smith was a dedicated performer, as Cecil B. DeMille testified when discussing the making of *Unconquered*: 'Sir Aubrey, well past 80 years of age, would come onto the set each morning with his lines letter-perfect, giving the director a joy which much younger actors, alas, sometimes deny him.'[7]

As a footnote to Smith, it is worthy of mention that one of the greatest delights in all cinema is the sight of Aubrey Smith, in the role of a French duke, singing 'Mimi' in Rouben Mamoulian's entrancing musical *Love Me Tonight*. It is a delight paralleled only by that unforgettable trio of Cedric Hardwicke, William Bendix and Bing Crosby singing 'I'm busy doing nothing' in Tay Garnett's *A Connecticut Yankee at King Arthur's Court* (1949), ample evidence that the Imperial actor could unbend and forget his duties for the odd occasion.

Gentler and less authoritative than Aubrey Smith, both Henry Stephenson and H. B.

29 (opposite)
C. Aubrey Smith – doyen of British
Imperial actors (knighted in 1944)

The face of the English ruling class
During his film career, C. Aubrey
Smith impersonated virtually the
whole of the English ruling class.
30 (above) Aubrey Smith as the
Duke of Wellington in *Sixty Glorious
Years* (with Anna Neagle and Anton
Walbrook)
31 (centre) Aubrey Smith as the
classic Indian Army officer in *Lives
of a Bengal Lancer*
32 (below) Aubrey Smith preaching
the gospel of Empire as a bishop in
Eternally Yours

Warner sometimes filled the elder-states-man-of-Empire role. Stephenson was never entirely happy in uniform, though he did wear it memorably in *Charge of the Light Brigade* – presumably Aubrey Smith was out of town that day. But he was much happier as kindly, lovable old fathers or diplomats. He made his screen début at the age of sixty, playing a lovable old roué in *Cynara* (1932) and later memorably played General Catha-way, head of the Cathaway family, in *This Above All* (Anatole Litvak, 1942), Lord Ashleigh, British representative in Dublin during the troubles, in *Beloved Enemy* (H. C. Potter, 1936) and Lord Willoughby, British envoy in the West Indies, in *Captain Blood* (Michael Curtiz, 1935).

H. B. Warner, much loved character-actor, best remembered for the dignity and gentle-ness of his Christ in *King of Kings* (Cecil B. DeMille, 1927), went on in the thirties and forties to be a regular member of Frank Capra's stock company and to uphold the dignity of the British Empire with what James Agate described as 'his impenetrable moral grandeur' as the British Prime Minister, Lord Melbourne, in *Victoria the Great* (Herbert Wilcox, 1937), as the British consul in Bianco in *Our Fighting Navy* (Norman Walker, 1937) and as the gallant British officer, Major Crespin, who pits himself against the villainous Rajah of Rukh in *The Green Goddess* (Alfred E. Green, 1930).

Just behind Colman stands David Niven, who in a very real sense inherited his mantle when he went into semi-retirement in 1949. He is undoubtedly one of the cinema's finest light-comedy actors. Like Colman, he covers reliability and worth with a debonair, light-hearted exterior. He began his career with a line of breathless, fresh-faced young army officers (*Charge of the Light Brigade, Beloved Enemy, Four Men and a Prayer, The Prisoner of Zenda*), not to mention a spell as Bertie Wooster in *Thank You, Jeeves* (Arthur Greville Collins, 1936). He achieved full stardom after playing a British air force officer in *The Dawn Patrol* (1939). One of the first British actors to return to this country during the war, he served for six years in the army, rising to the rank of Lieutenant-Colonel. Since the war, along with a suc-cession of polished comedy roles and an Oscar-winning performance in *Separate Tables* (Delbert Mann, 1958), Niven has carved out a nice line in gentleman thieves for himself: *The Pink Panther, Bedtime Story* and his memorable television series *The Rogues*. He has also returned periodically to represent the Empire, notably as Phileas Fogg in *Around the World in 80 Days* (1956) and as Sir Arthur Robertson, the British Envoy, in *55 Days at Peking* (1962).

If anyone had any doubts about Niven's very real talent as an actor, his performance in the double role of dashing young army officer and lonely old general in Irving Reis's enchanting *Enchantment* (1948) should dispel them. Based on Rumer Godden's novel, this is one of the cinema's classic love stories. The house, at 99 Wiltshire Crescent, tells the story. At the turn of the century, General Sir Rollo Dane (David Niven), seen now as a tetchily Blimpish retired officer, but then as a dashing and debonair young officer, fell in love with the beautiful but impoverished Lark Ingoldsby (Teresa Wright). But they were tragically parted when Rollo's jealous sister, Selina, playing on Rollo's sense of duty and dedication to the service, got him posted to Afghanistan and Lark, in despair, married somebody else. But Rollo contrives, during the Second World War, to bring to a happier conclusion the romance of his grand niece, Grizel (Evelyn Keyes) and Lark's nephew, Pax (Farley Granger), when he sees it in danger of running the same course. The film ends with the death of Rollo and the destruction of the house in an air raid, Rollo's life having found, at the end, fulfil-ment in bringing to others the happiness denied to him. While at the same time, the 'death' of the family's house symbolizes the destruction of that old system of values which placed duty above personal happiness.

It is handled with a remarkable delicacy and sympathy, a lightness of touch coupled with a rewarding attention to detail. It employs sound and image, as the cinema should, to awaken an emotional response in the audience. The volume of Matthew Arnold

poems, with a rose crushed between their pages; the sound of piano music cascading across an Edwardian drawing-room; the fire-lit idyll of young lovers, arm in arm, heedless of what the future holds: these devices combine to evoke the tragedy of love thwarted and the painful loneliness of orphaned childhood and desolate old age, which are the film's themes, and which are underlined by Niven's very moving performance.

Clive Brook, jut-jawed, clear-eyed, pipe-smoking, is the classical Imperial hero. As with Colman and Niven, his voice added an extra dimension to his physical appearance. Like Colman and Niven, he had a light-hearted, jaunty insouciance, which perfectly offset the downward curve of the mouth, the set of the jaw and the narrowing of the eyes, which might otherwise have given the impression that he felt the defence of the Empire to be too serious a matter for banter. In fact a dry and engaging wit informed almost all of Brook's best performances. He reached his peak in Hollywood in the early thirties, classically incarnating Captain Durrance in *The Four Feathers* (1929 version), Sherlock Holmes in *Sherlock Holmes* (William K. Howard, 1932), Robert Marriott in Noël Coward's pageant of contemporary British history, *Cavalcade* (Frank Lloyd, 1933), and Captain Harvey, the British officer who falls in love with Marlene Dietrich, in *Shanghai Express* (Josef von Sternberg, 1932).

Brook returned to Britain in the mid-thirties but never quite attained the mythic peaks of his earlier career. After directing and starring in a typically urbane film version of Frederick Lonsdale's comedy *On Approval* in 1945, he returned to the stage and it looked as if films had seen the last of him. But he suddenly reappeared, at the age of seventy-two, to play, impeccably of course, the old Marquis of Gleneyre, fox-hunting and port-drinking in the grand manner, in John Huston's nostalgic and vastly entertaining country-house thriller, *The List of Adrian Messenger* (1963), with Herbert Marshall as the Commissioner of Police, Gladys Cooper as a tipsy aristocratic widow and George C. Scott trying to be Basil Rathbone.

One of the most interesting of Brook's British films is *Action for Slander* (1937), which looks like a cinematization of a 'well-made' play, but, for once, is not. Competently directed by Tim Whelan from a screenplay by Miles Malleson, it is a courtroom drama, built around the acceptance by the leading characters of the Code. It provides an interesting cross-reference for Jean Renoir's *La Règle du jeu* (1939), which in its own way detailed the Code of the French upper classes. Both films have an identical structure, intercutting between the lives and loves of the masters and those of the servants, lived out on completely separate levels. They even contain the same scene, of a grouse-shoot, in which the women demonstrate their allegiance to different men by loading for them.

Action for Slander opens with Major George Daviot (Clive Brook) stopping a fellow officer, Captain Hugh Bradford (Arthur Margetson) from beating his horse. This establishes at once that Daviot is an officer and gentleman and that Bradford is a cad. Back at home, however, Daviot's wife, Ann (Ann Todd) tells him she is leaving him because he has treated her as a 'pal' and not as a wife. So Daviot goes alone to the country-house weekend, at which it becomes clear that he has been having an affair with Bradford's wife, Josie (Margaretta Scott). That night, during a card game, Bradford accuses Daviot of cheating. A duel is out of the question, being against the rules, but Daviot is dissuaded from taking the other course open, action for slander, by his friends, who are afraid that the scandal might damage their careers. At the same time, Josie refuses to marry him, preferring an illicit liaison and Daviot in disgust breaks off the relationship.

Word of the accusation of cheating gets out. Daviot is cut by members of his club and shunned by his friends. He goes on leave from the regiment and retreats to a bed-sitter in Bayswater with only his pipe and a canary for company. Why? He cannot publicly refute Bradford's accusation because that would mean giving the real reason why he

33 (opposite) H. B. Warner lending his 'impenetrable moral grandeur' to the role of Lord Melbourne in *Victoria the Great* Other elder statesmen of Empire instruct the younger generation.
34 (right) C. Aubrey Smith with Douglas Fairbanks Jr and Basil Rathbone in *The Sun Never Sets*
35 (below) Henry Stephenson with Errol Flynn in *Charge of the Light Brigade*

made it – the discovery of Josie's affair with Daviot. That would mean ruining Josie's reputation and although he has broken with her, Daviot, as an officer and a gentleman, cannot bring himself to ruin her.

Expelled from his club and threatened with expulsion from the regiment, Daviot plans to shoot himself. His wife, however, returns in the nick of time and persuades him to take action for slander. The case goes badly for, unable to mention Josie (because the Code forbids it), he cannot produce an acceptable reason why Bradford would lie about the cards. But his counsel (splendidly played by Francis L. Sullivan) demonstrates by a reconstruction of the game that Daviot could not possibly have cheated. The case is won and Ann and George are reunited.

Herbert Marshall is one of the few actors who have ever convincingly portrayed 'goodness'. This is extremely hard to achieve. More often than not, pure 'goodness' comes out as either boring or sanctimonious. But Marshall managed to project 'goodness' and make it both sincere and likeable. It was something in the softness of his voice and his eyes. He could evoke audience sympathy even when playing villains, which he occasionally did, notably the German agent in Hitchcock's superb wartime thriller *Foreign Correspondent* (1940).

Typical of Marshall's parts was Gerald Shannon in *The Dark Angel* (Sidney Franklin, 1936), the sound re-make of Ronald Colman's silent success. Shannon is the best friend of the hero Alan Trent (Fredric March), blinded in the war. Believing Alan dead, he persuades Kitty Vane (Merle Oberon), the girl Alan loves, to marry him. But discovering that Alan is alive, he informs Kitty, reunites the couple and quietly fades out of the picture.

Similar is the film of Somerset Maugham's *The Painted Veil* (Richard Boleslavski, 1934), which M.G.M. turned into a minor Garbo vehicle. Katrin (Greta Garbo) marries the dedicated English doctor, Walter Fane (Herbert Marshall), who has taken up the white man's burden. ('The world needs help. In a small way, that's my job.') He takes her to Hong Kong and there she has an affair with dashing British diplomat Jack Town-

send (George Brent). But when she accompanies Walter to combat a cholera outbreak up country and he is injured in a riot, she realizes she loves him and nurses him back to health, explaining the position to Jack, who shakes her hand, wishes her 'all the best' and leaves.

During his years as a star in the thirties and forties, Herbert Marshall was most often cast as the wronged husband of a wife, who takes a lover, comes to grief and is then forgiven and taken back by her husband, who plays the sporting loser. This was his attitude to Garbo in *The Painted Veil*. It was also the part he played towards Dietrich in *Blonde Venus* (Josef von Sternberg, 1932), Norma Shearer in *Riptide* (Edmund Goulding, 1934) and Bette Davis in *The Letter* (William Wyler, 1940). Forgiving, though his heart is broken, he plays the game.

During the late forties and the early fifties, he matured into a character star, twice playing an urbane Somerset Maugham in *The Moon and Sixpence* (Albert Lewin, 1942) and *The Razor's Edge* (Edmund Goulding, 1946), and much in demand for costumed aristocrats (*The Virgin Queen*, *The Black Shield of Falworth*), and benign police officers (*The Weapon*, *The Fly*, *The List of Adrian Messenger*). He attained the highest rank, shortly before his death, when he played an unnamed British Prime Minister (who must, since the film is set in 1862, be Lord Palmerston) in *Five Weeks in a Balloon* (Irwin Allen, 1962).

Herbert Marshall, probably more than anyone else, set the pattern for the 'second leads'. These were young British actors who played leads in 'B' features and either suave villains or 'the other man' or the friend of the hero in 'A' features. Ian Hunter, most similar of all to Marshall in manner and appearance, was in Hollywood from 1934 to 1942, when he returned to England to serve in the R.N.V.R. Characteristic of his Hollywood roles are those he played in two Bette Davis vehicles, *That Certain Woman* (Edmund Goulding, 1937) and *The Sisters* (Anatole Litvak, 1938). In the first, he is the man, unhappily married, who falls in love with Bette Davis but refuses to be unfaithful to

David Niven's Imperial career took him from fresh-faced subaltern to elderly general. In *Enchantment* he played both.
36 (left) David Niven as subaltern (with Teresa Wright)
37 (right) David Niven as general (with Evelyn Keyes)
38 (below) He returned periodically to the Empire, for instance in *55 Days at Peking* (with Elizabeth Sellars and Robert Helpmann)

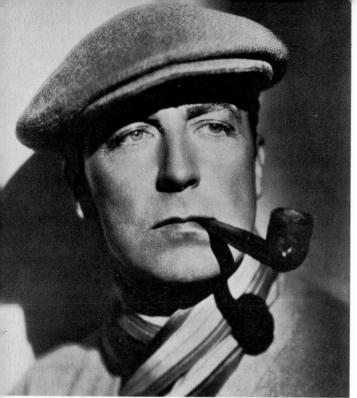

Clive Brook was the classical Imperial
hero.
33 (left) Publicity still. Note the down
ward curve of the mouth, the set of the
jaw and the narrowing of the eyes
40 (below) A stiff upper lip farewell fr
Cavalcade. Clive Brook and Diana
Wynyard

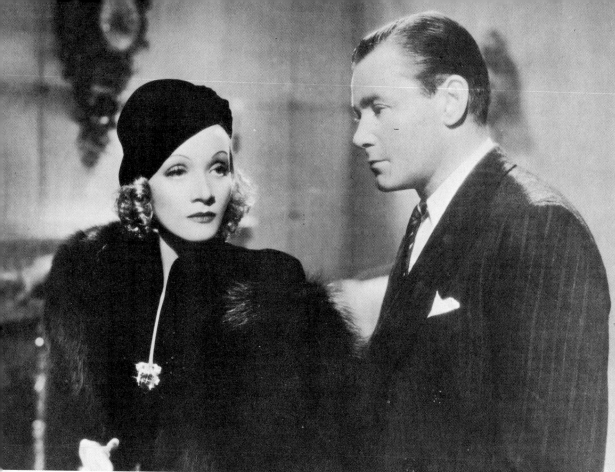

41 (above) Herbert Marshall, one of the few actors who have convincingly portrayed 'goodness', specialized in forgiving husband roles. Here he is forgiving Marlene Dietrich in *Angel*

42 (right) Ian Hunter, rather similar to Herbert Marshall in manner and appearance, about to forgive Kay Francis in *Another Dawn*

his wife. In the latter, he is the man who falls in love with Miss Davis but steps aside when he learns she is still in love with Errol Flynn. He was at his best, however, in John Ford's *The Long Voyage Home* (1940), in which he gave a beautifully conceived performance as 'Smitty', the Royal Navy officer cashiered for drunkenness, who, to spare his family the disgrace, enlists on a tramp steamer and dies bravely during an enemy attack, expiating his sin. We have already discussed his archetypal performance as Colonel John Wister in *Another Dawn*, in which he sacrificed his life to unite his wife and her lover. On his return to Britain, Ian Hunter continued to show the flag as governor of an Indian province (*Northwest Frontier*, *Kali-Yug*, *Goddess of Vengeance*) and as a Naval officer (*Battle of the River Plate*, *The Bulldog Breed*).

Similarly ever-reliable was Reginald Denny, who has been called 'one of the finest comedians of the silent screen'.[8] He played the bright and breezy young American hero of a score of comedies before the coming of sound revealed an impeccable British accent and removed him from that role to one of British character-actor. In his obituary, *The Times* described him thus:[9]

In Hollywood, Reginald Denny had the advantage of being every American's ideal image of the perfect English gentleman. Like Ronald Colman, with whom in early days he was often compared, he was tall, straight-backed and soft-spoken: he had brown hair and blue eyes, a neat military moustache and the air of being at home with a pipe in his mouth. Consequently, he was more often than not the good chap, the reliable standby who picks up the pieces after the heroine has been through the mill of suffering with more instantly exciting men.

Two of his most notable roles were as the gentleman ranker, George Brown, in John Ford's *The Lost Patrol* and as Frank Crawley, the estate manager, long secretly in love with the fascinating Rebecca, but remaining loyal to her husband, his old friend, in Hitchcock's *Rebecca*. He also played Bulldog Drummond's sidekick, Algy, in several of the Drummond films of the late thirties.

The fifties saw him securely ensconced in the Imperial service, showing the flag whenever film-makers turned to the Imperial theme. In the course of the decade he played Captain Brownell of the British Army in colonial North America in *Tomahawk Trail* (1950), gaining promotion to play Major Trevett of the Canadian Mounted Police in *Fort Vengeance* (1953) and Major Bone of British Intelligence in *World For Ransom* (1953). He then transferred to the civil branch to play the British Commissioner in Burma in *Escape to Burma* (1955) and an Inspector of Police in British India in *Around the World in 80 Days* (1956).

His last roles before his death in 1967, played when he was well on in his seventies, showed that he had lost none of his early comedy skill. For they were beautifully observed parodies of the tea-drinking, ultra-correct Englishman he had played since the coming of sound: the villainous Sir Harry Percival in *Cat Ballou* (1965) and Commodore Schmidlapp in *Batman* (1966), a memorable end to a thoroughly dependable career.

John Loder, still fondly remembered as John Ridd in the British film version of *Lorna Doone*, went to Hollywood in 1940 and there became the archetypal second lead, starring in 'B' features (*Jealousy*, *The Brighton Strangler*), playing villains in costume pictures (*Wife of Monte Cristo*, *The Fighting Guardsman*) and supporting roles in 'A' features (*Now Voyager*, *Old Acquaintance*). Typically sporting and British were his 'other man' roles, like aristocrat Carlton DeWitt in *Gentleman Jim* (Raoul Walsh, 1942) who gives up his fiancée Alexis Smith to pugilist Errol Flynn, whom he really rather likes, and as Captain Reginald Carstairs of the British Army, who surrenders his fiancée Alice Faye to John Payne when he discovers that she loves him and actually drives her to the dock to catch him before his ship sails, shaking him by the hand and saying 'Good luck, old man' (*Tin Pan Alley*, Walter Lang, 1940).

In like vein, Patric Knowles, at his most typical, played Brett, Lord Carstairs (no relation to Reggie, other than spiritually) in

Reginald Denny, reliable chap and dependable Imperial functionary

43 (right) A stiffly formal Reginald Denny breakfasts with the Bulldog Drummonds (John Howard and Heather Angel) in *Bulldog Drummond in Africa*

44 (below) Reginald Denny, representing the civil arm of Empire, and David Farrar, representing the military, lay down the law to a native ruler in *Escape to Burma*

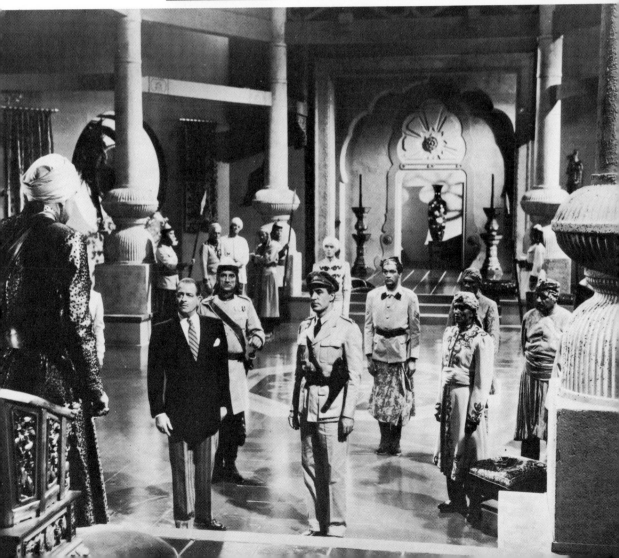

Kitty (Mitchell Leisen, 1946), who surrenders his fiancée Paulette Goddard to Ray Milland with a smile and the command: 'Be happy.' When not obligingly handing over his fiancées to 'better men', Patric Knowles could be found defending the British Raj in India (*Charge of the Light Brigade, Storm over Bengal, Flame of Calcutta, Khyber Patrol*). A likeable and good-looking actor, he recently returned to the screen, greying now but very distinguished, to show the flag in a trio of Andrew V. McLaglen films: as the British officer in command of a Hudson's Bay Company fort in *The Way West* (1967), as Lord Mountbatten in *The Devil's Brigade* (1968), and as the quiet, pipe-smoking English rancher, Henry Tunstall, who befriends Billy the Kid in *Chisum* (1970). Ian Hunter had played the part in David Miller's 1940 version of the story, *Billy the Kid*.

Ralph Forbes, appropriately enough, made his screen début in a British silent film version of Talbot Baines Reed's public school classic *The Fifth Form at St. Dominic's* (1921). What he learned at St Dominic's stood him in good stead later as he carved a niche for himself playing gentleman rankers in the Foreign Legion: *Beau Geste* (1926), *Beau Ideal* (1929) and *Legion of Missing Men* (1937). But he slipped from stardom with the coming of sound, unable to subdue completely a florid, large-scale style of acting more appropriate to the silent cinema. He continued, however, to wear period costume gracefully for another dozen years in supporting roles in historical dramas, ringing the changes to play, for instance, Lord Randolph in *Mary of Scotland* (1936), Lord Knollys in *Elizabeth and Essex* (1939) and the Duke of Buckingham in *The Three Musketeers* (1936).

These are examples enough to demonstrate how the Code has permeated films. The career profiles of these Hollywood British actors are enduring testimony to it. With the death of Aubrey Smith in 1948, the retirement of Ronald Colman the following year and the crisis in the film industry which signalled the end of Hollywood's Golden Era, the British colony began to split up. Some of its members died, some returned to the stage, others returned to Britain. Although a handful still survive, this colony, like so many others, is now a thing of the past.

Britain, ironically, produced no such body of actors filming regularly in Imperial themes. Perhaps this is because Hollywood regularly siphoned off much of the outstanding British talent in the thirties and forties. Perhaps it is because Britain was still living her myths and it was left to Hollywood, at a safe distance, to refine the elements of the myth and crystallize them in terms of theme and archetype. Actors like Leslie Banks, John Clements and Roger Livesey all turned in classic Imperial portraits but they hardly made a career out of doing so. It was really only in the post-Imperial age that the stiff-upper-lip service pictures showed a group of actors (including Richard Todd, Jack Hawkins and John Mills) spiritually and physically conforming to the archetype, maintaining the code of officers and gentlemen on land and sea and in the air.

It is true to say, in the cases of Todd and Hawkins for instance, that, comparatively speaking, their service pictures represent a small proportion of their acting roles. Richard Todd, when interviewed expresses irritation that people should assume that he has spent his career playing stiff-upper-lip officers, simply because he did so in *The Dam Busters* and *Yangtse Incident*. A quick look at his career profile reveals, on the contrary, a string of swashbuckling costume pictures in the early fifties (*Robin Hood, Rob Roy, The Sword and the Rose*) and a clutch of thrillers, notably Hitchcock's *Stage Fright*. But it is his service roles that have impressed themselves upon people's consciousness. That is what myth and archetype is all about. Todd is Wing Commander Guy Gibson and Lt Commander J. S. Kerans. The role finds the man and the man becomes the myth.

The same is true of Jack Hawkins. He had been around for years as a dependable supporting actor before finding stardom as Group Captain 'Tiger' Small in *Angels One Five* (George More O'Ferrall, 1951), a sort of *Dawn Patrol* of the Second World War. His

impact in this role, outwardly tough and authoritarian, inwardly decent and tender-hearted, combined with a craggy physical appearance which suggested total integrity and dedication, and his follow-up roles in *The Malta Story* (1953) and *The Cruel Sea* (1953) etched him indelibly into cinematic mythology. This is confirmed by an anecdote recalled by director Michael Powell.[10] When making *Battle of the River Plate*, Powell had to set up sea battles, foreign locations, Admiralty co-operation; and yet all 20th Century-Fox were interested in was 'Is Jack Hawkins going to play the Admiral?' This was the answer he got to every request for assistance that he sent them. Jack Hawkins's subsequent officer roles, in *The League of Gentlemen* (1960), *Bridge on the River Kwai* (1957) and *Lawrence of Arabia* (1962), for instance, showed him departing far from the conventional archetype. But he can never escape from the eternal cinematic role in which the public has cast him.

Still less of course can John Mills escape. He must be more at home in battle dress than any other British star with *In Which We Serve*, *Morning Departure*, *The Colditz Story*, *I Was Monty's Double*, *Above Us the Waves*, *Dunkirk*, *Ice Cold in Alex*, *The Valiant* to his credit. He too has sought escape in character parts, winning an Oscar for his performance as the village idiot in David Lean's *Ryan's Daughter* (1970). But his place in the cinematic mythology of the Forces is irrevocable.

These are all stars in the stiff-upper-lip service tradition, but there is one British star of the fifties who is a glorious throwback to the Golden Age of Empire – Anthony Steel. The perfect Imperial actor, born out of his time, blue-eyed, square-jawed, clean-cut, Steel managed to be around at the right time to be cast as Harry Feversham in the most recent remake of *The Four Feathers* (entitled *Storm Over the Nile*). He played a Police Inspector in Malaya during the troubles in *The Planter's Wife* (Ken Annakin, 1952), while his game-warden pictures, *Where no Vultures Fly* (1951) and *West of Zanzibar* (1954) set him in Africa shouldering the white man's burden. He also wore the King's uniform with distinction (*Albert R.N.*, *The Sea Shall Not Have Them* and *The Malta Story*) and was to be found protecting the person of Queen Victoria as a Guard's Officer in *The Mudlark*. Sadly, however, his career fizzled out in the late fifties after his abortive trip to Hollywood and his equally abortive marriage to Anita Ekberg. He has only been seen recently, looking understandably dispirited, in a couple of Italian pirate pictures and a handful of execrable British 'B' features, the most recent and most appalling being the Anglo-Czech co-production *Hell Is Empty* (1966), a sad end to an Imperial Career.

The inexorable influence of the archetype is demonstrated by the singular inability of actors who are officer and gentleman material to play N.C.O.s or rankers successfully. The failures in the careers of the Imperial actors emphasize this. Stewart Granger, elegant, sensitive, dashing, was a disaster as the chirpy Cockney private in *Soldiers Three* (1951). David Niven, debonair, poised, witty, was distinctly uncomfortable as the disgruntled intellectual corporal in *Guns of Navarone* (1959). Of Richard Todd's performance as a sergeant in *The Long and the Short and the Tall* (1960), Peter John Dyer wrote that he played it 'with the earnest dedication of a public school prefect slumming it on a farm in the hols'.[11]

The one exception to this failure to play a ranker convincingly is the 'gentleman ranker' and then we all know from the way he acts and speaks and bears himself that he is really an officer and gentleman down on his luck and that as soon as he can clear the family name, he will resume his commission and his place in the Quorn and Pytchley. The very concept of the role is based on the audience's presumed knowledge of the difference in the ways that an officer and a private will speak and behave.

Here then is the public school man immortalized on film; the man educated for 'leadership rather than citizenship', the man distinguished not so much for brains as for character, who can be depended on to do the right thing in a tight corner, lose gracefully and die well, if need be, for England, Home and Empire. The careers we have examined illustrate the characteristics of 'the Breed' in its classic form. Three

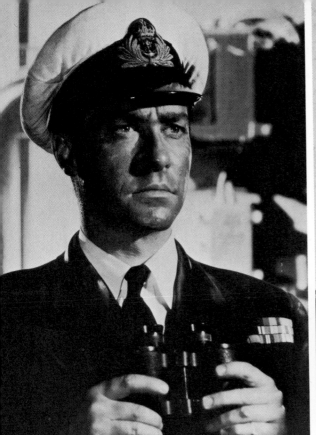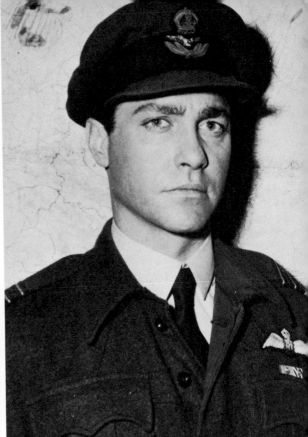

British service archetypes
45 (left) Richard Todd as Lt Cmdr Kerans in *Yangtse Incident*
46 (right) Richard Todd as Wing Cmdr Gibson in *The Dam Busters*

47 (opposite above) John Mills, more at home in battle dress than
any other British star, seen here in uniform for *Scott of the Antarctic*
48 (opposite below) Anthony Steel, last of the Imperial actors, in
Storm Over the Nile (with Mary Ure)

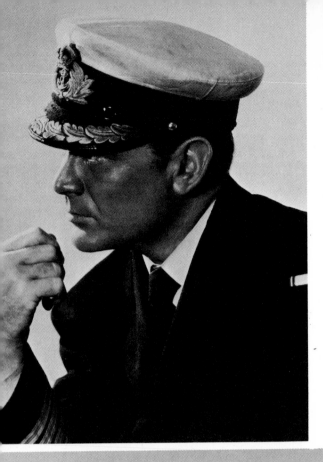

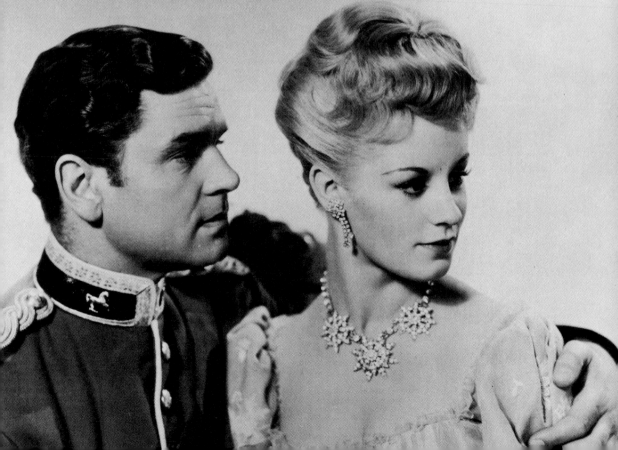

Archetype variations

49 (left) Variation 1: fresh-faced young subaltern Richard Cromwell in *Lives of a Bengal Lancer*

50 (below) Variation 2: the silly ass Nigel Bruce with Basil Rathbone in *The Hound of the Baskervilles*

51 (above right) Variation 3: the gentleman thief David Niven in *Raffles* (1939) (with Douglas Walton)

52 (below right) The courageous English memsahib Valerie Hobson defends Sabu in *The Drum*

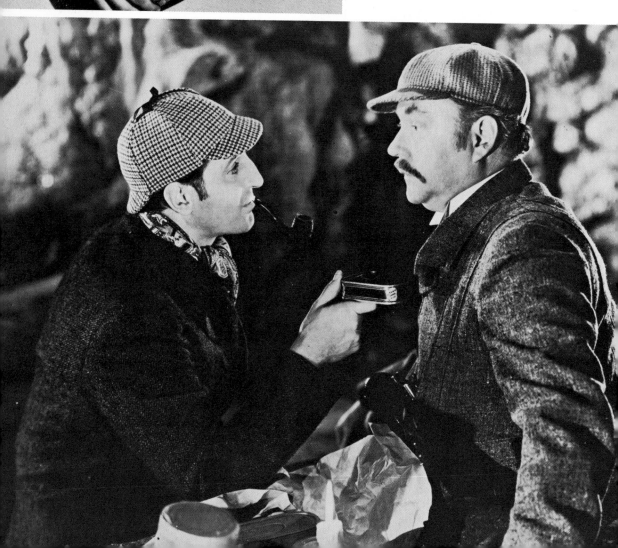

variations remain to be commented on, all of them inflections of the basic archetype.

There is the archetype in embryo. He is the fresh-faced, breathless 'I say, sir, jolly good show' subaltern, who will eventually mature into a responsible leader. David Niven's cinematic career, as we have noted, began with his playing subalterns in the late thirties and saw him making general by the late forties. Typical of the cinematic subalterns are John Lupton's Lt Jersey in *Rogues' March* (1952) ('I say, what luck, out of Sandhurst and into a jolly good scrap'), Hugh Williams's Frank Shelley in *One of our Aircraft is Missing* (1942) ('I say, what a wizard fire') and Hugh Burden's Sub-Lt Mickey Weatherby in *Ships with Wings* (1941) ('Gosh, sir, that's terrific').

Then there is the archetype in caricature. He is an exaggeration and formalization of some of the externals of the public school man, with the brainlessness accentuated to absurd proportions. He is, in fact, the 'silly ass', that hardy annual of literature, whose descent can be traced from P. G. Wodehouse's Bertie Wooster through Edgar Wallace's Bones to Frank Richards's Arthur Augustus D'Arcy and W. E. Johns's Lord Bertie Lissie. Invariably called Gussie, Bertie or Algy, he was incarnated on film notably by Ralph Lynn, Claude Hulbert and more recently, Ian Carmichael. A heartier version of the same species was Nigel Bruce, who played such diverse roles as Prince Rupert, Doctor Watson and Squire Trelawney in exactly the same manner, as a genial but empty-headed upper-class buffoon. The 'silly ass' was always surprised by anything that happened, talked without thinking and was so utterly guileless that one could not help liking him.

The third variation is the archetype gone wrong – the gentleman thief. The classic gentleman thief is E. W. Hornung's A. J. Raffles. Cool, determined, a master of disguise and a first-class cricketer, Raffles was created initially as a sort of joke reply to the more famous fictional creation of Hornung's brother-in-law, Conan Doyle. In fact, there is more than a passing resemblance between Doyle's story 'Charles Augustus Milverton' and Hornung's 'Wilful Murder'. In these stories, Hornung equates cricket with crime, just as Canon Rawnsley equated it with war. Raffles speaks of his crimes in cricketing parlance (having an innings, being bowled out, scoring points). He is very proud of his amateur status, both as cricketer and cracksman. He is annoyed when asked to a house party just for his cricket ('Nothing riles me more than being asked about for my cricket as tho' I were a pro myself'[12]) and in one story, 'Gentlemen and Players', he, the gentleman, is pitted against 'the players', the professional criminals, in a bid to steal Lady Melrose's necklace. But Raffles is a patriot. He steals a gold cup from the British Museum, simply as a challenge, and returns it to Queen Victoria as a jubilee present. ('We have been reigned over for sixty years by infinitely the finest monarch the world has ever seen. The world is taking the present opportunity of signifying the fact for all it is worth.'[13]) He drinks a toast to her health and his friend Bunny shakes his hand and calls him a sportsman. Bunny had been Raffles's fag at school and has graduated to being his partner in crime. However, Raffles expiates it all by dying for Queen and country in the Boer War.

The gentleman crook maintains a code of honour, which reflects his breeding. He abhors violence, robs only the rich and is in it for the sport as much as for the money. Once he has chosen his path, however, there is no going back. He must follow it to the bitter end. In the words of 'Sapper': 'For in his own peculiar code, a very worthless sinner must remain a very worthless sinner to the end – and he must run the course alone.'[14]

This means no romantic involvement. It would not be fair. Thus, in *The Unholy Garden*, Barrington Hunt (Ronald Colman), gentleman thief, takes refuge in a North African oasis of thieves. He is persuaded to romance the grand-daughter of an elderly embezzler to find out where his money is hidden. But he falls in love with the girl and when her uncle comes looking for her, he renounces both the money and her, because he does not want her to spend her life tied to a criminal.

Similarly in Harold French's engaging fog-and-gaslight thriller *The Hour of 13* (1953), based on Philip Macdonald's novel, Nicholas Revel, gentleman thief (Peter Lawford), helps the police to trap an insane murderer, 'The Terror', and courts the Police Commissioner's daughter, but gives her up in the end because of his way of life.

Raffles inevitably earned cinematization and almost equally inevitably was played, to perfection, by Ronald Colman in 1930 and by David Niven in the 1939 re-make. Based on three of the short stories, 'The Ides of March', 'Gentlemen and Players' and 'The Return Match', the film also adds a love interest. Raffles is in love with Bunny's sister, Lady Gwen (Kay Francis in 1930, Olivia de Havilland in 1939) and plans to give up crime at the outset of the film. But Bunny is so desperate for money to pay his gambling debts that he contemplates suicide until Raffles agrees to do one last job to save him. He steals Lady Melrose's diamonds and escapes with the police on his trail. It looks like the end for Raffles but he outwits the police by returning the jewels to Lord Melrose, who agrees to hush up the affair to avoid scandal. Raffles and Gwen are united. The re-make, in a more moral climate, insisted on a retributive ending. So, in 1939, Raffles gives Bunny the necklace, to return and claim the reward, and he then gives himself up to the police, consoled by Gwen's promise to wait for him.

The ladies have received short shrift in this study, and that reflects their role in the cinema of Empire. There is no great body of Imperial actresses, simply because there was no future in it. The Imperial lady was required to devote herself to her husband and efface herself, just like the wife in the service pictures. No actress could possibly make a career out of consistently playing submissive roles. There are notable Imperial ladies, but they are generally once-and-for-all performances: Valerie Hobson in *The Drum*, Ursula Jeans in *Northwest Frontier* and Diana Wynyard in *Cavalcade*. Otherwise, the memorable Imperial ladies are the elderly ones, those spirited, no-nonsense, umbrella-wielding memsahibs, whose Imperial days are done but who retain that strength of character which saw them through them. Pre-eminent among this select group are Dame May Whitty for the thirties and forties and the irreplaceable and sadly missed Dame Gladys Cooper for the fifties and sixties.

The woman's place in Imperial films was incontestably in the home, unless she was Queen Victoria, in which case it was on the throne. But even she was put firmly in her place by her husband. In *Victoria the Great* (1937), Prince Albert (Anton Walbrook), tired of Victoria's relegation of him to a subordinate role, asserts the husband's prerogative and locks Victoria (Anna Neagle) out of his apartments. She beats on the door angrily:

Albert Who's there?
Victoria The Queen.
 No answer. She knocks again.
Albert Who's there?
Victoria Victoria.
 No answer. She knocks again.
Albert Who's there?
Victoria (submissively) Your wife, Albert.
 Albert opens the door and lets her in.

That is how it was in the cinema of Empire.

Notes

1 R. J. Minney, *Hollywood by Starlight* (1935), pp. 117–18.
2 Alistair Cooke, *Garbo and the Night Watchmen* (1971), p. 130.
3 For a sketch of the British Colony see David Niven, *The Moon's a Balloon* (1971), pp. 165–6.
4 Joe Franklin, *Classics of the Silent Screen* (1959), p. 148.

5 Boris Karloff, greatest of all the horror-fantasy actors, was as English as it was possible to be. Off screen, a retiring, pipe-smoking, cricket-playing gentleman, he was born William Henry Pratt in Dulwich in 1887, his father being in the Indian Civil Service.
6 Sir Cedric Hardwicke, *A Victorian in Orbit* (1961), p. 204.

7 Cecil B. DeMille, *Autobiography* (1960), p. 361.
8 Kevin Brownlow, *The Parade's Gone By* (1968), p. 448.
9 *The Times*, 19 June 1967.
10 Kevin Gough-Yates, *Michael Powell* (1970), p. 11.
11 *Monthly Film Bulletin*, April 1961, p. 44.
12 E. W. Hornung, *Raffles* (1960), p. 49.
13 Ibid., p. 177.
14 'Sapper', *The Dinner Club*, p. 191.

The Importance of Being English

An empire so scattered and so diversified needed linking factors and one of the most important of these was the very Englishness of its rulers. Englishness was a religion, whose credo involved knowing your place at home and keeping to it, conducting yourself properly abroad and acting always in accordance with the tenets of the Code. To be English, as Ogden Nash once remarked, was to belong to the most exclusive club in the world. It was a club whose members, from the highest to the lowest, saw themselves as an elect, set apart from other men by virtue of their Imperial mission. James Morris has noted the badges of club membership:[1]

> There were tastes and taboos so pungently British that the whole world knew them and expected them to be honoured. *The Times*, the club, leaving the gentlemen to their cigars, the stiff upper lip, hunting halloos at midnight by tight young subalterns on guest nights, bacon and eggs, walking round the deck a hundred times each morning, cricket, 'Abide with Me' – all these were Imperial emblems, symbols of Britishness, parodied and envied everywhere.

He has put his finger on the paradox here. For underlying the many parodies there is so often, one feels, both envy and a grudging admiration.

The English abroad

For the British their island home was the centre of the world. Witness, for instance, the oft-quoted cod newspaper headline: 'Fog in channel. Continent cut off.' Or the fre-quent dialogue exchange in films:

> *Customs Officer* Are you foreign?
> *Englishman* No, I am English.

Even in other countries, the Englishman is never foreign. A little scene in *Goodbye, Mr. Chips* (1939) sums up the attitude perfectly:

> [Blériot has just flown the Channel.]
> *First schoolboy* Did you see some French chap's just flown the Channel?
> *Second schoolboy* What cheek!

The British never altered their very British way of doing things simply because they happened to be in some other part of the globe. They would dress for dinner in the middle of the jungle or the desert or on a tropic isle; and (to the astonishment of the natives) they would defiantly go out in the mid-day sun, when only mad dogs customarily stirred.

The simple result was that everyone thought that they were mad. Many believed, with Kipling, that 'Allah created the English mad – maddest of all mankind.' The English were frequently mocked and parodied, but never more completely or brilliantly than by Jules Verne, who disliked them intensely and who, out of his dislike, created the perfect fictional Englishman Phileas Fogg, hero of *Around the World in 80 Days*.

Fogg embodies all those English characteristics which impressed themselves most forcibly upon the foreigner. Even his name was redolent of Victorian London. Verne describes him thus:[2]

> Calm and phlegmatic with a clear eye,
> Mr. Fogg seemed a perfect type of the
> English composure which Angelica
> Kauffmann has so skilfully represented on

canvas. Seen in the various phases of his daily life, he gave the idea of being perfectly well-balanced, as exactly regulated as a Leroy chronometer. Phileas Fogg was, indeed, exactitude personified.

He was so exact that he was never in a hurry, was always ready and was economical alike of his steps and his motions . . . he made no superfluous gestures and was never seen to be moved or agitated. He was the most deliberate person in the world . . . He lived alone and, so to speak, outside every social relation. His sole passions were reading the papers and playing whist.

There you have it, in a nutshell: cold, precise, unemotional, anti-intellectual – the continental's idea of the English gent.

Even better, though much less well-known, is Verne's merciless parody of the two British officers, Colonel Heneage Finch Murphy and Major Sir John Temple Oliphant, in *Hector Servadac*. We first meet them, not surprisingly, playing chess:[3]

Remarkably similar in personal appearance, they were hardly less so in personal character. Both of them were about forty years of age: both of them were tall and fair with bushy whiskers and moustaches: both of them were phlegmatic in temperament and both much addicted to the wearing of their uniforms. They were proud of their nationality and exhibited a manifest dislike, verging on contempt, of everything foreign. Probably, they would have felt no surprise if they had been told that the Anglo-Saxons were fashioned out of some specific clay, the properties of which surpassed the investigation of chemical analysis. Without any intentional disparagement, they might in a certain way be compared to two scarecrows which, though perfectly harmless in themselves, inspire some measure of respect and are excellently adapted to protect the territory entrusted to their care.

These two worthies are on Gibraltar, when a chunk of the Earth is flung out into space to form a new planet and part of their colony is devastated, leaving only thirteen men out of an original garrison of 2,000. Their reaction to this cosmic event is typical.

But the transformation, though it had been marvellous, it cannot be said that either Colonel Murphy or Major Oliphant had made much demonstration of astonishment.

'This is all very peculiar, Sir John,' observed the colonel.

'Yes, colonel, very peculiar,' replied the major.

'England will be sure to send for us,' said one officer.

'No doubt she will,' answered the other.

Accordingly they came to the mutual resolution that they would stick to their posts.

With that they resume their game of chess. Verne has noted what the films were later to stress, that Imperialists look the same as well as just acting the same.

Verne's classic account of the Englishman abroad, *Around the World in 80 Days*, was brought to the screen in 1956 by master showman Mike Todd. Aside from Michael Anderson's anonymous direction and the obligatory 'travelogue' inserts, it is a wholly satisfying *hommage* to the foreigner's picture of the English archetype. Veteran humorist S. J. Perelman collaborated on the script to supplement Verne's wit. David Niven, accompanied on the sound track by the inevitable 'Rule Britannia', is perfectly cast as Phileas Fogg, cool, correct, aloof, running his life by his pocket watch, firmly clutching his umbrella, and having one eyebrow permanently raised.

Fogg accepts a half-joking wager by fellow members of the Reform Club to prove his claim that it is possible to travel around the world in eighty days, saying icily: 'An Englishman never jokes about a wager.' Having dismissed his valet (John Gielgud) for making his toast one degree too hot, he engages from an employment agency (run by Noël Coward) a volatile Frenchman,

Passepartout (Cantinflas), and sets off on his journey. His daily routine never varies for an instant. On a boiling hot day in the middle of the Indian Ocean, when the steward suggests a light lunch, Fogg replies that he will have the same lunch he always takes on that day of the week: Brown Windsor soup, beef steak and kidney pie, roly-poly pudding, Stilton and port.

Similarly there is a marvellous little scene showing Fogg sitting on deck on a sunny day, playing whist and being brought tea by his steward. The next scene is exactly the same, but takes place in the midst of a raging storm. Once again Fogg sits calmly playing whist with his top hat tied on his head, and the steward is blown against the side of the ship as he staggers on with the tea tray. In Japan, Fogg marches into a theatre and asks in English for two orchestra stalls. The only time he ever displays any animation is when discussing whist, which he plays throughout the trip, completely ignoring the scenery. He has no interest whatever in seeing the sights. He displays no emotion and is embarrassed when others do so. When Princess Aouda (Shirley MacLaine) thanks him effusively for rescuing her, he suggests a walk on the verandah and a glass of lemonade – in the hope of cooling her ardour. When arrested by detective Fix (Robert Newton) and faced with the loss of his wager and all his money, the greatest insult he can muster is to tell Fix that he does not play a good game of whist.

Once in India, the film provides the opportunity for a nostalgic reunion of all the old Imperial actors, greyer than of yore but with vitality undimmed. There is Reginald Denny as a police inspector in Bombay to whom Fix applies for a warrant to arrest Fogg. But the proceedings are interrupted when the clock strikes four. The inspector calls a halt for tea. 'But this is important,' protests Fix. 'Nothing is more important than tea, dash it all,' replies the inspector. Ronald Colman turns up as an official of the Indian Peninsular Railway, to whom Fogg complains when the railway line stops fifty miles short of its published destination.

Fogg But the newspapers said that the railroad was complete.

Colman That must have been the *Daily Telegraph*. You would never have read that in *The Times*.

Cedric Hardwicke appears as the Blimpish general Sir Francis Cromarty, who works out a brilliant ploy whereby he and Fogg can rescue the captive Aouda but admits ruefully: 'There's only one problem. It only works with seventy-five men.' Fogg tackles every obstacle in his path with aplomb, resorts to every means of transport available from balloon to elephant without turning a hair, and arrives back just as the clock is striking the hour for the completion of the eighty days.

The success of *Around the World* prompted several imitations, the most successful of which were probably *Journey to the Centre of the Earth* (Henry Levin, 1959) and *Five Weeks in a Balloon* (Irwin Allen, 1962). In the former, Sir Oliver Lindenbrook (James Mason), absent-minded Scottish professor, leads an expedition to the centre of the Earth, accompanied by his star pupil (Pat Boone), a resourceful no-nonsense baroness (Arlene Dahl) and a duck-loving Icelandic giant (Peter Ronson). They face dinosaurs, shipwreck, eruption and the discovery of Atlantis with commendable equanimity, stopping to make tea whenever things become too trying. In the latter, another Scottish professor, Samuel Fergusson (Cedric Hardwicke), accompanied by yet another star pupil, an improbably glamorous and resolutely 1960s-looking Canadian (played by the pop singer, Fabian), sets out to explore Central Africa by balloon. He is entrusted by the Prime Minister (Herbert Marshall) with the task of planting the British flag on a disputed territory before slavers can get there and raise a flag of convenience. The British Government is represented by Sir Henry Vining (Richard Haydn), monocled, clutching a teapot and threatening to write to *The Times* in moments of dire peril.

The superb screen adaptation of H. G. Wells's *First Men in the Moon* (Nathan Juran, 1964) is done in similar vein. It begins with

The English abroad

53 (below) The Englishman's Englishman Phileas Fogg (David
Niven) complaining about the Indian Railway Service to Ronald
Colman. Cedric Hardwicke and Cantinflas look on (*Around the
World in 80 Days*)
54 (right) Richard Haydn and Cedric Hardwicke plan to fly across
Africa by balloon (*Five Weeks in a Balloon*)
55 (below right) Kenneth More prepares to deal with the Indian
problem in *The Sheriff of Fractured Jaw*

one of the finest opening sequences in all cinema. It is the present. A United Nations expedition reaches the Moon. The first man steps out. The world goes wild with jubilation. Then the spacemen discover a Union Jack and a tattered paper claiming the Moon in the name of Queen Victoria as part of the British Empire. Then, in flashback, we see the expedition which made the claim, headed by the enthusiastic eccentric, Professor Cavor (Lionel Jeffries), whose first exclamation on landing is the highly appropriate: 'How ... Imperial!' He is accompanied by Arnold Bedford (Edward Judd), a failed businessman with an eye to a quick profit who wants the mineral rights on the Moon, and his American fiancée, Kate Callender (Martha Hyer), who insists on packing for the expedition an elephant gun, a supply of gin and bitters and some chickens to provide fresh eggs.

What all these films have in common is the unemotional, matter-of-fact way the Victorians tackle exploration. They assume that the Earth (and the Moon as well, come to that) belong, in some mystic way, to them and they only have to stroll along and plant a flag in order to claim it. They do not alter their way of living and they are unperturbed by disaster.

Alfred Hitchcock's *The Lady Vanishes* also lightheartedly examined the conduct of the English abroad. Most of the action takes place on a train crossing the central European country of Bandrika. Among its passengers are a couple of Englishmen, Charters and Caldicott (unforgettably played by Basil Radford and Naunton Wayne), who are hastening back to England for the Test Match. Cricket forms their sole topic of conversation. They had missed an earlier train because Charters had insisted on standing for twenty minutes for Liszt's Hungarian Rhapsody under the mistaken impression that it was the Hungarian National Anthem. When the train is stranded by an avalanche and they have to spend the night in a crowded hotel, they do not get any dinner because they spend so long dressing for dinner that when they get down everything has been eaten. They complain con-

stantly about the food and the accommodation.

The other English travellers are equally eccentric. They include Miss Froy (Dame May Whitty), the tweedy governess with her personal supply of herbal tea, who is in fact a British secret agent, and Gilbert (Michael Redgrave), a feckless musicologist who is writing a book on Bandrikan folk music. But when the chips are down, they all come through with flying colours. The restaurant car is uncoupled and besieged by the secret police, who are after Miss Froy. The only people in the car are the English passengers. Why? Because it is tea-time. Gilbert takes charge and organizes the defence and both Charters and Caldicott acquit themselves courageously. They manage to escape and the master spy Egon Hartz (Paul Lukas) concedes defeat as they steam away: 'As they say in English, jolly good luck to them.' He was a sportsman after all.

Yet another archetypal Englishman abroad is Jonathan Tibbs (Kenneth More), the English gun salesman, who arrives in the Wild West and gets himself appointed as Sheriff of Fractured Jaw in Raoul Walsh's 1958 film of that name. The film owes less to its veteran director, who obviously was not happy with the idea of sending up the Old West (and was saddled with a cosmically talentless leading lady in Jayne Mansfield) than to Kenneth More, who ad-libbed freely and improvised much of his dialogue, with hilarious results. When the stagecoach he is travelling in is attacked by Indians, Tibbs, clutching his umbrella, gets out; walks up the hill, to the strains of 'Rule Britannia'; calmly disarms the Indian chief, telling him to stop this disgraceful behaviour and 'trot along home, there's a good chap'; and resumes his journey, remarking that his grandfather had done something similar in Karachi once. Arriving in town, he checks in at the saloon and asks if they could manage a pot of tea and a plate of chicken sandwiches. He moves into his room but is disturbed by the noise. Asking if there is anywhere quieter, is told 'Boot hill' and replies: 'Then have my things moved there immediately.' His attempts to sell a fowling piece

to a dirty, food-guzzling squatter are a sheer delight. He informs him with commendable hauteur that the gun may be antiquated but it is better to shoot unarmed, defenceless birds than each other. His impeccable manners, his tea-drinking and his quietly foolhardy courage win through in the end. He stops a range war, is adopted by an Indian tribe and – though this can hardly be termed a success – marries Jayne Mansfield. The film ends with Tibbs settling down to his job of sheriff, attended by his latest acquisition – a perfectly trained Red Indian butler. As the Mayor of Fractured Jaw comments: 'The good Lord protects fools and Englishmen.'

One of the most decidedly un-English events of all is revolution. The British have a horror of it. They regard their own seventeenth-century revolution as a temporary aberration and all other revolutions as having been recklessly embarked upon by irresponsible foreigners. Foreigners are generally irresponsible when they are not being either sinister or comic. The rule is that they should be ignored unless they become too annoying, in which case they should be put very firmly in their place.

Whatever happens, however, the British, caught up in such unpleasantnesses, do not flap. When in *British Agent* (Michael Curtiz, 1935), there is rioting in the streets of St Petersburg in 1917 and bullets shatter the windows of the British Embassy during a ball, the Ambassador simply orders the orchestra to play louder and discusses last year's Derby. *Knight Without Armour* (Jacques Feyder, 1936) contains alternate scenes showing the Reds machine-gunning the Whites when they are on top in revolutionary Russia and the Whites machine-gunning the Reds when they have the upper hand. The message comes through clearly – how ghastly it is to be Russian and how much better to be Robert Donat, British, dashing, reciting Browning to Marlene Dietrich in a railway carriage and running rings round the Russkies.

An object lesson in keeping your head when all about you are losing theirs is provided by Sir Arthur Robertson, the British Minister in Peking (David Niven), in one of the last great films of Empire, *55 Days at Peking* (Nicholas Ray, 1962). Basically a late extra on the Yellow Peril, it reconstructs the siege of the Foreign Legations during the Boxer Rebellion in China in 1900. Although it involves representatives of all the 'civilized' (i.e. Western) nations (France, Italy, Germany, Russia, the United States) in the defence of 'Civilization', it emerges as a tribute to the British Imperial spirit. For when the crisis comes, the foreign envoys plan to leave Peking – all, that is, except for Sir Arthur. He announces that whatever the other nations decide to do, Britain will stay. So the others have to stay as well, for fear of losing face.

Sir Arthur keeps his head superbly while all about him are losing theirs, literally and figuratively. He has that serenity which causes the German envoy to observe admiringly: 'I like Sir Arthur. He always gives me the impression that God must be an Englishman.' Sir Arthur's philosophy is a simple one. 'If it would help to become excited, I'd gladly oblige but I think that all of us need to keep our heads,' he says. The nominal hero of the film, tough, cigar-chewing American Major of Marines Matt Lewis (Charlton Heston), starts out by disliking Sir Arthur as a 'stuffed shirt' but ends by admiring him as a gentleman and a hero. There is a superb scene in which Sir Arthur strolls nonchalantly through a fearsome mob of howling Boxers, after he has been to the Imperial palace to protest about Boxer outrages to the Dowager Empress (Flora Robson). The camera pulls back to show the tiny, isolated figure of Sir Arthur striding on through a sea of yellow bodies. Later, he coolly defies the attempts of the Boxer leader Prince Tuan (strikingly played by Robert Helpmann) to frighten him at Queen Victoria's Birthday Ball. Tuan could not possibly succeed with the Great White Mother blessing her representative and conferring her divine protection on him. Sir Arthur naturally continues to dress for dinner during the siege and even participates in a raid to destroy an ammo dump. Relief comes eventually and vindicates Sir Arthur's

stand. The Boxers are broken. Civilization has repelled the Yellow Peril again.

The French Revolution has come in for a great deal of criticism and the spirit of Baroness Orczy hovers over it still. French aristocrats die gracefully at the hands of the brutish, drink-crazed mob, unless rescued from Madame Guillotine by a resourceful Englishman. The classic version of this highly romantic and nationally self-satisfying British interpretation of the Revolution is *The Scarlet Pimpernel* (Harold Young, 1935). The film stars Leslie Howard as Sir Percy Blakeney, outwardly a languid, effete fop but secretly the dashing, daring Scarlet Pimpernel. The character is a living embodiment of the innate superiority of the English. He deliciously sends up the sinister, saturnine Citizen Chauvelin (Raymond Massey) ('Devilish clever, the French, how they speak that unspeakable language of theirs, I will never know'); and also teaches him how to tie his cravat. Chauvelin is not a gentleman and therefore does not know how to do it. Trapped at the end by Chauvelin, Sir Percy recites John of Gaunt's 'This England' speech from *Richard II* before effortlessly outwitting him again to escape and join his wife (Merle Oberon). The ship sails. Arm in arm, the Blakeneys gaze through the mist. Suddenly the watch cries: 'Land ahoy' and Percy says: 'Look, Marguerite, England.' The final music swells as our hero comes home, having proved yet again that even a sinister foreigner is no match for an Englishman.

Sir Percy was, of course, far too great an Englishman to vanish from the cinema screen after only one appearance and he returned, played by Barry K. Barnes, for a sequel, *The Return of the Scarlet Pimpernel* (Hans Schwartz, 1938) and, played by David Niven, for a re-make, *The Elusive Pimpernel* (Michael Powell, 1950). However, his greatest re-incarnation was in a modernized version, directed by and starring Leslie Howard: *Pimpernel Smith* (1941).[4] Gentle, witty and very English, this superb film had Howard as a vague, absent-minded Cambridge professor who rescues prisoners from Nazi Germany and smuggles them back to England. Like the French revolutionaries pitted against Sir Percy Blakeney, the Nazi officers pitted against Professor Horatio Smith are cruel and, what is even more unforgivable, humourless. There is a priceless scene in *Pimpernel Smith* in which Von Graum (Francis L. Sullivan) investigates, with typical Teutonic thoroughness, what he regards as the English secret weapon – their sense of humour. He ploughs through Edward Lear, Lewis Carroll, P. G. Wodehouse and *Punch*, reading bits out to his mystified staff. Finding it all utterly unfunny, he comes to the conclusion that the British sense of humour is a myth. This proves to be his downfall, of course, for although he captures Smith at the end, Smith slips through his fingers even as he lectures him on the greatness of the Herrenvolk.

The English at home

Just as important as behaving correctly abroad was behaving correctly at home, and that meant knowing your class, your place, your station in life. The English have always mistrusted change and as Disraeli says in *The Mudlark* are 'a proud and independent people, who will not yield to improvement without a struggle'. The upsurge of revolution in the eighteenth and nineteenth centuries served in the long run only to strengthen the *status quo* at home. The aristocracy, who had ruled throughout the eighteen century, responded to industrialization by widening the circle of power to admit the upper middle classes. But the public schools saw to it that the new powers were turned out with the same accents and attitudes as the old.

Society was rigidly hierarchic. Though divided basically into rulers and ruled, it was further subdivided within those two general categories. There was a servants' hierarchy every bit as rigid as the masters' and, if anything, it clung even more tenaciously to the *status quo*. The cinema's depiction of this situation is epitomized by Ernst Lubitsch's deliciously witty trifle *Angel* (1937). Set in the higher echelons of

Keeping your head

56 (above) David Niven
defies the might of
Imperial China in
55 Days at Peking
57 (centre) The English
tourists fight off the
secret police from the
restaurant car in *The
Lady Vanishes*
Naunton Wayne, Cecil
Parker, Linden Travers,
Basil Radford, Dame
May Whitty, Margaret
Lockwood, Michael
Redgrave
58 (below) Leslie
Howard effortlessly
outwitting the Nazis in
Pimpernel Smith

British Society (the Opera, Ascot, Country House weekends), it is basically a very civilized triangle romance between over-worked British diplomat Sir Frederick Barker (Herbert Marshall), his neglected wife Maria (Marlene Dietrich), and debonair man-about-town Anthony Halton (Melvyn Douglas). But Lubitsch, whose cinematic role seems to have been, in retrospect, to convey to the intrigued American bourgeoisie a taste of life in European high society, took time out to explore the world below stairs. In so doing, he created perfect archetypes of the perfect servant as he was to appear in countless British and American films: a man, who, far from feeling oppressed by the hierarchic system in which he finds himself, actually fervently supports it. There is Wilton the butler (Ernest Cossart), efficient, respectful, devoted to 'the family' and Conservative. He takes great pride in his work and knows his place. His attitude is summed up by his comment on another servant: '"That's John, Lord Aldegate's valet for twenty years. But it didn't last. Their political views differed. He left his Lordship when his Lordship joined the Labour Party."' This looks forward to the situation in *The Chiltern Hundreds* (John Paddy Carstairs, 1949), the film of William Douglas-Home's play, in which the family butler stands as Conservative candidate for parliament when his Lordship stands for Labour.

There is also, in *Angel*, Graham the valet (Edward Everett Horton), who knows his place and also knows everyone else's and expects them to act accordingly. He is suitably contemptuous of foreigners who have no real idea of class. He recounts with astonishment that the French delegate in Geneva had no valet and that the Russians turned up, much to his surprise, actually attired correctly for dinner.

J. M. Barrie's delightful fantasy-satire *The Admirable Crichton*, filmed in 1957 by Lewis Gilbert, took up the same themes. It opens in 1905 with Lord Loam (the inimitable Cecil Parker) proclaiming to the butler, Crichton (Kenneth More), that he is going to give a tea for the servants, served by his daughters. Crichton is appalled. He objects to being treated as an equal. Below stairs he is king; and this tea will involve him rubbing shoulders with the most inferior servants, a thing he has no desire to do. One boy actually dares to address him as 'Crichton' instead of 'Mr Crichton' and is instantly dismissed. The tea party is hilarious. Everyone is acutely embarrassed and the Tweeny (Diane Cilento) has no idea what to say when asked by one of the gentlemen: 'What's the weather like in the kitchen?'

The party breaks up in disorder, however, when news arrives that one of Lord Loam's daughters has been arrested for participating in a suffragette demonstration. The family go on a cruise to wait for the scandal to die down, the ship sinks and the family, Crichton and Eliza the Tweeny are cast ashore on a desert island. Initially, the hierarchy is preserved. When Crichton swims over to the lifeboat containing the family, he is told: 'You should be in the staff boat' and replies: 'I'm very sorry, my lord, shall I withdraw?' Once on the island, they dress for dinner and dine with candelabra, silver and spotless napery on diced coconut. But eventually, the family proves totally incapable of surviving; Crichton emerges as the natural leader and within a short time has become Governor, with Lord Loam as his valet. After several years, a rescue ship is sighted. Crichton declares: 'No man can fight civilization' and appears on the beach in his butler's outfit to serve drinks to the rescuers. Civilization then is seen to equal the hierarchic society, and it triumphs in the end. The spell on the island was simply wish-fulfilment.

Perhaps the film which most perfectly captures class attitudes on film is Frank Lloyd's film of Noël Coward's play *Cavalcade*. The *Observer* described it as 'the best British film that has ever been made – and it was made in America.'[5] James Agate called it 'a grand film in all its aspects'.[6] It remains to this day one of the greatest films ever to come out of Hollywood, completely faithful to its origins and flawless in photography, settings and atmosphere. It is an almost unbelievable re-creation, on the Fox Studios sounds-stages, of England in the first thirty

The English view of revolutions is summarized by *The Scarlet Pimpernel*.

59 (above) Elegant English aristo Leslie Howard mercilessly sends up humourless French revolutionary Raymond Massey

60 (right) 'Look Marguerite . . . England': the memorable last scene of the film. Leslie Howard and Merle Oberon

years of this century – Trafalgar Square, St Paul's, the East End, the sea-side, all specially built for the occasion. There is an entirely British cast, including several from C. B. Cochran's Drury Lane production: Una O'Connor, Merle Tottenham, Irene Browne. The entire stage production was, in fact, photographed by Movietone News and shipped to Hollywood for reference; and the American Frank Borzage, originally scheduled to direct, was replaced by British-born Frank Lloyd.

Subtitled: 'The story of a home and a family', the film opens on New Year's Eve, 1899. Lloyd intercuts: above stairs, Robert Marryot (Clive Brook) and his wife, Jane (Diana Wynyard), quietly celebrate the birth of the new century and below stairs, the servants do so rather more noisily, notably the Bridges, Alfred (Herbert Mundin) and his wife, Ellen (Una O'Connor). Both couples are apprehensive about what the new century will bring, particularly since both Robert and Alfred are off to the Boer War. 'Why does there have to be a war?' asks Ellen. 'We have to have wars now and then just to prove we're top dogs,' replies her husband.

A succession of extremely moving scenes follows. First, as Robert, now an officer, and Alfred, a private, sail for South Africa, there is a marvellous staccato Cowardian farewell ('I'm going to kiss you and then I want you to turn away.') Jane tells Robert that Bridges will look after him. So the relationship of master and servant will be preserved even at war. Ellen and Jane comfort each other as the ship sails away, with the soldiers on deck linking arms and singing 'Auld Lang Syne'. News of the relief of Mafeking, the return of the troops and, soon after, the death of the old Queen, are all charged with genuine emotion and handled with great sensitivity. The servants are just as much upset by the Queen's death as their betters. They weep, make a pot of tea and Alfred comments: 'England won't seem the same without the Queen.' The family and the servants, dressed in black, stand on the balcony to watch the funeral procession, in which Robert, who has won the Victoria Cross, is riding.

Robert is knighted. The Bridges leave service and take a pub in the East End. But Alf takes to drink and is eventually run over by a fire engine. A visit by Jane and her eldest son, Edward (John Warburton), now at Oxford, to the Bridges, is greeted with embarrassment on both sides because of Alf's drunkenness, patronizingly overlooked by Jane. Edward Marryot marries but he and his bride are drowned on the maiden voyage of the *Titanic*. Then in 1914, war.

The Marryots return suddenly from abroad. ('Why does one go abroad – you're miserable when you're away and you return to this: no servants and no food.') Joey (Frank Lawton), the younger Marryot son, is eager to join the army and thinks it is a great adventure. Both father and son join up and, during the war, Joey falls in love with Fanny Bridges (Ursula Jeans), daughter of Alf and Ellen and now a rising stage star. In 1918, Ellen, having discovered about the affair, calls on Jane. She is aggressive and insinuating and insists that Joey marries Fanny. Jane says that the children must decide for themselves. A telegram arrives. Jane reads it and announces in a dead voice: 'You needn't worry about Fanny and Joe any more, Ellen. He won't be able to come back at all, because he's dead.'

1918, Armistice Day. Then a montage of sequences: disabled soldiers, politicians calling for disarmament, generals discussing poison gas, a speaker declaring that God is dead, a cleric preaching to an empty church, an agitator advocating revolution in Trafalgar Square, a wild party at which Fanny Bridges sings 'Twentieth Century Blues'. The film reaches its climax with the unforgettable scene in which Robert and Jane, now silver-haired, toast the New Year on New Year's Eve, 1933 and Jane delivers what is unquestionably one of Coward's finest speeches:

'Let us drink to the future of England. Let us couple the future of England with the past of England. The glories and victories and triumphs that are over, and the sorrows that are over too. Let's drink to our sons who made part of the pattern,

and to our hearts that died with them. Let's drink to the spirit of gallantry and courage that made a strange heaven out of unbelievable hell, and let's drink to the hope that one day this country of ours, which we love so much, will find Dignity and Greatness and Peace again.'

They step out on to the balcony as the crowds sing 'Auld Lang Syne' and they kiss. The National Anthem plays and the camera pans up to the cross gleaming on top of St Paul's, a symbol of hope for the years that are to come.

The *Observer* remarked that *Cavalcade* evaded any real constructive issue but was 'so close to the emotional memories of every British man and woman that it must sweep British audiences off their feet wherever it is shown'. This is the key to an understanding of the enduring appeal of this film and the whole school of *Cavalcade* type movies that it sired. They evoke an emotional response by drawing on the nation's experiences in victory and defeat, joy and loss, and weaving them into the tapestry of myth. For there is no denying that *Cavalcade* is totally absorbing and totally compelling, a family saga in which the nation's tragedies (the war, the death of the Queen, the sinking of the *Titanic*) become personal tragedies.

But it is more than just the story of a family; it is also the story of thirty-three years of England and of change. The raw material of the film is nostalgia. The Boer War and the death of the Old Queen are seen as the end of an era, a century of security and self-confidence, in which we truly were 'top dogs' and everyone knew his place. The First World War is the watershed and its effects are observed at the end. But already the Bridges have left service. Alf takes to drink and is run over and Ellen becomes a vulgar, snobbish parvenu, who presumes to speak to her former employer on equal terms, thus decisively ending their friendship. The undoubted implication of the film is that they would have been much better off remaining in service. Just as the Bridges lose their place and their dignity, so too does the Age. The World War carries off the flower of England's manhood. Religion dies, discontent rises, immorality is rife. Is it the end for the British Empire? Robert and Jane, in spite of losing both their sons, believe that it is not and they drink to England's future with hope, putting into words the mood of quiet patriotism, abiding love and optimism for the future that has shone through their performances throughout.

The Marryots are the perfect idealizations of the upper classes, incarnating a fundamental decency and unspoken feeling of *noblesse oblige* that make it impossible for us not to like them. While the servants, cheerfully cockney, unthinkingly patriotic and inveterately tea-drinking, represent the stereotypes at the other end of the scale, as likeable in their own way as their masters. The performances of the cast are quite faultless, but one must single out for praise Clive Brook and Diana Wynyard, who could not be bettered, and dear Frank Lawton, who, as Joey, projects indelibly the bright-eyed innocence and freshness and eager hope of Youth, so soon to be tragically crushed by war, a quality which Lawton was to bring to his two other unforgettable classic performances in *David Copperfield* (George Cukor, 1935) and *Mill on the Floss* (Tim Whelan, 1937).

The image of England

It was as always Hollywood, the dream factory, which created for ever a completely stylized and mythic England, where nothing ever changed, where everyone knew his place and where civilized dramas of life and love could be played out. This became even more important with the outbreak of the Second World War. For the projection of this image as an ideal world reinforced the British in their struggle to preserve it and convinced the Americans that it might be worth fighting for too.

Sidney Franklin produced a series of films at M.G.M. which constitute the complete Hollywood view of England. All of them are fondly remembered by those who cherish forties cinema. Among them is Mervyn

The servant question

61 The master and mistress (Clive Brook and Diana Wynyard)
entertain the servants (Herbert Mundin and Una O'Connor) on
New Year's Eve (*Cavalcade*)

62 (below) Below stairs, there was a hierarchy every bit as rigid
as above stairs (*Angel*)

63 (opposite) The perfect butler, immaculate even on a desert island.
Kenneth More in *The Admirable Crichton*

Leroy's 1941 screen version of James Hilton's novel *Random Harvest*. This is one of the classic romantic dramas, artificial and unreal, perhaps, but utterly believable and hypnotic because it is entirely created and played out in that corner of M.G.M. that is forever England. It is a world which has never existed and yet has always existed, an idealized amalgam of elements half-remembered, half-imagined in the mind of the expatriate. Time has stood still in this world. Reality has never penetrated. It is a world in which you would expect to find, and indeed do find, old friends and familiar faces: Una O'Connor running the tobacconist's and Reginald Owen the pub, Arthur Shields managing the chemist's and Henry Travers doing his rounds as the genial local doctor. You would expect to find Random Hall with its faithful beaming butler and breakfast on silver salvers in an oak-panelled dining-room, tea and muffins on the lawn at four. You would expect to find Cleveden village with its quaint little church and white-painted country cottage, overgrown with lilac and skirted by a gentle stream. You would expect to find industrial Melbridge, paved with damp cobble stones, shrouded in fog and thronged by noisy Anglo-Saxon extras. For these are the mythic backdrops of this dream world.

In its central theme, too, the film awakens a response in the audience and echoes in a host of other Hollywood films. For it tells of the search for his past by the amnesiac ex-soldier Sir Charles Rainier (beautifully played by Ronald Colman). He carries on his watch-chain a key, which comes from this past and which he knows will in some way open the door through which he might pass to regain what once was. This search for the lost joys of a half-remembered past was a preoccupation of Hilton's (cf. *Lost Horizon*, *Goodbye, Mr. Chips*) and it is one of the factors which attracted middle-class audiences between the wars to his work. Conscious of a world changing around them, feeling that somehow the old values and traditions were slipping away, they felt an instinctive sympathy for the gently nostalgic tone of his works. It is no accident that

Frank Capra, supreme interpreter of the populist mood of the thirties, should have filmed *Lost Horizon* nor that Hilton himself should have contributed to the screenplay of *Mrs. Miniver*. For they are part of the same trend. During the thirties, they are Hollywood's key to open a door through which an anxious audience may escape into a reassuringly idealized dream world. With the outbreak of war, this middle-class fear of change and decline in status is only intensified. The need for reassurance continues but coupled with it now is the urgent necessity of defending the dream. Ironically, it is the war which finally destroys it. But while the war rages, that mythic England which Edgar Doe and Rupert Ray fought to defend in the First World War (in *Tell England*) is the same image for which the Allies are being encouraged to fight in the Second World War.

Mervyn Leroy had preceded *Random Harvest* with *Waterloo Bridge* (1940), the story of the doomed love affair of Captain Roy Cronin (Robert Taylor), nephew of the Duke of Revelstoke, and ballet dancer Myra Lester (Vivien Leigh), with its backdrop of a Scottish lordly estate complete with mist, sheep, loyal retainers and C. Aubrey Smith. But in 1942, the war finally intruded into the dream world with William Wyler's *Mrs. Miniver*, based on the novel by Jan Struther. Describing itself as 'the story of an average English middle-class family', it was basically an updated *Cavalcade*, which this time apotheosized the English middle class. The image it presents is fascinating.

The family is the Minivers: father, Clem (Walter Pidgeon), quiet, unassuming, pipe-smoking architect; mother, Kay (Greer Garson), serene, compassionate, rose-grower; three children (Vin, the eldest, at Oxford, Judy and Toby); the cook and the maid. They all live in a white-fenced, chintz-curtained cottage, 'Starlings', in the village of Belham on the South Coast. Their world is the Yacht Club Ball, the Flower Show and Sunday church services. The film opens just before the war. Vin comes down from Oxford with an over-developed social conscience, expatiating on the evils of society and how they are all still living under the feudal

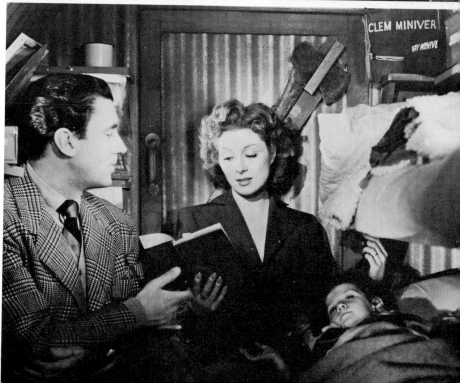

Mrs. Miniver –
apotheosis of the
English middle class.
64 (above) The Flower
Show – epitomizing a
world in which everyone
knows his place
On platform: Henry
Wilcoxon, Henry
Travers, Dame May
Whitty, Reginald Owen
65 (right) Kay Miniver
(Greer Garson) and
Clem Miniver (Walter
Pidgeon) read *Alice in
Wonderland* to the
children in the air raid
shelter

system. Mother is concerned, father is amused and the nonsense is soon knocked out of Vin (Richard Ney) when he falls in love with and marries Carol (Teresa Wright), grand-daughter of the endearing local feudalist, Lady Beldon (Dame May Whitty) ('Everyone is trying to be better than their betters').

War breaks out. Horace, the boy-friend of Gladys the maid, is called up. When he comes to the house to say goodbye to her, he is called into the living-room and given a glass of sherry. He leaves for the station with a tug of the forelock ('My best respects, mumo') and the whole family chorus 'Jolly good luck, Horace.' Vin joins the R.A.F., Clem goes to Dunkirk and Kay captures a downed Nazi flyer, going so far as to slap his face when he rants about the atrocities committed by the master race. The bombings begin and Kay reads *Alice in Wonderland* to the children in the shelter. The village is bombed and Carol is among those killed. The film ends with a service in the ruined church at which the Vicar (Henry Wilcoxon) urges them all to strive for victory and the congregation sing 'Onward Christian Soldiers' as the camera pans up through a hole in the roof to the R.A.F. planes overhead and the soundtrack bursts into 'Land of Hope and Glory'.

Critics in general have been contemptuous of the film. The usually reliable Charles Higham and Joel Greenberg dismiss it as 'a false and sentimental portrait of the English woman at war.'[7] Leslie Halliwell says it 'was never a good film', 'most people privately jibed at it' and 'it now seems a quaint curiosity.'[8] Whether or not anything is good is, of course, a purely subjective opinion. But it seems to me that these critics have missed the point of the film. It is intended to be sentimental and is bound to be, strictly speaking, false. Its importance, like that of *Cavalcade*, lies in the personalization and emotionalization of the war. The great issues are sidestepped and the war is observed simply in its effects on an idealized English family.

In short, it is a fable, set in a beautifully created never-never England, and sensitively directed by William Wyler whose great *forte* has always been the handling of actors and the exploration of intimate relationships, especially within the family. There are some particularly moving moments (Clem's return from Dunkirk, Carol's death, the ruined church finale) which can be seen as the counterparts of similar and equally moving scenes in *Cavalcade*. For the sociologist, the film has added fascination in its depiction of a world in which everyone knows his place: the old aristocrat is still lady of the manor, everyone is respectful to the class above and the Minivers are patronizingly kind to their servants. The Minivers also incarnate the middle-class virtues of selflessness and unflappability which are going to win the war.

Even without the wartime slant, Hollywood continued to project its idealized England throughout the war years. Alfred Hitchcock's *Suspicion* (1942), for instance, has a recognizable studio-England setting: the Hunt and the Hunt Ball, the country house, friendly bobbies, sheepdogs, tea at four, Nigel Bruce as a silly ass in plus fours, Cedric Hardwicke as a Blimpish general rhubarbing into his lunch about the evils of bottled horse-radish, and, representing the lower classes, Heather Angel, chirpy and respectful as Ethel the maid.

The image of England we have been examining was essentially a studio-created one, specially designed and built for use in films. The break-up of the studio system has inevitably meant a drastic decline in these meticulously created mythic backdrops. In the fifties, the cinema grew up, adopted 'significance' as a crowd-puller and became adult and boring. As its magical childhood faded, so too did its dreams and fantasies, among them its dreamlike England.

There is a single notable exception to this decline and that is the Walt Disney Studios, which still create a fantasy world in which there is a place for the studio-England. Among its most recent offerings, and certainly one of its best, is *Bedknobs and Broomsticks* (Robert Stevenson, 1971). It opens with a close-up of the White Cliffs of Dover and proceeds to tell the entrancing story of how

an apprentice witch, Eglantyne Price (played by Angela Lansbury as a heady mixture of Margaret Rutherford and Hermione Gingold), with the aid of a threadbare magician (David Tomlinson) and three young cockney evacuees, repels a German invasion in 1940. She does it by bringing to life the suits of armour, uniforms, banners and weapons in the local museum. There is a thrilling poetry about the scene in which these tattered and decaying memorials to Britain's former glories march across the Downs to drive the jackbooted Nazi hordes into the sea. To lend a background verisimilitude, survivors of the old days of Hollywood Englishry are mobilized to head the supporting cast. The most notable is dear old Reginald Owen, eighty-four years old and still acting, a career which spans over forty years and includes *Mrs. Miniver*, *Random Harvest* and *Kim*. He plays, appropriately enough, a retired general leading the Home Guard. Roddy McDowall, child star of *How Green was my Valley*, is on hand as the Vicar, Tessie O'Shea as the village postmistress and Sam Jaffe, fondly remembered as Gunga Din, the High Lama of Shangri-la and the mad Czar Peter III, as a London bookdealer.

This then is the English, serene in their self-confidence, firmly believing that God is on their side ('God who made thee mighty, makes thee mightier yet'), and echoing Flanders and Swann in their blithe assumption: 'The English, the English, the English are best – so up with the English and down with the rest.'

Notes

1 James Morris, *Pax Britannica*, p. 509.
2 Jules Verne, *Around the World in 80 Days* (n.d.), p. 13.
3 Verne, *Hector Servadac* (1882), pp. 87–8.
4 There is a detailed appreciation of this film in Leif Furhammer and Folke Isaksson, *Politics and Film* (1971), pp. 81–2.
5 *Observer*, 19 February 1933.
6 James Agate, *Around Cinemas* (2nd series) (1948), pp. 78–9.
7 Charles Higham and Joel Greenberg, *Hollywood in the Forties* (1968), p. 153.
8 Leslie Halliwell, *The Filmgoer's Companion*, (1967), p. 529.

The White Man's Burden

With the sense of English superiority went, in many cases, the very real desire to serve. One has only to read the Imperial memoirs to see this feeling put into words. Look, for instance, at Sir Kenneth Bradley's *Once a District Officer*[1] about his days in Central Africa or Sir Thomas Russell Pasha's *Egyptian Service*[2] or Sir Robert Warburton's *18 Years in the Khyber*.[3] All of them are shot through with love of the country, affection for the people and dedication to their duty: the maintenance of Law and Order, Peace and Justice. It is from the basic assumptions and attitudes of men like these that the pro-Imperial films spring, finding their literary inspiration in Kipling and his imitators and putting into cinematic terms the ideal so memorably expounded by Curzon.

The figure of the British District Officer is central both to the literature and the cinema of Empire. He is the lone figure, isolated amidst hundreds of miles of jungle or desert, ruling over thousands of tribesmen like a beneficent father, with only a handful of native troops at his back and no other white man within three weeks' march.

The classic film tribute to the District Officer is of course *Sanders of the River*, directed by Zoltan Korda in 1935 and filmed partly on location in West Africa. It was produced by Alexander Korda, one of the great men of cinema, a weaver of wonderful dreams, an arch-artificer of fantasy and the man who, single-handed, put British films on the map. A Hungarian by birth, he became, in the tradition of immigrants, more English than the English; and like Capra in America, he was responsible for expressing the national ideology in its purest form on film.

The film kept faithfully to the Edgar Wallace stories, except for changing the characterization of 'Bones' from archetype variation I ('silly ass') of the books, to archetype variation II (eager young sub-altern). The film's foreword states its intentions: 'Sailors, soldiers and merchant adventurers were the pioneers who laid the foundations of the British Empire. Today, their work is carried on by the civil servants – the Keepers of the King's Peace.' The film tells the story of one such man – Commissioner Sanders.

Sanders (marvellously played by Leslie Banks) administers the River territories and preserves peace and justice. Under his rule the natives enjoy prosperity. He rigorously bans slavery and wages a ceaseless campaign against the runners of guns and gin: 'the most dangerous gifts of civilization to the natives'. Quiet, pipe-smoking, authoritative, Sanders rules largely by force of personality. He is the superman who in the ten years during which he has ruled has converted a situation where you couldn't go on deck because of the showers of spears and where there was war, killing and torture everywhere, to one in which crossing the Territory is as safe as crossing London (arguably safer, in view of the absence of traffic in Africa). This has been achieved in spite of the numerical inferiority of the British, a handful of whites with their whiskies and sodas on the verandah of the Residency and a troop of faithful Houssas to defend them. This numerical inferiority is, however, compensated for by the feeling of moral superiority that goes with it. This is evidenced by the scene in which the Old King, Mofalaba, comes with his warriors to palaver. They outnumber the British ten to one. But Sanders summarily deals with the King and then declares: 'The palaver is

finished.' They all obediently leave.

The British rule through their nominated chieftains. Sanders's particular favourite is Bosambo (Paul Robeson), a brave, faithful and cunning ex-Liberian convict, who has made himself chief of the Ochori. He it is who sings the song lauding Sanders and his virtues:

'Sandi the strong, Sandi the wise,
Righter of wrong, hater of lies,
Laughed as he fought, worked as he
 played,
As he has taught, let it be made.'

When Sanders is going on leave, he bids Bosambo farewell. He wonders if Bosambo will still be a popular king when he returns. Bosambo replies: 'I have learned the secret of good government from your lordship. It is this, that a king should not be feared but loved by his people.' 'That,' replies Sanders, with a knowing smile, 'is the secret of the British.' The British may have liked to think this but it was rarely true. Their very hauteur and aloofness, so much an integral part of the archetype, set them apart and precluded love. As Sir Kenneth Bradley has commented: 'We were, I think, more often respected than loved.'[4] This was closer to the truth of it. But Sanders expresses the ideal.

The relationship between ruler and ruled was idealized as that of a father and his children. When Sanders has gone and law and order has broken down in the wake of rumours of his death, Father O'Leary, the missionary, tells Sanders's replacement, Commissioner Ferguson, that he must act like a father to his misguided children 'as Mr. Sanders would'. Both Farini the gun-runner and Captain Hamilton of the Houssas comment on the father-children relationship of Sanders and 'his people'.

In Sanders's absence, the Old King (a memorably malignant performance by Tony Wane), stirred up by white gun-runners, causes an outbreak of disorder. Ferguson goes alone into his camp to talk to him and is put to death. He dies bravely, warning Mofalaba that Sanders will surely come and avenge his death. Father O'Leary telegraphs London: 'Send four battalions or Sanders.'

Sanders returns from his leave, puts down the unrest and, although ill with malaria, sails up river in his gunboat, *The Zaire*, arriving in the nick of time to save the captured Bosambo.

The last shot of the film memorably crystallizes the image of the District Officer as hero. Sanders and Lt Tibbetts stand on the deck of *The Zaire*. Sanders, his elbows resting on the rail, pipe in mouth, is looking out over the river and the lands beyond. Above his head flutters the Union Jack. Around the bend in the river swing the native canoes, as Bosambo sings a paean in honour of Sanders and his administration.

It is sad to think of so sterling a character as Sanders ending up in a couple of sorry 'B' features. But that is what happened. Played now by Richard Todd, stripped of *The Zaire*, 'Bones' and even his solar topee, with the Territory about to become independent, he is reduced to some routine detective work into murder and diamond smuggling in *Death Drums along the River* (Lawrence Huntington, 1963). While in *Coast of Skeletons* (Robert Lynn, 1964), he undertakes his last mission, returns to England to receive his decoration from the Palace and takes a job as an insurance investigator.

The Edgar Wallace interpretation of the District Officer has remained the archetype, influencing all subsequent D.O. films. In *The Scarlet Spear* (George Breakston and Ray Stahl, 1953), set and filmed in Kenya, the hero is District Officer Jim Barneson (John Bentley), who says of his job: 'The District Officer is policeman, judge and father rolled into one. He keeps the Law where once there was no law, only savagery and darkness.' The plot centres on the initiation rites of a new chief. Barneson doesn't interfere with these rites except for their climax, in which the new chief is required to kill the chieftain of a neighbouring tribe with the sacrificial scarlet spear. This would mean inter-tribal warfare and therefore must be stopped. The confrontation between Barneson and Morasi (Morasi), who is his friend as well as being the new chief, is interrupted by an attack by renegade natives. During the fray, Morasi saves Jim's life. But

is mortally wounded. Dying, he breaks the scarlet spear, to end the tradition of killing. He has learned from Jim the need to maintain peace and order.

In Hollywood's Tarzan films, the District Commissioners are invariably pure Wallace. *Tarzan's Peril* (Byron Haskin, 1951) opens with the coronation ceremony of Melmendi (Dorothy Dandridge), the new Queen of the Ashuba. Watching the rites, as his last act before retirement, is quiet, moustached, pipe-smoking, pith-helmeted Commissioner Peters (Alan Napier). He tells his designated successor, quiet, moustached, pipe-smoking, pith-helmeted Commissioner Connors how he has devoted his life to keeping gin and guns out of the Territory. But his work is threatened now by the revived activities of gun-runners. Melmendi, a faithful vassal of the British crown, has rejected the offer of guns, but other chieftains are less reliable. Peters takes his leave of the Queen, who echoes Bosambo when she says: 'You are our father and mother, lord. We will never forget you.' But both Peters and Connors are murdered by the gun-runners and Tarzan, motivated undoubtedly by a sense of *noblesse oblige* since he is a member of the British House of Lords, sets out to avenge their deaths.

Similarly in *Tarzan and the Mermaids* (Robert Florey, 1948), the District Commissioner (Edward Ashley) is a quiet, pipe-smoking, moustached idealist, who wants to build schools and hospitals in his Territory and maintain peace and settled conditions. When he was not off discovering hitherto unknown cities and lost civilizations (*Tarzan and the Slave Girl*, *Tarzan and the Magic Fountain*), Tarzan too did his share of shouldering the white man's burden, until the wind of change blew through Africa. When that happened, the film producers deemed it prudent to get him out of the Dark Continent to less controversial areas. So the sixties saw Tarzan becoming a globe-trotter, going to India as a trendy animal conservationist (*Tarzan Goes to India*), to Siam (*Tarzan's Three Challenges*) and ending up in South America (*Tarzan and the Valley of Gold*, *Tarzan and the Great River*). Whether

he, like Sanders, will give up defending the Empire and become an insurance agent has yet to be seen.

While he was still in Africa, however, he had been enlisted on behalf of the free world to tackle the Nazis (*Tarzan Triumphs*, William Thiele, 1943) in a film directed by a man who was himself a refugee from Nazi Germany. In the Communist-conscious early fifties, Tarzan was to be found fighting against Communist attempts to overthrow the British Empire. The gun-runners of *Tarzan's Peril*, Radijek and Trask, are the agents of an unnamed Eastern European power who are running guns to the tribes with the avowed aim of stirring up inter-tribal war and weakening the Empire. In *Tarzan's Savage Fury* (Cy Endfield, 1952), Tarzan is tricked into helping the crooked Rokoff in a bid to obtain the Wazuri tribe's diamonds because he is told that England needs the diamonds to buy arms, not for war but to maintain the peace. Jane convinces Tarzan that he should help by claiming that for England to go unarmed in the world is like Tarzan going into the jungle without his knife.

The Nazi threat, as has already been noted, gave a last boost to the cinema of Empire. *The Sun Never Sets* (Rowland V. Lee, 1940) is a classic film of Empire, which sets up Imperialism as the antithesis of Fascism. Clive Randolph (Basil Rathbone) and his wife Helen (Barbara O'Neill) leave the Gold Coast, where Clive has served as a District Commissioner for two years, and return to London, hoping to settle down there. They arrive home in time to hear Clive's younger brother John (Douglas Fairbanks Jr) rebel against going into the colonial service simply because all the male members of the family have been in it for three hundred years. Engaged to pretty Phyllis Ransome (Virginia Field), John wants a career which will enable them to enjoy the comforts of life. The colonial service only brings hard work, discomfort and ingratitude. But his grandfather, Sir John Randolph (C. Aubrey Smith, of course), persuades him of his duty and the honour of his heritage and in due course, he proceeds to the Gold Coast.

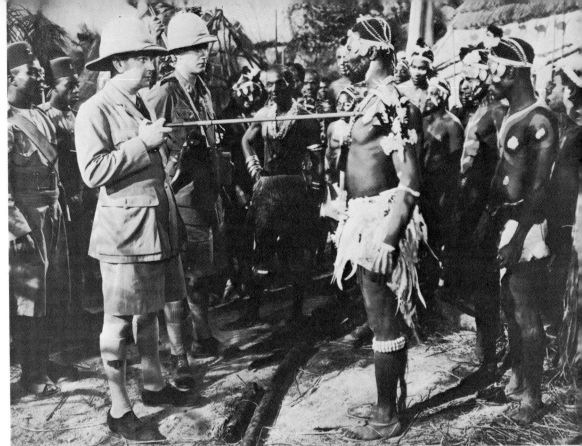

66 (above) The classic District Officer (Leslie Banks) holding
palaver in *Sanders of the River*
67 (left) Anthony Steel, as Game Warden Payton, a sort of updated
District Officer, in *West of Zanzibar*
68 (right) Michael Hordern and Gordon Jackson uphold British
Imperial rule in the South Seas in *Pacific Destiny*

Clive, instead of getting his hoped-for appointment in London, is sent back to his old post up country, with John as his assistant commissioner. A multi-millionaire munitions manufacturer, Hugo Zurof (Lionel Atwill), has taken up residence there, ostensibly in charge of a scientific expedition. But government officials fear that he is plotting to bring down the Empire. It is Clive's job to discover the truth.

John, meanwhile, is chafing at the rigid discipline of the Service. He cannot understand why Clive goes up country, leaving his wife ill and pregnant behind. The reason is simple: the Service must come first. But John sends a false message to lure Clive back, and in his absence an up-country commissioner is murdered by Zurof's men. Clive is disgraced and ordered to hand over his job to John and return to the coast. John, in remorse, takes to drink and when Zurof offers him a well-paid job, he is tempted to accept. But then Phyllis arrives. Sir John has died, bequeathing to her the map on which he keeps track of the members of the Randolph family, serving the Empire in all its far-flung outposts. She has come to realize the value of the Service. They are married at once and on his wedding night, John, putting the Service first, leaves his wife to go and tackle Zurof. Realizing that Zurof is using his headquarters to broadcast anti-British propaganda, he sees a chance to vindicate the honour of the family. He pretends to join them and, having thus gained access to the headquarters, broadcasts a warning message to the authorities. They send a bombing squadron (commanded by Clive) which, despite the danger to John's life, bombs the headquarters. But in one of those selective explosions which are so common in films, the villains are all killed but John is left unharmed. Clive is restored to favour and John is inspired with a real and lasting desire to carry on the family tradition and serve the Empire on which the sun never sets.

The film has a clear didactic purpose. The foreword declares it to be a tribute to the British colonial service and what it stands for, which is seen to be educated individualism as opposed to ruthless regimentation. Zurof is depicted as a Fascist fanatic who scoffs at the British policy of educating the natives towards eventual self-rule and instead advocates a totalitarian system, the rule of force and strength and the stamping out of all individualism. But this accords ill with what we already know from *Sanders of the River* to be the 'secret of the British', that a ruler should be loved rather than feared. The destruction of Zurof is, therefore, clearly as much in the interests of the natives as it is of the British. Consequently, the film eulogizes the tradition of service, incarnated by Sir John Randolph, and traces the process whereby John and Phyllis come to the same realization as Clive and Helen that duty must come before personal happiness.

A year later came *Sundown*, a taut and fast-moving Imperial thriller, directed by Henry Hathaway. District Commissioner Bill Crawford (Bruce Cabot), at Manieka, near the Kenya-Abyssinia border, radios Nairobi that the outlaw Shenzi tribe are being supplied with guns. Major Coombes (George Sanders) is sent to take control. The Italian prisoner of war, Major Pallini (Joseph Calleia), a former teacher of political history, delivers an impassioned warning to the British about the significance of the gun-running. The British, he says, have always depended on sea power. But that is not enough now. The Nazis use the land. They always come by land. 'Africa is the key. If you lose Africa, you lose the war.' The Shenzi guns are the beginning. They are being supplied by the Nazis to stir up the tribes in rebellion against the British, in the wake of which the Nazis will move in.

A beautiful and mysterious Arab girl, Zia (Gene Tierney), turns up and is invited to dinner, but has to eat out on the patio, where Bill, a Canadian, joins her and tells her reassuringly: 'The England that's gonna win this war is gonna do away with a lot of that nonsense' (i.e. racial discrimination). He tells her that he has modelled himself on Graham Fletcher, who had been District Commissioner there twenty-five years ago. Fletcher had believed, like Sanders, that

fear produces more fear and that force produces violence. But if a man really loved Africa, she would love him in return. He had loved Africa. He had known Africa. He could speak eighteen dialects. He dreamed of irrigating the land and turning it into a Garden of Eden and he believed that the black man, like the soil, needed care and cultivation. This speech reveals it all: the dedication to duty, the affection for the land and the people and above all, the paternalism, shared both by Fletcher and by Crawford.

Zia disappears with the Dutch mineralogist, Kuypens (Carl Esmond), who is in fact the Nazi gun-runner. Bill and the white hunter Dewey (Harry Carey) go after them. In the underground headquarters where they are training the Shenzi for a major uprising, Kuypens reveals that he knows Zia is really Graham Fletcher's daughter and has been sent by Nairobi to investigate the gun-running. He imprisons her and captures Bill too. But Dewey gets away and brings back Coombes and the troops. The Shenzi are routed and Kuypens killed.

Coombes is mortally injured in the fighting and his dying speech contains the message of the film. He had started out as something of a martinet, horrified that Crawford ran his post on 'instinct', but he comes to appreciate his worth and his methods in the end. His last words are:

'You carry on, Crawford. Don't lose your ideals. You don't realize it but they're the ideals of the church, the church of all. People of all churches, pulling together, that's what we need, people of faith pulling together. My father was a bishop. He wanted me to enter the Church. But I chose the army. The church and the army, they're both the basis of civilization: the church holds it together, the army defends it and the Crawfords make it good.'

The film ends in London in a bomb-damaged church with a finale similar to *Mrs. Miniver*. The choir sing 'Oh, God, our help in ages past'. Bishop Coombes (Cedric Hardwicke) has just married Zia and Bill, who are about to return to Africa 'to resume their life of service'. He reads a poem sent to him by his son.

'Hear it, hear it, I beg you. Hear it England, hear it all mankind:

'Fly high your flag upon the hill,
Keep bright your faith and hold until
Our England wins, as England will
Who waits with hope, waits with victory.'

There is a wealth of interest in this film. It draws inspiration both from Haggard (white Arab princess, underground caverns) and Kipling (the District Officer, the life of service). It adopts the wartime stance which we have seen expressed by Churchill and Coupland, of equating the British Empire with civilization. Thus the victory of the free world over Nazism means also the victory of the British Empire which is seen to symbolize the values we were fighting for. Similarly the British Empire is equated with the Church, as a religious faith, and Crawford is enjoined to hold on to his ideals, the ideals which he expressed to Zia and which can be seen to form that 'moral basis' for Imperialism which Curzon had called for. The warning about British over-reliance on sea power is fascinating, and the film's title and the scene where the Union Jack, unintentionally upside down, is lowered are strangely prophetic.

After the war, with the accession of Elizabeth II and the brief enthusiasm for the second Elizabethan age, came the 'Commonwealth Spirit'; and Ealing Studios filmed a series of semi-documentary dramas on location in Australia and Africa. But the two African dramas, *Where No Vultures Fly* (Harry Watt, 1951) and *West of Zanzibar* (Harry Watt, 1954), were really up-dated District Officer films, starring the last of the Imperial actors, Anthony Steel, as game-warden Bob Payton. In the former, he is protecting the wild-life of Kenya against poachers. But in the latter he has a much more traditionally Imperial role.

West of Zanzibar squarely pins the villain role on the Arabs in its opening narration: 'To the African of today, who is finding it hard enough to leap the centuries, their influence can be disastrous.' The Galanas, a

The Sun Never Sets enshrined several Imperial themes:
69　Douglas Fairbanks Jr learns the meaning of service from
C. Aubrey Smith
70 (below)　Basil Rathbone expounds the law to the natives
71 (opposite)　British rule in Africa depended on a handful of British
civil servants, backed by regiments of native troops.

fine, simple, happy agricultural people in the interior are struck by disaster when their top-soil blows away. A vote is held as to whether they move inland to fine rich land, as recommended by game-warden Payton, or to the coast near Mombasa. Eager for the delights of civilization, they choose the latter to Payton's distress ('They're not ready for that kind of civilization yet') and to the distress of chief Ushingo, who blames the British for introducing democracy to replace the power of the chief. If the old system of delegated authority had remained, Ushingo would have led his people inland without hesitation and, of course, without consulting them. For his people are not ready for democracy either.

However, since their decision is made, Payton helps them build a new village near Mombasa and returns to his job as a game-warden. One day, he captures the chief's sons poaching ivory. He takes them back to Ushingo but is distressed to see the Galanas drunk and brawling in the streets of Mombasa. He reports to his superior that the Galanas are falling apart, 'rotting into spivs and crooks'. But he says they are not to blame. For they are being exploited by wicked outsiders. He asks for permission to track down the leaders of the ivory poaching gang. His superior agrees – because of the revenue they are losing. But Payton makes his own motives quite explicit. ('It's Galanas, not revenue, I'm interested in.') Eventually he tracks down the ring-leader, a suave Persian lawyer, who begs to be arrested to protect him from the fury of the Galanas. Payton obliges but vents his feelings by socking him on the jaw. The tone of the film is paternalist and the moral is plain. The Africans are still being exploited by their age-old exploiters, the Arabs, who once preyed on them as slave traders and now use them for ivory poaching. They still need the British District Officer to look after them.

A far more progressive view of the negro in a changing world is taken by *Men of Two Worlds* (Thorold Dickinson, 1946), based on a story by Joyce Cary.[5] The film's hero is the African concert pianist, Kisenga (Robert Adams), who returns to his native land to find his people, the Litu, living in an area infested with tsetse fly, the carrier of sleeping sickness. Randall the District Commissioner (Eric Portman) wants to move the Litu to an area free from infection but is opposed by Magole the witchdoctor (Orlando Martins), who does not want his people to obey the white man. Kisenga tries to persuade the chief that it is in the tribe's interest to move but he meets with no success. The Commissioner resigns himself to watching the Litu die. But Kisenga challenges the power of Magole. In spite of his European outlook, Kisenga finds that 'the thousand years of Africa in his blood' have made him susceptible to the evil power of suggestion and when a curse is put on him by Magole, he falls ill. Randall, fearing that his death will mean a victory for superstition and ignorance, tries to give him back the will to live. Outside his hut the village children sing the choral sequence of one of his African symphonies and this, combined with Randall's exhortations, brings Kisenga safely through his illness. The power of Magole is broken, he leaves the village and Kisenga decides to stay and help his people towards a better future. The African thus moves to the centre of the stage; but for a little while longer, at least, the District Officer is still there, a disinterested, dedicated figure, labouring for others in a far-off country.

Pacific Destiny (Wolf Rilla, 1956), based on Sir Arthur Grimble's reminiscences, affectionately recounts the experiences of a fledgling D.O. in the Pacific. Young Arthur Grimble (Denholm Elliot), about to leave for Samoa as a colonial service cadet at the turn of the century, is given advice by his uncles in their club: 'Rule kindly and none but the most frightful bounder will doubt your sincerity' and 'Be a man and be a leader – in other words be British.' Grimble arrives in Samoa with his newly-married wife (Susan Stephen) and his piano, to find himself at an immediate disadvantage because of his ignorance of the language. He is welcomed irascibly by the Commissioner (Michael Hordern), who had wanted an experienced man and not one of the Colonial Office's

'heaven-born administrators'. His début is hardly auspicious. He blows up the commissioner's verandah and loses a prisoner when his canoe sinks. But he proves his mettle when sent to a neighbouring island, where a native sorcerer is stirring up trouble. He kills a dangerous man-eating shark and is adopted by the chief. He survives a trial of strength with the sorcerer, who has him poisoned. Finally, he rises from his sick-bed to march, alone and unarmed, between two sets of islanders who are all set for a pitched battle. When the commissioner arrives on the island, he finds a peace *luau* in progress, with the two tribes side by side and the Grimbles in the place of honour.

Grimble has carried out his uncles' injunctions and those of District Officer McAllister (Gordon Jackson): 'You are here to learn their customs and not to teach them ours.' There is one exception to this rule, however. He does teach the natives cricket, which proves an acceptable substitute for inter-tribal warfare. Why does he do the job? When asked this, Grimble replies with some embarrassment: 'Oh, king and country, you know.' Grimble is the typical public school boy and would have felt just like Stalky did at having his country's flag waved at him. He does not need to talk about his job or rationalize it. He just knows he has to do it. His victory over the sorcerer symbolizes the triumph of Enlightenment, Law and Order (i.e. Grimble, the British, the Empire) over native ignorance, fear and superstition (i.e. the opponents of Empire, the forces of darkness).

It is interesting to observe that in African films of Empire the District Officer is almost invariably the hero. There are one or two exceptions – for instance, *Storm over Africa* (Lesley Selander, 1953), in which Lt James Denham (Louis Hayward) of the King's African Rifles and his faithful negro companion, Corporal John (Roy Glenn), in 1914 track down some stolen machine guns, which white renegades intend to sell to dissident pro-German tribes to stir up opposition to the British in East Africa. In India, on the other hand, the military man is almost invariably the hero and the civilian admin-istrator the exception, in spite of the fact that India possessed, in the Indian Civil Service, incontestably the finest colonial service in the world. The predominance of the military among the Imperial heroes in India partly reflects the importance of the myth of the North West Frontier and its defenders and partly, and more mundanely, the business of film trends.

The Imperial film cycle was inaugurated in the thirties by *Lives of a Bengal Lancer* (Henry Hathaway, 1935), inspired by, though hardly based on, the book by Francis Yeats-Brown. Ernest B. Schoedsack was sent to India to film location sequences but the film stock deteriorated so badly in the heat that it was scrapped and the whole film was made on location at Lone Pine, California, Hollywood's perennial stand-in for India, which also saw service in *Charge of the Light Brigade*, *Gunga Din* and *Kim*. It is not an entirely satisfying film. With its ramshackle rag-bag of a plot and a distinctly uncomfortable performance from Gary Cooper, who is called upon to deliver lines like 'Does the colonel think there's only one person who can speak Pushtu around here', it lacks the cohesive power of *Charge of the Light Brigade*. But the action is briskly handled by Henry Hathaway and the film is a seminal text for what it has to say about the white man's burden, military tradition and the concept of duty to India.

The film opens at headquarters, where an eager young subaltern (Reginald Sheffield) extols his new life ('Romance, Kipling and all that, you know'). But he is sternly informed that the handful of men on the frontier have a hard job, protecting millions of people, and we cut to the frontier and a scouting expedition, led in person by the Commanding Officer of the Lancers, Colonel Stone (Sir Guy Standing). He has given orders that no hostilities be engaged in, for it is the mission of the British in India to maintain peace. Lt Alan McGregor (Gary Cooper), a young Canadian eager for action, disobeys orders when snipers open fire and attacks and drives off the Afridis. The colonel angrily reminds him of the necessity of obeying orders and is nicknamed 'Ramrod'

by McGregor.

Back at headquarters, Major Hamilton (C. Aubrey Smith) informs the colonel that two new replacement officers are due: Lt Forsythe of the Blues and Lt Stone from Sandhurst. The latter is the colonel's son, sent for by Hamilton to 'keep the name of Stone in the 41st' after the colonel retires. The colonel welcomes the new officers at morning durbar but makes no sign to his son. McGregor sends young Donald Stone (Richard Cromwell) to see his father and there is an important scene between them which illustrates perfectly father-son relations in an Imperial context and the unspoken ethic of service, handed down from generation to generation. The colonel stiffly makes it clear that he did not send for Donald and that he will receive no special treatment. He must make his own way and prove himself. 'The service comes first. Something your mother never understood.' His mother, an American, had hated the army but Donald had gone to Sandhurst. Why? 'We've been soldiers for generations' is Donald's reply. He is his father's son.

The Colonel learns from his spies that the Afghan chieftain Mohammed Khan is raising the tribes for a coalition against the British. McGregor is all for an immediate expedition against the Khan. Instead, the colonel orders the regiment to proceed to Gopal for pig-sticking as usual. At the Emir of Gopal's court, they find the suave Mohammed Khan (Douglass Dumbrille), with a glamorous Russian spy, Tania, in tow. He joins them for pig-sticking.

The splendid pig-sticking sequences take up again the theme of young Stone's initiation into the mysteries of the Service. The colonel orders the young officers not to go after the pigs on foot because it is dangerous. ('Foolhardiness is not courage. It's not good soldiering and it's not good sport.') Donald disobeys the order and the colonel has to rescue him from a maddened pig. He curtly orders the boy back to camp, concealing from him the fact that he has been badly gored in the process of saving Donald's life. The boy is bitter against his father. McGregor asks Forsythe (Franchot Tone)

whose fault it is. His answer is: 'Partly the old man, partly the system, mostly the boy.' Donald has not yet understood the need for discipline.

Donald is lured to a meeting with the seductive Tania and kidnapped. The Colonel refuses to send any of his men after the boy. Mac denounces him for his heartlessness and is placed under arrest. Hamilton, who understands Stone, tries to explain him to Mac. The colonel is near retirement. All he has to look forward to is an armchair in his club (cf. *The Broken Road*), that is, unless his son is in the Regiment. The Regiment is his life. 'Men of his Breed have made British India. They put the job above everything. When that Breed of men dies out, that's the end.' His wife left him because she did not understand that and his son has not yet learnt to understand it either.

But Mac and Forsythe, concerned over Donald's fate, desert and go, disguised as natives, to the Khan's lair north of the Khyber. They are discovered and imprisoned, with Donald. The Khan suavely deprecates the need for violence and then orders them to be tortured (bamboo slivers under the finger nails) in order to learn the route of a vital ammunition train. Mac and Forsythe hold out but Donald breaks and gives the information. Consumed with self-pity, Donald blames his father for the way he has turned out. Mac slaps his face and delivers to him exactly the same speech about his father that Hamilton had made to Mac earlier.

The captured ammo train arrives, with the regiment in hot pursuit. The captives' course is clear. Pausing only for Forsythe to recite a W. E. Henley poem:

'Ever the faith endures,
England, my England,
Take and break us, we are yours,
England my own,
Life is good and joy runs high,
Between English earth and sky,
Death is death but we shall die
To the song on your bugles blown, England,
To the stars on your bugles blown.'

they break out of their cell. Mac blows up the ammo at the cost of his own life and

Donald redeems himself by killing the Khan. The regiment arrives to disperse the rebellious tribesmen. In the final scene, the whole regiment is drawn up to witness the award of a posthumous V.C. to Mac as the National Anthem is played on the sound track and the Union Jack flutters proudly in the breeze.

Like *The Sun Never Sets*, *Bengal Lancer* exalts the life of service and obedience to discipline as the ideal and traces the process by which two outsiders are initiated into it. The outsiders are McGregor, who is a Canadian, and Donald Stone, who is an unblooded Sandhurst fledgling. At the outset, McGregor does not understand the colonel's obsession with discipline and is hostile to him. But by the end, he has not only accepted the need for it, but, in what is perhaps the key scene in the film, he teaches young Stone, who has also kicked against authority, the meaning of discipline. The clear implication of the film is that Donald Stone, Forsythe and McGregor are the next generation of the Breed and that in a few years' time they will perfectly resemble Colonel Stone and Major Hamilton, who presently incarnate the ideal.

The success of *Bengal Lancer* prompted Warner Bros to try their hand at a British Indian epic, and they came up with one of the masterpieces of Empire, *Charge of the Light Brigade* (1936), directed superbly by Michael Curtiz, cinematic maestro *par excellence*, and beautifully acted by Errol Flynn, then at the height of his powers. Originally designed to tell the story of the events leading up to the Charge, it was decided, in view of *Bengal Lancer*'s success, to jettison the historical events and fabricate a narrative about British India, utilizing the Cawnpore Massacre (thinly disguised, in the film, as the Chukoti Massacre), and transfer the heroes to the Crimea for the climactic Charge.

Dedicated to 'the officers and men of the Light Brigade, who died victorious in a gallant charge for Queen and Country', it opens in India in 1856 with a diplomatic mission to the Emir Surat Khan of Suristan to inform him that the pension granted by the British government to his predecessor has lapsed. The mission is accompanied by a detachment of the 27th Bengal Lancers, commanded by Captain Geoffrey Vickers (Errol Flynn), who contrives to save the Khan's life in a thrilling tiger shoot (Warner Bros' reply to Paramount's exciting pigsticking sequences).

Meanwhile back in Calcutta, Geoffrey's fiancée, Elsa Campbell (Olivia de Havilland), has fallen in love with Geoffrey's brother, Lt Perry Vickers (Patric Knowles). As they debate what to do, their personal crisis is overtaken by a national one. Surat Khan goes over to the Russians and Elsa's father, Colonel Campbell (Donald Crisp) is ordered to take command of the fort at Chukoti, which guards the pass into Suristan. His orders are: 'We must maintain peace at all costs.' (Cf. Colonel Stone to McGregor at the start of *Lancer*.) Geoffrey is also posted to Chukoti and Elsa decides to tell him about her and Perry. They reminisce about England: 'England – Ascot, cricket, boating on the Thames, we'll see it again together.' Elsa turns the subject on to Perry and at that point the Suristanis attack the fort. After several days of siege. Surat Khan offers the defenders safe conduct if they will surrender. Geoffrey advises them not to accept, but the colonel, trusting the Khan's word, agrees to his terms. The survivors march out of the fort and are gunned down. Geoffrey and Elsa, however, manage to escape, and report the atrocity. The British swear vengeance on the Khan and he flees from India to the Crimea to join his Russian allies.

Britain declares war against Russia. The film leaves us in no doubt that it is a just war. The British commanding officer, Sir Charles Macefield (Henry Stephenson), declares: 'Peoples do not fight peoples. England is fighting the tyranny of the Czar.' The 27th Bengal Lancers are ordered to the Crimea. On the eve of departure, Elsa confesses to Geoffrey that she loves Perry and is desperately concerned for him because he has rejoined his regiment and gone to the Crimea. Flinching briefly, Geoffrey remembers his public school training, and lights his

pipe with a brave smile: 'He's a grand lad, Elsa; he'll make you very happy.' He promises to look after Perry.

In the Crimea, the Light Brigade is ordered to withdraw from Balaclava because of the superior Russian guns. But Geoffrey, knowing that Surat Khan is there and also knowing that a frontal assault will divert and hold the Russian army, enabling the English and French forces to take Sebastopol, compelling the Czar to treat and in effect, therefore, ending the war, forges an order to the Light Brigade to advance. He orders Perry back to headquarters with a letter explaining his action, and joins the charge. The charge of the Light Brigade is unquestionably one of the most thrilling pieces of screen action in all cinema. Tennyson's poem flashes across the screen as thundering horsemen surge over the plain, cannons roar and sabres gleam in the sunlight. 'Onward, onward, men,' cries Flynn, racing ahead. He clears the cannon in a spectacular leap and there cowers Surat Khan. He pauses, the Khan whips out a revolver and fires and Flynn, mortally wounded, gallops forward and transfixes the Khan with his lance. He slides from his horse and, dying looks up to see the lances of his comrades thudding into the Khan's body one after another. The debt is paid. Finally the camera pans up from Flynn's body to the Union Jack flying proudly over the captured guns. The charge turns the tide of the war and Sir Charles Macefield burns Geoffrey's letter 'for conspicuous bravery'.

In the cinema of Empire the Charge is no blunder but a heroic and self-sacrificing act of strategy fully in keeping with the traditions of the service. The Crimean War is inspired by England's hatred of oppression just as the British Raj in India is dedicated to keeping the peace. Russia, threatening the maintenance of British rule in India and, in international affairs, offending against the British love of fair play, is unequivocally the enemy. Geoffrey's personal act of sacrifice in the cause of the Empire, stemming as it does, in part, from his sporting reaction to the revelation that his fiancée loves his brother, shows him to be a fully paid-up

member of the Breed and, as the man who caused the charge of the Light Brigade, he must qualify as a leading contender for the position of the greatest fictional hero of Imperial films.

It is instructive to compare Curtiz's version of the charge with the later version, presented by Tony Richardson in his *The Charge of the Light Brigade* (1968). An hysterical philippic against Victorian England, Richardson's film overflowed with scenes of squalid slum conditions, brutal floggings and crude surgery. It characterized the generals as dunces and lechers and the charge as a tragic farce. Anti-war, anti-army and anti-aristocracy, it drove home its 'message' with all the finesse of a steam-hammer. Curtiz's film, on the other hand, is a spell-binding exercise in cinematic legerdemain. There is a message there but we do not go looking for it and it is not thrust down our throats. We absorb it by identification with Flynn. We become spectators and participants in the ritual re-enactment of the battle between Good (the British) and Evil (the Russians). Curtiz's charge is something noble and glorious, something to be cheered to the echo. In complete contradistinction, the impotent and despairing rage of Richardson's film leaves one either bored, alienated or dissatisfied. The effortless superiority of Curtiz's film to Richardson's is the measure of the power of the myth over 'the message'.

20th Century-Fox's entry in the Imperial India stakes came the following year and starred Shirley Temple in an adaptation of Kipling's *Wee Willie Winkie* (John Ford, 1937). Kipling's short story, the hero of which suffered a sex-change from Percival to Priscilla Williams in order to accommodate Miss Temple, was crossed with 'Little Lord Fauntleroy' (child and widowed mother from the U.S.A. soften and humanize starchy British aristo grandfather) in order to provide the story-line. Joyce Williams (June Lang) arrives in India in 1897 with her daughter Priscilla (Shirley Temple). They travel to Rajpore, where they are to live with the father of Joyce's dead husband, Colonel Williams (C. Aubrey Smith), com-

Where the civil admini-
strator was the hero of
the African films, the
military man was the
hero of the Indian films.
72 (right) *Lives of a
Bengal Lancer* was the
prototype. Franchot
Tone and Gary Cooper
73 (below) Its success
prompted Warner Bros
to set the story of
*Charge of the Light
Brigade* in India. Patric
Knowles and Errol Flynn

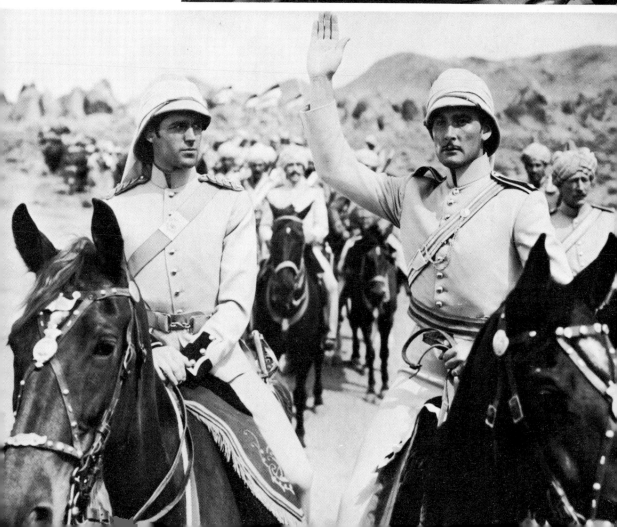

mander of the British garrison there. Williams comes to love the little girl and at the same time to instruct her in Britain's Imperial mission: 'Beyond that pass, thousands of savages are waiting to sweep down and ravage India. It's England's duty, it's my duty, to see that this doesn't happen and while I live that duty will be done.'

During the regimental dance, the tribesmen attack the post and rescue their imprisoned leader, Khoda Khan (Cesar Romero). The post is surrounded and a patrol which attempts to get through is stopped; Sgt MacDuff (Victor McLaglen), who has befriended Priscilla and who christened her 'Wee Willie Winkie', is mortally wounded. 'Why did he have to die?' Priscilla asks her grandfather. 'He died as a brave soldier should – for his Queen,' the colonel tells her. The scenes of MacDuff's funeral are intercut with scenes of Priscilla wandering disconsolately through the empty barracks, a fine example of what Andrew Sarris has called Ford's 'extraordinary camera prose passages from the wide-eyed point of view of a child'.[6]

Having befriended Khoda Khan during his captivity, Priscilla is curious as to why he and the colonel are always fighting. The colonel denies that he wants war: 'The Empire wants to be friends with everyone, to keep the Pass open and bring peace and prosperity.' She decides to go and explain this to the Khan and is taken there by a native servant, secretly a spy of the Khan. When the colonel finds she has gone, he calls out the regiment and they pursue. Khoda Khan's fortress is impregnable. When the colonel realizes it cannot be taken, he goes forward alone. Priscilla runs out to meet him. The tribesmen aim their rifles but the Khan, impressed by Priscilla's trusting innocence, stays their hands and goes out to talk. The film ends with Priscilla, accompanied by the colonel and the Khan, now the best of friends, taking the salute at a march past of the regiment.

It is a fine film from the greatest of Hollywood directors, who sympathetically depicts the pageantry of Empire (balls, parades, flag-raisings) and persuasively argues the premise that the mission of the British will be understood by the natives if only it is explained to them, preferably by Shirley Temple. The one flaw in the film is Miss Temple herself, whose knowing precocity and calculated emotions strike a consistently false note and who is totally lacking in the spontaneity and genuine feeling that virtually any other child star (Margaret O'Brien or Peggy Ann Garner for instance) would have brought to the part.

Ford had made an earlier foray into British India with his film version of Talbot Mundy's *King of the Khyber Rifles* (1929). It was Ford's first full-length talkie but the love scenes, which Ford has repudiated, were directed by the actor Lumsden Hare and contain what William K. Everson has called 'some classic overblown dialogue'.[7] He quotes the scene in which half-caste Myrna Loy tells hero Victor McLaglen that it is better to be a woman in the arms of a white man than to be a goddess to thousands of natives.

The film tells the story of Captain King[8] (Victor McLaglen) who, at the outbreak of the First World War, is sent on a secret mission to India to prevent a native uprising. His inability to leave for France with his regiment results in his being branded a coward by his fellow officers. In India he gains the confidence of the half-caste Yasmani (Myrna Loy), one of the leaders of the tribes, and she leads him to their stronghold. She falls in love with him and this enables him to learn the plan of attack. He and his followers destroy the arms supply and the revolt is put down. Yasmani is conveniently killed and King returns to his regiment to be offered apologies and congratulations by his brother officers. A less significant work than *Wee Willie Winkie*, the film none the less contains what have emerged as the major themes of the cinema of Empire: fear of native uprising, dedication to duty, even at the expense of reputation, and a narrow escape from miscegenation.

Even little Republic Pictures, home of Gene Autry and the science-fiction serial, contributed an Imperial film to the cycle, in *Storm Over Bengal* (Sidney Salkow, 1938), so closely patterned after *Bengal Lancer* that

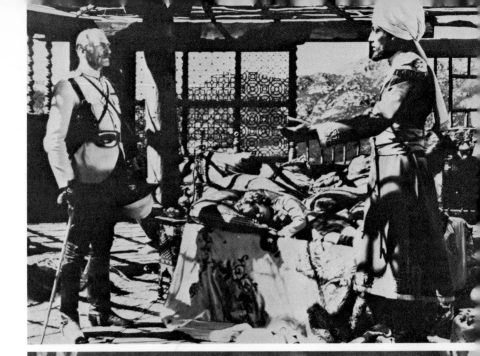

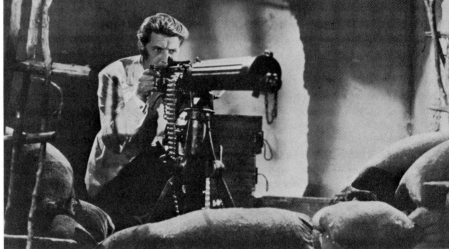

74 (above) British colonel C. Aubrey Smith and native leader Cesar Romero are brought together by Shirley Temple (asleep on divan) in *Wee Willie Winkie*
75 (centre) Roger Livesey defends the British Residency in *The Drum*
76 (below) Order is restored and Sabu ascends the throne with British protection (*The Drum*)

it utilized three of its cast. Captain Jeffrey Allison (Patric Knowles) and his brother Neil (Richard Cromwell) help put down an Indian frontier rising. Jeff has to postpone his wedding to do so, but duty comes first. Sedition is being spread in the state of Llanapur by means of broadcasts from a secret radio station. The regiment is saved from ambush in the nick of time, Jeff kills the rebel Khan and order is restored.

Britain's entry came the same year and was the equal of its American counterparts. It was *The Drum*, produced by Alexander Korda, directed by Zoltan Korda and written by A. E. W. Mason. Establishing scenes were shot in India and blended with footage taken with the actors in North Wales, on locations chosen by the army as most resembling the terrain of the North West Frontier. The film opens with the mission of Captain Tony Carruthers (Roger Livesey) to the border state of Tokot to establish a treaty of friendship with the ruler, who tells his son: 'If England is our friend, we shall have peace.' But the ruler is murdered by his brother Ghul Khan (Raymond Massey), who usurps the throne. In spite of this Carruthers returns there to take up his duties as British Resident. He is accompanied by his wife, Marjorie (Valerie Hobson), who insists on coming even though she will be the only English woman up there. ('It won't be the first time that's happened in India.') This gesture is greatly appreciated by the Residency staff, who drink a toast to her 'and all the women who come up with their menfolk to lonely outposts and bring the sweetness and gentleness of the life they have left behind'.

But Ghul is plotting with the Russians and plans the massacre of the Residency staff. Marjorie begs Tony not to go to dinner at the palace. Quietly Tony explains that he realizes that he may die and is ready to, if need be. He cites the cases of Sir Lewis Cavagnari at Kabul and of Gordon at Khartoum. ('A not unusual preliminary to our establishing law and order is the murder of one of our representatives.') Even in the establishment of law and order, however, the British are at a permanent disadvantage because of their

sense of fair play. ('In the game of international politics, it is the scoundrel who holds the trump cards.') At the crucial moment, however, Azim (Sabu), the rightful heir to the throne and a friend of the British, beats the drum to warn the British, a relief expedition arrives, Ghul is killed and Azim is placed on the throne.

Korda's hypnotic epic re-creates, in Technicolor, the full panoply of Empire: polo ('An Indian invention, an English sport, an American profession'), the regimental dinner and the toast to the King-Emperor amid a swirl of scarlet tunics and the sound of the pipes, the Governor's Ball at Peshawar, the ceremonial entry into Tokot, the full-dress parade. Its protagonists present an effective contrast in archetypes. Carruthers, representing the Raj, is moustached, wise, self-sacrificing, phlegmatic but good-humoured. The fanatical Ghul (a riveting performance from Raymond Massey) is menacingly double-faced: in public he pays flowery compliments to the British; in private, he dreams his mad dreams with shining eyes ('The Empire is ready to be carved in pieces') and purrs to himself about 'the white throats ripe for the knife'.

A late entry in the field, but one entirely in keeping with the Imperial spirit, is J. Lee Thompson's splendid *Northwest Frontier* (1959). 'Men find many reasons for killing each other,' says Kenneth More over the titles, '—greed, jealousy or because they worship God under different names'; and we are back in India in 1905. As Captain William Scott (Kenneth More) escorts the infant Prince Kishan and his American governess, Mrs Catherine Wyatt (Lauren Bacall), from the palace, Moslem rebels sweep across the plain, enter the palace and cut down Kishan's father, the Hindu Maharajah. Scott gets the prince safely to Haserabad to find the last train gone and the Moslems laying siege to the city. Kishan has to be got out. He is the spiritual leader of millions of Hindus and if the Moslems kill him, the country will go up in flames. An old shunting engine, *The Empress of India*, is therefore pressed into service, together with its garrulous engineer Gupta (I. S. Johar). The film tells the story

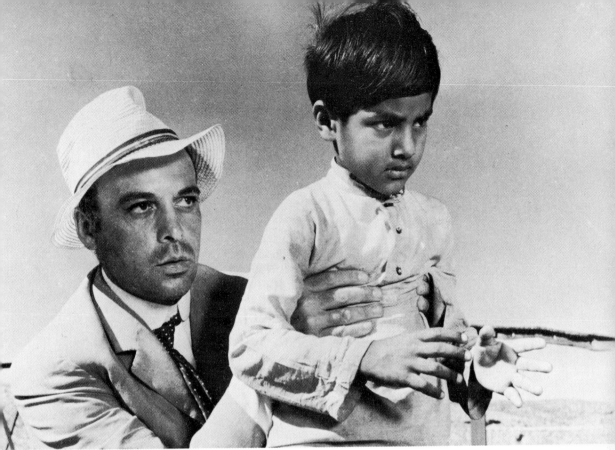

Northwest Frontier
77 (above) Half-caste Moslem journalist
Herbert Lom threatens the life of a Hindu
prince
78 (left) The process by which the
outsider becomes an insider: American
Lauren Bacall shoots the rebel Herbert
Lom to save the British officer Kenneth
More

of the train's journey across rebel-infested territory to safety.

The passengers on the train are a beautifully contrasted bunch and the interplay between them demonstrates all that is best and most endearing in the British character. There is the forthright, independent American governess, who thinks the British are slow and stuffy and accuses Scott in particular of playing at soldiers and the British in general of never doing anything until they have had a cup of tea. But by the end she is won over. She falls in love with Scott, accepts the British Imperial mission and shoots Van Leyden when he tries to kill Scott. The case of Mrs Wyatt is like that of McGregor in *Bengal Lancer*: one in which the outsider becomes an insider.

There is Lady Windham (Ursula Jeans), who is what Marjorie Carruthers would have become in later life. She is devoted to her husband, Sir John Windham (Ian Hunter), the Governor of Haserabad, and does not want to leave him. She has accompanied him on all his different postings and being with him is the only home she has ever known. She is unflappable (playing patience on the train, cf. Phileas Fogg), resourceful (improvises a feeding bottle for the baby they discover), self-sacrificing (we first meet her tending the wounded in the Residency ballroom), level-headed and quietly confident. ('Half the world mocks us and half the world is only civilized because we have made it so.') Her Englishness is reinforced by that of Mr Bridie (Wilfrid Hyde White), an endearing old stick, a typical civil servant with a dry sense of humour. He is constantly making cups of tea but is able to turn his hand to manning the Maxim gun when it becomes necessary.

A sort of chorus on the action is the self-centred but likeable rogue of an armaments salesman, Mr Peters (Eugene Deckers), who has a British passport and a foreign accent and has in fact supplied the rebels with guns, purely as a matter of business. Scott tells him that he should sell guns to the 'right side' and his wry reply is: 'You think we should be, like God, on the side of the British.' It is Peters who explains Bridie's

attitude. Bridie disliked Van Leyden when he thought he was a Dutch journalist, sympathized when he learned he was a half-breed and defended him when he was arrested as an anti-British fanatic, because he had become an underdog. 'It's better than kicking them,' retorts Bridie.

Finally there is Van Leyden (Herbert Lom), the Dutch journalist, whose anti-British articles, according to Lady Windham, have been partly responsible for stirring up the violence. Van Leyden says that violence is sometimes the only answer. It soon emerges, however, that he is an agent of the rebels and his attempts to murder Kishan provide the tension on the journey. His reason is that he is a half-breed, concerned about his place in the world and hoping that he will find it by helping to create a Moslem India. But the character is not treated sympathetically. He is an out-and-out villain, whose origin is regarded as no excuse for child-murder, which is how his actions must be regarded in the context of the film. He is a murdering fanatic, who, like Ghul Khan and Surat Khan, meets a thoroughly well-deserved end.

There is a very powerful scene in an impressive Raj-style railway station, where they find the refugee train with all its occupants slaughtered. Sweat runs down their faces, flies buzz and the camera pans along the still, body-littered train.

Scott You see what happens when the British aren't around to keep order?
Van Leyden Divide and Rule, the British policy, is responsible for this.
Scott Moslems were fighting Hindus thousands of years before the British came.

Scott here personifies the Empire. He is a soldier doing his duty quietly and efficiently. ('A soldier's job is not primarily to kill. We have to keep order.') He believes, with typical paternalism, that the rebels are like children, and Van Leyden's argument that they are men fighting for their freedom is discounted by the film. When they reach safety and Kishan is handed over to the

authorities, he thanks Captain Scott gravely:

Kishan My father says that I must fight the British to make them go away. Will I have to fight you?

Scott I hope not.

Mrs Wyatt You see, you will have to fight Kishan. That's all the thanks you get.

Scott That's all the thanks we ever get.

It is the ingratitude that Balfour had spoken of seen in action. But it does not throw Scott. With an apposite quote from Kipling to sum up his creed ('Be thankful that you're living and march to your front like a soldier'), he leaves with Mrs Wyatt and the Indian orphan baby they had found on the refugee train.

It is a superbly entertaining film, drawing on the British nostalgia for old railway trains (cf. *The Titfield Thunderbolt, Oh, Mr. Porter*) as well as for the halcyon days of the Empire. This mood of nostalgia is beautifully captured by the musical score of Mischa Spoliansky, who had scored *Sanders of the River* some twenty-five years earlier; at one point it is positively inspired, in its choice of 'The Eton Boating Song' to accompany shots of the train sailing serenely along with Gupta the engineer resting on the tender under a pink parasol.

It is also brilliant as propaganda. For it employs the technique of personalizing issues to perfection. Scott incarnates the solid virtues of the Raj, Bridie and Lady Windham the old-fashioned and lovably eccentric aspects of the British character. Mrs Wyatt is American scepticism, converted to admiration by seeing the British in action. Peters is self-interested, foreign-accented opportunism with a sneaking admiration for the British. He cannot be wholly bad because he has a British passport, and he duly ends up selling weapons to the British. The enemy is personalized in Van Leyden, a fanatic, a stirrer-up of violence and a would-be child assassin. It was a masterstroke to make the Hindu leader a child, for it makes the British action in protecting him all the more laudable and the

rebel action in seeking to destroy him twice as villainous. The successful accomplishment of the mission by a handful of resourceful and courageous Britons in the face of a numberless horde of screaming fanatical tribesmen, completes the inexorable process of audience identification with the British and everything they stand for.

There can be no doubt about the view of British Imperialism that these films sought to present. For it is common to almost all the films we have examined. The entire action of what are, after all, ostensibly action pictures is based on certain common assumptions. The basic assumption is that British rule is a jolly good thing. Its aim is consistently declared to be the preservation of peace and law and the protection of its subject peoples. There is never any question but that the British are there in the interests of their subjects. There is nothing in it for them save the feeling of a good job well done.

The films' heroes, administrators and soldiers alike, are of a type: utterly dedicated, selfless, disciplined and fair-minded, loving the country they serve and the people they rule 'as a father would his children'. In general there is little interference in native customs except in cases where it is likely to provoke disturbance of peace and order (e.g. *The Scarlet Spear*).

The chief threat to British rule and, by association, to the happy and contented lives of the natives is conspiracy, and here we see in the cinema the same paranoid fear that we have already noted in connection with the literature of Empire. Tribal uprisings are always being fomented by outsiders: Russians, Germans, Arabs; and tribal unrest exploited by ruthless white men, gun-runners for instance, for their own ends. The British have consistently to be on the look-out for evidence of this sort of clandestine activity; hence the importance of 'the Great Game'. The implication is that without such outside stimulus the tribes would be perfectly happy under British rule but, being children, they are all too easily seduced by guns and liquor. The motives of the outsiders, it need hardly be added, are

always self-interested: conquest, self-aggrandizement, profit: concepts entirely alien to the altruistic image of the British Empire which we are being asked to accept.

Here, then, are the themes and elements of the Imperial mythos. It is possible, too, by examining the British India films to give them, at least, a definite time-limit. For the British India film, whether set in 1856, like *Charge of the Light Brigade* and *Bengal Rifles*, or in 1938 like *The Drum* and *Storm Over Bengal*, belongs spiritually to the 1890s. It is as if the myth has frozen these films into that decade, which is seen to epitomize and summarize British rule in the sub-continent. The uniforms, the attitudes, the political situation, all belong to the latter part of the nineteenth century. There is never any mention of the East India Company in films set at the time of the Mutiny. The Queen-Empress is assumed to be ruling and the action is undertaken in her name. Similarly it comes as a great jolt to see radio being used in a film like *The Drum* with its theme of Russian infiltration over the Khyber, which has given every appearance of being set in 1890 and turns out to be set in the present day (i.e. 1938). As far as the cinema is concerned, it will always be 1890 in India. The Queen-Empress is on the throne, the Bengal Lancers are guarding the North West Frontier and the secret operatives of 'the Great Game' are on the track of yet another Russian intrigue to stir up the Afghan tribes and send them streaming through the Pass to plunder, rape and burn in the fertile valleys of India, whose peoples look to the Raj for protection.

Notes

1 Sir Kenneth Bradley, *Once a District Officer* (1966).
2 Sir Thomas Russell Pasha, *Egyptian Service 1902–1946* (1949).
3 Sir Robert Warburton, *Eighteen Years in the Khyber* (1970).
4 Bradley, op. cit., p. 16.
5 There is a detailed discussion of the production of this film in Peter Noble, *The Negro in Films* (1947), pp. 128–36.
6 Andrew Sarris, *American Cinema: Directors and Directions* (1968), p. 45.
7 William K. Everson, 'Forgotten Ford', *Focus on Film* (6) (Spring 1971), p. 17.
8 The name of the book's hero, Captain Athelstan King, has been changed in both screen versions. In 1929 he is Donald King and in 1954 Alan King – though the latter version jettisoned the entire plot of the book as well as the hero's Christian name.

9 The Gods of Empire

The nineteenth century was an age of heroes and hero-worship. Edmund Gosse said of the Victorians that 'They carried admiration to the highest pitch. They marshalled it, they defined it, they turned it from a virtue into a religion and called it hero-worship.'[1] Thomas Carlyle wrote the classic exposition of it in 'On Heroes and Hero-Worship' and it was basic to the Victorian mentality. Naturally the Imperialist religion had its pantheon of heroes: Gordon of Khartoum, Clive of India, Rhodes of Africa, Raffles of Singapore, Lugard of Nigeria.

The heroes of Imperial history became the gods of Imperial mythology, the supreme examples of the Breed. As such, they were ripe for cinematic representation and Clive, Rhodes, Gordon and Livingstone all achieved celluloid apotheosis. It is not important that their film biographies are historically distorted and inaccurate, as they undoubtedly are, for the cinema does not deal in reality, it deals in dreams. In the course of their transmutation, these heroes lose their three-dimensional human qualities. Certain key characteristics are taken from their personalities and stylized into an ideal. This is why they are important. They represent the lives of the great men of Empire as viewed from a time when the Empire exists and when their part in the pattern of its development is secure. The whole structure of the films presupposes a knowledge on the part of the audience of the importance of their roles in the creation of Empire.

Clive of India (Richard Boleslavski, 1934) is a spectacular if not outstanding biographical picture, too closely based on the W. P. Lipscomb – R. J. Minney play, hampered by a superfluity of explanatory titles and reaching its climax in a confused and scrappily staged battle of Plassey. But Ronald Colman is excellent as Clive, unforgettable in the quiet moments, like the scene in which he has to tell his wife he is going to war and the shadow of bayonets falls across their faces, or his defence speech in parliament, delivered with dignity, humility and restraint. He believes himself to be a man of destiny. ('India is a sacred trust. I must keep faith'.) He is conscious always of what he is about. ('We play for an Empire,' he declares before Plassey.) To his duty he sacrifices all: the life of his child, the love of his wife, his honour and his reputation. But he establishes British control over Southern India, and when Suraj-ud-Dowlah, Nawab of Bengal (Mischa Auer) threatens this control, Clive marches against him and defeats him at Plassey. Suraj is only glimpsed briefly and then it is as a half-insane tyrant, whipping his dancing girls as he perpetrates the Black Hole of Calcutta, thus providing an effective contrast to our hero. Plassey is seen as establishing peace and prosperity and bringing Clive's work to an end.

He returns home but conditions in India deteriorate. A régime of corruption and extortion prevails, sanctioned by the greedy and self-interested officials of the East India Company. Clive's work is threatened. So he goes out again to stamp out the abuses and he treads on so many vested interests that there is a mounting campaign against him in England. He returns to answer the charges of his enemies before parliament. Colman delivers a moving speech: 'I have done what I have done for India and for my country. It has cost me what I hold most dear. This action is unworthy of the British people. When they come to decide on the question of my honour, I trust that they will not forget

their own.'

But the vote goes against him and he returns home, alone, ill, broken. The film, however, ends on an upbeat note. Clive's wife (Loretta Young) having heard the speech, returns to him, and the Prime Minister, the Earl of Chatham (the obligatory C. Aubrey Smith) arrives to tell him that although parliament has passed a vote of censure, 'King George desires me to tell you that he remembers with gratitude that you have added a great new dominion to the Empire.' This makes everything worthwhile and the film ends with 'God Save the King'.

Clive is idealized as a 'man of destiny', a paladin of Empire, doing battle against native tyrants who oppress their own people and hamper British expansion, and against vested interests which offend against the basic Imperial principles of disinterested and just administration. It is his work, as King George's words confirm and as the titles after Plassey tell us: 'What happened at Plassey will live forever as a monument to one man's courage, and revenge for the Black Hole of Calcutta.'

The archetypal Victorian hero of Empire, however, was Charles George 'Chinese' Gordon, Gordon of Khartoum, the true 'Christian Soldier', who came to the screen in Basil Dearden's *Khartoum*, filmed on location in the Sudan in 1966. Aided by a literate script from Robert Ardrey, author of *African Genesis* and *The Territorial Imperative*, it became yet another triumph for that generally under-rated actor, Charlton Heston, who gave a superb performance as Gordon, the mystic patriot, the man who knew no fear, the idealist who waged a one-man war against slavery. Heston contrived to act Laurence Olivier, playing the Mahdi as a sort of poor man's Othello, right off the screen.

The film opens spectacularly with the massacre of Colonel Hicks and his army in the Sudan. The government of W. E. Gladstone (Ralph Richardson) in London is confronted with popular demands for vengeance. But Gladstone is adamant. He will not send a British army down the Nile. ('I will not undertake a British obligation to police the world.') But a solution is offered. He will satisfy public opinion by sending one man – General Gordon, the man who had stamped out the slave trade in the Sudan, who had led the armies of the Emperor of China to victory armed only with a swagger stick, a man who was already 'a hero to the Sudanese, to the English, to the anti-slavery people, to the churchmen and to Her Majesty herself'. Although he has reservations about Gordon ('I don't trust any man who consults God before he consults me'), Gladstone sends him, ordering him to go to Khartoum, evacuate the Egyptians and retire. He warns him that he will receive no official backing.

As it is with Clive, so it is with Gordon, a case of a hero pushing forward the bounds of Empire in spite of the failure of the men of little faith at home to support him. Gordon is indisputably a man of destiny. He travels to Khartoum and fortifies the city. For he cannot leave the Sudanese to their fate. ('I am not a loving man but I love this country.') He sends appeal after appeal for aid, but Gladstone refuses to act until it is too late. Then he sends Sir Garnet Wolseley (Nigel Green) down the Nile with an expedition that cannot possibly reach Khartoum in time.

There are two scenes which strikingly illustrate the incredible charisma of Gordon. The first is the scene of his arrival in Khartoum where he is rapturously received by the populace and picks up and carries on his shoulder a little native girl, symbolic of his assumption of the white man's burden to defend the oppressed against the oppressor. The second is at the end. As the Mahdi's troops swarm into the city, Gordon appears at the top of a flight of steps and slowly descends, his hand outstretched. The shrieking soldiers fall silent and stare at him, mesmerized. Then suddenly one of them flings a spear, the spell is broken and they swarm over him. Gordon dies but his legend lives on and his death is the prelude to the eventual British occupation of the Sudan and the establishment of Law and Order.

Another Christian hero of Empire who caught the imagination of the Victorian public was Dr David Livingstone, missionary and explorer. A respectful but

Gods and heroes of Empire
79 Ronald Colman as Clive of India
80 (below left) Charlton Heston as Gordon of Khartoum
81 (below centre) Spencer Tracy as Henry Morton Stanley
82 (below right) Irene Dunne as Queen Victoria

episodic and generally uninspiring account of his life, called simply *David Livingstone*, was produced in Britain in 1936. It features an impressive performance from Percy Marmont in the title role. Dedicated to 'the memory of a great man', it recounts his call to missionary work, his trip to Africa, his marriage, the burning of his mission station by slave traders, his escape and return to England, where he receives an interview with Queen Victoria. He returns to Africa with his wife, leaving their children behind. She dies and he goes on alone. He discovers the Victoria Falls, disappears into the interior, is found by Stanley and dies in the service of the people he has loved and served. It shows yet again dedication to Africa and the sacrifice of personal happiness for the Cause.

It was completely eclipsed by 20th Century-Fox's lavish and professional *Stanley and Livingstone*, made three years later (1939). Safari sequences were filmed in British East Africa, in stunning locations with spectacular native and animal footage. This was then integrated with footage of the actors, filmed in the Fox Studios in Hollywood.

Immaculately directed by Henry King, the film tells of the expedition of Henry M. Stanley (Spencer Tracy) in search of Livingstone (Cedric Hardwicke). After surviving fever, native attacks and wild animals, Stanley finds the doctor and stays with him, learning to admire his many activities: his medical ministrations, his mapping of uncharted territories, his cataloguing of flora and fauna, his conversion of the heathen to Christianity, winning over a thief to honesty by love and not fear. One of the most inspiring scenes in all cinema is that of Livingstone conducting his African choir in 'Onward Christian Soldiers'.

In due course Stanley returns to London with Livingstone's maps but there is a growing feeling that they are forged and that he never found Livingstone at all. Stanley defends himself in an impassioned speech to the Royal Geographical Society. But the vote goes against him and he is just leaving the hall when word arrives that Livingstone has died and his body has been brought into Zanzibar with a last message for Stanley.

Stanley is acclaimed by the meeting and returns to Africa to continue Livingstone's work.

The film exalts dedication to Africa, that all-consuming love of the country and sense of duty to it that Gordon also embodied. John Kingsley, the British Consul in Zanzibar (Henry Travers) envies Stanley his safari and speaks longingly of safaris which his health forbids him from taking. He loves Africa. 'It is in his blood,' his daughter says. But at fifty he is already an old man, sick and broken by the climate. None the less he refuses to go home to England, preferring to stay in the land he loves. Similarly Livingstone, though racked by fever, continues his work. His life's work has been to map Africa. 'White men have only seen Africa through eyes of ignorance – and that means fear,' he says. He wants to remove that fear with maps, so that doctors and teachers and pioneers will come and slavery will be abolished, and the word of the brotherhood of man spread.

Cedric Hardwicke is magnificent as the doctor, living alone in the middle of Africa, sustained only by his own spirit and his faith in God. The last shot of him standing alone on a hilltop as Stanley's safari leaves for home symbolizes his loneliness and his destiny. After meeting him, Stanley becomes imbued with much the same spirit. Friends remark on how much like Livingstone he acts and sounds. The film ends with Stanley, his faithful guide, garrulous and grizzled Walter Brennan, and their native bearers marching across the map of Africa to the strains of 'Onward Christian Soldiers'. Spencer Tracy's playing, like that of Hardwicke, is inspired and their portraits of Stanley and Livingstone are definitive: sincere, idealistic, animated by a spiritual fervour which is as real as it is undemonstrative.

The myth-makers were on rather more difficult ground with the life of Cecil Rhodes because of his deep involvement in power politics and profit-making, both activities beneath the contempt of the genuine Imperialist. But in *Rhodes of Africa* (Berthold Viertel, 1936), they made a reasonably

Mythic moments of Empire

83 (right) Clive of India (Ronald Colman) about to sign the document that will ensure British control of Bengal (*Clive of India*)

84 (below left) 'Dr Livingstone, I presume.' Cedric Hardwicke and Spencer Tracy in *Stanley and Livingstone*

85 (below right) Cecil Rhodes (Walter Huston) acquires Rhodesia from the Matabele (*Rhodes of Africa*)

successful attempt to deify Rhodes, though the result admittedly lacks the sweep and conviction of its Hollywood counterparts like *Clive* and *Stanley*.[2]

It opens in 1870 with the discovery of diamonds and the diamond rush. Among the prospectors is Cecil Rhodes (Walter Huston) who is informed by his doctor, Jameson (Basil Sydney), that he has six years to live if he takes it easy. 'So much to do, so little time to do it,' replies Rhodes and he tells Jameson of his dream: to unite Africa and people it with English settlers. England must expand or perish and Africa is the answer for her: 'Vast, empty, magnificent, fertile.' Empty? One might ask what about the Africans – but that would interfere with the image.

Ten years later Rhodes has acquired control of the Kimberley Diamond Mines and this gives him effective control of ninety per cent of the world's diamonds. At a board meeting, standing before a great map of Africa, Rhodes declares that it is his intention to use his wealth to extend British influence northwards. He talks of his dream of a railway to run from the Cape to Cairo. The directors oppose the plan, seeking to concentrate on profit-making; but one of them, Barney Barnato, prophetically observes: 'I have a fancy for diamonds. Mr Rhodes has a fancy for continents and he will get his way.'

Rhodes goes north and so impresses King Lobengula with the force of his personality that he signs over all the mineral concessions in Matabeleland to Rhodes. Rhodes goes to see President Kruger (Oscar Homolka), the leader of the Boers, whom he has outwitted in getting the mineral concession, to try and establish peaceful conditions, but Kruger, suspecting him of the murder of his agent, refuses to treat with him. Rhodes predicts that because of this refusal to treat there will one day be war between the English and the Boers.

Rhodes becomes Prime Minister of the Cape. A horde of prospectors descends on Matabeleland and the young Matabele warriors, whom Lobengula is no longer able to control, attack an English patrol. Dr

Jameson cables Rhodes for permission to take punitive action. As the telegram arrives, Rhodes is giving an interview to a young writer, Anna Carpenter (Peggy Ashcroft), telling her how South Africa means more to him than anything in life and how he wants to tend and educate the natives. ('I always think of the natives as children.') But if they misbehave, they must be punished. He telegraphs Jameson to act. This sparks off the Matabele War. It is not shown because of the impossibility of staging full-scale battle scenes with African extras. It was felt in the thirties that there was too much danger of native extras getting out of hand and turning the mock battle into the real thing. So *Rhodes* and, similarly, *Sanders* are without scenes of pitched battles, even though the script calls for them.

Rhodesia is born, but it proves to have no gold. There is gold in the Rand and English miners go there but are discriminated against by Kruger, although they are numerically superior there to the Afrikaaners. They petition for redress of grievances and Kruger rejects their address. So they go to Rhodes and ask him to intervene on their behalf. He allows a column of pioneers to move to the frontier under the command of Jameson but forbids them to cross. Jameson disobeys and invades (the famous Jameson Raid) only to be captured. Rhodes feels that he has no other course open but to resign all his offices; he goes as a suppliant to Kruger to plead for the life of his friend. Titles tell us that a few years later the war Rhodes had predicted comes, but from it the Union of South Africa springs. Rhodes does not live to see it. The film ends with him on his deathbed, muttering: 'So much to do, so little done.' He is buried in the Matopa Hills, saluted by Matabele warriors. 'Living he was the land and dead his soul shall be her soul,' says the narrator as the camera tracks in to a close-up of his epitaph which reads simply: 'Here lie the remains of Cecil John Rhodes.'

The film is a classic case of cinematic whitewashing. It plays down certain elements and plays up others to create the image it seeks. The titles indicate what elements these are, proclaiming before the

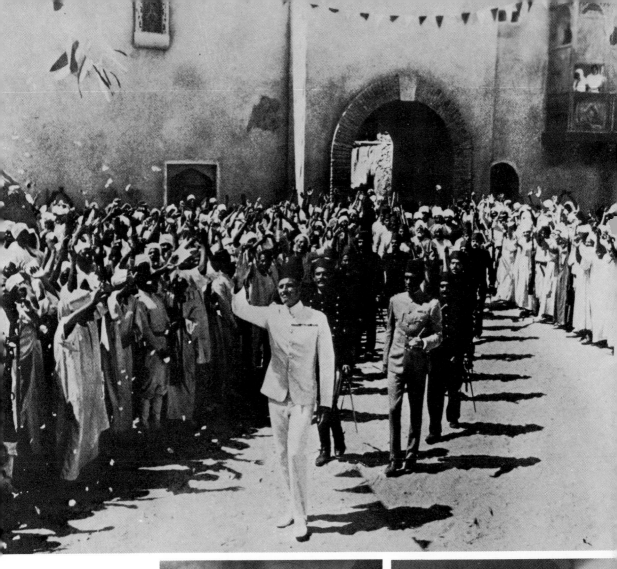

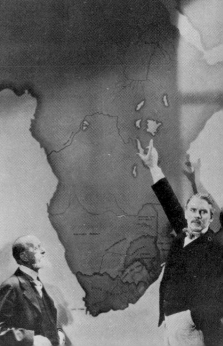

86 (above) General Gordon enters Khartoum in triumph (*Khartoum*)
87 (below left) The martyrdom of General Gordon (*Khartoum*)
88 (below right) Rhodes plans the Cape to Cairo Railway (*Rhodes of Africa*)

film begins that it is:

> The drama of a man who set out single-
> handed to unite a continent. He spared
> neither himself nor others. Hailed by
> some as an inspired leader, by others as
> an adventurer. To the Matabele, he was
> a royal warrior, who tempered conquest
> with the gift of ruling and who gave him
> at his death the royal salute 'Bayete'.
> They came close to understanding him.

First, his dream is continually emphasized.
He describes it early in the film and it lies
behind his acquisition of the mines; later he
is seen as explicitly rejecting the directors'
obsession with profit in favour of his own
expansionist plans. He is guided by it in
times of triumph and sustained by it in
times of stress.

Second, his love of the native is empha-
sized. They love him, call him 'Great White
Father', salute him on his death. He loves
them and cares for them. On the other hand,
the Matabele are shown as provoking the
war which destroys them, Jameson is blamed
for the Raid and Kruger is blamed for the
Boer War, which occurred because he refused
to treat with Rhodes. The acquisition of the
De Beers Co., the Matabele Wars and Rhodes's
dealings with the miners in the Rand are all
firmly played down. There is a concession
to criticism in the person of Anna Carpenter,
who writes a book attacking his conduct of
the Matabele Wars. But she remains con-
vinced that he is a great man.

Both Lobengula and Kruger are sympa-
thetically, even likeably, portrayed, but they
are lesser men than Rhodes. Lobengula is
subdued by the force of Rhodes's charisma.
Kruger, a canny, pipe-smoking, old Dutch
farmer, longs for peace but clings obstinately
to the past and is blinded to Rhodes's true
worth by the suspicion that he is a mere
adventurer. By contrast Rhodes is depicted
as a believer in action now in the interests of
progress, and his record as Prime Minister –
sound education and financial policies and a
fair native policy – backs this up.

The emphasis is undoubtedly on the heroic
aspects of Rhodes. Inspired by a dream of
epic proportion, he battles with Death to
gain time to make it reality. He accom-
plishes much, and at the end – and this is
clearly what the last scene and the words of
the narrator mean – he achieves that im-
mortality which is accorded to all great men
of the Empire.

The death of the god king is one of the
recurrent elements of all mythologies. Be
he Christ or Osiris or Dionysus, the god king
dies that his people might live. The gods of
Empire have common characteristics (dedi-
cation, loneliness, the inspiring dream) and
a common destiny: death. Clive's meta-
phorical death, with his vote of censure,
leaves him a broken man. Gordon is
murdered. Livingstone and Rhodes wear
themselves out and die in the service of their
countries, native and adopted. Their blood
and their strength are subsumed into the
living, growing body of the Empire. They
have become one with the thing they served.

Benjamin Disraeli was too wily and too
Jewish to be a Christ-figure. But he holds a
special place in the Imperial portrait gallery.
Although, as Robert Blake has observed,
Disraeli says 'tantalizingly little about his
concept of Empire',[3] in the mythology of
Empire he is seen as the harbinger of
Britain's greatest era. He is the man who
acquired the Suez Canal, who crowned
Victoria as Empress of India and who made
Britain and the world aware of our Imperial
destiny. He has been memorably incarnated
for three successive generations of filmgoers
by George Arliss, John Gielgud and Alec
Guinness.

For the older generation of filmgoers,
George Arliss was Disraeli, just as he was
also Alexander Hamilton, Cardinal Richelieu
and Voltaire. He made two film versions, one
silent and one sound, of Louis Parker's play
Disraeli, which was one of his favourite stage
vehicles. For the 1929 *Disraeli*, he received an
Oscar as best actor of the year. The film
centres on Disraeli's bid to secure the con-
trolling shares in the Suez Canal in order to
gain control of the sea route to India. The
Russians plot to prevent him, ruining the
bankers whom he plans to use. However,
Disraeli coerces the Governor of the Bank of
England into coming to his assistance and

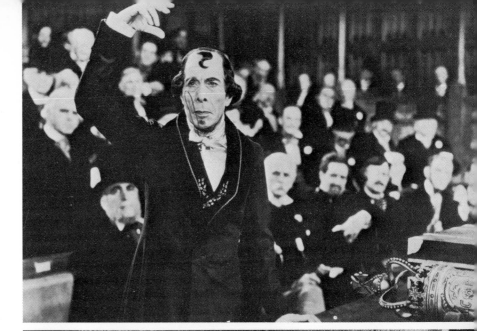

Disraeli – 'the impresario of Empire'
89 (above) Disraeli –
George Arliss style
(*Disraeli*)
90 (centre) Disraeli –
John Gielgud style
(*The Prime Minister*)
91 (below) Disraeli –
Alec Guinness style
(*The Mudlark*)

carries the scheme through successfully.

Disraeli is totally uncinematic, little more than a photographed stage play, but it survives the years on the strength, precision and control of Arliss's performance in the central role. If Disraeli was not like Arliss, then one feels that he ought to have been. For Arliss is totally convincing in his genial egotism ('She thinks I'm the greatest man in the world. She's quite right'), his epigrammatic wit ('The less a Prime Minister does, the fewer mistakes he's likely to make. I must remember to say that to Gladstone one night in the House') and his fervent patriotism ('With India lost, England crumbles into insignificance, a Belgium at sea'). He constantly scores off the stiff and humourless juvenile lead, Lord Deeford (Anthony Bushell), whom he sends up unmercifully but whose romance with Lady Clarissa (Joan Bennett) he takes time out to repair. It is a vehicle film of the kind one rarely sees any more. Its big speeches and throwaway lines are alike tailored to the personality of its star and Arliss delivers them with relish, enjoying himself hugely, whether posing as an ailing invalid to deceive a glamorous Russian spy or delivering a thundering ultimatum to the Governor of the Bank of England.

It is Disraeli the Imperialist which the film glorifies. At the outset one of his enemies describes him as 'a dreamer, a dangerous visionary, reaching out for Empire with greedy hands', and the entire action of the film is built around this interpretation. The film culminates in a triumphant reception to celebrate the acquisition of the Canal. As the National Anthem strikes up, double doors are flung open and we get our first and only glimpse of Queen Victoria, waiting to receive Disraeli and enthroned at the far end of the room like some massive idol at whose feet Imperial tribute is to be laid.

During the war, Disraeli was revived as a morale-booster in Thorold Dickinson's characteristically painstaking and impressive *The Prime Minister* (1940). The film traced the career of Disraeli (John Gielgud) from 1837 to 1878 and included the Chartist riots, his marriage to Mary Anne Wyndham Lewis,

his rivalry with Gladstone and his conduct over the Russo-Turkish War. Its most important theme, however, was Disraeli's concern to warn Britain of the menace of Germany in Europe. In the climactic sequence of the film he outwits Bismarck at the Congress of Berlin to achieve peace with honour and save England and the Empire.

Soon after this, *Young Mr. Pitt* sought to show William Pitt (Robert Donat) warning Britain against the threat of the dictator Napoleon and leading Britain to victory, and *Lady Hamilton* had Nelson (Laurence Olivier) doing the same thing. In both cases France is clearly meant to equal Germany and Napoleon Hitler, though Dickinson's film was on even safer ground in equating Hitler with Bismarck because the Germans had done so in their own films. It is all given added piquancy by the fact that Disraeli was Jewish as well as British, which would, to the Nazis, seem like a case of adding insult to injury. After the war, Alec Guinness brilliantly played Disraeli in *The Mudlark*, in which he not only got his reforming legislation passed but also got the Queen to come out of seclusion. In all the Disraeli films the same image is conveyed, the popular image of the brilliant, witty, unpredictable Conservative Prime Minister who runs rings round his opponents while shepherding Britain towards greatness.

While there were many gods and heroes in the Imperial pantheon, there was only one goddess – the Queen. Her position was succinctly described by Gwilym Morgan, head of the Welsh mining family in John Ford's *How Green Was My Valley*. When his son, Ivor, is invited with the Choir to sing before the Queen at Windsor Castle, he leads the village in prayer for her safety before they all sing the National Anthem. He says: 'O God, you are our father but we look to the Queen as our mother.' She was indeed the Mother Goddess, the Great White Queen. Lord Curzon remarked on the potency of the myth of the great Queen: 'The British government, the monarchy and the Empire were summed up and symbolized in the mind of the Oriental by the personality of the Queen.'[4]

It was never quite the same Empire after she died, In *The Rains Came* (Clarence Brown, 1940), set in 1938, Tom Ransome (George Brent) drinks a toast to a statue of Queen Victoria, which he describes as 'A living reminder of the fine brave days before the world went to seed, before the bombs started dropping, when all Americans were millionaires and people still danced in Vienna and we weren't concerned with dictators and appeasement.'

That was how it seemed, as war engulfed Europe. Although the Old Queen had only been dead for thirty-nine years, she was already a myth. Indeed, she had been a myth even while she was alive. At least one chieftain is recorded as believing that she never existed and had been invented by the British simply to keep the Empire in order. It certainly did that. The wrath of the Great White Mother was invoked by the Canadian mountie heroes of *Northwest Mounted Police* (Cecil B. DeMille, 1940) and *Macdonald of the Canadian Mounties* (Joseph M. Newman, 1953) to hold rebelling tribes in check.

The definitive hagiographical account of the Queen is in Herbert Wilcox's two films *Victoria the Great* (1937) and *Sixty Glorious Years* (1938), which enshrine two fine performances from Anna Neagle as Victoria and Anton Walbrook as Albert. Both films have the ritual formality of a pageant or perhaps a mystery play, detailing, stage by pre-ordained stage, the progress towards deification. Many scenes allegorically represent one or other of the divine virtues (Compassion, Dedication, Peace), and the loss of the Consort, who wears himself out in the service of the Empire, emphasizes the loneliness and destiny of the Great Mother. Her central place in the pantheon is emphasized by the appearance in the two films of almost all the great myth figures of the age, who are seen to revolve around her: Wellington, Palmerston, Gordon, Disraeli, Rhodes.

Victoria the Great covers her proclamation, coronation, courtship and marriage and deals largely with her partnership with Albert in the administration of affairs. Victoria and Albert back Sir Robert Peel in his bid to repeal the Corn Laws so that the people can have bread, even though powerful vested interests and large sections of Peel's own party oppose it. Victoria and Albert stand for peace and oppose Palmerston's warlike policy, preventing at the eleventh hour the dispatch of a telegram to President Lincoln, so worded as to provoke inevitable war with the United States. But then Albert dies and Victoria goes into seclusion at Windsor, causing mounting popular protest, until Gladstone convinces her that Albert would not have wished it and she therefore resumes her duties.

In 1877 she is proclaimed Empress of India and accepting the title she makes a speech perfectly in keeping with her image, to the strains of 'Land of Hope and Glory' on the soundtrack. She says it is her greatest wish to see her new subjects on an equality with the other subjects of the crown. She greets the assembled representatives of the Empire and tells them that she feels neither a Queen nor an Empress but the mother or grandmother of a great family and that is the proudest title of them all: 'For the British Empire is one of the greatest families of mankind, which if it remains true to the principles on which it was founded: democracy, tolerance, freedom, may well move the destinies of the whole world.' This of course assumes that the British Empire was founded on the principles stated, which is debatable as far as history is concerned but is central to the myth. The speech scene is the film's climax. The next scene is the last. The Queen on the steps of St Paul's acknowledges the cheers of her subjects on the occasion of her Diamond Jubilee. 'May God bless all my people,' she declares.

Sixty Glorious Years was virtually a remake, in Technicolor this time. It chronicled Victoria's marriage and family life, the opening of the Great Exhibition, the repeal of the Corn Laws, the purchase of the Suez Canal, the Crimean War, the death of the Prince Consort, the retirement at Windsor, the death of Gordon at Khartoum, the Diamond Jubilee and the death of the Old Queen.

But where *Victoria the Great* had tended to concentrate on the relationship of Victoria

The Great White Mother

92 (above) Queen Victoria (Anna Neagle) proclaimed Empress of India (*Victoria the Great*)

93 (above right) The Diamond Jubilee (*Victoria the Great*)

94 (right) Queen Victoria (Mollie Maureen) rejecting the use of a British secret weapon to maintain Imperial naval supremacy (*The Private Life of Sherlock Holmes*). Robert Stephens and Christopher Lee

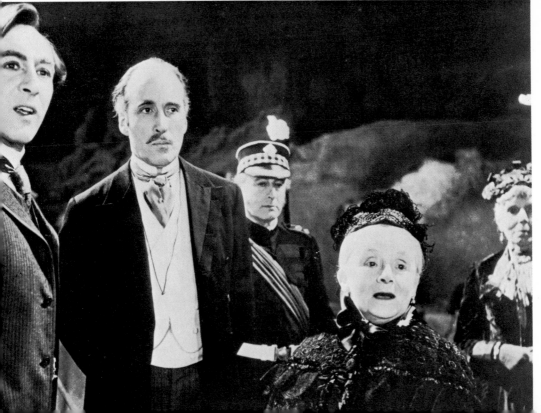

and Albert, *Sixty Glorious Years*, as its title implies, broadened the scope to become much more a portrait of the age, or more accurately of those aspects of the age that fitted the myth (the Great Exhibition, Gordon's Death at Khartoum and the Charge of the Light Brigade). The inclusion of scenes of the royal couple and their children, absent from the previous film, gives a more rounded view of the family life and enables the film-makers to inject rather more humour than there had been in *Victoria the Great*.

The Crimean War section particularly impresses, including a very moving little scene in which the Queen visits injured soldiers at Chatham and weeps as the crippled and dying cheer her, and a revealing scene in which the Queen presents the first Victoria Crosses and receives Florence Nightingale with the words: 'We women were not meant for governing. But you have given us a stirring example of what our mission should be.'

Where *Victoria* ended on the triumphant note of the Jubilee, *Sixty Glorious Years* ends more appropriately with the Queen's death. Newspaper headlines announce that the Queen is dying and we get a cross-section of reactions: an old couple in their living room, a flower-seller in the street, politicians in their club, all lamenting the passing of their Queen and of her age. ('Sometimes narrow in mind but great in spirit.') Victoria sends for her son, holds out her hand for him to kiss and dies. Bells toll the sad news, the old flower-seller weeps and the camera tracks slowly into the coffin; Kipling's lines flash on the screen:

> The tumult and the shouting dies,
> The captains and the kings depart,
> Still stands Thine ancient sacrifice,
> A humble and a contrite heart,
> Lord God of hosts be with us yet,
> Lest we forget, lest we forget.

The great Queen reappeared in a charming little anecdote *The Mudlark* (1950), affectionately written by Nunnally Johnson, sensitively directed by Jean Negulesco and exquisitely photographed by Georges Perinal. Irene Dunne played Queen Victoria, and her casting caused a furore in Britain, firstly because she was American and secondly because she wasn't Anna Neagle. As a result the film flopped as did Miss Dunne's career, which is a pity because she is really rather splendid. The plot centres squarely on the myth of Victoria as the Widow of Windsor. When the film opens she has been in seclusion for fifteen years, mourning for her dead consort, and popular discontent is growing. Disraeli, as played by Alec Guinness an engaging and believably brilliant statesman, attempts to persuade the Queen by a mixture of dry wit and gentle flattery to reappear in public in order to demonstrate her support for his Reform programme, which is being put through parliament with her support, but is poised on the brink of defeat. He fails, but the Queen is awakened to her responsibilities by the devotion of the mudlark, Wheeler (appealingly played by Andrew Ray), who sneaks into Windsor to see her, is arrested as a 'dwarf assassin' and imprisoned in the Tower.

Wheeler becomes one of the major unknown forces in British history. For Disraeli, cashing in on the publicity his case has aroused, makes a major speech, quoting him as the sort of waif his Reform Bill will rescue from destitution, and triumphantly carries the day. The Queen, prompted by the episode, decides to resume her position as the Mother of England and the film ends with her first public appearance in years, cheered to the echo by delighted crowds.

The film contains some marvellous scenes, such as Disraeli attempting to explain to the Queen that someone has put a 'To Let' sign outside Buckingham Palace; and the scene of the intimate dinner party, at which the Queen is horror-struck to hear someone snoring as she relates an anecdote. While besides Miss Dunne and Mr Guinness, the film also contains the redoubtable Finlay Currie, giving a definitive performance in a role he was born to play: the plain-speaking and hard-drinking Scots gillie John Brown.

Of late, with the advent of the permissive society, the Victoria myth has come in for some (albeit gentle) debunking. In the amusing *The Wrong Box* (Bryan Forbes, 1966)

the old Queen (Avis Bunnage) accidentally slices off the head of someone she is knighting. In the unamusing *Jules Verne's Rocket to the Moon* (Don Sharp, 1967), the old Queen (Joan Sterndale Bennett) cuts the ribbon to open a new suspension bridge only to see the bridge collapse. But she returns triumphantly to form and myth in Billy Wilder's delightful *The Private Life of Sherlock Holmes* (1971). The diminutive Queen (Mollie Maureen) is shown the new British secret weapon, the submarine, and declares it to be 'unsportsmanlike, unEnglish and in downright poor taste'; she orders it to be destroyed. She is horrified to learn that it is to be used as a weapon of war, to fire at other ships from underwater without warning and without even showing the flag. She says: 'Sometimes, and this is one of them, we despair of the state of the world. ... What will these scientists think of next.'

How true those words are, even today. Long may the wise old lady continue to reign over her cinematic realm.

The incorporeal god of the Empire was steam. One of the cult mysteries of the Imperial age was the growth of the railways and an interesting sub-genre of the cinema of Empire is provided by the Imperial railway film. The nineteenth century was pre-eminently the age of the railways. They were a symbol of the industrial might and technological development of Victorian England. There was something strangely romantic about them. They seemed to be the instruments provided by Providence to link up the Empire. Cecil Rhodes dreamed of a Cape-to-Cairo railway to bind Africa together under the Union Jack. The building of the East African railway, in the face of plague, drought, man-eating lions and hostile natives constituted a technological epic of Empire, which the cinema has utilized, though not as yet in the production of a major work.

Several films took their inspiration from J. H. Patterson's celebrated book, *The Maneaters of Tsavo*. *Men Against the Sun* (Brendan J. Stafford, 1953), filmed entirely on location in Kenya, detailed the commencement of the railway in 1890. Engineer John Hawker (John Bentley) is persuaded by missionary Father Dowling (Liam O'Leary) to undertake the surveying of the railway route, on the grounds that such a railway will open up East Africa to trade and settlement and help stamp out the slave trade. Progress is impeded by two man-eating lions, who are eventually killed.

Bwana Devil (Arch Oboler, 1952), which achieved a certain notoriety as the first of the 3D films, dealt with the same events, having engineer Bob Hayward (Robert Stack) kill the man-eaters. *Killers of Kilimanjaro* (Richard Thorpe, 1959) had gallant engineer Robert Adamson (Robert Taylor) battling for the East African railroad against wild animals and slave traders who are persecuting the natives. *Drums of Africa* (James B. Clark, 1963) had gallant engineer Brian Moore (Lloyd Bochner) and canny old white hunter Jack Courtmayn (Torin Thatcher) defeating a gang of slave traders, persecuting the local natives.

None of these films could by any stretch of the imagination be called great. In fact, they are barely memorable, and *Men Against the Sun* is so bad that at times it looks like a home-movie. In spite of this they all reflect a common mythos. The theme which unites them to each other and, as rather shabby acolytes of the god steam, to the films glorifying other shining Imperial gods: Clive, Gordon, Livingstone and the Queen, is a deep hatred of slavery. The railway is invariably seen as the British secret weapon in the battle against the slave trade. In a wider context, the suppression of the slave trade is put forward as the reason for a British presence in East Africa. The British are there, not to further their own ends, but to protect the natives from the wicked Arab slavers. The films thus harmonize completely with the line pushed by the contemporary exponents of British rule in East Africa, such as Sir Harry Johnston, Sir Frederick Lugard and Sir John Kirk, and by the apologists of Empire, both earlier, such as Sir Charles Dilke, and later, such as Sir Reginald Coupland. Interestingly, the charter of the Imperial British East Africa Company contained the stipulation that one of the company's obligations was the suppression of

the slave trade. The railway, then, is a symbol of the march of progress and freedom – but of an Imperial progress and freedom.

The railway serves also to unify Canada. Gaumont British devoted one of their Imperial epics, *The Great Barrier* (Milton Rosmer, 1936), to the building of the Canadian Pacific Railway. Drama comes when they run up against the seemingly impenetrable Barrier of the Rockies, but it is eventually surmounted and the railway runs triumphantly on to the sea. *Canadian Pacific* (Edwin L. Marin, 1950) stresses the fact that the railroad is planned in order to bind British Columbia, which is threatening to secede, closer to the rest of Canada. The railroad is opposed by the half-breed settlers, who fear the coming of progress, civilization, law and order, which the railroad will bring and which will destroy their traditional way of life. So in Canada, as in East Africa, Imperial order is seen to travel with the train. Like the warrior gods, the god steam has played his part in the fulfilment of the Imperial destiny.

Notes

1 Edmund Gosse, 'The Agony of the Victorian Age', *Edinburgh Review* 228 (1918), p. 295.
2 Rhodes was to have been played by George Arliss but he declined the role on the grounds that he looked nothing like Rhodes. In the event Walter Huston who eventually played the part looked even less like Rhodes than Arliss did. See George Arliss, *George Arliss by Himself* (1940), p. 215.
3 Robert Blake, *Disraeli* (1969), p. 523.
4 Michael Edwardes, *High Noon of Empire* (1965), p. 125.

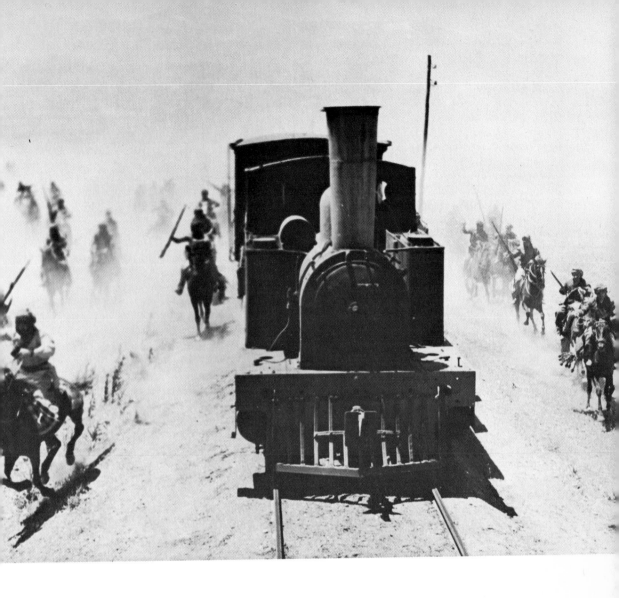

Steam – the incorporeal god of Empire.
95 The railway train attacked by rebels in *Northwest Frontier*

Officers and Other Ranks

As Professor Andrew Thornton has written, 'England's history is a history of a certain tradition and practice of government – a tradition of successful paternalism.'[1] It has based itself squarely on that natural conservatism and deference to authority which have long been ingrained in the British people. The governing classes have continued to govern because they have known just when to give way and how much to give way, how far to widen the charmed circle of power.

As we have seen in a previous chapter, each class had its own graded hierarchy. The same applies to the army. Some officers might rise from the ranks, just as some individuals rise from their own class and attain higher things. But they are exceptions which prove the rules of society. The trailer to *Forever England* describes the mother of the hero, ordinary seaman Brown, in the following terms: 'She was of humble origin – but she had the spark of greatness.' The implication is that the lower down the scale you are, the rarer the occurrence of greatness. This encourages the practice of paternalism. The paternalism of the army took the form of a headmaster-pupil relationship between senior and junior officers; and the feeling of responsibility towards the lesser orders which characterized the attitude of officers to other ranks. In both cases it accurately reflects the public school background of the officers.

There are very definitely officers and other ranks, and, in between, N.C.O.s. Each class conforms almost inexorably to an archetype. Each knows his place and keeps to it. The archetype characterizations are perfectly summarized by George Pearson, in his description of the characters in R. C. Sherriff's *Journey's End*, the film version of which he supervised in 1930:[2]

Lt Stanhope – a strong man afraid of being afraid, drinking to forget and only the love of a woman keeping him from giving way to fear.

Lt Osborne – schoolmaster and visionary, reading *Alice in Wonderland* while shells burst outside his dugout, but when ordered to lead a raid that means certain death, obeying with calm and a flow of trivial conversation.

2nd Lt Trotter – a cockney risen from the ranks, who thinks more of the apricots for supper than of saving his life, talks only of his 'missus' at home, his garden and the height of his hollyhocks.

2nd Lt Raleigh – straight from public school where he had been with Stanhope, whom he hero-worships, but arriving to find his god a whisky sodden churlish brute, but unaware of Stanhope's reason for resentment against him. Raleigh's sister was the girl whom Stanhope loved; it was fear that the boy might write to her of his drunken downfall that had embittered him.

Pvt Mason – cockney servant, his only problem how to keep the taste of onion out of the tea. His one aim to make bully beef look different.

2nd Lt Hibbert – cowardly, malingering, but eventually proving as brave as any when he conquers his cowardice and faces death.

Here it all is, in a nutshell: the stereotypes, lower class obsessed with tea and hollyhocks, upper class with the burden of command. Stanhope, of course, sticks to it. ('It's ... it's ... the only thing a decent man can do.') E. C. Mack has called it 'probably the most

effective propaganda for the English upper classes written in our time'.[3]

Officers and Gentlemen

The officers are generally the product of the public school system. The ultimate exposition of the public schoolboy at war is the early sound film, *Tell England* (1930), adapted from Ernest Raymond's book by Anthony Asquith and A. P. Herbert and directed by Asquith and Geoffrey Barkas. Presumably Barkas, who subsequently handled all the location shooting for the Gaumont British programme of Imperial adventures, *King Solomon's Mines*, *The Great Barrier*, *Rhodes of Africa* etc., directed the location sequences (in which Malta substituted for Gallipoli) and Asquith handled the actors. The film took more than a year to make, utilized a cast of 8,000 and received full Admiralty co-operation.

At first glance the film might appear to be pacifistic, but a more detailed examination reveals it as nothing of the sort. While the Germans (*Westfront 1918*) and the Americans (*All Quiet on the Western Front*) were making eloquent denunciations of war and the horrors of the trenches, the British were glorifying patriotic sacrifice and the public school code of the officer and gentleman in *Tell England*.

The film opens in 1914 and establishes the characters of its leading figures, close friends and pupils at the same public school (Kensingstowe). They are called, symbolically, Edgar Doe (Carl Harbord) and Rupert Ray (Tony Bruce). The first scene has the two boys out swimming on an idyllic English summer day. 'I'm going to dive orff the top of the weir,' says Edgar. 'Don't be an ass,' replies Rupert. But Edgar dives and after alarming his friend by pretending to have drowned, pops up declaring: 'It was a ripping dive' and the two of them proceed to tea with Edgar's Madonna-like mother Mrs Doe (Fay Compson), who represents the feminine interest in the film. The boys are devoted firstly to each other and secondly to her. There is no one else: Edgar is picked for the school swimming team and wins, watched by Rupert and Mrs Doe. But over the cheers of the crowd the tolling of bells is heard – signifying the outbreak of war.

Rupert and Edgar become second lieutenants and are introduced to the gruff Commanding Officer (C. M. Hallard). His first question is 'What school?' The boys tell him and he replies: 'I was there myself' and invites them to join him in a game of bridge one evening. His one piece of advice is: 'You know the rules. Don't forget them. Glad to have you.' He recognizes Edgar as the son of Major Doe, killed on active service, and Edgar recites in Greek (and then in English for the benefit of the audience) the epitaph of the Spartans at Thermopylae: 'Tell Sparta, you who pass by, that we lie here obedient to her command.' This is used to justify his father's death and his own entry to the service.

They are assigned batmen, Sims and Booth, 'comic' lower-class caricatures who drop their aitches and are patronized by the two boys. They represent the smiling, stupid, loyal 'other ranks'. The boys are posted to Gallipoli.

Rupert I say, Gallipoli.
Edgar God, I'm glad.

Assigned twenty-four hours' leave, they return home. Rupert is called into his father's study, offered a drink and wished good luck in a clipped, unemotional manner, understating to the point of formality the emotional feeling between the two. Raymond Durgnat has said of it that this 'scene could be the model for senior-junior relationships in doldrums-era movies about World War II.'

The ship sails for Gallipoli. The colonel wishes his officers good luck and they sing 'For he's a jolly good fellow'. Rupert and some of the younger officers sing 'Annie Laurie'. The pipe-smoking padre and the monocled, expansive Captain Hardy joke and chat. The sequence perfectly summarizes the corporate feeling of the regiment and the delicate balance of ranks within it: the C.O., revered father-figure, the senior officers chatting urbanely, the junior officers singing boisterously.

Once they have landed and Hardy is killed, Rupert is appointed commander of the detachment over Edgar's head. 'It seems so unfair,' says Rupert loyally. 'Oh rot,' replies Edgar, biting his lip but remembering to be a sporting loser: 'You'll do a far better job than I would.' In retrospect, H.Q. were right in their decision (as one would expect – for they are after all, authority) for Edgar cracks up under the strain of war but Rupert does not.

Constant bombardment by enemy cannon begins to get on their nerves. Edgar quarrels with Rupert and accuses him of heartlessness in refusing to pull back the men from a dangerous position. But Rupert cannot: burden of command, orders from H.Q. and all that sort of thing, what? Edgar chats to the men in the trenches: cheerful, illiterate dialect-speaking cannon fodder, who in the next shot are all blown up. Edgar is ordered out on a mission but his nerve is going and Rupert asks Sims to go with him and keep an eye on him. Sims agrees. ('Cor bless you, sir, it's all in a day's work.') When Edgar returns, he reports that Sims has been killed. Edgar takes to drink and, commenting on the Spartan epitaph, he changes 'Tell Sparta' to 'Tell England'. He says he knows what he would like to tell England. We see a montage of barbed wire, explosions and bloody slaughter.

Then Rupert and Edgar are ordered to destroy the big gun that is doing all the damage. The night before they go, they reminisce about the old days and we see, in flashback, an idyllic scene of punting on the river and tea on the lawn. Edgar says, 'If all that should be changed, I'd rather do anything', and he composes a new version of the Spartan epitaph. The next day, Edgar and his group destroy the gun but Edgar is mortally injured. In the hospital tent, he asks the doctor: 'Shall I get well?' The doctor shakes his head. 'Oh well,' replies Edgar cheerfully, 'it can't be helped.' Rupert comes to see him, obviously much moved: 'It was a grand explosion, wasn't it?' 'Ripping.' Rupert returns to his billet and weeps. The British forces withdraw from Gallipoli and the last scene is of two foreign soldiers walking among the crosses of the British dead and seeing carved on one of them, obviously Edgar's, the epitaph: 'Tell England, ye who pass this monument, we died for her and rest content.'

This is the film's moral. The uncompromising newsreel imagery of trench warfare and terrible carnage, the incessant whine of shells and blast of explosions suggest the futility and helplessness that characterized *All Quiet* and *Westfront 1918*. At one point Edgar too expresses this feeling, but only when he is drunk and cracking up. When he comes to himself again, he realizes that war and indeed death, though messy and a trifle unpleasant, are a small price to pay for the preservation of the England of the fine, brave days before the war, the England which they, as public school boys, were produced and trained to defend.

Like the good public school prefect the officer must win the respect of his men, and many films detail this process. To take an example, *The Desert Rats* (Robert Wise, 1953) tells the story of a raw British officer (Richard Burton) put in command of an Australian troop in the Western Desert. At first he antagonizes them by leaving the wounded behind on a raid, threatening courts martial and generally earning himself the reputation of a martinet. But eventually he realizes the importance of lightly-held power and inspires respect. The result is that when ordered to hold a vital position, they hold it, and even when he feels he can't order them to continue, they volunteer to do so out of respect for the officer. The men know what a genuine officer and gent is and respond accordingly. In Anthony Asquith's absorbing court martial drama, *Carrington V.C.* (1954), Carrington (David Niven), a war hero, a gentleman and a horse-riding champion, is accused of embezzlement by his commanding officer, Colonel Henniker (Allan Cuthbertson), a mean, petty and jealous nonentity. The case goes against Carrington but he is encouraged to appeal when the men publicly demonstrate their support for him. There is no doubt in their minds as to who is to blame, for Henniker has demonstrated his fundamental inability to be a real officer

Officers and gentlemen
96 (above) Public
school boys go to war.
Tony Bruce and Carl
Harbord in *Tell England*
97 (below) If they
survive, they will
almost certainly end up
looking something like
Colonel Blimp. Roger
Livesey in *The Life and
Death of Colonel Blimp*

and gent by reprimanding a top sergeant in front of a bunch of recruits, thereby transgressing against the unspoken hierarchic rules of the army.

The true officer and gentleman generally derives from a family with a tradition of service. The Vickers in *Charge of the Light Brigade*, for instance, are 'an old army family' and the Stones in *Bengal Lancer* have been soldiers for generations. But this can be a terrible responsibility if you think about it, as Harry Feversham was unfortunate enough to do in A. E. W. Mason's classic novel of Empire, *The Four Feathers*.

Its popularity is evidenced by the fact that no less than five film versions have been made of it (1915, 1921, 1928, 1939, 1955). The story concerns Lt Harry Feversham, who resigns his commission on the eve of war and is given four white feathers by his three brother officers and the woman he loves. Determined to prove himself, he goes out to the Sudan incognito, redeems his honour, returns the feathers and is united with his beloved Ethne.

The classic version of the story is the 1939 Alexander Korda production, filmed in Technicolor in the Sudan and directed by Zoltan Korda. R. C. Sherriff's screenplay made several changes in the original, in the interests of narrative cohesion. For instance, Durrance is made one of the officers who give the feathers, where in the original he was not. All four feathers are returned; in the original they were not. Harry is allowed to rescue Durrance when he is blinded and convey him to safety. The battle of Omdurman is added to the climax and during it Harry gets into Khartoum and rescues his two remaining brother officers, one of whom is Ethne's brother in the film. This has the result of making Harry the central figure, whereas in the book he takes second place, in the second half, to Durrance.

Although A. E. W. Mason, the author, wanted Laurence Olivier to play Harry and Alexander Korda, the producer, pressed Robert Donat to take the part, it was eventually played, quite creditably, by John Clements. Ralph Richardson gave an excellent performance as Durrance. The 1955 re-

make, renamed *Storm Over the Nile* and co-directed by Zoltan Korda and Terence Young, was filmed from the same R. C. Sherriff script. It incorporated the battle footage from the previous version, which had also seen service in Terence Young's *Zarak* (1956), William Witney's *Master of the World* (1961) and Nathan Juran's *East of Sudan* (1964). Anthony Steel played Harry, Laurence Harvey Durrance and Mary Ure the heroine, renamed Mary, presumably on the grounds that fifties audiences could not take a heroine called Ethne.

The 1928 version departed furthest from the novel. It was directed by Ernest B. Schoedsack and Merian C. Cooper, later to earn cinematic immortality for filming the incredible *King Kong*. Additional interiors were directed by Lothar Mendes after the completion of the film. Schoedsack and Cooper had made their name with two documentaries, *Grass*, filmed in Iran in 1925 and *Chang*, filmed in Siam in 1927. Following *Chang*, they spent a year in the Sudan and Tanganyika filming native and animal footage and returned to Hollywood in 1928 to shoot further exteriors at a specially constructed British fort in the desert near Palm Springs and interiors at Paramount Studios. The result was *The Four Feathers*, released in June 1929 as 'the last of the big silent films' with synchronized musical sound-track.

Almost all the meat from the book, incorporated in the later Korda versions, has gone: the Harry-Ethne-Durrance triangle, the blinding of Durrance, the subtlety, depth and interplay of characters. Streamlined and simplified, the story emerges as a roistering yarn in the best traditions of the *Boy's Own Paper*. The film draws on other pieces of Imperial lore (Kipling, the Black Hole of Calcutta), while the initial scenes of children playing at knights in armour and the later scenes in the beleaguered Fort Khar are lifted straight out of Paramount's film version of *Beau Geste*, which had been an enormous success a few years earlier.

The film opens, as do the later versions, with a short prologue in which Harry as a child is filled by his father with tales of

98 (right) The scene in the mess in *Tell England* which perfectly summarizes the corporate feeling of the regiment and the delicate balance of ranks within it

99 (below) Foreign film-makers still cherish an essentially pre-war view of the English officer as an endearing, upper class eccentric. Jack Hawkins and Christopher Plummer in *Waterloo*

courage and duty and what is expected of him. ('You're a Feversham – and the army expects every Feversham to be a hero'.) Harry becomes obsessed with the fear that he will be unable to live up to these high ideals. ('I'm not afraid of anyone or any-thing – just afraid of being afraid.') The scene, also included in the Korda versions, in which Harry, as a small boy, walks along a corridor, lined with huge portraits of his military forebears, effectively underlines the weight of tradition lying upon him. Time passes and Harry, now a lieutenant (Richard Arlen), plans to marry Ethne (Fay Wray) though feeling almost disloyal to his three close friends, Lt Trench (William Powell), Lt Castleton (Theodore von Eltz) and Captain Durrance (Clive Brook), since hitherto their only love has been the regiment. But then come the rumours of war, Harry's resignation and the four feathers. Harry's father dies of shame, leaving as his legacy to Harry a loaded revolver. (In the book, his father survives to welcome him home.) Harry leaves for the Sudan. Thereafter the film becomes a succession of hairsbreadth escapes, last-minute rescues and deeds of derring-do, leading to the climax, in which Harry crawls through the enemy lines to take command of the beleaguered Fort Khar, where an injured Durrance exhorts him: 'I don't know what brought you here, but for God's sake, carry on.' Harry rallies the garrison, defeats the attacking fuzzy-wuzzies and regains his honour and the hand of Ethne.

If the film fails to capture the depth of Mason, it has caught his spirit. The ritual elements of the film of Empire are all there: the Regimental Ball, the full-dress military parade, the relief column arriving to the sound of the pipes; and the key icons of the genre: the pipe, the flag and the Imperial moustache. Underlying the whole film are the assumptions expounded in the early scenes: that courage, patriotism and mili-tary service are the highest ideals to which a man can aspire and that cowardice is taboo.

The standards expected of an officer were firstly that of courage and devotion to duty, secondly that of obedience to orders. Cowardice was bad form, letting the side down, poor show. So one must do one's duty, even if the world thinks badly of one. This often meant pretending to go over to the enemy in order to learn their plans. This is the theme of several films, for instance *Bengal Rifles* (Laslo Benedek, 1953) and *Khyber Patrol* (Seymour Friedman, 1954) in which two very American British officers (Rock Hudson in the first and Richard Egan in the second) with cowboy names (Captain Jeff Claybourne and Captain Kyle Cameron) are both disgraced for disobeying orders and pretend to desert to the rebel natives. But they do so only to learn their plans and end up by foiling them and regaining their honour and the hands of the women they love, in both cases the commanding officer's daughter.

Another form of doing the right thing was to become a 'gentleman ranker'. Black sheep of the family, younger sons of noble houses and, most often, men nobly taking on them-selves the blame for crimes committed by others, join the army under assumed names, generally Smith, Jones or Brown. The most obvious, and most romantic, army to join is the French Foreign Legion. But in the classic Legion pictures, the heroes are often British Imperial heroes, and they find a white man's burden to bear. As the commanding officer in *Beau Ideal* remarks: 'We are the guardians of twenty million natives, looking to the Legion for protection and justice, a high duty and a hard one.'

Probably the best known of these tales is *Beau Geste*, P. C. Wren's novel, which has been filmed three times by Hollywood. The first version, directed by Herbert Brenon in 1926, had Ronald Colman, Neil Hamilton and Ralph Forbes as the three Geste brothers, Beau, Digby and John. The second version, directed by William Wellman in 1939, and almost a scene-for-scene re-make, cast Gary Cooper, much more comfortably than in *Bengal Lancer*, Robert Preston and Ray Milland. The opening of the film is one of the most celebrated in all cinema. A troop of legionaries rides up to Fort Zinderneuf to find it manned by dead men, propped up against the wall. Suddenly a shot is fired. The commander sends Digby Geste over the wall.

He never comes back. Instead there is an explosion which destroys part of the Fort. The film then relates in flashback the events leading up to this.

The Geste brothers live with their aunt, Lady Patricia Brandon, at her country house in England. Her priceless sapphire, 'The Blue Water', is stolen. Beau leaves a note confessing that he took it, and vanishes to join the Legion. Digby goes after Beau and John goes after Digby. They all end up together in North Africa, being trained as legionaries by the scarred, sadistic regimental sergeant (called Lejaune and played by Noah Beery in 1927; called Markoff and played by Brian Donlevy in 1939). As Beau remarks, he is 'a trifle uncouth, but the best soldier we'll ever see'.

Beau and John eventually find themselves part of the garrison of Fort Zinderneuf, under Markoff's command. Markoff's tyranny provokes a mutiny among the men, but this is interrupted by a splendidly staged Arab attack, which wipes out the entire command except for Beau, John and Markoff. Then Beau too is killed and John kills Markoff when he finds him rifling Beau's pockets. Beau, it transpires, had taken the sapphire, knowing it to be an imitation substituted by Lady Patricia when she secretly sold the real thing, because he wanted to save her the disgrace of exposure. When Digby appears, he gives Beau a Viking funeral by blowing up the Fort, and he and John escape over the back wall. Digby is killed as they cross the desert and John returns to England alone, honour satisfied. The film memorably dramatizes those attributes of the good public school boy that go to make him the good officer and the good Imperialist: loyalty, comradeship, self-sacrifice, duty and honour.

I have thus far omitted to mention the third and most recent version of the film, directed in 1965 by Douglas Heyes. It is a tasteless travesty, which must have made Cooper, Colman and Wren turn over in their graves. It transformed Beau into an American stockbroker, eliminated Digby and most of the plot and concentrated on the iniquities of the Sergeant, now called Dagineau and played by Telly Savalas, who gave the only half-way decent performance in the entire sorry farrago.

Herbert Brenon took up the story of the Gestes in *Beau Ideal* (1930). Surplus footage from *Beau Geste* had already been utilized to produce *Beau Sabreur*, with Gary Cooper, but that dealt with the adventures of a Foreign Legion officer who was actually French. *Beau Ideal* is acted, or rather overacted, by its cast as if no one has told them that silent pictures are over. Florid silent-film techniques and melodramatic over-projection make much of the film laughable when viewed today. It was another of P. C. Wren's fine mystery openings, however: a grain pit in the middle of the desert, full of legionary prisoners dying of thirst. The initial scene separates the officer and gent from the rest. While krauts and dagos whine and snivel, go mad and slash their wrists, the Englishman, legionaire John Smith (Ralph Forbes) keeps his head. The Spaniard Ramon Gonsalez (Don Alvarado) begs him for forgiveness and Smith pats him consolingly on the shoulder, saying: 'Come now, Ramon, old chap ... easy, easy.' He does forgive him and Ramon dies. Levine asks why Smith forgives him when Ramon denounced him as a deserter. With a nonchalant shrug, Smith replies: 'He did what I suppose he thought was his duty.' Levine gives Smith the last of his water and dies and Smith pats him on the shoulder, saying, 'Stout fellow.' Suddenly the other survivor, the American legionaire Brown (Lester Vail) takes Smith in his arms and cries: 'I've found you, found you at last.'

Contrary to what appearances might suggest, Brown's rather emotional behaviour can be explained by the fact that he has just realized that Smith is in fact John Geste, the man he has been searching for. Once again, the events leading up to this opening sequence are recounted in a flashback. Brenon cuts from the grain pit to a scene of the Geste children playing at knights in armour on the same hillside before the same country house as in the identical scene in *The Four Feathers*. Beau uses the words: 'Stout fellow, the highest honour that can be bestowed on man or beast', words which gave Brown the all-important clue. For among the children is

If one let the side down, it was necessary to try and redeem one's honour. Several courses were open.

100 (above) Drummed out of the regiment, Peter Lawford enlisted in another – as a private (*Rogues' March*)

101 (left) Disgraced Guards Officer Ronald Colman joined the French Foreign Legion (*Under Two Flags*)

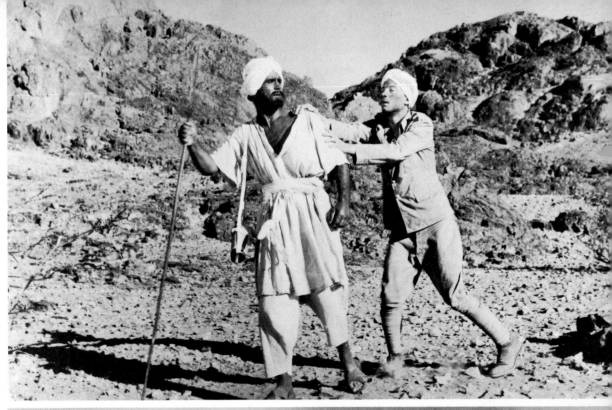

102 (above) Given four feathers for cowardice, Anthony Steel disguised himself as a native to rescue Laurence Harvey (*Storm Over the Nile*)

103 (below) In *Ships With Wings* John Clements redeemed himself by blowing up the dam on this German-occupied cardboard island

Otis Madison, who years later returns and learns from Isobel Brandon (Loretta Young) the story of the Gestes as it had been re-counted in *Beau Geste*. The sequel to the events at Zinderneuf had been the arrest of John as a deserter, his trial and his sentence to imprisonment in the penal battalion of the Foreign Legion. Isobel reveals that she loves John, and Otis, concealing his love for her, determines to find John for her. He enlists in the foreign legion as Brown, gets sent to the penal battalion and finds John. They are duly rescued from the grain pit and while they are recovering, Otis tells John all. 'Otis, old lad, you did all this . . . for me.' They share a cigarette and John pats Otis on the back and dubs him 'Stout fellow'. It is very much the equivalent of the 'captain's hand on his shoulder smote' of Newbolt lore. Later, John and Otis help repel an Arab attack on the Residency and are pardoned and return to England together. Basically it is, to use Howard Hawks's phrase, 'a love story between two men', another old public school tradition.

Ronald Colman resumed Foreign Legion uniform in *Under Two Flags* (Frank Lloyd, 1936). Freely adapted from Ouida's classic novel, previously filmed in 1922, by W. P. Lipscomb and Walter Ferris,[4] it was skilfully directed by Frank Lloyd and was punctuated by large-scale, exciting desert battle scenes, filmed by ace second unit director Otto Brower. Its hero is Corporal Victor (Ronald Colman), who from the first is clearly an officer and gentleman. He takes command of the survivors of a supply column, attacked by rebel Arabs, and maintains them in good order until relief arrives. He is constantly attended by his former servant, Rake (Herbert Mundin), who enlisted with him in order to look after him, and still calls him 'Sir'. It comes, therefore, as no surprise to learn, half way through the film, that he is in reality Ralph Brett, former Guards Officer, who left England under a cloud when accused of embezzlement. The real criminal was his brother, whom he is shielding and whose death and deathbed confession providentially leave the way free for Brett to return home at the end of the film.

Brett falls in love with Lady Venetia Cunningham (Rosalind Russell), niece of a visiting British peer: and in a midnight tryst at a moonlit oasis, they make love to the strains of Amy Woodforde-Finden's 'Kashmiri Love Song' in the ruins of an age-old monastery. But he renounces her because of his secret and goes off on a special mission. He has incurred the hatred of Major Doyle (Victor McLaglen) who has discovered that his mistress, the café-entertainer Cigarette (Claudette Colbert), really loves Brett. Doyle deliberately sends him out on mission after mission to get him killed but Brett always comes back alive. Finally Brett, Doyle and a handful of men are trapped in a desert fort when the Arab leader Sidi Ben Youssef rises in revolt. They need time for the relief force to arrive and Brett, learning who the rebel leader is, decides to make time. He marches boldly into the Arab camp and introduces himself to Ben Youssef, with whom, it tran-spires, he was at Oxford in 1892. ('You were at Balliol, I was at Magdalen.') He delays him long enough for a relief column to attack the Arab camp, led by Cigarette: she is mortally injured and dies in Brett's arms, leaving him free to return to England with Venetia.

Another gentleman-ranker picture, which actually took its hero to service in the Empire, was *Rogues' March* (Allan Davis, 1952), an excellent script, sloppily directed and edited but reaching its climax in a rousing battle, actually filmed on location at the Khyber Pass. Captain Dion Lenbridge (Peter Lawford), son of the Commanding Officer of the Royal Midland Fusiliers, is wrongfully suspected of selling military secrets to the Russians. He is court-martialled and drummed out of the regiment but enlists as a private in another regiment. He does not fool the other soldiers, who recognize him as a gentleman ranker and call him jokingly 'his lordship'. As fate would have it, the regiment is sent to join the Fusiliers at the Khyber Pass and there, Dion distinguishes himself in action against the enemy, a captured Russian agent vindicates him and he is reinstated and united with the girl he loves.

When the Second World War broke out

these same standards were still initially being applied. Typical of early wartime British films is *Ships with Wings* (Sergei Nolbandov, 1942), a glamorized and romanticized picture of the Fleet Air Arm, with locations shot on board the *Ark Royal* but otherwise so full of blatantly obvious cardboard models (everything from a Greek island to an Italian dam as well as most of the planes) that Noël Coward described it as 'Gamages, dear boy, pure Gamages'. It received such a hostile reception from the press that Ealing Studios turned to producing far more realistic pictures of the British at war, which still hold up well today, films like *Went the Day Well?*, *The Foreman Went to France* and *San Demetrio-London*.

But *Ships with Wings* is so four-square in the Imperial tradition that it bears analysis. It begins in 1937 with a visit by Admiral Weatherby (Leslie Banks) and his daughter Celia (Jane Baxter) to the Fleet Air Arm base, where they make the acquaintance of a trio of airmen: dashing, dare-devil Dick Stacey (John Clements), quiet, pipe-smoking David Grant (Michael Wilding) and dedicated, serious Peter Maxwell (Michael Rennie). All three are attracted to Celia and she is torn between them. But Dick tells his current girl-friend, Kay (Ann Todd), that he has fallen for Celia. Tearfully, in a scene that is *echt*-forties British, Kay gets up, in a white dress against a white nightclub background to sing her song: 'Santa sent me you.' Dick illegally takes up Celia's brother, Mickey, in a plane that has not been properly serviced; it crashes and Mickey is killed. Dick is court-martialled and dismissed the service. Celia marries David. Dick turns up on a (cardboard) Greek island, flying charter planes. When war breaks out, Dick applies for permission to re-enlist and is turned down. The fleet sails 'to have a smack at Mr Hitler'. The Germans take over the Greek island, aided by Wagner (Hugh Williams), the nasty German pilot with whom Dick has already had a run-in. ('Get up, you filthy Hun, I want to hit you again.') Dick takes the news to the British fleet. It is vital that a dam on an Italian-held island be knocked

out. The planes go after it and there are heavy casualties. 'It's sheer murder,' says a pacifistic Irish mechanic. 'There's a job to be done and they're doing it,' replies Dick. They are so short of pilots that Dick is allowed to go up. He pancakes his plane on top of Wagner's and crashes them both into the dam, causing it to burst and flood the (cardboard) Italian island. Back on the flagship, Admiral Weatherby reports the mission a success. 'I knew he wouldn't come back' says Captain Fairfax. 'I think he'd have preferred it that way,' replies the Admiral. 'Listen they're taking off again.' The Fleet Air Arm zoom off to continue the fight.

Dick by his reckless disregard for orders had let the side down badly. He was from a service family himself (his father had gone down with his ship at Jutland) and should have known better. Celia chooses the man who knows his duty and the meaning of discipline, David. Their curly-headed son is trained to say 'aye, aye, sir' in anticipation of the time when he will follow his father and his grandfather into the service. Dick expiates his sins by a heroic death. The ladies (Ann Todd, Jane Baxter) are game, tight-lipped, self-effacing, tears trembling on their eyelashes in stiff-upper-lip farewells. The officers (Basil Sydney, Leslie Banks, John Stuart) are phlegmatic and given to understatement. While the foreigners, as usual, are either comic (Greeks, Italians) or sinister (the Germans, as played by such unlikely Teutons as Cecil Parker and Frank Pettingell). Once into the war, the old standards seemed suddenly inadequate and this feeling led to the making of one of the greatest of all British films, *The Life and Death of Colonel Blimp* (Michael Powell and Emeric Pressburger, 1943). Michael Powell, arguably the greatest of all British film directors, is very much the cinematic counterpart of John Buchan. His films are bound together by recurring themes: Celtic-fringe mysticism (*Gone to Earth*, *I Know Where I'm Going*, *Edge of the World*); respect for our gallant Prussian foes (*The Spy in Black*, *Ill Met by Moonlight*, *49th Parallel*); and explorations of the conduct of the British officer and gentleman (*Battle of the*

River Plate, *One of our Aircraft is Missing* and pre-eminently *The Life and Death of Colonel Blimp*). As recently as 1960 he was excavating this vein of interest in *The Queen's Guards*, out of the première of which most critics staggered in shattered disbelief. The critic of the *Monthly Film Bulletin*[5] typifies their reactions when he contemptuously dismisses the film as a 'flagwaving museum piece', whose 'dialogue and characters were as dated as a Crimean cavalry charge'. *The Times*[6] took a more charitable, and perhaps more accurate view, when it praised the filming of the build-up to an actual performance of the Trooping of the Colour, saying it had 'the snap, jingle and authority of Kipling's rhyme plus a sense of discipline that is part of the Guards' tradition'.

Anachronistic it may be, but it is one with the films we have been examining and therefore an interesting insight into the attitudes and standards we have been examining. The hero of the film is Captain John Fellowes (Daniel Massey) of the Guards, who while taking part in the Trooping of the Colour recalls, in flashback, his life in the regiment: his training, his leisure and, finally, action. His father is a crippled former Guards Officer (Raymond Massey), who is writing a history of glorious British defeats, from Corunna to Dunkirk, and who still cherishes the memory of John's worthless elder brother, killed by the enemy during the war after he had let the side down by shooting a prisoner. But John redeems the family honour when he distinguishes himself in action in the desert helping clean out rebels in a friendly Arab state.

Powell himself was not happy with the finished product, even though he had liked the original idea, and it is certainly not in the same league as *Blimp*. Beautifully written and directed, *Blimp* opens in 1943 with a Home Guard exercise. Captain 'Spud' Wilson (James McKechnie) is informed that his objective is Home Guard H.Q. in London and that the exercise starts at midnight. Wilson tells his brother officers that they are depending on him to keep to 'the rules'. However, since Pearl Harbour changed the rules, he will move immediately and take

H.Q. by surprise. Wilson and his men capture General Clive Wynne-Candy (Roger Livesey), the Blimp, and his other H.Q. officers in the steam room of the Turkish Bath. Candy is angry and uncomprehending, able to repeat only over and over: 'Exercise starts at midnight.' Wilson retorts that he is a silly, old, out-of-date figure and that wars are not fought according to the rules any more. Candy attacks him and as the two of them struggle in the waters of the bath, the film flashes back to 1901.

The young Clive Candy, recently awarded a V.C., is on leave from the Boer War. He goes to Berlin to confront an old enemy of his who is stirring up anti-British feeling with false tales of atrocities. But he contrives to insult the entire German army in the process. Honour demands a duel, and in a beautifully observed little scene the representatives of the British Embassy and the German Army meet with strict formality to discuss the choice of weapons, seconds, venue. The scene encapsulates the standards of conduct expected of an officer and gentleman. The Regiment draws lots to see who shall fight Candy and the choice falls on Lt Theo Kretschmar-Schuldorf (Anton Walbrook), who disapproves of duelling but agrees to participate because of the Code. In fact, neither he nor Clive has ever fought a duel but they go to it, honour is satisfied, and the two become firm friends while recuperating from their injuries.

Back in England Clive resumes his service career and a succession of shooting trophies on the wall details his progress between 1901 and 1914 and his service in India and Africa. In 1914 comes war; and by 1918 Clive is a general, serving in Flanders, attended by his stupid but faithful batman, Murdoch (John Laurie), and proud of the sporting way the British are fighting. He questions German saboteurs, captured behind British lines, and assures them that the British do not use German methods of interrogation. Naturally they do not speak. But after he has gone, Captain Van Ziyl, the scarred Afrikaaner, takes over the questioning and sourly informs them that he is no 'simple English gentleman' and will use any method

to get them to talk. Clive finds the transport depot, run by Americans, in chaos. He denounces their inefficiency, saying it would never have been tolerated in the Boer War or Somaliland. But the Americans have never heard of Somaliland.

These scenes make it clear that Clive is already out of date, a figure from an Imperial pre-war past, overtaken by the march of events. News of the armistice is greeted by Clive with the joyful declaration that although the Germans have bombed hospitals, used poison gas and fought dirty, 'clean fighting, honest soldiering have won'. That is how it may appear to Clive, but we know different.

After the war Clive marries Barbara Wynne (Deborah Kerr), a wartime nurse of sound Yorkshire squirearchy stock, and sets up house in London, with the faithful Murdoch as servant. They go to a prisoner of war camp in Derbyshire to see Theo but to Clive's distress and bewilderment, Theo turns his back on him, refusing to speak. Some time afterwards, Theo telephones from Victoria Station to apologize. He is on his way back to Germany. Clive insists on bringing him over to join his all-male dinner party, which consists of admirals, generals, senior civil servants, colonial administrators, in fact a gathering of the Breed. With completely unselfconscious magnanimity, they assure Theo that they hold no hostility. 'We'll soon have Germany back on her feet again.' On the train to the coast, Theo tells his fellow officers with amazement of the childlike simplicity of the British: 'They win the shirts off our back and want to give them back. They are children, boys playing cricket.'

A photograph album traces Clive's post-war service in China and Japan. In 1926 his wife dies and Clive adds Wynne to his surname in memory. The trophy shooting resumes: Canada, Labrador, Scotland. 1939 and war again. Theo, greying now and very distinguished, arrives in England and in a moving soliloquy recalls how he left the army to begin a new career as a military chemist but lost his children to Nazism. When they did not attend the funeral of his

English wife, he decided to return to England, which his wife had loved and where the people had been so kind to him. Clive arrives to vouch for him and has become the Blimp of the cartoons, fat, bald, walrus-moustached.

After Dunkirk, Clive goes to the BBC to give a talk on the disaster but finds that the talk has been cancelled. When he gets home, Theo explains why. In his talk Clive had intended to say that he would sooner accept defeat than fight the Nazis by their methods. Theo says that they must fight the Nazis by their methods because England is fighting for her very existence against the most devilish idea created by the human brain – Nazism. 'If you lose, there will be no return match next year.' Clive's education, his training, his whole being has been that of a gentleman and a sportsman in peace and in war, but this is not a gentleman's war. Retired from active service, Clive joins the Home Guard and the opening sequence of the raid is reprised. Wilson achieves victory by breaking the rules. Bitter and humiliated, Clive sits in the park alone. Theo and 'Johnny' Cannon, his driver, find him and try to cheer him up. But he cannot understand how things have changed. Then the sound of music snaps him out of his reverie. It is 'The British Grenadiers'. Proudly, Clive draws himself up to salute a march past of soldiers. Affectionately, Theo describes him as 'a grand old man'.

The Blimp of David Low's wartime cartoons, petty-minded, choleric, anachronistic, achieves in this film the status of a tragic hero. He is the gentleman and sportsman who suddenly discovers that his style of life and war have gone out of fashion. The message of the film is quite explicit, being stated by Wilson at the outset and reiterated by Theo throughout. Britain must fight the Nazis by their methods if she is to win. It is total war. The old rules no longer apply. Yet by making Clive a sympathetic figure, whose losses and humiliations the audience share, it evokes a very real feeling of nostalgia for this rather pathetic old-style Englishman. Theo denounces the English for their childlike simplicity and their view of war as

cricket but he loves them for it. This is, more or less, the attitude of the film too. It becomes the apotheosis of the Blimp, the professional soldier, whose life is the Army, whose intelligence is limited but whose standards of conduct are irreproachable. Clive has no interest in politics or the arts, a healthy respect for the enemy and a love of sport: polo, shooting, riding. It comes as no surprise to learn early in the film that he is an old Harrovian. He is the public school soldier *par excellence* and writ large.

After the war it was possible to slip back to a neo-Blimp attitude and this can be seen in what Raymond Durgnat describes as 'doldrums-era war movies', the 'typical' British war film of the fifties. But towards the end of the fifties and into the sixties, with films like *The Long and the Short and the Tall*, *Private Potter*, *King and Country*, *The Hill*, *Play Dirty* and many more, the prevailing view of war became one which Clive Candy would not have recognized. It was a bleak, harsh, realistic view, in which there was no glory, no rules, no shining ideals, just kill or be killed, anything goes. Richard Attenborough made a devastating indictment of the First World War in his film of the stage musical *Oh, What A lovely War*, in which the British generals were caricatured and castigated and the stupid, tragic, wasteful folly of it all brought strikingly home.

In spite of all this, it would appear that the foreigner still cherishes an essentially pre-war vision of the English officer and gentleman. *Waterloo* (1970), directed by the Russian Sergei Bondarchuk, depicts all the English officers as endearing, upper-class eccentrics: Jack Hawkins's gruff, top-hatted, umbrella-wielding Picton, Michael Wilding's elegant, snuff-taking Ponsonby, Terence Alexander's Uxbridge, with his immortal line, more in surprise than pain: 'By God, sir, I've lost my leg', to which the Iron Duke replies: 'By God, sir, so you have.' Best of all is Wellington himself (Christopher Plummer), seen napping under a copy of *The Times*, drinking a toast with officers on horseback before the battle, complimenting one of his aides on his tailor, and proclaiming that although Napoleon is definitely not a gentle-

man, he cannot allow him to be shot at – it would not be sporting. Amid all this galaxy of gents there is one solitary other rank for good measure and this is Private O'Connor (Donal Donnelly), the perfect eighteenth-century stage-Irishman, complete down to the stolen pig stuffed in his knapsack, cheerful, grumbling, doing his job. Obviously the old myths are a long time a-dying.

Several common features link the Imperial officer films. One is the tradition of family service. Again and again our heroes are drawn from old army families, with standards and traditions to uphold: the Fevershams, the Vickers, the Stones, the Allisons, the Lenbridges and quintessentially, the Leighs in John Ford's *Four Men and a Prayer* (1938). In this film, Colonel Loring Leigh (C. Aubrey Smith), cashiered from the British Indian Army, returns home with a briefcase full of papers, proving that he has been framed by an armaments ring. He is murdered and the proofs stolen and his four sons then get together to clear his name. The sons are Wyatt Leigh (George Sanders), rising barrister, Christopher Leigh (David Niven), R.A.F. officer, Geoffrey Leigh (Richard Greene), attaché at the British Embassy in Washington, and Rodney Leigh (William Henry), Oxford undergraduate.

Another common feature is the fact that service heroes almost invariably marry service ladies. Thus Captain Perry Vickers marries Colonel Campbell's daughter; Captain Jeff Claybourne marries Colonel Morrow's daughter; Captain Kyle Cameron marries General Melville's daughter; Captain Alan King of the Khyber Rifles marries General Maitland's daughter; Lt Harry Feversham marries General Burroughs's daughter; Captain Dion Lenbridge marries Major Wensley's daughter; and Lt David Grant marries Admiral Weatherby's daughter. The women are generally little more than ciphers, however: well-bred, elegantly-gowned plot devices, someone for the hero to embrace dutifully at the fade-out, preparatory to climbing into bed with her to propagate a new generation of officers and gentlemen.

Even if a stilted love interest is injected,

the strongest and most genuine emotion displayed in the films is that of the all-male camaraderie. The proverb which prefaces the 1939 version of *Beau Geste* says it all: 'The love of a man for a woman waxes and wanes like the moon but the love of a brother for a brother is steadfast and endureth forever.' Isobel Brandon, the girl in love with John Geste (Mary Brian in *Beau Geste* [1927], Susan Hayward in *Beau Geste* [1939] and Loretta Young in *Beau Ideal*), appears only briefly at the beginning of the films and it is the love of the brothers for each other which is the film's main love interest. There is no romantic interest in *Bengal Lancer* at all. But Mac takes a motherly interest in young Stone and is chaffed by Forsythe for doing it. The principal relationship in that film, too, is the affection of the three lancers for each other. Geoffrey Vickers's surrender to his brother Perry of the girl he loves in *Charge of the Light Brigade* is obviously as much a matter of love for his brother as it is of love for Elsa, while in *Gunga Din*, which admittedly deals with the non-commissioned officers, the same standards obtain and are at their most explicit: marriage is seen as a threat to the long-time camaraderie of the three sergeants.

The military, therefore, can be seen in the cinema of Empire to form a self-perpetuating caste, sustained by and sustaining the public school ideals: duty, discipline, loyalty, courage and self-effacement within an all-male environment. Most of the British P.O.W. camp movies fit neatly into this category. Films like *The Wooden Horse* (Jack Lee, 1950), *The Colditz Story* (Guy Hamilton, 1955) and *Danger Within* (Don Chaffey, 1958) all show the British at their best with their backs against the wall, demonstrating an admirable phlegm, close comradeship and dedication to escaping (partly as a duty; partly, it must be admitted, as a game, to outwit the Boche). The P.O.W. camp, in fact, is the nearest thing the officer heroes of these films have experienced to their public school. Both school and camp are alike – in the absence of women, the spartan conditions, the rigorous discipline and a hierarchic system in which the Jerries

function as rather nasty prefects, who exist simply to be tricked and humiliated. To be a genuine officer and gentleman can be a heavy burden and one should not think about it too much or one might become 'afraid of being afraid'. This is why men of limited intelligence but highly-developed instincts are seen to make the best soldiers. It takes only the passing of time to turn the Clive Candy of today into the Blimp of tomorrow.

The N.C.O.

The typical N.C.O. is the mainstay of the traditional war film, the 'compleat' professional. He has been incarnated notably by Harry Andrews in *Ice Cold in Alex* (J. Lee Thompson, 1958) and *A Hill in Korea* (Julian Amyes, 1956), by William Hartnell in *The Way Ahead* (Carol Reed, 1944) and by Nigel Green in *Zulu* (Cy Endfield, 1963). He is a figure of 'titanic calm', the pillar of the troop, taking a fatherly interest in his often untried young officer and a headmasterly attitude, stern but fair, towards the men. He stands midway between the officers and the other ranks, accorded respect by both. Sometimes he is forced to take command like Victor McLaglen's Sergeant in *The Lost Patrol* (John Ford, 1934). But mostly he is the living embodiment of a lifetime of service and loyalty to the regiment, the exemplar of professional conduct.

There is a lighter side to the N.C.O. and here the inspiration is Kipling. Charles MacArthur crossed the poem 'Gunga Din' with the 'Soldiers Three' stories to produce *Gunga Din*, directed by George Stevens in 1939. It emerged as one of the greatest fun movies of all time, a joyous romp, 'an exhilarating piece of high adventure', which teamed together three sergeants: an old sweat, MacChesney (Victor McLaglen), the quick-witted intellectual Ballantine (Douglas Fairbanks Jr) and an irresponsible, irrepressible cockney joker, Cutter (Cary Grant). They are an inseparable, boozing, wenching, two-fisted threesome, whose brotherhood is threatened by Ballantine's impending marriage and retirement from the army.

MacChesney and Cutter determine to do

104 (left) All-male camaraderie was the most genuine emotion displayed in these films. Ray Milland, Robert Preston and Gary Cooper in *Beau Geste*
105 (below) The P.O.W. camp with its all-male environment proved the nearest thing to a public school for its officer inmates. Bryan Forbes, Leo Genn and Anthony Steel in *The Wooden Horse*

106 (right) Service heroes invariably married service wives. Their attitude to them was always shy and hesitant.
Richard Egan and Dawn Addams in *Khyber Patrol*

107 (below) But marriage was often an emasculating institution seen as breaking up the all-male group. Douglas Fairbanks Jr in the process of being domesticated by Joan Fontaine to the horror of Cary Grant and Victor McLaglen in *Gunga Din*

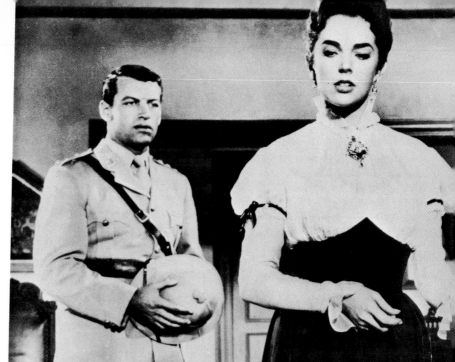

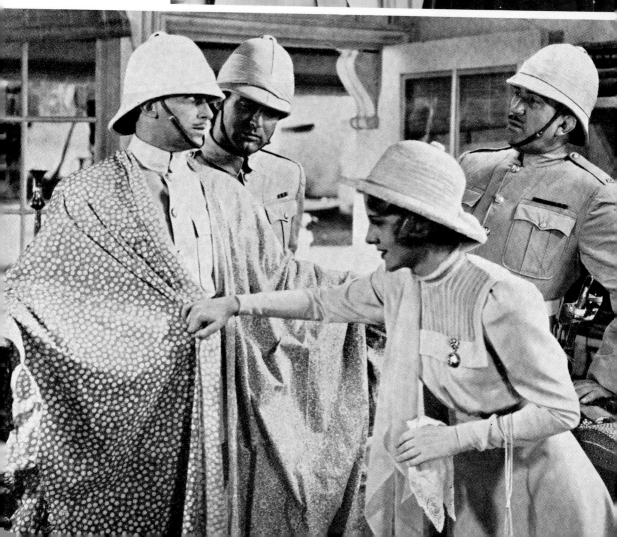

everything in their power to prevent the marriage. When they actually see Ballantine kissing Emmy (Joan Fontaine), they turn their faces away in disgust saying that they would not have believed it possible if they had not seen it with their own eyes. Their worst fears are realized when they come upon Ballantine in a shop, draped with curtain material, and subject him to a string of jibes. ('Your petticoat is showing' etc.) But when Cutter is captured by Thugs, Ballantine unhesitatingly re-enlists to rescue him. Emmy protests, asking him to choose between her and his friends. He chooses his friends and Emmy simply disappears from the narrative. With the aid of Gunga Din the Thugs are defeated. The colonel (Montagu Love) congratulates them and Cutter says: 'I'd rather hear that from you, sir, than get a bloomin' medal.' Again, it is the case of the captain's hand on his shoulder smote. The three comrades are reunited in their life of service.

Producer Pandro S. Berman tried to pull off another *Gunga Din* in his film *Soldiers Three* (Tay Garnett, 1951), but failed miserably. The result was an unhappy, knockabout farce, limply directed by veteran Tay Garnett. The heroes are reduced to privates for this film – and deservedly, since they are without exception inferior to the sergeants of the earlier film. Stewart Granger does a ham-fisted impersonation of Cary Grant, as Pvt Ackroyd. Robert Newton plays Pvt Sykes as Long John Silver without the wooden leg. Cyril Cusack's Pvt Malloy is the traditional sly, boozing stage-Irishman, wanting only a pig under his arm to make him complete. They help put down an Indian uprising in order to save the Colonel (Walter Pidgeon), whom they respect rather than love, from premature retirement.

The epitaph for the Imperial N.C.O. is John Guillermin's fine film *Guns at Batasi* (1964), dedicated to the 'warrant officers and N.C.O.s of the British army past and present, who have always upheld the high traditions of the service'. Its central figure is R.S.M. Lauderdale (a virtuoso performance by Richard Attenborough), the perfect stereotype of the traditional N.C.O. – which is the

root of his tragedy. The first shot is a low-angled view of him striding across the parade ground, immaculately turned out, saluting private soldiers who pass him. Suddenly he stops and bellows: 'That man, there.' He then proceeds to give a sloppy saluter a lesson in saluting. Going on to the sergeants' mess, he notices immediately that the Queen's portrait has been removed – for a bet that he would not notice it inside two minutes. The character is thus immediately established and the detail is soon filled in: the look of ecstasy as he listens to a record of the bugle calls of the British army, the constant homilies about discipline and the Queen's regulations, his pride in proposing the loyal toast on the Queen's birthday.

But the very caricature, the very exaggeration of attitudes serve in themselves to point up the tragedy of the man. He can recall his days of service on the North West Frontier and he talks longingly of the glitter and pageantry and pride of the Imperial army. But he is a man out of place in the post-Imperial army, the Blimp of the N.C.O.s. For he and his fellow sergeants are stationed in a newly independent African state, training a native regiment under a native C.O. When mutiny breaks out and the rebels seize control of the regiment, the British Embassy orders the sergeants to confine themselves to quarters and let the Africans fight it out. Lauderdale simply cannot understand this. He is not concerned with politics. He is a professional soldier. To him what has occurred is mutiny, pure and simple, and he acts accordingly. Just as Colonel Deal (Jack Hawkins) is congratulating the other sergeants on their non-involvement, Lauderdale blows up the rebel guns. In the heyday of Empire this would have earned him a medal. Instead, it brings him expulsion from the country. Angry, uncomprehending, he returns to the mess and flings a glass at the wall, shattering the portrait of the Queen. This brings him back to reality. He cleans up the mess, then, straightening his shoulders, steps outside and strides off into the future and whatever his life in the army holds for him.

For all his comic ways, it is Lauderdale to

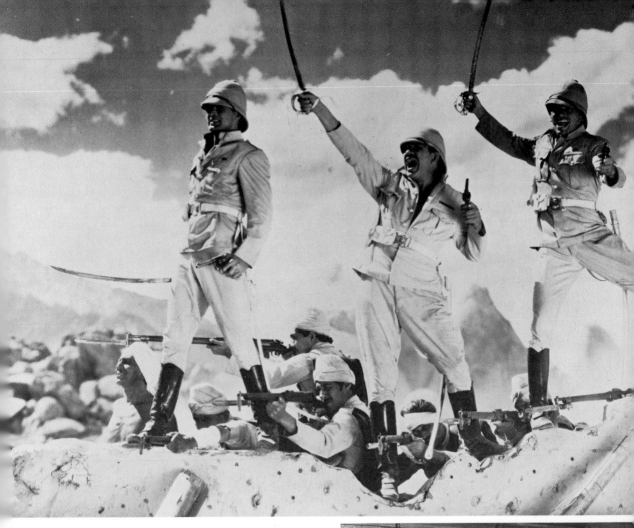

The N.C.O.

108 (above) Roistering N.C.O.s in the heyday of Empire
Cary Grant, Victor McLaglen and Douglas Fairbanks Jr in *Gunga Din*

109 (right) Epitaph for an Imperial N.C.O. Richard Attenborough in *Guns at Batasi*

whom the sergeants look when the mess is under siege and he takes command with practised ease. He uses his courage and initiative, in the best traditions of the service, to destroy the guns. It is what he has been trained to do: he can do no other. But events have left him and his kind behind and the world has moved on. It has also left the British officers behind too, and they are just as bewildered and embittered by the changes. Colonel Deal, for instance, in a weary and almost self-parodying performance by Jack Hawkins, refers to the mutiny as 'this spot of bother' and later, when telling Lauderdale of his expulsion, says that he would have done exactly the same himself (the tribute of one professional soldier to another). The Adjutant (Alan Browning) is unable to understand how the rebel leader can be in prison one day and President the next. The British ambassador, Sir William Fletcher (Cecil Parker), another representative of the old Breed, is forced to admit ruefully: 'Going to jail is considered a short cut to power these days.'

But the intellectuals, the antithesis of the professional soldier, come off worst of all. The schoolmaster sergeant, a slightly ridiculous figure with an oversize umbrella, tries to teach the native soldiers about parliamentary democracy only to have them mutiny. Miss Barker-Wise, the left-wing M.P. (Flora Robson), who believes fervently that the African is a rational and sensible human being, is violently disabused when her protégé, university-educated Lt Boniface (Errol John) leads the revolt and denounces her and her fellow white liberals for patronizing Africans and treating them as pets. Miss Barker-Wise denounces Lauderdale for having been brainwashed by the army and for not understanding the African. But he takes the eminently reasonable and un-patronizing view that 'their best are as good as our best and their worst as rough as ours, and that's very rough.' Boniface is a revolutionary fanatic, prepared to kill and mutiny. The 'good African', Captain Abraham (Earl Cameron), is the man who comes nearest to the British professional soldier, decent, humane, honourable, and it is he who is

ousted. Anti-revolutionary and anti-intellectual, the film's sympathies are firmly with Lauderdale and more generally, the bewildered British soldier, for whom the world is changing too rapidly.

Other ranks

The bulk of 'other ranks' are the cheerful, homely, ritually grumbling but faithful working-class soldiers, who invariably speak in dialect and who, when it comes to the crunch, maintain a decent respect for their officer, who adopts a resolutely paternal attitude to them. This attitude was accurately and devastatingly parodied by Dick Lester in *How I Won the War* (1967), an otherwise unhappy attempt to combine the absurdity and the horror of war. The film had one glorious character, Colonel Grapple, 'Grapple of the Bedou', magnificently played by the magnificent Michael Hordern. His war consisted of speeding across the desert in a succession of jeeps, which were constantly being blown up, shooting the fallen tanks to put them out of their misery, and commenting knowingly on the British soldier's devotion to his steed. He characterized all enemies of Britain as 'the wily Pathan', still living on his memories of service on the North West Frontier, and he believed, significantly, that 'give the British soldier his cup of char and look after his feet and he'll die for you.' This is only a slight exaggeration of the attitude displayed towards the men by the officer in the traditional British war film. The 'men' were there, by and large, to provide comic relief during time of peace and to die uncomplainingly and in great numbers in time of war, to illustrate to the audience just how beastly and humourless the enemy were.

There were few films which dealt exclusively with the private soldier and his attitudes and problems in anything other than stereotyped terms. But one of the most notable is *The Lost Patrol* (John Ford, 1934). Essentially a character study of a patrol, cut off and lost in the Mesopotamian desert and surrounded by unseen Arabs who pick them off one by one, it emerges as a

Other ranks

110 The stranded army patrol buries its officer in *The Lost Patrol*
J. M. Kerrigan, Victor McLaglen, Alan Hale, Boris Karloff, Brandon
Hurst, Reginald Denny and Douglas Walton
111 (below) The other ranks enjoy themselves between decks while
their officers drink champagne above (*Farewell Again*)

respectful and expertly handled tribute to The British Soldier.

In many respects they are a legion of the damned, men who expect to die sooner or later, professionals, drop-outs, misfits. There is a gentleman ranker, 'Brown' (Reginald Denny), a jovial, drunken Irishman (J. M. Kerrigan), a dour Scot (Paul Hanson), a broken-down ex-boxer (Sammy Stein), a religious fanatic (Boris Karloff, overacting rather badly), a cheerful cockney (Billy Bevan), a mother's boy inspired to join up by reading Kipling (Douglas Walton), and an ex-music hall artist who believes he is a Jonah (Wallace Ford). Gradually, as the tension mounts, each reveals his inner self, and one after another they die. It is the sergeant alone (Victor McLaglen), the tough professional, who survives to greet the relief column which arrives to the strains of 'The British Grenadiers'.

A combination of the light-hearted and the serious sides of army life can be seen in *O.H.M.S.* (Raoul Walsh, 1936), which Gaumont British produced, with official Army backing, to boost recruitment for the peacetime army. It tells of a small-time New York racketeer (Wallace Ford) who flees to England to avoid involvement in a murder trial and enters the British army under an assumed name. He does not take to the discipline at first but his friendship with a young lance-corporal (John Mills) and the favours of the sergeant major's daughter (Anna Lee) gradually open his eyes to the delights of army life. There is much full-dress parading and jolly barracks life with japes and escapades and finally the transfer of the regiment to China, where our hero dies heroically saving a party of whites from Chinese bandits. It is the familiar device, as in *Bengal Lancer* and *Northwest Frontier*, of introducing a foreigner and teaching him the delights of discipline and authority, the joys of life in camp and the opportunity for heroism and glory on active service.

The final word on the Imperial army can be safely left to Alexander Korda. *Farewell Again* (Tim Whelan, 1937) was produced by Erich Pommer under the auspices of Korda's London Films. It is a mosaic of stories, centred on a troopship returning from India. Behind the credits, a thumpingly martial score includes 'Pack up your troubles in your old kit-bag and smile, smile, smile', which might almost be the film's motto. Any doubts about its intentions and its allegiance are dispelled by the foreword:

All over the world, wherever the Union Jack is flown, men, from castle and cottage, city and village, are on duty, some have their families with them, many serve year after year, facing hardship, danger, death with only a brief glimpse of home. Each has his own joys and sorrows but a common purpose unites them all – their country's service.

The film opens with a succession of short sequences in which relatives await the return of their menfolk with eager anticipation. Then we cut to the troopship *Somersetshire* on which the 23rd Royal Lancers are returning to England after five years in India. We meet the characters, and their problems unfold against a background of routine, parades and drills. There is the dashing medical officer, Captain Gilbert Reed (Sebastian Shaw), who falls in love with the pretty nurse Ann Harrison and wonders how he will break the news to his fiancée, Lady Joan Anstruther. There is Pvt Smith, the fresh-faced, upper-crust recruit, whose name and accent and collection of Greek texts proclaim him a gentleman ranker – as indeed, he soon proves to be: the Winchester-educated son of a wealthy company director, who joined the army under an assumed name after forging his father's name to a cheque. There is Pvt Jim Carter (Robert Newton), the intense young soldier, who had saved Gilbert's life in India and who is consumed with jealousy for his girl, Elsie. There is Pvt Withers, the barrack-room lawyer, spreading discontent and disaffection among the men. There is Pvt Moore, increasingly concerned over whether his wife has been faithful and if his newly-born son is really his. There is Cpl Edrich returning home to marry his waitress fiancée, Lily. To cap it all, the commanding officer Colonel Blair (Leslie Banks) learns that his wife,

Lucy (Flora Robson), has a fatal illness and needs a long period of medical treatment.

In the midst of all this, a telegram arrives from the War Office. The regiment is ordered to the Near East with only six hours' leave in Southampton. The colonel draws up his men and addresses them. There is trouble in British mandated territories, a danger of civil war. The army is being sent there to keep order. It is a thankless task. They go not as soldiers but as policemen. 'We've got an empire, we've got to pay for it, and, you know ... there it is.' But the War Office is not without a heart. It arranges special trains, a special delivery of mail, a special reunion at Southampton. On board, discontent culminates in a free fight between decks. The colonel gives his men a pep talk: 'England comes first and that's all there is to it.'

The troopship arrives in Southampton, to a rapturous welcome. Lily and Edrich are married and taken on to the ship's married strength. Moore's fears about his baby are dispelled. Carter deserts to see Elsie and even threatens her with a knife but Joan and Gilbert talk to them both and all is put right. Joan turns out to be in love with her golf partner Roddy and that leaves Gilbert free to marry Ann. Smith's parents turn up for a reconciliation and offer to buy him out of the army but he decides to stay in. Withers, converted from his bolshie troublemaking, leads a loyal deputation of the men to express their support for the colonel: 'We're with you, sir, the whole blinking lot of us.' The troops and their families give three rousing cheers for the colonel and his lady. A telegram arrives from the King, wishing them good luck and a safe return. They give three cheers for the King. The six hours are up. The troops go back on board. Lucy and Harry say goodbye in a movingly under-stated scene, knowing that they will never meet again. She does not ask him to give up his career and stay with her: she knows that he cannot. In a *Cavalcade*-type finale the troops on the ship and their families on the dock sing 'Auld Lang Syne' and the ship sails away, a moving and emotional finale to a well-made film.

The whole thing is, as the foreword implies, a homily on duty and discipline. When the odious Mrs Swayle declares that people ought to learn more discipline, she means by it social distinction, and Blair tells her in no uncertain terms that discipline does not mean snobbery but service, organized service. That is what the army is about. It is the military expression of the perennial duty-theme of Empire. What distinctions there are are necessary for the working of the system. The hierarchy of ranks is cinematically maintained by intercutting the officers above decks and the men below, but they are all united by their common purpose – the service of their country. The officers help to solve the problems of the men and they bear their own problems with quiet dignity. All discontent is finally silenced by a telegram from the King and the regiment cheerfully takes upon its shoulders once again the burden of Empire. 'England comes first, and that's all there is to it.'

Notes

1 A. P. Thornton, *The Habit of Authority* (1966), p. 13.
2 George Pearson, *Flashback* (1957), p. 165.
3 E. C. Mack, *Public Schools and British Opinion since 1860* (1941), p. 415.
4 In this version the names of the characters were changed: Bert Cecil to the more aristo-cratic Ralph Brett and Commandant Chateauroy to the more Irish Commandant Doyle (probably due to the casting of Victor McLaglen).
5 *Monthly Film Bulletin*, December 1961, p. 172.
6 *The Times*, 13 October 1961.

11 The Naval Tradition

The sea is in our blood. As an island we have always had a special place in our affections for the navy, the senior service. In the nineteenth century the British had the greatest navy in the world, its popularity indicated by the vogue for maritime dramas in the theatre, the fashion of dressing Victorian children in sailor suits and the popular songs. Part of the repertoire of every self-respecting ballad singer were the song cycles, *Songs of the Sea* and *Songs of the Fleet*, words by Sir Henry Newbolt, memorably set to music by Sir Charles Villiers Stanford. It was the navy which physically linked together the far-flung outposts of the Empire. As Sir Edward Grigg wrote:[1]

> What the legions and the long tradition
> behind them were to the Roman world,
> the Royal Navy with its splendid record
> of world-wide service is to our empire
> today. Farther than the eagles ever flew,
> the white ensign waves and it protects a
> political system as vital as that of Rome
> to the peace of the world. We do not want
> these silent ships to be forced again into
> utterance; we want them to do their
> duty unheard.

The sea captain, pacing his bridge and sailing to the defence of the Pax Britannica, was, as has already been noted, one of the folk myths of Empire.

On board ship the same rigid distinctions between officers, N.C.O.s and other ranks as obtained in the army is to be observed, the same feeling of understatement and self-discipline. This is, if anything, intensified in a wartime situation. As in the Imperial army, so too in the Imperial navy officers and men are united by common purpose – the service of their country. But something which is impossible with armies becomes a recurrent theme of naval war films: the battle of wits between two commanders, the duel to the death between ships. It is perhaps not too fanciful to see a touch of the English gentleman's tally-ho foxhunting instinct in the pursuit of German battleships by dogged and determined squadrons of cruisers.

Sink the Bismarck (Lewis Gilbert, 1960) details the plotting of the pursuit and destruction of the *Bismarck*. It is masterminded, from the Admiralty War Room, by Captain Jonathan Sheppard (Kenneth More), archetypal imperturbable naval officer, very stiff-upper-lip ('Getting emotional about things is a peacetime luxury') and punctilious ('It's very simple – either you have discipline or you haven't'). It is these qualities which eventually win out over the Germans, commanded by Admiral Lutyens (Karel Stepanek), a glory-seeking, champagne-swilling Nazi fanatic. ('We are faster, we are unsinkable – and we are German.') He is such a contrast to the C.-in-C. Home Fleet (Michael Hordern), who after the epic battle is over and the *Bismarck* is sunk, turns to his officers and says quietly: 'Let's go home, gentlemen.' The job has been done without fuss, without display, and without rhetoric – as only archetypal British naval officers could do it.

Like *Bismarck*, Michael Powell's *Battle of the River Plate* (1956) is essentially an officers' film, and in their pursuit of *Graf Spee* they display just the qualities we would expect: quiet courage and modest understatement. Captain Parry (Jack Gwillim) is informed that he has been shot through the leg and replies: 'Good Lord, I never noticed that', as if someone has told him he has lost a button from his jacket. Captain Bell (John Gregson),

The Naval tradition

One of the key folk
myths of Empire was
the sea captain gazing
through his binoculars
from the bridge of his
ship. It is a recurrent
image in the cinema of
Empire.

112 (right) Second
World War: Clive Brook
with Allan Jeayes in
Convoy

113 (below) Napoleonic
War: Gregory Peck with
Robert Beatty in
*Captain Horatio
Hornblower R.N.*

with foredeck blown up, communications out of action and guns destroyed, sends a laconic message to the flagship: 'Request permission revise list of spares.' As always in Powell's films, the enemy is a man to respect and honour. Captain Langsdorff (Peter Finch) is a chivalrous, courteous professional sailor, respected even by his captives. The Germans give their British prisoners Christmas presents and the first thing they do on arriving in Montevideo is to free the British, who as they leave salute the German dead. At sea, it is still a gentleman's war.

In *Singlehanded* (Roy Boulting, 1953), based on C. S. Forester's *Brown on Resolution*, a British convoy under Captain Saville (Michael Rennie) chases the *Essen* round the Pacific until it is finally trapped thanks to the courage of A. B. Andrew Brown (Jeffrey Hunter), who holds it on Resolution island by sniping with a rifle until the British ships can arrive. An earlier version, *Brown on Resolution*, renamed on re-issue *Forever England* (Walter Forde, 1935) and described in its publicity as a 'sea drama to stir the blood of everyone of British stock', set the story of the First World War and had Commander Somerville (Barry McKay) chasing the *Zeithen*. It also had a different ending. In the 1935 version Brown (John Mills) is killed. In the 1953 version he survives to receive a decoration at Buckingham Palace. But common to both versions is that Brown is the product of a liaison between a tradesman's daughter and a young naval officer. He wanted to marry her but she has refused because the difference in their classes might harm his career. It is an interesting example of the interaction of the hierarchic systems of naval and civilian life.

Though the greater proportion of naval films have been war films, several have attempted to deal with the role of an Imperial Navy in peacetime. Probably the most splendid post-war Imperial naval epic is Michael Anderson's *Yangtse Incident* (1957), produced by Herbert Wilcox. Even the title has the feeling of British understatement about it, that same feeling which categorizes a revolution as 'a spot of bother' and a major

war as 'that recent unpleasantness'. The incident involved occurs when H.M.S. *Amethyst*, proceeding down the Yangtse River on 'her lawful and peaceful occasions' is fired on by Communist batteries. The Captain orders that the Union Jack be draped over the side, in a manner reminiscent of the scene in the Victorian melodramas when the heroine was wrapped in the flag to protect her from the enemy. But the ship is disabled and the captain killed. The British Embassy orders Lt Cmdr Kerans (Richard Todd), a steely-eyed 'spit and polish merchant' to take command. He negotiates with the Communists under the wily Colonel Peng (Akim Tamiroff), who insists on the British acknowledging that they are in the wrong. This, of course, they cannot do. Finally, after months of waiting, Kerans decides to try and escape. ('I don't know if we'll make it, but we'll have a damned good try.') They succeed, Kerans has a cup of tea to celebrate and sends an unemotional message to H.Q.: 'Have rejoined the fleet. God save the King.' The film ends with a message from the King superimposed over the flag and the Elgarian theme music. He praises the courage and enterprise of the crew and ends: 'Splice the mainbrace. George Rex.' The sailor king pays tribute to his sailor men.

In tone and character this film irresistibly recalls another Herbert Wilcox production of twenty years earlier, *Our Fighting Navy* (Norman Walker, 1937), a title which could well have been given to *Yangtse Incident*. Released to coincide with the Coronation, *Our Fighting Navy* had a grand charity première, attended by the Duke and Duchess of Kent. The film was produced with the full co-operation of the Navy and featured H.M.S. *Ark Royal* (playing H.M.S. *Audacious*) and H.M.S. *Curacao* (playing *El Mirante*). The publicity issued for the film is of interest, demonstrating as it does the very real propaganda intent of a production like this:

The film *Our Fighting Navy*, a true to life story, depicts our modern fleet in all its phases. There has always been a naval way of doing things and our film proves

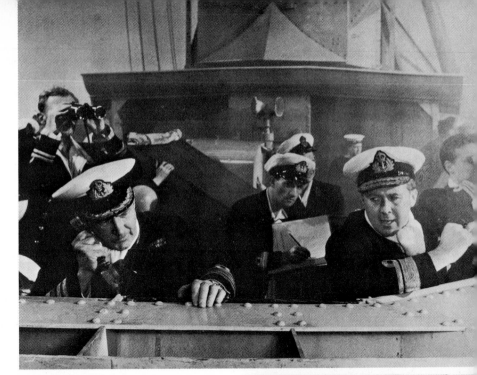

114 (right) British phlegm under fire. Ian Hunter and Anthony Quayle in *Battle of the River Plate*

115 (below) British phlegm contrasts favourably with German ranting. Karel Stepanek and Carl Mohner in *Sink the Bismarck*

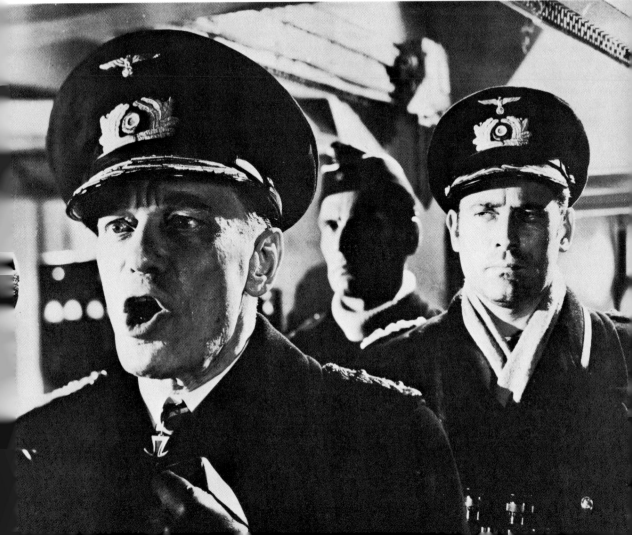

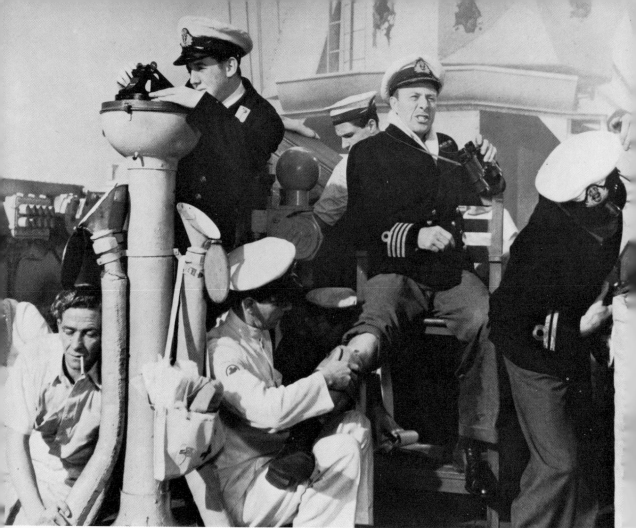

116 (above) It was the British way to regard a wound as a minor irritation. Jack Gwillim in *Battle of the River Plate*

117 (left) And to keep the flag flying at all costs (*Yangtse Incident*)

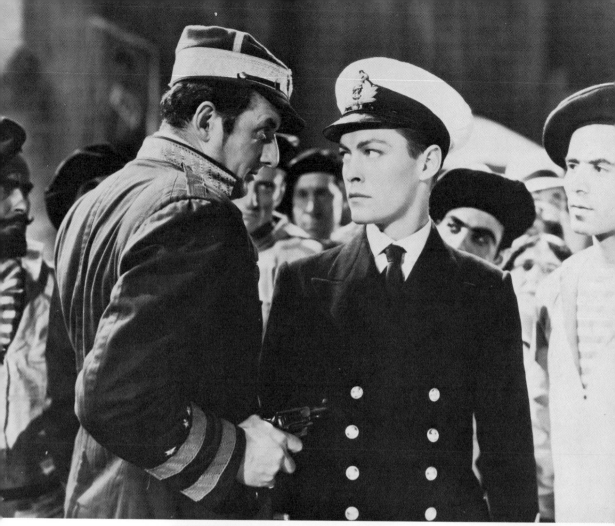

During peacetime the
job was to keep the
lesser breeds under
control.
118 (above) Richard
Cromwell defies the
dago in *Our Fighting
Navy*
119 (right) Richard
Todd defies the Yellow
Peril (Keye Luke) in
Yangtse Incident

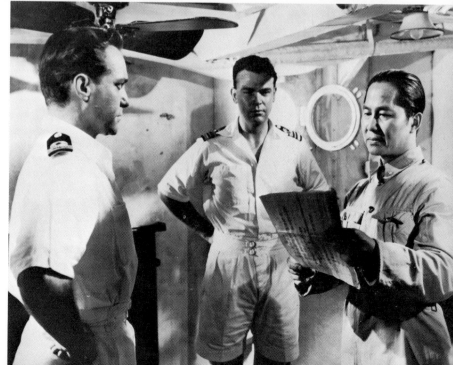

that the Navy way is the right way, a way that brings out the finest qualities in the men who have adopted the Navy as their one and only job in life. Truly the men of the Navy are the sons of their fathers and possess more salt in their blood than any other race, resulting in the fact that we are the proud possessors of the finest navy in the world. The British Navy has not been used in the picture as a background to some stirring love drama, but the story deals with the protection of these islands of ours and the far outposts of the Empire.

After this rhapsodic build-up, the actual film comes as something of a disappointment, being little more than rather second-hand *Boy's Own Paper* stuff. The Admiralty dispatch H.M.S. *Audacious* to the South American republic of Bianca on receiving news of unrest there. It arrives to find that a revolution has broken out. The President of the Republic (Noah Beery) takes refuge in the British Consulate – where else? The rebels demand his surrender and threaten to shell the Consulate. The Consul, Mr Brent (H. B. Warner, the erstwhile screen Christ), refuses. The rebels commence firing. But *Audacious* under keen-eyed, square-jawed Captain Markham (Robert Douglas) lays a smoke-screen and engages the principal rebel ship, *El Mirante*, though torn between his duty and his love for Pamela Brent (Hazel Terry), who is a prisoner on the ship. *Audacious* sinks *El Mirante*, Pamela is rescued and the revolution collapses. Three cheers for the red, white and blue.

Together with *Our Fighting Navy* we can couple another Herbert Wilcox production, *The Flag Lieutenant* (1933), as characteristic of British naval epics of the thirties. An unbelievable antique, this is a film only for connoisseurs and fanatics. A photographed stage play, in which the camera hardly moves, it lifts all the action footage from the silent version, directed by Maurice Elvey in 1926. This was easily matched because the star, Henry Edwards, played the same role in both versions as well as directing the remake. But it is easily spotted because it is all speeded up.

The film opens with a Ball on board ship which establishes the characters. Lt Dicky Lascelles, the cheerful, irresponsible 'playboy of the Mediterranean fleet', is the hero and is played by the director Henry Edwards, then nearly fifty, as a jaunty if rather elderly 'silly ass', reminiscent in manner of Jack Buchanan. He is courting Hermione (Anna Neagle), daughter of Admiral Sir Berkeley Wynne, C.-in-C. Mediterranean Fleet. His best friend, Major Thesiger of the Marines, is hopelessly in love with attractive widow Mrs Cameron, but fears to declare his love as he is nearing retirement and intends to retire to Southsea on half-pay. Word arrives that 10,000 Moslems are under arms in Candia, a British dependency in the Near East, and are besieging a Highland regiment in their camp. The destroyer H.M.S. *Blizzard* is ordered out there and Thesiger with it. He jumps at this chance to distinguish himself and earn promotion. Lascelles urges him to take care. ('You're the best man I've got. Don't let those niggers put you in the bag.') Dicky volunteers to go himself in order to prove himself. 'Rule Britannia' is played as the women watch their menfolk sail off to the Empire.

The relief force lands and fights its way to the camp ('A hell of a scrimmage'). Dicky saves Thesiger's life by casually shooting an Arab with one hand while peeling a piece of salami with the other, just to demonstrate the effortless superiority of the British. ('Thanks, old man.' 'Quite all right, old boy.') Word comes that the tribes are massing in the hills. News must be got to the fleet. Thesiger plans to go, disguised as a native, but he is stunned by a native bullet. Dicky goes instead and returns to find that Thesiger has lost his memory. He allows him to take credit for the exploit so that Thesiger will get the promotion he needs. But now Dicky has no explanation of where he was during the siege. When the Arab attack is beaten off, Thesiger is the hero of the hour. He is duly promoted colonel and wins his widow. At a dinner given in Thesiger's honour several people cut Dicky, now rumoured to be a coward. Dicky won't tell what really

happened because Thesiger is his 'pal'. He is faced with disgrace because of his silence. The truth, however, is discovered by the Admiral, who agrees not to reveal it because Thesiger has just been awarded the C.M.G. in the Birthday Honours. Instead he simply announces that Lascelles is officially cleared of any suspicion of cowardice and Lascelles takes his place on deck, left profile turned towards the camera, as the flag is raised and the national anthem played.

With British tars marching into battle singing 'I'm an honest British sailor' and a musical comedy hero acting in strict accord with the Code, there can be little doubt that the jabbering native rebels will be dispersed and Right (i.e. Britain) will triumph in the end. If anyone is in any doubt as to how this relic was received by contemporaries, they have only to consult the reviews of the period. For instance, *Picturegoer* said of it: 'It is a hundred per cent British in its outlook and its spirit – and this adds to the welcome it deserves from you and which I am sure you are going to give it.'[2]

The naval tradition is of course, a historical one and the cinema has depicted it in action in the days of the sailing ship. Sir Francis Drake, sturdily played by Rod Taylor, is one of the central characters of Rudolph Maté's stylish swashbuckler *Seven Seas to Calais* (1962). Drake claims what is now California (but was known to him as New Albion) for the British crown, he maintains discipline by hanging his best friend for mutiny and, in a historic display of *sang froid* but with the knowledge that the tide has not yet turned, he plays bowls while the Armada sails down the Channel. Later, of course, he sails out to beat them before returning to sea again at the end of the film.

Cut from much the same unemotional cloth is C. S. Forester's Captain Horatio Hornblower. He was magnificently brought to the screen by Raoul Walsh in *Captain Horatio Hornblower R.N.* (1951) with Gregory Peck a memorable Hornblower, nervous cough and restless deck-pacing done to perfection. Phlegmatic and unexcitable, he calmly orders lunch and demonstrates no apparent interest when a midshipman ex-

citedly informs him of the first sighting of land for 10,000 miles. Later when he hears a Spanish ship has anchored for the night prior to attacking, he quietly announces: 'Well, gentlemen, that leaves us time for a rubber of whist.' Scrupulously fair, he spares the life of Spanish prisoners of war and he disapproves of flogging, which he does not believe necessary to gain the respect of the men. The men not only respect him, they worship him – as the admiring whisper of one of them ('He ain't human') indicates. A superb navigator, a believer in discipline, a patriot fighting a patriotic war, he is the quintessential sea captain. By comparison, the enemy are a poor lot. Hornblower runs rings round the French, spectacularly outwitting them both on sea and on land, while the Spaniards are portrayed as scruffy incompetents and their leader, Don Julian Alvarado, as a ranting lunatic, revelling in his atrocities. With enemies like this it is small wonder that Britannia ruled the waves.

Even that memorable sea picture *Mutiny on the Bounty* (Frank Lloyd, 1936) contrived to fit the mutiny into the context of the naval tradition, declaring in a foreword that it led the way to a new discipline in the Navy, based on the mutual respect of officers and men 'which has enabled Britain to rule the seas since'. In an upbeat ending Midshipman Byam (Franchot Tone) is pardoned and rejoins the fleet, which sails off to the Mediterranean to fight the French to the strains of 'Rule Britannia'. We can only be grateful that this new naval discipline did not come early enough to deprive us of one of the cinema's most memorable creations, Charles Laughton's glowering Captain Bligh, the ultimate naval tyrant and antithesis of Hornblower.

Just as the cinema provided an epitaph for the Imperial officer in *Blimp* and the Imperial N.C.O. in *Batasi*, it has also created an amused and sympathetic memorial to the naval tradition in John Frankenheimer's witty, elegant and entertaining comedy, *The Extraordinary Seaman* (1969). A crew of incompetent American seamen come upon a beached British ship, H.M.S. *Curmudgeon*, on a Pacific island. Its captain, Lt Cmdr John

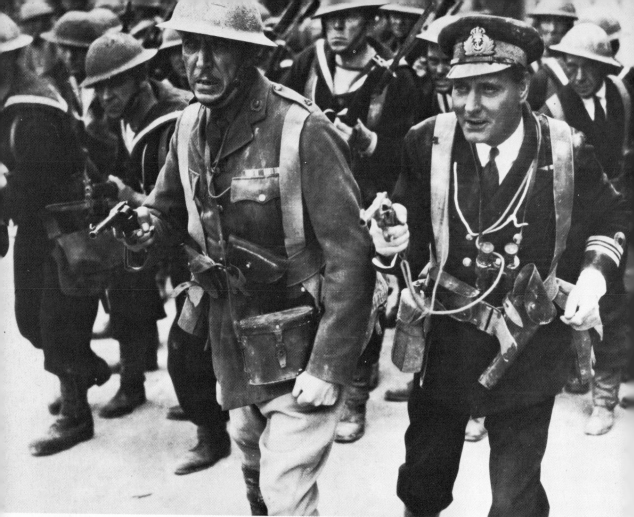

120 (above) The naval
tradition in its heyday.
Henry Edwards leads a
naval detachment to
relieve a besieged
British garrison
(*The Flag Lieutenant*)
121 (left) Epitaph for
the Naval tradition. In
Extraordinary Seaman,
David Niven is both a
drunk and a ghost

The R.A.F.
122 (right) Richard
Todd briefing the chaps
in *The Dam Busters*
123 (below) Basil
Rathbone reprimanding
the chaps (David Niven
and Errol Flynn) in
The Dawn Patrol

Finchhaven (David Niven), is an immaculate, imperturbable, old-fashioned officer and gentleman with a seemingly inexhaustible supply of whisky. He is the extraordinary seaman of the title and is very extraordinary indeed. In fact he is a ghost, condemned by his ancestors to sail the seas until he redeems the family honour, which he besmirched in the First World War when he fell overboard drunk and drowned when on the point of sinking a German battleship. His chance of redemption comes when he finds a Japanese battleship. He rams it, only to discover that it is the ship on which the Japanese are signing the surrender document. Wearily, Finchhaven sets off on his travels again.

The use of Gilbert and Sullivan's *H.M.S. Pinafore* in the score is inspired, capturing as it does the jaunty self-confidence of the bygone age of British naval supremacy. David Niven gives his best performance for some time, playing with 'mannered skill, witty nonchalance, emotional restraint yet with the empty despair of a man who knows that while on the outside he maintains the visage and posture of greatness, honour and tradition, he is really inside a small, empty man.'[3] Finchhaven somehow epitomizes the passing of the age of British naval supremacy.

A note on the R.A.F.

Too late an invention to qualify as part of the Imperial armed forces of the heyday of Empire, the R.A.F. none the less fitted easily into the tradition of the gentleman's war. They rapidly built up their own mythology and achieved their epic in the Battle of Britain, brought to the screen by Guy Hamilton in *Battle of Britain* (1968), in which the highspot is the balletic sequence of duelling planes which dramatizes the R.A.F.'s legendary, chivalric, personal war.

The public school tradition took to the skies in Michael Anderson's very long and very boring *The Dam Busters* (1954), scripted by the ubiquitous R. C. Sherriff and significantly one of the most popular films of the fifties. Richard Todd incarnates the archetypal air force commander, Wing Cmdr Guy Gibson, tight-lipped, authoritative, eagle-eyed, pipe-smoking. His love for his dog is the one hint of 'human interest' in the picture. The officers, who are indistinguishable from one another, are good chaps every one, who return from their bombing raids to cups of tea and plates of bacon and eggs, debag rival pilots in a display of cheerful high spirits and play cricket as their planes are being prepared for take-off.

The same spirit underlies one of the best First World War films on the British air force to be made: *The Dawn Patrol* (Howard Hawks, 1930, re-made by Edmund Goulding in 1939). The film tells of the 59th squadron of the R.F.C. in France and the desperate loneliness of command which devolves in turn on Major Brand (Neil Hamilton 1930; Basil Rathbone 1939), Captain Courtney (Richard Barthelmess 1930; Errol Flynn 1939) and Lt Scott (Douglas Fairbanks Jr 1930; David Niven 1939) Each has to shoulder the burden, for the job has to be done and it *is* done. As Brand says: 'It's a slaughter house, that's what it is, and I'm the executioner. You send men up in rotten ships to die . . . they don't argue or revolt . . . they just say right-o and go out and do it.' That is what public school had prepared them for, of course, and the public school spirit of camaraderie and horseplay in the mess is offset by the quiet dedication and efficiency with which they carry out the duties assigned to them. They just say 'right-o' and go out and do it.

Notes

1 Sir Edward Grigg, *The Faith of an Englishman* (1937), p. 334.

2 *Picturegoer*, 31 December 1932, p. 19.

3 Gerald Pratley, *The Cinema of John Frankenheimer* (1969), p. 167.

East is East and West is West . . .

The British Empire was racialist, from one point of view – though racialism was in the nineteenth century an as yet ill-defined term that involved both cultural and biological concepts. Basically, the British believed that the Anglo-Saxon race was superior to every other, not simply that white was superior to black. The old idea that wogs begin at Calais is deep-rooted in Anglo-Saxon consciousness. This instinctive belief came to be sanctioned by 'science' after Darwin's evolutionary theories, as expounded in *The Origin of Species* (1859) and *The Descent of Man* (1871), led to a burst of spurious anthropological argument and systematic investigation into racial differences.

One result of this was the construction of a cultural hierarchy with western civilizations at the top, followed by those of the East, with Africa at the bottom. This cultural superiority was reinforced by a spiritual superiority that came with the missionary impulse, the belief that the coloured races were unenlightened heathens waiting for the British to dispense to them the word of the Christian gospel. Another kind of superiority stemmed from the very fact that the British ruled such a vast Empire and did so with, comparatively speaking, only a handful of men. In addition a defensive superiority was engendered by the traumatic experiences of the Indian Mutiny and the Jamaica revolt and the subsequent continuing fear of a native uprising. It was reassuring for the British to be able to tell themselves that however many natives took up arms against them, they would ultimately triumph because of their innate superiority.

Within the whole body of the Empire it was probably the East which expressed the strongest siren call. The lure of the East has been a potent force both in the politics and literature of Empire. It has exerted a fascination which is at once part escape, part adventure, part dream. A vision of the East has been conjured up that has haunted the mind of Western man for centuries: a world of jewels and blossoms, spices and perfumes, palm trees and silver temple bells – and dark-skinned maidens. But it is a world with its own rules, its own myths, its own ambience, into which Occidentals stray at their peril. 'East is East and West is West and never the twain shall meet' is one of Kipling's best known lines and it forms one of the principal commandments of the cinema of Empire.

It is a reflection of the curious Calvinist strain in the Imperialist religion that the British should plant themselves firmly in the East and then steel themselves to resist its blandishments. It is almost as if they were seeking to prove their innate superiority by facing and overcoming the temptations inherent in the exotic atmosphere. It is for this reason that wherever they went the British sought to recreate their own world around them. They wanted to cocoon themselves against the subtle, insidious influence of the native cultures. They constructed strange, artificial British 'islands amid the alien snows', as Ghul Khan calls them in *The Drum*. The Residency, the Gymkhana Club, the cantonment, provided familiarly British points of reference in a world of crowded bazaars and teeming native cities. Within these bastions of Englishry, as H. C. E. Zacharias commented, the British 'under the inspiration of the ladies . . . succeeded in organizing English society . . . with devastating faithfulness upon the great models of Brixton and Upper Tooting'. We

have noted before how the English carried their Englishness with them wherever they went. The very attributes of Englishness that we examined earlier became exaggerated in these transplanted suburban communities and their existence served merely to emphasize that aloofness and sense of superiority which was so much a part of the Imperial mystique.

This aloofness and superiority had to be preserved at all costs. So too had the purity of the race. Miscegenation was taboo. The dangers of miscegenation formed one of the most popular bases for stage melodrama and three famous old melodramas, which were in the repertoires of many a touring company, turned up regularly on the screen. They are William Archer's *The Green Goddess*, which was filmed three times (1923, 1930, 1943); Leon Gordon's *White Cargo*, based on the novel *Hell's Playground* by Vera Simonton, and filmed twice (1930, 1943); and *The Chinese Bungalow*, adapted by Matheson Lang and Marion Osmond from the latter's novel and also filmed three times (1926, 1931, 1940). Their enduring popularity is ample evidence of the fascination of the theme, the *frisson* which it provided for an audience at once intrigued and repelled by the thought of mating with someone of a different colour.

The first two versions of *The Chinese Bungalow* both starred Matheson Lang, who had created the leading role on the stage. The third version, the only one still available, starred Paul Lukas. Yuan Sing, the Chinese millionaire (played with great dignity and sympathy by Lukas) marries, in Singapore, the English nightclub singer, Sadie Merivale (Kay Walsh) and takes her up country to his Chinese bungalow. He is devoted to her but she feels increasingly lonely and isolated since Sing goes off to Singapore on business for long periods. She turns for consolation to the only other white man within thirty miles, Harold Marquis, the rubber planter (Wallace Douglas). When Sadie's sister Charlotte (Jane Baxter), thoughtfully sent for by Yuan, arrives to stay, they get their first insight into the inscrutable Chinese. A vengeful Malay husband kills his wife and her lover in the courtyard of the bungalow. Sing watches unmoved. 'It's murder,' says Charlotte. 'I prefer to call it retribution,' says Sing. He explains that in the East marriage is a prized possession and a thief who steals it must be punished. He finds out about Sadie's affair with Harold and plans a fiendish vengeance.

Until now, our sympathy has been directed towards Sing, whom Charlotte describes as 'the gentlest and kindest man I have ever met' and against Sadie, who is manifestly weak and foolish. The tragedy lies in the fact that they ever married. For it is implied that she would never have behaved as she has in normal circumstances. But since she has, her husband, being a man of a different world, acts according to the rules of his race – and in so doing becomes the traditional Oriental villain of melodrama. He sends a cat with poisoned claws to finish off Harold and transfers his own sexual affections to Charlotte, imprisoning her with Sadie when she rejects his advances. Harold's brother, Commander Richard Marquis R.N. (Robert Douglas), clean-cut, square-jawed, steely-eyed, who is also in love with Charlotte, turns up, seeking explanations.

Sing, who has throughout the film worn European clothes, now assumes Chinese mandarin robes and takes Marquis to a locked room, where they drink from two goblets, one of which, Sing reveals, is poisoned. One of them will die. 'May the best man win,' says Sing. He explains his reasons and Marquis sees that underneath it all he is really a good chap, who has been trapped in the gulf between the races. 'Smooth sailing, Sing,' says Marquis. 'Happy Journey,' replies Sing. Inevitably it is Sing who dies, at the foot of the impassive Chinese idol. He had paid the price of transcending Kipling's rule. Though made on a low budget, with the upper reaches of the Thames standing in for the Malayan river Gula, this is a fluidly directed piece and emerges as a compelling if small-scale work.

Like *The Chinese Bungalow*, *White Cargo* was filmed in the early days of sound by J. B. Williams, director of *Bungalow*, with Leslie Faber, Gypsy Rhouma and Maurice Evans

heading the cast. But the definitive screen version remains the one directed in Hollywood in 1943 by Richard Thorpe and adapted for the screen by the play's author, Leon Gordon. It is far from being a good film by any standards but it must be relished by anyone with a taste for the bizarre, if only for the sight of a sultry Hedy Lamarr, skin darkened and scantily clad, slinking through the studio jungle in her role of the native temptress Tondelayo.

The film, like the play, is set in a rubber plantation in the Congo in 1910 and observes the lives and relationships of the small group of white men who run it. As in *Sundown* and *Sanders*, for instance, we see the all-male, close-knit white group, keeping themselves apart and not infrequently getting on each other's nerves. The old hands are the drunken, grandiloquent doctor (Henry Morgan), who has been there for twenty years and finds alcohol the only thing that makes life bearable (a similar character figures in *Bungalow*), and the plantation manager and local magistrate, Harry Witzel (Walter Pidgeon), pipe-smoking and moustached, irascible, hard-working and knowledgeable in the ways of the country and the natives. There is more than a touch of Sanders in the way in which he summarily pronounces judgment on errant natives from the basket chair on his verandah and in his view of the natives: 'They know a man like a horse knows a rider and they take liberties accordingly.' It is at least a variation on Sanders's view of the native as a good dog, but it carries with it all the same implications. In fact, without exception, the natives in the film are idle, stupid or hostile.

Witzel is the film's hero, the strong, silent, dedicated colonial administrator, and the film endorses his actions and his attitudes. The advice he gives to Langford, who arrives to assist him, again could have come straight from Sanders's handbook: 'Never let the men see that you're afraid of them and don't ... talk to the women.' 'Talk' is, of course, a euphemism and derives from the term the film uses for miscegenation, 'mammy palaver'. The instructions, being translated, then, are: don't lose face

and don't sleep with the women. But the heat, the boredom, the isolation take their toll and drive the weaker men towards the forbidden activities. There is a quintessential scene, designed to emphasize the loneliness and homesickness. All the white men for miles around, six in number, gather for dinner and plaintively sing 'There's no place like home'. The scene does not move one, largely due to Thorpe's uninspired direction, but the intention to do so is plainly there.

The film opens with the departure of Ashley (Bramwell Fletcher), a broken wreck of a man, and the arrival of his replacement, Langford (Richard Carlson), well-spoken, clean-shaven and immaculately white-suited. Witzel predicts that he will not stay that way long. It emerges that Ashley has been ruined by the local native temptress Tondelayo. She now sets her net for Langford and soon ensnares him. In fact he announces to the universal horror of his companions that he intends to marry her. The doctor declares that it is unwholesome and reminds Langford that they have to maintain certain standards. Witzel blows his top completely. He declares: 'There isn't a man along the coast, however far down he's gone, who wouldn't rather see you dead.' The attitude of the local missionary is even more startling. He affirms that it is against all his instincts to marry them but he is compelled by the precepts of his faith, which mistakenly believes all people to be equal in the sight of God. Langford and Tondelayo duly marry but she becomes bored with him quickly. She seeks to seduce the inflexible Witzel, who will have nothing to do with her. She begins to poison Langford. Witzel sees through her plot and forces her to drink 'the medicine' she has been feeding Langford. She rushes off screaming into the jungle and dies and Langford, broken like his predecessor, is shipped home, the 'white cargo' of the title.

Tondelayo incarnates forbidden native sex, sapping the integrity and vitality of the white man. 'By the time the sun's gone down,' confesses Langford, 'there's only one thought beating in my brain – Tondelayo, Tondelayo.' Naturally since it is 1943, the

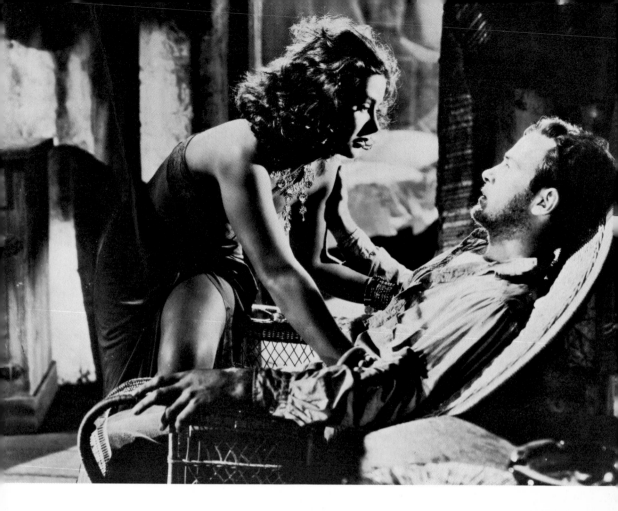

Miscegenation melodramas

The dangers of miscegenation formed one of the most popular bases
for melodrama.

124 (above left) George Arliss attempts to seduce Alice Joyce in
The Green Goddess

125 (left) Paul Lukas attempts to seduce Jane Baxter in *The Chinese
Bungalow*

126 (above) Hedy Lamarr attempts to seduce Richard Carlson in
White Cargo

sex is not too explicit. But the *reductio ad absurdum* of the whole incredible affair comes in the scene where Langford initially resists Tondelayo's advances. In reply, she wiggles her hips, narrows her eyes and suggests – making him a cup of tea!

The Green Goddess provided George Arliss with one of his most memorable stage roles, that of the archetypal educated native, suave, amusing and deadly. It was inevitable that he should translate his interpretation of the Rajah of Rukh to the screen and he did so, twice, in a silent version made by Sidney Olcott in 1924 and a sound version, directed by Alfred E. Green in 1930. A third version, appearing in 1943, was retitled *Adventure in Iraq* (director: D. Ross Lederman) and starred Paul Cavanagh as the Rajah with John Loder, Ruth Ford and Warren Douglas in the other leading roles. The change of locale is interesting. For it was made during the war at just the time that the production of *Kim* was being discouraged – on the grounds of the sensitivity of the Indians, whose assistance was needed in the war effort. Iraq was, presumably, felt to be less politically explosive than India.

The film opens as word of a native uprising reaches a British garrison, to the alarm of Mrs. Lucilla Crespin (Alice Joyce in both versions), for the place where her children are staying is threatened. Her husband, Major Crespin (Harry Morey in 1924; H. B. Warner in 1930) is drunk as usual. But Dr Basil Traherne (David Powell in 1924; Ralph Forbes in 1930) offers them the use of his plane to try and get the children out. They depart but the plane develops a fault and they are forced to land. They are met by the Rajah of Rukh (George Arliss), civilized, monocled Oxford graduate, who invites them to his palace. Over dinner, he casually reveals that the British are holding his three brothers and plan to execute them for murdering a British patrol. The Green Goddess demands their deaths in reprisal and the arrangements are being made. They plan to send a radio message to summon help, and when a servant of the Rajah threatens to betray their plan, they throw him over the balcony. ('At least we didn't take

it lying down.') But the Rajah shoots Crespin and offers Lucilla her life if she will marry him. She refuses. The Rajah smiles. 'At sundown, you are to die – not simply – but with torture. Personally I regret the course, but what am I before the gods?' Traherne confesses that he loves Lucilla and she offers to marry the Rajah to save his life. However, when she tries to kill herself to avoid that fate, the Rajah orders them both to be put to death. At this point the R.A.F. arrives and the Rajah is given the alternative of releasing his prisoners or being bombed to eternity. He releases good-naturedly, wishes them well and they depart. Then, turning to the audience, he remarks: 'After all, she'd probably have been a confounded nuisance.'

It is all vastly entertaining, with Arliss stealing the picture as he cheerfully plans lechery and torture and with the British maintaining a stiff upper lip: Crespin dying a hero's death to expiate his drunkenness and Traherne dutifully concealing his love for Lucilla until the last minute. Lucilla, naturally, prefers death to miscegenation.

The fear of miscegenation was, of course, one of the constituent fears which went to make up 'the Yellow Peril' and, as we all know, 'the Yellow Peril' was incarnate in one man – Dr Fu-Manchu. After featuring in a couple of silent serials made in Britain, Fu-Manchu was brought to the screen by Hollywood after the coming of sound. *The Mysterious Dr. Fu-Manchu* (Rowland V. Lee, 1929), *The Return of Fu-Manchu* (Rowland V. Lee, 1930) and *Daughter of The Dragon* (Lloyd Corrigan, 1931) all featured Warner Oland as the doctor, with Anna May Wong as his daughter, O. P. Heggie as Nayland Smith and Neil Hamilton as Petrie. But William K. Everson has written of them: "Rohmer's lightning-paced stories required tempo and steadily building tension that the static adaptations of 1929 lacked quite deplorably.'[1] Much more satisfactory was *The Mask of Fu-Manchu* (Charles Brabin and Charles Vidor, 1932) which M.G.M. produced and which emerged as a fast-moving, full-blooded, rip-snorting melodrama of classic dimensions. Boris Karloff and Lewis Stone were ideally teamed as the doctor and Nay-

land Smith. The doctor's aim was stated as being: 'to kill all the white men and mate with their women' and 'to wipe the whole accursed white race from the face of the earth'. To this end he employed a whole succession of fiendish devices and creatures, not to mention his daughter (Myrna Loy), who far from being the likeable creature in the book who often comes whimsically to the aid of our heroes, has been turned into a jewelled, sadistic nymphomaniac. But Nayland Smith carries the day in the end, when he turns a death ray on the Orientals and mows them down *en masse*.

Fu-Manchu reappeared, played by a shaven-headed Henry Brandon, in the fifteen-episode Republic serial of 1940, *Drums of Fu-Manchu*, directed by William Witney and John English, with William Royle as Nayland Smith and Olaf Hytten as Dr Petrie. In this opus Fu-Manchu is planning to raise the tribes of Central Asia in revolt as the first stage in his master-plan for world domination. But he is outwitted by our heroes after a succession of narrow escapes from such Oriental devilries as 'The Incense of Obedience' and 'The Thuggee Noose'.

Twenty-five years were to elapse before the doctor rose again, and then it was in the person of the memorably malignant Christopher Lee. He starred in a series of British-made Fu-Manchu pastiches, which began well with *The Face of Fu Manchu* (Don Sharp, 1965), proceeded competently with *The Brides of Fu Manchu* (Don Sharp, 1966) and *The Vengeance of Fu Manchu* (Jeremy Summers, 1967) and ended dismally with the execrable *Blood of Fu Manchu* (Jesus Franco, 1968), so bad that it was severely cut and issued as a second feature.

A succession of Nayland Smiths (Nigel Green, Douglas Wilmer and Richard Greene) accompanied by the same Petrie (Howard Marion Crawford) combat the doctor's plans to take over the world by the use of a poison gas (*Face*), a powerful energy beam (*Brides*), a world crime syndicate (*Vengeance*) and by the blinding of all his enemies (*Blood*). Only the first really captures the authentic spirit of Rohmer, with its mist-shrouded Lime-house graveyard, where eyes peer from inside

a statue; with its bid to steal the Young-husband Papers by sinister dacoits crawling through a disused sewer into the Museum of Oriental Studies; and with its splendid vintage car chase through the back streets and docks of Dublin (standing in for twenties' London). Besides all this it had a definitive Nayland Smith in Nigel Green, who brilliantly conveyed the suppressed intensity beneath a veneer of imperturbable calm.

Fu-Manchu turned up, lightly disguised, as Dr No (Joseph Wiseman) in the first of the James Bond film thrillers, *Doctor No* (Terence Young, 1962). Dr No, half-caste son of a German missionary and a Chinese girl and the possessor of a pair of metal hands (his real hands having been destroyed by radio-activity), plans world domination from his West Indian hideaway but is foiled by Bond. James Bond is basically only Bulldog Drummond with sex and it is, therefore, fitting that he should cross swords with an updated Fu-Manchu.

Raymond Durgnat has perceptively put Bond in context by describing him as 'the last man in of the British Empire's Super-man's XI' and discussing *Doctor No* in Imperial terms:[2]

> Whatever Brand X critics may have written, Bond isn't just an Organization Man, but a rigid jingoist, almost lovably archaic. If you have forelocks, prepare to touch them now, in fond farewell to the Edwardiana in modern drag lovingly panoplied forth in the first half of *Doctor No* (1962) as Bond glides along the Establishment's Old Boy Net. The British Raj, reduced to its Caribbean enclave, lords it benevolently over jovial and trusting West Indians and faithful coloured police-sergeants, the Uncle Toms of Dock Green. We might almost be back with Lieutenant Kenneth More on the North-West Frontier. Meanwhile out on Crab Key lurks Dr No, last of the war lords, whose 'chigro' minions ('I'm not racially prejudiced, but miscegenates tend to be untrustworthy and mixed-up'), blend of the Yellow Peril and the Mau-Mau, battle it out with his English co-anachronism.

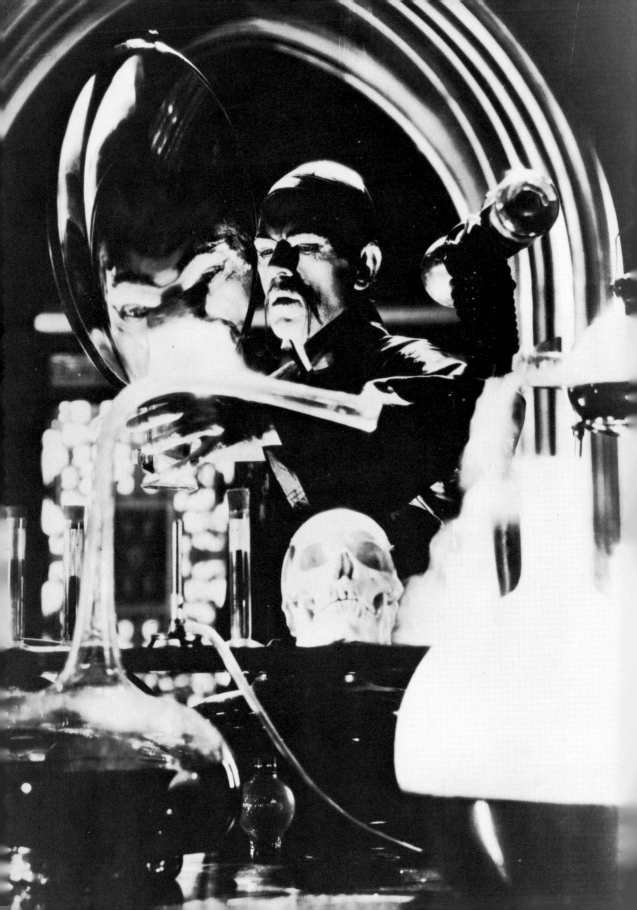

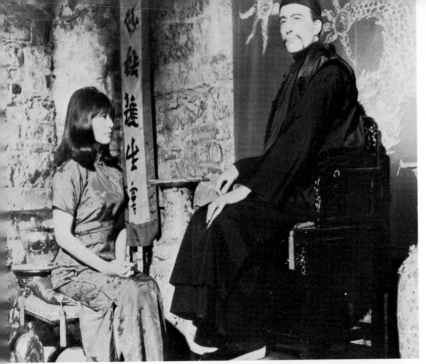

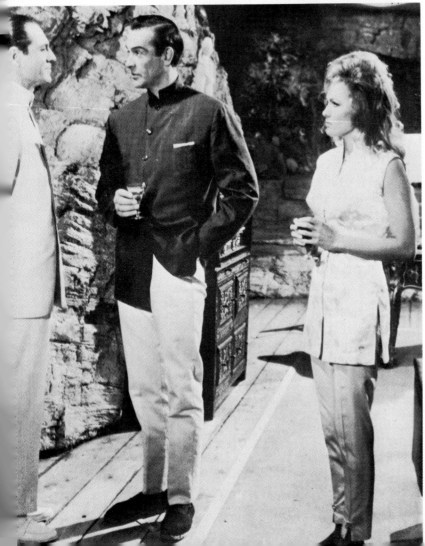

The yellow peril
127 (opposite) Boris
Karloff in *The Mask of Fu-
Manchu*
128 (above) Christopher
Lee with Tsai Chin in *The
Face of Fu Manchu*
129 (below) Joseph Wise-
man, the updated Fu-
Manchu, meets Sean
Connery, the updated
Bulldog Drummond, in
Dr No. Ursula Andress
watches

Even outside the realm of pure melodrama, miscegenation almost always carries with it disgrace and unhappiness. A familiar plot device is the native girl who falls in love with the white hero, helps him over some difficult hurdle and then is conveniently killed, usually saving his life. Yasmani in *King of the Khyber Rifles* (1929) and Amrita in *Kali-Yug, Goddess of Vengeance* fit into this category, and it must only be through a scriptwriter's oversight that Latah in *Bengal Rifles* escapes death, for she otherwise has all the attributes of the unrequited native lover.

In *Java Head* (J. Walter Ruben, 1934), based on Joseph Hergesheimer's novel about a feud between ship-owning families in the days of sail, mixed marriage is a central theme. Gerrit Ammidon (John Loder) loves the beautiful Nettie (Elizabeth Allan), but she is a member of the rival family. So he goes East and returns with a Chinese bride, Taou Yuan (Anna May Wong). Once back in Bristol, however, 'amongst his own kind', he finds the family extremely embarrassed and his love for Nettie reviving. Taou sees this too and dutifully commits suicide to save Gerrit any further embarrassment.

Another mixed marriage that goes on the rocks is the subject of *The Wife of General Ling* (Ladislao Vajda, 1938). Tai (Adrianne Renn), a European, marries the benevolent Chinese merchant Mr Wong (Inkijinoff) in Hong Kong. She is horrified to discover a propensity for violence in her husband when he cold-bloodedly kills a Chinese for giving information about him to British secret agent John Fenton (Griffith Jones), who suspects him of being in league with the bandit chief, General Ling. She eventually betrays her husband to Fenton, who rounds up the bandit gang and discovers that Mr Wong is really General Ling. Tai, sadder and wiser, marries Fenton, whom she had loved before meeting Mr Wong. She has learned the sad lesson of race, that two Wongs do not make a white.

The Squaw Man was a play by Edwin Milton Royle which became a favourite property of Cecil B. DeMille in that he filmed it three times: 1914 (co-directed with Oscar Apfel),

1918 and 1931 (retitled *The White Man*). It tells the story of English aristocrat Captain James Wynnegate (Dustin Farnum; Elliot Dexter; Warner Baxter), who accepts the blame for the theft of charity funds, actually stolen by his cousin Lord Kerhill (Monroe Salisbury; Thurston Hall; Paul Cavanagh), because he is in love with his cousin's wife Diana (Winifred Kingston; Katherine Macdonald; Eleanor Boardman). He goes West and marries an Indian squaw, Naturich (Red Wing; Ann Little; Lupe Velez), who has saved his life. However, in due course Lady Diana arrives in Wyoming with the news that Kerhill has died confessing his guilt, and that Jim is now Lord Kerhill. Naturich conveniently commits suicide when it is discovered that she has murdered an enemy of Jim's. Jim returns to England with Lady Diana.

Marriage to a native can mean nothing less than social ostracism. James Wynnegate enters into it because he is already ostracized. Otis Madison in *Beau Ideal* is willing to accept such ostracism because he has given his word. He promises to marry the Arab dancer Zuleika in return for her help in saving John Geste. Once John has been saved, however, and Otis is stiffening his upper lip in preparation for carrying out his bargain, John objects: 'Look here, old man, a dancing girl, a half caste, she doesn't expect it of you.' Otis insists that he is honour-bound to go through with it, even though it means cutting himself off from polite society for ever. Mercifully, at the eleventh hour he discovers her being unfaithful to him with another legionaire, considers himself absolved of his promise and chases off after John.

Perhaps the greatest miscegenation drama is *The Rains Came* (Clarence Brown, 1940), sensitively directed, exquisitely photographed and wonderfully acted by a hand-picked cast. To the Indian state of Ranchipur come Lord Esketh (Nigel Bruce), arrogant stuffed shirt, and his bored, glamorous wife, Edwina (Myrna Loy). She is attracted to the handsome doctor Major Rama Safti (Tyrone Power). ('Who is the pale copper Apollo?') The rains come, spectacularly well-staged,

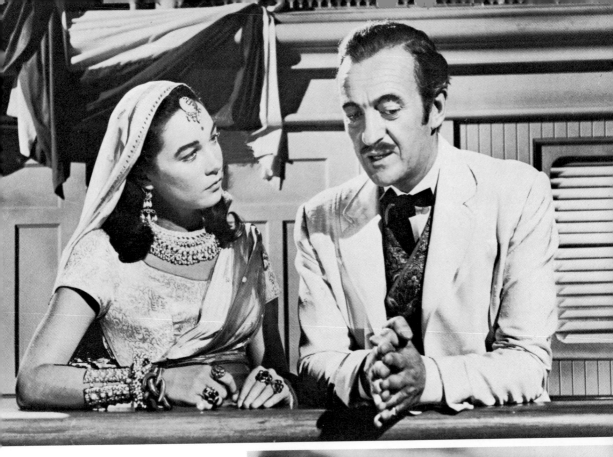

130 (above) Phileas Fogg (David Niven)
married an Indian princess (Shirley
MacLaine) in *Around the World in 80
Days* – but that was written by a
Frenchman who disliked the English.
131 (right) If an Englishman got
involved with a native girl, she was
usually killed at the end of the film
saving his life. This was the fate of
Myrna Loy in *King of the Khyber Rifles*.
She dies for Victor McLaglen

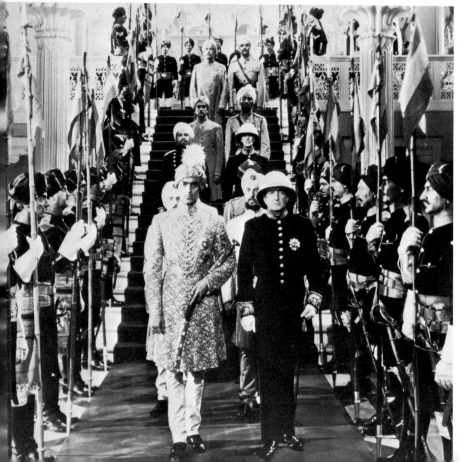

132 (above) Greatest
of miscegenation
dramas, *The Rains
Came*. Myrna Loy
attempts to seduce
Tyrone Power – over
tea, of course
133 (left) But she
dies and Tyrone Power
goes to meet his destiny
as Maharajah of
Ranchipur – under
British protection

Paternalism was the
predominant attitude to
natives in Imperial
films
134 (right) Paternalism
in 1935 – Leslie Banks in
Sanders of the River
135 (below) Paternalism
in 1957 – Richard Todd
with John Kitzmiller in
Naked Earth

a dam bursts and the state becomes a disaster area. It represents a crisis point for all the leading characters. Tom Ransome (George Brent), 'drunkard, bounder and remittance man', comes through with flying colours. He takes over the administration of relief and wins the hand of a missionary's daughter. But this is only to be expected. For all his faults he is the son of an earl and has worn the old school tie. Mr Bannerjee (Joseph Schildkraut), the anglicized Indian, who before the flood wears a monocle and dinner jacket and says things like 'awfully good to see you' and 'jolly good show', sees the disaster as the vengeance of the gods and reverts to speaking Hindustani, wears a loin cloth and shaves his head. He is the reverse of the Ransome coin, another lesson that blood will tell, that one's true character will show through in the end and it is no good trying to be what you are not i.e. a bounder when you are really a gent, an Englishman when you are really an Indian. Edwina, who had started out by merely lusting after Rama, comes to love him, and to prove her love goes to work as a nurse in his hospital, contracts cholera and dies beautifully in one of those tableau deathbed scenes that only Hollywood can do. Rama is left to fulfil his destiny as the new Maharajah of Ranchipur, a destiny which his love for Edwina had jeopardized for a while. Once again Fate intervenes in the form of a convenient death to prevent a mixed marriage – final and conclusive proof, if any was needed, that God must be an Englishman.

The film was re-made in 1955 as *The Rains of Ranchipur* and its sorry failure is an indication of how far Hollywood had fallen from her glittering pinnacle of forties' perfection. Directed by Jean Negulesco in colour and wide-screen, it is an anaemic travesty of the original. Updated, stream-lined (Bannerjee and the Maharajah elimin-ated), it becomes simply a glossy Lana Turner vehicle in which Edwina (Lana Turner) falls for Rama (Richard Burton), who, in this version, had been imprisoned by the British for fighting for independence. But she gives him up to fulfil his destiny and goes away with her husband, rather well

played by Michael Rennie as a former war hero fallen on hard times who had married Edwina for her money. Half-hearted soap operas might eschew the obligatory tragic ending but the full-blooded Imperial yarn did not and it crops up again, right on cue, in *55 Days at Peking*. Baroness Natalie Ivanoff (Ava Gardner), having been the mistress of the Chinese general Jung-Lo (Leo Genn), finds contentment and death, like Edwina Esketh, nursing the injured during the siege of the European legations.

It might be argued that the basic rule is broken by, of all people, the Englishman's Englishman, Phileas Fogg in *Around the World in 80 Days*. He marries an Indian princess. Aouda (Shirley MacLaine), who, even though she had been educated in England, was still an Indian and not a European stolen in childhood or raised by Indians. This, however, is due not so much to a change in the climate of world opinion as to the fact that the source of the story is French and the French have always been less chary of miscegenation than the Anglo-Saxons.

That the attitude of the cinema of Empire towards natives as a whole is one of undiluted paternalism will have become apparent already in these pages. Again and again in both the literature and the cinema of Empire an axiomatic truth has been stated: that the natives are children and, for their own good, need to be ruled by the British. Rhodes, Sanders, Bill Crawford, William Scott and all the other gods and heroes of the Empire see themselves as just but firm father-figures. If the natives are stirred up, it is invariably by outsiders, Russians, Germans, Arabs, unscrupulous profiteers playing on the simple, child-like nature of the native. The British do not exploit the native. They stand between him and exploitation. We have examined the role of the British in the suppression of the slave trade, both in the railroad films and the Imperial biographies. All the versions of *The Four Feathers* have demonstrated, in scenes of the writhing mass of black humanity imprisoned in the fortress-prison of Omdurman, the basic inhumanity of black man to black man, which is what

the British, according to the cinema of Empire, are in the Sudan to stop. It pays off in the affection that the natives show towards the British. In *East of Sudan* (Nathan Juran, 1964), for instance, a group of British fugitives, fleeing from Barash after the death of Gordon, are aided by a tribal chieftain because of Gordon's freeing of the slaves.

In spite of the wind of change that has blown both through Africa and through the cinema, purely paternalist pictures are still being turned out. In *Naked Earth* (Vincent Sherman, 1957), Danny Halloran (unconvincingly played by Richard Todd), a penniless Irish farmer, comes to Africa in 1895 to join a friend in a tobacco farming enterprise. When he finds the friend dead, he prepares to return home, but is persuaded to stay by Father Verity, the missionary (Finlay Currie), who tells him 'someone is needed to set an example for the natives'. A friendly Christian native, David (John Kitzmiller) arranges for native labour in the fields in return for meat, which Danny shoots. But when harvest time comes, the natives go off to a feast, which lasts for several days, and the tobacco crop is destroyed by the sun. Danny is understandably annoyed. Father Verity informs him sadly that the natives 'live only from day to day with no thought of the future'. So Danny sets about raising money for a new crop by shooting crocodiles. He amasses a fortune in hides, which are promptly stolen by the wicked trader and obligingly carried away for him by the very natives who have until quite recently been working for Danny. Danny curses all natives. David goes after them and persuades them to return the skins. For his pains he is killed by the crooked whites, who are in their turn thrown over the cliff by the vengeful natives. The hides are returned and Danny finally gives up a plan to return to Ireland and decides to make his home in Africa. The 'children' characterization of the natives is thorough and consistent throughout the film.

Similarly paternalistic is Ronald Neame's boring *Mister Moses* (1965), a laboured biblical allegory about a quack doctor (lethargically played by Robert Mitchum), who leads an African tribe to the promised land. The simple natives believe the Bible literally and see in Joe Moses a prophet who will lead them to safety. The missionary Anderson (Alexander Knox) is a benign old paternalist ('These are my people'), the District Officer (Ian Bannen) is blustering but well-meaning and the villain of the piece is the son of the witchdoctor, Ubi (Raymond St Jacques), who has been to New York, got himself an education and has returned to stir up trouble amongst his people in order to gain power. He leads them back to the old ways and superstitions but ends up by burning himself to death. The Africans reach the promised land, Mitchum goes off with the missionary's daughter and the audience, presumably, wake up and go home. In films like this the Imperial attitude has outlived the Imperial entity.

Notes

1 William K. Everson, *The Bad Guys* (1964), p. 38.

2 Raymond Durgnat, *A Mirror for England* (1970), p. 151.

We have examined in detail both the archetype of the British as a race and the characteristics of the archetypal British empire-builder. In the introductory chapter to this section I listed the four archetypes of natives which I believe it is possible to discern in the cinema of Empire, and we must now look at them more fully.

First, and most favoured of the British, is the faithful native. It is possible for the British to entertain a genuine affection for natives of this species. Allan Quatermain (Stewart Granger) in *King Solomon's Mines* (1950 version) genuinely grieves for two native bearers who die protecting him from harm. Harry Feversham (Richard Arlen) in *The Four Feathers* (1929 version) weeps over the body of the little black boy, Ali, whom he had earlier rescued from ill-treatment and who dies trying to free him from captivity. Azim (Sabu) in *The Drum* is much loved by the British, not least because he refuses to allow them to be massacred in Tokot, even though his advisers tell him the massacre would undoubtedly lead to his restoration to the throne. A genuine friendship springs up between him and the British drummer boy, Bill Holder (Desmond Tester), who teaches him to play the drum. Kipsang, the sergeant of the King's African Rifles, injured while getting a Shenzi gun for Crawford in *Sundown*, is clapped on the back by the District Officer. ('You're really a King's man, Kipsang'.) 'The captain's hand on his shoulder smote' stuff, African style. Bapu (I. S. Johar), the comic-faithful native bearer of Harry Black (Stewart Granger) in *Harry Black*, who is always cadging whisky and is strongly reminiscent of Allan Quatermain's faithful Hottentot tracker, Hans, in Haggard's novels, similarly has a special re-

lationship with his master, which involves affection on both sides. In two of Korda's epics, Amid Taftazani, a dashing Egyptian actor, played two pro-British native chieftains, tortured for their sympathy with the British and ultimately taking part in the victory over their enemies: Karaga Pasha in *The Four Feathers* and Mohammed Khan in *The Drum*.

There are probably three classic faithful natives, who set the pattern for all others. The first is Bosambo (Paul Robeson) in *Sanders of the River*. The ex-Liberian slave, chosen by Sanders as his head prefect among the unruly children of the River, has already been encountered in our discussion of that film. So too has the second classic faithful native, Gunga Din (beautifully played by Sam Jaffe), the humble regimental *bhisti* in *Gunga Din*. He is bullied by Sergeant MacChesney (Victor McLaglen), who lavishes more devotion on his elephant 'Annie' than he does on Gunga Din. He is patronized by Sergeant Cutter (Cary Grant), who amusedly drills him when he finds him practising with a stolen bugle. But Din is so grateful for this attention that when Cutter is imprisoned he releases him; he brings him help when he is caught by the Thugs in their secret temple; and at the end, when the regiment is marching into an ambush, he climbs a tower and blows his bugle to warn them, even though it costs him his life. The colonel recites the poem 'Gunga Din' – presumably dashed off by Kipling for the occasion – the regimental band plays 'Old Acquaintance' and MacChesney weeps. It is announced that Din has been posthumously appointed corporal in the regiment, the thing he had dreamed of all his life, and that his name will be inscribed in the rolls of the regiment's honoured dead.

The last shot, superimposed over the sunset, is the image of a grinning Gunga Din, resplendent in corporal's uniform, saluting. Dead in fact, he is alive in spirit and will serve Queen and regiment for ever in that great Empire in the sky. Thus does the Raj reward its faithful servants.

The third classic faithful native is Umbopa, the native guide of the gallant explorers in *King Solomon's Mines*. He has been incarnated twice, by Paul Robeson in Robert Stevenson's 1937 version of the story and by the Watusi tribesman Siriaque in the 1950 re-make, co-directed by Andrew Marton and Compton Bennett. Umbopa, of course, is the rightful king of the native tribe guarding the mines and after he has safely guided them there he is instrumental in saving the Britons' lives. The 1937 version remained reasonably close to the original, except for the obligatory introduction of a female, Kathy O'Brien (Anna Lee), who falls in love with Sir Henry Curtis (John Loder). Contemporary critics praised the quality of the African locations, directed by Geoffrey Barkas, and the genuinely spooky atmosphere created in the sequences at the native village and the mines themselves. They also had kind words for the performances of Robeson, Cedric Hardwicke as Quatermain and Roland Young, well cast as Commander Good, astonishing everyone by continuing to take his daily bath even in the middle of the jungle.

The re-make, however, was an emasculated travesty, which cut Gagool and Good (to all intents and purposes) and turned Sir Henry Curtis into a woman, Elizabeth Curtis (Deborah Kerr), while ladening the plot down with Freudian claptrap (Allan has a death wish, Elizabeth a guilt complex). Only Stewart Granger, as Allan, came anywhere near the spirit of the original. Umbopa remained unchanged however, the personification of that loyalty which the British sought in all their native subjects.

There was one sense in which the British feeling of superiority towards their coloured subjects was tempered and that was by respect for the fighting man, the worthy opponent. The other side of Kipling's 'East is East and West is West' axiom is: 'But there is neither East nor West, border nor breed nor birth, when two strong men stand face to face, though they come from the ends of the earth.' Something like a chivalric attitude can be detected in the British response to warrior races, like the Sikhs, the Maoris and especially the Zulus, whom Haggard regarded as black Vikings and whom he immortalized in an epic trilogy of Zulu history and in the character of the fearless axeman Umslopagaas. It was reciprocated by, for instance, the Nikalsaini fakirs of India, who worshipped the memory of Sir John Nicholson of the Punjab, and by the Maoris, who are recorded in one battle as calling out to the British soldiers to keep their heads down because they were about to fire.

This is carried over into the cinema of Empire. There is mutual respect and even affection between the native regiments of the Indian Army and their white officers, in, for example, *Gunga Din*, *King of the Khyber Rifles*, *Lives of a Bengal Lancer*. Witness also the emotional scene in which Colonel Savage (Stewart Granger) takes leave of his troops in *Bhowani Junction*. In *Charge of the Light Brigade* (1936), Michael Curtiz intercuts, after the Chukoti massacre, scenes of the grief of Puran Singh (J. Carrol Naish), the sepoy sergeant, and Major Jowett (George P. Huntley Jr), the Englishman, subtly establishing the unity of their grief as fellow soldiers and the common desire they are both to express for vengeance on the enemies of the Raj.

Towards the enemy, if he is no fanatic, there can also be sympathy and even understanding. Khoda Khan (Cesar Romero) in *Wee Willie Winkie* is a man of courage, dignity and presence, able to meet the British commander on an equal footing. So great is the mutual respect between Gordon and the Mahdi in *Khartoum* that the Mahdi gives specific orders that the General is to be spared, orders which are, in the event, disobeyed. Each believes himself to be a man of destiny and they recognize that, in some strange way, their destinies are intertwined. In the powerful scene of their confrontation in the Mahdi's camp, Gordon assures his

The faithful native

136 (above) Paul Robeson as Umbopa in *King Solomon's Mines* with
Cedric Hardwicke, Roland Young, Anna Lee and John Loder
137 (above right) Paul Robeson as Bosambo in *Sanders of the River*
138 (centre right) Sam Jaffe as Gunga Din being patronized by
Cary Grant in *Gunga Din*
139 (below right) The funeral of Gunga Din

enemy: 'I may die of your miracle but you will assuredly die of mine.' Thus it turns out, for the Mahdi dies soon after Gordon is killed. *The Four Feathers* (1929) pays tribute to the courage of the Sudanese enemies of Britain by flashing Kipling's lines on the screen when they first appear:

''Ere's to you, fuzzy-wuzzy, in yore home in the Sudan,
Yore a pore benighted 'eathen but a first-class fighting man.'

In the late fifties' revival of Imperial cinema there was a group of films centring on the battle of wits between British officers and rebel chieftains and highlighting the mutual respect which develops between them. The prototype of these films is *Zarak* (Terence Young, 1956) in which bandit leader Zarak Khan (Victor Mature) battles with Major Ingram (Michael Wilding). Such is the affection which develops between them that at the end, when Ingram is captured and tortured by marauding Afghans, Zarak gives his life to save him. Dying, Zarak proclaims: 'We have had much good sport together, haven't we, Major?', a sentiment well-calculated to endear even the most recalcitrant rebel to the sports-loving English. 'Greater love hath no man than he who lays down his life for his enemy,' intones Ingram.

Basically, it is a *Boy's Own Paper* yarn, full of battles, ambushes and escapes and celebrating the North West Frontier myth. It aspires to 'significance' at one point, however, when it interpolates a scene in the billiard room, where Lt Larkin (Patrick McGoohan) and Ingram discuss how the Indians should be treated. Larkin, a hard-liner, believes they should be kept in line by force. But Ingram advocates justice, fairness and humanity. The theme isn't pursued, however, and the film soon settles back into its 'high adventure' exploits. On that level it is quite well done, though the film is seriously flawed by its two leading ladies: Anita Ekberg as Zarak's sweetheart, whose busty Nordic charms seem far removed from the Oriental bazaar, and Eunice Gayson, who plays Ingram's wife as a vivacious twentieth-century soubrette.

The film was such a success that a sequel was rushed into production which incorporated much of the battle footage from *Zarak* and was in effect a disguised re-make. *The Bandit of Zhobe* (John Gilling, 1958) pitted Kasim Khan (Victor Mature again) against Major Crowley (Norman Wooland), with Crowley's daughter Zena (Anne Aubrey) as the voice of the liberal conscience and Anthony Newley giving a marvellous comic performance as the cheerful, grumbling, respectful Cockney corporal. Once again the bandit leader dies at the end, fighting with the British against the Afghans. What is interesting about both these films and fits them into an Imperial scheme is that both assume that the Indians do not have any real grievances against the British and that basically conflict between them was a game which when real danger threatened (Afghan invasion in this case) would be abandoned in favour of co-operation against the enemy.

The Long Duel (Ken Annakin, 1966) told exactly the same story but eschewed the unashamed schoolboy heroics of the previous films and opted for a more 'adult' approach. It featured the duel between Captain Freddy Young (Trevor Howard) and the native leader, Sultan (Yul Brynner), with the British as the villains of the piece. Sultan and his tribe are harassed and victimized by the unfeeling and tyrannical British authorities, headed by Superintendent Stafford (Harry Andrews). All the British officials in this film are prejudiced, stubborn, stupid or nasty with the exception of Young, a humane liberal who is a former anthropologist and genuinely admires the hill tribes and condemns British ignorance of them. ('We don't understand Indian ways. We simply assume that they'll accept ours, as if this were Surrey.')

Young conducts a very sporting long duel with Sultan, during the course of which each saves the life of the other. But eventually Young is replaced, being told that 'we can't afford your kind of misplaced chivalry'. Stafford tortures Sultan's woman into revealing the tribe's hiding place and then leads his men off into a trap. A total massacre is prevented by the timely arrival of Young.

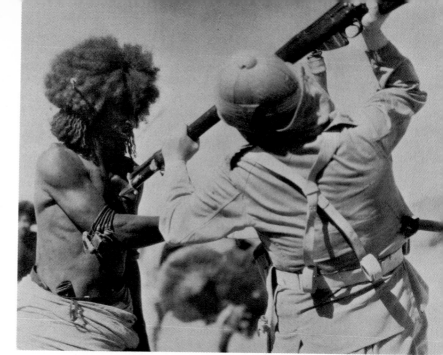

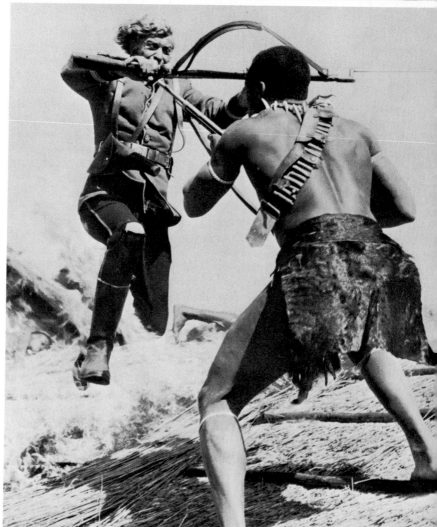

The British respected
their enemy even while
striking him down.
140 (above) The Fuzzy-
Wuzzy in *The Four
Feathers*
141 (below) The Zulu in
Zulu

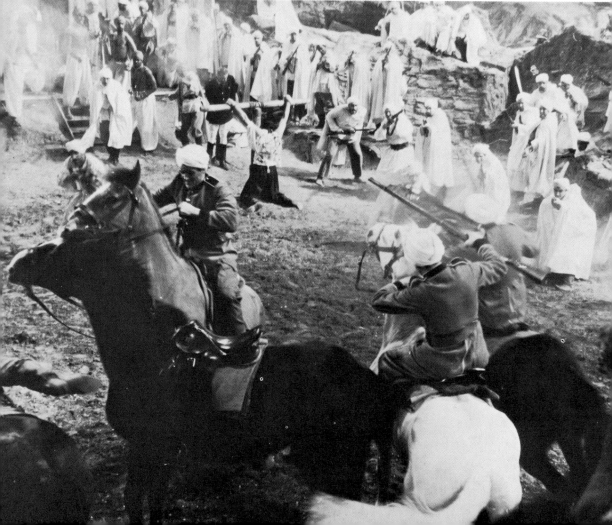

142 (left) The British desire to forgive a gallant enemy was extended from the Germans (Anton Walbrook and Roger Livesey in *The Life and Death of Colonel Blimp*) to rebel chieftains on the Northwest Frontier
143 (below left) In *Zarak*, Victor Mature gives his life to save the British officer who had been his enemy
144 (below) In *The Bandit of Zhobe* enemies Norman Wooland and Victor Mature join forces to repel the Afghans

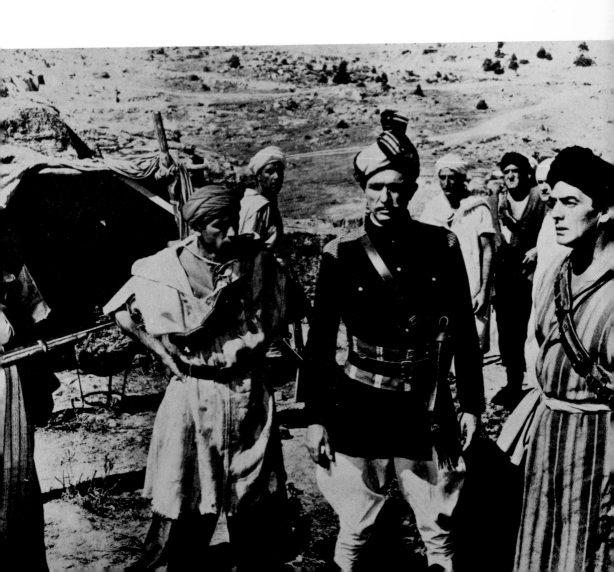

Sultan dies of his wounds, leaving Young to bring up his son. Though the overall tone is anti-British, the duel theme persists, as does the loyalty of the native regiment to their officers. For Young's constant companion is his sergeant Gyan Singh (David Sumner), who is devoted to him and is killed saving his life.

The only film to capture Haggard's black Viking interpretation of the Zulus has been *Zulu* (Cy Endfield, 1963), an awe-inspiring recreation of the battle of Rorke's Drift in 1879. Having massacred Lord Chelmsford's column, 4,000 Zulus descend on the mission station at Rorke's Drift, which is held by 105 men of the South Wales Borderers. They could withdraw, but their commander, Lt John Chard, decides to hold the position. Why? Because those are his orders. When a nervous private asks why they are the ones who must fight, Sgt Bourne (Nigel Green) replies with perfect military fatalism: 'Because we're here, lad, and nobody else.' One is reminded of Colonel Baird's remark: 'We've got an Empire, we've got to pay for it and, you know, there it is.'

The bulk of the film is one long, superbly choreographed battle scene, beside which almost any other cinematic conflict you care to mention pales into insignificance. During it two unforgettable and highly emotional scenes exalt the mutual respect of two fighting races. The first comes when the Zulus advance chanting their fearsome war song and the soldiers reply with a rousing version of 'Men of Harlech'. Some critics cavilled at this as a piece of typical Hollywood invention and thereby demonstrated their ignorance of Imperial history. For contemporary Matabele accounts of the massacre of Major Allan Wilson's patrol in Rhodesia in 1893 record that the survivors shook hands and sang 'God Save the Queen' before being slaughtered to the last man. The scene entered popular folklore and many Victorian melodramas featured a scene in which singing British tommies fought off chanting natives – for example Walter Howard's *Midst Shot and Shell* (1899) in which the song was 'Soldiers of the Queen'.

Even more impressive, however, is the final scene. The British think they have fought off the attack and are congratulating each other and thanking God that they are still alive when in the distance they hear the thunderous roar of the war chant again. The Zulus appear on the crest of the hill in massed ranks. But they have come only to salute the courage of their enemies, which they do before retiring from the battlefield. Eleven Victoria Crosses are awarded as a result of the action.

Characterizations in the film are sketchy but they conform to the archetypes. Chard (Stanley Baker) is one of Kipling's 'Sons of Martha', a bridgebuilder, a dedicated soldier. Lt Gonville Bromhead (Michael Caine), the other officer, is an effete aristocrat, more concerned with shooting impala and keeping his uniform immaculate, but he turns out to be true blue when the chips are down. Pvt Henry Hook (James Booth), the 'other ranks' lecher, scoundrel and malingerer, demonstrates his intrinsic worth by winning a Victoria Cross. Sgt Bourne is the classic N.C.O., a tower of strength throughout. But the missionary (Jack Hawkins) is interestingly characterized as a drunken irrelevance, whose work of conversion has been superficial and collapses the moment war begins. Respect for the Zulus has thus been extended to a condemnation of any attempt to interfere with their beliefs and customs.

The converse of British respect for the fighting native is British contempt for the educated native. This contempt almost certainly stemmed from fear that if the native acquired an education and learned the secrets of the Western World he might come to believe that he was capable of governing himself. That would never do. So his education was translated in literary and cinematic terms into a slavish imitation of British speech, manners and dress and a desire for personal power and the subjection of his fellows, something the British are determined to prevent – in the interests of the other natives, of course. The educated native is almost always the villain, even if he is driven to villainy by the gulf between the two cultures which has foredoomed the attempted 'Westernization' to failure. John

Buchan's *Prester John* is typical. It is the story of a Western-educated negro who seeks to play on the superstition of his people to turn himself into a godlike ruler. Laputa, the negro, who in pursuit of his ambition leads an uprising against the whites, is only the forerunner of many similar characters in the cinema of Empire, notably Ubi in *Mr. Moses* and Lt Boniface in *Guns at Batasi*.

Far more attractive than these dour and earnest revolutionaries are the cultured native leaders who can proudly boast an Oxbridge education and suavely deprecate the need for torture while inserting bamboo under the fingernails of their British captives. They are really an extension of the larger-than-life villains of melodrama and most of them are true to the archetype best incarnated by the Rajah of Rukh (B.A. Oxon). Surat Khan in *Charge of the Light Brigade* is English-educated and, as one guileless officer observes, 'anyone can see the man's a gentleman.' Mohammed Khan in *Bengal Lancer* is Oxford-educated, a keen cricketer and an expert foxhunter. Sidi Ben Youssef in *Under Two Flags* is a Balliol man. It is interesting to note the role of Balliol in Imperial literature and cinema, for it seems to have turned out a pretty well endless stream of unscrupulous native rebel leaders and down-and-out British remittance men who end up drinking themselves to death in the South Seas.

It will be recalled that Commissioner Sanders's pet hate was: 'the browny men of the Gold Coast who talked English, wore European clothes and called each other "Mr" '. This aspect of his character was a feature of *Old Bones of the River* (Marcel Varnel, 1938), a Will Hay comedy, which was not, as some writers have suggested, a parody of *Sanders of the River* but more of a comic adaptation of some of the Edgar Wallace short stories. There is a perfectly authentic sub-plot to the film, mixed in with the admittedly amusing antics of Will Hay, Moore Marriot and Graham Moffat. The foreword sets the scene: 'Darkest Africa – where a handful of Englishmen rule half a million natives, teaching the black man to play the white man.'

The film opens with Sanders of the River (Wyndham Goldie, surely chosen for the part because of his resemblance to Leslie Banks) ill with malaria and about to go on leave. He gives an audience to Bosambo (Robert Adams), who announces that his brother M'Bapi (Jack London) is returning from education in England, and asks for drink to celebrate his arrival. Sanders refuses the request. Drink is forbidden to the natives. Captain Hamilton (Jack Livesey), his aide, expresses reservations about M'Bapi. ('Educated natives always bring trouble into the country. Oxford and the Gold Coast don't mix.') These reservations are well-founded. For on board ship we see M'Bapi, immaculate in white ducks and a solar topee and speaking with an impeccable English accent, plotting with a white trader. He plans to seduce the natives with drink and raise rebellion against the English. The trader will supply guns in return for trading concessions.

The plot is put into action. M'Bapi wins over the Ochori from their allegiance to his brother, reintroduces human sacrifice (which Sanders has stamped out) and starts a revolt. Bosambo denounces him as a 'damn nigger' and flees to the British. The British rally at the Residency, led by Professor Tibbetts (Will Hay), the uncle of 'Bones', who has taken over as Administrator in Sanders's absence. The natives are defeated in a finale, lifted from the Laurel and Hardy comedy *Beau Chumps*, in which the British scatter tintacks in the path of the advancing natives, causing them to flee in pain.

Other than these educated villains, the enemies of the British Empire are invariably mad-eyed fanatics, seeking the extermination of the whites and the establishment of personal power. Thus, for instance, Ghul Khan in *The Drum*, the Guru in *Gunga Din* and Kurram Khan in *King of the Khyber Rifles* (1954) are depicted. More often than not they are devotees of the goddess Kali and members of the strangling brotherhood of Thuggee. This is true of the villains of *The Bandit of Zhobe*, *Gunga Din* and *Kali-Yug, Goddess of Vengeance*.

We should perhaps pause briefly over the latter. For *Kali-Yug, Goddess of Vengeance*

The archetypal native leader was the suave English educated villain.
145 (above) The Rajah of Rukh (George Arliss) menaces Alice Joyce,
H. B. Warner and Ralph Forbes in *The Green Goddess*
146 (above right) Sidi Ben Youssef (Onslow Stevens) in *Under Two
Flags*, here pouring tea for Ronald Colman, had been at Balliol
147 (right) M'Bapi (Jack London), Oxford-educated brother of
Bosambo (Robert Adams), tries to pervert the natives with alcohol in
Old Bones of the River

(Mario Camerini, 1963) is that curiosity of curiosities, an Italian film of Empire. Along with their imitation Roman epics, spy thrillers and westerns, the Italians turned out a short cycle of pastiche Imperial films (*Temple of the White Elephant*, *Adventures of the Bengal Lancers* etc), the best of which was undoubtedly *Kali-Yug*. It boasted an international cast, including the former screen Tarzan, Lex Barker, dubbed into impeccable Oxford English, as a British major; Sergio Fantoni as a spirited villain; I. S. Johar as the hero's faithful Indian sidekick; and Ian Hunter, virtually repeating his role from *Another Dawn*, as the British Resident. A glittering ball, a fireworks display, a period tennis match and a civilized discussion of murder around the tea table form the splendidly archetypal backdrop to the events, which centre on the activities of the evil Brotherhood of Kali, headed by Prince Ram Chand (Sergio Fantoni), which plans to drive the British out of India.

After independence, however, a distinction had to be drawn, but it was drawn in favour of the British. In *Soldiers Three* (1951), the leader of resistance to the British is Govind Lal (Richard Hale), but he believes in peaceful resistance and waiting for 'the slow, sure turn of the world towards truth and justice'. He is the latter-day good native. The villain is Malik Rao (Michael Ansara), a fanatic who believes in violence now and not peaceful protest. So the British crush him and everyone is happy. Even a nostalgic adventure thriller like *Bengal Rifles* (1954) paid lipservice to the idea of eventual independence. After the devoted Havildar Puran Singh (Michael Ansara, fighting on the right side this time) has helped the British put down the Indian Mutiny, he asks Rock Hudson when the Indians will be free and receives the classic answer: 'When all Indians are brothers and the British too.' In other words, never.

The last category of native to appear in the cinema of Empire is the half-caste, and because of the British sympathy for the underdog, his plight was often viewed with a measure of compassion – as it was, for instance, in the only one of John Masters's eminently filmable novels to be adapted for the screen thus far, *Bhowani Junction* (George Cukor, 1956), which deals with the last day of the Raj. The central character is Victoria Jones (Ava Gardner), a beautiful half-caste who epitomizes the tragic dilemma of the Anglo-Indians, who are neither truly English nor truly Indian. She is loved by three different men, each of whom offers her a place in a different world.

One of them is Colonel Rodney Savage (Stewart Granger), the British officer, honest, fair-minded, doing a difficult job to the best of his ability, loved by his men and the latest representative of a family that has served India since the days of the Mutiny. The second is Patrick Taylor (Bill Travers), the railway superintendent. He is an Anglo-Indian, painfully conscious of his superiority to the Indians and his inferiority to the British. Still he rejects half-breed status and clings ferociously to his Englishness (wearing a topee, affecting exaggerated English attitudes, calling the Indians 'wogs'). He is a brave man but a stubborn one, who refuses to contemplate the future and the end of the Raj. Eventually he dies, in pursuit of his duty, as he must – for there is no other way out for him. The third man is an Indian, Ranjit Kasel (Francis Matthews), a sensitive, gentle visionary and dreamer, who hopes after independence to work in Education, which he sees as the key to India's future.

Victoria is initially engaged to Patrick but breaks the engagement because of his refusal to look beyond the present. She tries to solve her problem by becoming an Indian, adopting Indian dress, agreeing to marry Ranjit and even agreeing to be initiated into the Sikh religion. But at the last moment, she cannot go through with it. She does not feel herself to be part of this world. Finally she falls in love with Savage but refuses to go to England with him and live an English life, because of the failure of her attempt to live a fully Indian life. She decides – and this is the film's answer to her dilemma – to accept what she is and to live in India as an Anglo-Indian. Savage ultimately decides to marry her and stay on in India too.

Bhowani Junction, the film's setting, is

More archetypal native leaders

148 Mohammed Khan (Douglass Dumbrille) prepares to insert bamboo slivers under the fingernails of Gary Cooper in *Bengal Lancer*

149 (below) Raymond Massey as Ghul Khan fanatically dreaming of conquest and slaughter in *The Drum*

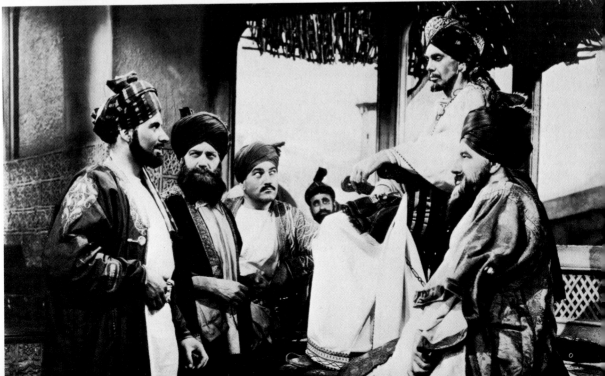

seen as a microcosm of India. The Congress Party is doing everything in its power (strikes, passive resistance, disrupting communications) to hasten the departure of the British, the date of which has not yet been fixed. The Communists have infiltrated the movement and turn every peaceful demonstration into a riot, as well as blowing up trains and fomenting revolution. The British troops do their best to keep the peace in an increasingly impossible situation.

The different Indian points of view are incarnated by three characters. The Collector Govindaswami (Marne Maitland) is the sensible Indian. He hopes for eventual independence but in the meantime works with the British, fully conscious of the threat posed to his country by Communism. Surabhai (Abraham Sofaer), the Congress Party organizer, is the foolish Indian. A man of integrity and an opponent of violence, he is none the less blind to the Communist infiltration of his movement and unable to see that everything he does is only playing into their hands. The out-and-out villain is the Communist leader Ghanshyan (Peter Illing), a ruthless revolutionary, prepared to kill any number of people to create the conditions necessary for takeover. Ironically he uses Joseph Chamberlain's dictum 'You can't make an omelette without breaking eggs' as he surveys the heap of dead and dying Indians, victims of a train wreck he has caused. The film's sympathies are engaged totally with the Anglo-Indians, the British officer and the sensible Indian.

A similar problem of identity confronts the orphan Kim in Kipling's novel, *Kim*. 'I am Kim. I am Kim. But what is Kim?' he cries plaintively in the book, which reaches the screen in 1951 in a simplified but reasonably faithful adaptation directed by Victor Saville. M.G.M. had planned two previous versions of the book. But the 1938 version with Freddie Bartholomew, Robert Taylor and Cedric Hardwicke, which was to have been filmed in India, was called off when war broke out. The 1942 version, with Mickey Rooney, Conrad Veidt and Basil Rathbone, to have been filmed in the United States, was shelved at the request of the

Office of War Information. But in 1951, M.G.M. finally made it, their completed version being filmed partly in India and partly at Lone Pine, California, which stood in for the Khyber. The direction was, however, prosaic and uninspired and the sets lack-lustre. Of the stars Dean Stockwell, as Kim, though spirited, was too American and too modern, Errol Flynn, as Mahbub Ali, was sadly ageing and jaded and Paul Lukas, as the Lama, contrived to give a moving and credible performance whenever the script allowed, which was not often. There were, however, in compensation, some richly rewarding supporting performances, notably from Arnold Moss as the sinister jeweller-hypnotist Lurgan Sahib and from Cecil Kellaway as the jovial, bespectacled secret agent, Hurree Chunder.

Kim is the child of two cultures. By birth he is a white man, a sahib. By upbringing and background he is an Indian. He is faced with a fundamental choice between 'the Way' (the Buddhist life of contemplation and meditation, personified by the Lama, whom he serves as chela [disciple]) and 'the Great Game' (the English life of a secret service agent defending India against tribal unrest and Russian intrigue, personified by Mahbub Ali, Afghan horsetrader and secret agent, and Colonel Creighton (Robert Douglas), Head of the British Secret Service, square-jawed, moustached, pipe-smoking archetypal British officer). The film details his adventures as he seeks the solution to his problem. We follow him through the unhappy days at St Xavier's College, the sahibs' school, where he is an uncomfortable misfit, the carefree days on the road with the Lama, and the exciting days when he is initiated into the Great Game by Mahbub Ali and helps foil a Russian plot to foment rebellion.

But the final choice is never really in doubt. Though he loves him, the Lama sends him away and raises the money to pay for his schooling at St Xavier's. ('Thou must stay with thine own people.') Mahbub Ali, whom he also loves, returns him to the British when he tries to run away. ('A true man like a true horse runs with his breed.') As he is dying, the Lama adjures Kim not to

follow the way of violence but to return to 'the Way', the road of learning. But the film ends with scenes of the British army on the march, flags flying and drums beating as Mahbub Ali prepares to return to school the fast-growing Kim, who now dreams of the day when he will join the regiment and fight to defend the Raj. Unlike Victoria Jones, Kim isn't a true half-caste and therefore takes his place with the sahibs in the end.

The half-caste becomes hero in the post-Imperial film cycle. Kim is a cultural half-caste. But Captain Alan King (Tyrone Power), the hero of *King of the Khyber Rifles* (Henry King, 1954), is a real one. This version owes nothing but the title to Talbot Mundy's novel, filmed straight by John Ford in 1929. It uses a North West Frontier story as the framework for a drama of caste and colour. The film is supposedly set in 1857 but costumes, attitudes and settings are those of the 1880s.

It is the hundredth year of British rule, and when King reports to General Jonathan Maitland (Michael Rennie) at Peshawar, there is already a prophecy current that British rule is approaching its end. King is assigned to command of the Khyber Rifles. But when it is discovered that he is the son of an English father and an Indian mother, the bigoted Lt Heath (John Justin) moves out sooner than share a bungalow with him. ('A native doesn't change colour when he joins up.') King is deliberately not invited to the Queen's Birthday Ball at the Officers' Club. But when General Maitland hears, he is furious and makes it clear that he will not tolerate this attitude towards King. ('Whites, half-castes and natives are all British soldiers and will be treated as such.') It is a commendable attitude, but it is one that is put severely to the test when King falls in love with Maitland's daughter, Susan (Terry Moore), and they plan to marry. Maitland prepares to pack her off back to England and makes the position clear to King: socially Susan's life would be ruined if she married him.

Meanwhile King discovers that tribal unrest is being fomented by his foster brother, Kurram Khan (Guy Rolfe), who plans to use the anti-British prophecy to start a war and carve for himself an Empire. Significantly, even in a post-Imperial yarn the villain wants power for himself and not freedom for his people. King volunteers to try and kill Kurram, but when he gets him at his mercy, he finds he cannot kill him in cold blood. The Indian Mutiny breaks out and it becomes imperative that Kurram be destroyed. King is ordered to take a detachment of the Khyber Rifles into the mountains and get Kurram. The soldiers refuse to take their rifles because of the rumours that they are greased with pork fat. But because of their devotion to King, they agree to go, armed with knives. The rèbels are defeated, Kurram is killed and King is united with Susan. The film ends with a regimental review, the sure sign that all is well again. The Empire has triumphed, the rebels have been crushed and racial prejudice has bitten the dust.

In 1954 it is still possible to have the traditional North West Frontier trappings in a half-caste tale, with a happy ending and the Raj vindicated. But as the years pass the view becomes bleaker, as testified in John Gilling's execrable *The Brigand of Kandahar*, made in 1965. Patchily acted against a succession of luridly painted back-cloths, its locations looked more like the North West Frontier of Rutland than that of India. A hirsute Ronald Lewis, as the hero, looked bewildered by the whole thing – as well he might. Duncan Lamont, as the Commanding Officer, strutted and ranted like a stage melodrama villain. Only Glyn Houston as a resourceful *Times* correspondent emerged with any credit.

The hero is Lt Case (Ronald Lewis), who runs up against racial prejudice because he is a half-caste and is expelled from Fort Kandahar by Colonel Drewe (Duncan Lamont) when he is suspected of abandoning a brother officer to enemy tribesmen because he covets his wife. He joins the rebel leader, Eli Khan (Oliver Reed), and trains his men for an attack on the British fort. Appalled, however, by Eli's inhuman treatment of prisoners, he kills him, then leads the tribesmen against the British and is killed himself.

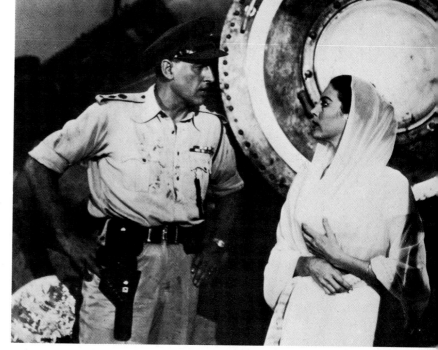

The half-caste

The plight of the half-caste figured in latter-day films of Empire

150 (above left) In *Kim*, Dean Stockwell was faced with two alternatives: the life of 'the Great Game' and service to the Raj (represented by Errol Flynn and Robert Douglas)

151 (below left) and the life of meditation and contemplation, personified by the Lama (Paul Lukas)

152 (above) Half-caste Tyrone Power joins the British Army to the disgust of his rebel foster-brother Guy Rolfe in *King of the Khyber Rifles*

153 (right) In *Bhowani Junction*, half-caste Victoria Jones (Ava Gardner) tries going Indian to solve her identity problem. Eventually she will marry British officer Stewart Granger

But the *Times* correspondent, Marriott, determines to tell his story to the British public to prevent further such tragedies occurring.

It is perhaps significant that the plight of the half-caste comes to figure prominently only in the second, the post-Imperial, cycle of Empire films. The half-caste of the heyday Imperial films, if he was featured at all, would more than likely be a Peter Van Leyden, sympathized with by the Britons in the film, but vigorously hissed by the Britons in the cinema audience as he perpetrated yet another villainy.

Afterword

We have ranged over much territory, political, literary and cinematic, in our search for the secret of the Imperial cinema. The basic fact that has emerged, I think, from the investigation is that the whole genre bears the distinct imprint of the public school. The virtues and characteristics of the Imperial archetype are the virtues and characteristics bred into him by his public school. The male camaraderie and the subordinate role of women reflects the all-male environment of the public schools. Most significant of all, all the relationships in the Imperial structure, between masters and servants, officers and men, Imperial administrators and native subjects, can be paraphrased into an identical headmaster-pupil relationship along the lines of the public school. In the last resort, the Empire was Eton and Harrow writ large.

Part 2 The Cinema of
 Populism

The Ideology of Populism

The United States of America was born out of a dream, the noble dream of a Utopian state in which Man could achieve that perfection which eighteenth-century philosophers believed to be within his grasp. Whatever the squalid politico-economic truth of the Revolutionary War, its myth is uncorrupt and has endured. In American mythology the revolution was a struggle of Good against Evil, of Freedom against Oppression, fought in defence of a fundamental faith. The articles of this faith were embodied in the Declaration of Independence:

We hold these truths to be self-evident, that all men are created equal, that they are endowed by their creator with certain inalienable rights, that among these are life, liberty and the pursuit of happiness – that to secure these rights, governments are instituted among men, deriving their just powers from the consent of the governed, that whenever any form of government becomes destructive of these ends, it is the right of the People to alter or abolish it and to institute new government.

The American Revolution was undeniably a radical revolution, radical in the very fact of securing independence by violent means from the British Empire, radical in the institution of a republican form of government and most radical of all in the formulation of a political philosophy based on individualism and equalitarianism.

Adapting the doctrine of Natural Rights to an American context, the Revolution's aim was the recasting of society along democratic lines: no monarchy, no established church, no federal government, no titles of nobility. When peace came in 1783, the aim had been achieved: thirteen separate states, each governed by a representative assembly.

But post-war political and economic crises threatened the survival of the newly independent states and a conservative counter-revolution was carried through which resulted in the promulgation of the Constitution of 1787. This meant the establishment of a federal government with executive, judiciary and bicameral legislature and centralized control of taxation, commerce and the armed forces.

From the troubled days of its birth through all the troubled days of its history until half way through the present century, two distinct strains have been discernible in American development. We may loosely call them federalism, identified with the Constitution, and anti-federalism or populism, identified essentially with the Declaration of Independence. The conflict between the two creeds has been one of the shaping themes of American history. But populism, much more than its rival, has been forced to adapt and change in response to the irreversible process of industrialization. What we must now trace is the elaboration of the populist doctrine and the extent of its adaptation in order to arrive at some kind of definition of the basic attitudes and ideals that were to find expression in the cinema of populism.

The one thing that the fathers of the Constitution had not envisaged was the development of political parties. But the emergence of these two opposing views of the new state made it inevitable. More than anyone else it was Alexander Hamilton who was responsible for the emergence of the party system. He developed a keen admiration for the British way of life, social,

political and economic, and saw a golden opportunity for greatness if America were only to emulate it. He envisaged an American empire, based on trade, banking and manufactures, a thriving industrial society, supported by a factory system. Hamilton ensured that the Federalist party, the group which had brought about the achievement of Union, should stand for the merchant oligarchy of New York and New England. This gradually alienated first the backwoodsmen and then the Southern planters, whose alliance had helped make the Constitution. With the alliance broken, South and West set out to create their own representative party. For all his visionary genius, Hamilton never recognized, as Thomas Jefferson did, that the frontier was the new, dynamic, democratic element in America.

The Federalist doctrine and the federalist theme emerges clear-cut and consistent. It stood for strong central government, the predominance of the nation over the state, a public economy based on the manufacturing-trading interest with a solid financial foundation. It sought to encourage independent action by the President and the development of a central administration, independent of the states and empowered to act in the national interest. The Federalists, conservative, oriented towards business and the professions, drawing their strength from the cities and the seaboards, believed with Hamilton that the people were not capable of ruling themselves and needed leadership from men of wealth and breeding.

For Thomas Jefferson, author of the Declaration of Independence, the Hamiltonian System was not a dream but a nightmare. He became instrumental in founding the Republican Party, formed to combat everything the Federalists stood for. The Republicans saw the struggle in terms of a defence of the Land and of agrarian society in the face of the encroachments of Northern finance and business. Land was the common denominator and formed the basis for a potent political alliance between the small farmers of the West and the large planters of the South.

The thinking of Thomas Jefferson was to lie always at the core of populism. For he is the foremost exponent of American agrarian democracy. He did not invent it. He took it over from the Physiocrats of the French Enlightenment, who preached that agriculture was the noblest and most productive of occupations, that it was the duty of governments to protect and advance agriculture and that a nation's prosperity was directly dependent on the prosperity of her farms. It was an application of Locke's theory of Natural Rights to economic life and Thomas Jefferson further applied it – to the new United States. He wrote:[1]

> I think our governments will remain virtuous for many centuries, as long as they are chiefly agricultural: and this will be as long as there shall be vacant lands in any part of America. When they get piled up on one another in large cities as in Europe, they will become as corrupt as Europe . . . Cultivators of the earth are most valuable citizens. They are the most vigorous, most independent, the most virtuous and they are tied to their country and wedded to its liberty and interests by the most lasting bonds.

His ideal was a republic of yeoman farmers which he saw as the best guarantee of liberty. He was no social democrat, but an enlightened slave-owning gentleman who saw no harm in his class of gentleman planters leading the republic. It was the merchant capitalists who posed the serious threat to democracy. Fundamentally Jefferson wished to diffuse power, Hamilton to concentrate it. Jefferson saw the future as a network of farms, dominating the continent, Hamilton saw it as a network of cities. Jefferson feared tyranny, Hamilton feared anarchy. Jefferson espoused Rousseau's optimistic view of the perfectibility of man by education, Hamilton took a gloomy Hobbesian view of the people as 'a great beast' to be feared and dominated. Jefferson articulated the theory: 'that government is best which governs least', believing, as he outlined in a letter of 1799, in the preservation of states' rights, the maintenance of a frugal and simple government, no multiplication of offices, a small

army and free commerce with all nations, political connection with none. For Hamilton, the idea of such a lightly-run republic was mischievous, sentimental nonsense.

But Hamilton's Federalists were too narrowly based to survive. Jefferson appealed to the idealism, simplicity and hopefulness that was young America and after his election as President in 1800 the Federalists went into a decline. Ironically, however, the Jeffersonians came to preside over the realization of the Hamiltonian System, driven inexorably towards it by war and expansion.

Rigid economists, the Jeffersonians spent money like water. Believers in the diffusion of power, they concentrated it. Strict interpreters of the Constitution, they were forced to assume an authority which no one even pretended was written into the Constitution. They attacked the Federalists for building a fleet and built a bigger one. This has all led to Jefferson being branded as a demagogue. He was not. He genuinely believed in the ideas he expounded but he was also a pragmatist. He regarded 'the laws of necessity, self-preservation and saving our country when in danger' a higher law than any other. He was not too doctrinaire to see that the practical application of his ideas at that time would have been fatal. It was sheer physical necessity that forced him to abandon his principles. Not for the last time did war prove the nemesis of populism.

By the time James Monroe became president in 1817 the Jeffersonian Republican party had widened its base to accommodate many of the former Federalists. Its policies became more and more nationalist until one wing of the party espoused 'The American System' of Henry Clay, a virtual restatement of the old Hamiltonian System, and successfully accomplished the foundation of a National Bank. John Quincy Adams, son of the Federalist president John Adams, elected President himself in 1825, embodied the new spirit, calling in his inaugural address for a massive programme of government-sponsored internal improvements, a Department of the Interior and a national

University, a far cry from the old principles of Jefferson. It was in fact this wholesale abandonment of the old ideals that caused the party to split, paving the way for the emergence of two new political parties, the Democrats and the Whigs.

The period between the decline of Jeffersonian Democracy and the rise of Jacksonian Democracy was, to begin with, a period of nationalist exuberance. With the signing of peace with Britain in 1815 the United States turned her back on Europe and set her sights on her own internal expansion. Manufactures increased, westward migration became increasingly popular, there was a boom in land and cotton. But it was a false nationalism that was shattered by the collapse of 1819, when credit was halted, banks were ruined and mortgages were foreclosed. Discontented debtors began to question the government's economic policy. They didn't attack free enterprise or *laissez-faire*. They simply wanted to see more people participating in it. In pursuance of this, they advocated the revival of the Jeffersonian democratic ideal and sought wider suffrage, public education and the reduction of the influence of the money power to bring it about. It was in listening to these ideas that General Andrew Jackson became one of the most popular leaders in American history.

When Jackson came to power in 1829 he stood for little except opposition to John Quincy Adams. But Jacksonian Democracy was a widely based movement, born of a spirit of social unrest. Many came to believe that the Republican party had betrayed its trust. The Jacksonians realized that their support grew out of the desire to achieve equal opportunity and adopted the theories of the Old Republicans, as outlined, for instance, in John Taylor's *An Inquiry into the Principle and Policy of the government of the United States*. He believed that a free agrarian society was essential for the maintenance of democracy, with wealth, like suffrage, widely distributed. He saw the Bank and the new financial aristocracy as a threat to popular rights. He called for a return to frugality and free trade, the abolition of privilege, the surrender of legislative patron-

age, the restraining of manufactures and the abolition of paper money. States' rights must be protected as the only effective constitutional bulwark against the aggressions of the central government, controlled by the moneyed aristocracy.

These ideals were taken up by the Jacksonians. Like the Jeffersonians they attacked the money power, by which they meant not the rich but the corporate money power, buttressed by special privilege. What really stamped them with their identity was the Bank War. The National Bank was made the scapegoat for the nation's ills. It was seen as the incarnation of all the anti-democratic tendencies which were perverting the original Jeffersonian dream. It was thought that victory over the Bank would mean the beginning of the new era. But the destruction of the Bank was followed by a new financial disaster when the speculative bubble of the 1830s burst in 1837. Land speculation had become a mania, vast state improvement schemes had been undertaken without adequate financial backing, too much paper money had been issued. The government was blamed and the 1840 election was lost.

The Whig Party now adopted the tactics which had won the Democrats their period in office. They attacked executive despotism, exalted the labouring man as the heart of the nation and, adopting no real electoral platform, ignored the issues and appealed to the emotions rather than the intelligence. The election was fought against a background of despair following the panics of 1837 and 1839. In place of an electoral programme the Whigs fought on myth, choosing as their candidate General William Henry Harrison, who claimed to have been born in a log cabin and was a hero of the Indian wars. The honest, God-fearing, humble-born soldier who would set the nation on the right path – the Harrison myth was identical with the Jackson myth and its continuing potency is evidenced by the overwhelming victory of the Whigs at the poll.

But the party system was soon to break down again, this time under the impact of sectionalism. The slavery issue moved to the centre of the stage, intensifying the split between North and South, which had always formed two entirely different societies and cultures within the bonds of the Union. Around slavery crystallized the issues that were to plunge the United States into civil war. It became a symbol, a holy cause to be fought over, a crusade for which thousands were to die. More than any other factor it dominated the years leading up to the Civil War as the focal point for national emotions.

Great changes had occurred since the war of 1812 in commerce, industry and finance. The North East had been transformed by the coming of the factory. In an era of unprecedented capitalist growth the ties of town and country, North and South became increasingly strained. The North, dynamic and expanding, looked to the future and national progress. The South, hide-bound by tradition and a refusal to adapt, found herself falling behind in population, wealth and political strength. The old alliance of South and North West that had for so long ruled, dissolved as the North West's consciousness of the moral evil of slavery was awakened, and as the South opposed those internal improvements so dear to the hearts of the North West. The Mason-Dixon line came to stand for something more than just a geographical division. Two nations existed within the Union and they were growing apart.

The Civil War ended, perhaps inevitably, with victory for the North and there was a massive industrial boom in post-war America, based on the abundant supply of natural resources in the interior, the increasing supply of immigrant labour and the transportation revolution. Railroads, canals and telegraphs opened up the country, facilitating mass production and large-scale distribution. Success became the goal, the driving force of society. The business of America was now business. Andrew Carnegie, the steel magnate, argued that men of talent and ability should not go into politics, which he considered unimportant, but into business. This was a danger signal. So too was the phenomenal success of Orison Swett Marden's *Pushing to the Front*, in which he argued that the major element of success was the will to succeed, and which ran into

two hundred and fifty editions.

The West was won and the Red Indians crushed. Gold and silver were discovered in Colorado and Nevada, railroads snaked out from coast to coast and in their wake came an iron and steel boom. Determined individuals, like Andrew Carnegie, J. P. Morgan, J. D. Rockefeller, created vast industrial and financial empires. Huge interlocking complexes acquired monopolistic control of whole sections of industry: Standard Oil, Consolidated Tobacco, Amalgamated Copper, United States' Steel.

Industrial control spilled over into political life. The captains of industry amassed their wealth by exploiting the workers, fixing the judiciary, dominating Congress. Corruption was rampant. A succession of scandals, like the Credit Mobilier affair, rocked the nation. Rival rings fought each other for the exploitation of patronage and it was a disappointed office-seeker who shot President James Garfield in 1881. The mushrooming of the cities led to the evils of Bossism and the political machines: franchise bartering, the marshalling of the immigrant vote, the exacerbation of existing social problems (slums, poverty, vice). The régime of President Ulysses S. Grant was one of the most unsavoury and disreputable in the history of the United States. Yet while the tide was running towards wealth and success, no one wanted to know about reform. It was the 'Gilded Age', the horrifying fulfilment of everything Thomas Jefferson had hated and feared in the Hamiltonian vision.

The agrarian America of Jefferson's dream had gone for ever and yet while it was not possible to turn back the clock and stamp out the industrialization, it was deemed possible by some men to reassert the values and beliefs embodied in Jeffersonian Democracy. When depression finally came in 1873 the forces of Reform started to make their voices heard and once again, as twice before, a populist movement was born out of a mood of national despair.

Two different groups, each drawing on the same populist ideals, set themselves to oppose the prevalent trend in American development. These groups were the farmers, the mainstays of the old agrarian set-up, who were unable to hold their own in the world market and were suffering from the side-effects of industrialization, and the middle classes, the professional gentlemen and the declining aristocratic families, who had been hit by loss of status, deference and power and were distressed by the rampant materialism and corruption and more important, the spectacular rise of the *nouveaux riches*.

These groups gave their support respectively to two successive reform movements, the Populists and the Progressives. Populism was essentially rural and lower-class, Progressivism more urban and middle-class. Both movements accepted that industry was here to stay and both sought the same antidote to it as that prescribed by the previous democratic movements.

As Tom Watson declared, Populism's enemy was 'monopoly – not monopoly in the narrow sense of the word – but monopoly of power, of place, of privilege, of wealth, of progress'.[2] Its battle cry was 'Keep the Avenues of Honour free. Close no entrance to the poorest, the weakest, the humblest.' Its aim was to 'recreate an America that said to ambition "the field is clear, the contest fair: come and win your share if you can."' It is important to stress that they called not for equality or levelling but the restoration of the equality of opportunity. Once that was established the individual would then be free to resume the pursuit of happiness. A Populist party had been formed by 1890 with a broad platform that attacked political corruption and monopoly capitalism. But beaten after they had merged with the Democrats in a bid for the Presidency in 1896, they faded rapidly away, leaving the way clear for the rise of the Progressives.

As D. E. S. Maxwell has observed: 'The political aspirations of the Federalists and the anti-Federalists had their artistic cognates.'[3] Literature had already expressed the populist ideals in their purest form. The poetry of Philip Freneau, William Cullen Bryant and Walt Whitman hymned the glories of the American democratic tradition, just as the prose of Thomas Jefferson,

Benjamin Franklin and Hector St Jean de Crèvecoeur extolled the agrarian republic of the Founding Fathers' dream.

The first great novelist of the United States, James Fenimore Cooper, who intriguingly prefigures John Ford, trod a very personal path between the two divergent trends in his country's history. 'Europe appealed to his native aristocratic prejudices but repelled his democratic: Jacksonian America appealed to his democratic prejudices but rode roughshod over his aristocratic,' wrote V. L. Parrington.[4] Cooper believed in the virtues of the agrarian smallholding system but saw also the need for a framework of law and order and a social structure which represented a check on the free-ranging development of the democratic spirit. His *Leatherstocking Tales*, a classic evocation of America's mythic past, were written at a time when he was becoming increasingly disillusioned with the way things were going in contemporary America.

It was in the middle of the nineteenth century that the age of widespread publication and mass literature began, at just the time when the old agrarian ideal had been submerged by the tide of industrialism. But 'the Gilded Age' provoked a literary reaction, which constituted an essentially populist critique of industrial society. Novels like *The Gilded Age* (1873) by Mark Twain and Charles Dudley Warner, *Democracy* (1881) by Henry Adams and *An American Politician* (1884) by Marion Crawford attacked the miasma of corruption at the centre, detailing the chicanery and greed and political manipulation that was clouding the shining vision of the Founding Fathers. The political machine and the brutal and avaricious party Boss were denounced in Francis Churchill Williams's *J. Devlin – Boss* (1901) and Elliott Flowers's *The Spoilsmen* (1903).

But most notable were the economic novels, which sought an answer to what was after all at root an economic problem. The balance of equality and sufficiency implicit in the agrarian democracy had been upset by industrialization. William Fuller Taylor singles out Henry George as the writer who best represents the unbroken continuity of tradition linking the era of the Revolution with the era of Reform.[5] George's book *Progress and Poverty*, which graphically outlined the effects of industrialization on America, was a best-seller many times over and a tremendous influence on subsequent writers. George, inspired by the Jeffersonian democratic tradition, viewed the evils of his age through the eyes of an archetypal populist and divined that what was missing from the new society was freedom of opportunity. It was monopoly that was the evil. Once it was destroyed America could then resume her wonted course, onward and upward to perfection.

The writers who followed George, men like Hamlin Garland and William Dean Howells, didn't attack industry *per se*. They attacked the abuse of industry, that monopoly capitalism which was destroying the old pattern of middle-class life. Slums, vice, depression, strikes were all seen as the products of a heartless plutocratic system which was the antithesis of the American tradition, middle-class, democratic and springing from the old Jeffersonian agrarian ideal: democracy in political and economic life and a fair chance for all to achieve a reasonable standard of life.

Hamlin Garland rejected monopoly but he also rejected collectivism, seeing both as alien to the American scene. *Main Travelled Roads* (1891) painted a grim picture of the drab, hopeless life in the depressed Middle Border and it was drawn to indicate what happens when equality of opportunity disappears. *A Spoil of Office* (1892), reading like the script of a Capra film, dealt with the rise of the hero from hired hand to state legislator, traced his disillusionment with politics, his surrender to the temptation to become a 'political pensioner', his salvation by the heroine and his embracing of the moral fervour of the Farmers' Alliance.

But by the mid-1890s, Garland's optimism for the Populist movement had faded. The Progressive movement, springing from roots different from Garland's own, left him behind. *A Son of the Middle Border* (1917) reflects this feeling of resignation to the march of events and contains melancholy

echoes of a cause already dead.

Others were on hand to take up the torch of protest, however. The Age of Reform saw the great age of the Utopian novel, idealistic projections of the future. The genre was virtually created by Edward Bellamy with *Looking Backward* (1888) in which he depicted America in the year 2000. The government preserves economic, as well as democratic, liberty. There is no heaping up of wealth, an adequate income for all, and universal education to fit Man for the good life. With an optimism reminiscent of the eighteenth century Bellamy saw his Utopian state as the proof of the perfectibility of Man and argued that America could become Utopia, once security and plenty for all was assured and the machine was harnessed for the benefit and not the domination of Man.

William Dean Howells dramatized the social inequality that was the outcome of economic inequality. He too drew a Utopia in *A Traveller in Altruria* (1894) in which the machine served man, in which there was no money but an adequate supply of goods for all and where life was lived not on the farm (as the old populist ideal envisaged) nor in the big city (as industrialization had decreed) but in the small town (which becomes the ideal milieu of the new populism). It was Howells too who denounced the ineffectiveness of charity (*Annie Kilburn, The Minister's Charge*) and argued that only a complete reform of the economic and democratic system would bring about the restoration of social justice. Howells and Bellamy were tending, unlike Garland, towards collectivism, but collectivism as adapted to the American democratic and middle-class tradition.

These men and men like them were the spokesmen of middle-class ideals in literature, dramatizing the issues raised by the political reformers and suggesting solutions. Far more than the Populists, however, the Progressives appreciated the tremendous influence of the printed word and utilized the growing power of the press to the full to advance their cause. Progressivism built its campaign on information and this was provided by the so-called 'muckraking'

magazines: *McClure's, Colliers, Cosmopolitan*, in which sensational exposés of the vices of the new industrial society appeared. Ida Tarbell revealed the secrets of Standard Oil. Lincoln Steffens took the lid off urban corruption. David Graham Phillips created a storm of protest with 'The Treason of the Senate'. As a later critic has observed,[6] these journalists:

> . . . traced the intricate relationship of the police, the underworld, the local political bosses, the secret connexions between the new corporations . . . and the legislature and the courts. In doing this, they drew a cast of characters for the drama of American society: bosses, professional politicians, reformers, racketeers, captains of industry. Everybody recognized these native types . . . but they had not been characterized before; their social functions had not been analyzed.

Once they have been defined and described, however, these characters become American archetypes which are taken over by the screen and frequently represented in films. The muckraking journalism also provided one of the matrixes of the new 'realistic' school of American fiction which combined drama with exposé in such novels as Upton Sinclair's *The Jungle*, describing the gruesome meat-packing industry of Chicago, and Frank Norris's *The Octopus* and *The Pit*, dealing with the grain industry.

Progressivism capitalized on the discontent already expressed by the Populists and the Liberal Republican 'Mugwumps', who, after failing to create their own party, called for the restoration of the spirit of the Declaration of Independence and adopted a policy of supporting candidates of either main party whom they deemed honest men. They stood clearly in the Jeffersonian tradition. For as Samuel Tilden, Chairman of the New York State Democratic Committee, declared, the spirit of the 1870s was like that when Jefferson became President: over-centralization, speculative fever, myriads of office holders. He sought Jefferson's solution: states' rights, purity and honesty

in administration. 'The reformatory work of Mr Jefferson must now be repeated,' he said.

The Progressives sought to maintain the integrity of the individual in an increasingly organized society. Typical of them was Woodrow Wilson who believed that the economic system was organized to stimulate and reward certain traits of personal character: frugality, efficiency, perseverance and insight. The creation of industrial monopolies blocked the avenues for the development of these traits. So the Progressives sought to reform business and maintain healthy competition by regulating monopoly and expanding credit facilities in the interests of the consumer, the farmer, the small businessman.

While the money power was the enemy of the Progressives in the economic field, the political machine was the enemy in the political field. The Progressives attacked the evils of Bossism and machine politics and called for leadership by decent men. Wilson sought a system in which the voice of the ordinary man counted for as much as anyone's. The direct primary, the secret ballot, women's suffrage were campaigned for to limit the power of the machine.

Progressivism transcended party boundaries. Both Republican President Theodore Roosevelt and Democrat President Woodrow Wilson were Progressives. It was Roosevelt who set up the anti-trust division of the Department of Justice to tackle the giant monopolistic complexes, while Wilson outlawed child labour and tried to ban monopolistic practices, believing that the judicious use of the legislative power could restore to the individual his chance to pursue happiness.

Once again war killed the movement and the end of war brought the Republicans to power under such unlikely figures as Warren Gamaliel Harding and Calvin Coolidge. The nation retreated into isolation and headed full tilt into business. The Oil scandals, the dismissal of the Attorney-General for corruption and other such unsavoury episodes gave Harding's administration the stamp of U. S. Grant's. The government encouraged big business, monopoly, high tariffs and private ownership of utilities.

The nation spiralled towards the inevitable collapse just as it had in the boom periods of the 1830s and the 1870s. The Wall Street crash of 1929 saw the beginning of the greatest depression ever experienced in the U.S.A. With supreme irony the crash came in the presidency of Herbert Hoover, who personified the basic beliefs of Jefferson, Jackson and Lincoln: opportunity, individualism and enterprise, and who in his rise from blacksmith's son to President was a classic self-help success story. This shattering national catastrophe brought to a sudden devastating end nine years of Republican normalcy. Millions of investors lost their savings, prices collapsed, wages were slashed, trade slumped. Factories, banks and farms went out of business. A nation of unemployed, confused Americans looked to the Democratic party to provide a saviour.

He came in the person of Franklin D. Roosevelt, who inaugurated the 'New Deal', a comprehensive, thorough-going programme of reform, designed to galvanize the ailing economy and save the country from its plight. The implementation of this 'New Deal' meant the end of populism. The New Dealers, unsentimental, hard-bitten and realistic, faced with the task of recreating the nation out of the chaos of economic collapse, had no time for moral crusades or outmoded Jeffersonian dreams. The *bêtes noires* of the Populists and Progressives, the trust and the political machine were of little concern to F.D.R. In the interests of the larger national goals he worked with the bosses whenever they would work with him. The New Dealers sought neither to destroy consolidated industry nor to restore competition.

Herein lies the difference between the old reform movements and the New Deal. Far from glorifying the individual and attacking organization as its greatest weapon, the core of the New Deal was the extension of government power. The needs of individualism did not figure in their thinking. The President became the central figure in this organization and to buttress him it seemed as if the

whole nation was being organized. There was a phenomenal growth of centralization, an increase in bureaux, boards and departments, civil servants and expenditure and the extension of government control over agriculture, industry, banking, transport, crime-fighting, labour relations, conservation and welfare.

It was thus Roosevelt, the New York aristocrat, who presided over the death and burial of the populist ethic. In 1932 he pronounced its epitaph: 'Equality of opportunity as we have known it no longer exists. Our industrial plant is built. Our last frontier has long been reached.'[7] American capitalism had come of age and the era of individualism was at an end. Now the government was to step in and guide the growth of the new economic order. Just as the civil war had signalled the end of the Jeffersonian Arcadia and the First World War had put an end to the Progressive mood of reform, so the Second World War set the seal on the extinction of the populist trend in American History.

It had become inevitable once industrialization had begun and already the Reform movements had had to make major concessions to it. The novels and pamphlets of Populism and Progressivism recognize this by accepting industrialization as a fact and increasingly calling on government to regulate it in the interests of the individual, signifying the end of another Jeffersonian tradition: unobtrusive central government.

Thus it was that the New Deal with its patrician President and its Brains Trust of intellectuals came to stand for everything the populists hated: strong, obtrusive central government, the acceptance of the big business complex, the dictatorship of the intellectuals, the triumph of the organization over the individual. The intellectuals, mostly left-oriented, and the underprivileged, a rapidly increasing number, placed their hopes in the New Deal. The middle class did not. In Richard Griffith's evocative phrase: 'It stood for the preservation of values already lost.'[8] They had no concrete programme for dealing with the ills of society, they simply had a feeling and that

was all. But armed with this feeling the battled against the New Deal. It is to th[i] period of struggle between the New Deal an[d] the old values that the populist moralitie[s] of Frank Capra's mature period belong.

Until now each great depression had bee[n] met by a revival of the Jeffersonian ideals But by 1929 this simply was not possibl[e] For they were the ideals of a world which ha[d] ceased to exist. Characteristic of this failur[e] of the old ideals was the disastrous result o[f] the doctrine of self-help, which had bee[n] central to populist thinking. The populis[t] orthodoxy declared that the pursuit o[f] happiness was the business of the individua[l] and it was up to him to improve his lot. [A] failure to rise in society was not the fault o[f] society but of the individual, the manifes[t] demonstration of his incapacity due t[o] idleness, indulgence or simply natural in[-]adequacy. Grounded in the Puritan work ethic and dramatized by popular novels lik[e] those of Horatio Alger, the self-help doctrin[e] made the progress 'from rags to riches' th[e] economic equivalent of 'from log cabin t[o] White House'. However, the industrial revo[-]lution had marked the apogee of self-help an[d] had resulted in a handful of individual in[-]dustrialists gaining wealth and power b[y] their own efforts, while the rest went to th[e] wall. The Populists had detected thi[s] anomaly, as an editorial in *The Farmers Alliance* reveals: 'The plutocracy of today i[s] the logical result of the individual freedo[m] which we have always considered the prid[e] of our system.'[9] It was individuals who ha[d] created the monopoly capitalism that wa[s] oppressing America. Social Darwinism ha[d] only meant the survival of the stronges[t] and most ruthless, and not of the fittest. Th[e] rat race was a self-help hell, the sweet smel[l] of success the narcotic which had intoxicate[d] a nation.

An antidote was clearly needed to th[e] ruthlessly single-minded pursuit of self-hel[p] and this was provided by populist writers i[n] the early twentieth century. Largely middle class, writing chiefly for magazines (notabl[y] the *Saturday Evening Post*), they elaborate[d] 'the fantasy of goodwill'. These writer[s] diagnosed the cause of the American malais[e]

in the disappearance of good neighbourliness, the help of the less well off by the better off. Their answer, then, was to temper self-help with humanity. They took the view that there was nothing basically wrong with the country and that if friends rallied round and people loved and helped one another a bit more, everything could be solved without government interference. In this way, again in Richard Griffith's memorable phrase, they could restore 'the world of the day before yesterday'. The answer of the populist middle classes to the dilemma of the age was simply good neighbourliness. It was a poor substitute for the solid, realistic programme of the 'New Deal'. But it was dramatized in the popular and successful stories of writers like Clarence Budington Kelland, Samuel Hopkins Adams and Damon Runyon, all of whom, significantly, provided source material for Frank Capra films.

Symptomatic of the failure to provide any real answer to the problems of depression and the dawning recognition of the failure of the old Jeffersonian dream was the popularity from the turn of the century onwards of literary evocations of 'the world of the day before yesterday' – the idealized and romanticized myths of pre-urban and extra-urban American worlds in which the old ideals were still possible and were still practised, where everyone loved his neighbour and where Good triumphed over Evil: the old South (the 'Uncle Remus' stories of Joel Chandler Harris), the Civil War dramas (*Heart of Maryland* etc.) of David Belasco, the mountains and the mountain folk (John Fox's *Trail of the Lonesome Pine*, Edward Westcott's *David Harum*), the small town (pre-eminently described by Booth Tarkington: *Penrod*, *The Magnificent Ambersons* etc.) and the sentimentalized world of childhood (Eleanor Porter's *Pollyanna* and Gene Stratton Porter's *Freckles* and *A Girl of the Limberlost*). Large sections of the middle class retreated into nostalgia, unable to come to terms with the changed, strange, unsympathetic world which had come in the wake of the machine.

It is possible, then, for us to analyse the changing face of the populist dream. Its ideal initially is the ideal of Thomas Jefferson, a republic of yeoman farmers, each man working his own land, free to develop in his own way. It stood for democracy, honest and unobtrusive central government, leadership by decent men, equality of opportunity, self-help; and it opposed big Business, the political machine and intellectualism as the things most likely to hamper the individual's pursuit of happiness. It became necessary to modify this ideal in the face of industrialization, and late nineteenth-century populists accepted industry while deploring some of its effects, replaced the farmstead by the small town as the ideal unit of life and advocated a limited increase in government power to secure their aims. Later still, good neighbourliness was advocated to temper self-help. Essentially there are two major phases in populism: agrarian populism, which is basically eighteenth-century; and what we might call small-town populism, which belongs to the nineteenth and twentieth centuries. Though its conditions might change, its basic inspiration never did. Simple, idealistic, optimistic, these populist movements took their stand on the fundamental truths of the Declaration of Independence and their continuing and unvarying theme was the defence of individualism against the forces of Organization.

The two pre-eminent entertainment media during the thirties and the forties were radio and the cinema and it would be reasonable to expect them to reflect populist ideas in some form. During the 1930s there were between 120 and 130 million people living in the continental United States. It has been estimated that 85 million of them went to the cinema every week. By 1939 there were 17,000 cinemas situated in more than 9,000 towns. So comparatively few people were out of range of a movie.

It was truly the movies' Golden Age. It was the era too of the great fan magazines. Avidly read, they gave the ordinary cinema-goer an *entrée* into the glittering world of the stars. They catered on the one hand to the vicarious desire for luxury, with stories about the fabulous homes and clothes and parties of the film celebrities, and on the

other hand to the need for identification with the stars, by showing that underneath it all they were ordinary, decent, hard-working people like you or me, who had, as often as not, been discovered by accident working as a soda jerk or a shop assistant. The implication was that movie stardom was within the grasp of all. 'From rags to riches' became in the new mythology 'from Small Town to Tinseltown'.

The movies influenced the way people talked and dressed and fixed their hair. It gave the language new catch-phrases ('Come with me to the Casbah' for instance), new words even (the verb 'to sheik', current in the twenties, derived from Valentino's activities in his desert pictures). The wartime fashion for women's turbans was inspired by the cycle of Jon Hall-Maria Montez Oriental extravaganzas. But the classic example of this kind of thing occurred in a populist film. In a scene in Frank Capra's *It Happened One Night*, Clark Gable took his shirt off to reveal that he wasn't wearing a vest. Vest sales in the United States plummeted as a result and delegations from the Unions and the manufacturers were sent to Columbia Studios to ask them to delete the scene from the film.

Movies were big business, a complex industry geared to making as large a profit as possible. The studios have justly been called 'film factories', for that is what they were. They operated in effect a production line, turning out a product designed as nearly as possible to meet the requirements of the customer. People indicated at the box office what they wanted to see and box office returns, audience research and the opinions of various consumer bodies gave the production companies some guide-lines to follow. It has been said that 'no art has ever been shaped and influenced by its audience as the art of the cinema.'[10]

What sort of people went to the movies is a question which has been investigated in a number of sociological studies over the years. One of the best and most revealing is that of Margaret Thorp, published in 1939. She found – and other studies have confirmed this – that cinema audiences could be divided not into age groups or into sectional groups (with one exception) but into socio-economic groups. The age of cinema audiences ranged from fourteen to forty-five and, unlike the situation today, there was not a distinctive split between older and younger cinema-goers. The single exception to the absence of sectional division is, as might be expected, the Deep South. The South did for some purposes form a distinctive audience bloc and this certainly explains why movies consistently perpetuated the chivalric myth of the Old South. The North had forgotten the Civil War and did not mind seeing a romantic, idealized Old South on the screen. The South had not forgotten and they loved it.

Much more interesting than this anomaly, however, is the fact that the middle class emerges as the largest cinema-going group. This was particularly true during the Depression when the working classes simply could not afford to go as often. Margaret Thorp has described the average American movie-goer as a man with an income of over $1,500 a year living in a city with a population of more than 50,000. More than half the cinema industry's revenue came from this type of man.

It is the middle-class tone of the cinema audience which explains the great popularity of the populist films of the thirties. For these films reflected what they felt and thought about life and the state of the nation. This is revealed in, for instance, the fascinating study *Middletown in Transition* by Robert and Helen Lynd, published in 1937. They investigated a typical Middle Western town of about 50,000 inhabitants and analysed its pattern of life and culture. Middletown is the sort of milieu from which Margaret Thorp's average cinema-goer would spring.

The Lynds, from reading the local newspapers and talking to civic groups and representatives of all sections of society, came up with a description of what they called 'The Middletown Spirit'.[11] Middletown's ideal person emerged as someone who was honest, kind, successful, a good neighbour and a good sport, someone who had character rather than brains, who was simple and unpre-

tentious, who had 'common sense', who, when problems arose, adhered to the tried practices that had worked in the past. The ideals of Middletown were a belief in the sacred institution of the family, in a community spirit, in the American democratic form of government as the best and finest in the world, in Christianity as the final form of religion, a belief that 'Big City' life was inferior to Middletown life, that socialism, communism and fascism were disreputable and un-American, that the government should leave things as much as possible to private initiative and that problems such as corruption could be largely solved by electing better men to public office.

What we have here is nothing less than a description of the hero and the plot elements of any Frank Capra film you care to mention. It is not surprising, then, that Capra was one of the most fêted film directors of the thirties. His films literally put Columbia Pictures, who produced them, on the Hollywood production map. The company was able to sell its entire year's product on the promise of a Capra film being part of the batch. Millions of people saw and loved his films, as the Gable incident indicates. The box-office success of Capra's films meant the increase of his salary from $10,000 a year for producing, directing and writing five feature films in 1928 to over $300,000 a year for producing and directing one feature film in 1939. It was a success story that was recognized in the Academy Award ceremonies. *It Happened One Night* alone carried off an unprecedented five Oscars: Best Picture, Best Director, Best Writer, Best Actor and Best Actress. Neither Ford nor McCarey has achieved quite the same box-office power, but Ford has won no less than six Academy Awards for directing and is proud of the fact that he has maintained a fairly consistent record of box-office success, while in *Variety*'s list of the blockbusting box-office successes of all time[12] we find up there along with *Gone with the Wind* and *The Sound of Music* both of Leo McCarey's Catholic popularizations, *Going My Way* and *The Bells of St. Mary's*. There can be no doubt that the three directors we are about to examine were men whose films were seen and enjoyed by millions of cinemagoers. It is interesting that as early as 1939, Margaret Thorp was able to single out precisely these three directors, Ford, Capra and McCarey, as the men who had achieved the greatest success, financial, critical and artistic, within the framework of an industry.[13] Looked at from the standpoint of 1972, that verdict still holds.

Notes

1 A. Whitney Griswold, *Farming and Democracy* (1952), p. 31.
2 Eric Goldman, *Rendezvous with Density* (1956), p. 42.
3 D. E. S. Maxwell, *American Fiction: The Intellectual Background* (1963), p. 46.
4 V. L. Parrington, *Main Currents in American Thought*, vol. ii (1930), pp. 224, 226.
5 William Fuller Taylor, *The Economic Novel in America* (1969), p. 43.
6 William Miller, *A New History of the United States* (1970), p. 276.
7 Richard Hofstadter, *The American Political Tradition* (1962), p. 325.
8 Paul Rotha and Richard Griffith, *The Film Till Now* (1949), p. 449.
9 Norman Pollack, *The Populist Response to Industrial America* (1962), p. 19.
10 Margaret Thorp, *America at the Movies* (1939), p. 1.
11 Robert and Helen Lynd, *Middletown in Transition* (1937), pp. 403–17.
12 *Variety*, Wednesday 8 January 1969, p. 14.
13 Thorp, op. cit., p. 148.

Frank Capra: The Classic Populist

'Life, Liberty and the Pursuit of Happiness', the inalienable rights of man which inspired the Declaration of Independence, have found their fullest and purest expression in the films of Frank Capra. Capra is an Italian-American, born in Palermo in 1897, who moved to Los Angeles at the age of six. He was thus able to turn on the American scene a completely fresh eye and from what he saw, he distilled the quintessence of the American Dream. This meant, in effect, the ideals of the populist middle class, for it was the middle class which conserved and perpetuated the basic ideals of the society. In the tradition of immigrants, once he had isolated the essential ingredients of the national philosophy, he made them his own. In translating them into cinema he laid out a clear statement of the continuing fundamental principles which underlay American life from the Revolution to the New Deal.

As Capra himself has said: 'My whole philosophy is in my films. People are basically good or can be made good. Sentimental? Of course, but so what? Let's not be hard-boiled about this. Happy endings – life is full of them.'[1] The genius of Frank Capra has created, in nearly a dozen film masterpieces, an enduring testament to the spirit of populism. For his is passionate, committed film-making and only the most crabbed of misanthropes could fail to be swept along by its optimism and panache. His films constitute the classic personalization of an ideology, for we, the audience, weep with the hero as he is reduced to despair and stand up and cheer him to the echo when he puts the forces of darkness to flight and makes a blazing speech in defence of Life, Liberty and the Pursuit of Happiness.

The mythology of populism

Like all movements populism had its mythology and like all movements this mythology was often more important than the facts. The populists cherished the 'log cabin to White House' success story as the mythic fulfilment of their ideal of a man of the people rising to be leader of the people by the vote of the people. We have already had cause to mention the Jackson myth. Andrew Jackson, though a wealthy planter and land-owner, was portrayed as a man of the people, an untutored child of nature, the people's champion against the power-lusting aristocracy of wealth. Ulysses S. Grant, though he presided over one of the most corrupt administrations in American history, had risen from Ohio ploughboy to President via the battlefield, on which he had led the armies of the Union to victory in defence of the democratic principle. This inevitably qualified him for mythic status.

But the most significant figure of all, the man who personified the ideals and aspirations of America and whose legend stands at the heart of populism, is Abraham Lincoln. Lincoln, the humble-born, self-made lawyer, rose to the White House at a time when political parties were in dissolution, the South was on the point of seceding and a mood of desperation gripped the nation. Lincoln took on his shoulders the suffering and the sins of America and his reward was an assassin's bullet.

It is no coincidence that one who knew him described him as 'the greatest character since Christ'. Christ is the ultimate prototype and all the populist heroes, whatever their real origins and characters, came to reflect the Christ figure. After all, Christ was

a Jewish Mr Deeds, the carpenter's son from the little country town who came to the sinful metropolis, confounded the city slickers and preached a gospel of 'Love thy neighbour'.

Lincoln was tailor-made to fit this image. The classic Good Man, the sort of leader the populists envisaged for the nation, Lincoln was also a simple soul, who called his wife 'mother' and received distinguished visitors in his shirt sleeves. He was one with the people he led. Physically he represents the archetype: tall, lean, dignified, with humility, honesty and integrity etched into every line of his rugged, frontiersman face. Spiritually too he was perfect. For the Declaration of Independence was the central core of his thought and his ideals were the ideals of the middle class: hard work, frugality, improvement by ability. His rise is thus a classic self-help success story, an inspiration and a pattern for others to follow.

Capra's films are full of references to the great populist myth figures. His heroes worship them. Jefferson Smith's first visit when he reaches Washington is to Lincoln's statue, Longfellow Deeds's first stop is Grant's tomb. In *You Can't Take It With You*, Martin Vanderhof eulogizes the great American presidents, who for him are significantly Washington, Jefferson, Lincoln and Grant. A scene in *It Happened One Night* sums up Capra's view of the myth figures. Peter Warne (Clark Gable) introduces Ellie Andrews (Claudette Colbert) to the delights of the simple life, which he illustrates by the examples of doughnut dunking and piggyback riding. The piggyback riding in particular serves as a symbol of populist values. Peter declares: 'Show me a good piggybacker and I'll show you a real human. I never met a rich man yet who could give piggybacks.' As a good example of the piggybacker, he cites Abraham Lincoln. Thus piggyback riding epitomizes the simple, homely pleasures. People caught up in the rat race (especially the big business-money rat race) do not have time for it. Lincoln did.

The Capra hero and the Capra heroine

The heroes of the films of Capra's maturity

fit perfectly to the Lincoln populist prototype, both physically and spiritually. There is a clear development in the emergence of the classic Capra hero. Capra began his career as a scriptwriter for Mack Sennett and his first important assignment was to evolve a screen character for Sennett's new discovery, Harry Langdon. Significantly Capra chose the classic figure of the simpleton who goes from the country to the city and outsmarts the city slickers. In Capra's own words:[2]

> The character I evolved for Harry Langdon was a very selfless man, who hadn't any allies; his only ally was God, his only protection was his own goodness and what he did was to love everybody, not unlike Good Soldier Schweik. That became the basis of all the Harry Langdon comedies. He just shot right to the top with this characterization.

Capra wrote a dozen two-reelers for Sennett around this characterization and when Langdon moved to First National to make feature-length films, he took Capra with him as writer-director. *The Strong Man* (1926), regarded by many as one of the finest of all silent comedies, reveals the Capra *Weltanschauung* already in existence. Langdon, returning from the war, goes to the big city looking for Mary Brown, the girl he has corresponded with. There a vamp tries to pass herself off as Mary, at first successfully. But Langdon eventually outwits her and escapes. He then finds Mary in a small town and marries her. He defeats the corrupt elements in the town and cleans out the saloon, the main haunt of the forces of evil.

However after *Long Pants* Capra and Langdon split up over Langdon's insistence on what Capra regarded as an excessive amount of pathos. No subsequent Langdon film was a success and his career as a major star came to an abrupt end. But Capra too found difficulty in getting work and it was only when he had almost decided to give up films that he landed a job at Columbia Pictures, then a Poverty Row studio, turning out cheaply-made quickies. It was Capra's films which during the next ten years were to

make Columbia Pictures a major production company.

The Langdon character prefigures in many ways the fully-formed Capra hero: tackling seemingly impossible tasks, giving his love wholeheartedly to the heroine, winning through by his innate goodness. But the element missing from the Langdon character is common sense. Langdon is an innocent abroad, like the later heroes, but, unlike the later heroes, he is also a moron.

When Capra went to work for Columbia, he abandoned the small-town innocent. The heroes of his early sound films derive from the city. The are outwardly tough, shrewd, wisecracking, essentially urban figures, in their trilby hats and double-breasted suits (Clark Gable, Warren William, Robert Williams). But they conceal beneath the tough exterior a heart of gold, a broad streak of sentimentality and a fund of essential goodness which links them securely to the fully-developed Capra hero. However, they are also imbued with the common sense that Langdon lacked. They are innocent at heart but the innocence is overlaid with a veneer of cynicism, resulting from their life in the Big City. This ultimately cracks to reveal the heart underneath.

Interestingly it is this characterization which is transferred during the Capra maturity to his heroines. The classic Capra heroines, Jean Arthur and Barbara Stanwyck, are ace newspaperwomen, toughened by life in the city jungle but melted by contact with the unconcealed goodness and innocence of the Capra hero, who is 'so fresh and wholesome he looks like a freak to us' (Jean Arthur on Mr Deeds). They are generally involved in an initial betrayal of the hero, but at the end rally round to restore his shattered confidence in human nature and marry him. Their characters are the same as those of the ace newspapermen of the earlier films (Gable in *It Happened One Night*, Robert Williams in *Platinum Blonde*) and the later films (Van Johnson in *State of the Union* and Bing Crosby in *Here Comes the Groom*). This in itself is indicative of a significant characteristic of American society: female domination. For in the hero-heroine

relationships it is the heroine who is the capable, realistic, dominant partner, whose protective maternal instincts are aroused by the helplessness of the innocent, idealistic, vulnerable hero.

When Capra began his series of social moralities with *Mr. Deeds Goes to Town* his classic hero-figure emerged. He combined the innocence, innate goodness and determination of the Langdon character with the common sense of the earlier urban heroes. They are perfect Lincoln-Christ figures, hailing from Small Town, U.S.A. There is an endearing element of uninhibited boyishness about them too, reflecting this innocence: Deeds sliding down the banisters of his mansion, George Bailey suggesting to his girl that they run barefoot through the grass, climb Mount Bedford and swim in the pool.

The first and most famous of the Capra populist heroes is Mr Deeds and he provided the pattern for the subsequent heroes: Mr Smith, Long John Willoughby, George Bailey. Particularly felicitous in this connection was Capra's choice of actors. The four principal populist heroes were incarnated by Gary Cooper (Deeds, Willoughby) and James Stewart (Smith, Bailey). Both actors are popular archetypes of the good American and both fit physically to the Lincoln prototype (tall, lean, slow-talking). Also for us, the audience, they are associated from their other film roles with the Old West and everything it suggests, particularly the simple code of right and wrong.

The attributes of the Capra heroes are carefully selected to epitomize the American and populist ethos. Longfellow Deeds writes rhymes for Christmas and birthday cards extolling Home, Love and Mother (the middle-class ideals), he doesn't smoke or drink and cherishes a romantic view of love (old-fashioned morality), he is captain of the Mandrake Falls Volunteer Fire Brigade (community service) and he plays the tuba in the town band (community feeling). Jefferson Smith comes from a western state (the Old West and its values) and is a Boy Scout leader (community service, training the young, the qualities of leadership).

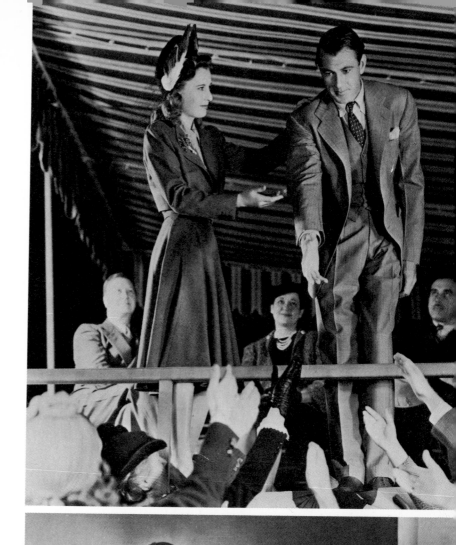

The Capra hero and the Capra heroine

154 (above) The classic Capra Good Man is presented to the people. Gary Cooper and Barbara Stanwyck in *Meet John Doe*

155 (below) The classic Capra heroine functioned as protector, confidante and ultimately spouse of of the hero. Jean Arthur and James Stewart in *Mr. Smith Goes to Washington*

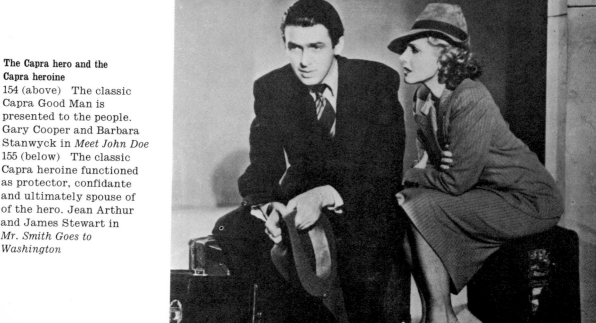

Long John Willougby is a baseball player. Baseball is America's national sport (thus he embodies America) and he is also known as John Doe, the name of the American Everyman figure. Associated with the 'sporting' concept are ideals of fair play and the victory of the one best endowed by nature, through self-help, in free and equal competition. So in every way the Capra heroes are fitted to do battle for the American way of life, populist style.

Capra and politics

During his maturity Capra made a trilogy of films which constitutes a fully articulated statement of the populist credo on politics. The first, *Mr. Smith Goes to Washington* (1939), exposed corruption in national politics. Jefferson Smith (James Stewart) is selected to succeed a senator who has died suddenly because the party bosses believe him too naïve to see the corrupt practices in which they are engaged. But arriving in Washington Smith is put wise as to why he was elected by his secretary, Saunders (Jean Arthur). Horrified, Smith decides to fight the machine and takes up a lost cause. Capra reveals the full extent of the machine's power. Control of newspapers and radio stations enables them to manipulate public opinion and they are well on the way to putting into the White House their front man, the popular and respected but corrupt Senator Joseph Paine (Claude Rains), known as 'The Silver Knight', whose advice to Smith is: 'You have to check your ideals outside the door like you do your rubbers.' For his pains Smith is framed and faced with imprisonment. But he makes a twenty-three-and-a-half hour speech in the Senate, rallies the people to his support and triumphs with the aid of his now converted secretary. Paine confesses his guilt and the Senate and the people in the gallery cheer until they are hoarse for Smith and Liberty.

With the outbreak of war Capra is on hand to warn America of the danger of Fascism, with *Meet John Doe* (1941). Financier and oil magnate D. B. Norton (Edward Arnold) takes over a newspaper and fires many of the staff. One of them, ace newspaperwoman Ann Mitchell (Barbara Stanwyck), writes a powerful final article purporting to be from one 'John Doe', in which he threatens to jump off the tower of City Hall on Christmas Eve as a protest against social injustice. The article causes a sensation. Everyone wants to know who John Doe is and Ann, to save face, produces a down-and-out baseball player, Long John Willoughby (Gary Cooper), who becomes John Doe. She writes a successful series of articles in his name, John Doe clubs spring up all over America and the John Doe philosophy of good neighbourliness sweeps the country. When the movement is at its height, Norton reveals his plan to use it to further his own Fascist ambitions. But John, who genuinely believes in what he is doing, determines to expose Norton at a huge John Doe convention. Norton, however, beats him to it, uses his police to keep John from speaking and reveals that he is a fake, killing the movement. John feels that the only way he can redeem himself is to jump off the tower as he promised. The now converted Ann begs him not to in a speech which makes explicit the parallel with Christ. She tells him that someone has already died for the John Doe ideals, the first John Doe (i.e. Christ): 'And he has kept that idea alive for almost 2,000 years. If it's worth dying for, it's worth living for . . . this is no time to give up.' The little people who had supported him rally round too, begging him to help them revive the John Doe clubs. He agrees to live and to carry on the fight against Fascism. The newspaper editor triumphantly declares to the discomfited Norton: 'There you are, Norton – the people. Try and lick that,' and the sound-track bursts forth with Beethoven's 'Ode to Joy'.

Capra renewed his attack on the political machine in *State of the Union* (1948), taking in also the occasional tilt at Communism, the new enemy 'ism'. It is based on a hit Broadway play by Howard Lindsay and Russell Crouse, the plot of which was suggested by the phenomenon of Wendell Willkie. Willkie, a self-made man of German immigrant origin,

was a successful lawyer and company executive who had been a Democrat but had broken with Roosevelt over the implications of the New Deal (e.g. its anti-individualism) and had moved over to become a popular figure in the Republican party. In 1940 and again in 1944 he was nominated by the Republican rank and file, in opposition to the wishes of the party bosses, to run against Roosevelt for President.

The film centres on millionaire aircraft manufacturer, Grant Matthews (Spencer Tracy), classic Capra Good Man, who is caught up in the political rat race when various interests propose him as Republican nominee for the Presidency. Deluded by visions of the White House, his honesty is sapped by the party machine. But at the end, helped by his wife (Katharine Hepburn), his honesty triumphs and he uses a radio programme designed to boost his image to denounce the corrupt interests supporting him and the idleness of the voters, who allow themselves to be deceived and manipulated by crooked politicians. He then embarks on a campaign to eradicate corruption from political life.

The film is given a breathless topicality by its constant references to contemporary figures and it exposes the various elements that make up the hated party machine. The chief power behind Matthews's bid for the nomination is a tough, hard-bitten female tycoon Kay Thorndyke (Angela Lansbury), who inherits from her father (himself once cheated of the Republican nomination) a chain of newspapers and the burning ambition to put a President in the White House and be the power behind his throne. Her campaign is managed by a cynical professional manager (Adolphe Menjou), whose philosophy is 'The only difference between Democrats and Republicans is that they're in and we're out.' The campaign is supported by a prize collection of selfish and grasping bosses: the unscrupulous, hard-faced manipulator of the foreign minorities, the bland, ever-smiling agriculture boss, the back-slapping, hand-shaking industrialist, the overdressed, despotic, parvenu labour boss, the genial and effusive but rather dumb ('Abyssinia, that's

somewhere up north, isn't it?') Southern Judge.

It is important to emphasize that Capra is not attacking the foreign minorities, agriculture or labour *per se*. He is attacking their apathy in the face of manipulation. On the other hand (in the persons of the industrialist and the judge) he is attacking the intrusion into politics of big business and of the Old South, an institutionalized caste society which offends against the ideal of equality of opportunity. The title has a double reference: the condition of the nation and the marriage of Grant and Mary are both in a bad way at the start of the film but look more hopeful at the end.

Common to all three films is the blistering denunciation of the party machine, of the domination of the organs of communication by corrupt interests seeking to manipulate the voter, of the intrusion into politics of big business, of the ambitions of the wealthy and influential (Kay Thorndyke, D. B. Norton, Senator Joseph Paine) who seek power for its own sake and not for the good of the country. These constitute the threats to liberty and to combat them the nation needs the leadership of the Good Man, the Lincoln, the Saviour (Jeff Smith, John Doe, Grant Matthews). It is no coincidence that Capra's own production company was called Liberty Films. This trilogy represents his affirmation of faith in Liberty, populist style.

Anti-intellectualism

Intertwined with populism is anti-intellectualism and this, like populism, is as old as the United States itself. Its roots lie in the easily grasped fundamental truths behind the political philosophy: the evangelical tradition, the democratic tradition, the self-help tradition. Because these ideas are simple and easy to understand, their enemy is seen to be the intellectual, the patronizing, jargon-ridden, ivory tower dweller, isolated from the common people. It is the intellectual who is blamed for the ills of society, for bringing in innovations, for

Capra and society

Capra's films consituted an articulate attack on the forces in society which were deemed to be perverting the American Dream.
156 (below) Gary Cooper denounces the corrupt forces of big business (personified by Edward Arnold) in *Meet John Doe*
157 (right) James Stewart denounces corrupt politicians (as personified by Claude Rains) in *Mr. Smith Goes to Washington*
158 (below right) Gary Cooper denounces shallow, patronizing and effete intellectuals in *Mr. Deeds Goes to Town*

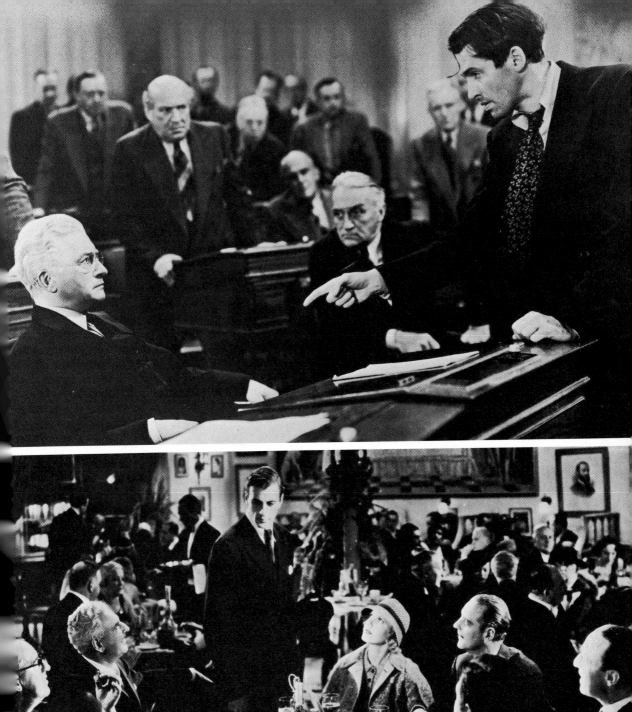
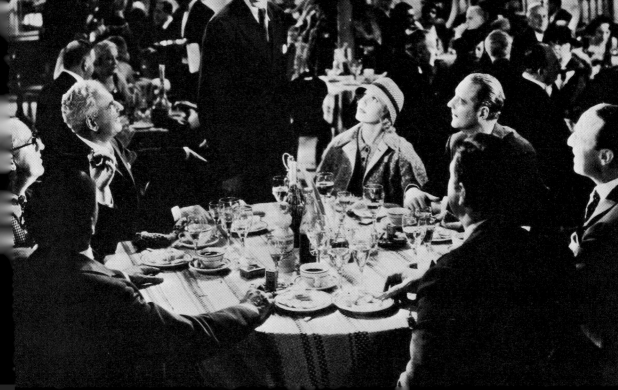

adulterating the American philosophy with outlandish ideologies (Darwinism, Freudianism, Communism), 'isms' which all smack of Europe, decadence and impiety, the very things the Pilgrim Fathers sailed to the New World to escape.

You Can't Take It With You is notable for an impassioned speech against 'isms' made by Martin Vanderhof (Lionel Barrymore), a sort of elder statesman of populist cinema: 'Whenever things go wrong, people turn to an ism, Fascism, Communism ... why don't they ever think of Americanism?'

The classic confrontation of the hero and the intellectuals comes in *Mr. Deeds Goes to Town* (1936). Deeds refuses to subsidize the opera, which loses money, simply because opera has always lost money. He insists that it be run on business lines, with tickets reduced in cost and the people given what they want to see. In a restaurant he confronts a group of highbrow poets who openly laugh at his rhymes, expecting him to be too stupid to see it. He punches them on the jaw. In court his future is threatened by the testimony of a Viennese psychiatrist who trots out a whole string of gibberish to prove that Deeds is insane, whereas the judge declares him 'the sanest man who ever walked into this court'.

In no other film is there such an onslaught on the intellectuals. In general they do not appear, simply because they have no place in the 'real world' of Capra's films. The one exception is Capra's screen transcription of Joseph Kesselring's *comedie noire*, *Arsenic and Old Lace* (1941), about two sweet old ladies who murder their suitors and bury them in the cellar. Untypical of his mature work, the film was made, as Capra confesses, partly as 'a cheap film for a fast buck to keep my family going'[3] and partly to recharge his batteries after pouring his creative energy into *Meet John Doe*. The film is really Capra on sabbatical, indulging in that very American institution, telling a Hallowe'en story. ('This is a Hallowe'en tale of Brooklyn, where anything can happen and probably does.') Capra genially sends up his own themes. Populist myth figure Theodore Roosevelt appears, impersonated by Uncle Teddy

Brewster, a harmless lunatic, who, thinking he is the President, is digging the Panama Canal in the cellar. The two old ladies, Aunt Abby and Aunt Martha, poison the old men as a practical demonstration of good neighbourliness – they are sorry for their loneliness and want to send them to 'the happy land far, far away'. But the film can also be interpreted as a glorious joke at the expense of the intelligentsia as personified by urbane and sophisticated drama critic Mortimer Brewster (Cary Grant), the hero, who having for years denounced marriage as an old-fashioned superstition and written a book *Mind over Matrimony* to prove it, is seen at the start of the film getting secretly married – to a clergyman's daughter. During the course of the film he discovers that his entire family is insane and is himself reduced to the verge of insanity by the discovery.

The ultimate Capra statement on the intelligentsia, however, would probably have come in a film he never actually made. After *You Can't Take It With You*, he worked for a year preparing a film biography of Chopin. The script was written by Sidney Buchman, who wrote *Mr. Smith Goes to Washington*, and the result might well have been titled *Mr. Chopin Goes to Paris*. Columbia's New York office was apparently 'aghast at the prospect of trying to sell an expensive costume film about a piano player and a woman novelist who wore pants and smoked cigars'[4] and vetoed the project.

However Buchman's script was revived in 1945 and filmed by Charles Vidor under the title *A Song to Remember*. To this day it remains one of the famous 'bad films' of Hollywood, the sort everyone quotes when they are trying to denigrate the film capital. Cornel Wilde played Chopin like a strapping, expatriate American football player and Merle Oberon was distinctly ill-at-ease as the imperious George Sand, having to speak such unspeakable lines as 'Discontinue that so-called Polonaise jumble you have been playing for days.' However, one can see what appealed to Capra in the plot outline. Basically it debunked the idea that the artist had a duty only to himself and that intellectuals were a kind of super race, im-

pervious to the world around them. Simple, talented, patriotic country boy, Frederic Chopin, comes to the big city (Paris) and having achieved fame, is faced with a conflict between his patriotic duty (to help his struggling Polish countrymen against Russia) and his love for George Sand (who encourages him to devote himself to her and to art). Under the debilitating influence of the posturing Parisian literati, he succumbs and retires with George to Majorca. But when he is given a bag of Polish earth, he is reminded of his duty, embarks on a concert tour of Europe to raise money for the Polish resistance and dies of exhaustion.

Capra and wealth

As we have seen, populism was never equalitarian. It took the view that there was nothing wrong with the acquisition of wealth as long as everyone had a chance to acquire it. Lincoln once said: 'Republicans are for both the man and the dollar, but in the case of conflict, the man before the dollar.' This is Capra in a nutshell.

In the climactic court scene in *Mr. Deeds*, Deeds speaks with the populist voice. He says that society has its leaders and its followers and it is up to the leaders to give the followers a hand (i.e. good neighbourliness). The villainous lawyer, John Cedar, speaks with the voice of the New Deal when he condemns private charitable schemes as likely to cause revolution and says that everything should be left to the government.

The populists, while they did not disapprove of great wealth in itself, did not believe that one needed great wealth. Deeds does not need it. He earns a comfortable living from his rhymes and – something that has been consistently ignored in analyses of the film – he owns a tallow works and thus personifies small-scale enterprise. He has a large house and a motherly house-keeper. When the lawyers come to announce that he has inherited twenty million dollars, he does not bat an eyelid. He simply sits down, orders lunch and invites the lawyers to join him. Why? Because he does not need the money.

Eventually, when his attention is drawn to the plight of the dispossessed, he puts the money to good use, capitalizing small farmers with two acres and a cow each – not money but the wherewithal for private enterprise and self-help. Similarly, in *It's a Wonderful Life*, George Bailey runs a Building and Loan Company and organizes working parties of slum-dwellers to co-operate in building themselves new houses (i.e. good neighbourliness in action, obviating the need for governmental intervention).

The figure of the big businessman, crabbed by his pursuit of wealth, is a constantly recurring one in Capra. In *A Hole in the Head*, it is outwardly genial, inwardly ruthless Jerry Marks (Keenan Wynn) who refuses to help a friend in need (Frank Sinatra). In *Wonderful Life*, it is the ultimate Scrooge, Henry F. Potter (Lionel Barrymore), a mean, narrow-minded old misanthrope, totally obsessed by wealth and controlling almost all the industry in Bedford Falls.

Obsession with money has its physical aspects. Semple in *Mr. Deeds*, obsessed with getting hold of Deeds's fortune, has a facial twitch. So does Blakely, the grasping estate agent in *You Can't Take It With You*. Anthony P. Kirby, the tycoon, in the same film, and Mrs Schuyler in *Platinum Blonde* both have upset stomachs and are constantly in need of bicarbonate. Henry F. Potter is a cripple, confined to a wheelchair, an outward and physical sign of a soul crippled by wealth.

A corollary of wealth is snobbery, usually to be found in the womenfolk of the rich (Mrs Schuyler, Mrs Kirby, the socialites in *Mr. Deeds*). Ellie Andrews, the heroine of *It Happened One Night*, is converted from incipient snobbery by her encounter with Peter (Clark Gable). Capra reprehends this attitude of mind, epitomized by the Schuyler family 'who refused to come over on the *Mayflower* because they didn't want to rub shoulders with the tourists'. However, if the rich man retains humanity and humility, then good luck to him and his wealth. Grant Matthews, hero of *State of the Union*, is a millionaire industrialist. Mr Deeds becomes a millionaire and uses his money for good purposes. Ellie Andrews's father (Walter

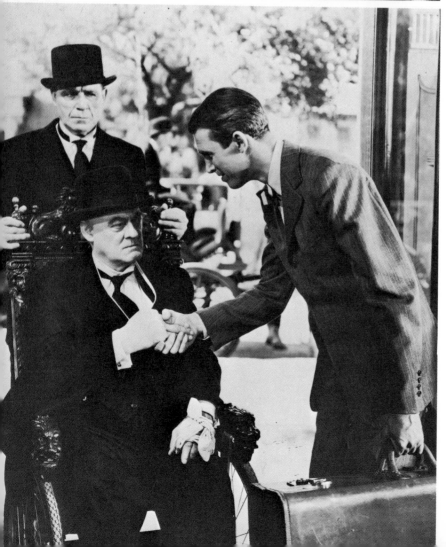

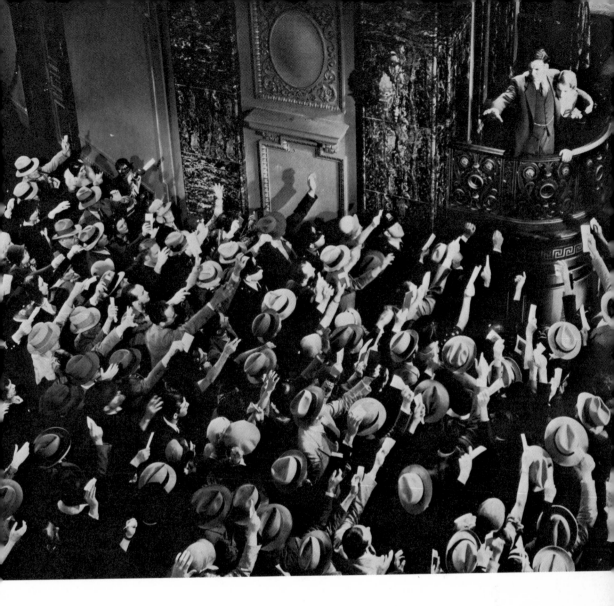

Capra and wealth

159 (above left) A classic Capra archetype is the bloated Wall
Street shark. Edward Arnold in *You Can't Take It With You*

160 (below left) The figure of the big businessman crabbed in his
pursuit of wealth is a recurrent one in Capra. Often a physical disa-
bility accompanies it as an outward sign of a soul crippled by
wealth.

Lionel Barrymore in *It's a Wonderful Life*

161 (above) According to Capra the solution to the financial
problem of the Depression was for the depositors to leave their
savings in the banks rather than draw them out.

Walter Huston defies a run on the bank in *American Madness*

Connolly) is a multi-millionaire but also a good chap, whose irascibility stems from his deep love for his daughter, who sees through and buys off her fortune-hunting fiancé and who finally connives at his daughter's elopement with Peter, whom he has liked from the start.

American Madness, made in 1931 at the height of the Bank failures, takes as its hero the noble bank manager (Walter Huston) and blames popular panic for the failures. The solution of the bank problem, according to Capra, is for the ordinary people, the depositors, to rally round and contribute their savings to keep the banks open. The manager affirms his credo to the bank's directors:

'You say banks should lend money only to those who can put up material assets as collateral. Well, gentlemen, it isn't news that the Depression has pretty well wiped out people's material assets. But it hasn't yet wiped out what Alexander Hamilton called America's greatest asset – character. We must have faith in character, make loans on character.'

There are two notable cases of the conversion of big businessmen, who are taught humanity and humility and who will, it is implied, use their wealth for good in future. In *You Can't Take It With You* (1938), the tycoon is Anthony P. Kirby (Edward Arnold), who at the start of the film is planning a series of mergers which will give him a monopoly of all the munitions plants in the country. But it is clear that he is acquiring for the sake of acquiring and not for the good of anybody. He symbolizes at the same time the big business monopoly and the evils of conscienceless wealth. During the course of the film, by contact with the happy-go-lucky Vanderhof family, he learns his lesson and when on the eve of the merger his son (James Stewart) leaves home and abandons his job to marry Martin Vanderhof's granddaughter, Kirby abandons his merger and rushes off to join them.

Similarly in *Broadway Bill* (1934), re-made by Capra as *Riding High* in 1949, the grim tycoon J. L. Higgins (Walter Connolly in

1934; Charles Bickford in 1949), who has spen his life taking over firm after firm, learr the virtues of the simple life from his pro spective son-in-law Dan Brooks (Warne Baxter in 1934; Bing Crosby in 1949). A dinner one night Dan makes a speech de nouncing obsessive money-making and tak ing over firms which little men have spen their lives building and walks out to devot his life to racing his horse, Broadway Bil At the end of the film Higgins joins him an his daughter, whom Dan will marry.

Capra and the pursuit of happiness

The pursuit of happiness is perhaps, mor than any other, the central theme of Capra work. Happiness is to be found in peace contentment, enjoyment of life and, abov all, freedom from the rat race, the individua asserting himself to escape from the op pressive hand of the forces of Organization This idea was expressed in abstract terms i *Lost Horizon* (1937), a film dismissed by almos all influential critics as pretentious and absurd. Raymond Durgnat describes it as 'a O altitudo! of absurdity'.[5] Lewis Jacob dismisses it as vulgar and pretentious, a 'fantasy of unfantastic proportions'.[6] I fact it is one of the most dazzling films to come out of Hollywood in the thirties, a virtuoso piece of film-making, marvellously acted and consistently riveting.

The foreword sets the film in a populist context, telling us that everyone is searching for something: some call it Utopia, others the Fountain of Youth and others 'that little chicken farm'. The film tells of another suct place – Shangri-la. A plane is hi-jacked while flying from revolution-torn China to the safety of British India and lands in the mountains of Tibet. The passengers are taker to the hidden valley of Shangri-la, where they are treated well and looked after. Their leader, Robert Conway (Ronald Colman), is told the secret of the valley by the High Lama (an electrifying performance by Sam Jaffe). The atmosphere is such that life is prolonged indefinitely and Man is given what he never had before – Time. In this isolated

valley there is no rat race, no striving after power, wealth, success and men can spend their time improving themselves and simply enjoying life. They have one basic rule: 'Be kind', in other words 'good neighbourliness'. The High Lama looks forward to the day when the strong shall have devoured each other and the Christian ethic will be fulfilled: the meek shall inherit the earth. Then the world will look to Shangri-la where all that is best in the old world is preserved. Conway has been chosen as the next High Lama. But his brother, George, cannot accept the situation and persuades him to accompany him in an escape bid. The others of their party prefer to stay on. During the escape George is killed but Robert manages to reach civilization. He now finds that life is empty and peace of mind impossible. The last, memorable image of the film is of Robert, a lone, tiny figure, against a vast expanse of snow, struggling onward through a blinding storm, trying to find his way back to Shangri-la.

The plane's passengers in the film version of *Lost Horizon* are not exactly the same as the passengers in James Hilton's original novel. Conway (called 'Hugh' in the book) and Bryant (Thomas Mitchell) are preserved. But Charles Mallinson, the vice-consul in the book, becomes Conway's brother, George (John Howard), the better to explain Conway's decision to accompany the escape bid. Miss Roberta Brinklow, the middle-aged American missionary becomes Gloria Stone (Isabel Jewell), tubercular American showgirl; and Capra and writer Robert Riskin add an entirely new character, Alexander P. Lovett (Edward Everett Horton). These new passengers have been carefully chosen to illustrate different aspects of the rat race. Robert Conway is a soldier and diplomat (the double-dealing world of diplomacy), Chalmers Bryant is a failed businessman (victim of the big business rat race), Gloria Stone is a showgirl (the empty glitter of show business) and Alexander P. Lovett is a palaeontologist (the aridity and incomprehensibility of the intellectual world). All find peace and contentment in Shangri-la, their participation in the rat race at an end.

The film which immediately followed *Lost Horizon, You Can't Take It With You*, applied the Shangri-la philosophy to the contemporary American scene. Here Shangri-la is Martin Vanderhof's house. Thirty years ago he decided he was not having any fun and so he gave up his job to devote the rest of his life to enjoying himself. Now he spends his time playing the harmonica and collecting stamps. His daughter Penny writes plays which she never finishes and her husband and Mr De Pinna the ice-man (who came to deliver ice nine years ago and stayed on) manufacture fireworks in the cellar. They do not have much money but they do have a lot of friends and when they are arrested for manufacturing fireworks without a licence it is these friends who rally round and pay the fine.

However, Martin Vanderhof is more than just an American High Lama of Shangri-la. He is also a populist, seeing obtrusive central government as one of the principal obstacles to the pursuit of happiness. In a beautifully judged scene he is confronted by a tax inspector who wants to know why he has not paid any income tax for twenty-two years. The answer is: 'Because I don't believe in it.' Vanderhof insists on being shown value for his money. The inspector protests that someone has got to pay for the President, the Supreme Court and Congress. 'Not with my money,' comes the reply. What about inter-state commerce? If that is not paid, trade will not be able to move from state to state. 'Why? Are there fences?' There is no answer to that. The inspector retires in confusion amid the cheers of the audience.

In *It Happened One Night* Ellie Andrews is freed from confinement by wealth and learns what life can really be like, thanks to Peter Warne. Significantly Peter too has his Shangri-la. He tells Ellie that he was once in the Pacific and saw an island and determined that this was where he would take his wife, where life could really be lived. In *Platinum Blonde* (1931) reporter Stew Smith (Robert Williams) falls for and elopes with a society heiress (Jean Harlow) in spite of the forebodings of his friends. ('She's in the Blue Book; you're not even in the phone

Capra and the pursuit of happiness

162 (above) Clark Gable introduces Claudette Colbert to the
delights of the simple life (as symbolized by doughnut-dunking) in
It Happened One Night

163 (above right) The idealized escape to happiness was to be found
in Shangri-la. Ronald Colman and Jane Wyatt in *Lost Horizon*

164 (right) Shangri-la-American style.

Everyone doing their own thing in *You Can't Take It With You*.

L. to r.: Jean Arthur, James Stewart, Dub Taylor, Lionel Barrymore,
Spring Byington, Ann Miller, Mischa Auer, Lillian Yarbo, Donald
Meek, Eddie Anderson, Samuel S. Hinds, Halliwell Hobbes

book.') She persuades him to move into the family mansion and tries to turn him into a stuffed shirt but eventually he rebels, asserts his independence and settles for life in a down-town flat, writing the play he has always dreamed of writing and married to fellow reporter (Loretta Young), who has secretly loved him all along.

One of the fascinating things about this early film is that it marks the beginning of Capra's association with his long-time screenwriter Robert Riskin and contains many of the ideas subsequently incorporated into *Mr. Deeds*. The press christen Stew 'The Cinderella Man' (just like Deeds), Stew settles his problems by socking people on the jaw (just like Deeds) and, most important, Stew, like Deeds, tests the echo in the family mansion by 'who-whoing' with the aid of the butler. This scene serves both to illustrate the vast emptiness of high society life and to point up the loneliness of the hero when transplanted from his real environment to an alien one.

In Capra's comeback film, *A Hole in the Head* (1959), the pursuit of happiness is still very much in evidence. Hero Tony Manetta has his Shangri-la in his Miami hotel, appropriately called 'The Garden of Eden'. He is threatened with the loss of it and his adored young son, and the film traces his efforts, ultimately successful, to preserve both. At the end, Tony's staid elder brother, New York merchant Mario (Edward G. Robinson), decides, if only temporarily, to give the rat race a rest and join in the care-free life in Miami.

Capra and good neighbourliness

In keeping with the new populism Capra is also concerned to preach the virtues of good neighbourliness as a corrective to the exclusive pursuit of happiness, which might cause misery to others. The first recognizably populist film of Capra, *Lady for a Day* (1933), which, re-made as *A Pocketful of Miracles* (1961), is also his last film, takes good neighbourliness as its theme. Adapted from a Damon Runyon fable, it tells how a gang of bootleggers, panhandlers and generally lovable rogues rally round to help old Apple Annie ('an old souse, maybe, but she's full of dreams') pose as a wealthy socialite to deceive a Spanish count, whose son Annie's daughter is due to marry. Not only is the message one of 'good neighbourliness', it also underlines the general optimism of the populist position by showing that even crooks can have hearts of gold.

The re-make showed that Capra had lost none of the magic or compassion of his heyday. Annie (gleefully played by Bette Davis) is helped principally by bootlegger Dave Conway (any relation to Robert?), better known as Dave the Dude (Glenn Ford), his lugubrious henchman Joy Boy (unforgettably played by Peter Falk) and 'Judge' Henry Blake (Thomas Mitchell), a grandiloquent con man who is also significantly an intellectual (implying the equation of the two), quoting Pascal and swapping Scott quotations with the butler Hutchings (inimitably played by Edward Everett Horton). The finale of the film demonstrates the beneficial effects of good neighbourliness on all concerned. The Spanish count decrees a party to celebrate the engagement and hopes to meet all of Annie's socialite friends. Just as it seems that disaster is on hand, the Governor, the Mayor and a host of real socialites turn up, having heard of the story, and greet Annie as an old friend. It is a triumph. Everyone gathers at the dockside to sing 'Old Acquaintance' as the ship bearing the young lovers sails away. A warm glow suffuses all. The Governor and the Mayor resolve their political differences, Dave decides to marry his sweetheart and retire to a farm in the country and Joy Boy goes home to his wife.

Capra has little doubt where good neighbourliness chiefly survives and is practised. It is in Small Town, U.S.A. This belief is affirmed at the opening of *Mr. Deeds* when the inhabitants of Mandrake Falls gather to see him off on the train, singing 'For he's a jolly good fellow' and loading him with flowers and picnic baskets. This theme is more fully expounded in the film which is Capra's personal favourite and probably his

Capra and good neighbourliness
165 (above) The townsfolk gather to see their favourite son (Gary Cooper) off to the big city in *Mr. Deeds Goes to Town*
166 (centre) Gary Cooper preaches the philosophy of good neighbourliness in *Meet John Doe*. Walter Brennan looks sceptical
167 (below) Friends rally round in a crisis to help James Stewart and Donna Reed in *It's a Wonderful Life*. The friends include: (l. to r.) Ward Bond, Todd Karns, H. B. Warner, Gloria Grahame, Beulah Bondi, Frank Faylen, Thomas Mitchell

greatest single work, *It's a Wonderful Life* (1946). It is the ultimate Capra film, incorporating elements from many of his previous films: the run on the bank (*American Madness*), the self-help co-operative scheme (*Mr. Deeds*), friends rallying round with financial help in a crisis (*You Can't Take It With You*), contemplated suicide and a Christmas Eve dénouement (*Meet John Doe*).

It tells the story of George Bailey (James Stewart), who has found his Shangri-la in the small town of Bedford Falls where he has lived all his life, and for whom happiness has meant a life spent in helping others and serving the community. When faced with ruin after the loss of 8,000 dollars he is reduced to despair and contemplates suicide. Heaven is perturbed and sends down an angel, second-class, Clarence Oddbody (beautifully played by Henry Travers), who shows him in flashback his life and, finally, what Bedford Falls would have been like if he had never lived. Henry F. Potter, the tycoon, has taken over and it has become Pottersville, a noisy, jazzy, neon-lit hell, full of clipjoints, bars and worse, where everyone dislikes and distrusts everyone else. George decides to live, his friends rally round to provide the money and everyone lives happily ever after.

Throughout Capra's work, the tone is unashamedly sentimental, a fact which many critics decry and which calls for some comment. The only comment that one can make is that it is simply not possible to eliminate the sentimentality, for it is at the root of his vision. It is this which links him to John Ford. The work of both is permeated by nostalgia for a vanished America, an idealized pre-urban America where a purer, better, freer life was lived. Sentimentality is an integral part of nostalgia and so there is simply no point in decrying it.

The comparison to Ford can be taken further. In the constant use of the same writers (in Capra's case Robert Riskin), and the same photographers (for Capra Joseph Walker), in the tendency to self-quotation, in the consistent return to favourite themes and above all in the use of a regular stock company, the work of both directors forms a recognizable, integrated whole. It is the stock company which is the most obvious continuity mechanism and Capra's stock company, which in some cases (Ward Bond, Thomas Mitchell) overlaps with Ford's, is one of the most powerful instruments for success. The familar gallery of faces: dear H. B. Warner, genial Raymond Walburn, timid Donald Meek, fragile Harry Davenport, dignified Halliwell Hobbes and many more become old friends, whose reappearances we greet with delight and who age along with us, the audience. It also provides Capra with the opportunity to put flesh on the archetypes of American life mentioned by William Miller in his discussion of the muck raking magazines. The most notable of these was Edward Arnold, who invariably played the big businessman or corrupt party boss in Capra's films (D. B. Norton, Anthony P. Kirby, party boss Jim Taylor in *Mr. Smith*). He was chosen because Capra believed that he 'had the power and presence of a J. P. Morgan'.[7] On a lower level the government snooper was invariably played by long-nosed, thin-faced, bespectacled Charles Lane, the perfect incarnation of the interfering representative of obtrusive central authority.

Capra post-war

The series of populist comedy-moralities, which emerged fully formed with *Mr. Deeds Goes to Town*, culminated in *It's a Wonderful Life* (1946) and *State of the Union* (1948). With them it was as if Capra was saying his last word on the populist philosophy. For since them he has made only four films and in them he reverts to his pre-*Deeds* period (two of the films actually being re-makes of early pre-*Deeds* successes). Gone is the detailed ideological content, gone too is the Cooper-Stewart innocent. In Capra's later films his heroes are reversions to the urban figures of the early films (newspaperman in *Here Comes the Groom*, hotel-owner in *A Hole in the Head*, bootlegger in *A Pocketful of Miracles*).

The reason for this easily becomes apparent. Capra has realized that the world has moved on and that the forces of Organization

have finally triumphed. The need for unified state control of the war effort set the seal on the victory of the New Deal. Though there was a backlash after the war, with McCarthyism, anti-intellectual, anti-communist witch hunts, and the triumph of the Republicans under the new folk hero, Eisenhower, the heart had gone out of populism.

It's a Wonderful Life marks Capra's last, great, triumphant affirmation of faith in individualism. It becomes an allegory of post-war America. Bedford Falls represents the nation, Henry Potter the forces of Organization and George Bailey the spirit of individualism. In the film it is George Bailey who triumphs, but in fact it has been Henry Potter.

Notes

1 David Zinman, *Fifty Classic Motion Pictures* (1970), p. 225.
2 Frank Capra, 'Do I make you laugh?', *Films and Filming* (September 1962), p. 14.
3 Capra, *The Name Above the Title* (1971), p. 309.
4 Bob Thomas, *King Cohn* (1967), p. 152.
5 Raymond Durgnat, *The Crazy Mirror* (1969), p. 126.
6 Lewis Jacobs, *The Rise of the American Film* (1968), p. 476.
7 Capra, *The Name Above the Title*, p. 243.

Leo McCarey: The Fantasy of Goodwill

The career of Leo McCarey runs interestingly parallel to that of Frank Capra. Both entered the film industry in the mid-twenties and gained their initial experience as gagwriters and later directors of silent comedies (Capra for Harry Langdon, McCarey for – among others – Laurel and Hardy). Both made unspectacular transitions to sound, learning their craft painstakingly during the early thirties. Both hit their stride in the mid-thirties and both won Academy Awards for direction (Capra for *It Happened One Night* in 1935, *Mr. Deeds Goes to Town* in 1936 and *You Can't Take It With You* in 1938 and McCarey for *The Awful Truth* in 1937 and *Going My Way* in 1944). Both reached their peak in the forties and then retired, to make comebacks in the late fifties and to retire again, finally, in the early sixties. McCarey died in 1969 and Capra has said he will not film again.

The similarity between them was recognized at the time. Harry Cohn, head of Columbia Pictures, hired McCarey to replace Capra when Capra left that studio in 1937[1] and Capra himself paid McCarey the charming compliment of having his film *The Bells of St. Mary's* playing at the Bedford Falls cinema in his masterpiece, *It's a Wonderful Life*. But McCarey was never as great a director as Capra. He had none of the narrative drive or epic sweep of Capra. His films were often amusing, sometimes moving, but rarely inspiring in the way that Capra's were. One only has to compare *Good Sam* and *It's a Wonderful Life*, the point at which Capra and McCarey come closest to coinciding, to see that Capra's film is superior to McCarey's both in its dazzling use of the film-making art and in its eloquent expression of a coherent view of society and of man's place in it. Similarly compare McCarey's *Once upon*

a Honeymoon with Capra's *Meet John Doe*, both of them attacks on Fascism, and once again Capra wins hands down.

McCarey will probably be remembered as a director of great moments rather than great movies. He himself admitted in an interview[2] that he liked moments in all his films and if these could have been put together he might have had something. McCarey's special brilliance lay in his talent for improvisation and it is from this talent that his great moments spring. But it is a talent which is also a limitation. For while improvisation can create great moments, it can rarely create entire great movies. As Andrew Sarris observes, it was his relaxed digressions rather than his rigorous direction that earned McCarey his directorial reputation.[3]

The key to understanding McCarey's films lies in something he once said in an interview about what films should be. He said that every film should be something of a fairy tale. He said: 'I'll let someone else photograph the ugliness of the world. It's larceny to remind people of how lousy things are and call it entertainment.' With this statement McCarey places himself alongside those writers of the twenties and thirties, such as Damon Runyon and Clarence Budington Kelland, who elaborated 'the fantasy of goodwill', built on the premise that the problems of America were soluble if only people would be a little nicer to one another. This is the other side of populism, the helpless reaction of the middle classes to the Depression. They rejected the New Deal but instead of offering an alternative programme they simply expressed the feeling that a little more goodwill would see America through.

Where Capra enshrines the ideals of popu-

lism in its heyday and puts forward a vigorous and consistent political, economic and social programme, McCarey represents populism in its decline, the turning towards fairy tale and fantasy with no central core of ideas to restore the health of the nation. The difference between them is enshrined in the names they chose for their production companies. Capra's was Liberty Films, symbolic of the ideology that produced the explicitly populist political trilogy (*Mr. Smith Goes to Washington*, *Meet John Doe* and *State of the Union*). McCarey's was Rainbow Productions, with its much more generalized fantasy associations with the land somewhere over the rainbow and the pot of gold to be found at the end of it.

During the period that McCarey was under contract to Paramount Pictures (1933–6), he directed six films. Of the six, however, he was in future years to show affection for only two of them: *Ruggles of Red Gap* and *Make Way for Tomorrow*. He actively disliked *Duck Soup* and *The Milky Way* and seems to have liked *Belle of the Nineties* only in so far as it gave him the opportunity to work with Duke Ellington and his orchestra. It is significant that in each of these four films he was working with star personalities, whose already fully formed and widely known comedy characters would dictate to a large extent the structure, style and content of the films: the Marx Brothers (*Duck Soup*), Mae West (*Belle of the Nineties*), Harold Lloyd (*The Milky Way*) and W. C. Fields (*Six of a Kind*). McCarey must have felt that this restricted his scope for impressing his own personality and interests on the films. There is every reason to believe, then, that *Ruggles of Red Gap* and *Make Way for Tomorrow* give us the first clear indications of what this personality and these interests were.

Duck Soup (1933) deserves notice in passing, however, for, despite McCarey's reservations, it remains the best of the Marx Brothers' comedies, seventy minutes of the freshest, fastest and funniest comedy on film. If one sits down to analyse the film when it is over, one can detect among its strands certain familiar populist ideas, though admittedly one doesn't notice them while the film is on

because of the constant stream of verbal and sight gags and the incomparable clowning of the magnificent Brothers.

The setting of the film is the mythical European country of Freedonia, a fantasy version of America complete with Coney Island peanut vendors in the streets and baseball games on the radio. Freedonia (=Freedom-ia) is threatened from without by the neighbouring country of Sylvania, whose national emblem is a dollar sign. Its principal representatives are a suave and scheming ambassador and a sultry Latin spy, both suspiciously un-American types. But Freedonia is also threatened from within by a dictator, Rufus T. Firefly (Groucho Marx), appointed at the insistence of Mrs Gloria Teasdale (Margaret Dumont), multi-millionairess, who, in return for the appointment, pays twenty million dollars into the empty State Treasury (the control of government by the moneyed interest).

The lunacy of dictatorship is brilliantly satirized in the person of Firefly, who bursts into song upon his appointment ('If you think this country's bad off now, just wait till I get through with it'), makes advances to Mrs Teasdale to get hold of her money, appoints Chico, who is an enemy agent, as Secretary of War, can't understand official documents ('A four-year-old child could understand this.' 'Run out and get me a four-year-old child. I can't make head or tail of it'), plays havoc with cabinet meetings and, finally, provokes war with Sylvania over a triviality.

The film culminates with a hilarious satire on war, in which, as Allen Eyles has observed, 'War has become an absurd farce: without meaning, without logic.'[4] The war has to be fought because Firefly has paid a month's rent on the battlefield. In a succession of military uniforms from different periods in history, Firefly shoots at his own men, sends generals out to buy trenches, advises bicarbonate of soda when notified of a gas attack and when Harpo is volunteered to go for help, tells him: 'While you're out there risking life and limb through shot and shell, we'll be in here thinking what a sap you are.' Any idea that the war is being fought for

patriotic motives is dispelled by the final image of the Brothers pelting Margaret Dumont with apples as she bursts into the Freedonian national anthem to celebrate victory.

The film is remorseless and unsentimental in its castigation of the folly of war, diplomacy, dictatorship and the moneyed interest and it is the total absence of sentimentality which probably prevented the film endearing itself to McCarey. For sentimentality is one of the key elements in the fairy tales of McCarey's mature period, ushered in by the favourite Paramount films *Ruggles of Red Gap* and *Make Way for Tomorrow*.

Ruggles of Red Gap (1935) is a classic populist fairy tale. It tells the story of Marmaduke Ruggles (Charles Laughton), the perfect butler, symbol of the aristocratic and deferential tradition of the Old World, who is lost in a card game by his employer Lord Burnstead (Roland Young) to American *nouveau riche* millionaire Egbert Floud (Charles Ruggles) and goes to Red Gap in the United States, where he learns the benefits of the democratic system, leaves service and sets up a restaurant.

The acting of a hand-picked cast is impeccable and McCarey's direction is just right, full of wit and inventiveness, making the film as endearing and entertaining now as when it was made, if not more so. There is a very funny sequence early on in the film which shows the beginning of the breaking down of Ruggles's reserve and disapproval of his new employer, a typical check-suited, backslapping 'Hail fellow, well met' American abroad. Floud insists on calling Ruggles 'Colonel' and invites him to sit down and join him for a drink. Ruggles protests: 'It doesn't do for a gentleman's servant to sit with his superior.' Patiently, Egbert explains: 'I'm as good as you and you're as good as me.' Unruffled, Ruggles replies: 'That may be all very well for America but it would never do for us.' However, Ruggles gets drunk, goes riding on a merry-go-round and when reprimanded by Mrs Floud, falls on the floor laughing uproariously.

The counterpoint to the democratization of Ruggles is the discomfiture of the snobs and would-be aristocrats of Red Gap society, who represent a betrayal of the American democratic tradition by their attempts to introduce the social distinctions and snobbish manners of the Old World. The arch-snob is Boston blueblood Charles Belknap Jackson, who married Effie Floud's sister for her money and now lords it over Red Gap. He fawns over Ruggles when he thinks he is a colonel but then insults and even kicks him when he learns he is a servant. But he finally gets his come-uppance when Ruggles, amid rousing cheers, ejects him from his restaurant. Also discomfited but having the good grace to accept it and join in the general acclaim of Ruggles at the end is Effie Floud, who affects a mispronounced French which she thinks is fashionable and who is ashamed of her mother, a plain-talking no-nonsense old frontierswoman Ma Pettingill (Maude Eburne), and of her husband, whose check suits she orders to be burned. ('Even the moths wouldn't eat them.') She gets her come-uppance when the reception she has planned for Lord Burnstead as her greatest social triumph collapses when his lordship, with the easy democracy of the true aristocrat, prefers to go with Egbert to Nell Kenna's club, where in a deliciously funny sequence she teaches him to play 'Pretty Baby' on the drums.

One of the film's high-spots is Ruggles's recitation of Lincoln's Gettysburg address. He is planning to return to England when Egbert and Ma take him to the saloon for a drink and advise him to stay in America: 'a land of opportunity where all are created equal, as Lincoln said at Gettysburg'. But no one in the saloon knows exactly what Lincoln said at Gettysburg. It is the foreigner, Ruggles, who knows the greatest speech of the greatest populist myth figure by heart. He decides to stay and open the Anglo-American Grill. But there is a moment of crisis when Lord Burnstead cables that he is coming to Red Gap and wants to take Ruggles back. The habit of loyalty is strong in Ruggles. Three generations of his family have been valets. But he finally decides to remain in Red Gap where he has become 'someone' and he opens his restaurant to a

singing of 'For he's a jolly good fellow' by the assembled cast. Ruggles, therefore, comes to epitomize the virtues of the equality of opportunity tradition in American history and to bring about the defeat of the snobbish elements, who personify the lack of goodwill in American society.

Make Way for Tomorrow (1936), a film which made such a loss at the box office that Paramount settled up McCarey's contract, remains an unsung masterpiece, one of the enduring classics of personal film-making to come out of Hollywood. If he had made nothing else, McCarey would have earned his place in the history books for this.

Simply and movingly it tells the story of Barkley and Lucy Cooper, an old retired couple who lose their home to the Bank (the heartless money interest again) and have to go and live with their children. But at first they are separated since none of the children can take both parents – though, they are assured they will be reunited within three months. The plans fall through, however. None of the children wants the parents. Bark is sent to California for his health and Lucy is put in an old people's home.

As the old couple, Victor Moore and Beulah Bondi give the performances of a lifetime. Beulah Bondi is unforgettable in the scene in which she receives a long-distance telephone call from her husband while the house is full of people playing bridge. We see the irritation on the faces of the guests softening to sympathy as Lucy, speaking slightly too loudly and with her back to the assembled company, chides Bark for spending so much on a phone call when he could have bought himself a warm winter scarf and then goes on to say how good the children are to her, how nice their guests are and how much she misses him and wants to be with him again. On the verge of tears, she puts down the phone and retires to her room, saying that she is tired. It is beautifully done and entirely in character. So too is the delightful little comic scene in which Bark, ill in bed with a bad cold, is visited by the doctor. First Bark objects to the doctor's youth, then he refuses to say ninety nine and finally he bites the doctor. It is a display of endearingly childish querulousness and temperament that makes the Coopers' tragedy that much more real for happening not to perfect, noble, stereotyped martyrs but to a very human old couple who can be irritating and annoying at times.

The film's climax is unbearably moving. The old couple spend their last afternoon together, revisiting the hotel where they had spent their honeymoon fifty years ago. They reminisce about their life and agree that they have been very lucky. Finally they go to the station. Bark plans to get a job in California so that they can be reunited. But we know and they know that the plans are hopeless. They will never meet again. 'In case it should happen that I don't see you again, it's been very nice knowing you, Miss Breckenridge,' says Bark. 'And in case I don't see you for a while – I want to tell you that it's been lovely. Every bit of it. The whole fifty years. I would sooner have been your wife, Bark, than to have been anybody else on earth,' she replies. They kiss. He gets on the train and with one backward glance she walks away as, on the sound-track, the orchestra plays: 'Let me call you sweetheart', the tune to which they had danced for the last time at the hotel.

Arguably the finest treatment of the problem of the aged and of what is fashionably called 'the generation gap' ever to come out of Hollywood, the film represents a critique of those who forget the biblical commandment which the film takes as its text, 'Honour thy father and mother'. There is no magic formula that can bridge the gap between the young and the old, the film's foreword tells us, but the film clearly calls for the exercise of goodwill towards the old. This goodwill is notably absent from the five Cooper children and their spouses, none of whom wants the old couple, grand-daughter Rhoda who will not bring her friends home while Grandmother is staying in the house, and even the maid Mamie, who objects to staying in during the evenings to look after the old lady. As one would expect from someone of McCarey's Irish immigrant background the film resoundingly affirms the integrity of the family. It is the job of the

Early McCarey

168 (above left) *Duck Soup*: an all-out satire on war, diplomacy and dictatorship. Louis Calhern, Margaret Dumont and Groucho Marx

169 (left) *Make Way for Tomorrow*: arguably the finest treatment of the problem of the aged ever to come out of Hollywood. Beulah Bondi and Victor Moore on their last outing together

170 (above) *Belle of the Nineties*: quintessentially demonstrating the dominance of the female in American Society. Mae West surrounded by adoring men

family to take care of its old ones and here McCarey can be cross-referenced with Ford, another Irish-American, one of whose favourite themes is the sanctity of the family.

Both *The Awful Truth* (1937), a screwball comedy of manners about the marital misadventures of the Warriners (Cary Grant and Irene Dunne), who eventually patch up their marriage with the aid of their dog, Mr Smith, and *Love Affair* (1938), a charming romantic story about an irresponsible playboy (Charles Boyer) and a nightclub singer (Irene Dunne) who fall in love on an ocean liner, are essentially fairy tales: unreal, fragile but wholly delightful. They remain, however, at best on the fringes of the category of the 'fantasy of goodwill' which we are examining.

A screen story which McCarey wrote with Frank Adams and which came to the screen as *The Cowboy and the Lady* in 1938, directed by H. C. Potter, is more explicitly populist. Basically that familiar thirties tale of a rich heiress (Merle Oberon) who poses as a lady's maid and falls in love with a poor but honest cowboy and after various misunderstandings is united with him, it has a populist finale in which the cowboy Stretch Willoughby, played by Gary Cooper, Mr Deeds himself, and clearly first cousin of Long John Willoughby (also Cooper), denounces the pomposity of career politicians and their patronizing attitude to the people. His resounding defence of the simple life and his castigation of politicians for being removed from this life and an understanding of the people causes the heiress's father, Judge Horace Smith, to abandon the election rat race on which he has embarked with the hope of becoming President and to sample instead the delights of the simple life.

In 1943 McCarey opened up a new vein of comedy with his popularizations of Catholicism and hit pay-dirt. An American cardinal was to say of these films that they did more for the Catholic church than a dozen bishops could have done over a period of twelve months. By allying the fantasy of goodwill to the Catholic church, McCarey was giving it an explicit Christian slant which was generally only implicit in Capra. It could be seen as tacit recognition of the death of populism as a faith and a turning towards the older teachings of the Catholic Church as a framework within which what could be salvaged from populism could be accommodated. It was a reflection also, of course, of the wartime religious revival, which produced such films as *The Song of Bernadette* and a host of films about angels coming down to earth to do good (*The Bishop's Wife, Heaven Only Knows, The Horn Blows at Midnight* and greatest of them all, Capra's *It's a Wonderful Life*).

The first of the Catholic goodwill fantasies was *Going My Way* (1943). It centres on the conflict between a crotchety, but lovable, old-fashioned parish priest Father Fitzgibbon (Barry Fitzgerald) and the young, progressive, pipe-smoking, baseball-playing, songwriting curate, Father Chuck O'Malley (Bing Crosby), sent by the bishop to extricate the parish from its financial difficulties. Along the way, Father O'Malley regenerates a gang of street urchins (played by the Robert Mitchell Boys' Choir) by turning them into a boys' choir, sets a runaway girl on the right path by singing 'The day after forever' at her and raises money by selling his songs to pay off the church's mortgage to the grasping Mr Haines (Gene Lockhart) who wants to tear down the church and build a parking lot (conflict between spiritualism and materialism). Crisis strikes when the church burns down. But everyone rallies round to help raise money, and Mr Haines, converted at last, agrees to grant a new mortgage for a new church. There is a grand Christmas Eve finale at which Father Fitzgibbon is reunited with his old mother from Ireland whom he has not seen for forty years, the choir sings 'Tooralooraloora' and Father O'Malley, his work done and his job as curate handed on to his old friend, cheerful, golf-playing Father O'Dowd (Frank McHugh), slips away through the gently falling snow, going his way.

Crosby's relaxed and sincere playing and his teaming with Barry Fitzgerald's lovable old leprechaun of a priest works and the film remains charming and enjoyable, a deft blending of comedy and sentimentality. Indeed, it was such a success that McCarey promptly re-made it as *The Bells of St. Mary's*

Catholic popularizations

171 (right) Baseball-playing priest Bing Crosby reforms juvenile delinquents by turning them into a choir in *Going My Way*

172 (below) Crooning priest Bing Crosby saves a convent school, run by Ingrid Bergman (at the piano), from being torn down in *The Bells of St. Mary's*

(1945) using the same story line fleshed out with different incidents and adding a consumptive nun for good measure. This time Father O'Malley (Bing Crosby again) is sent to the run-down convent school of St Mary's to extricate it from its financial difficulties. He clashes there with Sister Benedict (Ingrid Bergman), who is the old-fashioned counterpart of Father Fitzgibbon. Along the way, O'Malley reconciles the estranged parents of a mixed-up girl called Patsy by singing 'The land of beginning again' at them, sets Patsy on the right road by arranging for her to graduate even though she has failed her examinations, and persuades the grasping Mr Bogardus (Henry Travers), who wants to pull down the school and build – would you believe? – a parking lot, to finance the building of a new school. However, the method he uses to accomplish this end is, ethically speaking, highly suspect. When singing fails to move him, O'Malley terrifies the old man into thinking he is dying so that he will make provision for the school in order to save his soul. Even if he is a heartless old capitalist, he is still elderly and ailing and might perhaps have expected something other from his friendly neighbourhood priest than a song and a trick.

Both films are based on the assumption that there is good in everyone and it only needs to be brought out, preferably by a crooning priest, who here embodies the spirit of goodwill. Young delinquents, estranged couples and crusty old capitalists are all, as Father Fitzgibbon says of Father O'Malley, 'a little better for having known him'. Even members of the Metropolitan Opera Co., who might be expected, on the analogy of *Mr. Deeds*, to live in a world of Art apart from real life, are all turned into useful citizens and help raise funds to rebuild the church. The only out-and-out bad hat in either film is the self-confessed atheist Mr Belknap (Porter Hall), who demonstrates that he is beyond the pale by throwing a child's football under a lorry, and who incidentally bears the same name as the arch-snob in *Ruggles of Red Gap*.

McCarey's next film, *Good Sam*, represented a corrective to too much do-gooding and while it affirmed the basic populist belief in tempering good neighbourliness with self-help, taken in conjunction with the Catholic films it also had the effect of suggesting that doing good was really the job of the priest, who could devote himself to it full time and didn't have family ties which he must honour first.

Sam Clayton (Gary Cooper) is a department store manager in a small town. He is an incurable good Samaritan who believes in making everything he possesses available to his friends and neighbours to the dismay of his wife Lu (Ann Sheridan). He loans his car to the Butlers, who wreck it, landing him with a suit for damages. He lends his savings to the Adamses to start their own business, leaving himself with no money to pay for his new house. He saves one of his shopgirls from suicide and she promptly moves in with him. Finally, on his way to deposit the store employees' benevolent fund he stops to help a sick woman and is robbed. He cannot get help from his debtors or from the bank and arrives home to find his wife moving into a house which they can't pay for. Lu denounces him as 'a double-crossing, two-faced, sneaking Samaritan'. In despair he goes out to a bar with the intention of getting drunk, but even there he cannot resist the temptation to give away his clothes to a tramp. Finally he is brought home by the Salvation Army in a state of maudlin repentance and finds that the bank has agreed to give him a loan, accepting 'a warm heart' as security. There is a joyful reunion and the prospect of Sam's reform from the temptation of doing too much good. The moral is clear: put your own house in order before you start helping others, but by all means help others once your house is in order – and paid for.

McCarey's contribution to the war effort, *Once Upon a Honeymoon* (1942), is an interesting film in that it demonstrates at once his strength and weakness as a director. For he chooses to tell a fairy tale romantic comedy, as the title suggests, but sets it against the background of war-torn Europe to enable him to comment on Fascism. The result is two films in one. On one level we have a delicious comedy with Ginger Rogers

as Katie O'Hara, an American showgirl married to a German baron, and Cary Grant as Pat O'Toole, a newspaperman who pursues her from capital to capital. There are some memorable McCarey moments: notably Cary posing as an Austrian fitter measuring Ginger for a new dress and a marvellous drunk scene where Cary tries to get Ginger drunk in Warsaw and ends up roaring drunk himself.

But on the other, ostensibly more serious, level we have the anti-Fascist message intertwined with some populist comment on being yourself – 'yourself' being preferably a solid, down-to-earth, red-blooded American. The film opens in Vienna in 1938 with Katie O'Hara, vaudeville dancer posing as socialite Katherine Butt-Smith (pronounced Bute-Smith) complete with snobbish la-de-dah accent and airs and graces, telephoning her mother to tell her that she has netted a baron and is going to marry him. But mother is a down-to-earth Irish washerwoman in Brooklyn and is unimpressed. 'I'm gonna marry a baron, momma,' says Katie. 'I knew them high falutin' books you were reading would do you no good,' replies Momma. Later, Katie quotes Schopenhauer at Pat and he replies with a quote from Irving Berlin. The film charts her gradual awakening to what is going on in Europe and her gradual abandonment of the airs and graces and affected highbrow culture under the guidance of Pat, who represents the red-blooded American tradition. At the beginning of the film she switches off the radio in the middle of Seyss-Inquart's broadcast announcing that Austria is to be absorbed into the Reich. She isn't interested. But she becomes interested when she sees at first hand the persecution of the Jews, the German sterilization policy and the concentration camps, in which she and Pat are confined for a short time after helping a Jewish chambermaid to escape from Poland. She also learns about the fifth-column activities of her husband, Baron von Luber (Walter Slezak), described by Pat as 'Hitler's personal finger man' (establishing a gangster parallel), who sprints round Europe softening up Czechoslovakia, Poland, Norway and finally France for the German

invasion. The *reductio ad absurdum* of this activity is the short scene which opens with von Luber having dinner with a man in Norway who assures him that he will find conditions favourable in Norway and to whom he replies, 'I'm sure I will, Mr Quisling', and ends with a shot of von Luber strolling into the villa Laval in Paris. Even Hitler is reduced to a bit part, glimpsed walking down a hotel corridor.

In contrast there is a heavy-handed injection of American patriotism in the person of an American secret agent (Albert Dekker) who to convince Katie that he is an American does a grotesque series of impersonations of American regional accents and ends by observing – as if we didn't know by now – 'It's a wonderful country.' The film ends with Katie demonstrating her commitment to the democratic cause by pushing her erstwhile husband, the Baron, overboard from a liner bearing him to America to continue his devilish work, after he has lectured her about the masses not wanting to think and great men being needed to do it for them. It represents a resounding victory for Irving Berlin and all he stands for (the New World, the people and popular culture) over Schopenhauer and all he stands for (the Old World, the intellectuals and highbrow culture).

Scrappy, ramshackle and ultimately ludicrous, the film demonstrates McCarey's inability to handle a 'serious message picture'. He goes so far out that he enters the realm of the absurd. But at least one can salvage the comedy and the felicitous teaming of Cary and Ginger, which is more than can be said for the later anti-Communist films.

McCarey became obsessed with the menace of Communism. As Donald Ogden Stewart, who worked with him on *Love Affair*, recalled: 'He just had this Catholic anti-Communist thing. He almost devoted his life to destroying Communism if he could.'[5] He became one of the leading lights in the Society for the Preservation of American Ideals and testified on Communism in the film industry to the House Un-American Activities Committee.

In 1951 he made his anti-Communist

Populist fables
173 (above) An English butler is instructed in the ways of the
democratic American society in *Ruggles of Red Gap*.
Charles Laughton with James Burke and Charles Ruggles
174 (above right) Cary Grant sends up the Nazis (personified by
Walter Slezak) in *Once Upon a Honeymoon*
175 (right) Good neighbourliness can be overdone.
Gary Cooper and Ann Sheridan in *Good Sam*

testament *My Son John*, a film which won him an Oscar nomination and which Robert Warshow described as 'an attack on Communism and an affirmation of Americanism that might legitimately alarm any thoughtful American whether Liberal or conservative'.[6] Significantly McCarey has said that had it not been for the death of Robert Walker, it might have been his greatest film.[7] The death of the star, Robert Walker, before the film was completed certainly caused headaches and involved the rewriting of the script, the use of doubles and the utilization of Walker's death scene from Hitchcock's *Strangers on a Train*, with McCarey himself dubbing the voice, to round off the film. But it is difficult to see, even taking all this into account, how *My Son John* could ever have hoped to match up to *Make Way for Tomorrow* or *Ruggles of Red Gap* or *The Awful Truth* or even *Going My Way*. *Once Upon a Honeymoon* had conclusively demonstrated McCarey's inability to handle a 'serious message' picture but it had at least been able to send up the Nazis by making great play of their lack of a sense of humour, which of course the American protagonists possessed in abundance. But *My Son John*, produced in the era of McCarthyism, was in deadly earnest and was a subject close to McCarey's heart, probably too close for effective translation to film.

The script by Leo McCarey and Myles Connolly demonstrates how the old populism turned aside into anti-Communism after the war had taken the guts out of it. For it utilizes all the populist elements of the Capra comedy moralities but works them into a highly schematic framework which sets up a series of antinomies: Americanism v. Communism, Catholicism v. Atheism, Anti-intellectualism v. Intellectualism and comes down firmly in favour of the former in each case.

The Jefferson family (bearing the same name as the author of the Declaration of Independence) enshrine all that is best in Americanism. They live in a small town. Father, Dan Jefferson (Dean Jagger), is a staunch member of the American Legion and superintendent of the local school, where he is teaching the children of America 'the simple down-to-earth fundamentals o morality and Americanism'. Mother, Lucille Jefferson (Helen Hayes), is revered by the family as the classic all-American Mom, her entire world and outlook summed up by two books, the Bible and the cookery book. The two younger sons, Chuck and Ben, are just off to serve their country fighting Communism in Korea.

However, this all-American family nurses a viper in its red-blooded bosom, the eldest son, brilliant young government official John (Robert Walker), who is in fact a Communist. Although he swears on the Bible that he is not a Communist, his mother discovers that he is and is quite prepared to turn him over to the authorities for treason to his country. But she manages to persuade him to give himself up. Before he can do so, however, he is gunned down in the street by a car-load of Communists, again establishing a gangster parallel for the enemies of America.

Before he dies John records a speech to be delivered to his old university on graduation day. In the speech he declares that he had always prided himself on being an intellectual and had mixed with intellectuals and that this had proved his downfall. This speech vindicates the position of his father, who, although a teacher, prides himself in being a non-intellectual, consistently denounces the intellectuals as the root of the nation's troubles and actually refers to the Communists, in true anti-intellectual fashion, as 'scummies'.

In addition to all this, the family is Catholic. The film opens and closes with them going to church and their parish priest is none other than our old friend Father O'Dowd (Frank McHugh) from *Going My Way*, thus linking the anti-Communism with the Catholicism of the earlier films. John, who quarrels with his father and with Father O'Dowd and lies on oath, reveals his antipathy both to Catholicism and Americanism which they embody. The film's true hero turns out to be the hopelessly bigoted father, whose espousal of the truth is represented by such subtle devices as hitting John

The anti-communist crusade
176 (right) All-American parents Dean Jagger and Helen Hayes nurse a Communist viper (Robert Walker) in their red-blooded bosom (*My Son John*)
177 (below) Evil Chinese Communists menace Catholic priests William Holden and Clifton Webb in *Satan Never Sleeps*

over the head with the Bible. McCarey returned again to this theme in his last film, *Satan Never Sleeps* (1961), which cross the genial Catholicism of *Going My Way* with the fervent anti-Communism of *My Son John* and sets it in China in 1949. Father O'Banion, young ex-marine (played by William Holden, looking acutely embarrassed by the whole business), arrives at a Catholic mission to take over from elderly, waspish but basically lovable Father Bovard (the great Clifton Webb in his last screen appearance). But the Red Army appears and takes over the mission, driving the people away, looting the buildings and destroying the medical supplies. The Communist leader, colonel Ho-San (Weaver Lee), a brutal, self-aggrandizing fanatic, terrorizes his own parents, who are Christians, gloats over the sufferings of the old priest and rapes an innocent young girl, Siu-Lan (France Nuyen). Then suddenly when Siu-Lan bears his son, when his parents are shot for worshipping in the chapel and when he is threatened with dismissal, he changes sides. He helps the priests escape with Siu-Lan and her baby, shooting a guard in the back and blithely declaring as he does so: 'This is my last act as a non-Christian.' Father Bovard sacrifices his life to help the others get across the frontier and the film ends with the child being baptized and Ho-San settling down as a respectable Christian capitalist in Hong Kong. Apart from a few characteristically acidic remarks from Clifton Webb, nothing at all can be salvaged from this tasteless, one-dimensional farrago. It is a sad end to a career which had produced many memorable moments and half a dozen movie milestones.

Like Capra, McCarey has, consciously or unconsciously, consistently depicted America as a matriarchal society. The single common factor in all his films is that it is the women who are the dominant characters. The only men who can ever assert themselves are priests, who are able to escape marriage – and even then they have assertive nuns to contend with. McCarey's very first feature film, *The Sophomore* (1929), set the pattern with the sophomore Joe (Eddie Quillan), a young man devoted to his mother, losing his college fees by gambling and being kept by a young waitress (Sally O'Neill). The reversal of the male-female roles is made even more explicit by Joe's playing the female lead in the college show. Mae West, in *Belle of the Nineties*, playing Ruby Carter 'the most talked-about woman in America' is the ultimate symbol of the domination of the female. Men are merely sexual objects which she chooses and discards at will. In one scene the screen is filled with dinner-jacketed men all surrounding a single woman, Mae, who appraises them with hands on hips and half-lidded eyes and says things like 'Take care of these men. Give them all my address' and 'I am in the habit of picking my own men.' She is the aggressor, the man is the prey.

In *Duck Soup* Freedonia is dominated by the millionairess Mrs Teasdale, whose attentions are courted both by Rufus T. Firefly and by Ambassador Trentino. In *My Son John*, it is the mother who discovers her son's treachery, threatens to turn him in and gets him to give himself up. In *The Milky Way*, there are three couples (Burleigh and Polly, Gabby and Ann, Speed and Mae) and in all of them the woman is the dominant partner. In *Good Sam* while Sam is out doing good, it is his wife Lu, sensible, level-headed, who keeps the family together. In *Once Upon a Honeymoon* it is Katie who pushes her husband overboard, having trapped him into marriage in the first place. In *Make Way for Tomorrow*, Bark, bumbling, optimistic, lovable, confesses that he has been a failure. Lucy assures him that he has not. But he has. He has failed to provide for their old age and it is clear from the film that she was the guiding force in the family. She knows always exactly what is going on. In *Ruggles* Egbert is run by his wife Effie; genial, bumbling Lord Burnstead ends up married to spirited, dominating saloon owner Nell Kenna, who will keep him in hand; and Ruggles will marry Mrs Judson, who will manage him. In *Rally Round the Flag, Boys* predatory neighbour Angela Hoffa pursues and compromises Harry (Paul Newman) and he is completely subservient to his wife,

committee woman and local organizer Grace. Wives and mothers rule, not obtrusively but completely.

There is no escape for the hapless male; but there is one outlet and that is sport, and the other motif of the McCarey world is that of sport. Unable to assert themselves in the home, they assert themselves on the sports field. Joe in *The Sophomore*, devoted to his mother and kept by his waitress, is a football star. Burleigh Sullivan in *The Milky Way*, a meek, bespectacled milkman, devoted to his horse and his sister in that order (the horse, Agnes, is female too) wins the middle-weight championship of the world. Ruby Carter in *Belle of the Nineties* rejects the suave saloon owner and the wealthy socialite for a boxing champion, the Tiger Kid (Roger Pryor). Eddie in *The Kid from Spain* poses as a bullfighter and has to prove himself in the ring. The priests in *Going My Way* all play golf. The marriage of Edmund Lowe and Leila Hyams in *Part-time Wife* is broken up by her addiction to golf, which he has to take up to win her back. And in the *Bells of St. Mary's* the boys are being taught boxing by Sister Benedict, ready for the time when they will go out into the world, find subjection under their wives and take up sport to rid themselves of their aggressions.

McCarey had recognized that his strength lay in the fairy-tale world of comedy. When he broke his own rule about not photographing the ugliness of the world and lectured us on the evils of Communism, the films failed to convince. The essential and charming fragility of his talent was crushed by the elephantine demands of dogma. It is arguable that this talent was smothered beyond recovery by *My Son John*. For McCarey's last two films are frankly dreadful: *Rally Round the Flag, Boys* (1958) a comedy about the small community of Putnam's Landing trying to prevent the installation of an army base, is ponderous, witless and boring and isn't much helped by Paul Newman, who flounders around trying to convince us that he is Cary Grant and failing dismally. *Satan Never Sleeps* (1961) is even worse and is absolutely irredeemable. It is perhaps significant that the only worthwhile film he made after *My Son John* was *An Affair to Remember* (1957), with Cary Grant and Deborah Kerr, and this was a re-make of *Love Affair* (1938) based on a script written before the shadow of Communism had fallen across the fairy-tale world of perfect butlers and madcap heiresses, base-ball-playing priests and battling milkmen inhabiting the never-never-land of the classic McCarey 'fantasy of goodwill'. Perhaps John Jefferson had the last laugh after all.

Notes

1 Bob Thomas, *King Cohn*, p. 125.
2 Leo McCarey, interview in *Cahiers du cinema* (163) (February 1965), p. 20.
3 Andrew Sarris, *American Cinema: Directors and Directions* (1968), p. 99.
4 Allen Eyles, *The Marx Brothers: Their World of Comedy* (1966), p. 86.
5 Donald Ogden Stewart interview, *Focus on Film* (5) (Winter 1970), p. 54.
6 Robert Warshow, *The Immediate Experience*, (1970), p. 163.
7 McCarey interview, op. cit., p. 20.

John Ford: The Folk Memory

The cinema of John Ford is a cinema of dreams and memories. His films are luminous images, tinged with an elegiac melancholy for a vanished, irrecoverable innocence, the innocence of Man and Society, of his hopes and his visions, which the course of history and progress and politics has doomed to unfulfilment. There is a recurring scene in Ford's films which somehow seems to hold the core and meaning of his world. It is the scene in which the Ford hero soliloquizes over the grave of a loved one and gives voice to the hopes and memories he has long borne in his heart: Abe Lincoln at the grave of his first love Ann Rutledge in *Young Mr. Lincoln*, Wyatt Earp at the grave of his murdered brother James in *My Darling Clementine*, Captain Nathan Brittles at his wife's grave in *She Wore a Yellow Ribbon*. In the same way Ford's work can be seen as a single extended soliloquy by the director over the grave of the American Dream. The opening speech of Huw Morgan in *How Green Was My Valley* represents the key to the gates of Ford's world:

'I am going from my valley. And this time I shall never return. I am leaving behind me my sixty years of memory – memory. It is strange that the mind will forget so much of what only this moment is passed and yet hold so clear and bright the memory of what happened years ago – of men and women long since dead. For there is no fence or hedge around time that has gone. You can go back and have what you like of it – if you can remember.'

Ford is the keeper of a folk memory compounded of the ideals of America's Founding Fathers, the legends of her past, the aspirations of her immigrant peoples. It is no coincidence that Ford and Capra regard each other as being the greatest American director. Ford writes: 'A great man and a great American, Frank Capra is an inspiration to those who believe in the American Dream.'[1] Each recognizes in the other what he most admires: a total mastery of the cinematic medium and a commitment to the ideals of populism.

But where Capra makes the classic populist statements and retires when the populist mood is no more, Ford carries on working throughout the fifties and into the early sixties, a prophet crying in the wilderness, seeking to remind a heedless people of what they had been and what they had once wanted to become. Elements of populism occur and recur in Ford's work but there are personal preoccupations too. His work is as intensely personal as that of any poet – and few would deny that Ford is one of the screen's foremost poets. Fittingly he called his production company Argosy Films, symbolic of that journey, which, as Jim Kitses has put it, has been 'a long and deeply private one through green valleys of hope to bitter sands of despair.'[2] One can indeed trace in his films a darkening mood, from the optimism of the thirties to the pessimism of the sixties, and this must be linked with the death of the populist ethic.

Perhaps the most important fact about Ford is that he is Irish-American, the son of an immigrant family, and as with most immigrants, his principal preoccupation has always been the need to belong. The most obvious unit to which to belong is the family. But the pressures of twentieth-century society, political and economic, all tend towards the break-up of the family and the break-down of traditional values. Again and

again Ford has returned to the theme of the tragedy of the break-up of the family (*Four Sons* [1928], *The World Moves On* [1934], *The Grapes of Wrath* [1940], *How Green Was My Valley* [1941], *My Darling Clementine* [1946], *Rio Grande* [1950], *How the West Was Won* [1962]).

Next to the family are the larger traditional groups which provide a framework of security, an assurance of permanence, a sense of belonging. There is the tribe, doomed to break-up by the onset of civilization (the Indians in *Cheyenne Autumn* [1964], the Polynesians in *The Hurricane* [1937]). Even closer to Ford's heart, there are the armed forces, also doomed to break-up by the onset of war. Paradoxically Ford does not see the purpose of the armed forces as killing and being killed. War comes as a tragic agent of destruction to break up the fellowship, just as economic depression broke up the Joads and the Morgans. As Ford gets older, increasingly bitter denunciations of war occur in his films, for instance *The Long Gray Line* (1955) and *The Horse Soldiers* (1959). The leading characters give vent to their bitter anguish at the senseless destruction of young lives. 'We teach them duty, honour, country and then send them out to die,' reflects Martin Maher (Tyrone Power) in *The Long Gray Line*.

The purpose of the armed forces, as Ford sees it, is to provide expression for the need to serve one's country, for the desire to belong, for the yearning for fixed terms of reference in a changing world. Ritual elements (the parades and patrols, the regimental ball, the raising of the flag) link Ford's service pictures. Similarly the characteristics of the various sub-groups in the service films: the friendly horseplay of the ranks, the gruff goodheartedness of the N.C.O.s, the wisdom and dedication of the commanding officers, the puppy love and exaggerated chivalry of the subalterns indicate a comforting situation in which everyone knows his place. There is discipline, patriotism, duty, a sense of belonging. That is why Ford's characters are so often in uniform. This feeling comes over most obviously in *Sergeant Rutledge* (1960), which

is about a negro cavalry regiment in the United States army. When one of the soldiers questions their role ('We're fools to fight the white man's war') Rutledge (Woody Strode) tells him: 'It ain't the white man's war. We're fighting to make us proud'; just as later, in court, Rutledge declares: 'The Ninth Cavalry was my home, my real freedom, my self-respect.'

This is the unspoken assumption behind all Ford's service films. His heroes belong to the cavalry (*Fort Apache, She Wore a Yellow Ribbon, Rio Grande*), the navy (*The Seas Beneath, Submarine Patrol, They Were Expendable*), the army (*What Price Glory?, When Willie Comes Marching Home, The Long Gray Line*), even the police (*Gideon of Scotland Yard*). Though Ford claims not to be fond of them – due to a lack of sympathy with the British and British Imperialism – his Indian army trilogy (*King of the Khyber Rifles, Wee Willie Winkie, Four Men and a Prayer*) prefigures the later U.S. cavalry trilogy, with many of the same rituals and with Victor McLaglen playing in *Wee Willie Winkie* exactly the same role he is later to take in the cavalry films: the tough sergeant with a heart of gold.

For Ford the greatest tragedies in life are either not belonging and having no home or losing your home and your sense of belonging. It is the latter which gives the tragic dimension to his depiction of the break-up of family, tribe, and military unit. It is this which adds a deep poignancy to *She Wore a Yellow Ribbon*, the story of Captain Brittles's (John Wayne) last mission before retirement. Although he is later recalled and given an honorary post, the film's emotional climax comes when he receives a watch from his men, sheds his uniform and rides off into the sunset, having ceased to be part of the cavalry unit which has been his life.

The former aspect is present too. *The Searchers* (1956), for instance, is, in Ford's own words, 'the tragedy of a loner'.[3] It tells of Confederate veteran Ethan Edwards (John Wayne) who devotes ten years of his life to hunting for his niece, who has been carried off by Indians. Though welcomed by his brother's family, he is never truly part of it

and the final shot of a door closing on him indicates that he never can be.

'Home' is one of the prime thematic concepts in Ford's cinema and it is the desire to go home which is the motivating force of Sean Thornton (John Wayne) in *The Quiet Man* (1952) and Terangi (Jon Hall) in *The Hurricane* (1937). But perhaps Ford's most profound statement on this theme is his intensely moving film of Eugene O'Neill's *The Long Voyage Home* (1940). An undoubted masterwork, eloquent, poetic, indescribably sad, it is truly a film from the heart.

'With their hates and desires, men are changing the face of the earth. But they cannot change the sea. Men who live on the sea never change. They live apart in a lonely world, moving from one rusty tramp steamer to another.' These introductory words introduce us into the lonely world, brilliantly evoked by Ford. The crew of the *Glencairn*, drop-outs, misfits, drifters, cling together under the leadership of Driscoll (Thomas Mitchell). They fight, booze, chase women, convincing themselves that they are enjoying life, and that they will all eventually leave the sea and the steamers and settle down. But they are deluded. The wartime voyage of the *Glencairn*, with a cargo of explosives, gradually exposes the futility and emptiness of their lives.

With tenderness and compassion Ford interweaves the stories of the crew, of Drisc and Smitty, of Yank and Cocky. What links them all together in the end is the plan of Ole Olsen, the gentle Swedish giant (John Wayne at his most self-effacing), to give up the sea, go home to Sweden and settle on the farm with his mother and brother. The others laugh at him at first but protective little Axel (wonderfully played by John Qualen) leaps to his defence: 'You don't make fun of Ole. He go home. You got no home. I got no home. But Ole – he got a home.'

Eventually, the whole crew determines to see that Ole gets home, as if, in some strange way, by seeing that he makes it, they somehow make it too, to the homes they had lost or had never had. When Ole is shanghaied, Drisc leads his friends in a rescue bid. They get Ole safely aboard a ship for Sweden and

home but Drisc is taken instead on the shanghai ship, *Amindra*. The last shot of the film is of the headline of an old newspaper, floating in the water: '*Amindra* torpedoed.' 'The Olsens come and go, the Driscolls live and die, the Smittys and Yanks leave their memories, but for some, the long voyage never ends.'

The year after *The Long Voyage Home* Ford created the richly nostalgic and deeply moving portrait of a Welsh mining family, *How Green Was My Valley*. The film is narrated by Huw Morgan, who we see in 1930 packing his belongings and preparing to leave his valley for ever. As he does so he recalls his childhood there in the 1890s. Whether or not it is an accurate picture of the life of a mining family is irrelevant, for it is life as seen through the eyes of a child, the boy Huw (Roddy McDowall), just as life on an Indian frontier post in the 1890s is observed through the eyes of the child, Priscilla Williams (Shirley Temple), in *Wee Willie Winkie*. It is bathed in the golden glow of reminiscence.

With an affection born of personal experience, Ford recreates the rituals of family life: Mother (Sara Allgood) waiting in the yard for the men to drop their pay into her apron as they pass; the scrub-down at each day's end, dinner with the whole family silent around the table because Father (Donald Crisp) believed that 'no talk I ever heard was as good as good food'; the distribution of the family's spending money, the joys (marriages, births) and the sorrows (deaths, illnesses, departures). The family is so important that Huw gives up the chance of a career outside the valley and insists on going down the pit to support Ivor's widow, Bronwen, who no longer has anyone to provide for her. But with the passing of time the family dissolves (Father and Ivor are killed in mine disasters), the mine closes, slag heaps obscure the once green hillside. Huw leaves but he will always have his memories to sustain him, a sense of having belonged and of belonging still to a family: 'Men like my father cannot die. They are with me still – real in memory as they were real in flesh – loving and beloved for ever. How

178 The twin mood of memory and loss that is so characteristic of Ford. Henry Fonda mourns his lost love in *Young Mr. Lincoln*

green was my valley then.'

The last scene of the film shows the family, united in memory, walking over the green hills. The same scene occurs at the end of *The Long Gray Line*. The friends and relations, now long dead but alive in the memory of the aged Martin Maher, link arms and cross the screen. The same spirit informs the film and there are even similar details of the family dinner rituals with Father (Donald Crisp again) presiding. However the Mahers are unable to have children and their family is West Point – whose successive generations of young men they teach and help and guide and love.

The structure of Ford's film families is perfectly summed up by Huw Morgan, who described his family thus: 'Our father was the head but our mother was the heart.' Ford is in no doubt as to the woman's place. It is in the home. Her destiny is to become the perfect wife and mother and as such 'the spiritual centre of the family'. It is Ford's Mother figures who are far and away the most convincing of his women: Beth Morgan in *How Green Was My Valley*, Ma Joad in *The Grapes of Wrath*, Hannah Jessop in *Pilgrimage*, Abigail Clay in *Young Mr. Lincoln*. His younger women tend to be conventionalized types rather than 'people'. They fall into two main categories. One is the fiery Irish colleen (usually Maureen O'Hara) who is tamed by the masterful male (usually John Wayne); thus *Rio Grande*, *The Quiet Man*, *The Wings of Eagles*. The other is the idealized 'lady', pure, beautiful, distant, kept on a pedestal 'and worshipped from afar by the hero. The classic example of this type is Clementine Carter (Cathy Downs) in *My Darling Clementine*. Wyatt Earp's courtship of her, hesitant, reverential, formal, is typical of the attitude of Ford's heroes to their ladies. The process by which Spitfire becomes Mother is traced in *The Long Gray Line*, during the course of which Maureen O'Hara ages and matures from one type into the other. Ford's last word on the role of the woman in society comes in his last film to date, *Seven Women* (1965), which examines the plight of a group of female missionaries stranded in China at the mercy

of bandits. For one reason or another, all of them have denied their 'natural', domestic role and are in consequence depicted as tragic misfits, incomplete human beings.[4]

The Mother figure is central to *The Grapes of Wrath* (1940), one of the key films in the Ford canon since it links the Family with the Land and Westward expansion to give us a classic exposition of populism. Unlike Capra or McCarey, Ford dramatizes the role of the frontier in American history. As long as there was land in the West, it was believed, a man could always head out there to create the ideal agrarian state. Henry Nash Smith in his seminal work *Virgin Land* has traced in American literature and politics the two opposed images of the Desert and the Garden, the former becoming the latter under the plough and forming the true milieu of the yeoman farmer. The shifting role of these two contrasted images is of fundamental importance to Ford's world view.

One of the fascinating things about *The Grapes of Wrath* is the way in which the book, a radical, left-wing, denunciation of the economic exploitation of the poor, becomes on film a right-wing, populist, traditionalist affirmation of faith in the old values (the People, the Family, the Land). The religious satire of the book, which attacked Bible-Belt evangelicalism, is eliminated and much of the political radicalism (an attack on capitalist practices, corrupt politicians and industrial exploitation and a defence of the unions as the only salvation) is muted. What remains is nostalgia for the old days and the old ways. As Ma Joad (Jane Darwell) says: 'Once it was the family whole and clear and there was some boundary to it. We were on the land and the old 'uns died and the young 'uns were born. We ain't clear no more.'

The preface of the film, however, makes it clear that the plight of the Joads is not the fault of the system or of exploitation; it is natural disaster (the Dust Bowl). The scene which expresses this and emphasizes the changing times comes near the start of the film when Tom Joad (Henry Fonda) meets Muley, a wild-eyed, ghost-like figure (brilliantly played by John Qualen), who relates what has happened to him. The bulldozers

came to demolish his farm. He brought out his gun to shoot the driver of one of them, only to discover that it was the son of a neighbour, who needs the work. He asks who he can shoot, but is told that the land has been bought by a land company, which is owned by a bank, which is owned by its stockholders, the people. The old days when a man could solve his problems by shooting his enemy are gone. Progress is the enemy now. In despair, Muley falls on his knees, clutching at the earth: 'It's my dirt, it's no good, but it's mine.' It is the plaintive cry of the populist farmer overtaken by events. Muley gives up and simply haunts his old neighbourhood.

But the Joads' answer, in the tradition of America's pioneers, is to go West, to the land of milk and honey – California. The way is long and hard and the family inevitably splits up under the strain. Grandpa dies, Grandma dies, Connie runs off, Pa loses his spirit, but Ma holds the family together and keeps them moving. After ill-treatment and hardship they finally reach a government camp, where they can feel clean, decent, dignified human beings again. A Saturday evening hoe-down celebrates this with all the optimism of the ritual barn dances and house-raisings in the Westerns. Where the book ended on a note of hopelessness with Tom Joad clubbed, Casy the preacher murdered and Rose o'Sharon's stillborn baby floating down the river, the film ends with a triumphant cry of hope. Tom leaves the family and goes off to help organize a Union. He tells Ma: 'Fella ain't got a soul of his own. Just a little piece of a big soul. One big soul that belongs to everybody. I'll be around. Wherever there's a fight so hungry people can eat. Wherever there's a cop beating up a guy, I'll be there . . . and when the people are eating the stuff they raise and livin' in the houses they build, I'll be there.' With this speech, Tom becomes the populist Christ-figure, an omnipresent redeemer whose mission is to make the populist image of America into reality. Ma accepts this and when she and what remains of the family drive off, she says: 'Rich fellas come up. They die. Their kids ain't no good.

And they die out. But we keep a comin'. We're the people that live. Can't lick us. We'll go on for ever. 'Cause we're the people.' In 1940 this message can still be preached but not for much longer.

During the thirties and forties Ford can be seen actively subscribing to an optimistic populist view of history and society. In his films, the move is always westwards: from Europe to America (*Mother Machree*, *Four Sons*, *The Informer*), the dream of the immigrant; and in America from East to West, the aim of the pioneer (*The Iron Horse*, *Drums Along the Mohawk*, *Wagonmaster*). During this period Ford created the definitive screen portrait of the key myth-figure of populism in *Young Mr. Lincoln* (1939). Henry Fonda, looking at times uncannily like portraits of Abraham Lincoln, is superb in the title role. He brings Lincoln to life with his loping walk, his shy smile, his social gaucheness and his folksy humour.

Lincoln is portrayed at once as a very human figure, seen participating in log-splitting, pie-judging, a tug o'war, and as the incarnation of the Law and of America. When he watches an Independence Day parade in which veterans of the Revolution and the War of 1812 participate, it is as if he is taking the salute of America's past. As a lawyer he takes on the seemingly hopeless case of the Clay brothers, accused of murder, and wins against all the odds, because he is defending the Right. ('I may not know much about the Law. But I know what is right and what is wrong.') Because Lincoln is Right he can accept no compromise, and when the judge offers a lesser sentence, if the defendants plead guilty, he refuses the offer. Lincoln wins the case and by his victory prevents the break-up of the Clay family.

The film ends with a foreshadowing of his tragic destiny. Against a swirling, stormy sky he bids the Clay family farewell and walks up the hill. For a moment he stands alone, as a roar of thunder and a flash of lightning rend the sky above him. Then he walks out of our sight, as 'The Battle Hymn of the Republic' swells on the soundtrack. He has gone to meet his destiny.

This final scene, with its suggestion of

Belonging
The need to belong has always been a principal preoccupation of Ford.
179 (above) Hence the idealization of the Family. The courtship ritual in *How Green Was My Valley*.
Donald Crisp, Roddy McDowall, Patric Knowles, Anna Lee and others
180 (left) Hence the idealization of the Armed Forces. The regimental dance ritual in *Fort Apache*. L. to r. Victor McLaglen, Anna Lee, Henry Fonda, Irene Rich, George O'Brien, Shirley Temple, Ward Bond

Home
Home is a prime thematic
concept in Ford
181 (above) John Qualen
and family defend their
home in *The Grapes of
Wrath*
182 Jon Hall longs for his
home in *The Hurricane*

Calvary, makes explicit the Christ parallel, already implied both in Lincoln's arrival in Springfield, riding on an ass, and in his quoting from the 'Sermon on the Mount' to quell a lynch mob. The film as a whole deals with his life from 1832 to 1837 but presupposes the audience's knowledge of his historic and mythic future role by introducing characters from that future (Stephen A. Douglas and Mary Todd). It also carefully selects its incidents to stress the emergence of the classic populist leader. When we first see Lincoln he is the owner of a small store (thus personifying the small businessman and private enterprise cf. Mr Deeds). He sells goods to a pioneer family, unknown to him the very Clays he is later to save, on credit (good neighbourliness in action). Unwilling to accept charity, the family insist on giving him something in return and, to Lincoln's delight, present him with a barrel of books, which includes Blackstone's Law Commentaries (thus symbolizing the handing over by the people of the custody of the Law to their chosen Leader).

In a key scene, Lincoln, lying in the grass with his feet up against a tree trunk, reads from Blackstone: 'The Law is the right of a person to life, reputation and liberty, the right to acquire and hold property. Wrongs are violations of these rights.' Lincoln's comment on this is significantly: 'That's all there is to it: Right and Wrong.' Thus the basic principles of populist thought are invested with moral force.

There are strong links between *Young Mr. Lincoln* (1939) and *My Darling Clementine* (1946), which apotheosizes a later myth-figure, Wyatt Earp. It is not simply that Henry Fonda plays both parts, for tiny details of character and habit are reproduced, like the fact that Earp balances in his chair with his feet against a rail in exactly the same way as Lincoln. Earp agrees to become Marshal of Tombstone, when his brother James is murdered, so that he can make the country safe for other boys like James. Once again there is a Christ parallel. Doc Holliday (Victor Mature) declares on meeting Earp: 'You haven't taken it into your head to deliver us from all evil?;

to which Earp replies: 'I hadn't thought of it like that. But it's not a bad idea.' The evil in Tombstone takes the form of the Clanton clan, who are eventually destroyed in the gunfight at the O.K. Corrall. When it is over, Vergil Earp is dead, Doc Holliday is dead and the fellowship is broken. Wyatt rides away, like Lincoln to take his place in history and legend – the definitive incarnation of the Western lawman.

In *The Iron Horse* (1924), Ford recounted the story of the expansion of the railroad, bringing civilization and progress to the West – just as in *Stagecoach* (1939) he celebrated the means of transport which linked the West before the railroad. In *Drums along the Mohawk* (1939) Ford lovingly recreated the trials and tribulations of the early settlers in the Mohawk Valley, centring on the newly-married Martins, Gil and Lana (Henry Fonda and Claudette Colbert), who leave New York for the frontier and there in a society of exuberant optimism, determination and self-sacrifice create the agrarian community of the populist ideal. Idyllic pastoral scenes show us Gil and Lana, side by side in the fields, bringing in the harvest, the fruit of the land they themselves have worked. The pioneer spirit underlies a succession of memorable scenes: the neighbours turning out to help the Martins clear their land; the booze-up by all the men awaiting the birth of the Martins' child; the parson thundering hellfire and damnation from the pulpit and ending his sermon with an advertisement for the local store; the widow McKlennar refusing to leave her bed when drunken Indians set fire to her house but ordering them to carry her outside, which they duly do. The film culminates in the siege of the fort by a combined force of Indians and Tories. There are no troops to spare to defend the frontier and the settlers have to look after themselves. They are victorious and word comes through at the end that the British army has surrendered at Yorktown and the colonies are free. The American flag is raised and 'My country, 'tis of thee' is played on the sound-track. The Martins, who have lost both their baby and their farm, decide to stay on and continue

Populist myth figures
183 (right) Henry Fonda
as Abraham Lincoln in
Young Mr. Lincoln
184 (below) Henry Fonda
as Wyatt Earp in *My
Darling Clementine*

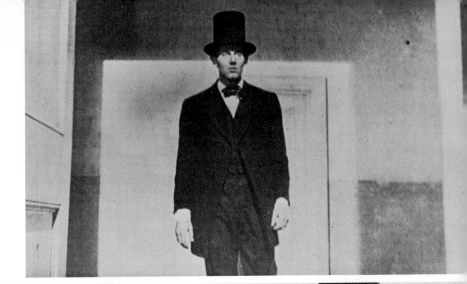

building the populist society: 'I reckon we better get back to work; there's gonna be a heap to do from now on.'

Ford's films reach an optimistic peak with *Wagonmaster* (1950), a leisurely and affectionate account of a Mormon trek across the desert in search of the Promised Land. It is one of Ford's favourite films and it comes closest, he says, to what he has tried to achieve in films.[5] Truly a piece of folk art, it consists of a string of loosely connected, expertly told anecdotes accompanied by a score composed of cheerful folksongs ('Red River Valley', 'Wagons West', 'Chuck-a-walla Swing' etc.). The pioneers are menaced by the evil Cleggs clan, who take over the train, but they are eventually defeated and the Promised Land is reached. They gaze at it from across the river, a land shining with the brightness of their hopes, and they celebrate by first singing 'Shall we gather at the river' and then having a joyous square dance.

But from then on, just as the populist mood in America has faded, so too do Ford's films become increasingly sad in tone. Ford turns from the optimistic age of frontier America and the dream of the ideal society to be created there, a dream made impossible by the logic of events. He eulogizes instead settled societies with what is basically a paternalist form of government, sustained by simple Christian faith, good neighbourliness and their own traditional rituals: thus the fond depictions of the Old South (*The Sun Shines Bright*), Old Ireland (*The Quiet Man*) and the South Seas (*Donovan's Reef*). These are very much the equivalent of the literary evocations of idealized societies which appeared at the turn of the century as the Populist movement declined.

By the sixties Ford's sympathies have done a complete about-face. In *Cheyenne Autumn* (1964) the Indians, who had been the savage and merciless enemies of the heroic white settlers in *Drums along the Mohawk*, become the tragic heroes of a saga of the dispossessed in the tradition of the Joads. The enemy is the central government which has condemned them to an arid reservation. Theirs is the driving desire to go home. Theirs is the traditional society which

breaks up under the strain of modern living. It is the whites who are the savages. The Dodge City interlude, mistaken by some critics as a piece of irrelevant comic padding, serves as a counterpoint to the plight of the Indians and as Ford's ironic comment on the legend of the West as viewed from the America of the sixties. Wyatt Earp (James Stewart), the idealized Western lawbringer of *My Darling Clementine* (1946), has become a 'wily, dandified joker' who shoots a derringer through his pocket and wearily leads the citizens out in pursuit of the Indians, knowing them to be nowhere near Dodge City. Doc Holliday, the tragic, consumptive poet of *Clementine*, has become Earp's comfortable, well-fed sidekick (Arthur Kennedy) and they spend their days playing cards with Major Jeff Blair (John Carradine), ageing Southern gent of dubious honesty, who is surely what the courtly, enigmatic Southern gambler of *Stagecoach* (also Carradine) has become. Peter Wollen has described Donovan's Reef as 'a sort of Valhalla for the homeless heroes of *Liberty Valance*'.[6] Similarly *Cheyenne Autumn* shows us how the formerly tragic and heroic figures of the winning of the West have become crafty, tired old men, content to rest on their laurels. Someone once said that all great events in history are played twice, first as tragedy and then as farce. Perhaps the same can be said of Ford's films. The Dodge City episode, broad, farcical, shows us what the once proud, hopeful and often tragic struggle to tame the West has led to.

A comparison of Ford's two Polynesian pictures is equally instructive on the question of his change of attitude. *The Hurricane* (1937) has been unaccountably neglected by critics, who have without exception dismissed it as a pot-boiler.[7] In fact *Hurricane* is one of Ford's undiscovered masterpieces, a gem of glowing romanticism, pure, noble, beautiful, superbly directed, thrillingly scored (by Alfred Newman) and culminating in the unforgettable hurricane. Set on the island of Manikura, 'the most beautiful and enchanting bit of paradise in all the world', it tells of the conflict of European ways and ideas with the traditional

Folk memory

Ford is the keeper of the American folk memory, lovingly re-creating her past.

185 (right) The settlement of the frontier in *Drums along the Mohawk*

186 (below) The Indian Wars in *Rio Grande*

ways and simple emotions of the islanders. Terangi (Jon Hall), a native of Manikura and the mate on Captain Nagle's schooner, knocks down a man in a fight in a bar in Tahiti and because the man has influence, he is imprisoned for six months. Nagle begs the authorities to release him on the grounds that confinement will kill him, but he is ignored. Desperate to return to his home and his wife Marama (Dorothy Lamour), Terangi tries again and again to escape, and each time his sentence is extended, until it totals sixteen years. One man could save him: Eugene Delaage, governor of Manikura (magnificently played by Raymond Massey), and all those around him, including his wife Germaine (Mary Astor), beg Delaage to intercede for Terangi. He refuses, explaining that Terangi got his long sentence 'for thinking himself greater than the law. For breaking jail. For defying authority. I am doing my duty. I come from a family which has administered the affairs of my country for centuries. It is a question of upholding the law under which these islands are governed. I am not asking for anyone's smiles as my reward.'

Eventually Terangi escapes and, determined to find him, Delaage commandeers Nagle's schooner and scours the seas. While he is away a hurricane devastates the island. But Terangi rescues his family and Germaine. Delaage locates his wife on a sandbank as Terangi and his family put off in a canoe. Delaage watches them through his binoculars and then turns away, saying: 'It is only a floating log.' For Delaage the hurricane represents catharsis. He has at last accepted the islanders' ways.

But the film sympathizes with Delaage, a sensitive, decent, honourable man gradually being destroyed by the hatred of the islanders but standing inflexibly by what he believes to be his duty. Ford also depicts with warmth and affection the idyllic life and traditional ways of the simple, innocent islanders and the desperate, overmastering desire of Terangi to go home. A succession of memorable images linger in the memory: Father Paul serenely playing the organ as the hurricane batters at the walls of the church;

a tortured Delaage, tense and silent, sitting down to dinner in evening dress with his wife; Terangi, curled, ragged and unshaven, in the shadowy corner of his rat-infested cell; the sun-bleached headland, ringed with barbed wire, where convicts toil under the sadistic eye and lash of the warder; and the anguish in Terangi's eyes as he watches the white schooner sailing out towards the home he cannot reach.

Donovan's Reef (1963), on the other hand, broadens and farcicalizes the themes of *Hurricane*, just as the Dodge City interlude did with the westerns. The Governor of the island, significantly also called Delaage (Cesar Romero), is no longer the tortured, dedicated aristocrat but a suave, crafty rogue with an eye to a rich marriage; Dorothy Lamour, the lovely Marama of *Hurricane*, is the middle-aged saloon entertainer; while the township on the island of Haleakaloha is a parody of a Western township, complete with saloon and church, just as its heroes are a debasement of the classic Western heroes. Michael Donovan (John Wayne), although a brawling, two-fisted adventurer, is also college-educated and actually reveals at one point that he knows his Mozart from his Chopin, while 'Boats' Ghilhooley (Lee Marvin) fascinatedly and childishly plays with a train set. They have retired, together with the old top sergeant of the cavalry pictures (Mike Mazurki), to the South Seas, since the western frontier, their natural habitat, no longer exists. The idealized figures in the film are Doc Dedham (Jack Warden), who has turned his back on his Boston relations and their millions and dedicated his life to helping the islanders, and his daughter, Lelani, the hereditary princess of the island. It is the native life which is now the ideal and the displaced cowboy heroes in their western township are the brawling intruders.

One of the cardinal tenets of populism had been opposition to the political machine, and yet in *The Last Hurrah* (1958) Ford nostalgically celebrated the passing of the old party machine, depicting it as something which ensured contact between the people and the politicians, thereby securing a

Elegy

The wheel comes full circle and Ford
creates memorable elegies for the vanished
world he has loved.

187 (right) The death of the old-style
politics in *The Last Hurrah*.
Spencer Tracy, Jeffrey Hunter and Dianne
Foster

188 (below) The death of the Old West was
the subject of *The Man Who Shot Liberty
Valance*.
The old West (John Wayne) confronts the
new West (James Stewart), with faithful
negro servant Woody Strode looking on

measure of democracy. The film tells of the last old-style political campaign in an age when radio and television and the organization men are taking over. It contrasts the opposing styles in politics of the two candidates. Frank Skeffington (Spencer Tracy), the old-fashioned politician, is also old-style Irish, the son of an immigrant family who has pulled himself up from the slums by his own efforts and has devoted his life to serving the people as mayor of his New England town. He fights for re-election, as he has always fought, by gathering his old friends and associates (a gallery of nostalgic performances from old-timers Pat O'Brien, Ricardo Cortez, James Gleason and Edward Brophy), fund-raising, meeting the people, holding razzle-dazzle parades and dinners.

Kevin McCluskey (Charles Fitzsimmons), his opponent, the new-style politician is also new-style Irish, a college-educated fool who is the puppet of Yankee aristocrats (led by Basil Rathbone and John Carradine, both on splendid form) who have always resented the predominance of Skeffington, the slum kid made good. McCluskey makes full use of the media in his campaign and there is a splendid scene, sending up the supposedly unscripted TV broadcast, of the McCluskey family at home with Kevin nervously mouthing platitudes, his wife stiltedly reading her comments from a prompt-board, the children self-consciously paraded in their Sunday best and a barking dog all but ruining the transmission. Inevitably – and again it is a sign of the times – Skeffington loses and the aristocratic puppet with none of Skeffington's feeling for the people is elected. Soon after, Skeffington succumbs to a heart attack and dies. His death symbolizes the death of the old-style politics, the politics that cared, when honest and sincere men like young Mr Lincoln led a young, optimistic nation to its dream of a better future. But young Mr Lincoln has become old Mr Skeffington and he dies, just as the hopes and the dreams have died. The faceless, conscienceless Organization men have won.

Like the old politics, the old West has also died, and *The Man Who Shot Liberty Valance* (1962) constitutes a beautiful and melancholy epitaph for the Old West. Watching it one constantly gets the feel and atmosphere of a silent film: the grainy black and white photography, the sometimes crude studio 'exteriors', Wayne in his enormous white stetson and leather chaps resembling Harry Carey Sr in Ford's silent westerns. There is a rawness and newness in the people and in the buildings, evoking both the early days of the West and the early days of the western film.

Liberty Valance (Lee Marvin) terrorizes the town of Shinbone. The shooting of Valance, ostensibly by young lawyer Ranse Stoddard (James Stewart), paves the way for the coming of civilization, law and order and statehood. Stoddard goes on to be Governor, senator and Ambassador to London. Stoddard represents the New West, arriving from the East an idealist tenderfoot, with a handful of lawbooks and a dream of progress. He holds lessons in the school room, flanked by portraits of Lincoln and Washington, and tries to teach the people the meaning of democracy and the principles of the Declaration of Independence in true populist fashion. But before these processes can begin, Valance has to be destroyed. Ranse goes against him. But Valance is really killed, from hiding, by Tom Doniphon (John Wayne), his reason being that Hallie (Vera Miles), Tom's girl but attracted to Ranse and his ideas, didn't want Ranse killed. Tom represents the Old West, a man's man, cattle rancher and fast gun, tough, self-sufficient, independent. He does not want to be involved with the town or Ranse's crusade, but because of his love for Hallie he kills Valance and nominates Ranse to represent the town at the statehood convention. Tom burns down the ranch-house he had built for married life with Hallie and she marries Ranse. Later Tom dies, a pauper, having sacrificed his happiness and his future. But without this sacrifice there would have been no future for Shinbone.

The film opens with the return of Ranse and Hallie to attend Tom's funeral. Link Appleyard (Andy Devine), the former sheriff, tells Ranse: 'You're the only one from the old days still working steady, senator.' Shin-

bone is now settled, peaceful and orderly and Ranse decides to retire there. He tells the editor of the local newspaper the true story of the shooting of Liberty Valance, but the editor refuses to print it. 'This is the West,' he says. 'When a legend becomes fact, print the legend.' It is its legends which give a nation its soul, its pride, its traditions. So for history Ranse Stoddard will remain the man who shot Liberty Valance.

As they travel back to Washington, Hallie looks out of the window of the train and says: 'It was once a wilderness. Now it's a garden.' Her action in placing a wild cactus rose on Tom's coffin indicates her love of the Old West, the wilderness, and Ford clearly shares this love. The film's title, *The Man Who Shot Liberty Valance*, refers to both Ranse and Tom but one feels that, for Ford, it is Tom who is the true hero. The film sees the reversal of the old Garden-Desert antithesis. Ford contemplates a situation in which the Desert has become a Garden but the dreams attaching to the latter image have failed to become reality. So Ford turns nostalgically to the Desert and the freedom it signifies, to the world of the day before yesterday. In a recent interview, Ford said: 'Our ancestors would be bloody-ashamed if they could see us today.' For him, the dreams have turned to ashes. For him, there are only the memories.

Notes

1 Frank Capra, *The Name Above the Title*. Foreword by John Ford, p. ix. During the course of the book (p. 246) Capra pays a warm tribute to Ford, describing him as 'the dean of directors, undoubtedly the greatest and most versatile in films'.

2 Jim Kitses, *Horizons West* (1969), p. 13.

3 Peter Bogdanovitch, *John Ford* (1967), p. 92.

4 For a Women's Lib view of Ford's attitude to women see Nancy Schwartz, 'The role of women in *Seven Women*', *The Velvet Light Trap* (2) (August 1971), pp. 22–4.

5 Bogdanovitch, op. cit., p. 88.

6 Peter Wollen, *Signs and Meanings in the Cinema* (1969), p. 101.

7 Thus for instance Lewis Jacobs, *The Rise of the American Film*, p. 483; John Baxter, *Hollywood in the Thirties* (1969), p. 109: and Lindsay Anderson, 'The method of John Ford' in *The Emergence of Film Art* (ed. Lewis Jacobs) (1969), p. 236.

Some critics have, I suspect, dismissed *Hurricane* by association with the string of Dorothy Lamour 'sarong' pictures which followed it (*Aloma of the South Seas*, *Typhoon*, *Beyond the Blue Horizon*), each of them worse than the one before.

Part 3

The Cinema of National Socialism

The Ideology of National Socialism

Up to this point, in examining British and American films, we have been dealing with cinema in a democracy. Except in wartime, the state has not generally sought to control the content of and ideas expressed in films. The views and attitudes we have analysed are those of individual film-makers: directors, writers, producers, even studio executives, who find themselves subscribing to the same ideologies. It has been the totalitarian states, Russia and Germany, who have been swiftest to perceive the enormous propaganda potential of the cinema and to act accordingly, and it is to Germany that we turn for our final case study of the Cinema of the Right.

Within a few short years after the appointment of Adolf Hitler as Chancellor of Germany in 1933 the Nazis achieved complete *Gleichschaltung*: the recasting of the whole of German life in the National Socialist mould. Political parties were abolished, trades unions were abolished, constitutional guarantees of individual liberty were suspended, the Judiciary and the Civil Service were purged of opponents. The Hitler Youth indoctrinated the next generation of rank-and-file Germans; the Labour Front and the Farmers' League took charge of this generation. A complex, super-efficient, utterly conscienceless machinery of repression, centred on the Secret State Police (the Gestapo), was set up to safeguard the régime and implement its orders. Germany became the textbook totalitarian state.

Over every aspect of life brooded the malign influence of the demonic Führer, Adolf Hitler. At Hitler's command the machine moved into action, whether it was to extend German rule over an entire continent or to begin the extermination of an entire race. How was it, historians have asked, that within such a short space of time the Nazis could have ensured so completely the passive acquiescence of a nation of some seventy millions of people in the perpetration of the most horrifying deeds recorded in the annals of history?

The timing was certainly impeccable. Hitler capitalized on the Depression, the great slump which had hit the world in the wake of the Wall Street crash. Unemployment rose from 1,300,000 in 1929 to three millions in 1930 to six millions in 1933. Correspondingly, Nazi representation in the Reichstag rose from 12 in 1928 to 107 in 1930 to 230 in 1932.

It was the final crushing blow to the Weimar Republic, which had never been able to overcome the circumstances of its birth amid the ashes of German defeat. It was irrevocably associated in the minds of the bourgeoisie with the bitter national humiliation of the Versailles treaty, which had detached huge chunks of the homeland and granted them to inferior peoples, the Poles, the Czechs and (even more inferior) the League of Nations, and which had deprived Germany of her colonial empire and her fleet and committed her to the payment of crippling reparations. It was also blamed for the rise of immorality and free expression, which characterized the artistic and sexual life of the Republic and which greatly offended the Puritan conscience of the middle classes. Finally, it was held responsible for the rise of the working classes, which was thought to be the first step on the road to Red revolution. The Spartacist Rising in Berlin and the creation of a Munich Soviet in the aftermath of war had given substance to this fear and Hitler had shrewdly capital-

ized on it by staging and then profiting from the Reichstag Fire, seen by many as the prelude to a new outbreak of Communist terror.

There was a swing to the right on the part of both the youth and their elders. The Germans were basically unprepared for democracy anyway. They had been for too long conditioned to the acceptance of strong state authority. As Richard Grunberger has observed, when the German empire was created in 1871, it was a case of Germany merging into Prussia rather than Prussia merging into Germany.[1] The Empire was stamped with the Prussian image: authoritarian, militarist, demanding absolute obedience. The need for a strong leader to reverence and the need for a purified patriotism to overcome the disgrace and degradation of Weimar prepared the German people, spiritually and psychologically, for the advent of Hitler.

Hitler preached little that was new. Instead he modified and adapted a tradition that had been seeping steadily into the fabric of German life and thought for over a century – the Volkist tradition. Volkism was a product of nineteenth-century romanticism. Essentially it idealized the Volk, a racial unit which, being rooted in the soil of the homeland and in spiritual communication with Nature, achieved a sense of oneness with the cosmos. It looked back to an idealized medieval past, it apotheosized the peasant and it execrated progress and modernism. Early Volkists such as Julius Langbehn and Paul de Lagarde called for the regeneration of the individual by membership of the Volk and posited the Jew as the antithesis of Volkist Man. The Jew was characterized as materialist and thus the enemy of Volkist spiritualism, as a rootless wanderer and therefore the opposite of Volkist rootedness, and as the epitome of finance, industry and the town and thus alien to the agrarian peasant ideal of the Volk. So anti-semitism was already a respectable part of this key ideological development early in the nineteenth century.

Gradually, however, Volkism became the centre of a school of thought to which other ideas attached. There was the glorification of an idealized Germanic past. The Volkists believed that contemporary Germans had to identify with the virtues that had carried the ancient German tribes to victory over Rome, as described in Tacitus's *Germania*. The philosopher Oswald Spengler called for a rejection of the corruption of democracy in favour of the purity of a heroic past. Books apostrophized the gods and heroes of ancient Germany, glorified war and conflict as the means of attaining spirituality and preached courage and physical prowess to their readers. The Edda and the Nibelungenlied, which were seen to detail this ideal Teutonic world, became the sacred texts of Volkism.

There was a revival of ancient religious beliefs, which came to be seen as sanctifying primeval strength, a quality lacking in modern religious doctrines, especially Christianity. Ancient symbolism, such as the Rune and the Swastika, reappeared and solar occultism (particularly the celebration of the summer solstice) became the central feature of this regenerated paganism.

With all this went a rejection of the individual in favour of the race. Race consciousness had always been integral to Volkism but when equated with anti-semitism it became explosive. The great proponent of Volkist racial theory was the Englishman, Houston Stewart Chamberlain, son-in-law of Richard Wagner and towards the end of his life a great admirer of Hitler. He based his ideas on the work of Arthur de Gobineau, who in 1853 in his *Essai sur l'inégalité des races humaines* had put forward the first complete 'scientific' theory of racial inequality. Wagner was a great supporter of Gobineau's ideas, a fervent anti-semite and an apostle of Germanism. His 'Ring' cycle became its most notable artistic expression and under Hitler the Bayreuth Festival became an annual Nazi ritual.

Chamberlain's great work was *Die Grundlagen des XIX. Jahrhunderts* (*Foundations of the Nineteenth Century*), published in 1900. In it he expounded a schematic view of past and future in which he saw Racism as the hope of mankind. He saw history as a struggle between the Germanic and Jewish races, the

former representing Good and the latter Evil. If only Evil could be destroyed, then a cosmic breakthrough was at hand. He saw everything that was good in the past as due to Germanic influence and went so far as to reclassify Christ as a blond-haired, blue-eyed Galilean. The adoption of a cosmic anti-semitism into Volkist thought institutionalized what was already a strong strain in Germanic society and thinking.

A third major element entering Volkism was the principle of leadership. At the turn of the century both intellectuals and Volkists felt a sense of frustration at the lack of ideals and heroism and leadership. What was needed was a mythos to embody the aspirations of the German people. They turned to Nietzsche, idealized as a Nordic prophet. Writers such as Arthur Bonus, Ernst Bertram and, later, Alfred Baümler, who specifically adapted Nietzsche for National Socialist use, removed him from his historical context and elevated him, picking out certain of his ideas and weaving them into Volkist thought: most notably the heroic superman and the triumph of the will.

To back up the heroic Leader the concept of the Bund, the tightly knit all-male community, was conceived. The great theorist of the Bund was Hans Bluher and he saw it epitomized by the phenomenally popular and predominantly middle-class German youth movement, the Wandervogel, founded in 1901. He analysed it in his book, *Wandervogel as an Erotic Phenomenon* (1912) and defined its elements as: charismatic leadership by the exceptional few, an all-male community sublimating its sexual feelings in the pursuit of perfection, and the idealization of the male body, lithe, muscular, blond and Nordic.

The Bund structure became one of the principles of Volkism and spawned many offspring, notably the Pan-German Association founded in 1890. Veterans, associations and the Freikorps were infused with Bundisch ideas and a whole plethora of secret Volkist Bünde grew up after the war.

By the end of the nineteenth century, then, Volkism was being institutionalized. Even more important, it was finding its way into the educational system. Nineteenth-century school textbooks were full of Volkist ideas. In the universities students and professors enthusiastically took to Volkism and it was Heinrich von Treitschke, professor of history at Berlin University, who coined the phrase: 'The Jews are our misfortune.' In George Mosse's words: 'Bourgeois youth was lost to the Weimar Republic even before the Republic got properly started.'[2]

The middle classes in Weimar Germany were searching for an ideology, an alternative to democracy and communism. Volkism was already part of their thinking. The Conservative party (the D.N.V.P.) became increasingly Volkist, particularly after Alfred Hugenberg, a founder of the Pan-Germans, became its leader. The Stahlhelm, the largest German veteran association, pledged itself to attain a Volkist state and the largest white-collar union, the D.H.V., adopted an anti-semitic platform.

But although Volkism prepared the way, we cannot equate it with the National Socialist philosophy expounded by Hitler. Both the Pan-Germans and the youth movements held aloof from Hitler because he rejected one of their most firmly held principles – Bundism. Hitler rightly saw that the élitism implicit in the Bund was no base from which to achieve power and he therefore introduced the appeal to the masses with a concrete programme of social reform, the brilliant use of propaganda and an emphasis on dynamic leadership. None the less elements of the Bund structure did survive: the subordinate position assigned to women in the state, the emphasis on comradeship and brotherhood and the all-male coteries of power at the top of the Nazi pyramid, with Goering's circle and Goebbels's circle and the S.A., which, under Ernst Röhm, was an openly homosexual clique.

Where Hitler demonstrated his satanic brilliance was in making anti-semitism the cornerstone of his ideology. By turning the people's hatred against the Jews, he averted a genuine social revolution. German high finance was not the enemy but Jewish international high finance was. German

socialism was not the enemy but international Jewish Marxism was. The theory of a world-wide Jewish conspiracy against the Aryan race was elaborated. The Jews were said to be seeking to destroy German racial purity by miscegenation. They were said to be responsible for Germany's defeat in the war, the rise of Bolshevism, the Depression, the Weimar Republic and the decline in morals. The prominence of Jews in finance and the arts and the fact that a Jew had drawn up the Weimar constitution were all adduced as evidence of this theory.

As a corollary to this, the Germanic race was eulogized as the master race, the Herrenvolk. Hitler declared: 'The Nordic Race has a right to rule the world. We must make this right the guiding star of our foreign policy.' Alfred Rosenberg elaborated the greatness and purity and destiny of the Nordic race in his influential book *The Myth of the Twentieth Century*, a sort of updating of Houston Stewart Chamberlain.

Linked to this, and a direct inheritance from Volkism, was the concept of 'Blut und Boden' (Blood and Soil) as the source of the Herrenvolk's strength. Nordic physical beauty, the heroic Teutonic past, the Earth as the source of strength, peasant virtues and all the rest of it, passed directly into National Socialist dogma.

Finally there was the Führerprinzip. Democracy was based on the idea of the freedom of the individual. Nazism turned to Volkism, to Nietzsche and to the Bünde for its concept of the heroic Leader, a charismatic figure embodying and guiding the nation's destiny. It derived from many sources: the Messianic principle of Christianity, the thaumaturgic kings of the Middle Ages and the Nietzschean superman of Volkist myth. It was the antithesis of democracy.

Führer-worship was central to Nazism. Hitler was, for his people, a mystical figure, teetotal, vegetarian, celibate (as far as the world was concerned), his life totally dedicated to the State. He demanded absolute obedience from his followers. Soldiers in the armies of the Reich were required to swear an oath: 'I swear this holy oath to God: that I shall give unconditional obedience to Adolf Hitler, the leader of the Reich and the people, supreme commander of the army, and that as a brave soldier, I shall be ready to risk my life at any time for this oath.'[3] Hermann Goering wrote in 1934: 'Just as Roman Catholics consider the Pope infallible, in all matters concerning religion and morals, so do we National Socialists believe with the same inner conviction that for us the leader is, in all political and other matters concerning the national and social interests of the people, simply infallible.'[4] The slogan 'The Führer knows best' was one to which the majority of Germans wholeheartedly subscribed.

So the Nazi ideology can be broken down into three basic doctrines. These are the doctrine of the Herrenvolk (based squarely on anti-semitism), the doctrine of 'Blut und Boden' (the Nordic past, the warrior hero, the landscape, the blood) and the Führerprinzip (absolute obedience to the Leader). It is these ideas that we must look for when examining the cinema of the Third Reich.

One of the major means the Nazis used to achieve power was propaganda. The mass rally, the indoctrination of youth, the control of the arts and communications media – all these served to disseminate Nazi ideas. Hitler laid great stress on propaganda. In his book *Mein Kampf*, which rapidly became the Nazi Bible, he wrote:[5]

Towards whom must propaganda be directed? Towards the scientific intelligentsia or towards the uneducated masses? It must always be exclusively directed towards the masses ...
Propaganda can no more be science in its contents than a placard can be art ... the task of propaganda does not lie in the scientific instruction of individuals but in the orientation of the mass towards specific facts, cases, needs etc., whose importance should thereby be placed first in the eyes of the multitude ... the teachability of the great masses is very limited, their understanding small and their memory short.

This is the importance of propaganda in a

nutshell and the appreciation of this was one of the most powerful weapons in the Nazi armoury.

The Nazis took over all forms of public expression (press, radio, film, theatre, music, literature, art) and placed them under the overall control of the Ministry of Propaganda, whose brilliant overlord, Dr Josef Goebbels, set up a series of Reichskulturkammer, with himself as President, for each outlet of expression. Membership was compulsory for the practice of the arts and denial of membership meant the effective stifling of the individual creative voice. However, the production of anything of any merit was seriously jeopardized by the mass exodus of artists in every field.

The aim was a total culture, producing only those works which subscribed to the ideology. Literature was limited to four prescribed themes: the glorification of war, the race, the soil, leadership. Common to all these themes was the submergence of the individual and self-sacrifice in the cause of the nation. War was portrayed as a spiritual experience, producing courage and comradeship, in the novels of Werner Beumelberg, Heinz Steguweit and Ernst Jünger. Josefa Behrens-Totenohl wrote novels heroizing the medieval peasant and Hermann Burte and Hans Friedrich Blunck, drawing on the ancient legends and sagas, hymned the Race in such works as *Wiltfeber der ewige Deutsche* (*Wiltfeber the Eternal German*) and *Die Urvatersaga* (*Legend of the Primeval Father*). In 1936 literary criticism was abolished. The Nazi writers were encouraged by prizes, publicity and party sponsorship but virtually nothing of any literary merit was produced during the period and the ordinary reading public devoured instead conventional war stories and Karl May's westerns.

The theatre confined itself largely to popular comedies and to the classics, with the occasional Nazi hero-epic such as Hanns Johst's play *Schlageter*, glorifying the early Nazi martyr, Albert Leo Schlageter, and Volkist epics about the Gothic king Totila or the Saxon chieftain Widukind.

Modern music, both atonal music and jazz, was banned. Most composers and conductors left the country. The Bayreuth Festival became the most notable musical event of the year and concerts were an unending diet of Wagner and Brückner, who were seen to capture the spirit of the race in their music. Modern art (surrealism, cubism, expressionism etc.) was attacked as aesthetically repellent and politically subversive. All evocations of pain and anguish were banned. In 1936 there was a purge on 'degenerate painting' and many canvases were burned. Nazi painting, which was almost uniformly mediocre, consisted of pastoral landscapes, jolly German peasants, heroes in uniform and Nordic nudes. Adolf Ziegler, who became known as 'Reichsmaster of the Pubic Hair', and Richard Klein turned out scores of meticulously painted nudes. Arno Brecker sculpted vast, bulging-muscled nude men holding swords and torches and Professor Josef Thorak constructed a huge nude monument to the workers on the Autobahn.

As for the buildings, Hitler, himself a tenth-rate painter, was, as Hellmut Lehmann-Haupt comments, obsessed with the national element in architecture. 'He wants to prove Germanic superiority by linking it up with the universally recognized culture of classical antiquity. He has no place for modern art or for the contributions of any other people anywhere in the world.'[6] The result was, on the one hand, pseudo-medieval dwelling houses with thatched roofs, high gables, wooden balconies and oak beams and, on the other, massive, ceremonial architecture: stadiums, plazas, museums. Typical is the House of German Art at Munich, derisively labelled 'Athens Railway Station'. There were plans for the complete remodelling of Germany architecturally and a major building programme was inaugurated, presided over by Albert Speer and typified by the Rally Buildings, which were to play such an important part in Leni Riefenstahl's *Triumph of the Will*, and the new Chancery, described by Lehmann-Haupt as: 'a mixture of ancient Hellas with sober, severe Prussian classicism . . . and on top of that the gaudy, lavish incrustation of Nazi symbolism.' This description succinctly sums up the Nazi architectural style.

The cinema, like the other arts, came

under the supervision of the Reichskultur-kammer and Goebbels, as an ardent cinéaste, always took a detailed personal interest in German films. But the Nazis did not initially plan total, direct state control. As Marcus Phillips has pointed out, the general plan was 'to achieve control over the content of films, place the industry on a sound economic footing and purge it of subversive elements. There was no question of nationalization.'[7]

So in 1933 Jews were excluded from the film industry. In 1934 a Nazi censor was appointed to vet all scripts and in 1936 film criticism was abolished. But film exports declined, production costs rose and the German films failed to capture 'the spirit of the New Germany'. The audiences preferred American films anyway and these, though subject to censorship, were not finally banned until 1941. The studios, fearful of causing offence, concentrated on escapist entertainment and the heart went out of the German film industry. Goebbels's desire to create a film industry that would glorify the Third Reich was ultimately frustrated by the fact that Nazi policies had resulted in the flight of most of the people who were talented enough to do this.

Germany's three leading producers (Erich Pommer, Max Schach and Seymour Nebenzal) fled. The cream of Germany's film directors went too: men like Fritz Lang, William Dieterle, Henry Koster, Kurt Bernhardt, E. A. Dupont, Robert Wiene, Richard Oswald, Berthold Viertel, Robert Siodmak, Douglas Sirk, Frank Wysbar, Reinhold Schunzel, Joe May, William Thiele, Erik Charell, Hans Schwartz. Top stars, who had put German films on the map, removed to London and Hollywood: Marlene Dietrich, Conrad Veidt, Elizabeth Bergner, Peter Lorre, Fritz Kortner, Anton Walbrook, Richard Tauber and many others. To be fair, Hollywood had already poached many major talents before the coming of Hitler: Paul Leni, F. W. Murnau and Ernst Lubitsch, for instance. But the men who were rising in the German film industry and might ultimately have filled the gap they left, men of the calibre of Billy Wilder, Fred Zinnemann and Edgar G. Ulmer, fled also and made their careers in the United States. Try as he might – and he did try – Emil Jannings, the one major star to stay behind, could not fill the gap created by such an exodus.

In the face of increasing mediocrity and the prevailing faintheartedness of the studios, Goebbels, hoping to spur the industry into the production of more and better films, arranged for the shareholders of the major companies to be bought out in 1937. When this failed to produce the desired results, he finally nationalized the reluctant industry in 1942. But all the state control in the world cannot stimulate genuine creativity when it is not there and when the people who possess it have, by and large, gone.

Notes

1 Richard Grunberger, *Germany 1918–1945* (1964), p. 31.
2 George L. Mosse, *The Crisis of German Ideology* (1966), p. 193.
3 Franz Neumann, *Behemoth: the Structure and Practice of National Socialism* (1942), p. 75.
4 Hermann Goering, *Germany Reborn* (1934), pp. 79–80.
5 Frederick L. Schumann, *Hitler and the Nazi Dictatorship* (1936), p. 82.
6 Hellmut Lehmann- Haupt, *Art Under a Dictatorship* (1954), p. 51.
7 M. S. Phillips, 'Nazi control of the German film industry', *Journal of European Studies, 1* (1) (March 1971), p. 45.

Leni Riefenstahl – the Documentary and Myth

The one notable exception to the large-scale absence of talent in the Nazi cinema is Leni Riefenstahl, who gave brilliant cinematic expression to the myths of National Socialism. Whether or not she herself was a Nazi – and she denies it[1] – her two magnificent documentaries, *Triumpf des Willens* (*Triumph of the Will*) and *Olympische Spiele* (*Olympiad*), are powerful evocations of the Nazi ethos and therefore seminal texts for anyone trying to understand the ideology of Nazism.

Prelude to 'Triumph'

Leni Riefenstahl was born in Berlin on 22 August 1902. As a girl she studied painting and dancing, and in the mid-twenties she was engaged as a star ballerina by Max Reinhardt and toured the capitals of Central Europe. She has said in an interview: 'Dance and painting have undoubtedly played a part in forming the style I adopted in the composition and montage of images.'[2] Her films bear this out. They are pervaded by a sense of rhythm, a feeling for symmetry, a tremendous visual quality, and what can perhaps be seen as the catalyst of these qualities, an instinct for the theatrical.

It was from Dr Arnold Fanck that she learned the technical side of film-making. For she starred for him in a notable series of mountaineering films,[3] made between 1926 and 1931, *Der heilige Berg* (*The Holy Mountain*), *Stürme über dem Mont Blanc* (*Storm over Mont Blanc*), *Der weisse Rausch* (*The White Frenzy*) and most famous of all, *Die weisse Hölle vom Pitz Palü* (*The White Hell of Pitz Palü*), which was co-directed by Pabst.

In 1932 she turned to production and wrote (with Bela Balazs), directed and starred in her own mountain film *Das blaue Licht* (*The Blue Light*), which won the Gold Medal at the Venice Film Festival. It is a re-telling of an old legend of the Italian Dolomites about a mysterious blue light, radiating from an outcropping of crystals on the mountainside, which lures young men to their deaths in vain bids to reach it. The only person who can climb up and return safely is Junta (Leni Riefenstahl), a mysterious and beautiful witch-girl who lives alone in the hills. A young painter, Vigo (Mathias Wieman), visiting the village, falls in love with her and discovers her route up the mountain. He informs the villagers of it and they climb up and remove the crystals. When Junta goes up again, the light is no longer there and, distracted by grief, she falls to her death.

It is a simple story, which becomes in Riefenstahl's hands a subtle screen poem of exquisite delicacy and mythic power. It is told entirely through the images and reveals her extraordinary visual sense, already fully developed. A paean to Nature, the film lovingly captures the milieu of the tale: the cluster of rough stone houses forming the lonely village, the strong, authentic peasant faces of its inhabitants, the beauty of a mist-veiled moonrise, a waterfall shimmering in the early morning sunlight, the mountains with a swirl of angry clouds around their majestic peaks, great gnarled trees and little roadside shrines. The symbol of this world is Junta, 'a true incarnation of elemental powers', who worships the beauty of the Blue Light and who dies when it is taken away.

Siegfried Kracauer, in trying to fit the film into his all-embracing interpretation of the German cinema which sees all films

before 1933 as inexorably forecasting the rise of Hitler, does the film an injustice. It is stretching the imagination a long way to describe Junta as 'a mountain girl (who) conforms to a political régime (i.e. Nazism) which relies on intuition, worships nature and cultivates myths'.[4] A much more realistic interpretation of the film is to see it as a piece of pure pre-Hitler Volkist romanticism. As we have seen, Volkism contributed elements to Nazism, but that is not the same as saying that all pre-Hitler Volkist figures, like Junta, are *ipso facto* Nazi sympathizers.

But the film did serve to bring her to the notice of Hitler, a keen film fan and an admirer of Leni Riefenstahl's work. It was the Führer personally who commissioned her to produce 'an artistically shaped film' of the Nazi Party Annual Rally. Her first attempt, made in 1933, was *Sieg des Glaubens* (*Victory of Faith*). But no known copies survive and it is possible that the film was never completed due to the Nazi leadership purge of 1934, which removed several men who must have figured prominently in the 1933 Rally. However, in 1934 she prepared to film the new Rally, which had been given the name: 'The Party Day of Unity and the Party Day of Power'.

In the published account of the filming,[5] she reveals that 'preparations for the Party Convention were made in concert with the preparations for the camera work'. There is no doubt that the whole of the 1934 Party Congress was staged with filming in view. For it was in preparation for the Congress that the first permanent installations in the Luitpold Stadium were built: the review stands, the speakers' platform, the towers, the flagpoles and the huge eagles. The manoeuvres, march pasts and parades were drilled relentlessly beforehand, so that everything would look perfect. 30 cameras, 22 private cars and 120 assistants were assigned for the filming. Special wooden platforms were built on the field, and throughout the city wooden tracks were laid. Concrete pits were sunk in front of the rostra. New techniques of wide-angle photography and telescopic lenses were used to sweep the crowds for reactions. The result

was *Triumph of the Will*, one of the most spellbinding and at the same time terrifying films ever created. For one is hypnotized, riveted, swept irresistibly along by the spectacle, the music, the roar and the glitter. Hitler had written in *Mein Kampf* that the people were a great mass, swayed by emotion and feelings, and that these were to be awoken and utilized by the Leader. *Triumph* does just this. It touches the well-springs of human emotion, it awakens an exultant nationalism. Every sequence, every shot in the film is calculated to this end, and one constantly has to remind oneself that behind the infectious swagger and pomp of the ceremonial lay the terrible reality: corruption, madness, evil more horrifying than any before spawned by the mind of man.

The cult of the leader

The Nazi ethos was, as we have seen, essentially anti-individualist. The strength of the nation was seen to lie in the submergence of the individual will in the will of the nation, as expressed by the Leader. This is the underlying theme of the film. The triumph is twofold. It is the triumph of the will of the nation over individual will and the triumph of the will of the Leader, in moulding the will of the nation.

The literature of the Volkist movement and of National Socialism lauds an apostolic succession of Germanic heroes: Arminius, the Teutonic chieftain who slaughtered the Roman legions in the Teutoberger Wald, Widukind, the pagan Saxon chieftain who defied the onslaught of Charlemagne and Christianity, Frederick Barbarossa the medieval German Emperor, believed to be sleeping under a mountain till the day his people needed him again, and Frederick the Great, whose iron will forged the Prussian state and made it great and feared in Europe. Greatest of them all, however, is Siegfried, the embodiment of the Germanic spirit, archetype of the blond Nordic superman of Nazi racial theory, Siegfried, celebrated in opera by Wagner, the favourite composer of Nazi Germany, and on film by Fritz Lang, a

film which became Hitler's favourite and served as a textbook for Leni Riefenstahl in the making of her documentaries. Her endless panning shots along rows of soldiers, the medieval houses and classical stadium buildings, her handling of the crowd scenes, the constant close-ups of earnest blond Nordic stormtroopers, all gazing purposefully into the distance and trying to look like Paul Richter, who had incarnated the ultimate Aryan folk hero in *Siegfried*, all irresistibly recall the castles and palaces, gods and warriors of the mythological Germany depicted by Lang.

In Nazi mythology Adolf Hitler is the latest incarnation of the Germanic Leader. The opening sequence of *Triumph*, one of the finest in all cinema, celebrates the apotheosis of Adolf Hitler. A montage of cloud formations. The cockpit of an aeroplane, cutting through the clouds. Suddenly, the plane breaks through the clouds and into open sky. Spread out below, medieval Nuremberg, with its towers, spires and battlements thrusting into the sky. A dazzling aerial photography sequence follows as the plane crosses Nuremberg, and already we can see in its streets lines of party members, all in perfect formation, converging on the Congress Stadium. The Horst Wessel song swells on the sound-track. The plane lands and taxis to a halt. Hitler emerges, in his uniform, to acknowledge the cheers of the crowd. It is a marvellous evocation of the descent from the heavens of the Saviour, the Germanic god, the Baldur or Thor of Nazi literature, coming to move among his people and effect their salvation.

Throughout the film this theme recurs, with Hitler almost always seen in isolation, photographed from below waist height so that he seems to tower above us from the screen. It is always the Leader alone, whether haranguing the multitudes from the rostrum or reviewing the troops from his car or acknowledging the serenading Gestapo from his balcony. Shots of the lone figure of the Führer are intercut with shots of the masses, solid dehumanized blocks, waiting for the Word from the Leader. In the sequence of Hitler's motorcade through Nuremberg the camera is placed behind Hitler, his arm extended in the Nazi salute, and it gives us a Führer's eye view of the crowd. Shots of individuals are picked out: faces of men, women, children, even a cat, gazing adoringly at the Leader. The statues of the great men of old gaze down approvingly and, later, Nurembergers in eighteenth-century peasant dress, symbolizing the old Germany, are presented to Hitler the Leader, who symbolizes the new.

This continuing theme reaches its crescendo in the closing ceremony of the Congress. Rudolf Hess, his eyes blazing with an exultant fanaticism, declares: 'The Party is Hitler. But Hitler is Germany, just as Germany is Hitler.' From the masses filling the Congress Hall comes a full-throated roar: 'Sieg Heil.' The camera pans across a sea of outstretched arms hailing the Leader. Again scenes of mass homage are intercut with shots of Hitler alone, a smile of triumph on his face. The film ends with a swastika banner, the Horst Wessel song on the sound-track and superimposed stormtroopers marching under the leadership and inspiration of the Führer to the glorious Nazi future. This final sequence sums up what the film is all about; it represents the final consummation of the triumph of the will.

There are also echoes of this in *Olympiad*. For Hitler, as Head of State of the host country, can be seen as the figure to whom the homage of the athletes of the world is being paid. His keen concern for athletics and all that it implies for Nazism – health, strength, beauty etc. – is illustrated by shots of him watching the events intently and discussing them with his aides.

Ritual and imagery

The Nazis had proclaimed the birth of the Third Reich, a world empire that was to last for a thousand years. This meant that they had to create, virtually overnight, a fully-formed programme of ritual, ceremonial and imagery to go with it. There is something in the human soul which craves for panoply and splendour and the Nazis set out to supply

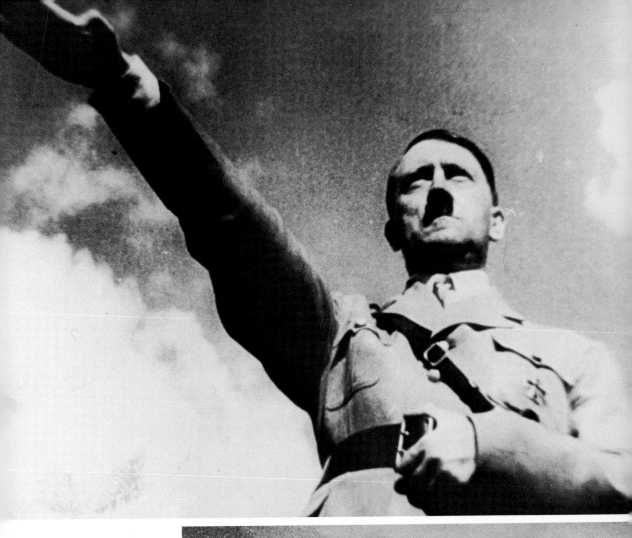

The cult of the leader
189, 190 Throughout
Triumph of the Will,
Hitler is almost always
seen in isolation,
photographed from
below waist height so
that he seems to tower
above us from the screen

this need, again as a deliberate attempt to play on the basic emotions. The emphasis in their films, books, paintings and sculptures is insistently on the elaboration of this ritual, a ritual of National Socialism which will supersede that of both Church and State. The key icons in the creation of this ritual are the flag, the eagle and the uniform.

The anti-Nazi author Verrina wrote in 1941: 'It is almost impossible to overestimate how important a factor was the revival of the uniform in the propaganda of Nazism.'[6] Indeed there can be little doubt that the wearing of a uniform, any uniform, imbues the wearer with an almost mystical sense of his own power. This sense of power is conveyed to the audience in *Triumph* as men in uniform surge across the screen in a succession of different patterns and combinations, men in the uniform of the Gestapo, the Land Army, the regular Army, the S.S., even the police. Not just the breathtaking long-shots of uniformed hordes, but also close-ups of details of uniforms: a long pan along a line of police, arms linked to hold back the crowd, the camera focusing on their belts and belt-buckles; close-ups of marching jackbooted feet; close-ups of faces, topped by peaked caps, bearing a variety of insignia.

Even more perhaps than the uniform, the flag emblazoned with the swastika is emphasized and re-emphasized throughout the film. As Hitler drives through Nuremberg, Nazi banners hang from every building and from every window. There is a superb moment when the camera pans slowly beneath a line of enormous overhanging Nazi banners and then stops and tilts upwards, so that the screen is filled by the flag. There is the final scene, already mentioned, when the flag again fills the screen. Throughout the ceremonies, also, flags proliferate. As flags and standards are borne into the Congress Hall we lose sight of the people carrying them and the screen is filled with a moving forest of banners. We see Hitler attending the parade of standard bearers; he shakes hands with them and then, clutching the flag with an almost religious fervour, he draws it across the face of the bearer as he moves on to the next man. Probably the two most

memorable sequences in the entire film centre on the flag. The first is the blessing of the flags, filmed in long-shot, with Hitler, Himmler and Lutze walking together between the massed ranks of the party to the tomb of the German Dead of the First World War, where an eternal flame burns, and where the flags wait to be blessed. The second, another stunning long-shot sequence, is of the procession of flags, seemingly endless, down the stadium and up past both sides of the rostrum on which Hitler stands.

We get the same insistent repetition of close-ups with all the other icons: the great stone eagle of the Luitpold Stadium poised against the sky, the swastika armbands, the trumpets blaring out the fanfare of the new Germany, and at night, torches, symbolizing the hope of National Socialism in the darkness of national disgrace.

With this emphasis on the icons is linked the ceremonial, the succession of parades, processions and reviews, the constant elements in which are precision movement and quasi-religious liturgical responses. The latter element is most perfectly expressed in the sequence of the Labour Front reviews, where the section leaders roar the questions and the sections intone the responses, affirmations of faith in Hitler, the Party and the Fatherland. ('Ein Volk. Ein Reich. Ein Führer.') But there is the overall pattern of response, also, of a statement or speech by one of the leaders being punctuated at intervals by a ritual 'Sieg Heil'. Throughout the film, where the masses are involved, the emphasis is on symmetry and order. The classical simplicity of the Nazi architecture is paralleled by the repeated panning shots along lines of outstretched arms, lines of flags, lines of policemen, always straight lines, and by the high-angled overhead shots of people on the move, always in organized solid blocks, squares, rectangles, oblongs, their individuality submerged by their participation in these geometric patterns of humanity.

Throughout the film the imagery is of the barbaric might of pagan Germany mingled with the splendour and ritual formality of Imperial Rome. In the bonfires and torchlit

processions, the communal singing, the standards modelled on those of Attila's Huns, the very choice of Nuremburg, shrine of German romanticism, as a setting, the emphasis is on Germany in its heroic essence; while in the massive march pasts and processions, the flag-blessings and motorcades, in the emphasis on uniforms, eagles, trumpets and the 'Sieg Heil' salute and in the stark classical simplicity of the stadium buildings, the reference is to Rome and Empire. Thus the film's imagery links the two: 'Deutschland und Reich'; and the scenes evoke at once a Roman triumph, a pagan cult mystery and a Teutonic folk moot.

The same obsession with ritual and ceremonial informs *Olympiad*, and cross-references can be found in the film to most of the elements making up the ritual content of the *Triumph*. The Games begin with an opening ceremony. The athletes enter the Olympic Stadium in formation, their national flags preceding them. The oath is taken. Birds are released. The torchbearer runs into the stadium to light the Olympic flame. The film from then on is punctuated regularly with ceremonial, and ceremonial in which the emphasis is on Nationalism rather than Internationalism: the raising of the national flags and the playing of the national anthems for each result, the crowning of the victors with laurel wreaths, the constant panning shots along the lines of flags and, perhaps most notably, the super-imposition of the national flag over the face of a victorious athlete. The liturgical chanting of *Triumph* is paralleled here by the crowd chants, notably of the Americans, the Germans and the Japanese. Thus in the pole vault the American chant 'U.S.A.' is answered by the Japanese chant 'Nisheida' (the name of their star pole-vaulter). Again shots of the massed watching crowds are intercut with those of the lone athletes, to emphasize their isolation and the burden of responsibility on them. Riefenstahl's most notable image of the human pattern occurs in *Olympiad*, in the eurhythmics sequence. The camera focuses on a single girl, twirling her hoop, and pulls back gradually to reveal more and more girls until we see a perfect symmetrical pattern of anonymous human dots, bending their bodies in perfect unison. Once again the icons, not specific Nazi icons this time, but abstract ones, recur: the flag, the flame, the trumpet.

Health and strength

Where *Triumph of the Will* celebrated the first two elements of the Nazi *Weltanschauung*, the Führer principle and the Herrenvolk principle, Leni Riefenstahl's second great documentary, *Olympiad*, celebrated the third element, the concept of health and strength, which was so much a part of the doctrine of 'Blut und Boden' (Race and Soil).

The Race is the Germanic race, and the soil is the Land, the source of its strength. For the purity of both, the Nazis looked to antiquity, to 'the days of long ago that have no beginning'. It was not just to the old days and the old Volk that they looked, but to the ancient beliefs too. A religion emerged which was essentially pagan and pre-Christian, whose virtues were strength and will, and whose great exponent was Nietzsche. Christianity, with its religious individualism, its stress on conscience, renunciation, forgiveness, concern for the eternal salvation of the soul, was foreign to the whole Nazi ethos.

So the Nazis sought to turn their ideology into an alternative religion, in which Hitler was the new Messiah, in which the swastika replaced the Cross, in which the key doctrines were strength and will and in which the Germans were the chosen people. A physical archetype was evolved to embody all the ideals and aspirations of the Nazi creed: the Nordic superman, tall, blond, clean-cut; and, to foster the archetype, great emphasis was laid on athletics. The Olympic Games, which linked antiquity and athletics, particularly appealed to them, as witness Hitler's keen interest. Speaking at the opening of the House of German Art in Munich he linked all these ideas: 'The new age of today is at work on a new human type. Men and women are to be more healthy, stronger: there is a new feeling of life, a new

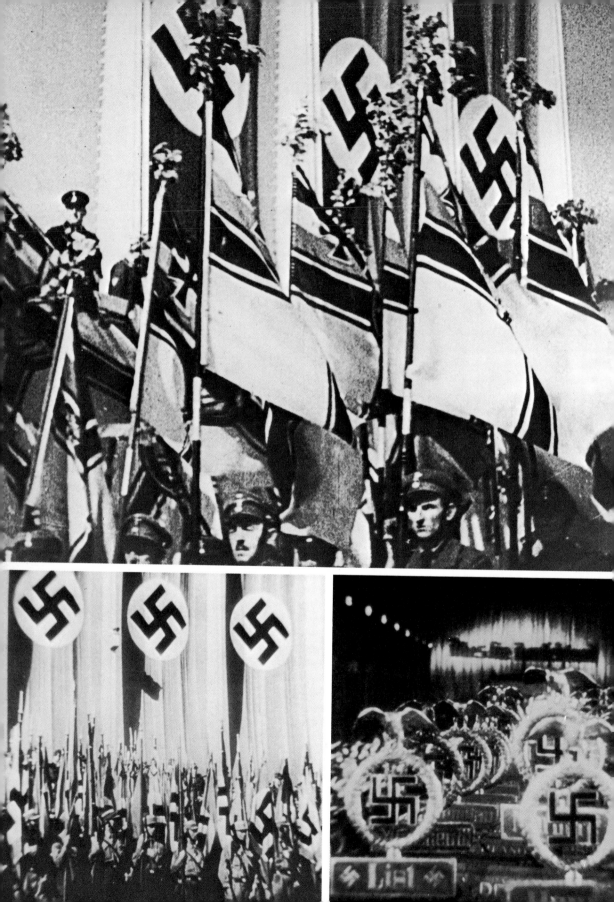

Ritual and imagery
191–6 The emphasis in Nazi culture
was insistently on the elaboration
of a ritual which would supersede
that of both church and state. The
key icons in the creation of this
ritual were the flag, the eagle and
the uniform

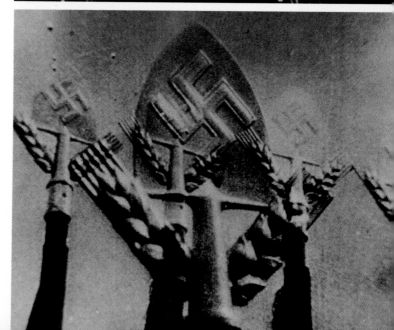

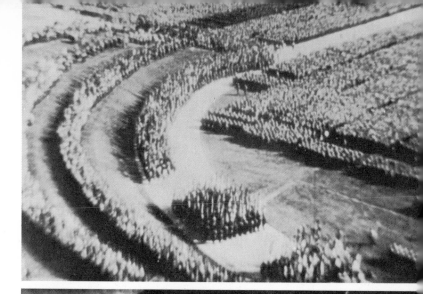

Patterns of people
197–9 Throughout
Riefenstahl's films the
emphasis is on symmetry
and order. The individuality
of the people is submerged by
their participation in
geometric patterns of
humanity

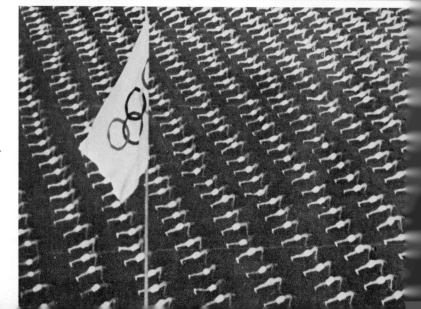

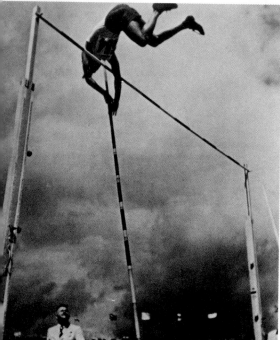

203–6 Some of the events in *Olympiad*
(notably the marathon and the pole vault)
are portrayed as athletic triumphs of the
will

joy in life. Never was humanity in its external appearance and in its frame of mind nearer to the ancient world than it is today.'[7]

The cult of the physical form, pre-eminently the male form, and the idea of *Kameradschaft*, comradeship between men, with its wealth of association with Sparta and all that the adjective 'spartan' implies, was central to all Nazi art. Naked, muscular, Nordic supermen are the constant models of Nazi artists. It is in this that Leni Riefenstahl's *Olympiad* can be seen as the cinematic counterpart of the sculptures of Arno Brecker and the paintings of Adolf Ziegler and Richard Klein.

The film is far more than simply a documentary account of the 1936 Berlin Olympics. It is a hymn to the human body and to the glories of competitive sport, an athletic triumph of the will and the strength. It opens with a memorable evocation of the myth of antiquity and physical beauty. A long, slow, tracking shot through the swirling mist; a stark landscape glimpsed vaguely in the background; fallen stones loom up and vanish again; and then ruins. A montage of ruined Greek temples follows; then a slow pan along a line of statues of Greek athletes, turning on their bases; and these are gradually transformed into human bodies, naked, muscular, beautiful, posed against skies dark with swirling clouds. In slow motion they bend and twist, flinging the javelin and the discus. Naked women, their bodies swaying and weaving, perform eurhythmics. Finally a runner, with the Olympic torch, runs down the dusty roads and through the marble temples of Greece. The torch is borne northwards from Greece to Germany, symbolizing, as it were, the transfer of the torch of Aryan civilization from Greece, now ruined and derelict, to Germany, now strong and vigorous. It is cinematic expression, again, of the words of Adolf Hitler: 'It is felt in the depths of the German soul that in the Nordic Aryan the Hellenism of antiquity is revived.' In the marvellous opening sequence it is all there: the mists of antiquity, the pagan idealization of beauty, the Nazi idealization of strength.

Inevitably *Olympiad* is more uneven than *Triumph*, much less of an organic whole due to the necessity of choosing the items. The film contains areas of straight reportage as well as artistically shaped sequences. We get, on the one hand, straight filming of the track events, rather perfunctory snatches of polo, football, hockey, and yachting. But on the other hand, we get brilliant set-pieces, all designed to illustrate the basic theme of the film.

There is the pole vault, which develops into a grim duel between the Americans and the Japanese, going on from day into night as the bar is raised higher and higher; the athletes become more and more tired, but hold on desperately until the Americans achieve victory. There is the marathon, where Son, the Japanese athlete, wins, beating the Englishman, Harper, into second place. His run is filmed by intercutting shots of him gliding serenely on towards victory and subjective camera shots of the road beneath him, the trees above and the waving grass beside the road: the linking of Man and Nature.

There is the decathlon, where from the start our attention is drawn to the unknown American athlete Glenn Morris, the future screen Tarzan, and we follow his progress, dogged, determined, ever upwards, until he achieves final victory after the ten events to become the greatest all-round athlete in the world. He becomes the living incarnation of the myth of the Aryan body and the Aryan spirit as he is crowned with the laurel wreath of victory and gazes purposefully into the distance. In all these events we see a ritual pattern, the testing of the strength and the will of man to win.

The human body itself is the object of the camera's loving veneration throughout, but several sequences stand out. At the start of Part II of the film there is a lyrical sequence which opens in a wood, shrouded in the early morning mist; the camera picks out symbols of nature: a delicate cobweb, crawling insects, a rain-splashed leaf, chirping birds, a stream, and then through the trees, a line of athletes running, out for an early-morning training session. Later we see them scything, naked, into a pool; men showering

together and sweating together in the steam-room. Once again, then, it is a memorable evocation of the Man-to-Nature, Man-to-Man links which form an integral part of the Nazi *Weltanschauung*. It can be cross-referenced with the sequences in camp in *Triumph*, where the camera pans across lines of Nordic stereotypes, combing each other's hair, washing together, singing together, eating together and indulging in friendly horseplay, the constant emphasis being on youth, comradeship and physical fitness.

The film reaches its climax with a superb diving montage, which begins as a straight filming of diving but develops gradually, with the use of slow motion, reverse shots and rhythmic cutting, into a glorious ballet of human bodies, diving and swooping in the sunset.

The sun cult was taken over by the Nazis from the New Romanticism preached at the start of the twentieth century by Eugen Diederichs. He had said: 'My view of God is this, that I regard the sun as the source of all life.' He revived the festival of the summer solstice, which was taken over and insti-tutionalized by the Nazis. The sun cult was patronized by Goering and preached by youth leader Baldur von Schirach. The sun was seen by them as the means by which cosmic strength is transferred to man. This provides each of the documentaries with a visual metaphor, which serves as a final link between them.

In *Triumph* there is a beautiful evocation of dawn. Through the window of an old stone building, across a swastika banner fluttering in the breeze, we see the sun rise over the medieval roofs and spires of Nuremberg. It symbolizes all that we associate with the sun: rebirth, renewal, cosmic strength. At the end of *Olympiad* lances with flags are lowered after the Olympic flame has guttered and died in the dusk. Then the lances are raised up, become shafts of light and merge at the centre into the ultimate light source, the sun, fountainhead of cosmic strength for the chosen people, the Herrenvolk.

In both style and structure the films of Leni Riefenstahl represent the peak of German film-making, a peak which it has

never regained since and perhaps never will They represent the climax of the Golden Age of German films, which virtually ended with the accession of Hitler to power. That is to say, their great strength lies in their visual appeal. Music, of course, enhances the mood and atmosphere of the films and the music of Herbert Windt, who scored the films, is particularly effective. But dialogue is largely superfluous. It is the images which evoke all the savage power and panoply of Nazism. In *Olympiad* commentary helps with the identi-fication of the athletes. But all too often the words are obtrusive and spell out crudely what the images on the screen suggest. In *Triumph* the subtlety of the image is some-times compromised by the bombast and the banality of the words of the Nazi leaders – though the great exception to this is Hitler's final speech, the climactic event of the Rally, in which, with lunatic fanaticism blazing in his eyes, he proclaims that the Reich will last for a thousand years.

In interview Leni Riefenstahl has laid great stress on two things, both of which stand out in her films: structure and rhythm. Her films are constructed like symphonies, divided into movements and permeated by motifs, which occur and recur in varying combinations. Like the music of Wagner and Brückner, her films are massive in a way that only Teutonic works can be. They represent an all-out assault on the senses and the emotions. She has said of *Triumph* that in making it, she set out to make a film 'qui frappe et qui émeuve' and she certainly succeeded.

Both films are miracles of construction. Their rhythm was imposed and controlled during the editing. She spent, for instance, a year and a half editing *Olympiad*. But both films followed a clear plan and on this question her own evidence is contradictory. Interviewed in 1965 she said: 'I didn't write a single page of text for either *Triumph of the Will* or *Olympiad*. The moment I had a clear picture of the film in my head, the film was born. The structure of the whole imposed itself. It was purely intuitive.'[8] She says this in support of her argument that *Triumph* is not propaganda but objective documentary,

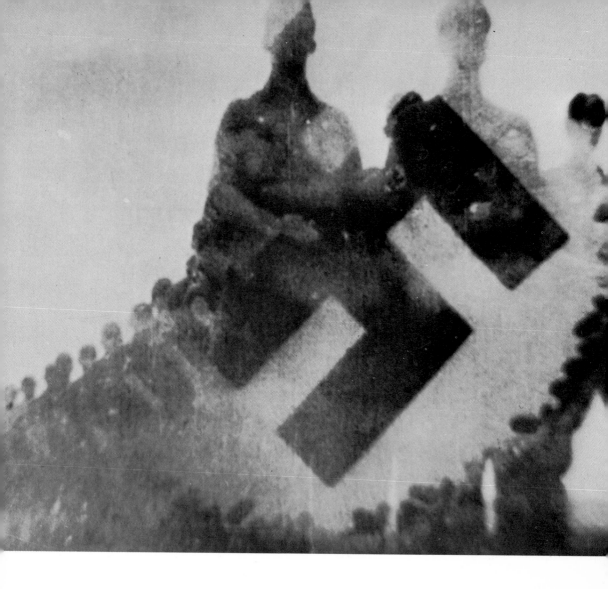

Today Germany, tomorrow the world
207 *Triumph of the Will* ends with a swastika banner, the Horst
Wessel Song and storm troopers marching under the leadership and
inspiration of the Führer to the glorious Nazi future

film *vérité*. But this conflicts with the statement she made to the party newspaper *Völkischer Beobachter* in 1933, when she said that the film of the Nazi conference would be based on a carefully prepared script.[9] The finished product would certainly seem to bear out the latter statement. In its hypnotic power and enthusiastic intensity, in its epic sweep and visual grandeur *Triumph of the Will* stands alongside Eisenstein's *October* and *Battleship Potemkin* as one of the greatest propaganda films of all time.

Leni Riefenstahl's association with Nazism, even if it was only cinematic as she claims, ensured that there would be no place for her in the post-war German cinema. Since 1945 her life has been an endless round of legal battles and failed projects. An undoubted cinematic genius has been wasted. But in *Triumph of the Will* and *Olympiad* she has left us two enduring monuments to this genius.

Notes

1 Her denial has been supported in a carefully argued article by Arnold Berson: 'The truth about Leni', *Films and Filming* (April 1965), pp. 15–19.

2 Leni Riefenstahl, interview in *Cahiers du cinema* (170) (September 1965), p. 44.

3 For rival interpretations of the mountain films see Siegfried Kracauer, *From Caligari to Hitler* (1947), pp. 110–11, 257 and Arnold Berson, op. cit., p. 16.

4 Kracauer, op. cit., p. 259.

5 Leni Riefenstahl, *Hinter den Kulissen des Reichsparteitagfilms* (*Behind the Scenes of the Rally Film*) (1935).

6 Verrina, *The Nazi Mentality* (1941), p. 61.

7 George L. Mosse (ed.), *Nazi Culture* (1966), 15.

8 Riefenstahl interview, op. cit., p. 62.

9 Hamilton Burden, *The Nuremberg Party Rallies 1923–1939* (1967), p. 94.

What is remarkable about the cinema in Nazi Germany is not how many overtly propagandistic films were produced but how few. Of the 1,097 films produced in Germany between 1933 and 1945 only some 96 were specifically commissioned by the Film Section of the Propaganda Ministry.[1] They are the so-called 'Staatsauftragsfilme'. The failure of the three earliest Nazi propaganda features, *S.A.-Mann Brand*, *Hans Westmar* and *Hitlerjunge Quex*, to make money amply demonstrated that people would not go and see blatant propaganda features. Consequently Goebbels changed his policy and concentrated the bulk of his propaganda in the newsreels, which were eventually extended in length to forty-five minutes. Thus people who were lured into the cinema by the prospect of a 'straight' comedy or thriller or musical could also be brainwashed as they sat through the newsreel. It is this policy which lay behind Goebbels's bitter hostility to the making of *Triumph of the Will*,[2] a feature-length documentary which could not be construed as anything other than direct propaganda. But since it was a personal project of Hitler, filming went ahead, though not without Goebbels doing everything he could to hamper it.

The undoubted emphasis of the bulk of German films under the Reich was 'escapism', increasingly so as the war began to go badly. But the offical outlook and certain policy decisions were dramatized in the annual output of state-commissioned films. Even in the purely 'escapist' films the all-pervading presence of National Socialism could often be observed. Many otherwise innocuous comedies and dramas were banned by Allied authorities after the war because of the prevalence of Nazi symbols: flags, uniforms, salutes, insignia. The significance of these icons has already been commented on. They are sometimes assigned a central role, as, for instance, in *Ein Robinson* (Dr Arnold Fanck, 1940). The hero of the film, having left Germany because of his disgust with post-war conditions, lives on a desert island, like Robinson Crusoe. But he keeps his naval cap with the German emblem on it as a sort of sacred relic. So anxious to keep it is he that in going back for it he misses the rescue ship which comes for him.

As Hitler had said, one of the major functions of propaganda lay in 'the orientation of the mass towards specific facts', and certain of the state-commissioned films were designed to present certain specific facts of the Nazi programme in dramatic, fictionalized form. The most notable of these was the group of films seeking to justify the extermination of the Jews, and we shall look at them in detail in a later chapter. After them perhaps the most important, and certainly the best produced and most convincing, was *Ich klage an* (*I Accuse*) (Wolfgang Liebeneiner, 1941), which set out to justify the Nazi policy of euthanasia.[3]

Ich klage an is a classic example of presenting a point of view in the tear-jerking emotional terms of a personal tragedy. It evokes and manipulates the feelings of the mass audience, swayed, as Hitler had noted, by emotion and not reason. It is an unashamed 'weepie', calculated to have the spectator reaching for his handkerchief with alarming regularity. Professor Thomas Heyt (Paul Hartmann), brilliant young medical researcher, discovers that his wife, Hanna (Heidemarie Hatheyer), beautiful and talented pianist, has multiple sclerosis. He devotes all his energies to discovering a

cure for it. But she begs him to put her out of her misery. At first he resists, because he has always believed it to be a doctor's duty to preserve life and not to take it. When her suffering increases and the cure does not materialize, he finally gives in to her pleading and gives her an overdose. She dies in his arms. He tells his best friend, Dr Bernhard Land (Mathias Wieman) what he has done and the friend, horrified, reports him to the police. He is brought to trial for murder.

The trial allows the arguments for euthanasia to be presented in such a manner as to sweep away all the objections. A priest (representing the Church) declares that he does not believe the old idea that God wants people to suffer before they die and that he is in favour of shortening unnecessary suffering. Bernhard (representing the medical profession), after visiting a hospital where children suffering from multiple sclerosis have been kept alive but are all mad, blind and in terrible pain, comes over to Thomas's side and testifies on his behalf. An old huntsman on the jury (representing the voice of the common people) says that he has just put his dog down to prevent him suffering and that it is not common sense to treat people worse than animals. Finally Thomas makes an impassioned speech justifying his action and putting it to the jury (i.e. the audience) that what he has done is entirely right and proper. He calls for the law to be changed. ('A legal order which prohibits the mercy killing of an incurable, sick person is inhuman and artificial.') In the light of all this the action of the state in approving euthanasia would seem to be the wished-for answer to the predicament of the film's hero and the satisfying resolution, in real life, of the hypothetical drama postulated on the screen.

One of the earliest state-commissioned films is *Das alte Recht* (*The Old Right*) (Igo Martin Andersen, 1933), a crude and simplified rustic tale planned as a justification of the Nazi *Erbhofgesetz* (the Heredity Farm Law) which had been passed in 1933. The law stipulated that farm estates over a certain size could not be sold for debt and that the estate should pass to the eldest son of the owner. The action, on one level, was a working out of this principle, but the film also served the larger purpose of glorifying the life of the peasant and the ideal of agrarian life on the Land.

The Anschluss found cinematic justification in *Wetterleuchten um Barbara* (*Summer Lightning about Barbara*) (Werner Klingler, 1941). Nazi sympathizers in the Austrian Tyrol are persecuted by the authorities. Their secret meetings are broken up by the local militia but their leaders flee across the border into Germany. They are just in time to join the German troops in their victorious march into Austria, which prevents further action being taken against the Nazi heroes. Personalization and audience identification centres on the dilemma of Barbara (Sybille Schmidt), who in court, after the flight of her husband, has to accuse him of murder in order to save the life of his best friend. But her dilemma is resolved by the Anschluss, which is thus seen both on a personal level and on a national level to be a good thing.

The official party line on degenerate art was dramatized in *Venus vor Gericht* (*Venus in Court*) (Hans H. Zerlett, 1941). In pre-Hitler Germany a young German artist buries one of his statues in Bavaria. It is discovered and declared by Jewish art experts to be an ancient Greek masterpiece. One of them buys it and sells it to the government at a fantastic profit. But the artist, a good Nazi, announces that he made it and buried it to show up the degeneracy of modern art and the dishonesty of the Jewish art experts. He is prosecuted by the state and the Jews testify that he could not possibly have made it. So he produces the girl who was his model and the Jews are confounded. The Jews are portrayed as utterly unscrupulous villains, who propagate decadent, modern art while profiting from the true, ancient Aryan art.

Much more than specific items of policy, however, Nazi feature films sought to highlight significant themes and motifs of the National Socialist ideology. Pre-eminent among these was, of course, the leadership principle. Among Nazi cinematic archetypes

208, 209 Some state-commissioned films were designed to present elements of the Nazi programme in dramatic, fictionalized form. *Ich klage an* set out to justify the Nazi policy of euthanasia

the Great Leader came first. Thus several films were commissioned to glorify Hitler-style German leaders of the past.

The most notable was Frederick the Great. There had already been a popular cycle of militarist and nationalist 'Fridericus' films in the pre-Nazi period, films like *Fridericus Rex* (Arzen von Cserepy, 1922), *Das Flöten-konzert von Sanssouci* (*The Flute Concert of Sanssouci*) (Gustav Ucicky, 1930) and *Barberina, Die Tänzerin von Sanssouci* (*The King's Dancer*) (Friedrich Zelnik, 1932). Siegfried Kracauer has commented on these films:[4]

> The screen Frederick is given two major virtues. He appears as the father of his people – a patriarchal ruler using his absolute power to mitigate legal hardships, further general welfare and protect the poor from exploitation by the rich. Simultaneously, he appears as the national hero, who, through several successful wars, elevates little Prussia to the rank of a great power. The whole construction overtly aims at convincing the audience that another Frederick might not only prove an effective antidote against the virus of socialism, but might also realize Germany's national aspirations ... The moral of the Fridericus films was to submit unconditionally to absolute authority.

It is not Frederick the philosopher-artist of 'the Enlightenment' but Frederick the warrior-hero of Prussia who is apotheosized on film. In this guise he was an ideal proto-type Führer and the events of his reign were, in due course, to be re-written to fit in with contemporary events and to make the parallel even more direct.

The earliest of the Nazi 'Fridericus' films is *Der Choral von Leuthen* (*The Chorale of Leuthen*) (1933), directed by Carl Froelich, one of the keenest Nazis in the film industry and later Head of the Reichsfilmkammer. It starred in the leading role Otto Gebühr, who had played Frederick in all the pre-Nazi 'Fridericus' films and who was fated to spend the best part of his career impersonating the Prussian king. The film showed Frederick as

the all-wise and all-knowing Leader, who insists on fighting the Austrians at Leuthen in spite of the contrary advice of his generals. Naturally he wins the battle. Later he demonstrates his effortless superiority over the enemy by single-handedly outwitting them when he arrives alone at a country house, still occupied by Austrian troops.

In 1935 Hans Steinhoff, another loyal Nazi, directed *Der alte und der junge König* (*The Old King and the Young King*). It shows how Frederick (Werner Hinz), when Crown Prince, learned the meaning and value of absolute, unquestioning obedience to his Leader and father, King Frederick William (Emil Jannings). Frederick is seen, at first, as a court dandy. All attempts to reform him fail and he is finally responsible for a criminal act, of which his best friend is suspected. The old King, knowing full well who the real culprit is, none the less executes the friend for the crime. Frederick learns from the sacrifice of his friend and decides voluntarily to reform and become a true soldier of the Fatherland. He comes to understand that his father is motivated, as he himself becomes motivated, by the glory of Prussia. So the youthful rebel, putting rebellion behind him, is ready to take over from his father as the next great Leader.

By contrast with Steinhoff's film, which was lavishly produced and well-acted, the next instalment in the saga, *Fridericus* (also known as *Der alte Fritz*) (Johannes Meyer, 1936), was poorly written and scrappily directed. It begins with the defeat of the Austrian army by Frederick (Otto Gebühr again). Then it shows Prussia encircled by French and Russian armies. But Frederick, by virtue of his genius as Leader, achieves victory, repels the invaders and returns to Potsdam to begin building the new Reich.

By 1942 the historical events are being deliberately rigged to suggest a contemporary parallel. *Der grosse König* (*The Great King*) (Veit Harlan, 1942) opens with the defeat of Frederick (Otto Gebühr again) at Kunersdorf. The Austrian generals report to their Empress that Prussia is beaten. Frederick's generals urge him to make peace. His family urge him to make peace. The people urge him

to make peace. But Frederick refuses, preferring death to surrender. He takes over personal command of the troops. His enemies fail to follow up their advantage and the fortune of war turns. The Russians offer an alliance against Austria and Frederick, knowing that he cannot trust them, agrees but keeps a wary eye on'them and is able to outwit them when they go back on their word and break the treaty. At Leuthen he defeats the numerically superior Austrian army and Prussia is victorious; Frederick's genius is vindicated. Substitute Hitler for Frederick and you have a Nazi view of the events of the past few years.

All the films emphasize the loneliness and dedication of the Leader. In *Der alte und der junge König*, Frederick's best friend is executed. In *Fridericus* his beloved sister Princess Wilhelmine dies and he finds himself alone. In *Der grosse König* Prince Heinrich, the only person in the world he loves, dies and state duties prevent Frederick from being at the deathbed. The fact that the Leader knows better than his people is constantly stressed. It is by virtue of the genius of the Leader that victory is achieved, almost always against overwhelming odds. The Leader outfights (as in *Fridericus*) and outwits (as in *Der Choral von Leuthen*) the enemy. For he has learned early (in *Der alte und der junge König*) to consecrate himself totally to the State. The State is his life. He is the State, its greatness and its destiny.

The other Prussian leader to be cast in the same mould is Bismarck, the Iron Chancellor, cinematically deified in two rather heavygoing films of Wolfgang Liebeneiner: *Bismarck* (1940) and *Die Entlassung* (*The Dismissal*) (1942). Both films were produced on a large scale with elaborate sets and high-quality casts: Paul Hartmann played Bismarck in the first and the almost obligatory Emil Jannings took the part in the second.

In *Bismarck* we see the Great Leader in his prime, as he seeks the fulfilment of his unshakeable aim, a strong and united Germany. The film opens in 1862 with Germany divided into forty states. The Prussian King, Wilhelm I, is unable to get his demand for a strong army through the Landtag and so he calls in Bismarck as Chancellor. When the Landtag continues its opposition, Bismarck dissolves it and introduces press censorship. He declares blood and iron to be the basis of the true state and says that the Germans must be forced into unity for their own good. Like Frederick, Bismarck knows what is best for the people. He builds up a strong modern army and begins to implement his blueprint for the unification of Germany. Schleswig-Holstein is incorporated after a war with Denmark. Austria, Prussia's rival for German hegemony, is defeated in war and France, which has demanded the Rhine province as the price of non-intervention, is outwitted by Bismarck. Bismarck survives an assassination attempt by the English Jew, Cohen, and the film ends with the coronation in 1871 of Wilhelm I as Emperor of Germany.

Bismarck is clearly seen as an early prototype Führer. His enemies, like Hitler's, are democracy (as represented by the Landtag), England and the Jews (as represented by Cohen) and rival European powers (Austria and France) who seek to encroach on the sacred soil of the Fatherland. But, like Frederick before and Hitler since, Bismarck outfights and outwits his enemies to unite the Fatherland.

The sequel, *Die Entlassung*, opens in 1888 with the deaths of Wilhelm I and Friedrich Wilhelm III within a short space of time and the accession of Wilhelm II (Werner Hinz), who is portrayed as an arrogant and irresponsible degenerate. He and Bismarck clash at once and Bismarck retires. But he has to be recalled. Wilhelm's criminal folly threatens all that Bismarck has done. He manages to preserve his life's work and thwart Wilhelm's plans. However, charges are trumped up against him and he is forced to resign. The moral is plain. Bismarck's work is left unfinished, awaiting the rise of a new Leader. That Leader is Hitler, whose reign is seen as the fulfilment of Prussia's destiny. Significantly this film was also released under the title *Schicksalwende* (*The Fateful Turning Point*).

Early apostles of Pan-Germanism were lauded in film biographies, which departed

The leader
Among Nazi cinematic archetypes, the Great Leader came first.
210 (above) Otto Gebühr as Frederick the Great in *Der grosse König*
211 (left) Paul Hartmann as Bismarck in *Bismarck*
212 (opposite) Emil Jannings as the steel magnate in *Der Herrscher*

from the facts in order to fit the heroes for the Nazi pantheon. The hero of *Der unendliche Weg* (*The Unending Road*) (Hans Schweikart, 1943) is Friedrich List (Eugen Klöpfer), the nineteenth-century economist and professor of political science. He campaigns against the customs barriers, which perpetuate the division of Germany into small states. His dream is a politically and economically united Germany. He is opposed, however, by the Austrian statesman, Prince Metternich, whose plans do not include a united Germany. Metternich has him imprisoned. Eventually he emigrates to America and there participates in the building of the railroads. He returns to Germany and becomes a pioneer in the building of the German railway system, seeing in them one method of bringing about greater unity. Metternich again intrigues against him and List believes himself beaten when suddenly a popular insurrection breaks out and the people burn the customs barriers. It is the first step towards unity. In actual fact what List had been really fighting for was self-government for the municipalities against the despotism of centralized bureaucracy. But for the purposes of Nazi propaganda, he becomes one of the great Pan-Germans.

The Nazis found a genuine Pan-German in Schiller, but with his Pan-Germanism went a love of freedom and hatred of militarism which would seem, on the face of it, to make him the antithesis of Nazism. Nothing daunted, the Nazis went ahead and produced a film biography, *Friedrich Schiller* (Herbert Maisch, 1944). Freedom-loving young poet Friedrich Schiller (Horst Caspar) opposes the Duke of Wurtemberg (Heinrich George), who seeks to make him learn discipline. The Duke compels him to serve in the army against his will, forbids him to write plays and even imprisons him. Schiller persists, writing *The Robbers* in prison and getting it published before escaping from confinement and crossing the border to freedom. With its freedom-loving hero and its tyrannical Duke, who suppresses free speech and stands for unquestioning obedience to authority, the film looks like a classic anti-Nazi parable. But the Nazis, by emphasizing the Pan-

Germanism of the hero and casting the Duke as representative of petty German states who oppose the unification of the Fatherland, brought it into line. None the less, Goebbels thought it as well to cut the film's final line, 'Freiheit', whispered by Schiller as he left Wurtemberg.

Thus far all the Leaders discussed have been historical characters, but the Nazis created their fictional Great Leaders too. The most notable of them was the hero of the important film *Der Herrscher* (*The Ruler*) (Veit Harlan, 1937), which was awarded the National Film Prize. The Ruler is the German steel magnate, Matthias Clausen (Emil Jannings), head of an industrial dynasty clearly modelled on the Krupps. After the death of his wife he falls in love with his young secretary, Inken (Marianne Hoppe). His children, fearful of losing their inheritance, try to have him certified insane. Their attempt fails and after much drama, Clausen and Inken are united.

The importance of the film lies in the characterization of Clausen. He is the archetypal Leader. He refuses to retire because no one on the board of directors is worthy to carry on his ideals, which include helping the state at great expense to the company. He has built and created the steel empire and only he has the strength and the will and the genius to carry it on. He demands absolute obedience from his workers, who call him 'Führer', and from his directors, who he says must obey him even if it means ruin. Finally he dictates a will leaving his empire to the people because his relatives are not worthy of it. But lest this be construed as a democratic act, he makes a climactic speech outlining his true hopes:

'All I won will belong to my country, to the people with whom I worked and who worked for me. One day, out of their midst, a leader will grow, strong enough to continue my work. And no-one shall be allowed to interfere with the decisions of this leader. All leaders are responsible to their own conscience and their strength.'

The impact of the leadership films cannot

be underrated. A survey published in 1944 revealed that the six most popular films with German youth were, in this order, *Der grosse König, Bismarck, Die Entlassung, Friedrich Schiller, Heimkehr* and *Ohm Krüger*.[5] Five of them are classifiable as Great Leader films. On the face of it this is strong evidence for the theory of a psychological need in the Germans, for reasons we have already gone into, for a Great Leader to admire and to obey. It had been one of the factors contributing to the rise of Hitler and to his maintenance of power once he had obtained it.

The corollary to the Great Leader is, of course, the loyal follower. The only films of the Reich to be devoted totally to depicting party members, *S.A.-Mann Brand, Hans Westmar* and *Hitlerjunge Quex*, all made in 1933, are of fundamental importance because of their idealization of Nazi party archetypes.

The first and least successful of them, *S.A.-Mann Brand*, was a crude and cheaply-made tract, directed by a hack (Franz Seitz) and featuring a cast which was largely unknown. It was set in pre-Hitler Germany and personalized the conflict in a family. The hero Brand is a loyal Nazi and because of this is expelled from his trade union, which thereby reveals itself to be corrupt. His father, a Social Democrat, opposes him, though his mother secretly supports him, and eventually he leaves home. He goes to lodge with a Nazi widow, whose beloved son, Erich, a member of the Hitler Youth, he takes under his wing. Erich longs for a uniform and his mother sews all night to get money to buy him one. The Communists, who are seen as brutal gangsters, plan to attack the S.A., but their plans are betrayed to Brand by a Communist woman who is in love with him, and they are foiled. Hitler Youth Erich marches for the first time in the street with his uniform on and is shot down. Brand carries him to his mother and he dies with the words: 'I am going to the Führer.' There is an upsurge of popular anti-Communist feeling as a result of such outrages as this and the Nazis are swept to power in the elections.

Much superior to this film is *Hans Westmar*, directed by Franz Wenzler. It is one of the classic personalizations of an ideology and is expertly constructed to argue its case. There is not a single sequence in the film which is not designed to strengthen and expand the doctrinal themes it enshrines. Initially, however, the film ran into difficulties. Intended as a biography of Horst Wessel, it was banned on the day of its scheduled première and sent back to the studio for re-editing on the grounds that it inadequately represented Horst Wessel and National Socialism. When it emerged, it was as *Hans Westmar*, a figure far removed from the real Wessel, a notorious pimp who had met his end in a street brawl. Whatever it had been like before, there can be little doubt that as it stands now, *Westmar* is a powerful and highly instructive Nazi text.

The title, which indicates the personalization aspect, is *Hans Westmar, one of the many, a German Fate of the year 1929*. Sonorous, funereal music, disturbingly reminiscent at first of 'God Save the Queen', is heard on the sound-track and two requiem candles burn with a huge swastika between them. Spring flowers are in bloom, the River Danube flows and folksy peasants waltz merrily in a Viennese beer garden. Handsome young student, Hans Westmar – ascetic features, Nordic profile – is there with his Austrian girlfriend and her father. She asks him if Vienna is as nice as Berlin. In reply the film cuts to Berlin. The 'Internationale' plays softly on the sound-track as men queue hopelessly for jobs, doss down in hostels or live in squalid hovels in poverty conditions. The Berlin Communist leader (Paul Wegener), deliberately made up to look like Lenin, surveys the squalor and complacently declares: 'Suffering is our best friend.' It is these conditions that have brought them control of three-quarters of post-war Germany.

Westmar comes to Berlin. At his classes the professor announces to a restless and angry audience of students the losses that Germany has sustained under the treaty of Versailles and declares that Germany is now part of Europe and that there will never again be war. 'Down with weapons,' he

declares. The reply is two sabres flashing across the screen and a voice announcing 'Up with weapons'. The camera pulls back to reveal Westmar and another student fighting a duel, a demonstration of manhood and a reminder of the militarist values of old Germany. It is broken up by the arrival of the police. The students watch out of the window as the Communists march through the streets and, turning his profile to the camera, Westmar declares: 'I tell you all Germany's at stake down there on the street. And for that reason, we must go amongst the people. We should not stand aside now. Everything's at stake. We must fight, hand in hand with the worker.' When someone observes that the workers do not want anything to do with Nazi students, he replies: 'There should be no more classes now. We are workers too, workers of the brain and our place is next to our brothers, workers of the fist.'

Hans's girlfriend comes to Berlin and he takes her and her father on a trip around the city. Her father declares incredulously: 'Berlin – Germany's capital – I don't recognize it.' For internationalism is rampant: U.S.-style bars, 'English spoken' signs and in the nightclub they visit a coloured singer, gross cigar-smoking Jewish plutocrats mauling Aryan women and, the ultimate insult, only English beer. This all contrasts unfavourably with the jolly Volkist entertainment we saw in Vienna at the start of the film. When the negro jazz band starts jazzing up 'Watch on the Rhine', Hans can stand it no longer. He denounces them all and leaves, crying: 'This isn't Germany.' The scene of frantic jitter-bugging fades into scenes of the trenches in the First World War as the Germans fight for the Fatherland and this in turn fades into a landscape of crosses in a cemetery of the war dead. In purely visual terms and without a word of dialogue, Wenzler asks the question: Is this what we fought for?

Westmar's answer is to join the Nazi party, the party dedicated to making Germany proud and great again and purging her of her decadence. Hans addresses a Communist meeting and provokes a riot, in which the Nazis chant 'Deutschland erwache' as they wade into the Communists. Later a Communist gang sets upon one of Hans's Nazi friends, beats him up and drowns him. The S.A. march, with Hans in the front rank, banners, uniforms, swastikas, chanting 'Deutschland Heil' and they demonstrate outside the Communist H.Q., which is plastered with signs saying: 'There is no Fatherland, only the Internationale.' Hans's girlfriend complains that she never sees him, but he says his duty must come first. In pursuance of his earlier statement, in which he explicitly rejected an élitist role for students, he moves amongst the workers, taking a job first as a taxi driver and later as a labourer. He begins to make great gains for the party. His girl and her father leave for America but Hans refuses to go with them. His place is in the Fatherland. The elections arrive. There is turmoil in the streets. The Communists lose heavily and blame Westmar, whom they plan to kill. Ill with his exertions on behalf of the party, Hans refuses to go away and convalesce. The work must go on. But the Communist gang burst into his room and gun him down. The last reel of the film is superb, echoing Riefenstahl in its marshalling of Nazi pageantry and raising Hans to the status of epic hero.

A lavish funeral procession is staged, in spite of the apprehension of the authorities. The coffin, draped in the swastika banner and heaped with wreaths, one of which is conspicuously from a certain A. Hitler, is followed by a seemingly endless line of carriages. The Communists try to break it up but are fought off. At the church the coffin is reverently carried along the path between a line of fluttering banners, lowered in homage, and packed ranks of party members, their arms raised in salute. The banners dip over the grave and then a voice, clearly intended to be Hitler's, declares: 'Raise the flag. That means the flag will climb again from death to shining life and with it, his spirit will enter us from the grave and march with us in our ranks, once we have taken power for the glory and magnificence of the New Reich.' The film ends with the fulfilment of this dream. The Nazis stage a torch-

lit procession through the Brandenburg gate to celebrate their assumption of power, and as the Horst Wessel song rings out on the sound-track, the image of Hans, carrying the banner, is superimposed over the marching men, his spirit infusing them with new supernatural strength. In the background the clenched fists of the Communists slowly, reluctantly, but inevitably, rise in salute to the new order, and the last shot is of the massed Volk marching towards the future.

The film says everything the Nazis wanted it to. It dramatizes the Nazi rejection of Bundist élitism in favour of mass participation, it denounces the decadent internationalism of the old order, characterizes the Communists as gangsters and enemies of the Fatherland, exalts militant dedication to the Party and to the Führer and, in passing, takes side-swipes at the Jews, the negroes and pacifist intellectuals.

The most popular and expensively produced of the three films was, however, *Hitlerjunge Quex*, directed by Hans Steinhoff and personally backed by Youth leader Baldur von Schirach. Like *Westmar* it is a fictionalized biography of a true-life Nazi martyr, in this case, Herbert Norkus, a Nazi youth murdered by the Communists in 1932. It is, as its foreword declares: 'A film about young people's spirit of sacrifice' and it uses as its theme song 'Unsere Fahn', the battle song of the Hitler Youth. What the film did was virtually a reprise of the plot of *S. A.-Mann Brand* but in a Youth context. The leading part was taken by an unidentified member of the Hitler Youth, chosen because he was typical.

Once again the divided family is the context. The hero is the significantly named Heini Völker. His father (Heinrich George) is a Communist, though he is portrayed as a man misguided rather than evil, a victim of the Weimar Republic. He believes that the only way out of Germany's problems is for everyone to unite behind the Communists and he therefore forces his son to join in Communist youth activities. Heini goes on a Young Communist outing and is disgusted by their behaviour and appearance: slovenly, noisy, undisciplined, smoking and drinking and flirting shamelessly. It contrasts starkly

with the bearing and appearance of the Hitler Youth on the same train: clean-cut, well-behaved and orderly. So attracted is Heini that, at night, he creeps out of the Communist camp to listen to the young Nazis singing around their camp fire, in celebration of the summer solstice. He is so taken with their song, 'Unsere Fahn', that he sings it at home to the horror of his father, who forces him to sing the 'Internationale', which he does with tears streaming down his face.

Heini's disillusionment with the Communists is completed when he learns that they are planning to attack and blow up the Nazi Youth Hostel. Heini reports their plan to the Nazis, who forestall the attack by detonating the Communists' store of dynamite. Heini's mother, driven to distraction by fears for her son's life after this, tries to gas herself and Heini. She succeeds with herself and duly dies but Heini is rescued, and while he is recuperating in hospital he is visited by members of the Hitler Youth, who present him with his uniform.

In a key scene, the Nazi Bannführer (Claus Clausen) confronts Heini's father. They discuss their ideologies; the Bannführer skilfully engineers the argument so that he wins and the father agrees to allow Heini to go and live at the Nazi Youth Hostel. Heini earns the nickname 'Quex' ('Quicksilver') since he undertakes all the most hazardous missions in the period preceding the all-important elections. Finally he goes to distribute election pamphlets in a Communist area of the city and is murdered in the streets. Dying, he has a vision of thousands of Hitler Youths marching to victory. The swastika looms up behind them and fills the screen. His dying words are the first line of 'Unsere Fahn': 'Our flag is fluttering before us.' The flag, with Heini's blood on it, becomes the symbol of the Hitler Youth.

An analysis of the three films reveals that each is concerned to stress much the same things. Each film involves the death of a martyr to the cause (Hans Westmar, Hitlerjunge Erich, Hitlerjunge Quex) and the audience, encouraged to identify with them, absorbs the idea that heroic death for the

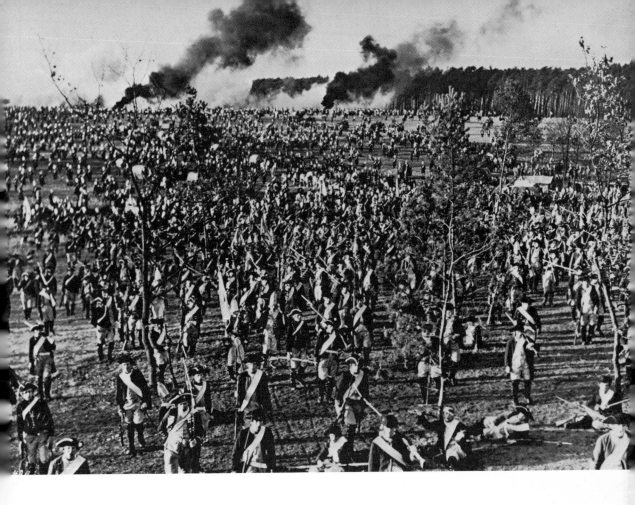

The followers
The corollary of the Great Leader is the loyal follower and absolute loyalty to the Leader is encouraged in many films.
213 (above left) *Hans Westmar* – the funeral of the loyal follower, who has died for the cause
214 (left) *Hitlerjunge Quex* – the idealization of the dedicated Hitler Youth
215 (above) *Der grosse König* – soldiers following the Leader to death or glory

Führer is the finest destiny open to any true member of the Volk. Each film invests its symbols with a mystic significance. The uniform is the object of the desires of Erich and Heini and both of them, obtaining the uniform after much struggle, die proudly wearing it. Even more symbolic is the flag. Hitler declares that Hans's soul will enter the flag and we see a vision of him carrying it. Heini's blood stains the flag and it becomes a holy icon for his comrades.

The Party is seen, in all three films, to take the place of the family as the proper milieu for the good German. Both Heini's family and Brand's family break up, with fathers hostile and mothers secretly sympathetic but ineffectual. Both Heini and Brand find their true home in the Party, in the comradeship of the S.A. and the Hitler Youth respectively. Hans Westmar's mother appears only at the end of the film, in time to weep at his funeral. His father does not appear at all and it is clear that he too has rejected home for the Party.

The affections of the three heroes all centre squarely on the Führer, whose portrait appears prominently. This means rejection of all distracting sexual involvement. Hans rejects his girlfriend because of his duty. Heini recoils from the advances of the girl Communist, Gerda. Theirs is a spiritual mission, the purification of the Fatherland, and their emotional needs are catered for by comradeship within the predominantly male groupings to which they belong. The contrast of archetypes completes the picture. The Communists are seen as greedy, dirty, treacherous thugs opposing the clean-cut, keen-eyed, blond Nordic supermen, or in the case of Erich and Heini, superboys. But these films are not repeated. They stand alone as the cinematic tributes to the archetypal Party members. Goebbels said that the place for the S.A. was on the streets and not on the screen and he preferred to use films to inculcate in his audience the virtues and attributes that the Nazis could best exploit to maintain and extend their power.

What these films do, interestingly, show is just how much of the Bundisch ethos the Nazis had absorbed. Hitler may have rejected élitism in favour of mass participation as far as running the country was concerned (viz. *Hans Westmar*, *Triumph of the Will*), but within the structure of the Party itself, as revealed by these three films, we see expressed all the elements of Bundism defined by Hans Bluher: charismatic leadership by the exceptional few, the all-male comradeship group, the sublimation of sex in the purity of the heroic mission and, of course, the idealization of the Aryan stereotype.

Notes

1 *Allied Control Commission Catalogue of Forbidden German Films* (1951).
2 Arnold Berson, 'The truth about Leni', *Films and Filming* (April 1965), p. 17.
3 On the importance of *Ich klage an* in the euthanasia campaign see Gerald Reitlinger, *The Final Solution* (1961), p. 132.
4 Siegfried Kracauer, *From Caligari to Hitler*, pp. 115–16, 118.
5 David Stewart Hull, *Film in the Third Reich* (1969), p. 194.

216 (right) Heini receives his uniform
(*Hitlerjunge Quex*)
217 (below left) Aryan archetypes in the
service of the Party (*S. A.-Mann Brand*)
218a & b (below right) The party on the march
(*Hans Westmar*)

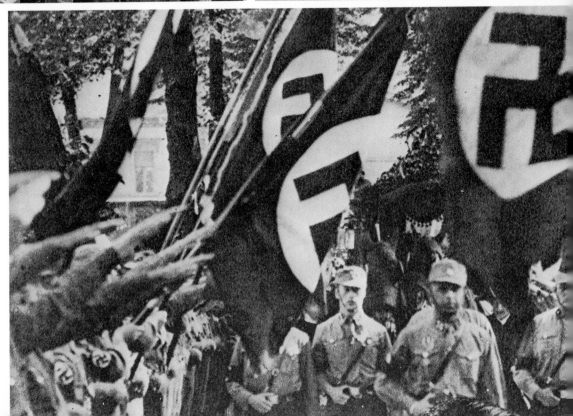

2: Discipline, Comradeship and Fatherland

What links the great Leaders and patriots in the leadership epics is their all-consuming love of the Fatherland. Their lives are consecrated to the service of the Fatherland. No sacrifice is too great for the Fatherland. This devotion to the Fatherland is constantly hymned in the propaganda films of the Reich. It was classically expressed in Hans Springer's eulogistic film poem *Der ewiger Wald* (*The Eternal Forest*), made in 1936, which renders the Nazi 'Blut und Boden' doctrine in vivid cinematic terms.

Declaring that the Reich is imperishable like the forest, it elaborates on this metaphor to interpret the history of the Fatherland. It begins with a lengthy and beautiful evocation of the primeval forest, demonstrating its beauty and strength as season succeeds season. It re-creates the earliest days of settlement, with pagan dances and sun-worship. The true German race, deep-rooted like the forest, is seen quickening to life from the good earth. This Teutonic Volk is threatened by the onslaught of the legions of Imperial Rome but it defends the homeland fiercely and preserves its identity.

In the Middle Ages the trees of the forest are cut down to build the German cities and there is a montage of Gothic architecture to symbolize the building achievements of the German race. The Peasant Wars of the sixteenth century and the Thirty Years' War of the seventeenth wreak great havoc, but a great Leader arises, in Frederick the Great, to restore the fortunes of Germany and with it the strength of the forest.

The First World War breaks out and once again the felling of trees is used as a symbol for the destruction wrought on Germany and the defeat of the Fatherland. We see French occupation troops hewing down and carting off German trees after the war and the narrator declares: 'How can you bear this suffering, my folk, my forests?' The answer comes with a new forest, the forest of Nazi swastika banners. The wheel comes full circle with Nazi rituals deliberately recalling the pagan ceremonial of the start of the film. The forest has risen again and the National Socialists have affirmed their unshakeable faith in the destiny of a German race, whose roots are planted deep in the soil of the Fatherland. Beautifully photographed and scored, *Der ewiger Wald* stands as the major cinematization of this important Nazi doctrine.

It seems to sum up in visual terms what the German felt, or was expected to feel, for the Fatherland. It is this feeling which lies behind the crop of films devoted to the desire of German exiles to return to their homeland. Rudolf Hess declares, in his speech in *Triumph of the Will*: 'Germany is home for all Germans from all over the world.' Once the Nazis take over in Germany and it becomes again a land fit for Germans to live in, the expatriates, who had left because of disgust with conditions under the Weimar régime, are expected to flood back. The cinema shows them doing so.

One of the earliest of the 'return' films is the lavishly produced and technically impressive *Flüchtlinge* (*Refugees*) (Gustav Ucicky, 1933), set in 1928 in Manchuria. A group of Volga German refugees, headed by Laudy (Eugen Klöpfer), an engineer wanted by the Russians for industrial sabotage, seek sanctuary in the International Settlement at Harbin. A League of Nations Commission is there debating the status of the Volga Germans. The German delegate tells them that the Volga Germans have been forced to

flee from Russia in order to avoid persecution and are still being pursued by the Russians. But the Commission carries on its futile debate without coming to a conclusion, as the brutal Russian commissar and his men search the town for the fugitives.

The refugees are joined by another German, Arneth (Hans Albers), who had been so disgusted with conditions in post-war Germany that he had gone to China as an instructor in the service of the Nanking Government. But now they all decide that there is only one place for them – the Fatherland. So in the exciting final sequence, with the Russians hot on their heels, they steal a train and head for home. Together with the basic theme of homecoming, then, we are also given an embryonic Führer in Laudy (whom the refugees all obey implicitly having decided that he knows best), a picture of the League of Nations as a farcical talking shop and the characterization of the Russians, predictably, as brutal thugs.

Ein Mann will nach Deutschland (*A Man Must Return to Germany*) (Paul Wegener, 1934) is set in July 1914 and details the trials and tribulations of two German engineers working in South America, who set out to return to Germany to help with the war effort. They eventually reach home in spite of all the attempts of the British to stop them – attempts which include imprisoning them in a prisoner-of-war camp in Jamaica.

Das Gewehr über (*Shoulder Arms*) (Jürgen von Alten, 1939) is a pitiful comedy, of interest because its plot centres on the decision of a German settler in Australia, fearful that his son is becoming decadent through contact with democracy, to send the boy to Germany for military service. Initially unwilling to go, the boy eventually comes to appreciate the value of discipline and to embrace the ideals of the new Germany.

Homecoming forms the dramatic climax of *Geheimakte W.B.I.* (*Secret Paper W.B.I.*) (Herbert Selpin, 1942) a film biography of the nineteenth-century German inventor, Wilhelm Bauer, who in 1834 invents the submarine. After detailing how the British try to sabotage his invention and the Russians to steal it, the film ends with the Germans

stranded in Russia at the outbreak of war. The Russians refuse them permission to return home, so they break out of confinement, seize the submarine and escape back to the Fatherland. The film ends with shots of U-Boats going out to sea to continue the fight against the villainous British and Russians.

The 'return home' theme could generally be combined with propaganda against the enemy who try to stop the heroic Germans; thus the British are the villains of *Ein Mann will nach Deutschland*, the Russians of *Flüchtlinge* and both of *Geheimakte W.B.I.* Two films made during the war, *Feinde* and *Heimkehr*, combined the 'return home' theme with an inflammatory depiction of Polish atrocities against peace-loving Germans, designed to swing popular support behind Germany's action in occupying Poland.

In *Feinde* (*Enemies*) (Viktor Tourjansky, 1940), Germans in Poland, living near the border, are terrorized by Polish thugs, secretly supported by the authorities. German farmers are killed, their homes burned down, their belongings stolen. Daily their position grows worse until they realize it is only a matter of time before they are massacred. So, packing their belongings, they leave by night, and after a dangerous journey, under their Leader (Willy Birgel), who knows best and whom they all obey, they reach the Reich in safety.

Heimkehr (*Homecoming*) (1941), which reworked the same ideas, was even more extreme. It saw director Gustav Ucicky and his favourite collaborator, scriptwriter Gerhard Menzel, returning to the theme they had first explored in *Flüchtlinge*. Arguably the classic 'return home' picture, it is atmospherically photographed and spaciously produced but demonstrates all the faults of the full-blown Nazi propaganda film. The message is hammered and hammered and hammered until any 'entertainment' value which the film might have had is eliminated – though it is questionable if any such value existed in what is basically a hysterical catalogue of atrocities, deliberately contrived to arouse the indignation of the German cinema audience.

A crashing symphonic score is heard over shots of the soil and the titles tell us that groups of Germans left the Fatherland centuries ago in search of *Lebensraum* but that in 1939 they returned to a new, strong homeland. The film tells the story of one such group, the German inhabitants of the small Polish town of Luzk. In March 1939 brutal Polish police close down the German school and throw all the furniture into the street and burn it, watched by a gaggle of smirking Jews. Marie Thomas (Paula Wessely), the heroine, daughter of the local German doctor, goes to plead with the Polish mayor on behalf of the German community, only to be told that they are Polish citizens and not Germans and to be threatened with a gun. In discussion with her sweetheart, Fritz, she advocates restraint in dealing with the Poles. But Fritz says that the time for restraint is over and he is soon to be proved right.

A deputation goes to the provincial capital to complain to the Governor but he refuses to see them. With commendable good taste, Marie, Fritz and another German friend, Carl, decide to visit the local cinema to see Jeanette MacDonald and Nelson Eddy in *Maytime*. But they arrive as the newsreel is being shown, and when scenes of the Polish army appear, the audience stand up and ecstatically sing the Polish National Anthem. The Germans refuse to sing, the Poles turn on them and beat them up. Fritz, bleeding and unconscious, is carried into the street by Marie and Carl, who are beset by a howling mob. They manage to get hold of a carriage and drive Fritz to the nearest hospital. The hospital refuses to take him in and he dies. As the politicians talk and the months pass, atrocities against the Germans continue: Dr Thomas is blinded by Polish children, a young German girl, wearing a swastika, is stoned to death in the streets.

September 1939. The Germans gather in a barn to listen to the Führer speaking over the radio. He declares that Germany will not stand aside if Poles commit any further crimes against the Germans. The police surround the barn and arrest all the Germans. They are dragged off to prison and crammed into dank, filthy cells, dripping with water, so tightly packed that they all have to stand up. But Marie keeps their spirits up by making speech after endless wearisome speech. A typical example, which deserves quotation, is her climactic oration:

'People, there is no doubt we'll go home. No doubt at all, we'll go home. Why shouldn't we? Everything is possible and that's not just possible, it's certain. Back home in Germany, they're no longer weak and people there are not indifferent to our fate. On the contrary, they . . . are very interested in us and why shouldn't we go home if we want to? Just think what it'll be like, people, just think. Everything around us will be German and when you go into a shop you won't hear someone speaking Yiddish or Polish but German. And it won't just be the whole village that is German but everything here and round about us will be German and so we'll be in the middle of it, in the heart of Germany. Just think, people, what it'll be like. Why shouldn't it be like that? We shall live on the good old warm earth of Germany. At home, at home. And at night, in our beds, when we wake up again from our sleep, the heart will know suddenly with a sweet shiver that we're sleeping in the middle of Germany, at home, and round about us is the consoling night and there millions of German hearts are beating, beating, beating softly as one. You're at home, Man, at home with your family – all this is German. Like ourselves. Belonging to us. Because it has grown out of millions of German hearts, which have been buried in the earth and have become German earth. Because we don't just live a German life, we die a German death and in death we remain German and are part of Germany.'

And so it goes on, reel after reel. It has been estimated that in this one speech of Paula Wessely, Germany is mentioned 36 times.[1]

It is, after all that, perhaps not surprising that the Poles decide to shoot them. But before they can do so, German planes fly over

Themes and archetypes
219 (above) Homecoming
was the theme of
several films –
Flüchtlinge for instance
220 (centre) The
subversion of Weimar
democracy by early
Nazi heroes was the
subject of *Pour le
Mérite*
221 (below) The defence
of the homeland to the
last ditch was
encouraged in *Kolberg*

and start bombing the town, German tanks rumble through the streets, the prison gates are smashed down and to a triumphal chorus on the sound-track, the prisoners are freed. Then comes the day when the German people go home. A wagon train is prepared and the blind doctor, like some ancient Teutonic seer, expatiates with tearful exultation on the greatness of the Fatherland. The film ends with scenes of the wagon train crossing the frontier into Germany along roads lined with the·swastika banner and portraits of the Führer and the film's final shot is a close-up of the Führer, gazing complacently out as his beloved people return to their Fatherland.

It is difficult now to take this heavy-handed production seriously, though at the time it was, understandably, very highly regarded and designated 'Film of the Nation', one of the highest awards that could be bestowed. Its interest lies purely in its propaganda content, as typified by Paula Wessely's speech in which she makes a classic statement of the doctrine of 'Blut und Boden'. Naturally the Germans are all heroic and beautiful – with the notable exception of Paula Wessely, who makes up for being rather homely by emoting like mad. The Poles are all ugly and treacherous and eventually get their come-uppance, thanks to the Führer, who makes his obligatory guest appearance (via poster) at the end.

However, for sheer nerve in piling on the agony, Karl Ritter's *Über Alles in der Welt* (1941) (*Above All in the World*) probably takes the prize. An arrogant piece of Herrenvolk self-glorification, it relates five separate stories, all on the theme of 'return home' and all designed to illustrate the effortless superiority of the Germans over all other races.

The stories all begin on 2 September 1939 when Britain and France declare war on Germany. A German journalist in Paris, Karl Weigand (Carl Raddatz), is arrested and imprisoned in a French concentration camp but, by pretending to work for the enemy on propaganda radio broadcasts, he escapes and finds his way back to the Fatherland. Members of a Tyrolean jodelling troupe

in London are arrested and imprisoned in a British concentration camp. They pretend to agree to join the Free Austrian Forces, are shipped to France and also escape back to Germany.

The German tanker *Elmshorn* is at sea when war is declared. It is attacked by a British destroyer. The Captain orders his crew to sink the ship to prevent it falling into British hands. They are then picked up by the destroyer. As they listen to a B.B.C. broadcast announcing that the U-Boat menace is beaten, a U-boat rises from the sea, sinks the destroyer and rescues the Germans. They are put ashore in Spain and from there return to Germany.

A Heinkel, making a bombing run over Poland, is forced down behind enemy lines but its crew are rescued by a Dornier 17, which takes them safely back to base to continue the fight. A German survey plane over France is shot down. Its crew, which includes Karl's brother Hans (Hannes Steltzer), parachutes to safety and escapes across the Alps into Italy. The film ends with a triumphant air engagement in which thirty-seven out of forty-five British planes are shot down by the Luftwaffe. The moral is that all the Germans all over the world are rushing back to the homeland and once gathered there, they will be invincible. Today, France, tomorrow the world. Sieg heil!

After the Fatherland, one of the most common themes in Nazi propaganda features was the need for discipline and absolute obedience. It found one outlet of expression in a group of films glorifying the indoctrination of German youth. It was, of course, vital to win and hold the youth of Germany and the party's concern for this had been shown by the early production of *Hitlerjunge Quex*. Subsequent Nazi Youth films were created from exactly the same motifs we see in *Quex*: the all-male group, the reverence for the Leader and the substitution of Nazi organizations for the family.

The film *Himmelhunde* (*Sky Hounds*) (Roger von Norman, 1942) poses the question: is good comradeship more important than iron discipline or vice versa? It supplies the

answer that there cannot be one without the other. The plot shows how a Hitler Youth learns this lesson the hard way. His Group Leader designs a glider. It is damaged on a test flight and the Leader forbids its use in the next day's competition. The boy and his comrades disobey the order and secretly repair it. The boy flies it and wins but is disqualified because he makes a crash landing. He and his comrades are expelled from the Hitler Youth and the Leader denounces 'Schweinehunde who always think of themselves first and ask the reason for an order instead of carrying it out. We do not need Schweinehunde.' The boy sulks but eventually realizes that his Leader was right. ('The order stands above him who receives it and him who gives it.') There can only be discipline if the Leader's orders are obeyed implicitly. He is duly readmitted to the Hitler Youth.

In *Junge Adler* (*Young Eagles*) (Alfred Weidenmann, 1944), a rich aeroplane manufacturer, worried because his son is neglecting his studies for sporting activities, sends him into the factory as an apprentice. There he learns discipline, and when there is a fire at the factory which destroys many important components, the boys prove the value of their training and their discipline by working day and night until the parts are replaced.

In *Jakko* (Fritz Peter Buch, 1941), the hero, Jakko, an undisciplined circus boy drifting into crime, is adopted by a middle-class family and sent to join the Naval Hitler Youth, where he learns discipline, comradeship and dedication to the state. In *Jungens* (*Guys*) (Robert A. Stemmle, 1941), a Hitler Youth Leader, sent to a remote East Prussian village, organizes the 'guys' of the local youth and together they break up a smuggling ring; while in *Kopf hoch, Johannes* (*Chin up, John*) (Viktor de Lowa, 1941), Johannes, the son of a German father and an Argentine mother, who has been brought up abroad, returns to Germany when his mother dies. He likes neither Germany nor his father. So his education is entrusted to the Nazi Political Education Institute and he is sent to a Nazi boarding school, where he learns discipline and comradeship and, from being a sensitive and artistic misfit, is processed into an aggressive and dedicated young Nazi, to the delight of his father and the authorities.

But far and away the most common theme is that of comradeship and self-sacrifice. A glance down the list of Staatsauftragsfilme indicates the prevalence of this theme, extolling the male-male relationships of Bundist tradition. There titles are self-explanatory: *Kameraden* (*Comrades*), *Soldaten-Kameraden* (*Soldier-Comrades*), *Zwei gute Kameraden* (*Two Good Comrades*), *Kameraden auf See* (*Comrades at Sea*), *Blutsbrüderschaft* (*Bloodbrotherhood*) and so on. It was deliberate policy to encourage close male relationships, on grounds similar to those which induced the Spartans to favour homosexual relationships among their soldiers. The theory was that on the battlefield the male lovers would not desert each other and that discipline under fire is thus given an added boost.

The theme had been set by the earliest of the Staatsauftragsfilme, *Morgenrot* (*Dawn*) (Gustav Ucicky, 1933), a competent but fairly routine submarine drama. The U-Boat commander Liers (Rudolf Forster) and his First Officer, Fredericks (Fritz Genschow), both love the same girl but Fredericks is prevented from revealing it because of his affection for Liers. When the submarine is trapped and there are only eight diving suits for ten survivors, there is a problem. The crew refuse to choose who shall go, declaring resolutely: 'All or None' and thus demonstrating the spirit of comradeship and self-sacrifice. But Fredericks and another crew member reveal those feelings to an even greater degree by shooting themselves to resolve the difficulty, enabling the remaining eight to escape in the suits.

The story of *Drei blaue Jungs – Ein blondes Madel* (*Three Young Men in Blue – One Blonde Maid*) (Carl Böse, 1933) concerns three sailors on shore-leave. Two fall in love with the same girl and become enemies. On subsequent sea manoeuvres one of them is accidentally left on board the target ship in a gunnery exercise. The other overcomes his

222–3 (opposite) The service films encouraged those attributes which the Nazis could use in their war effort. Self-sacrifice (*Morgenrot*)
224 (above) Discipline (*Stukas*)
225 (centre) Male comradeship (*Stukas*)
226 (below) Dedication even among the young (*Kadetten*)

animosity, informs the commanding officer and saves his friend's life. The enmity of the two is over and the problem of the girl is solved when on the next shore-leave the two sailors find the girl in the arms of the third. The implication is that the love of the girl is bad because it breaks up the male friendship and ultimately the girl is proved to have been not worth bothering about in the first place.

It is a plot which sees service over and over again. In *Zwei gute Kameraden* (Max Obal, 1933) two soldiers in the First World War, who are friends, fall out when they both become enamoured of the same girl. Their friendship is re-awakened, however, when they are jointly responsible for tricking the Americans into evacuating a town. One of them gets the girl and the other marries another girl, who has already borne him a child.

Drei Unteroffiziere (Werner Hochbaum, 1939) is the story of three warrant officers in the German army. One of them falls in love with a young actress and neglects his duties but the other two save him from himself. *Blutsbrüderschaft* (Philipp Lothar Mayring, 1941) centres on the comradeship of two young men in the First World War, which is continued in the post-war years. A girl enters their lives and causes conflict between them but when the war breaks out in 1939, the two renew their comradeship and march off together to serve the Fatherland.

In *Spähtrupp Hallgarten* (*Hallgarten's Reconnaissance Patrol*) (Herbert Fredersdorf, 1941) two mountaineers, in love with the same girl, join the army, serve in Norway and resolve their differences when one saves the life of the other and dies gloriously. His sacrifice is praised in the film in the following terms: 'Our comrade Hallgarten had to stay outside. His fate as a good soldier has been fulfilled. His soldierliness was crowned by the sacrifice of his life. He has died that our people may live. His military deeds will enter the traditions of the mountain hunters. They were an example of real comradeship, ready for sacrifice.'

Comradeship frequently goes hand in hand with self-sacrifice. *D III 88* (Herbert Maisch, 1939) and its sequel, *Kampfgeschwader Lützow* (*Battle Squadron Lützow*) (Hans Bertram, 1941) dealt with the exploits of the Luftwaffe in peace and war and told virtually the same story each time. The comradeship of two pilots, in love with the same girl, is temporarily broken but they are re-united in time for one of them to die gloriously in the service of the Fatherland. Their comradeship must be re-established, as their commandant tells them in *D III 88*: 'Personal differences there are everywhere, but in the service you must give your whole person. Frictionless co-operation, unconditional obedience, only in this way can our armed forces become an instrument on which our Leader can rely unconditionally in an emergency.' Comradeship and self-sacrifice even extends to the workers on the Autobahn, as these qualities are extolled in *Mann für Mann* (*Man for Man*) (Robert A. Stemmle, 1939). The comradeship becomes self-sacrifice when the day shift risk their lives to rescue the night shift, trapped after a freak earthquake.

One director who made a career out of popularizations of the Nazi ethos was Karl Ritter, who declared: 'My movies deal with the unimportance of the individual ... all that is personal must be given up for our cause.'[2] Not surprisingly he was highly regarded by the Nazis and his films take up again and again the theme of self-sacrifice and blind obedience.

Kadetten (*Cadets*) (1941) is set in 1760 when Frederick the Great is facing the Austrians at Torgau. The Russians make a sneak attack on Berlin. Only the Fourth company of Cadets, aged between nine and twelve, remain and they are captured. Imprisoned under the control of a renegade Prussian, Rittmeister von Tzuelow, they awaken his patriotic feelings by their pride and dignified bearing and he helps them to escape. They dig in at a disused fort to await relief. The Russians surround them and von Tzuelow goes out alone and kills the Russian leader, sacrificing his own life in the process. He does so partly to gain time and partly to expiate his treachery to the Fatherland. The

cadets are duly rescued. The film preaches comradeship and self-sacrifice, the importance of the collective body and obedience to orders and – what is so insidious – it aims the message at children.

Stukas (1941) is devoted to the exploits of the Luftwaffe and is notable for its delirious finale. A pilot, sent home to recuperate after being shot down, loses his will to fight. The doctor prescribes a trip to the Bayreuth Festival and there the pilot after hearing the first strains of 'Siegfried's Call' miraculously regains the fighting spirit and sprints off back to the Front to rejoin his comrades. Once again individual needs and identity are sublimated in collective service to the Fatherland.

Unternehmen Michael (*Operation Michael*) (1937) was made with the express intention of showing 'the German youth that senseless sacrificial death has its moral value'.[3] During the First World War the commander of a German infantry column in France orders surrender in the face of overwhelmingly superior British numbers. But his unit refuses to surrender and proposes *Heldentod* instead. A false cease-fire order is given and when the British advance, they order German artillery to destroy them and the British. The commanding officer declares: 'You know as well as I do that we shall be measured one day not by the greatness of our victory but by the extent of our sacrifice.'

Urlaub auf Ehrenwort (*Leave on Word of Honour*) (1937) tells the story of a group of soldiers *en route* for the Front in 1918 who are given a few hours' leave in Berlin and put on their honour to return by a certain hour. They all choose to return and face almost certain death for the Fatherland rather than desert and find the personal happiness they had sought. The young composer prefers to die with his comrades rather than live to see the première of his symphony. The lonely youth, who has experienced his first love with a lonely girl, leaves her, to die for Germany. The left-wing intellectual rejects the comradeship of his fellow subversives for the 'real' comradeship of fighting men. They all put duty before self.

The poisonous influence of these films cannot be exaggerated for it has been estimated that some six million boys had seen Ritter's films by 1939[4] and these are the boys who went out to fight and die for their Führer. Perhaps Ritter's most notorious film in a career about which it is impossible to find anything good to say, is *Pour le Mérite* (1938), a tribute to the men who subverted the Weimar Republic. The film opens with scenes of the Richtofen Air Squadron in the last months of the First World War. The war ends and there is revolution at home. The squadron refuse to surrender their planes and fly them to Darmstadt, where they are attacked by a Communist mob. They decide to burn their planes and pledge themselves to overthrow the government. They continue to meet, still calling each other by their old ranks and maintaining their wartime comradeship. Eventually the squadron is attacked by men of the Reichsbanner and they fight back with machine guns. They are arrested and imprisoned. At his trial, the squadron leader (Paul Hartmann) declares:

'I will have nothing to do with this state because I hate democracy like the plague. Whatever you would like to do, I will disturb and disrupt whenever I can. We must get Germany on its feet – a Germany that will meet the demands of the fighting soldier. I consider that it is my life's work to assist this process. I will do so in a soldierly manner.'

Eventually they escape from prison and go abroad, but when Hitler comes to power and they see their work fulfilled, they return and reform the old Richtofen squadron to fight for the new Reich.

It is perhaps fitting that we should end this chapter with *Kolberg* (Veit Harlan, 1945) for it constitutes, cinematically, the last gasp of the Third Reich. In more than one sense it is the twilight of the gods. It was Goebbels's personal project. He allocated to it a budget of eight and a half million Reichsmarks. Whole units of desperately needed troops were pulled out of front line duty to participate in the film's battle scenes. While

ammunition ran out on the Eastern front, the German armaments factories were turning out blank bullets for use in *Kolberg*.

Goebbels plunged into the film with more enthusiasm than all the cast and technicians put together. For they were by now gloomily aware that the Reich was doomed. But 'Mickey Mouse', as Goebbels was derisively known to the *Filmwelt*, had finally crossed the footlights and was living in a cinematic world of his own imagination. He announced to his disbelieving staff after the screening of *Kolberg*:[5]

> 'Gentlemen, in a hundred years' time they will be showing another fine colour film describing the terrible days we are living through. Don't you want to play a part in this film, to be brought back to life in a hundred years' time? Everybody now has the chance to choose the part he will play in the film a hundred years hence. I can assure you that it will be a fine and elevating picture. And for the sake of this prospect it is worth standing fast. Hold out now so that a hundred years hence the audience does not hoot and whistle when you appear on the screen.'

Kolberg was designed to prepare the entire people to fight to the last man, woman and child. It was a tribute to the idea of *Volks-sturm*, the mobilization of the civilian population in hastily trained Home Guard units. Its central figure, Joachim Nettelbeck, is the last of the Great Leaders of the Nazi cinema. He refers to himself as 'Führer' and even though others cry 'Hold, enough', he is prepared to lead his shattered people on to *Heldentod*. Typically, apart from the spectacular battle footage, the film is a verbose, heavy-handed, slow-moving bore and thus an entirely fitting epitaph for the cinema of National Socialism.

Its interest lies in the fact that it brings to final fruition the themes and archetypes of the Nazi cinema. It opens with a scene of people and troops marching arm in arm through the streets, singing joyfully as they prepare for war with the French. It is 1813, and in the royal palace at Breslau the young general Gneisenau (Horst Caspar) tries to persuade the Prussian king, Friedrich Wilhelm II, to enlist the aid of the people in the war. The king takes the view that war is a matter for the army. But Gneisenau declares that a German leader who is not up to leading the German Volk should step down, and he relates the story of Kolberg to back up his point. Flashback to 1806 when Napoleon has beaten Prussia and is at the height of his victorious career. Kolberg is introduced and established as a true Volkish town with scenes of jolly peasants in national dress singing, dancing and swilling beer. The mayor, Joachim Nettelbeck (Heinrich George) and his cronies discuss the threat from Napoleon. One of them declares that Napoleon has said that he is only interested in the peace and security of Europe, but Nettelbeck replies grimly: 'One must use cannon against cannon.'

The heroine of the film is Nettelbeck's niece Maria (Kristina Söderbaum), who is portrayed as the archetype of German womanhood, blonde, cheerful, dressed in typical peasant costume and seen singing as she sits at her loom. As she sings, scenes of peasants reaping the corn and fishermen catching fish flash on to the screen – the spirit of 'Blut und Boden'. She wholeheartedly supports the stand of her uncle and demonstrates her support by falling in love with the heroic Rittmeister von Schill (Gustav Diessl), who is wounded while fighting the French.

The French send an ultimatum calling for the surrender of Kolberg and the council meets to debate it. Nettelbeck castigates the weak-hearted and tells the French envoy that the people of Kolberg would rather die in the rubble of their city than surrender. Kolberg prepares to fight.

The film now sets up two parallel conflicts to emphasize the Nazi line on last-ditch resistance. There is, firstly, conflict between Colonel von Lucadou (Paul Wegener), the elderly commandant of the garrison, who makes only half-hearted preparations for defence and is prepared to surrender if the going gets too rough, and Nettelbeck, who wants to hold out and fight with every weapon at their command until the bitter

NAZI FEATURE FILMS: DISCIPLINE, COMRADESHIP AND FATHERLAND 335

end. They quarrel so violently that Lucadou arrests Nettelbeck. He has to release him, however, when the people demonstrate in the streets in his favour. The people are thus seen to indicate their support for the Leader and his policy and the audience are encouraged to do likewise.

The other conflict is between von Schill and Lucadou. Von Schill starts training volunteer militia (the equivalent of the *Volkssturm*) in the square. Lucadou orders him to dismiss them and derisively calls them 'Sunday soldiers'. But von Schill tells him that it is not equipment but hearts that make soldiers and that the Kolbergers have the right hearts. Once again it is a case of one of the film's heroes defending and advocating the official Nazi policy.

Napoleon, receiving the news of Kolberg's defiance, orders his troops to demoralize the citizens by bombardment – the equivalent of Churchill's policy of saturation bombing. But the citizens simply reply with their own cannon. Maria's father, Werner (Otto Wernicke), is ordered to destroy his farm because it blocks the firing range of the Kolberg cannons. He does so with his own hands. The citizens flood part of their town in order to deny the French easy access. These two episodes dramatize the policy of 'scorched earth'. The Kolbergers do it cheerfully and are set up as an example to the Germans of the present.

Nettelbeck sends Maria to the King of Prussia with a message asking for a new commandant. The King is absent from Königsberg but Maria is received by the Queen (Irene von Meyendorff) in an incredible scene which gives ultimate cinematic expression to adoration of the Leader, here rendered in female terms. Maria, ushered into the presence, gazes awe-struck at the Queen. Tears of religious ecstasy tremble on her eyelashes, her voice fails with emotion and she haltingly delivers the message. The Queen, unreal, statuesque, distantly radiant in jewels, silk and lace stands utterly immobile, barely moving her lips as she speaks: 'I press Prussia and Kolberg to my heart so closely. There are now only a few gems left in our crown. Kolberg is one of them.' It is in a very real sense the prostration of a worshipper before her idol and its aim is clearly to encourage the populace to take the same attitude to the Führer.

Gneisenau is sent to take command and he declares: 'The best defence is attack' and launches a counter-attack. But the French cannot be dislodged. Their cannonade increases and they send another ultimatum. Gneisenau rejects it and summons the people to hear his decision. He addresses them from a window of the Town Hall: 'You have lost everything. But you have won everything. Germans from all walks of life should model themselves on Kolberg. I see the dawn of German freedom breaking.' The French launch an all-out assault. Gneisenau tells Nettelbeck that they cannot hope to hold out and that the sensible course is surrender. Nettelbeck replies passionately:

'Gneisenau, you weren't born in Kolberg. You were ordered to Kolberg. But we grew up here. We know every stone and every corner, every house here and we're not going to give it up now. And even if we have to do so by the skin of our teeth, we shall hang on to our city. You'd have to cut off our hands or kill us one after another. Gneisenau, you can't shame an old man like me and give our city to Napoleon. I've promised it to our king ... we'd rather be buried under the rubble than capitulate.'

Gneisenau replies: 'That is what I wanted to hear from you, Nettelbeck, now we can die together.' They prepare to fight to the death. But Napoleon, alarmed at the losses he has sustained, orders his guns to cease fire and the Kolbergers are saved. In actual fact Kolberg did fall, but that would have ruined the film and so history is altered.

On the seashore Nettelbeck comforts the heroic Maria, saying: 'Whoever takes our suffering upon himself is great. You are great, Maria.' For during the siege she has lost her father, both her brothers (one a pacifist musician and the other a fighting soldier) and her lover, von Schill. Yet according to Nettelbeck, and his *alter ego* Hitler, it is not too much to sacrifice for the state. For the

state must come first and German woman-hood is ennobled by its suffering on behalf of the Fatherland.

The flashback ends and the story persuades the King to agree to Gneisenau's suggestion and sign a decree mobilizing the people for the war. Gneisenau gazes out at the singing, marching people and declares elatedly: 'The people arise, the storm breaks loose' (the Volk and the Sturm). Then turning to the camera, he announces: 'From the ashes and ruins a new Volk will arise like a phoenix, a new Reich.' The banners of Germany are superimposed over his face as the film ends.

But it was already too late. By the time the film was ready for showing early in 1945, almost all the cinemas were closed and virtually the only people who saw it were the garrison of La Rochelle, then completely surrounded by the Allies. A print of the film was dropped by parachute to encourage them in their resistance. But though Goebbels might change history on film, there was no chance of changing history in fact and, like the historic Kolberg, La Rochelle fell. So too did the Reich. The infallible Führer and his irrepressible Propaganda Minister ended their lives by their own hands amid the blazing ruins of their capital and the bitter ashes of their demented dreams. Wherever he is now, 'Mickey Mouse' must be reflecting sadly on the fact that his cinematic immortalization has come not, as he had envisaged, in a German epic about a noble and idealistic Volk leader fighting off overwhelming odds with unquenchable courage and resourcefulness, but in the films of his enemies and in the eyes of history, as a wizened, reptilian Machiavelli deluding the people into plunging blindly to their destruction in the wake of a madman.

Notes

1 Helmut Blobner and Herbert Holba, 'Jackboot Cinema', *Films and Filming* (December 1962), p. 20.
2 Karl Ritter, quoted by John Altmann, 'Movies' Role in Hitler's Conquest of German Youth', *Hollywood Quarterly*, iii (4), p. 383.
3 Ibid.
4 Ibid., p. 382.
5 Roger Manvell and Heinrich Fraenkel, *Dr. Goebbels* (1960), p. 276.

The Eternal Jew and Perfidious Albion

The full venomous force of Nazi malevolence was reserved for the Jews and the British. Hatred of the Jews was the corner-stone on which Hitler had erected the monstrous ideology of National Socialism. The British were the one defiant force standing between the Germans and the total victory which would enable them to construct the thousand-year Reich of their insane dreams.

Interestingly, it was not until the outbreak of war that the German film industry produced specifically anti-semitic tracts, and then the three major anti-semitic films, *Die Rothschilds*, *Jud Süss* and *Der ewige Jude*, all came out in 1940. There can be little doubt that they represent the government's cinematic effort to prepare the German public for the full-scale extermination of the Jews. As Josef Wulf has written:[1]

> Unquestionably Goebbels had those three films made and shown because of the planned and later actually executed Final Solution of the Jewish Problem, even though the actual date when that final problem was decided by the powers of the Third Reich has not been established with total accuracy.

We should not underestimate the power of the propaganda they contain. For instance, a case is reported from Vienna of an old Jewish man trampled to death in the street by a group of Hitler Youths who had just been to see *Jud Süss*.[2] Himmler pronounced that *Süss* was compulsory viewing for all members of the armed forces, the police and the S.S. The government made sure that these films received the widest possible showing and they were frequently shown in Eastern Europe as a direct preliminary to the transportation of Jews to the death centres.

The earliest and perhaps least significant of the anti-Jewish films is *Robert und Bertram* (Hans Heinz Zerlett, 1939). It was a comedy which sought to satirize the Jews: their physiognomy, their manner of talking, their customs. As David Hull observes:[3]

> Viewed almost thirty years after the film was made and compared with the evil, smirking *Rothschilds*, *Jud Süss* and *Der ewige Jude* in all their oily professionalism, the anti-Semitism of *Robert und Bertram* seems simple-minded, with roots in the eighteenth- and nineteenth-century vulgar comedies popular in Germany, featuring distorted Jewish characters.

The film tells the story of two genial German tramps, Robert (Rudi Godden) and Bertram (Kurt Seifert), who, having escaped from prison, fetch up at a village inn. There they discover that the innkeeper has borrowed money from a Jewish moneylender, Ipelmeyer (Herbert Hübner), and is unable to repay him. Ipelmeyer insists therefore that in lieu of payment the innkeeper's daughter marry a Jewish friend of his. Robert and Bertram decide to help and go to Berlin posing as the Count of Monte Cristo and his music teacher. Invited to a ball at Ipelmeyer's they proceed to send up the Jews unmercifully and finally to rob them of their valuables and escape. They give the proceeds of the robbery to the innkeeper to pay off his debt and enable his daughter to marry her lover, a true German and a soldier in the army of the local prince, before proceeding on their way.

The film lays down the themes which the subsequent films are to take up with much

greater virulence. The Jews are stereotyped: greasy, fat, hook-nosed, physically repellent. They are represented as a threat both economic (the debt) and sexual (the innkeeper's daughter). They are outwitted by two criminals, whose escape from jail and whose act of theft are excused by their Germanic motivation in seeking to preserve racial purity and outwit the Jewish plutocracy. The denigration of the Jewish race and the glorification of criminal acts against them, then, emerge as the purposes of this so-called comedy.

But Goebbels wanted something more than rural japes to dramatize the Final Solution and the three remaining major anti-semitic films gave it to him. The earliest of them is *Die Rothschilds*, directed by a man with some reputation for film-making in pre-Nazi days, Erich Waschneck. It emerged, however, as an extended and heavily slanted rant, which few people went to see.

It gives an account of the rise to power and wealth of the Jewish banking family of Rothschild. It opens in 1806 in Frankfurt. William IX, Landgrave of Hesse, preparing to flee from the advancing armies of Napoleon, entrusts his fortune to Meyer Amschel Rothschild (Erich Ponto). It amounts to some 600,000 pounds, money obtained by selling German soldiers as mercenaries to the British. Meyer decides to use the money to advance the family fortunes and dispatches it to his son, Nathan (Carl Kuhlmann), who is established as a banker in London. Nathan is despised and hated by the English bankers both because he is Jewish and because he is successful. But his worth is appreciated by the crafty British finance minister Herries (an engagingly suave and unscrupulous portrayal by Walter Franck), who uses the Rothschilds to get money to Wellington in Spain.

Rothschild is the first to learn of Napoleon's escape from Elba and the only banker to gamble on his defeat. He arranges – for a price – for the British general 'Lord Wellington' (Waldemar Leitgeb) to set up a system of couriers to supply him with advance information about the outcome of the engagement. He learns in due course of the victory at Waterloo and subsequently spreads word of a British defeat, causing a panic on the Stock Market. By buying up all the securities he can, Nathan makes eight million pounds. Poor and rich alike are ruined. His principal rival, Turner (Herbert Hübner), dies of a heart attack. The family's power and wealth are assured.

The whole account is rigged to arouse the maximum indignation in a German audience. For Rothschild fortunes are said to have been built on the blood of Germans. Their initial impetus comes from the Landgrave of Hesse's blood-money, which they use to begin their evil schemes; and their final victory comes with the exploitation of Waterloo, which is stated over and over again to have been a Prussian victory. Wellington is an elegant popinjay, more interested in dallying with his mistress than fighting, and the victory is the work of Blücher.

The Rothschilds, Meyer, Nathan and James, and their satellites, Hersch, Bronstein etc., are all unctuous, scheming opportunists, smoking fat cigars, rubbing their hands together and deviously plotting their way to riches. Their international network of agents and relations is what enables them to function so well. We see it springing into operation to get Wellington's money to Spain. Meyer asserts that only the Jews could do it. For they have no national patriotism. They are international. This was, of course, one of the major accusations that the Nazis made against them. In case the audience have not quite grasped the message, the last scene of the film heavily underscores it. Nathan demonstrates to Herries the extent of Rothschild power. He uses a map of Europe to indicate the centres of Rothschild power and then draws a family tree, which, when its branches are joined together, forms the star of David. The star is then superimposed over a map of England and the end-title declares: 'Even as this film is being completed, the last members of the Rothschild family are leaving Europe as refugees and escaping to their allies in England, where the British plutocrats are carrying on.' The economic threat posed by

The eternal Jew

227 (above) The earliest
Nazi anti-semitic film
was a comedy – *Robert
und Bertram*

228 (centre) But they soon
graduated to more vicious
propaganda with *Der
ewige Jude*, which included
extracts from other films
taken out of context and
given an anti-semitic
slant. The psychotic
murderer (Peter Lorre) in
Fritz Lang's *M* was made
out to be a typical Jewish
criminal

229 (below) George Arliss's
comically exaggerated
portrayal of the banker
Rothschild in *House of
Rothschild* was also seen as
being typical

the Jews in *Robert und Bertram* is, in this film, elevated to global proportions. Another carry-over from the previous film is the theme of ridicule of Jewish appearance, accent and pretensions. In this case it is the desire of Nathan Rothschild to be accepted into English high society. The English bankers laugh themselves sick when they learn that Nathan has described himself as 'an English gentleman'. For all his wealth Nathan is never accepted by English society and remains the outcast which the film clearly believes he ought to be. Once again the film highlights the fundamental conflict between Jews and Germans and suggests that the Jews are now receiving their just deserts from the Reich for having in the past utilized the suffering of the German people to further the acquisition of their ill-gotten wealth.

The Rothschilds was really little more than a succession of uninterestingly staged interiors, in which the Jews schemed and their enemies derided them, though a slender romantic sub-plot was thrown in for good measure. Where the film failed to bring home the Jewish 'menace' was in not personalizing the Germans who had suffered from the Rothschilds. The Germans could summon up very little indignation at the sight of the British being robbed by the Jews, for it must have seemed to them a case of poetic justice.

This omission on the part of the film-makers was more than made up for by the next film, *Jud Süss*, one of the most notorious films to come out of Nazi Germany. The film bore no relation to Lion Feuchtwanger's best-selling novel of the same name, which had been filmed in England in 1932 with Conrad Veidt in the title role. It was an original screenplay by Ludwig Metzger, Eberhard Wolfgang Möller and Veit Harlan and claimed to be based on fact. A collection of so-called 'original documents' dealing with the case of Jew Süss were circulated to leading newspapers and periodicals while the film was in production, creating a wave of publicity which helped to turn the finished film into a box-office hit.

Speaking after the war, Veit Harlan, the film's director, claimed that he and the

entire cast were acting under duress from Goebbels and that none of them wanted anything to do with the film but were forced to take it on for fear of reprisals.[4] The finished product, however, bears little trace of reluctance or half-heartedness. It is a sumptuously produced, darkly photographed Nazi sermon of sinister and compelling power, building up to a cathartic crescendo of hate. It weaves all the elements of the Nazi anti-semitic policy into a full-blooded melodrama and uses all the techniques of film to achieve its devilish purpose.

The film opens in Stuttgart in 1733 with the coronation of Karl Alexander (Heinrich George) as Grand Duke of Wurtemberg. Karl is characterized as a gross and extravagant lecher, whose sensualism leads him into the hands of the Jews. He sends his adjutant to Frankfurt to the Jew Süss Oppenheimer (Ferdinand Marian) to buy a pearl necklace. Süss reduces the price in return for a passport to Stuttgart, which is forbidden to the Jews.

Karl Alexander does not have the money to pay for the necklace and, furthermore, is denied money by his ministers to finance his latest fads, opera and ballet. So Süss offers to raise the money for him and is appointed finance minister. He institutes a savage system of tolls and taxes, causing much suffering to the honest people of the duchy. A good German carter, who objects to paying, is taunted by Süss's secretary, Levy (Werner Krauss), who increases the amount he must pay. A good German blacksmith, who gives vent to his feelings by striking at Süss, is publicly hanged. Süss tells the elderly Rabbi Loew (Werner Krauss again) that he intends to turn Wurtemberg into 'The Promised Land'. He persuades Karl Alexander to throw the city open to the Jews and a seemingly endless procession of scruffy-looking Jews arrives, chanting weird un-German songs and watched with disgust by the German inhabitants of the town.

Süss, meanwhile, has cast lascivious eyes on the beautiful Dorothea (Kristina Söderbaum), daughter of the chief minister Sturm (Eugen Klöpfer). She rejects his advances and is backed up by her father, who arranges

for her to marry the man she really loves, upright German youth Christian Faber (Malte Jäger). In retaliation Süss has Sturm arrested for treason and imprisoned. The other ministers and the leading citizens meet to discuss how to end the ascendancy of Süss over the Duke. They send a deputation to Karl Alexander, but he rejects any proposal which involves the dismissal of Süss. The people riot demanding the release of Sturm and Süss is forced to grant their wish. But he arrests Faber instead and borrows money from the Rabbi to maintain his control of the armed forces. He tells the Duke that if he will only leave Stuttgart for a day, he will put down the threatened insurrection and make the Duke absolute ruler of the state. Karl Alexander agrees.

At this point the film begins to spiral inexorably towards its climax. There is a powerful sequence in which Harlan intercuts sequences of Faber being tortured and scenes of Süss terrorizing Dorothea in his apartments. He offers her her husband's life if she will submit to his advances; and tormented by the shrieks of agony coming from the dungeons, she agrees but still shrinks from him with loathing. So he rapes her and, distracted with grief and shame, she wanders off and drowns herself.

Faber, released according to the bargain, discovers her body and the mob rises up crying: 'Away with the Jews.' Karl Alexander dies suddenly of a heart attack and Süss is arrested. At his trial he insists he was only carrying out orders, an ironic defence considering that it was the Nazis' own justification after the war. However, he is convicted of raping a Christian woman and sentenced to be hanged. With the snow falling gently and the people ranged in silent ranks to watch, the drums beat, and Süss is hoisted up in a cage, where he dies, screaming: 'I was only a poor Jew, carrying out orders.' Sturm announces that the Jews have three days in which to get out of Wurtemberg. He pronounces the hope that this case will never be forgotten by their descendants and that they will hold to the anti-Jewish laws for ever and spare themselves the misery suffered by the Wurtembergers.

The film brilliantly orchestrates the themes and archetypes of Nazi propaganda to stimulate the righteous wrath of the audience. It is superbly acted: by Heinrich George, alternately drooling with lust and ranting with fury as the bestial Karl Alexander, by Ferdinand Marian, giving his strongest ever performance as Süss, the ultra-suave, utterly cynical and ruthless manipulator and by Werner Krauss, playing, with diabolical skill, not one but two Jewish roles and creating in them the classic Nazi hate-figures: secretary Levy, cunning, venal, slimy; and the rabbi Loew, hideously aged, bloated and grasping.

Contrasted with this sinister gang are the true Germanic prototypes: Dorothea, Sturm and Faber. Dorothea is the classic German maiden, blonde, buxom, fair-complexioned. Her husband, called Christian (just so you do not forget he is the arch-enemy of the Jews) is the thin-lipped, burning-eyed, ascetic young man most favoured as the proto-Nazi demagogue in the films of the Reich. Malte Jäger's performance can be set alongside two similar portrayals: Emil Lohkamp as Hans Westmar in *Hans Westmar* and Horst Caspar as Gneisenau in *Kolberg*. All are earnest, dedicated young men, given to periodic bursts of patriotic rage when they contemplate the wrongs suffered by the Fatherland. Sturm – another symbolic name – is the archetypal burly, beer-drinking, frank and honest German burgher, rather like Heinrich George's Nettelbeck in *Kolberg*.

Süss personifies the Jewish threat, both economic and sexual, in all its horror, and he also symbolizes the rootlessness and abhorred internationalism of the Jew. He sheds his distinctive Jewish garb and beard and tries to pass as an ordinary person in Stuttgart. But he gives himself away by the smatterings of French in his conversation and by his answer to the key question asked by Dorothea when they first meet. He has described himself as a cosmopolitan.

Dorothea When travelling the world, where do you feel most at home?
Süss Everywhere.
Dorothea Everywhere? Do you have no homeland?

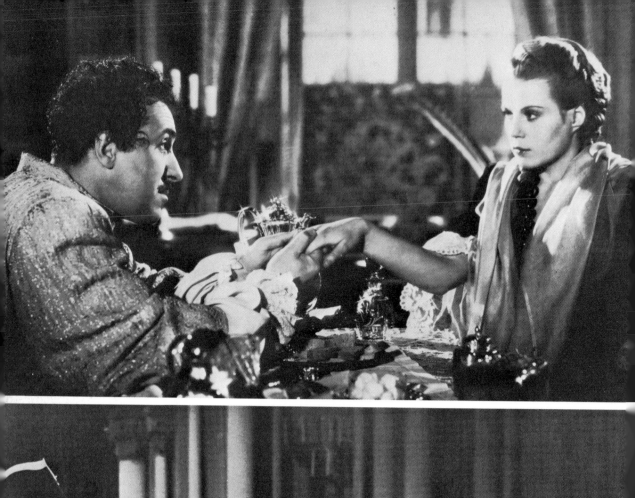
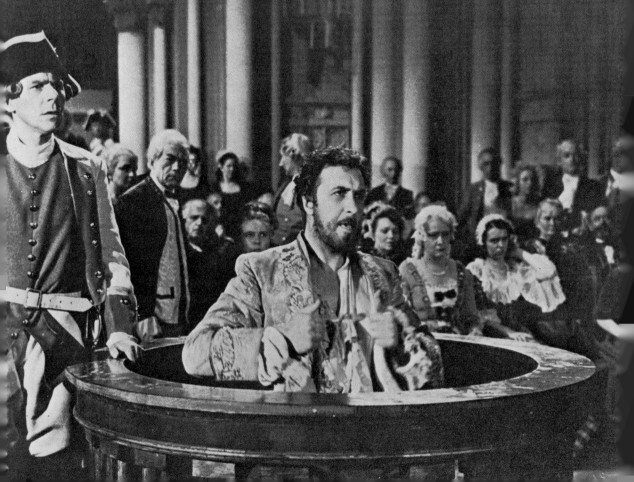

Jew Süss
One of the most notorious films to come out of Nazi Germany,
Jud Süss wove all the elements of the Nazi anti-semitic policy into
a full-blooded melodrama.
230 (opposite above) Jew Süss (Ferdinand Marian) seeks to seduce
Aryan heroine (Kristina Söderbaum)
231 (opposite below) On trial, Süss pleads that he was only
following orders
232 (above left) The archetypal Jew of Nazi propaganda (Werner
Krauss)
233 (above right) The archetypal Aryan of Nazi propaganda (Malte
Jaeger)

Ohm Krüger

234-5 The greatest of the Nazi anti-British films, *Ohm Krüger* contained one of Emil Jannings's finest performances as the Great Leader, Krüger. It depicted the Boer War as the war of a united free people against a tyrannical Imperialist aggressor

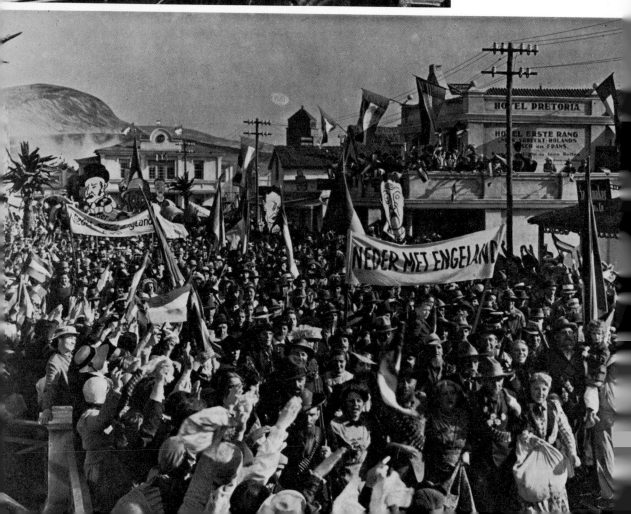

What a give-away.

The equation of the Jews with money is accomplished by camera zooms in on to heaps of jewels and coin whenever the Jews produce them and by Süss winning heavily at cards, to the predictable disgust of Faber. This, then, was the fictional film which gave the Nazis what they wanted, and among the feature films it was never surpassed for sheer malignant expertise.

However, for sheer concentrated nastiness Süss is put in the shade by the forty-five minute documentary, *Der ewige Jude* (*The Eternal Jew*), compiled by Dr Fritz Hippler, who had previously produced the highly-praised documentary account of the Polish invasion *Feldzug in Polen* (*Campaign in Poland*). This was the last of the anti-semitic releases of 1940, and to this day it remains a sickening reminder of the use to which film can be put in the interests of propaganda, a brilliant exercise in calculated evil, with hate oozing from every frame.

Its avowed aim is, as the narrator tells us, to show the world the real face of Jewry before it hid behind the mask of civilization and it is a systematic denunciation of every facet of Jewry. The first section of the film establishes the repellent nature of the Jewish stereotype and his natural environment. The film opens with footage of the Warsaw ghettos, squalid streets, overflowing with ragged, dirty, shuffling Jews. The camera picks out faces, heavily-bearded, thick-lipped, ugly. We are taken into a 'typical' Jewish home, the walls crawling with flies, filth everywhere. Then we are taken back into the streets to see them bartering, in shrill Yiddish voices, from the unhygienic open-air stalls, to support the statement that they are non-productive parasites. Over these sequences, the narrator keeps up a stream of manic abuse:

'Jews have no indigenous civilization; they are unclean; they are not poor, they simply prefer to live in a state of squalor; their community life is on the streets; they hardly ever make anything for themselves; they do not want to work. Their only desire is to trade; their pride lies in haggling over a price. They have no ideals; their divine law teaches them to be selfish, to cheat any non-Jew. On the other hand, the Aryan wants to work, to make things.'

In support of this last statement we are shown shots of honest German workmen, sweating good Aryan sweat and posed picturesquely against the skyline as they swing their picks.

The film moves on to examine the spread of the Jews. By their loathsome methods the Jews have, we are told, risen to wealth and power. There is a series of stills of the great houses of the Jewish plutocrats. It is in order to make their wealth that the Jews want to spread across Europe. 'That is what they are, parasites – the Eternal Jew.' Animated maps show how the Jews, starting from Palestine, have diffused across the world, particularly in the nineteenth century, 'with its vague notions about human dignity and equality'. The maps show the Jewish expansion as great black blobs, which look like festering sores. Then Hippler cuts to a sequence of rats devouring grain and scurrying in packs to fill the screen. The narrator compares the spread of the Jew to that of the brown rat, who carried disease with him from Asia across Europe. Finally we cut back to the Polish ghettos, where the Jews have congregated.

The next sequence returns to the theme of physiognomy. A succession of 'typical' Jewish faces are shown, bearded and in Jewish garb. Then we see the same faces, westernized, shorn of beards and distinctive clothing and we are given a lesson in how to recognize those Jews who have infiltrated society. We are shown Jews infiltrating Berlin society.

Then comes a demonstration of the financial might of the Jews, beginning with a long extract from Alfred Werker's Hollywood film *The House of Rothschild*, with George Arliss, in which the Rothschilds cheat the tax gatherer by pretending to be poor. The comic intent of the original film is, of course, quite obliterated by its new context. The film then traces how the Rothschilds have spread their banking power across Europe

and how they are operating now from the New York Stock Exchange, 'centre of Jewish might'. A succession of photographs of prominent Jewish financiers leads on into politics and photographs of Jewish politicians (Morgenthau, Hore-Belisha, Léon Blum). The Jews are declared to be responsible for Germany's post-war humiliation. Weimar leaders like Rathenau and Communists like Rosa Luxemburg are quoted as examples. Spurious statistics are given to prove Jewish domination of the professions in Germany and also Jewish control of all aspects of crime.

Jews also dominate the fields of art and culture. A montage of the Aryan cultural heritage follows: Greek temples and sculptures, Renaissance paintings, Bach music, the true beauty of which the Jews are said to be unable to appreciate. Jewish methods of artistic expression (cubism, surrealism, expressionism, jazz) are shown and denounced and they are held responsible for moral decadence. Their infiltration of the entertainment industry is revealed and a succession of stills of Max Reinhardt, Richard Oswald, Kurt Gerron, Rosa Valetti, Peter Lorre, Fritz Kortner, Curt Bois, Ernst Lubitsch, Richard Tauber etc. is shown to prove it. Hippler goes so far as to include an extract from Fritz Lang's *M*, implying that the child murderer (played by Peter Lorre) is a typical Jew.

Finally there comes a denunciation of the Jewish religion. Trading goes on during their services. Their religious schools are used for political indoctrination. The film concludes with an unwatchable sequence of Kosher butchery. Then Hitler's Race Laws are flashed on the screen and Hitler delivers an impassioned speech: 'If the Jews succeed in starting a new world war, it will not be the end of the world but the end of the Jews.' The film ends with scenes of Nazi troops of blond Nordic stereotypes on the march and close-ups of the Nazi banners. The Aryan race will triumph, if racial purity is preserved. Though it is never explicitly mentioned, there is clearly only one solution to the danger from these filthy parasites and that is the Nazi Final Solution – mass ex-

termination. Once again it was to prepare the population for this that, for instance, in 1941 the Nazis ordered that every cinema in Holland should show the film.

Der ewige Jude brings to a nauseating height the use of stereotype for the purposes of damnation. Over and over again the film returns to shots of 'typical' Jewish faces, with the shots of blond, clean-cut Aryans at the end, intended as a breath of fresh air after the preceding parade of degeneracy and ugliness. It is without doubt the ultimate Nazi statement on the Jews. Their loathsome physical appearance is seen to epitomize their essential worthlessness. There is no alternative now, according to the Nazis, but extermination to rid the Aryan world of the creeping poison of their presence. It is in a very real sense the cinematic equivalent of Houston Stewart Chamberlain or Alfred Rosenberg.

There were no other full-length anti-semitic feature films made in Germany after 1940 but there were two anti-semitic features, both state-sponsored, made in Austria by or for Wien Film of Vienna. They take up the themes of the German features. The first, *Leinen aus Irland (Irish Linen)* (Heinz Helbig, 1939) is set in the Austro-Hungarian Empire in 1910 and, again, dramatizes the economic and sexual threat of Jewry. Here the Jewish villain gains the confidence of the president of a large Bohemian concern dealing in linen, and puts forward a plan to undercut all the other dealers by importing cheap Irish linen. His aim is to make a fortune for himself and marry the president's daughter, who hates him. He is opposed by an honest and upright young civil servant in the Ministry of Commerce, who seeks to prevent him getting an import licence, realizing that if he does all the humble hard-working Bohemian linen workers will be ruined. But the Jew succeeds in getting his licence because the government officials are all stupid, senile or corrupt. However, at the eleventh hour, the president of the company wakes up to the fact that he is being used, sacks the Jew, cancels the order for Irish linen and agrees to the marriage of his daughter and the

civil servant, who have fallen in love during their campaign to thwart the Jew.

Wien 1910 (*Vienna 1910*) (E. W. Emo, 1942) centred on the career of Dr Karl Luger, the mayor of Vienna. Blind and dying, he summons up his last energies to prevent the Jews from taking over the city finances, which they are plotting to do. On his deathbed, he summons his life-long political enemy, Ritter von Schönerer, and urges him to continue the fight. The moral is that all true Germans must submerge their personal differences and fight against the common enemy, Jewry, which is seeking to gain power, as always, through money.

These are the principal films then, six in all, which are devoted specifically to denouncing the Jews. But Jews crop up, constantly and unflatteringly, to menace the heroes of the Reich's films. It is Jewish art experts who seek to vilify the young sculptor hero of *Venus vor Gericht*. It is a Jew, Cohen, who tries to assassinate the Iron Chancellor in *Bismarck*. It is Jewish moneylenders who try to cheat champion German horseman, Rittmeister von Brenken, out of his stud farm in *Reitet für Deutschland* (*Riding for Germany*) (Arthur Maria Rabenalt, 1941). There are many similar examples. The Jews were the all-time villains of the Nazi culture.

Second only to them were the British, and it was inevitable that the two arch-enemies of the Reich should be linked. Goebbels went so far as to describe the British as 'the Jews among the Aryans'.[5] Cinematically they were linked. For *Die Rothschilds* depicted the Jewish banking family gaining power in Britain, while the plot of *Leinen aus Irland* was built on the scheme to import cheap linen from Ireland, which was only cheap because of the low wages paid to the workers under the tyrannical rule of the British.

The greatest of the Nazi anti-British films is without question *Ohm Krüger* (1941), a supremely clever and utterly cynical reading of the events of the Boer War, whose importance, so the contemporary film programme assures us, lay in the fact that 'for the first time, the entire world of culture realized that England is the brutal enemy of order and civilization'.[6] Sombrely photo-graphed by the great Fritz Arno Wagner, it was directed in full-blown monumental Teutonic style by Hans Steinhoff, with assistance from Karl Anton and Herbert Maisch, who shot some sequences when the film ran over schedule. The title role was played by Emil Jannings and it afforded him the opportunity to give his finest performance under the Reich, demonstrating some of the magic which had made him one of the greatest actors of the golden age of German films and which was so sadly missing from many of his Nazi-period performances. His interpretation of the role is not substantially different from that of Oscar Homolka in the British film *Rhodes of Africa*: canny, folksy, determined; but in *Krüger*, he is elevated to the centre of the stage and takes on the dimensions of the classic Führer-figure. The action of the film begins more or less where *Rhodes of Africa* left off, but it is still instructive to compare their differences of characterization and emphasis.[7]

The story is told in flashback by the now blind, aged and ailing Paul Krüger (Emil Jannings) as he waits in his Geneva hotel to die. He recalls the birth of his 'Fatherland' – the Transvaal – with the Great Trek ('We had only one aim, peace and liberty') in a memorable image of a wagon train, wreathed in dust, pressing on towards the sunrise. But then came the English, seeking to extend their Imperial rule in all directions and lusting after gold. They are epitomized by the suavely villainous Cecil Rhodes (Ferdinand Marian), who is plotting with Joseph Chamberlain to rob the Boers of their goldfields. Rhodes tells his friends that he has a secret weapon – the missionaries. There follows a deliciously satirical scene in a church with a large Union Jack over the altar, in which pious missionaries, with eyes uplifted, sing, in heavily accented English, 'God save the Queen' while handing out rifles to the natives with one hand and prayerbooks to them with the other.

We first meet Krüger in this flashback when Dr Jameson is brought before him after the failure of the Jameson Raid. Krüger contemptuously dismisses him, realizing that the real danger is not from him

Ohm Krüger contained a set of devastating caricatures of British leaders.

236 (above) An oily, scheming Cecil Rhodes (Ferdinand Marian) tries to bribe Krüger

237 (centre) A sadistic Kitchener (Franz Schafheitlin) plans total war against the Boers

238 (below) A bloated Churchill (Otto Wernicke) cruelly ill-treats the inmates of a British concentration camp

239 (opposite) An icily suave Chamberlain (Gustaf Gründgens) persuades a tipsy Queen Victoria (Hedwig Wangel) to go to war

but from Rhodes. Krüger's son Jan (Werner Hinz) returns from England where he has been studying at Oxford and Krüger discovers to his horror that he is now pro-British. They have a violent quarrel when Jan insists that it is possible to negotiate with Britain and Krüger intones over and over the ritual chant: 'England is our enemy.'

The scene changes to London, Buckingham Palace. A dour John Brown feeds the aged Queen Victoria (Hedwig Wangel) with Black and White whisky while an icily arrogant Joseph Chamberlain (Gustaf Gründgens), impeccably dressed down to the obligatory orchid and monocle, tells the Queen that they must annex the Transvaal. He says: 'Providence has called upon England to educate small and backward nations. It is our duty to take over the Boer Lands.' This is an entirely accurate statement of the Imperial credo, but the conversation soon reveals it to be a completely hypocritical cover for Britain's true motive, greed. The Queen tells Chamberlain that Britain has no friends in the world and that such an act would simply alienate everyone even more. But when Chamberlain tells her there is gold there, she nods sagely: 'If there's gold there, then of course it's our country.' But she insists that they try to get it by peaceful means first.

One of the high points of the film follows, in the sequence of Krüger's entirely fictitious state visit to London and his reception at Buckingham Palace. Krüger and the Queen compare notes about their rheumatism and Krüger signs a treaty of friendship with Chamberlain. Jameson is afraid that negotiations will hamper their plans but Rhodes is not perturbed. He goes to see Krüger personally and offers him a blank cheque if he will sell out his people. Krüger throws him out.

The war begins and a spectacular battle, fought on shimmering white sand beneath the darkling skies, results in victory for the Boers. Kitchener (Franz Schafheitlin) is called in to take command and at a war council declares fiercely: 'No more humanity. We must be without mercy. We must set up concentration camps for the women and children, Make no distinction between civil and military.'

Johannesburg is bombarded. A drunken British sergeant tries to rape Jan Krüger's wife and Jan kills him and joins the Boer army. Krüger receives the news that the British army are using women and children as shields and goes blind with horror. Jan persuades him to undertake a trip to Europe to raise support among the powers. In England Queen Victoria dies, hoarsely prophesying a future vengeance on Britain for waging an unjust war. The British burn down Jan's house and arrest his family. They are sent to a concentration camp.

The scenes of the British concentration camp are simply unbelievable when one considers that the Nazis themselves were perpetrating all the horrors of which they were accusing the British and many far worse besides. Pitiful, hollow-eyed, black-clad women, who look for all the world like inmates of Dachau, are beaten and starved while the brutal commandant (Otto Wernicke), clearly intended to be Churchill, takes time off from gorging himself to shoot a couple of women who complain about rotten food.

Jan approaches the camp at night and signals to his wife. She comes and there is a moving little scene as their hands reach out through the barbed wire but are unable to touch. Jan is captured and the film reaches its climax with an apocalyptic sequence, modelled on Eisenstein's Odessa Steps massacre in *Battleship Potemkin*. On a dead, arid hill beneath a glowering sky, with only a single gaunt and twisted tree upon it, preparations are made to hang Jan. The imagery is of Golgotha and Jan takes on Christ-like proportions. Declaring that it is worth dying for the Fatherland, he is hanged. His wife is shot by the Commandant and when the women riot, they are fired upon and flee down the hillside. The camera surveys the carnage in eloquent long-shot: crumpled bodies litter the ground and somewhere a small child is sobbing pathetically. The scene dissolves into a landscape of crosses. The flashback ends and Krüger prophesies that only when England is beaten can there

be a better world. The Boers were too small, he says; but one day a greater nation will arise to bring England to her knees. There are no prizes for guessing which nation that is.

The film sets up a series of antinomies which is completely damning to England.

Good	Evil
The Boers	The British
Land	Gold
Settlement	Conquest
Freedom	Empire
Honesty	Duplicity
The People	Military Force

Similarly patriotism, the Volk, the Fatherland (Paul Krüger) are contrasted with intellectualism, liberalism, pacifism (Jan Krüger), a conflict resolved when Jan comes over to his father's side. He rejoins the Volk. For the war is a people's war. The British army, moving in orderly ranks with military precision, contrasts with the surging, enthusiastic mass of the people's forces who attack them.

Krüger is the Great Leader, compared to Hitler when he stands on the balcony to receive the frenzied homage of his people, waving, singing, flag-carrying, with all the trappings of the Nazi Rally except for the 'Sieg Heil' salute. He is compared also to Christ in the scene where he gives thanks for victory over the English. The sequence, shot over his shoulder as he stands on top of a hill to bless his kneeling followers grouped at the bottom, looks like nothing less than the Sermon on the Mount. He is photographed throughout to emphasize his isolation and dedication, especially when he is blind. His appearances are low-lit so that it appears at times as if he has a halo around his head. The camera tracks slowly in to close-ups of his face whenever he has anything to say, thus fixing the spectator's attention on him. However, nothing is perhaps as effective as our first unforgettable glimpse of him in his darkened hotel room. His image bursts upon the screen in a dazzling explosion of popping photographic light bulbs. He is the indomitable spirit of his country, stretched out stiffly like a statue, a shock of white hair and dark glasses imprinting themselves on our memory.

His mythic role is cleverly offset by scenes which stress his Volkist attributes and genuine human qualities, the face of the man behind the myth. He emerges as a folksy, homely but very shrewd man. A single sequence serves to demonstrate this. In it he first deals swiftly with the blustering Jameson, then indulges in a friendly trial of strength with a bearded Old Testament figure whom he has alleged to be too old to fight and finally makes short work of a pair of richly-dressed appeasers, who try to persuade him to come to terms with the English and whom he kicks out. Later on Krüger is seen smoking his pipe, playing with his grandchild and drinking coffee with his ministers, served by his wife. There are similar sequences to these involving Oscar Homolka's Krüger in *Rhodes* but the difference there is that Homolka's Krüger is all man and no myth and never emerges as the Great Leader, a role reserved in that film for Rhodes himself.

Ohm Krüger is an object lesson in the use of archetype. For while it creates one of the greatest Great Leaders in Nazi cinema in Krüger, it also mercilessly parodies the British. Rhodes is an oily schemer, his face often seen half in shadow, his voice soft, his eyes gleaming with cunning. Chamberlain is an aloof, expressionless, impeccably attired scoundrel, a monstrous caricature of British *sang froid*. The Prince of Wales (Alfred Bernau) is a lecherous voluptuary who, while his mother lies dying, is ogling dancing girls in a very Germanic English music hall whose denizens look like refugees from *The Blue Angel*. Kitchener is a beetle-browed sadist, Churchill a bloated despot and Queen Victoria a whisky-sodden old wreck.

Much as one may admire the techniques of propaganda, however, one cannot but be appalled at the sheer cynicism of the exercise. The Nazis denounce the British for inventing concentration camps and total war and they actually use Nazi slogans for the enemy. Rhodes declares: 'One must be a dreamer to become a ruler', which was one of Hitler's maxims. Krüger denounces the

British tyranny
240–3 British atrocities
in Ireland were depicted in
Mein Leben für Irland
(240 left) and heroic Irish
freedom-fighters were
celebrated in *Der Fuchs
von Glenarvon* (241 below).
German heroes resisted
British aggression in
Africa in *Die Reiter von
Deutsch-Ostafrika*
(242, right) and *Germanin*
(243, below right)

British for branding him as a murderer and war-monger in their newspapers, saying sadly: 'If a lie is repeated often enough, people will come to believe it in the end.' This was Goebbels's cardinal tenet.

It was Goebbels's brother-in-law, Max W. Kimmich, who came up with the idea of making a film to dramatize the conflict between the freedom-fighting Irish and their British oppressors. Kimmich himself directed and the result was the extremely entertaining *Der Fuchs von Glenarvon* (*The Fox of Glenarvon*), made in 1940 and strongly reminiscent, both in plot and atmosphere, of John Ford's *Hangman's House*, which had appeared in 1928. It lovingly re-creates, on the sound-stages of Tobis Film, the emerald isle of Celtic legend and cinematic myth: waves crashing on a rocky coast, dank and forbidding bogs, mist-wreathed moors and lonely stone cottages. Kimmich creates some memorable images, aided by Fritz Arno Wagner's brooding photography: cloaked riders looming up out of the mist, a torch-lit funeral procession, a wild storm at sea. Added local colour is provided by ersatz Gaelic melodies, warbled in German.

'Ireland, the emerald isle, the oldest victim of English oppression, which has suffered for eight centuries from the methods of British politics, as witnessed by the millions of suffering and exiled people,' proclaims the foreword. The film opens with a secret meeting of Irish patriots, who intone a litany of hate, ending with the cry: 'Who is our enemy? England.' (Cf. *Krüger*.) The Fox of the title is the suave, treacherous Philip Grandison (Ferdinand Marian again), an English judge who, since he is married to an Irish woman, improbably named Gloria (Olga Tschechowa), is counted as part of the Irish aristocracy. Pretending sympathy with the rebels, he is in fact secretly working for the British authorities, unknown to his wife. Sir John Ennis of Lowland (Karl Ludwig Diehl) returns after a long absence abroad. (With characteristic continental confusion over British titles, he is referred to in the film variously as 'Sir John', 'Sir Ennis' and 'Sir Lowland'.) He blames himself for the death of his wife, killed seven years earlier

while taking part in a rising against the British. At a ball he hears Gloria singing an old Irish folk song and falls in love with her. He also joins the Underground.

The rebels wreck a British ship, believed to be bearing the newly appointed British commander, Sir John Tetbury (Werner Hinz), better known as 'The Hangman of India'. Grandison has Ennis arrested, suspecting him of being in league with the rebels, but he is released and ordered to quit Ireland within five days. The rebels hold a secret meeting at the church but are betrayed to the British. Gloria, discovering that her husband is responsible, leaves him. Learning that the British are on their way to break up another secret meeting, she hurries off to warn them and arrives to find Ennis and Grandison being tried by a secret court for treason. The court, however, is unable to decide which of them is the traitor. Gloria's evidence convicts her husband and at that point the British troops appear. The Irish lure them to their destruction in the bogs and Grandison, trying to escape, is swallowed up too. Gloria and Ennis join the rebels, who march off, carrying torches and singing a song about freedom, to carry on the fight against the British. Once again, it is the people, who are on the march (cf. *Kolberg*, *Krüger*) against the hated British, characterized as arrogant, monocled and brutal oppressors.

The success of this film prompted Kimmich to produce another Irish piece, *Mein Leben für Irland* (*My Life for Ireland*), which he directed in 1941 from a script by himself and Toni Huppertz, this time aimed at the youth market. The hero is Michael O'Brien (Werner Hinz), an Irish youth, whose father has been executed by the English and who is put into an English school for the children of Irish nationalists. Unsuccessful attempts are made to make them abandon their nationalist views. An Irish American boy Patrick (Claus Clausen) unwittingly causes the arrest of Michael's mother and is branded a traitor. The Irish rebellion breaks out and as the fight turns against the rebels, Patrick leads them through a secret tunnel into Dublin Castle, thus vindicating himself. The English

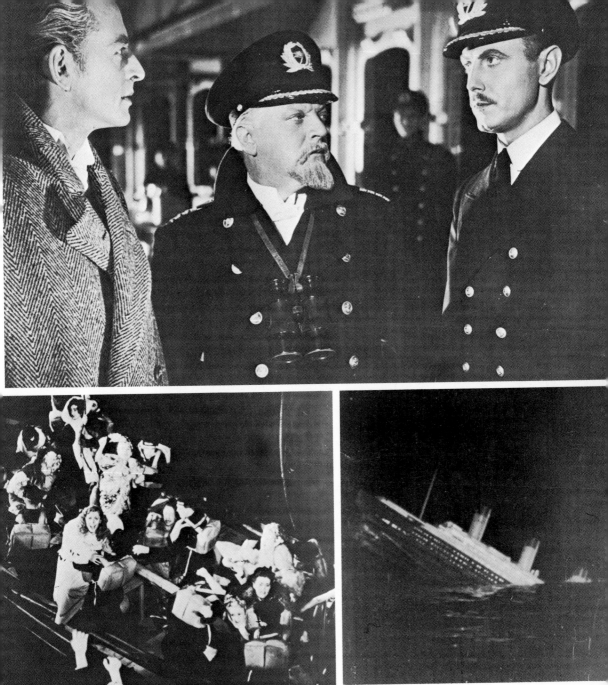

Titanic
244–6 The last full-scale anti-British film accurately reflected, in
allegorical terms, the real state of affairs in Germany: a corrupt
leader (244, above), panicking passengers (245, left), the Reich
heading full tilt to destruction (246, right)

are beaten and Patrick, mortally wounded at the moment of victory, dies in the arms of Michael's mother, who, with other Irish prisoners, has been released. It is the familiar blending of elements: Fatherland, comradeship, self-sacrifice, but in the novel setting of Ireland. Considering that prints of *Jud Süss* are still circulating in the Middle East and being, presumably, received by the Arabs with rapturous applause, one is led to speculate on how much an enterprising entrepreneur would make if he circulated dubbed prints of these two pictures in Eire.

The earliest specifically anti-British film is *Die Reiter von Deutsch-Ostafrika* (*The Riders of German East Africa*) (Herbert Selpin, 1934). It tells of the adventures of two friends, one British and one German, who find themselves on opposite sides at the outbreak of the First World War. The Briton is forced to burn down the German's plantation but the German and his wife escape, to the secret relief of the Briton. The film did not go far enough for the Nazis' taste and was banned by the censor as pacifist. Ironically, after the war, the Allies banned it as militarist and anti-British.

Selpin returned to the East African setting for *Carl Peters* (1941), a film biography of the German colonialist, which featured the popular Hans Albers in the title role but made no impact at the box-office. It opens in London in 1882 with the young Carl attracting attention from the British secret service because of his desire to obtain colonies for Germany in Africa. He returns to Germany but can find no support for his schemes and so plans to go ahead alone. He acquires Zanzibar for Germany and receives an official letter of protection from the Kaiser. His further plans are hampered, however, by the British, who make an unsuccessful attempt to assassinate him, and by a Jew, who is director of the German Colonial Office. Recalled from Africa, Peters is appointed Reichskomissar after the dismissal of the Jew. England accuses him of brutality to the natives on the faked evidence of a negro bishop and he is relieved of office. But in the pages of his diary we are shown how right his ideas proved to be in the light of history.

Both of Selpin's films dramatize Germany's role in East Africa and detail Britain's attempts to cheat her of her colonial destiny. Carl Peters, like Schiller and Bismarck in the other Nazi film biographies, prefigures Hitler. He is one of the great German patriots and pioneers whose work was left unfinished but will be completed by the Führer.

Max Kimmich made Africa the setting of *Germanin* (1943), in which another heroic German pioneer falls victim to British oppression. Dr Achenbach (Peter Petersen) is working in Africa on a serum to combat the dreaded sleeping sickness when the outbreak of the First World War recalls him to Germany. He perfects the serum and after the war, although Germany has been robbed of her colonies, he insists on taking the serum to the suffering natives of Africa. The British hamper his progress by constant acts of sabotage and finally incite the natives to destroy his lab. But when the British District Commissioner succumbs to the disease, he comes to Achenbach for help. By now Achenbach too is infected but, in the spirit of heroic self-sacrifice, he injects the Commissioner with the sole surviving capsule of serum. Achenbach dies but his assistants continue his work. So here we have a German bringing the benefits of civilization to the natives of Africa, in the face of British opposition.

These were the major state-sponsored anti-British films. There were a couple of other adventure melodramas on the list. *Anschlag auf Baku* (*Attack on Baku*) (Fritz Kirchhoff, 1942) had gallant Germans foiling wicked British attempts to seize the Baku oilfields and *Aufruhr in Damaskus* (*Uproar in Damascus*) (Gustav Ucicky, 1939) interestingly featured Lawrence of Arabia stirring up the natives of Syria against the Germans during the First World War. There was even an anti-British musical, *Das Herz der Königin* (*The Heart of the Queen*) (Carl Froelich, 1940) in which popular Swedish singing-star Zarah Leander sang her way to the block as Mary, Queen of Scots and the English were vilified.

The last full-scale anti-British film was probably *Titanic* (1943), though the background to the film is even more dramatic

than its contents. For half way through the making of the film, the director Herbert Selpin was arrested and executed for treason: the film was completed by Werner Klingler. It tells the dramatic story of the ill-fated maiden voyage of the *Titanic* and lays the responsibility for the tragedy at the door of Sir Bruce Ismay (Ernst Fürbringer), president of the White Star line. He it is who orders the ship to sail at full speed along the dangerous northern route in order to win the Blue Riband, which he hopes will further his corrupt financial machinations. The hero is, of course, a German, First Officer Petersen (Hans Nielsen) who tries in vain to keep the speed down and prevent tragedy. When the crisis comes, the German passengers behave impeccably and the British panic. Ismay gets off scot free and this is seen as typical of British justice.

It was a spectacular film, a big-budget epic, but when he viewed the finished print, Goebbels banned it. The scenes of disaster were so grimly realistic they evoked sympathy for the British passengers. Even more important, in the context of the Nazi cinema, the Führer-figure, Ismay, was shown to be corrupt and self-seeking and responsible for the needless deaths of hundreds of people. This portrait came far too close to home for comfort. It did in fact accurately reflect, in allegorical terms, the real state of affairs in Germany. Like the *Titanic*, the Reich, under the orders of its Führer, was steaming at full speed towards catastrophe.

Notes

1 Josef Wulf, *Theater und Film im Dritten Reich* (1964), pp. 9–10.
2 Helmut Blobner and Herbert Holba, 'Jackboot Cinema', *Films and Filming* (December 1962), p. 16.
3 David Stewart Hull, *Film in the Third Reich* (1969), p. 159.
4 Ibid., p. 167.
5 Erwin Leiser, *Deutschland Erwache!* (1968), p. 30.
6 Blobner and Holba, op. cit., p. 19.
7 See the discussion of *Rhodes of Africa* in chapter 9.

Conclusions

I have set out in this book to explore what I have called the Cinema of the Right, three basically conservative movements which have through the medium of film projected their own visions of the perfect society. But while all three movements, American populism, British Imperialism and German Nazism, are right-wing, they are certainly not to be equated and are in many respects very different from one another. For each is the culmination of a long process of historical, cultural and ideological development within its own country of origin. It would perhaps be true to say that all of them began as radical alternatives: populism to federalism, Imperialism to Little England-ism and Nazism to Weimar democracy. But all three rapidly took on the status of orthodoxies and as such became hallowed and enshrined.

By the time the cinema came to express these movements they were all middle-class ideologies with a definite commitment to turning back the clock to the world of the day before yesterday, be it the heyday of British Imperialism, the Golden Age of Teutonic might or the Arcadian paradise of the American yeoman farmer. Hence there is a very high nostalgia quotient in all three cinematic genres. The need for reassurance on the part of the middle classes also helped to dictate the format of the films: the mythic backdrops of unchanging, idealized societies and the absolute standards of right and wrong, good and bad, us and them that they reflected.

Having said this, however, it must be reiterated that there are fundamental differences between the three movements which must already have become apparent. We have noted the dominant role of women in populist films and the subordination of women in Imperial and Nazi films. The populists attacked the political machine, the Nazis glorified it. The populists exalted individualism, the Nazis suppressed it. Good neighbourliness was a cardinal principle of populist cinema, bad neighbourliness of Nazi cinema; while the British had no neighbours at all, being far too superior. Yet the idea of strength being drawn from the soil is one which links populism and Nazism. But on the whole the compassion, warmth and humanity of the populist films is totally absent from the heavy-handed and humourless products of Nazi cinema.

There are closer similarities between Imperial and Nazi films but this is partly a reflection of the fact that both movements are products of the Old World whereas populism springs from the New. Both movements are based on an idea of racial superiority. But where the Germans believed that the inferior race should be destroyed, the British believed that the inferior races should be governed wisely and justly. The basic difference is one of spirit. The concept of the gentleman, with his Code of behaviour, his sense of obligation and the virtues inculcated in him by his public school, lay at the heart of the Imperial cinema. For the Germans, in contrast, absolute obedience to an all-knowing and all-powerful leader was mandatory. In short, the British Imperial cinema had that 'sense of humour and sense of proportion' to which I have often referred. The Nazi cinema had neither.

Their images of the perfect society, then, were different. Where these genres did resemble each other was in their methods of dramatizing their images. In each case we see over and over again the simplification,

personalization and emotionalization of issues e.g. conflict within a family resolved in a way which dramatizes the ideology. In a very real sense, all three of the movements we have been examining were religions and the films can be seen as ritual enactments of the creed. Kipling wrote that 'all ritual is fortifying' and this gives us the key to understanding these films. Their purpose was, I would contend, not to convert the unbeliever but to sustain and encourage the believer. The greatness of Leni Riefenstahl lies in part in her brilliantly ritualistic depiction of the Nazi creed. Similarly Meyer Levin, reviewing *Charge of the Light Brigade* in 1936, was able to analyse why this film and others of the same genre were so hypnotic: 'It is as satisfying as *Bengal Lancer*, as faithful as *Under Two Flags*. You are willingly hypnotized and each time the trance is deeper because you have completely given up suspicion, you know the litany, you know the ritual will never be betrayed.' This explains why my account may have appeared repetitious at times. Repetition is an integral part of ritual. It is only by repetition that the message is drummed home. It also explains why these movies are anti-intellectual. Intellect implies a questioning of beliefs. These genres required unquestioning acceptance of the creed.

The fundamental elements of the litany, such as 'The Führer knows best', 'Life, Liberty and the Pursuit of Happiness' and 'The White Man's Burden', were dramatized over and over again. As with all religions these cinematic expressions of the creed have their gods and heroes who are apotheosized, their icons to provide focal points for emotion, their archetypes for audience identification. The heroes are ritualized: the Lincoln-Christ populist 'Good Man', the 'heaven-born' administrator of the Imperial films, the Nazi Führer-figure. So too are the villains: the despised money-grubbing Jew, the bloated Wall Street plutocrat, the educated native chieftain. They constitute a sort of cinematic shorthand, visual representations, immediately identifiable, of Good and Evil.

The film stars are important in this context. They are the high priests of the celluloid religions, the ritual enactors of the dramatized creed, the hierophants in the masks. Gary Cooper, James Stewart and John Wayne bring their legendary *personae* to the expression of the populist ideology. Ronald Colman, David Niven and Clive Brook do the same for Imperialism. This is one reason why the Nazi films are much less successful cinematically than the other two genres. Many of the great German stars left Germany. The German star system was further undermined by the suicide of two enormously popular stars, Joachim Gottschalk and Renate Müller, hounded to their deaths by the Gestapo. The really charismatic stars of German films either kept out of the political films or were only intermittently on form.

The musical scores too had their religious function, being chosen to heighten the mood. The folk songs and hymns of America are an integral part of John Ford's films, the Nazi party marching tunes crop up constantly in their films and Elgar is the obvious inspiration for the musical scores of some of the Imperial films, notably *Khartoum*, *Yangtse Incident* and *Victoria the Great*.

Little did the average cinema-goer realize as he entered the Stygian darkness of the local Roxy or Gaumont that his visit to the cinema was the equivalent of a visit to the underground temples of the Mithraic cult or the Eleusinian mysteries. The time-honoured rituals were re-enacted on the silver screen for the assembled congregation of the faithful and they went out into the light again fulfilled, their beliefs and assumptions triumphantly reaffirmed.

Appendix: Filmographies

This is a list in alphabetical order of the principal films discussed in Part 1.
Abbreviations: p=producer, d=director, sc=screenwriter, p.c=production company.

1 Films of Empire

The Admirable Crichton (1957) p.c: Columbia d: Lewis Gilbert p: Ian Dalrymple sc: Vernon Harris (from the play by J. M. Barrie).
With Kenneth More, Diane Cilento, Cecil Parker, Sally Ann Howes, Martita Hunt, Peter Graves, Jack Watling, Gerald Harper, Miles Malleson, Miranda Connell.
16 mm print available from Columbia Pictures, Film House, Wardour Street, London W1U 44H.

Another Dawn (1937) p.c: Warner Bros d: William Dieterle sc: Laird Doyle.
With Errol Flynn, Kay Francis, Ian Hunter, Frieda Inescort, Herbert Mundin, G. P. Huntley Jr, Billy Bevan, Clyde Cook, Reginald Sheffield, Mary Forbes.

Around the World in 80 Days (1956) p: Mike Todd (for United Artists) d: Michael Anderson sc: John Farrow, James Poe and S. J. Perelman (from the novel by Jules Verne).
With David Niven, Cantinflas, Shirley MacLaine, Robert Newton, Ronald Colman, Cedric Hardwicke, Noël Coward, Reginald Denny, and thirty-six other guest stars.

The Bandit of Zhobe (1958) p.c: Columbia-Warwick d-sc: John Gilling (from a story by Richard Maibaum) p: Harold Huth.
With Victor Mature, Anne Aubrey, Anthony Newley, Norman Wooland, Dermot Walsh, Sean Kelly, Walter Gotell, Paul Stassino, Denis Shaw, Lawrence Taylor.
16 mm print available from Columbia.

Beau Geste (1939) p.c: Paramount d-p: William Wellman sc: Robert Carson (from the novel by P. C. Wren).
With Gary Cooper, Robert Preston, Ray Milland, Brian Donlevy, Susan Hayward, J. Carroll Naish, G. P. Huntley Jr, Heather Thatcher, James Stephenson.

16 mm print available from Columbia.

Beau Ideal (1930) p.c: Radio Films d: Herbert Brenon p: William Le Baron sc: Paul Schofield (from the novel by P. C. Wren).
With Ralph Forbes, Loretta Young, Lester Vail, Don Alvarado, Irene Rich, Leni Stengler, Otto Matiesen, Frank McCormack, Paul McAllister.
16 mm print available from Kingston Films, 645–7 Uxbridge Road, Hayes End, Middlesex.

Bengal Rifles (U.S. title: *Bengal Brigade*) (1954) p.c: Universal-International p: Ted Richmond d: Laslo Benedek sc: Richard Alan Simmons (from the novel by Hall Hunter). With Rock Hudson, Arlene Dahl, Ursula Thiess, Torin Thatcher, Dan O'Herlihy, Michael Ansara, Harold Gordon, Arnold Moss, John Dodsworth, Leslie Dennison.

Bhowani Junction (1955) p.c: M.G.M. d: George Cukor p: Pandro S. Berman sc: Sonya Levien and Ivan Moffat (from the novel by John Masters).
With Stewart Granger, Ava Gardner, Bill Travers, Francis Matthews, Peter Illing, Abraham Sofaer, Marne Maitland, Edward Chapman, Lionel Jeffries.
16 mm print available from Rank Film Library, P.O. Box 70, Great West Road, Brentford, Middlesex.

Bwana Devil (1952) p: Arch Oboler (for United Artists) d-sc: Arch Oboler.
With Robert Stack, Barbara Britton, Nigel Bruce, Ramsay Hill, Paul McVey, John Dodsworth, Hope Miller, Bhupesh Guha.

Cavalcade (1932) p.c: Fox d: Frank Lloyd sc: Reginald Berkeley (from the play by Noël Coward).
With Diana Wynyard, Clive Brook, Herbert Mundin, Una O'Connor, Frank Lawton, John Warburton, Ursula Jeans, Irene Browne, Margaret Lindsay, Billy Bevan.

Charge of the Light Brigade (1936) p.c: Warner Bros d: Michael Curtiz sc: Michel Jacoby and Rowland Leigh (from a story by Jacoby).
With Errol Flynn, Olivia de Havilland, Patric

Knowles, David Niven, Donald Crisp, Henry Stephenson, Nigel Bruce, G. P. Huntley Jr, Reginald Sheffield.

The Chinese Bungalow (U.S. title: *Chinese Den*) (1940) p.c: British Lion d-p: George King sc: A. R. Rawlinson (from the play by Marion Osmond and Matheson Lang based on Marion Osmond's novel).
With Paul Lukas, Jane Baxter, Robert Douglas, Kay Walsh, Wallace Douglas, Jerry Verno, John Salew, James Woodburn, Mayura.
16 mm print available from Mobile Movies, Film House, Muscott Street, St James, Northampton.

Clive of India (1935) p.c: 20th Century Pictures (for United Artists) d: Richard Boleslavski sc: W. P. Lipscomb and R. J. Minney (from their play).
With Ronald Colman, Loretta Young, Cesar Romero, Colin Clive, C. Aubrey Smith, Francis Lister, Mischa Auer, Montagu Love, Leo G. Carroll, Lumsden Hare.

Disraeli (1930) p.c: Warner Bros d: Alfred E. Green sc: Julien Josephson (from the play by Louis Parker).
With George Arliss, Joan Bennett, Florence Arliss, David Torrence, Doris Lloyd, Anthony Bushell, Ivan Simpson, Margaret Mann, Gwendolen Logan, Henry Carvill.

The Drum (U.S.title: *Drums*) (1938) p.c: London Films (for United Artists) d: Zoltan Korda p: Alexander Korda sc: Arthur Wimperis, Patrick Kirwan and Hugh Gray.
With Sabu, Raymond Massey, Roger Livesey, Valerie Hobson, Desmond Tester, Francis L. Sullivan, David Tree, Archibald Batty, Amid Taftzani, Martin Walker.

Drums of Africa (1963) p.c: M.G.M. d: James B. Clark p: Al Zimbalist and Philip N. Krasne sc: Robin Estridge and Arthur Hoerl.
With Frankie Avalon, Mariette Hartley, Lloyd Bochner, Torin Thatcher, Hari Rhodes, George Sawaya, Michael Pate, Ron Whelan, Peter Mamakos.
16 mm print available from Ron Harris Cinema Services, Glenbuck House, Glenbuck Road, Surbiton, Surrey.

East of Sudan (1964) p.c: Columbia-Ameran p-d: Nathan Juran sc: Jud Kinberg.
With Anthony Quayle, Sylvia Syms, Derek Fowlds, Jenny Agutter, Johnny Sekka, Joseph Layode, Harold Coyne, Derek Blomfield, Ellario Pedro, Desmond Davies.

The Face of Fu Manchu (1965) p.c: Anglo-Amalgamated d: Don Sharp p: Harry Alan Towers sc: Peter Welbeck (from the novels by Sax Rohmer).
With Christopher Lee, Nigel Green, Joachim Fuchsberger, Karin Dor, Tsai Chin, Howard Marion Crawford, James Robertson Justice, Walter Rilla.
16 mm print available from Columbia.

Farewell Again (1937) p.c: London Films (for United Artists) d: Tim Whelan p: Erich Pommer sc: Clemence Dane and Patrick Kirwan (from a story by Wolfgang Wilhelm).
With Leslie Banks, Flora Robson, Robert Newton, Sebastian Shaw, René Ray, Patricia Hillard, Martita Hunt, Anthony Bushell, Robert Cochrane, Edward Lexy.
16 mm print available from Watso Films, Charles Street and Vine, Coventry.

55 Days at Peking (1962) p: Samuel Bronston (for Rank) d: Nicholas Ray sc: Philip Yordan and Bernard Gordon.
With Charlton Heston, Ava Gardner, David Niven, Robert Helpmann, Flora Robson, Leo Genn, Paul Lukas, John Ireland, Harry Andrews, Elizabeth Sellars.

The First Men in the Moon (1964) p.c: Columbia-Ameran d: Nathan Juran p: Charles Schneer sc: Nigel Kneale and Jan Read (from the novel by H. G. Wells).
With Edward Judd, Lionel Jeffries, Martha Hyer, Peter Finch, Erik Chitty, Gladys Henson, Paul Carpenter, Huw Thomas, Hugh McDermott, Sean Kelly.
16 mm print available from Columbia.

Five Weeks in a Balloon (1962) p.c: 20th Century-Fox d-p: Irwin Allen sc: Charles Bennett, Irwin Allen and Albert Gail (from the novel by Jules Verne).
With Cedric Harwicke, Red Buttons, Barbara Eden, Peter Lorre, Richard Haydn, Herbert Marshall, Reginald Owen, Billy Gilbert, Henry Daniell, Barbara Luna.
16 mm print available from Rank.

The Flag Lieutenant (1933) p.c: British and Dominion Films d: Henry Edwards p: Herbert Wilcox sc: Joan Wentworth Wood (from the play by Lt Col. W. P. Drury and Major Leo Trevor).
With Henry Edwards, Anna Neagle, Peter Gawthorne, Louis Goodrich, O. B. Clarence, Sam Livesey, Abraham Sofaer, Joyce Bland, Michael Hogan, Peter Northcote.

The Four Feathers (1929) p.c: Paramount p-d: Ernest B. Schoedsack and Merian C. Cooper (with Lothar Mendes) sc: Howard Estabrook (from the novel by A. E. W. Mason).
With Richard Arlen, Fay Wray, Clive Brook, William Powell, Theodore von Eltz, Noah Beery, Harold Hightower, Noble Johnson, Philippe de Lacy, George Fawcett.
16 mm print available from Columbia.

The Four Feathers (1939) p.c: London Films (for United Artists) d: Zoltan Korda p: Alexander Korda sc: R. C. Sherriff (from the novel by A. E. W. Mason).
With John Clements, Ralph Richardson, June Duprez, C. Aubrey Smith, Allan Jeayes, Jack Allen, Donald Gray, Amid Taftzani, Henry Oscar, Archibald Batty.

Four Men and a Prayer (1938) p.c: 20th Century-Fox d: John Ford p: Darryl F. Zanuck sc: Richard Sherman, Sonya Levien and Walter Ferris (from the novel by David Garth).
With Richard Greene, Loretta Young, David Niven, George Sanders, C. Aubrey Smith, William Henry, John Carradine, Reginald Denny, John Sutton, Alan Hale.

Goodbye, Mr. Chips (1939) p.c: M.G.M. d: Sam Wood sc: R. C. Sherriff, Claudine West and Eric Maschwitz (from the novel by James Hilton).
With Robert Donat, Greer Garson, John Mills, Paul Henreid, Terry Kilburn, Milton Rosmer, Austin Trevor, Judith Furse, David Tree, Edmond Breon.

Goodbye, Mr. Chips (1970) p.c: M.G.M. d: Herbert Ross p: Arthur P. Jacobs sc: Terence Rattigan (from the novel by James Hilton).
With Peter O'Toole, Petula Clark, Michael Redgrave, George Baker, Jack Hedley, Sian Phillips, Alison Leggatt, Clinton Greyn, Michael Culver, Clive Morton.
16 mm print available from Rank.

The Great Barrier (U.S. title: *Silent Barriers*) (1936) p.c: Gaumont British d: Milton Rosmer sc: Michael Barringer and Milton Rosmer.
With Richard Arlen, Lilli Palmer, Antoinette Cellier, Barry McKay, Roy Emerton, J. Farrell MacDonald.

The Green Goddess (1930) p.c: Warner Bros d: Alfred E. Green sc: Julien Josephson (from the play by William Archer).
With George Arliss, Alice Joyce, Ralph Forbes, H. B. Warner, Ivan Simpson, Reginald Sheffield, Betty Boyd, David Tearle, Nigel de Brulier.

Gunga Din (1939) p.c: R.K.O. Radio Pictures d-p: George Stevens sc: Joel Sayre and Fred Guiol (from a story by Charles MacArthur based on Kipling's poem).
With Cary Grant, Douglas Fairbanks Jr, Victor McLaglen, Sam Jaffe, Joan Fontaine, Eduardo Ciannelli, Montagu Love, Abner Biberman, Lumsden Hare.
16 mm print available from Kingston.

Guns at Batasi (1964) p.c: 20th Century-Fox d: John Guillermin p: George Brown sc: Robert Hollis (from his own novel).
With Richard Attenborough, Mia Farrow, John Leyton, Flora Robson, Jack Hawkins, Cecil Parker, Errol John, Earl Cameron, David Lodge, Bernard Horsfall.

The Housemaster (1938) p.c: Associated British d: Herbert Brenon p: Walter Mycroft sc: Dudley Leslie (from the play by Ian Hay).
With Otto Kruger, Diana Churchill, Phillips Holmes, Joyce Barbour, René Ray, Kynaston Reeves, Walter Hudd, Cecil Parker, Jimmy Hanley, John Wood.

Java Head (1934) p.c: Associated Talking Pictures d: J Walter Ruben sc: Martin Brown and Gordon Wellesley (from the novel by Joseph Hergesheimer).
With Edmund Gwenn, John Loder, Anna May Wong, Ralph Richardson, Elizabeth Allan, Herbert Lomas, George Curzon.

Journey to the Centre of the Earth (1959) p.c: 20th Century-Fox d: Henry Levin p: Charles Brackett sc: Walter Reisch and Charles Brackett (from the novel by Jules Verne).
With James Mason, Pat Boone, Arlene Dahl, Diane Baker, Peter Ronson, Thayer David, Alan Napier, Robert Adler, Alan Caillou, Frederick Halliday.
16 mm print available from Ron Harris.

Journey's End (1930) p.c: Tiffany d: James Whale supervisor of production: George Pearson sc: Joseph Moncure March (from the play by R. C. Sherriff).
With Colin Clive, Anthony Bushell, David Manners, Ian Maclaren, Billy Bevan, Charles Gerrard, Robert Adair, Thomas Whitely, Jack Pitcairn.

Kali-Yug, Goddess of Vengeance (1963) p.c: Serena-Criterion-Eichberg (for British Lion release) d: Mario Camerini p: Roberto Dandi sc: Guy Elmes, Leo Benvenuti and Piero de Bernardi (from a story by Robert Westerby).
With Paul Guers, Senta Berger, Lex Barker, Sergio Fantoni, Ian Hunter, Michael Medwin,

I. S. Johar, Claudine Auger, Joachim Hansen, Klaus Kinski.

Khartoum (1966) p: Julian Blaustein (for United Artists) d: Basil Dearden sc: Robert Ardrey.
With Charlton Heston, Laurence Olivier, Ralph Richardson, Richard Johnson, Alexander Knox, Nigel Green, Hugh Williams, Johnny Sekka, Douglas Wilmer.
16 mm print available from F.D.A.

Khyber Patrol (1954) p.c: World Films (for United Artists) d: Seymour Friedman p: Edward Small sc: Jack De Witt (from a story by Richard Schayer).
With Richard Egan, Dawn Addams, Raymond Burr, Patric Knowles, Paul Cavanagh, Donald Randolph.

Killers of Kilimanjaro (1959) p.c: Columbia-Warwick d: Richard Thorpe p: John R. Sloan sc: John Gilling (story by Richard Maibaum and Cyril Hume).
With Robert Taylor, Anne Aubrey, Anthony Newley, Gregoire Aslan, Orlando Martins, Earl Cameron, Martin Benson, Donald Pleasence.

Kim (1951) p.c: M.G.M. d: Victor Saville p: Leon Gordon sc: Leon Gordon, Helen Deutsch and Richard Schayer (from the novel by Rudyard Kipling).
With Dean Stockwell, Errol Flynn, Paul Lukas, Robert Douglas, Thomas Gomez, Cecil Kellaway, Arnold Moss, Reginald Owen, Walter Kingsford, Ivan Triesault.
16 mm print available from Ron Harris.

King of the Khyber Rifles (U.S. title: *Black Watch*) (1929) p.c: Fox d: John Ford sc: James Kevin McGuinness and John Stone (from the novel by Talbot Mundy).
With Victor McLaglen, Myrna Loy, Roy D'Arcy, Pat Somerset, Lumsden Hare, David Torrence, Francis Ford, David Rollins, Mitchell Lewis.

King of the Khyber Rifles (1954) p.c: 20th Century-Fox d: Henry King p: Frank P. Rosenberg sc: Ivan Goff and Ben Roberts (from a story by Harry Kleiner, taking its title but nothing else from Talbot Mundy's novel).
With Tyrone Power, Terry Moore, Michael Rennie, Guy Rolfe, John Justin, Richard Stapley, Murray Matheson, Argentina Brunetti, Frank de Kova.

King Solomon's Mines (1937) p.c: Gaumont British d: Robert Stevenson sc: A. R. Rawlinson, Charles Bennett and Ralph Spence (from the novel by Rider Haggard).

With Cedric Hardwicke, John Loder, Paul Robeson, Anna Lee, Roland Young, Arthur Sinclair, Sydney Farebrother, Robert Adams, Frederick Leister.

King Solomon's Mines (1950) p.c: M.G.M. d: Andrew Marton and Compton Bennett p: Sam Zimbalist sc: Helen Deutsch (from the novel by Rider Haggard).
With Stewart Granger, Deborah Kerr, Richard Carlson, Hugo Haas, Lowell Gilmore, Kimusi, Siriaque.
16 mm print available from Ron Harris.

The Last Outpost (1935) p.c: Paramount d: Louis Gasnier and Charles Barton sc: Philip Macdonald, Frank Partos and Charles Brackett (from a story by F. Britten Austin).
With Cary Grant, Gertrude Michael, Claude Rains, Kathleen Burke, Colin Tapley, Akim Tamiroff, Billy Bevan, Jameson Thomas, Georges Renavent.

The Life and Death of Colonel Blimp (1943) p.c: The Archers p-d-sc: Michael Powell and Emeric Pressburger.
With Roger Livesey, Anton Walbrook, Deborah Kerr, Ursula Jeans, Roland Culver, Albert Lieven, John Laurie, Robert Harris, Arthur Wontner, Harry Welchman.
16 mm print available from Rank.

Lives of a Bengal Lancer (1935) p.c: Paramount d: Henry Hathaway p: Louis D. Lighton sc: Waldemar Young, John L. Balderston and Achmed Abdullah (from the book by Francis Yeats-Brown).
With Gary Cooper, Franchot Tone, C. Aubrey Smith, Sir Guy Standing, Richard Cromwell, Kathleen Burke, Douglass Dumbrille, Monte Blue, Colin Tapley.
16 mm print available from Columbia.

The Lost Patrol (1934) p.c: R.K.O. Radio d: John Ford sc: Dudley Nichols and Garrett Fort (from the novel by Philip Macdonald).
With Victor McLaglen, Reginald Denny, Boris Karloff, Wallace Ford, J. M. Kerrigan, Billy Bevan, Alan Hale, Brandon Hurst, Douglas Walton, Sammy Stein.
16 mm print available from Kingston.

The Mask of Fu-Manchu (1932) p.c: M.G.M. d: Charles Brabin and Charles Vidor sc: Irene Kuhn, John Willard and Edgar Allen Woolf (from the novel by Sax Rohmer).
With Boris Karloff, Lewis Stone, Karen Morley, Charles Starrett, Myrna Loy, Jean Hersholt, Lawrence Grant, David Torrence.

Men Against the Sun (1953) p.c: Monarch-Kenya d: Brendan J. Stafford p-sc: Alastair Scobie. With John Bentley, Zena Marshall, Liam O'Leary, Alan Tarlton, Edward Johnson, Ambrose, Shanti Pandit.
16 mm print available from Kingston.

Mrs. Miniver (1942) p.c: M.G.M. d: William Wyler p: Sidney Franklin sc: Arthur Wimperis, Claudine West, George Froeschel and James Hilton (from the novel by Jan Struther). With Greer Garson, Walter Pidgeon, Teresa Wright, Richard Ney, Dame May Whitty, Henry Travers, Henry Wilcoxon, Reginald Owen, Rhys Williams, Helmut Dantine.
16 mm print available from Ron Harris.

The Mudlark (1950) p.c: 20th Century-Fox d: Jean Negulesco p-sc: Nunnally Johnson (from the novel by Theodore Bonnett). With Irene Dunne, Alec Guinness, Andrew Ray, Finlay Currie, Anthony Steel, Beatrice Campbell, Raymond Lovell, Edward Rigby, Ernest Clark, Barry Jones.

Naked Earth (1957) p.c: 20th Century-Fox-Foray d: Vincent Sherman p: Adrian Worker sc: Milton Holmes. With Richard Todd, Juliette Greco, Finlay Currie, John Kitzmiller, Laurence Naismith, Christopher Rhodes, Orlando Martins, Blasio Kigaya.
16 mm print available from Ron Harris.

Northwest Frontier (U.S. title: *Flame over India*) (1959) p.c: Rank d: J. Lee-Thompson p: Marcel Hellman sc: Robin Estridge (from a screenplay by Frank Nugent, based on a story by Patrick Ford and Will Price). With Kenneth More, Lauren Bacall, Herbert Lom, Ian Hunter, Wilfrid Hyde-White, Ursula Jeans, Eugene Deckers, I. S. Johar, Jack Gwillim, Govind Raja Ross.
16 mm print available from Rank.

Old Bones of the River (1938) p.c: Gainsborough d: Marcel Varnel sc: J. O. C. Orton, Val Guest and Marriott Edgar (from the stories of Edgar Wallace). With Will Hay, Moore Marriott, Graham Moffatt, Robert Adams, Jack London, Wyndham Goldie, Jack Livesey.

Our Fighting Navy (1937) p.c: Butchers Films d: Norman Walker p: Herbert Wilcox sc: Guy Mollack and Gerald Elliott (from a story by 'Bartimaeus').

With Noah Beery, H. B. Warner, Robert Douglas, Hazel Terry, Richard Cromwell, Esmé Percy, Richard Ainley, Henry Victor, Frederick Culley, Binky Stuart.

Pacific Destiny (1956) p.c: British Lion d: Wolf Rilla p: James Lawrie sc: Richard Mason (from the book *A Pattern of Islands* by Arthur Grimble). With Denholm Elliott, Susan Stephen, Michael Hordern, Gordon Jackson, Inia Te Wiata, Felix Felton, Ollie Crichton, Ezra Williams.
16 mm print available from Kingston.

The Prime Minister (1940) p.c: Warner Bros d: Thorold Dickinson sc: Michael Hogan and Brock Williams. With John Gielgud, Diana Wynyard, Stephen Murray, Owen Nares, Fay Compton, Will Fyffe, Frederick Leister, Nicholas Hannen, Lyn Harding, Irene Browne.

The Queen's Guards (1960) p.c: 20th Century-Fox-Imperial p-d: Michael Powell sc: Roger Milner (from an idea by Simon Harcourt-Smith). With Daniel Massey, Raymond Massey, Robert Stephens, Ursula Jeans, Ian Hunter, Elizabeth Shepherd, Jess Conrad, Jack Watling, Nigel Green.

The Rains Came (1940) p.c: 20th Century-Fox d: Clarence Brown p: Darryl F. Zanuck sc: Philip Dunne and Julien Josephson (from the novel by Louis Bromfield). With Tyrone Power, Myrna Loy, George Brent, Nigel Bruce, Brenda Joyce, Joseph Schildkraut, H. B. Warner, Maria Ouspenskaya, Henry Travers.

The Rains of Ranchipur (1955) p.c: 20th Century-Fox d: Jean Negulesco p: Frank Ross sc: Merle Miller (from the novel by Louis Bromfield). With Richard Burton, Lana Turner, Fred MacMurray, Michael Rennie, Joan Caulfield, Eugenie Leontovich, Madge Kennedy, Gladys Hurlbut.
16 mm print available from Ron Harris Cinema Services.

Rhodes of Africa (1936) p.c: Gaumont British d: Berthold Viertel sc: Leslie Arliss, Michael Barringer and Miles Malleson (from the book by Sarah Gertrude Millin). With Walter Huston, Oscar Homolka, Basil Sydney, Frank Cellier, Peggy Ashcroft, Lewis Casson, Bernard Lee, Ndansia Kumalo, Felix Aylmer.

Rogues' March (1952) p.c: M.G.M. d: Allan Davis p-sc: Leon Gordon.
With Peter Lawford, Janice Rule, Richard Greene,

Leo G. Carroll, John Abbott, Patrick Aherne, John Dodsworth, Lester Matthews, Hugh French, John Lupton.

Sanders of the River (1935) p.c: London Films (for United Artists) d: Zoltan Korda p: Alexander Korda sc: Lajos Biro and Jeffrey Dell (from the stories by Edgar Wallace).
With Leslie Banks, Paul Robeson, Nina Mae McKinney, Robert Cochrane, Martin Walker, Allan Jeayes, Charles Carson, Tony Wane, Jomo Kenyatta.

The Scarlet Spear (1955) p.c: Present Day Productions (for United Artists) d-sc: George Breakston and Ray Stahl p: Charles Reynolds.
With John Bentley, Martha Hyer, Morasi, Duncan Fletcher.

Scott of the Antarctic (1948) p.c: Ealing d: Charles Frend p: Michael Balcon sc: Ivor Montagu and Walter Meade.
With John Mills, Derek Bond, Harold Warrender, Kenneth More, James Robertson Justice, Diana Churchill, John Gregson, Christopher Lee, Barry Letts.
16 mm print available from Rank.

Sheriff of Fractured Jaw (1958) p.c: 20th Century-Fox d: Raoul Walsh p: Daniel M. Angel sc: Arthur Dales (from a story by Jacob Hay).
With Kenneth More, Jayne Mansfield, Robert Morley, Henry Hull, Bruce Cabot, William Campbell, Ronald Squire, David Horne, Sid James, Donald Stewart.
16 mm print available from Ron Harris.

Ships With Wings (1942) p.c: Ealing d: Sergei Nolbandov p: Michael Balcon sc: Patrick Kirwan, Austin Melford, Diana Morgan and Sergei Nolbandov.
With John Clements, Leslie Banks, Michael Wilding, Michael Rennie, Jane Baxter, Ann Todd, Basil Sydney, Hugh Williams, Cecil Parker, Hugh Burden.

Sixty Glorious Years (1938) p.c. R.K.O. Radio d-p: Herbert Wilcox sc: Charles de Grandcourt, Miles Malleson and Robert Vansittart.
With Anna Neagle, Anton Walbrook, C. Aubrey Smith, Walter Rilla, Lewis Casson, Felix Aylmer, Malcolm Keen, Wyndham Goldie, Laidman Browne, Charles Carson.

Soldiers Three (1951) p.c: M.G.M. d: Tay Garnett p: Pandro S. Berman sc: Marguerite Roberts, Tom Reed and Malcolm Stuart Boylan (from the stories by Rudyard Kipling).
With Stewart Granger, David Niven, Robert

Newton, Walter Pidgeon, Cyril Cusack, Greta Gynt, Richard Hale, Michael Ansara, Robert Coote, Dan O'Herlihy.
16 mm print available from Ron Harris.

Stanley and Livingstone (1939) p.c: 20th Century-Fox d: Henry King p: Darryl F. Zanuck sc: Philip Dunne and Julien Josephson (from a story by Hal Lang and Sam Hellman).
With Spencer Tracy, Cedric Hardwicke, Walter Brennan, Richard Greene, Charles Coburn, Nancy Kelly, Henry Travers, Henry Hull, Miles Mander, David Torrence.
16 mm print available from Rank.

Storm Over Africa (U.S. title: *Royal African Rifles*) (1953) p.c: Allied Artists d: Lesley Selander p: Richard Heermance sc: Dan Ullman.
With Louis Hayward, Veronica Hurst, Michael Pate, Angela Greene, Steven Geray, Bruce Lester, Roy Glenn.

Storm Over Bengal (1938) p.c: Republic Pictures d: Sidney Salkow p: Herbert J. Yates sc: Dudley Waters.
With Patric Knowles, Rochelle Hudson, Richard Cromwell, Douglass Dumbrille, Colin Tapley, Douglas Walton, Claud Allister, Clyde Cook, Halliwell Hobbes.

Storm Over The Nile (1955) p.c: London Films for British Lion d: Terence Young and Zoltan Korda p: Zoltan Korda sc: R. C. Sherriff (from the novel *The Four Feathers* by A. E. W. Mason).
With Anthony Steel, Laurence Harvey, Ronald Lewis, Ian Carmichael, James Robertson Justice, Mary Ure, Christopher Lee, Michael Hordern.

Sundown (1941) p: Walter Wanger (for United Artists) d: Henry Hathaway sc: Barré Lyndon (from his own story).
With Gene Tierney, Bruce Cabot, George Sanders, Cedric Hardwicke, Reginald Gardiner, Carl Esmond, Joseph Calleia, Harry Carey, Marc Lawrence.
16 mm print available from the British Film Institute, 42–3 Lower Marsh, London S.E.1, and Watso.

The Sun Never Sets (1940) p.c: Universal Pictures d-p: Rowland V. Lee sc: W. P. Lipscomb (from a story by Jerry Horwin and Arthur FitzRichard).
With Basil Rathbone, Douglas Fairbanks Jr, Barbara O'Neill, Lionel Atwill, Virginia Field, Melville Cooper, Mary Forbes, Douglas Walton, Cecil Kellaway.

Tell England (1930) p.c: British Instructional Films

d: Anthony Asquith and Geoffrey Barkas p:
H. Bruce Woolf sc: Anthony Asquith and A.P.
Herbert (from the novel by Ernest Raymond).
With Carl Harbord, Tony Bruce, Fay Compton,
Dennis Hoey, C. M. Hallard, Frederick Lloyd,
Gerald Rawlinson, Lionel Hedges, Hubert Harben.

Tom Brown's Schooldays (1939) p.c: R.K.O. Radio
Pictures d: Robert Stevenson p: Gene Towne and
Graham Baker sc: Gene Towne, Graham Baker,
Walter Ferris and Frank Cavett (from the novel
by Thomas Hughes).
With Cedric Hardwicke, Jimmy Lydon, Freddie
Bartholomew, Josephine Hutchinson, Hughie
Green, Ernest Cossart, Gale Storm, Alec Craig,
Forrester Harvey.
16 mm print availabel from Watso.

Tom Brown's Schooldays (1950) p.c: Renown
d: Gordon Parry p: Brian Desmond Hurst sc: Noël
Langley (from the novel by Thomas Hughes).
With John Howard Davies, Robert Newton, Diana
Wynyard, John Charlesworth, John Forrest,
Michael Hordern, James Hayter, Hermione
Baddeley, Max Bygraves.
16 mm print available from Connoisseur Films
Ltd, 167 Oxford Street, London.

Under Two Flags (1936) p.c: 20th Century-Fox
d: Frank Lloyd p: Darryl F. Zanuck sc: W. P.
Lipscomb and Walter Ferris (from the novel by
Ouida).
With Claudette Colbert, Ronald Colman, Victor
McLaglen, Nigel Bruce, Gregory Ratoff, Rosalind
Russell, Herbert Mundin, John Carradine,
Lumsden Hare.

Victoria the Great (1937) p.c: R.K.O. Radio Pictures
d-p: Herbert Wilcox sc: Miles Malleson and
Charles de Grandcourt.
With Anna Neagle, Anton Walbrook, H. B.
Warner, Felix Aylmer, Walter Rilla, C. V. France,
Charles Carson, Derrick de Marney, Lewis Casson,
Percy Parsons.

Wee Willie Winkie (1937) p.c: 20th Century-Fox
d: John Ford p: Darryl F. Zanuck sc: Ernest
Pascal and Julien Josephson (from the story by
Rudyard Kipling).
With Shirley Temple, Victor McLaglen, C. Aubrey
Smith, June Lang, Cesar Romero, Michael
Whalen, Constance Collier, Gavin Muir, Brandon
Hurst, Clyde Cook.

West of Zanzibar (1954) p.c: Ealing d: Harry Watt
p: Leslie Norman sc: Max Catto and Jack
Whittingham (from a story by Harry Watt).
With Anthony Steel, Sheila Sim, William Simons,
Juma, Edric Connor, Orlando Martins, Martin

Benson, Peter Illing, Bethlehem Sketch.

The Wheel of Life (1930) p.c: Paramount d: Victor
Schertzinger sc: John Farrow (from the play by
James B. Fagan).
With Richard Dix, Esther Ralston, O. P. Heggie,
Regis Toomey, Arthur Hoyt, Larry Steers,
Myrtle Steadman, Nigel de Brulier.

Where No Vultures Fly (U.S. title: *Ivory Hunter*)
(1951) p.c: Ealing d: Harry Watt p: Michael
Balcon sc: W. P. Lipscomb, Ralph Smart and
Leslie Norman.
With Anthony Steel, Dinah Sheridan, Harold
Warrender, Meredith Edwards, William Simons.
16 mm print available from Rank.

White Cargo (1943) p.c: M.G.M. d: Richard Thorpe
p: Victor Saville sc: Leon Gordon (from his own
play based on Vera Simonton's novel).
With Walter Pidgeon, Hedy Lamarr, Richard
Carlson, Henry Morgan, Reginald Owen, Bramwell
Fletcher, Henry O'Neill, Clyde Cook, Leigh
Whipper.
16 mm print available from Ron Harris.

The White Man (U.S. title: *The Squaw Man*)
(1931) p.c: M.G.M. d-p: Cecil B. DeMille sc: Lucien
Hubbard and Lenore Coffee (from the play *The
Squaw Man* by Edwin Milton Royle).
With Warner Baxter, Lupe Velez, Eleanor
Boardman, Paul Cavanagh, Lawrence Grant,
Roland Young, Charles Bickford, Raymond
Hatton, J. Farrell Macdonald.

The Wife of General Ling (1938) p.c: R.K.O. Radio-
Premier d: Ladislao Vajda p: John Stafford
sc: Akos Tolnay (from a story by Peter Cheney).
With Griffith Jones, Inkijinoff, Adrienne Renn,
Alan Napier, Anthony Eustrel, Gibson Gowland,
Hugh McDermott, Gabrielle Brune, Lotus
Fragrance, George Merritt.

Yangtse Incident (U.S. title: *Battle Hell*) (1957) p.c:
British Lion d: Michael Anderson p: Herbert
Wilcox sc: Eric Ambler (from the book by
Lawrence Russell).
With Richard Todd, William Hartnell, Akim
Tamiroff, Donald Houston, Keye Luke, Sophie
Stewart, Robert Urquhart, James Kenney,
Richard Leech.
16 mm print available from Rank.

Zarak (1956) p.c: Columbia-Warwick d: Terence
Young p: Irving Allen and Albert Broccoli
sc: Richard Maibaum (from a story by A. J. Bevan).
With Victor Mature, Michael Wilding, Eunice
Gayson, Anita Ekberg, Patrick McGoohan,
André Morell, Finlay Currie, Conrad Phillips,

Bonar Colleano.
16 mm print available from Columbia.

Zulu (1963) p.c: Paramount-Diamond d: Cy
Endfield p: Stanley Baker and Cy Endfield
sc: John Prebble and Cy Endfield (from a story by
Prebble).
With Stanley Baker, Michael Caine, Jack
Hawkins, Ulla Jacobsson, James Booth, Nigel
Green, Ivor Emmanuel, Paul Daneman, David
Kernan, Gary Bond.

2 Populist filmography

JOHN FORD

There is a complete Ford filmography, with
full cast-lists and technical credits, in Peter
Bogdanovitch, *John Ford* (London, 1967), pp.
109–44. Here I shall give a complete list of titles
and a note on 16 mm availability.

Silent films

1917 *The Tornado, The Scrapper, The Soul Herder,
Cheyenne's Pal, Straight Shooting, The
Secret Man, A Marked Man, Bucking
Broadway*

1918 *The Phantom Riders, Wild Women, Thieves'
Gold, The Scarlet Drop, Hell Bent, A Woman's
Fool, Three Mounted Men*

1919 *Roped, The Fighting Brothers, A Fight for
Love, By Indian Post, The Rustlers, Bare
Fists, Gun Law, The Gun Packer, Riders of
Vengeance, The Last Outlaw, The Outcasts of
Poker Flats, The Ace of the Saddle, The
Rider of the Law, A Gun Fightin' Gentleman,
Marked Men*

1920 *The Prince of Avenue A, The Girl in No. 29,
Hitchin' Posts, Just Pals*

1921 *The Big Punch, The Freeze Out, The Wallop,
Desperate Trails, Action, Sure Fire, Jackie*

1922 *Little Miss Smiles, Silver Wings* (Prologue
only), *The Village Blacksmith*

1923 *The Face on the Barroom Floor, Three Jumps
Ahead, Cameo Kirby, North of Hudson Bay,
Hoodman Blind*

1924 *The Iron Horse, Hearts of Oak*

1925 *Lightnin', Kentucky Pride, The Fighting
Heart, Thank You*

1926 *The Shamrock Handicap, The Blue Eagle,
Three Bad Men*

1927 *Upstream*

1928 *Mother Machree, Four Sons, Hangman's
House, Napoleon's Barber* (short talkie),
Riley The Cop

1929 *Strong Boy* (Ford's last silent, released with
synchronized music and sound effects)

Sound films

1929 *The Black Watch* (British title: *King of the
Khyber Rifles*) (Fox), *Salute* (Fox)

1930 *Men Without Women* (Fox), *Born Reckless*
(Fox), *Up the River* (Fox)

1931 *Seas Beneath* (Fox), *The Brat* (Fox),
Arrowsmith (United Artists-Goldwyn)

1932 *Air Mail* (Universal), *Flesh* (M.G.M.)

1933 *Pilgrimage* (Fox), *Doctor Bull* (Fox)

1934 *The Lost Patrol* (R.K.O. Radio Pictures)
16 mm print available from Kingston Films,
645–7 Uxbridge Road, Hayes End, Middlesex
The World Moves On (Fox), *Judge Priest*
(Fox)

1935 *The Whole Town's Talking* (Columbia)
16 mm print available from Columbia
The Informer (R.K.O. Radio)
16 mm print available from Kingston Films
and the British Film Institute, 42–3 Lower
Marsh, London S.E.1
Steamboat Round the Bend (Fox)
16 mm print available from Rank Film
Library, P.O. Box 70, Great West Road,
Brentford, Middlesex

1936 *The Prisoner of Shark Island* (Fox)
16 mm print available from Rank
Mary of Scotland (R.K.O. Radio)
16 mm print available from Kingston Films
and the B.F.I.
The Plough and the Stars (R.K.O. Radio)

1937 *Wee Willie Winkie* (20th Century-Fox),
The Hurricane (United Artists-Goldwyn)

1938 *Four Men and a Prayer* (20th Century-Fox)
Submarine Patrol (20th Century-Fox)

1939 *Stagecoach* (United Artists-Wanger)
16 mm print available from the B.F.I.
Young Mr. Lincoln (20th Century-Fox)
16 mm print available from Rank
Drums Along the Mohawk (20th Century-Fox)

1940 *The Grapes of Wrath* (20th Century-Fox)
16 mm print available from Rank
The Long Voyage Home (United Artists-
Wanger)
16 mm print available from the B.F.I.

1941 *Tobacco Road* (20th Century-Fox)
16 mm print available from Rank
How Green Was My Valley (20th
Century-Fox)
16 mm print available from Ron Harris
Cinema Services, Glenbuck House,
Glenbuck Road, Surbiton, Surrey

1942 *Battle of Midway* (U.S. Navy), *Torpedo*

Squadron (U.S. Navy)
1943 *We Sail at Midnight* (U.S. Navy)
1945 *They Were Expendable* (M.G.M.)
1946 *My Darling Clementine* (20th Century-Fox)
16 mm print available from Ron Harris
Cinema Services
1947 *The Fugitive* (R.K.O. Radio-Argosy)
16 mm print available from Kingston Films
1948 *Fort Apache* (R.K.O. Radio-Argosy)
16 mm print available from Kingston Films
Three Godfathers (M.G.M.)
1949 *She Wore a Yellow Ribbon* (R.K.O. Radio-Argosy)
16 mm print available from the B.F.I. and
Kingston
1950 *When Willie Comes Marching Home* (20th
Century-Fox)
16 mm print available from Ron Harris
Cinema Services
Wagon Master (R.K.O. Radio-Argosy)
16 mm print available from Kingston Films
Rio Grande (Republic Pictures-Argosy)
16 mm print available from Intercontinental
Films, Somerset Lodge, 90 Merthyrmawr
Road, Bridgend, Glamorgan
1951 *This is Korea* (U.S. Navy)
1952 *What Price Glory?* (20th Century-Fox)
The Quiet Man (Republic Pictures-Argosy)
16 mm print available from Intercontinental
1953 *The Sun Shines Bright* (Republic Pictures)
Mogambo (M.G.M.)
16 mm print available from Ron Harris
Cinema Services
1955 *The Long Gray Line* (Columbia)
16 mm print available from Columbia
Pictures, Film House, Wardour Street,
London WIV 4AH
Mister Roberts (Warner Bros) (film
completed by Mervyn Leroy)
16 mm print available from Rank (black and
white print only)
1956 *The Searchers* (Warner Bros)
16 mm print available from Rank
1957 *The Wings of Eagles* (M.G.M.)
16 mm print available from Ron Harris
Cinema Services
The Rising of the Moon (Warner Bros)
16 mm print available from Rank
1958 *The Last Hurrah* (Columbia)
16 mm print available from Columbia
1959 *Gideon of Scotland Yard* (British title:
Gideon's Day) (Columbia)
16 mm print available from Columbia
Korea (Department of Defense)
The Horse Soldiers (United Artists-Mirisch)
1960 *Sergeant Rutledge* (Warner Bros)

16 mm print available from Rank
1961 *Two Rode Together* (Coumbia)
16 mm print available from Columbia (black
and white print only)
1962 *The Man Who Shot Liberty Valance*
(Paramount)
16 mm print available from Columbia
How the West Was Won (M.G.M.) (Civil War
section)
1963 *Donovan's Reef* (Paramount)
16 mm print available from Columbia
1964 *Cheyenne Autumn* (Warner Bros)
1966 *Seven Women* (M.G.M.)

FRANK CAPRA

There is a complete Frank Capra filmography,
with full cast lists and technical credits, in the
magazine *Cinema* no. 5 (February 1970), pp. 31-3.

Silent films

1923 *Fultah Fisher's Boarding House*
1926 *Tramp, Tramp, Tramp, The Strong Man, Long
Pants*
1927 *For the Love of Mike*
1928 *That Certain Feeling, So This Is Love, The
Matinée Idol, The Way of the Strong, Say It
With Sables, Submarine, The Power of the
Press*
1929 *The Donovan Affair*

Sound films

1929 *The Younger Generation* (Columbia), *Flight*
(Columbia)
1930 *Ladies of Leisure* (Columbia), *Rain or Shine*
(Columbia)
1931 *Dirigible* (Columbia), *The Miracle Woman*
(Columbia), *Platinum Blonde* (Columbia)
16 mm print available from Columbia
1932 *Forbidden* (Columbia), *American Madness*
(Columbia)
1933 *The Bitter Tea of General Yen* (Columbia)
16 mm print available from Columbia
Lady For a Day (Columbia)
1934 *It Happened One Night* (Columbia)
16 mm print available from Columbia
Broadway Bill (Columbia)
1936 *Mr. Deeds Goes to Town* (Columbia)
16 mm print available from Columbia
1937 *Lost Horizon* (Columbia)
16 mm print avilable from Columbia
1938 *You Can't Take It With You* (Columbia)
1939 *Mr. Smith Goes to Washington* (Columbia)
16 mm print available from Columbia
1941 *Meet John Doe* (Warner Bros)

Arsenic and Old Lace (Warner Bros)
16 mm print available from Film
Distributors Associated, P.O. Box 2JL,
Mortimer House, 37–41 Mortimer Street,
London W1A 2JL

1941 Capra Head of the U.S. War Department
–5 Documentary Film Unit producing the
series 'Why We Fight'.

1946 *It's a Wonderful Life* (R.K.O. Radio-Liberty
Films)
16 mm print available from Watso Films,
Charles Street and Vine, Coventry

1948 *State of the Union* (M.G.M.-Liberty Films)
16 mm print available from Columbia

1949 *Riding High* (Paramount)

1951 *Here Comes the Groom* (Paramount)

1959 *A Hole in the Head* (United Artists-Sincap)

1961 *A Pocketful of Miracles* (United Artists-
Franton)
16 mm print available from F.D.A.

LEO McCAREY

There is a complete Leo McCarey filmography,
with full cast lists and technical credits, in
Cahiers du cinema no. 163 (February 1965) pp. 33–5.

Feature films

1929 *The Sophomore* (Pathé), *Red Hot Rhythm*
(Pathé)

1930 *Wild Company* (Fox), *Let's Go Native*
(Paramount), *Part-time Wife* (Fox)

1931 *Indiscreet* (United Artists-Schenck)

1932 *The Kid from Spain* (United Artists-Goldwyn)

1933 *Duck Soup* (Paramount)
16 mm print available from Columbia
Six of a Kind (Paramount)

1934 *Belle of the Nineties* (Paramount)
16 mm print available from Columbia
Ruggles of Red Gap (Paramount)
16 mm print available from Columbia

1935 *The Milky Way* (Paramount)

1936 *Make Way for Tomorrow* (Paramount)

1937 *The Awful Truth* (Columbia)

1938 *Love Affair* (R.K.O. Radio)

1942 *Once upon a Honeymoon* (R.K.O. Radio)
16 mm print available from Kingston

1943 *Going My Way* (Paramount)

1945 *The Bells of St. Mary's* (R.K.O. Radio-
Rainbow Productions)

1948 *Good Sam* (R.K.O. Radio-Rainbow
Productions)

1951 *My Son John* (Paramount-Rainbow
Productions)

1957 *An Affair to Remember* (20th Century-Fox)
16 mm print available from Ron Harris

Cinema Services

1958 *Rally Round the Flag, Boys* (20th Century-
Fox)
16 mm print available from Ron Harris
Cinema Services

1961 *Satan Never Sleeps* (20th Century-Fox)
(British title: *The Devil Never Sleeps*)
16 mm print available from Rank

3 Staatsauftragsfilme

This is a list of those films produced between 1933
and 1945 by order of the Film Section of the
Propaganda Ministry. It is interesting to note the
recurrence of the same directors and casts. I
have attached a note on the contents of those
films not discussed in the text of the book.

1933

Das alte Recht (*The Old Right*) p: Andersen Film
d: Igo Martin Andersen sc: Igo Martin Andersen
and Armin Petersen.
With Edit Linn, Bernhard Goetzke, Hans Kettler,
Fritz Hoopts, Hans Rastede, Agnes Diers.

Der Choral von Leuthen (*The Chorale of Leuthen*)
p: Carl Froelich Film GmbH d: Carl Froelich sc:
Dr Johannes Brandt and Ilse Spath-Baron (from
an idea by Friedrich Pflughaupt based on themes
in the novel *Fridericus* by Walter von Molo).
With Otto Gebühr, Olga Tschechowa, Elga Brink,
Harry Frank, Paul Otto, Werner Finck, Veit
Harlan, Paul Richter, Wolfgang Staudte, Josef
Dahmen.

Drei blaue Jungs – Ein Blondes Madel (*Three Young
Men in Blue – One Blonde Maid*) p: Carl Böse
Film GmbH d: Carl Böse sc: Marie-Luise Droop.
With Charlotte Anders, Heinz Rühmann,
Friedrich Benfer, Fritz Kampers, Hans Richter,
Sophie Pargay, Adolf Fischer, Hans Albin.

Drei Kaiserjäger p: Sirius Film d: Robert Land and
Fritz Hofer sc: Fred Angermeyer (based on his
own play).
With Paul Richter, Else Elster, Grit Haid, Fritz
Kampers, Heinz Salfner, Erna Morena, Fritz
Alberti, Oskar Marion, Carl Wery, Heinrich
Heilinger. The story deals with the comradeship of
three members of the Kaiserjäger regiment before
and during the First World War.

Flüchtlinge (*Refugees*) p: Ufa d: Gustav Ucicky
sc: Gerhard Menzel (from his novel).
With Hans Albers, Käthe von Nagy, Eugen
Klöpfer, Ida Wüst, Franziska Kinz, Veit Harlan,
Hans A. Schlettow, Andrews Engelmann, Carsta
Löck.

Hans Westmar p: Volksdeutsche Film GmbH
d: Franz Wenzler sc: Hanns Heinz Ewers (from his
book *Horst Wessel*).
With Emil Lohkamp, Carla Bartheel, Paul
Wegener, Grete Reinwald, Arthur Shröder,
Heinrich Heilinger, Otti Dietze, Imgard Willers.

Hitlerjunge Quex (*Hitler Youth Quex*) p: Ufa
d: Hans Steinhoff sc: K. A. Schenzinger and B. E.
Lüthge (from Schenzinger's novel).
With Heinrich George, Bertha Drews, Hermann
Speelmanns, Rotraut Richter, Karl Meixner,
Claus Clausen, Franziska Kinz, Hans Richter.

Morgenrot (*Dawn*) p: Ufa d: Gustav Ucicky
sc: Gerhard Menzel
With Rudolf Forster, Adele Sandrock, Fritz
Genschow, Camilla Spira, Paul Westermeier,
Gerhard Bienert, Franz Nicklisch, Hans Liebelt.

S.A.-Mann Brand p: Bavaria d: Franz Seitz
sc: Joseph Dalman and Joe Stöckel.
With Otto Wernicke, Heinz Klingenberg, Elise
Aulinger, Rolf Wenkhaus, Joe Stöckel, Max
Weydner, Manfred Pilet, Wastl Witt.

Spione am Werk (*Spies at Work*) p: Cine-Allianz
d: Gerhard Lamprecht sc: Dr Georg C. Klaren and
Herbert Juttke (from the novel by Max W.
Kimmich and Dr Georg C. Klaren).
With Karl Ludwig Diehl, Brigitte Helm, Eduard
von Winterstein, Günther Hadank, Oscar
Homolka, Theodor Loos, Paul Otto, Harry Hardt.
Espionage in the First World War.

Volldampf Voraus (*Full Steam Ahead*) p: Carl
Froelich Film d: Carl Froelich sc: E. F. von
Spiegel and Carl Froelich.
With Karl Ludwig Diehl, Peter Ekelenz, Margit
Wagner, Karl Danneman, Hans Junkermann,
Christine Grabe, Max Koske.
Young officer refuses to leave navy to join
father-in-law's firm.

Zwei gute Kameraden (*Two Good Comrades*) p: Aafa
Film d: Max Obal sc: B. E. Lüthge.
With Paul Hörbiger, Fritz Kampers, Jessie
Vihrog, Margot Walter, H. H. Schaufuss, Senta
Söneland, Albert Paulig, Rudolf Platte.

1934

Die Reiter von Deutsch-Ostafrika (*The Riders of
German East Africa*) p: Terra d: Herbert Selpin
sc: Marie-Luise Droop.
With Ilse Strobrawa, Sepp Rist, Peter Voss,
Rudolf Klicks, G. H. Schnell, Arthur Reinhardt,
Louis Brody, Ernst Rückert, Adolf Fischer.

Ein Mann will nach Deutschland (*A Man Must
Must Return to Germany*) p: Ufa d: Paul Wegener
sc: Philipp Lothar Mayring and Fred Andreas
(from the novel by Andreas).
With Karl Ludwig Diehl, Brigitte Horney,
Siegfried Schürenberg, Ernst Rotmund, Hermann
Speelmanns, Willy Birgel, Charlotte Schultz.

Die Vier Musketiere (*The Four Musketeers*) p: Terra
d: Heinz Paul sc: Sigmund Graff, Hella Moga,
Heinz Paul (from Graff's play).
With Hans Brausewetter, Fritz Kampers, Paul
Westermeier, Hermann Speelmanns, Werner
Schott, Fritz Odemar, Käthe Haack, Hans Albin.

Heldentum und Todeskampf unserer Emden (*The
Heroism and Death-Struggle of our* Emden) p:
Richard Herzog and Co. d-sc: Louis Ralph.
With Louis Ralph, Willi Kaiser-Heyl, Fritz
Greiner, Werner Fuetterer, and officers and men
of the cruiser *Emden*. The exploits of the cruiser
Emden in the First World War.

Ich für Dich – Du für Mich (*I for You – You for Me*)
p: Carl Froelich Film d: Carl Froelich sc: Hans
G. Kernmayr.
With Maria Wanck, Inge Kick, Ruth Eweler,
Ruth Claus, Karl Danneman, Carl de Vogt, Knut
Hartwig, Eleanore Stadie, Paul W. Krüger.
Drama of the Womens' Labour Corps.

Schwartzer Jäger Johanna (*Black Huntress Johanna*)
p: Terra d: Johannes Meyer sc: Heinrich
Oberlander and Heinz Umbehr (from the novel by
Georg van der Vring).
With Marianne Hoppe, Paul Hartmann, Gustaf
Gründgens, Genia Nikolajewa, Paul Bildt,
Margarete Albrecht, Harry Hardt, Erich Fiedler.
Patriotic resistance to Napoleon in early
nineteenth-century Germany.

Stosstrupp 1917 (*Shock Troop 1917*) p: Arya Film
d: Hans Zöberlein and Ludwig Schmid-Wildy
sc: Franz Adam, Marian Kolb, Hans Zöberlein
(based on Zöberlein's book *Der Glaube an Deutsch-
land*). With Ludwig Schmid-Wildy, Albert
Penzkofer, Beppo Brem, Karl Hanft, Max Zankl,
Hanns Erich Pfleger, George Emmerling, Toni
Eggert. Comradeship and courage on the Western
Front in the First World War.

Um das Menschenrecht (*For Human Rights*) p: Arya
Film d: Hans Zöberlein sc: Hans Zöberlein and
Ludwig Schmid-Wildy.
With Hans Schlenk, Kurt Holm, Ernst Martens,
Beppo Brem, Ludwig Ten Kloot, Hanns Erich
Pfleger, Paul Schaedler, Ludwig Körösy.
Four wartime comrades, disillusioned by post-war
Germany, decide to emigrate to wait for better
times (i.e. Hitler).

1935

Der alte und der junge König (The Old King and the Young King) p: Deka d: Hans Steinhoff sc: Thea von Harbou and Rolf Lauckner.
With Emil Jannings, Werner Hinz, Leopoldine Konstantin, Carola Höhn, Marieluise Claudius, Georg Alexander, Rudolph Klein-Rogge.

Der Höhere Befehl (The Higher Command) p: Ufa d: Gerhard Lamprecht sc: Philipp Lothar Mayring, Kurt Kluge, Karl Lerbs.
With Karl Ludwig Diehl, Lil Dagover, Karl Danneman, Gertrude de Lalsky, Heini Finkenzeller, Eduard von Winterstein.
Prussian patriots resist Napoleon – with the aid of the British!

Frisennot (Frisians in Misery) p: Delta d: Peter Hagen sc: Werner Kortwich.
With Friedrich Kayssler, Helene Fehdmer, Inkijinoff, Jessie Vihrog, Hermann Schomberg, Ilse Fürstenberg, Martha Ziegler, Kai Moller.
The Frisian Germans in Russia are persecuted by the Bolsheviks.

Henker, Frauen und Soldaten (Hangmen, Women and Soldiers) p: Bavaria d: Johannes Meyer sc: Max W. Kimmich and Jacob Geis (from the novel *Ein Mannsbild namens Prack* by Fritz Reck-Malleczewen).
With Hans Albers, Charlotte Susa, Jack Trevor, Bernhard Minetti, Aribert Wäscher, Hubert von Meyerinck, Otto Wernicke.
Drama about the adventures of a First World War air ace, who is dissatisfied with conditions in post-war Germany.

Mein Leben für Maria Isabell (My Life for Maria Isabell) p: Lloyd Film d: Erich Waschneck sc: F. D. Andam and Ernst Hasselbach (from the novel by Alexander Lernet-Holenia).
With Viktor de Kowa, Peter Voss, Maria Andergast, Fritz Pfaudler, Hans-Joachim Büttner, Hermann Frick, Julia Serda, Karin Evans.
Drama about the Austrian Army in the last days of the war.

Wunder Des Fliegens (The Wonder of Flying) p: Terra d: Heinz Paul sc: Peter Francke and Heinz Paul.
With Ernst Udet, Käthe Haack, Jürgen Ohlsen.
Air ace Ernst Udet teaches a young boy to fly.

1936

Fridericus p: Diana Film d: Johannes Meyer sc: Erich Kröhnke and Walter von Molo (from the novel by von Molo).
With Otto Gebühr, Hilde Körber, Lil Dagover, Agnes Straub, Käthe Haack, Bernhard Minetti, Paul Westermeier, Paul Bildt, Harry Hardt.

Soldaten-Kameraden (Soldier-Comrades) p: Cinephon d: Toni Huppertz sc: G. O. Stroffregen, H. H. Fischer and Toni Huppertz.
With Ralph Arthur Roberts, Herti Kirchner, Hans Richter, Vera Hartwegg, Franz Nicklisch, Gustl Stark-Gstettenbaur, Walter Jensen.
Two young men, one rich and one poor, join the army and learn discipline and comradeship.

Verräter (Traitors) p: Ufa d: Karl Ritter sc: Leonhard Fürst (from an idea by Walter Herzlieb and Hans Wagner).
With Lida Baarova, Willy Birgel, Irene von Meyendorff, Theodor Loos, Paul Dahlke, Sepp Rist, Karl Junge-Swinburne, Herbert Böhme.
Espionage in pre-war Germany.

Weisse Sklaven (White Slaves) p: Lloyd Film d: Karl Anton sc: Karl Anton, Felix von Eckhardt and Arthur Pohl (based on a report by Charlie Roellinghoff).
With Camilla Horn, Agnes Straub, Werner Hinz, Karl John, Theodor Loos, W. P. Krüger, Fritz Kampers, Albert Florath, Werner Pledath.
Anti-Russian drama of the Bolshevik revolution.

Standschütze Bruggler (Home Guardsman Bruggler) p: Tonlicht d: Werner Klingler sc: Joseph Dalmen (from the novel by Alfred Graf Bossi Fredengotti).
With Ludwig Kerschner, Franziska Kinz, Rolf Pinegger, Eduard Köck, Gustl Stark-Gstettenbaur, Viktor Gehring, Beppo Brem, Friedrich Ulmer.
The exploits of the Tyrolean Home Guard in the First World War.

1937

Der Herrscher (The Ruler) p: Tobis-Magna d: Veit Harlan sc: Thea von Harbou and Curt J. Braun (from the play *Vor Sonnenuntergang* by Gerhard Hauptmann).
With Emil Jannings, Marianne Hoppe, Harald Paulsen, Hilde Körber, Paul Wagner, Käthe Haack, Herbert Hübner, Theodor Loos, Paul Bildt.

Menschen ohne Vaterland (Men without a Fatherland) p: Ufa d: Herbert Maisch sc: Walter Wasserman, C. H. Diller, Ernst von Salomon and Herbert Maisch (from the novel by Gertrud von Brockdorff).
With Willy Fritsch, Maria von Tasnady, Willy Birgel, Werner Stock, Josef Sieber, Alexander

Golling, Karl Meixner, Siegfried Schurenberg.
Drama of the Freikorps and their fight against
Communism.

Patrioten (Patriots) p: Ufa d: Karl Ritter
sc: Philipp Lothar Mayring, Felix Lützkendorf and
Karl Ritter (from an idea by Ritter).
With Lida Baarova, Mathias Wieman, Bruno
Hübner, Hilde Körber, Paul Dahlke, Nikolai
Kolin, Kurt Siefert, Edwin Jürgensen.
Drama of German P.O.W. in wartime France.

Togger d: Jürgen von Alten p: Minerva Tonfilm
GmbH sc: Walter Forster and Heinz Bierkowski.
With Renate Müller, Paul Hartmann, Mathias
Wieman, Heinz Salfner, Hilde Seipp, Paul Otto,
Fritz Odemar, Walter Franck, Fritz Rasp.
An international concern tries to gain control of
German industry.

Unternehmen Michael (Operation Michael) p: Ufa
d: Karl Ritter sc: Karl Ritter, Mathias Wieman
and Fred Hildebrandt (from the play by Hans
Fritz von Zwehl).
With Heinrich George, Mathias Wieman, Paul
Otto, Otto Graf, Christian Kayssler, Kurt
Waitzmann, Hannes Steltzer, Willy Birgel.

Urlaub auf Ehrenwort (Leave on Word of Honour)
p: Ufa d: Karl Ritter sc: Charles Klein and Felix
Lützkendorf (from an idea by Kilian Koll, Charles
Klein and Walter Bloem).
With Ingeborg Theek, Rolf Moebius, Fritz
Kampers, Bertha Drews, René Deltgen, Carl
Raddatz, Käthe Haack, Otto Graf, Ludwig
Schmitz.

1938

Kameraden auf See (Comrades at Sea) p: Terra
d: Heinz Paul sc: Peter Francke and J. A. Zerbe
(from an idea by Toni Huppertz and J. A. Zerbe).
With Paul Wagner, Fred Döderlein, Carola Höhn,
Ingeborg Hertel, Theodor Loos, Jasper von
Oertzen, Julius Brandt, Josef Sieber.
Comradeship in the navy during the Spanish
Civil War.

Musketier Meier III p: Germania d: Joe Stöckel
sc: Karl Bunje and Axel Eggenbrecht.
With Rudi Godden, Günther Lüders, Hermann
Speelmanns, Hildegard Barko, Aribert Mog,
Beppo Brem, Gustl Stark-Gstettenbaur.
Comedy and comradeship of the Western Front
in 1917.

Pour le Mérite p: Ufa d: Karl Ritter sc: Fred
Hildebrandt and Karl Ritter.
With Paul Hartmann, Jutta Freybe, Albert

Hehn, Herbert Böhme, Carsta Löck, Fritz
Kampers, Malte Jäger, Wolfgang Staudte.

Ziel in den Wolken (Target in the Clouds) p: Terra
d: Wolfgang Liebeneiner sc: Philipp Lothar
Mayring and Eberhard Frowein.
With Käthe Dorsch, Ruth Hellberg, Albert
Matterstock, Johannes Riemann, Hans Adalbert
Schlettow, Albert Florath, Paul Bildt.
The story of Walter von Suhr, German pioneer
aviator.

*Dreizehn Mann und Eine Kanone (Thirteen Men
and a Cannon)* p-d: Johannes Meyer sc: Fred
Andreas, Georg Hurdalek and Peter Francke
(from an idea by Pizarro Forzano).
With Alexander Golling, Otto Wernicke, Herbert
Hübner, Erich Ponto, Friedrich Kayssler, Edwin
Jürgensen, Paul Wagner, E. F. Fürbringer.
The comradeship and courage of a gun battery on
the Eastern Front.

1939

Aufruhr in Damaskus (Uproar in Damascus)
p: Terra d: Gustav Ucicky sc: Philipp Lothar
Mayring and Jacob Geis.
With Brigitte Horney, Joachim Gottschalk,
Hans Nielsen, Paul Otto, Ernst von Klipstein,
Willi Rose, Adolf Fischer, Ludwig Schmid-Wildy.

Das Gewehr über (Shoulder Arms) p: Germania
d: Jürgen von Alten sc: Kurt Walter (based on the
novel by Wolfgang Marken).
With Rudi Godden, Rolf Moebius, Carsta Löck,
Hilde Schneider, Charlotte Daudert, Horst Birr,
Franz W. Schröder, Adolf Fischer.

D III 88 : Tobis d: Herbert Maisch sc: Hans
Bertram and Wolf Neumeister (from an idea by
Alfred Stöger, Hans Bertram and Heinz Orlovius).
With Heinz Welzel, Carsta Löck, Christian
Kayssler, Hermann Braun, Paul Bildt, Adolf
Fischer, Malte Jäger, Eduard von Winterstein.

Drei Unteroffiziere p: Ufa d: Werner Hochbaum sc:
Jacob Geis and Fred Hildebrandt (from an idea
by Werner Schoknecht).
With Albert Hehn, Fritz Genschow, Wilhelm
König, Ruth Hellberg, Hilde Schneider, Malte
Jäger, Wolfgang Staudte, Christian Kayssler.

Leinen aus Irland (Irish Linen) p: Styria Film for
Wien Film d: Heinz Helbig sc: Harald Bratt.
With Irene von Meyendorff, Rolf Wanka, Friedl
Harlin, Georg Alexander, Hans Olden, Oskar
Sima, Otto Tressler, Siegfried Breuer.

Mann für Mann (Man for Man) p: Ufa d: Robert A.

Stemmle sc: Hans Schmodde, Otto Berhard Wendler and Robert A. Stemmle.
With Josef Sieber, Carl Kuhlmann, Gisela Uhlen, Gustav Knuth, Heinz Welzel, Hermann Speelmanns, Walter Lieck, Ellen Bang.

1940

Bismarck p: Tobis d: Wolfgang Liebeneiner sc: Rolf Lauckner and Wolfgang Liebeneiner.
With Paul Hartmann, Friedrich Kayssler, Maria Koppenhöfer, Werner Hinz, Ruth Hellberg, Walter Franck, Lil Dagover, Kathe Haack.

Achtung! Feind hört mit (Attention! The Enemy is Listening) p: Terra d: Arthur Maria Rabenalt sc: Kurt Heuser (from an idea by Dr.Georg Klaren).
With Kirsten Heilberg, Rolf Weih, René Deltgen, Lotte Koch, Michael Bohnen, Christian Kayssler, Josef Sieber, Erich Ponto. British espionage activities in September 1938.

Der Fuchs von Glenarvon (The Fox of Glenarvon) p: Tobis d: Max W. Kimmich sc: Wolfgang Neumeister and Hans Bertram (from the novel by Nicola Rohn).
With Olga Tschechowa, Karl Ludwig Diehl, Ferdinand Marian, Elizabeth Flickenschildt, Werner Hinz, Aribert Mog, Traudl Stark.

Die Rothschilds p: Ufa d: Erich Waschneck sc: C. M. Köhn and Gerhard T. Buchholz (from an idea by Mirko Jelusich).
With Carl Kuhlmann, Erich Ponto, Walter Franck, Gisela Uhlen, Herbert Hübner, Albert Lippert, Waldemar Leitgeb, Albert Florath.

Feinde (Enemies) p: Bavaria d: Viktor Tourjansky sc: Emil Burri, Arthur Luethy and Viktor Tourjansky.
With Brigitte Horney, Willy Birgel, Ivan Petrovich, Heinz Peters, Hedwig Wangel, Ludwig Schmid-Wildy, Nikolai Kolin, Carl Wery.

Jud Süss (Jew Süss) p: Terra d: Veit Harlan sc: Ludwig Metzger, Eberhard Wolfgang Möller and Veit Harlan.
With Ferdinand Marian, Werner Krauss, Heinrich George, Kristina Söderbaum, Eugen Klöpfer, Malte Jäger, Albert Florath, Theodore Loos.

Wunschkonzert (Request Concert) p: Cine-Allianz d: Eduard von Borsody sc: Felix Lützkendorf and Eduard von Borsody.
With Ilse Werner, Carl Raddatz, Joachim Brennecke, Heinz Goedecke, Ida Wüst, Hans Adalbert Schlettow, Malte Jäger, Albert Florath.
Romantic drama about a young couple united by a request programme.

Fahrt ins Leben (Journey into Life) p: Bavaria d-sc: Bernd Hoffman.
With Ruth Hellberg, Hedwig Bleibtreu, Herbert Hübner, Karl Ludwig Schneider, Ursula Herking, Karl John, Paul Westermeier.
Comradeship and training in a school for sailing cadets.

1941

Blutsbrüderschaft (Bloodbrotherhood) p: Terra d: Lothar Mayring sc: P. L. Mayring and H. G. Petersson.
With Anneliese Uhlig, Hans Söhnker, Ernst von Klipstein, Rudolf Plette, Paul Westermeier, Fritz Odemar, Wolfgang Staudte.

Annelie p: Ufa d: Josef von Baky sc: Thea von Harbou (from the play by Walter Lieck).
With Louise Ullrich, Werner Krauss, Karl Ludwig Diehl, Käthe Haack, Albert Hehn, Ilse Fürstenberg, Eduard von Winterstein.
A sort of German *Cavalcade*, covering the life of a woman and her family from 1871 to 1941, emphasizing the obligation to serve the state.

Carl Peters p: Bavaria d: Herbert Selpin sc: Ernst von Salomon, Walter Zerlett-Olfenius and Herbert Selpin.
With Hans Albers, Karl Danneman, Fritz Odemar, Hans Liebelt, Toni von Bukovics, Herbert Hübner, E. F. Fürbringer, Jack Trevor.

Heimkehr (Homecoming) p: Wien Film d: Gustav Ucicky sc: Gerhard Menzel.
With Paula Wessely, Peter Petersen, Attila Hörbiger, Ruth Hellberg, Carl Raddatz, Otto Wernicke, Elsa Wagner, Eduard Köck, Bertha Drews.

Ich klage an (I Accuse) p: Tobis d: Wolfgang Liebeneiner sc: Eberhard Frowein and Harald Bratt (based on themes in the novel *Sendung und Gewissen* by Hellmuth Unger and on an idea by Harald Bratt).
With Heidemarie Hatheyer, Paul Hartmann, Mathias Wieman, Christian Kayssler, Harald Paulsen, Albert Florath, Franz Schafheitlin.

Kopf hoch, Johannes (Chin up, John) p: Majestic d: Viktor de Kowa sc: Toni Huppertz, Wilhelm Krug and Felix von Eckhardt (from an idea by Huppertz).
With Albrecht Schönhals, Dorothea Wieck, Klaus Detlef Sierck, Leo Peukert, Volker von Collande, Karl Danneman, Otto Gebühr.

Jakko p: Tobis d: Fritz Peter Buch sc: Buch (from novel by Alfred Weidenmann).

With Norbert Röhringer, Eugen Klöpfer, Aribert Wascher, Albert Florath, Carsta Löck, Paul Verhoeven, Paul Westermeier, Ewald Wenck.

Jungens (*Guys*) p: Ufa d: Robert A. Stemmle sc: Otto Berhard Wandler, Horst Kerutt and Robert A. Stemmle (from Kerutt's novel).
With Albert Hehn, Bruni Löbel, Eduard Wenck, Hilde Sessak, Georg Thomalla, Wolfgang Staudte, Wilhelm König, Wilhelm Grosse.

Kadetten (*Cadets*) p: Ufa d: Karl Ritter sc: Felix Lützkendorf and Karl Ritter (from an idea by Alfred Menne).
With Mathias Wieman, Andrews Engelmann, Carsta Löck, Theo Shall, Klaus Detlef Sierck, Josef Keim, W. P. Krüger, Lydia Li, Martin Brendel.

Kameraden (*Comrades*) p: Bavaria d: Hans Schweikart sc: Peter Francke and Emil Burri.
With Willy Birgel, Martin Urtel, Karin Hardt, Rudolf Fernau, Maria Nicklisch, Rolf Weih, Karl Wery, E. F. Fürbringer, Herbert Hübner.
Prussian freedom-fighters resist Napoleon.

Kampfgeschwader Lützow (*Battle Squadron Lützow*) p: Tobis d: Hans Bertram sc: Hans Bertram, Wolfgang Neumeister and Heinz Orlovius.
With Heinz Welzel, Carsta Löck, Christian Kayssler, Hermann Braun, Peter Voss, Ernst Stimmel, Adolf Fischer, Hans Bergmann.

Mein Leben für Irland (*My Life for Ireland*) p: Tobis d: Max W. Kimmich sc: Max W. Kimmich and Toni Huppertz.
With Anna Dammann, Werner Hinz, René Deltgen, Will Quadflieg, Heinz Ohlsen, Eugen Klöpfer, Paul Wegener, Claus Clausen, Karl John.

Menschen im Sturm (*Men in the Storm*) p: Tobis d: Fritz Peter Buch sc: George Zoch (from an idea by Karl Anton and Felix von Eckhardt).
With Olga Tschechowa, Siegfried Breuer, Kurt Meisel, Gustav Diessl, Franz Schafheitlin, Heinz Welzel, Josef Sieber, Walter Brückner.
Heroic Germans resist Serbian persecution.

Ohm Krüger p: Tobis d: Hans Steinhoff sc: Harald Bratt and Kurt Heuser (from the book *Mann ohne Volk* by Arnold Krieger).
With Emil Jannings, Gustaf Gründgens, Ferdinand Marian, Hedwig Wangel, Otto Wernicke, Franz Schafheitlin, Werner Hinz, Alfred Bernau.

Sechs Tage Heimaturlaub (*Six Days' Leave*) p: Cine-Allianz d: Jürgen von Alten sc: Walter Forster and Rudo Ritter.

With Gustav Fröhlich, Maria Andergast, Hilde Sessak, Käthe Haack, Günther Lüders, Wilhelm Althaus, Lotte Spira, Lutz Götz.
Warrant officer finds romance on six days' leave.

Spähtrupp Hallgarten (*Hallgarten's Reconnaissance Patrol*) p: Germania d: Herbert Fredersdorf sc: Kurt E. Walter and Herbert Fredersdorf.
With René Deltgen, Paul Klinger, Maria Andergast, Ursula Herking, Gustav Waldau, Karl Martell, Gustav Püttjer, Rudolf Carl.

Stukas p: Ufa d: Karl Ritter sc: Felix Lützkendorf and Karl Ritter.
With Carl Raddatz, Albert Hehn, Hannes Steltzer, O. E. Hasse, Josef Dahmen, Ernst von Klipstein, Georg Thomalla, Karl John, Adolf Fischer.

U-Boote Westwarts (*U-Boat Westwards*) p: Ufa d: Günther Rittau sc: Georg Zoch.
With Ilse Werner, Herbert Wilk, Heinz Engelmann, Joachim Brennecke, Josef Sieber, Carsta Löck, Karl John, Clemens Hasse, Herbert Klatt.

Über Alles in der Welt (*Above All in the World*) p: Ufa d: Karl Ritter sc: Felix Lützkendorf and Karl Ritter.
With Carl Raddatz, Hannes Steltzer, Fritz Kampers, Marina von Ditmar, Bertha Drews, Carsta Löck, Joachim Brennecke, Paul Hartmann.

Wetterleuchten um Barbara (*Summer Lightning about Barbara*) p: Rolf Randolf Film d: Werner Klingler sc: Hans Sassmann and H. G. Petersson (from the novel by Irmgard Wurmbrand).
With Sybille Schmidt, Attila Hörbiger, Viktor Staal, Oskar Sima, Maria Koppenhöfer, Eduard Köck, Heinrich Heilinger, Karl Meixner.

1942

Anschlag auf Baku (*Attack on Baku*) p: Ufa d: Fritz Kirchhoff sc: Hans Weidemann and Hans Wolfgang Hillers.
With Willy Fritsch, René Deltgen, Lotte Koch, Fritz Kampers, Aribert Wascher, Erich Ponto, Hans Zesch-Ballot, Paul Bildt.

Der Fall Rainer (*The Rainer Affair*) p: Tobis d: Paul Verhoeven sc: Jacob Geis, Wilhelm Krug and Paul Verhoeven (from the novel *Der Mann mit der Geige* by Herbert Reinicker).
With Luise Ullrich, Paul Hubschmid, Karl Schönbock, Sepp Rist, Maria Koppenhöfer, Norbert Röhringer, Viktor Gehring, Walter Janssen.
Drama about a treacherous attempt to end the

First World War and the opposition to this by gallant officers.

Der grosse König (The Great King) p: Tobis d-sc: Veit Harlan.
With Otto Gebühr, Kristina Söderbaum, Gustav Fröhlich, Paul Wegener, Kurt Meisel, Claus Clausen, Klaus Detlef Sierck, Herbert Hübner.

Die Entlassung (The Dismissal) p: Tobis d: Wolfgang Liebeneiner sc: Curt J. Braun and Felix von Eckhardt.
With Emil Jannings, Werner Krauss, Werner Hinz, Theodor Loos, Karl Ludwig Diehl, Paul Bildt, Herbert Hübner, Fritz Kampers.

Die grosse Liebe (The Great Love) p: Ufa d: Rolf Hansen sc: Rolf Hansen and Peter Groll (from an idea by Alexander Lernet-Holenia).
With Zarah Leander, Viktor Staal, Paul Hörbiger, Hans Schwartz Jr, Wolfgang Preiss, Leopold von Ledebur, Paul Bildt, Grethe Weiser.
Musical about the trials and tribulations of a young married couple during the war.

Fronttheater p: Terra d: Arthur Maria Rabenalt sc: Georg Hurdalek, H. F. Köller and Werner Plücker (from an idea by Werner Scharf).
With Heli Finkenzeller, René Deltgen, Lothar Firmans, Willi Rose, Bruni Löbel, Adolf Fischer, Peter Elshholtz, Arnim Münch.
Married couple, parted by the war, are reunited in Athens where the wife is entertaining the troops.

G. P.U. p: Ufa d: Karl Ritter sc: Andrews Engelmann, Karl Ritter and Felix Lützkendorf (from an idea by Engelmann).
With Laura Solari, Will Quadflieg, Marina von Ditmar, Andrews Engelmann, Hans Stiebner, Maria Bard, Ivo Veit, Lale Anderson.
Drama about the evils of the Russian Secret Police.

Geheimakte WB I (Secret Paper WB I) p: Bavaria d: Herbert Selpin sc: Herbert Selpin and Walter Zerlett-Olfenius (from the novel *Der eiserne Seehund* by Hans Arthur Thies).
With Alexander Golling, Eva Immerman, Richard Haussler, Günther Lüders, Herbert Hübner, Gustav Waldau, Willi Rose, W. P. Krüger.

Himmelhunde (Sky Hounds) p: Terra d: Roger von Norman sc: Philipp Lothar Mayring (from an idea by Hans Fischer-Gerhold and Hans Heise).
With Malte Jäger, Waldemar Leitgeb, Lutz Götz, Albert Florath, Toni von Bukovics, Klaus Pohl, Siegfried Schneider, Rudolf Vones.

Schicksal (Fate) p: Wien Film d: Geza von Bolvary sc: Gerhard Menzel.
With Heinrich George, Gisela Uhlen, Will Quadflieg, Werner Hinz, Christian Kayssler, Walter Lieck, Heinz Olsen, Heinz Wöster.
A drama of the Bulgarian Revolution in 1919.

Wien 1910 (Vienna 1910) p: Wien Film d: E. W. Emo sc: Gerhard Menzel.
With Rudolf Forester, Heinrich George, Lil Dagover, O. W. Fischer, Carl Kuhlmann, Otto Tressler, Herbert Hübner, Karl Hellmer.

Zwei in einer grossen Stadt (Two in a Big City) p: Tobis d: Volker von Collande sc: Volker von Collande and Ursula von Witzendorff.
With Monika Burg, Karl John, Marianne Simson, Hansi Wendler, Volker von Collande, Hannes Keppler, Käthe Haack.
Romance during leave from the front.

1943

Der unendliche Weg (The Unending Road) p: Bavaria d: Hans Schweikart sc: Walter von Molo and Ernst von Salomon (from the novel *Einer Deutsche ohne Deutschland* by von Molo).
With Eugen Klöpfer, Lisa Hellwig, Eva Immerman, Hedwig Wangel, Alice Treff, Kurt Müller-Graf, E. F. Fürbringer, Herbert Hübner.

Ein schöner Tag (A Beautiful Day) p: Tobis d: Philipp Lothar Mayring sc: Harald Röbbeling and Philipp Lothar Mayring.
With Gertrud Meyen, Carsta Löck, Sabine Peters, Volker von Collande, Günther Lüders, Karl Danneman, Eduard Wenck.
Comedy about domestic problems of two couples, which are solved while the husbands are on leave from the front.

Germanin p: Ufa d: Max W. Kimmich sc: Max W. Kimmich and Hans Wolfgang Hillers (from the novel by Hellmuth Unger).
With Peter Petersen, Lotte Koch, Luis Trenker, Albert Lippert, Carl Günther, Joe Münch, Gerda van den Osten, Ernst Stimmel.

Liebesgeschichten (Love Stories) p: Ufa d: Viktor Tourjansky sc: Gustav Kampendank (from the novel by Walter Lieck).
With Willy Fritsch, Willi Rose, Hannelore Schroth, Elizabeth Flickenschildt, Norbert Röhringer, Walter Franck, Eduard Wenck.
Romantic drama about the love of a shoemaker's son and a nobleman's daughter.

1944

Die Degenhardts (The Degenhardts) p: Tobis

d: Werner Klingler sc: Wilhelm Krug and Georg Zoch (from an idea by Hans Gustl Kernmayr).
With Heinrich George, Renée Stobrawa, Wolfgang Lukschy, Ernst Schröder, Gunnar Möller, Erich Ziegel, Heinz Klingenberg.
Drama about a 'typical' German family and its contribution to the war effort.

Die Affäre Rödern (*The Rödern Affair*) p: Berlin Film d: Erich Waschneck sc: Gerta Ital and Toni Huppertz.
With Paul Hartmann, Annelies Reinhold, Clementia Egies, Rudolf Fernau, Karl Danneman, Franz Schafheitlin, Herbert Hübner.
Love versus patriotism in the First World War.

Junge Adler (*Young Eagles*) p: Ufa d: Alfred Weidenmann sc: Herbert Reinecker and Alfred Weidenmann (from an idea by Reinecker).
With Willy Fritsch, Herbert Hübner, Ditmar Schönherr, Albert Florath, Aribert Wascher, Paul Henckels, Josef Sieber.

1945

Kolberg p: Ufa d: Veit Harlan sc: Veit Harlan and Alfred Braun.
With Heinrich George, Kristina Söderbaum, Paul Wegener, Horst Caspar, Gustav Diessl, Otto Wernicke, Irene von Meyendorff, Claus Clausen, Kurt Meisel, Franz Schafheitlin, Paul Henckels.

Note on 16 mm

Regrettably few of the Nazi films I have discussed are available for hire at present, though prints of many of them, confiscated after the war, are in the country. But it is possible that the B.F.I.'s policy of producing more 16 mm prints of the films in the National Film Archive will bring more of them to light. At present it is possible to hire a representative selection of the films I have discussed, sufficient certainly for a short course. The B.F.I. have *Olympiad* and *Das blaue Licht* and the Imperial War Museum have *Triumph of the Will*, *Ohm Krüger*, *Morgenrot* and *Der ewige Jude*.

Select Bibliography

Periodicals

The following periodicals proved very helpful:
Bioscope
Cinema
Encounter
Films and Filming
Films in Review
Focus on Film
Magnet
Monthly Film Bulletin
Observer
Picturegoer
Sight and Sound
Silent Picture
Spectator
The Times
Today's Cinema

Books and articles

Adam Smith, Janet, *John Buchan* (London, 1965; Boston, 1966).

Agate, James, *Around Cinemas* (second series) (London, 1948; New York, 1972).

Allen, F. L., *The Big Change* (New York, 1952).

Allied Control Commission Catalogue of Forbidden German Films (Hamburg, 1951).

Altmann, John, 'Movies' role in Hitler's conquest of German youth', *Hollywood Quarterly*, iii (4), pp. 379–86.

Amery, Leopold S., *The Empire in the New Era* (London, 1928).

Anderson, Lindsay, 'The method of John Ford' in *The Emergence of Film Art*, ed. Lewis Jacobs (New York, 1969), pp. 230–45.

Anderson, Lindsay and Sherwin, David, *If . . .* (London, 1969).

Arliss, George, *George Arliss By Himself* (London, 1940). U.S. title: *My Ten Years in the Studios* (Boston, 1940).

Balcon, Michael, *A Lifetime of Films* (London and New York, 1969).

Bateson, Gregory, 'An analysis of the film *Hitlerjunge Quex*', in *The Study of Culture at a Distance*, eds Margaret Mead and Rhoda Métraux (Chicago, 1953), pp. 302–14.

Bauer, Dr Alfred, *Deutsche Spielfilm Almanach 1929–1950* (Berlin, 1950).

Baxter, John, *Hollywood in the Thirties* (London and New York, 1969).

Behlmer, Rudy, 'Merian C. Cooper', *Films in Review* (January 1966), pp. 17–35.

Bennett, George (ed.), *The Concept of Empire* (London and New York, 1962).

Berson, Arnold, 'The truth about Leni', *Films and Filming* (April 1965), pp. 15–19.

Blake, Robert, *Disraeli* (New York, 1968; London, 1969).

Blobner, Helmut and Holba, Herbert, 'Jackboot cinema', *Films and Filming* (December 1962), pp. 12–20.

Bluestone, George, *Novels into Films* (Los Angeles, 1957).

Bodelsen, C. A., *Studies in Mid-Victorian Imperialism* (Copenhagen, 1924).

Bogdanovitch, Peter, *John Ford* (London, 1967; Berkeley, 1968).

Bolt, Christine, *Victorian Attitudes to Race* (London and Toronto, 1971).

Booth, Michael, *English Melodrama* (London, 1965).

Bradley, Sir Kenneth, *Once a District Officer* (London and New York, 1966).

Bramsted, Ernest K., *Goebbels and National Socialist Propaganda 1925–1945* (Michigan, 1965).

Brown, Hilton, *Rudyard Kipling* (London and New York, 1945).

Brownlow, Kevin, *The Parade's Gone By* (London, 1968; New York, 1969).

Buchan, John, *Memory Hold the Door* (London, 1940).

Bucher, Felix, *Germany: An Illustrated Guide* (Zwemmer's Screen Series) (London, 1970).

Burden, Hamilton, *The Nuremberg Party Rallies 1923–1939* (London and New York, 1967).

Burrows, Michael, *John Ford and Andrew V. McLaglen* (St Austell, 1970).

Capra, Frank, 'Do I make you laugh?', *Films*

and Filming (September 1962), pp. 14–15.

Capra, Frank, *The Name Above the Title* (New York, 1971).

Carrington, Charles, *Rudyard Kipling: His Life and Work* (New York, 1955; London, 1970).

Chandler, Albert R., *Rosenberg's Nazi Myth* (Ithaca, 1945).

Cohen, Morton, *Rider Haggard* (London and New York, 1968).

Connell, Brian, *Knight Errant* (London and New York, 1955).

Cooke, Alistair (ed.), *Garbo and the Night Watchmen* (London, 1971; New York, 1972).

Coulson, Alan A., 'England and Anna Neagle', *Films in Review* (March 1967), pp. 149–62.

Coupland, Reginald, *The Empire in These Days* (London, 1935).

DeMille, Cecil B., *Autobiography* (Englewood Cliffs, New Jersey, 1959; London, 1960).

Disher, M. Willson, *Blood and Thunder* (London, 1949).

Disher, M. Willson, *Melodrama: Plots that Thrilled* (London and New York, 1954).

Dobrée, Bonamy, *Rudyard Kipling: Realist and Fabulist* (London and New York, 1967).

Durgnat, Raymond, *The Crazy Mirror* (London, 1969; New York, 1970).

Durgnat, Raymond, *A Mirror for England* (London, 1970; New York, 1972).

Durgnat, Raymond, 'Spies and ideologies', *Cinema* (2) (March 1969), pp. 5–13.

Edwardes, Michael, *High Noon of Empire* (London, 1965).

Eisner, Lotte, *The Haunted Screen* (London and Berkeley, 1969).

Ekirch, Arthur E., *The American Democratic Tradition* (New York, 1963).

Everson, William K., *The Bad Guys* (New York, 1964).

Everson, William K., 'Forgotten Ford', *Focus on Film* (6) (Spring 1971), pp. 13–19.

Everson, William K., *A Pictorial History of the Western* (New York, 1969).

Eyles, Allen, *The Marx Brothers: Their World of Comedy* (London, 1966; New York, 1969).

Faber, Richard, *The Vision and the Need* (London, 1966).

Fenton, Robert W., *The Big Swingers* (New Jersey, 1967).

Franklin, Joe, *Classics of the Silent Screen* (New York, 1959).

Furhammer, Leif and Isaksson, Folke, *Politics and Film* (London, 1971).

Gifford, Denis, *British Cinema: An Illustrated Guide* (London and New York, 1968).

Gilbert, Martin, *Servant of India* (London, 1966).

Goldman, Eric, *Rendezvous with Destiny* (New York, 1956).

Gough-Yates, Kevin, *Michael Powell* (London, 1970).

Green, O. O., 'Michael Powell', *Movie*, no. 14 (Autumn 1965), pp. 17–20.

Grigg, Sir Edward, *The Faith of an Englishman* (London, 1937).

Griswold, A. Whitney, *Farming and Democracy* (Yale, 1952).

Grunberger, Richard, *Germany 1918–1945* (London, 1964).

Grunberger, Richard, *A Social History of the Third Reich* (London, 1971).

Hall, Dennis John, 'Gentleman Jack', *Films and Filming* (September 1970), pp. 74–81.

Halliwell, Leslie, *The Filmgoer's Companion* (New York, 1965; London, 1967).

Hardwicke, Sir Cedric, *A Victorian in Orbit* (London and New York, 1961).

Harlow, Vincent, *The Founding of the Second British Empire 1763–1793* (New York, 1952; London, 1964).

Hart, James D., *The Popular Book* (New York, 1950).

Hays, Samuel S., *The Responses to Industrialism* (Chicago, 1957).

Higham, Charles and Greenberg, Joel, *Hollywood in the Forties* (London and New York, 1968).

Himmelfarb, Gertrude, *Victorian Minds* (London and New York, 1968).

Hofstadter, Richard, *The Age of Reform* (London, 1962; New York, 1963).

Hofstadter, Richard, *The American Political Tradition* (London, 1962).

Hofstadter, Richard, *Anti-Intellectualism in American Life* (New York, 1963; London, 1964).

Houghton, Walter E., *The Victorian Frame of Mind* (Yale, 1957).

Howe, Suzanne, *Novels of Empire* (New York, 1949).

Hull, David Stewart, *Film in the Third Reich* (London and Los Angeles, 1969).

Hutchins, Francis, *The Illusion of Permanence* (Princeton, 1967).

Huttenback, Robert A., 'G. A. Henty and the vision of Empire', *Encounter*, 35 (1) (July 1970), pp. 46–53.

Jacobs, Lewis, *The Rise of the American Film* (New York, 1968).

Killam, G. D., *Africa in English Fiction* (Ibadan, 1968).

Kitses, Jim, *Horizons West* (London, 1969).

Knight, Arthur, *The Liveliest Art* (New York, 1959).

Koebner, R. and Schmidt, H. D., *Imperialism* (Cambridge, 1964).

Kracauer, Siegfried, *From Caligari to Hitler* (Princeton, 1947).

Lancelyn Green, Roger, *A. E. W. Mason* (London, 1952).

Lancelyn Green, Roger, *Tellers of Tales* (London, 1965).

Lane, Margaret, *Edgar Wallace* (London, 1939).

Lehmann-Haupt, Hellmut, *Art Under a Dictatorship* (New York, 1954).

Leiser, Erwin, *Deutschland Erwache!* (Hamburg, 1968).

Lockhart, J. G. and Woodhouse, C. M., *Rhodes* (London and New York, 1963).

Mack, E. C., *Public Schools and British Opinion since 1860* (New York, 1941).

Manvell, Roger and Fraenkel, Heinrich, *Dr. Goebbels* (London and New York, 1960).

Manvell, Roger and Fraenkel, Heinrich, *The German Cinema* (London, 1971).

Marcorelles, Louis, 'The Nazi Cinema', *Sight and Sound* (Autumn 1955), pp. 65–9.

Martin, Jay, *Harvests of Change* (New Jersey, 1967).

Maxwell, D. E. S., *American Fiction: The Intellectual Background* (London and New York, 1963).

McCarey, Leo, Interview in *Cahiers du cinema* (163) (February 1965), pp. 11–21.

McVay, Douglas, 'The five worlds of John Ford', *Films and Filming* (June 1962), pp. 14–17, 53.

Miller, William, *A New History of the United States* (London, 1970).

Minney, R. J., *Hollywood by Starlight* (London, 1935).

Mitry, Jean, *John Ford* (Paris, 1954).

Morris, James, *Pax Britannica* (London and New York, 1968).

Moss, George L., *The Crisis of German Ideology* (New York, 1964; London, 1966).

Mosse, George L. (ed.), *Nazi Culture* (London and New York, 1966).

Neumann, Franz, *Behemoth: the Structure and Practice of National Socialism* (London and New York, 1942).

Newbolt, Sir Henry, *Collected Poems* (London, 1907).

Niebuhr, Reinhold and Heimert, Alan, *A Nation So Concieved* (London and New York, 1963).

Niven, David, *The Moon's a Balloon* (London and New York, 1971).

Noames, Jean-Louis, 'L'art et la manière de Leo McCarey', *Cahiers du cinema* (163) (February, 1965), pp. 23–31.

Noble, Peter, *The Negro in Films* (London, 1947; New York, 1972).

Oakley, Charles, *Where We Came in* (London, 1964).

Ogilvie, Vivian, *The English Public School* (London and New York, 1957).

Orwell, George, *Collected Essays, Journalism and Letters* (London, 1970). U.S. title: *Dickens, Dali and Others: studies in popular culture* (New York, 1946).

Parrington, V. L., *Main Currents in American Thought* (New York, 1930).

Pascal, Roy, *The Nazi Dictatorship* (London, 1934).

Pearson, George, *Flashback* (London, 1957).

Perham, Margery, *Lugard: The Years of Adventure 1858–1898* (London and Fair Lawn, New Jersey, 1956).

Phillips, M. S., 'Nazi control of the German film industry', *Journal of European Studies*, I (1)

Pollack, Norman, *The Populist Response to Industrial America* (Cambridge, 1962).

Porter, Bernard, *Critics of Empire* (London and New York, 1968).

Pratley, Gerald, *The Cinema of John Frankenheimer* (London and New York, 1969).

Rawnsley, Canon H. D., *Ballads of the War* (London, 1901).

Richards, Frank, *The Autobiography of Frank Richards* (London, 1952).

Richards, Jeffrey, 'Ford's Lost World', *Focus on Film* (6) (Spring 1971), pp. 20–30.

Richards, Jeffrey, 'The Four Feathers', *Focus on Film* (6) (Spring 1971), pp. 52–4.

Richards, Jeffrey, 'Frank Capra and the Cinema of Populism', *Cinema* (5) (February 1970), pp. 22–8.

Richards, Jeffrey, 'Leni Riefenstahl: Style and Structure', *The Silent Picture* (8) (Autumn 1970), pp. 17–19.

Richards, Jeffrey, 'Robert Donat: A Star without Armour', *Focus on Film* (8) (Winter 1971), pp. 17–27.

Richards, Jeffrey, 'Ronald Colman and the Cinema of Empire', *Focus on Film* (4) (September–October 1970), pp. 42–55.

Riefenstahl, Leni, *Hinter den Kulissen des Reichsparteitagfilms* (Munich, 1935).

Riefenstahl, Leni, Interview in *Cahiers du cinema* (170) (September 1965), pp. 42–50, 62–3.

Ringgold, Gene and Bodeen, DeWitt, *The Films of Cecil B. DeMille* (New York, 1969).

Robinson, Ronald and Gallagher, John (with Denny, Alice), *Africa and the Victorians* (New York, 1966; London, 1967).

Robson, E. W. and M. M., *The Film Answers Back* (London, 1939).

Rotha, Paul and Griffith, Richard, *The Film Till Now* (London, 1949; New York, 1960).

Russell Pasha, Sir Thomas, *Egyptian Service 1902–1946* (London, 1949).

Sandison, Alan, *The Wheel of Empire* (London and New York, 1967).

Sarris, Andrew, *The American Cinema: Directors and Directions* (New York, 1968).

Schumann, Frederick, *Hitler and the Nazi Dictatorship* (London, 1936). U.S. title: *The Nazi Dictatorship* (New York, 1935).

Schwartz, Nancy, 'The role of women in *Seven Women*', *The Velvet Light Trap* (2) (August 1971), pp. 22–4.

Shanks, Edward, *Rudyard Kipling* (London and New York, 1940).

Shipman, David, *The Great Movie Stars – the Golden Years* (London and New York, 1970).

Smith, Henry Nash, *Virgin Land* (New York, 1950).

Spear, Percival, *A History of India* (London, 1965).

Stewart, Donald Ogden, Interview in *Focus on Film* (5) (Winter 1970), pp. 49–57.

Stewart, J. I. M., *Rudyard Kipling* (London, 1966).

Tabori, Paul, *Alexander Korda* (London, 1959).

Taylor, William Fuller, *The Economic Novel in America* (New York, 1969).

Thistlethwaite, Frank, *The Great Experiment* (Cambridge, 1955).

Thomas, Anthony, 'David Niven's blithe career', *Films in Review* (February 1969), pp. 92–106.

Thomas, Bob, *King Cohn* (London and New York, 1967).

Thomas, Tony, Behlmer, Rudy and McCarty, Clifford, *The Films of Errol Flynn* (New York, 1969).

Thornton, A. P., *Doctrines of Imperialism* (New York, 1965).

Thornton, A. P., *For the File on Empire* (London and New York, 1968).

Thornton, A. P., *The Habit of Authority* (London, 1966).

Thornton, A. P., *The Imperial Idea and its Enemies* (New York, 1959; London, 1967).

Tompkins, J. M. S., *The Art of Rudyard Kipling* (London, 1959; Lincoln, Nebraska, 1965).

Turner, E. S., *Boys Will be Boys* (London, 1948).

Usborne, Richard, *Clubland Heroes* (London, 1953).

Vallance, Tom (ed.), *Westerns* (London, 1964).

Verrina, *The Nazi Mentality* (London, 1941).

Warburton, Sir Robert, *Eighteen Years in the Khyber* (Karachi, 1970).

Warshow, Robert, *The Immediate Experience* (New York, 1970).

Weiss, Richard, *The American Myth of Success* (New York, 1969).

Wilcox, Herbert, *25,000 Sunsets* (London, 1967).

Wilkinson, Rupert, *The Prefects* (London, 1964). U.S. title: *Gentlemanly Power* (New York, 1964).

Wollen, Peter, *Signs and Meanings in the Cinema* (London, 1969).

Wollenberg, H. H., *50 Years of German Cinema* (London, 1948; New York, 1972).

Wulf, Josef, *Theater und Film im Dritten Reich* (Berlin, 1964).

Zeman, Z. A. B., *Nazi Propaganda* (Oxford, 1964).

Zimmerman, Paul D. and Goldblatt, Burt, *The Marx Brothers at the Movies* (New York, 1968).

Zinman, David, *Fifty Classic Motion Pictures* (New York, 1970).

General index

Index of film titles